DESIGNING INTERIORS

www.IDIBC.org

DESIGNING INTERIORS

ROSEMARY KILMER · ASID

W. OTIE KILMER · AIA

WADSWORTH

━━━━━━━ ✦ ━━━━━━━ ™

THOMSON LEARNING

Australia • Canada • Mexico • Singapore • Spain
United Kingdom • United States

WADSWORTH

THOMSON LEARNING

Publisher: Ted Buchholz
Acquisitions Editor: Janet Wilhite
Development Editor: Terri House
Project Editor: Mark Hobbs
Art Director: Vicki McAlindon Horton
Text Designer: Lurelle Cheverie
Cover Designer: Vicki McAlindon Horton

Drawings in Text: W. Otie Kilmer, AIA
Production Manager: Kathleen Ferguson
Cover Image: R. B. Ferrier AIA architect
Cover Printer: RR Donnelley – Willard
Compositor: TechBooks
Printer: RR Donnelley - Willard

Printed in the United States of America

18 19 20 09 08 07

For more information about our products, contact us at:
Thomson Learning Academic Resource Center
1-800-423-0563

For permission to use material from this text, contact us by:
Phone: 1-800-730-2214
Fax: 1-800-730-2215
Web: http://www.thomsonrights.com

Library of Congress Catalog Card Number: 91-30717

ISBN-13: 978-0-03-032233-4
ISBN-10: 0-03-032233-2

Asia
Thomson Learning
60 Albert Street, #15-01
Albert Complex
Singapore 189969

Australia
Nelson Thomson Learning
102 Dodds Street
South Melbourne, Victoria 3205
Australia

Canada
Nelson Thomson Learning
1120 Birchmount Road
Toronto, Ontario M1K 5G4
Canada

Europe/Middle East/Africa
Thomson Learning
Berkshire House
168-173 High Holborn
London WC1 V7AA
United Kingdom

Latin America
Thomson Learning
Seneca, 53
Colonia Polanco
11560 Mexico D.F.
Mexico

Spain
Paraninfo Thomson Learning
Calle/Magallanes, 25
28015 Madrid, Spain

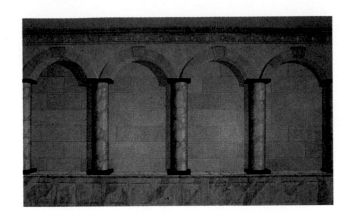

For Courtney and Lisa,
our daughters,
who have stood beside
us in this endeavor.
And to our former professor,
Ray Fink,
who taught us about
life, beauty, and the
love of teaching.

CONTENTS

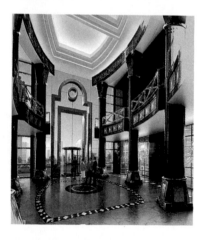

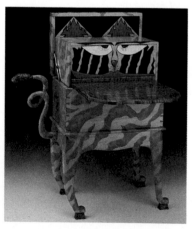

ACKNOWLEDGMENTS

We are indebted to many individuals and organizations for their invaluable help in shaping this book. Through their contributions of ideas, criticisms, photographs, and other illustrative materials has made "Designing Interiors" possible. Our goal in writing this textbook was to create a substantive foundation for learning about the scope of interior design, set a professional standard, and express the social awareness of designing interiors for people.

Without the help and encouragement of many special people, we could never have completed a book of this magnitude and complexity. Although we can not list the hundreds of individuals and their contributions, we do want to express our sincere thanks here to many.

Special appreciation is expressed to the many interior designers, architects, and photographers who have provided illustrations, photographs, and permission to use their materials to make this book a truly visual experience. We are especially thankful to Jim Follet, AIA—Vice President of Gensler and Associates; Neil Frankel, AIA—Vice President of Perkins and Will; Eric Miller, AIA; Kasler and Associates; DesignPlan Inc.; The Rowland Associates; Michael Graves, Architect; Centerbrook Architects; Victor Huff Partnership, Inc.; Media Five Architects; Charles Cunniffee and Associates/Architects; WilsonArt; Intergraph Corporation; ISICAD; and Herman Miller, Inc. Every effort has been made to correctly supply the proper credit information identifying interior designers, architects, photographers, and their projects. We apologize for any errors or omissions that may have occurred in these credits, if any.

We would like to thank our Dean, Dr. Don Felker, and our Department Head, Dr. Richard Feinberg, at Purdue University for their support and encouragement throughout this project.

We are grateful to a number of interior design educators throughout the country for their indepth reviews, criticism, and helpful suggestions as to the needs of the students and instructors in interior design. In particular, we would like to thank Jo Hasell, University of Florida;

Gunilla Finrow, University of Oregon; Fred Oberkircher, Texas Christian University; Steve Grout, Philadelphia College of Textiles; Ann Erickson, University of Minnesota; Lisa Waxman, Florida State University; Buie Harwood, Virginia Commonwealth University; Cigdem Akkurt, Iowa State University; Reed Benhamou, Indiana University; Margaret Weber, Oklahoma State University; Donald J. Sherman, Colorado State University; Ludwig Villasi, Kansas State University; Sheila Danko, Cornell University; for their reviews, and Dr. Chris Ladisch of Purdue University for her thorough review and contribution to the textile section in Chapter 13.

Special thanks to Gary Saxton, Bob Hosanna, and Brian Dunbar who gratiously took time out of their busy schedules to help do some of the line art.

The authors are deeply grateful to the dedicated staff at Harcourt Brace Jovanovich College Publishers. Without their guidance, assistance and dedicated work, this "great idea" of ours would have never become a reality. Among these individuals the authors are particularly indebted to Janet L. Wilhite, Acquisitions Editor—who believed in us at the beginning even after some doubtful setbacks, and moved this project into reality. To Kathryn M. Lang, former Development Editor, who was exceptionally dilligent and tireless in editing the text during the first three revisions and in coordinating the reviewers comments. To Terri House, Developmental Editor, who tirelessly and enthusiastically helped secure photographs and permissions for the art program, steered the project through countless difficulties and orchestrated the various elements that are part of a complex book—we are sincerely grateful. To the rest of the editorial, production, and design staff for Harcourt Brace Jovanovich College Publishers, who spent endless hours turning the manuscript into a finished book, we could not have proceeded without their help— Mark Hobbs, Vicki McAlindon Horton, Kathleen Ferguson, and Lurelle Cheverie.

Finally, we wish to express our deep appreciation for the continual support of our family and friends through this long project. Special recognition must be given to our daughters, who provided day-by-day encouragement and strength.

ROSEMARY AND OTIE KILMER

PREFACE

nterior design is an exciting and expanding profession. The responsibilities of an interior designer encompass all spaces, components, and elements within environments built for human needs and endeavors and to express human aspirations. The education of the professional interior designer aims for the highest levels of creativity and skill in designing for our increasingly complex and technological society. Interior designers are actively responsive to issues that concern our societies, our people, and this planet. These professionals have a commitment to conserving energy, ending pollution, preventing global warming, and recycling our resources. They support the preservation of endangered life and plant forms, as well as cultures and buildings. Interior designers try to understand the interrelationships of local and global factors and to make positive design decisions on both the macro and the micro levels. Above all, the interior designer is cognizant of human needs, cultural differences, and the contextual links necessary for responsive and responsible environments.

This book is intended to serve as a comprehensive overview of the basic knowledge required for the education of the professional interior designer. As the field of interior design becomes an increasingly regulated profession, education and practice will continue to emphasize a solid expertise in designing for people, their environments, and a better quality of life for all. Complex technical knowledge and creativity will be required to implement environments while protecting the health, safety, and welfare of the public. *Designing Interiors* incorporates material essential to the preparation of a designer who has a holistic view and is capable of communicating with other professionals to help create successful interior spaces.

Interior design is presented in this book as an integrated process applicable to both residential and nonresidential (commercial) interiors. Although interior designers and some colleges focus on one or the other of these, the design of residential interior environments and the design of commercial interior environments are presented herein as similar processes with similar

concerns. Although each area has special concerns, the education of interior design students has a base applicable to both.

This book is intended to be used primarily as an introduction to interior design at the college level, yet it is flexible. As beginning interior design courses can vary in their content, breadth of coverage, and approach, some parts of this book may not be applicable for a single course or for a particular instructor's teaching methods. Some chapters or sections might be bypassed or rearranged according to an instructor's preferences. Some of the technical matter might be saved for use in upper-level courses. However, this book can serve as an introduction to those topics and as a comprehensive reference for interior design students throughout their education.

The text is organized into parts consisting of related chapters. Content is introduced at basic conceptual levels and applied to the practice of interior design; then more complex information is added. This structure parallels the education and practice of interior designers from initial problem awareness and definition to incorporating various materials and building systems to create interior spaces.

Photographs and other illustrations are carefully chosen to reinforce ideas within the text. These images enhance the reader's appreciation and understanding of the principles and relationships of interior spaces.

Each chapter ends with a list of books, articles, etc., for further reading.

''PART ONE: THE HISTORICAL AND THEORETICAL BASES OF DESIGN'' introduces the reader to the field of interior design, discussing the foundations of design from early to modern times. The relationship of interior design to society and built environments is defined and explored. An overview of design history helps the beginning student understand the influences that created a particular solution or style. These insights provide the student with a contextual sense in design purpose, drawing from the past to understand tomorrow. The timeless elements and principles of design are defined and applied in making functional and aesthetic decisions about the conception and construction of interior spaces. Color and light are examined as interrelated concepts affecting our perceptions of our surroundings.

"PART TWO: PLANNING RESIDENTIAL AND COMMERCIAL SPACES"
provides an in-depth look at the active, creative processes interior designers use to recognize, organize, analyze, and solve problems in the built environment. Various sequences describe how designers achieve effective and unique solutions. Programming is detailed as a method for defining user needs and activities, gathering and evaluating facts, and arriving at specific parameters for the interior design. Space planning is presented with examples and applications.

"PART THREE: THE EXTERIOR AND INTERIOR ENVIRONMENTS"
encompasses the relationships and influences of the exterior and interior environments. Current concerns for energy efficiency, historical preservation/restoration, regulatory codes, design for the physically impaired, and other issues are discussed in relation to interior design. Environmental issues and technical systems that support and control interior spaces are defined and described as integral parts of the interior designer's practice. Coordination with other design professionals as part of the teamwork needed to construct buildings and interior spaces is discussed.

"PART FOUR: INTERIOR MATERIALS, ARCHITECTURAL SYSTEMS, FINISHES, AND COMPONENTS" examines materials used for constructing and finishing interior spaces. How these materials and assembly methods generate forms and serve as integral components for creating interiors is presented.

"PART FIVE: FURNITURE, FURNISHINGS, AND EQUIPMENT" includes a discussion of "accessories" as an integrated part of the furniture, furnishings, and equipment (FF&E) package that interior designers work with. FF&E items are planned for in the beginning of a project and refined to their specifics throughout the design process.

"PART SIX: ASPECTS OF PROFESSIONAL PRACTICE" focuses on the professional practice and the designer's methods of communication (drawings, photographs, models, oral and written presentations, etc.). A business sense is essential for successful designers. Basic practices and business operations are discussed to help the student understand and appreciate the variety and comprehensive practices of interior design before entering the profession. The future of interior design is highlighted and related to the profession's use of technological tools for designing tomorrow's interiors.

CONTENTS

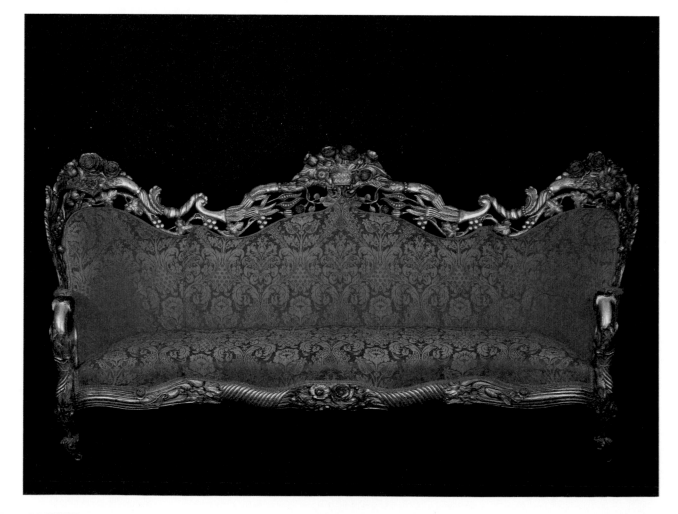

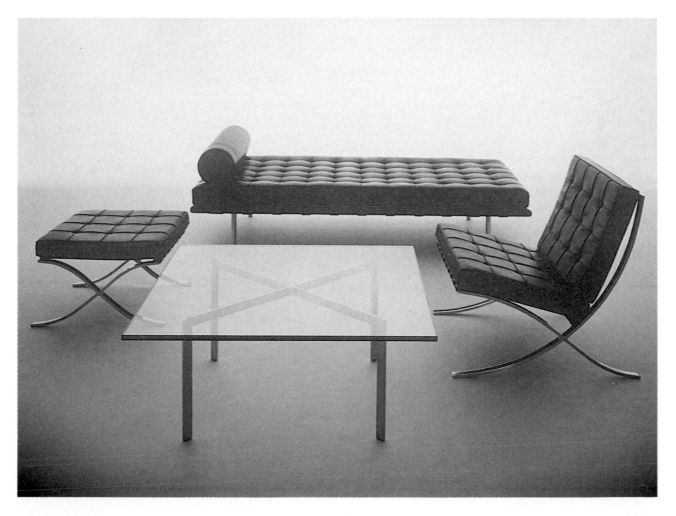

PART FIVE

FURNITURE, FURNISHINGS, AND EQUIPMENT

CHAPTER 16

FURNITURE 486

PART SIX

ASPECTS OF PROFESSIONAL PRACTICE

THE HISTORICAL AND THEORETICAL BASES OF DESIGN

PART ONE

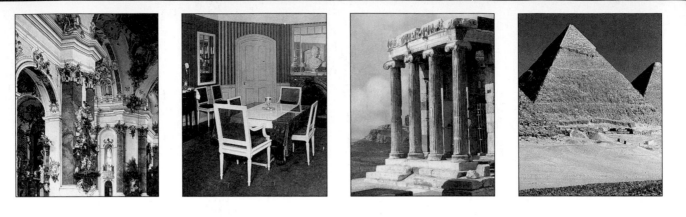

INTERIOR DESIGN: AN INTRODUCTION

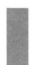Interior design is one of the most exciting and creative professions. A combination of art, science, and technology, interior design, in practice, manipulates space, form, texture, color, and light to enhance the quality of human life. This book is about interior spaces and their design and about interior design as a profession. The practice of actively designing interior space is a major commitment by those who enter the field—people who work toward improving our built environments.

We spend an increasing amount of our lives indoors in built environments. We wake from a night's sleep in some form of interior space and go to learn, work, or play in another space that gives a sense of purpose to our lives. We may briefly go outdoors to get to the site of our day's occupation, but the amount of time spent outdoors is usually only a fraction of the time spent indoors.

Why should we be concerned about the design of interiors? Well-designed spaces can contribute substantially to our sense of well-being, not just serve as shelters. They can be positive influences on our socialization, learning, and general appreciation of life. People's behavior can be positively or negatively reinforced by interaction with environmental forces.

The task of those who design our interior spaces becomes increasingly important as more people spend greater amounts of time indoors. Designers must devise spaces that serve the basic needs of the users and at the same time create positive and uplifting effects. Properly designed environments are efficient and harmonious. They can have a pervasive positive influence which interiors that are not carefully designed may not have.

HISTORICAL OVERVIEW

Presenting a history of interior design is a difficult task since no specific date, person, or space can be documented as the beginning point. The desire to create functional and pleasant interior environments existed long before freestanding buildings were being constructed. Designing interior spaces can be traced back to early cultures that painted pictures on the walls of their caves and furnished them with pelts for comfort. As people began to plan and construct buildings, the structure and the interior space within it were considered interrelated parts of a whole, which became known as architecture. Interior design, like architectural design, has been a basic part of the planning and building process from the beginning. Yet, the use and acceptance of the term *interior design* did not occur until after World War II. Previously, the term *interior decoration* described the finishing touches applied to the inside of a structure, but "interior decorating" was not recognized as a profession until the turn of the twentieth century. Like architecture, interior design and its practice have evolved from primitive enclosures to highly sophisticated structures and space enclosures.

Before the Nineteenth Century

Developing civilizations created shelter to protect people from the elements and serve other basic needs. As people became less nomadic, they began to build more permanent shelters. As farming replaced hunting, people gathered into communities—with structures for storage, shelter, and protection from enemies (Figure 1.1).

FIGURE 1.1 These basic shelters use the natural forms of grasses and thatch as design elements to protect the occupants from rain and wind.

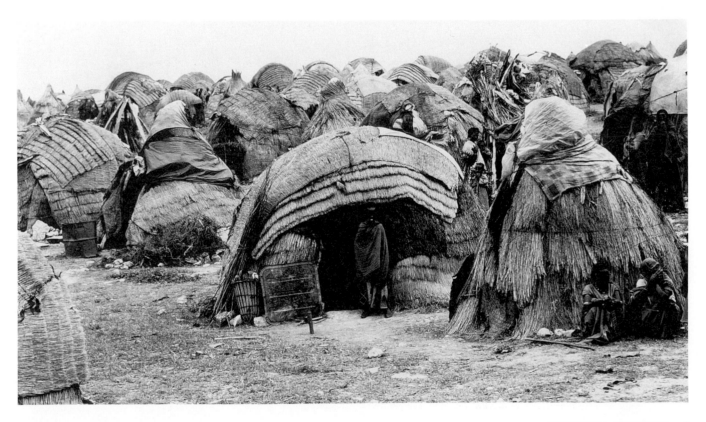

The Egyptians produced enough crops that they often needed to store or trade off the surpluses. As their civilization developed, they began to construct temples, ceremonial spaces, and monumental tombs (Figure 1.2). This specialization of buildings and their interiors became more common and could be considered the beginning of nonresidential design.

Greek and Roman civilizations constructed more elaborate and specialized spaces, such as temples, bath houses, and large arenas. They also pondered the meaning of beauty and the proportions of their structures, seeking to create "perfect" buildings (Figure 1.3). Many of these early structures were monumental. Architecture and the design of the interiors were an integral act, not separate endeavors.

As civilizations prospered, structures improved in materials, strength, and flexibility to serve a multitude of needs. Geographical factors also promoted variety in style as people sought to "personalize" their built environments according to the availability of materials and workmanship in a particular area.

By the eighteenth century, interior spaces had become more than simply functional; they served people's sense of taste, decor, and embellishment (Figure 1.4). Many of these interiors were created for the rich to display their wealth and luxury. However, the not-so-rich people were also living in interiors that, while not opulent, provided a continuum of design examples throughout the ages.

During this time, interior decoration was the responsibility primarily of the architects, artisans, and craftsmen. For example, English architects in the 1700s were designing interiors and even their furnishings. This trend was continued in America by later designers and architects, such as Samuel McIntire, Thomas Jefferson, and others before 1900.

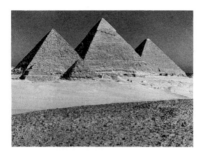

FIGURE 1.2 The Egyptian pyramids at Gizen (2723–2563 B.C.) provided permanence and concealment.

FIGURE 1.3 Temple of Athene Nike, Acropolis, Athens. This small temple (427–424 B.C.) is an excellent example of Greek architecture. The ionic order of columns is graceful, and the symmetry of the structure is well conceived.

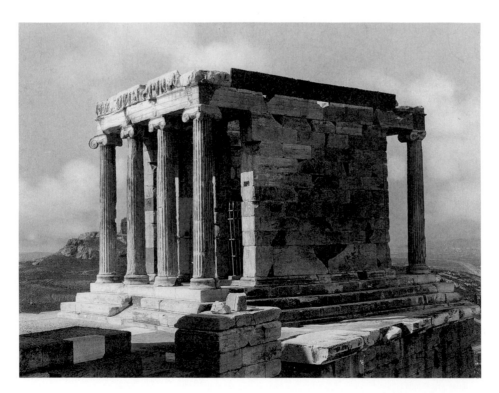

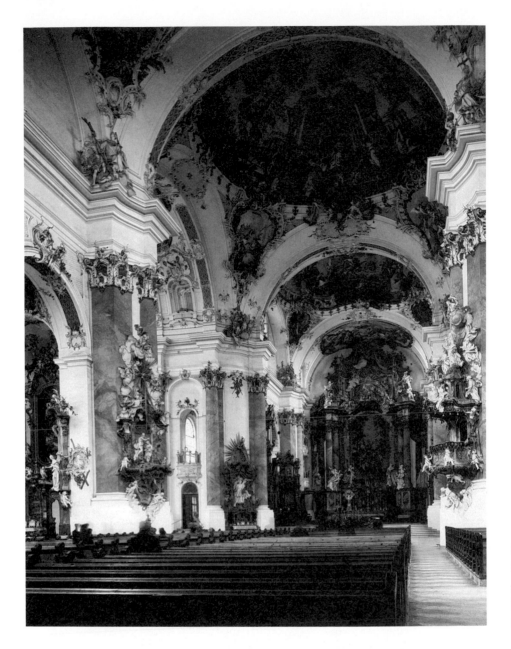

FIGURE 1.4 **Abbey of Ottobeuren, Bavaria (c. 1748). The interior of this space is lavishly decorated and highlighted with colored stucco to imitate marble.**

The Nineteenth and Twentieth Centuries: Decorating and Integrated Design

Interest in interiors and their furnishings was sustained through the nineteenth century and into the twentieth. During this time two distinct design directions developed. The first evolved from the term *decoration,* and the profession of decorating became established. Based on historical traditions, this direction was predominantly concerned with surface ornamentation, color, texture, furnishings, and accessories. The other direction was more concerned with the way things work, and it concentrated on innovation and invention. This design approach began to look at all aspects of interior design in terms of the overall shape of spaces, construction systems,

activity patterns, manufacturing processes, and the use of new materials. This approach was predominantly concerned with the integration of all elements within an interior space to achieve total design harmony. The work of Frank Lloyd Wright in the first decade of the twentieth century characterized this direction. Wright designed innovative interiors in which space was treated as a single entity where all materials, technologies, and ornamentation were integrated. His concept of total integration of all interior elements is called *organic design*. He defined interior space for specific activities by furniture arrangements rather than with enclosed walls. Wright achieved spatial variety and different areas within a single room by stepped floors and ceilings, so openness was not impeded.

Women also became active in the field of design and interior decorating. Candice Wheeler, who worked with the decorative artist L.C. Tiffany in the late 1800s, wrote an article entitled "Interior Decoration as a Profession for Women." Elsie de Wolfe (1865–1950) has been credited as being the first self-proclaimed interior decorator in America. She was born in New York City and went to finishing school in Scotland. As a member of the upper class and London society, she became used to elegance, refinement, and good taste. She began her career in 1904 as a professional interior decorator and got her first commission in 1905, for the Colony Club in New York City.

De Wolfe had a great impact on the decorating of interiors (Figures 1.5 and 1.6) and inspired other women to enter the profession. However, it was not until 1904 that courses were

FIGURE 1.5 Elsie de Wolfe designed this dining room in 1896; it reflected a dark and somber style that was prevalent at that time.

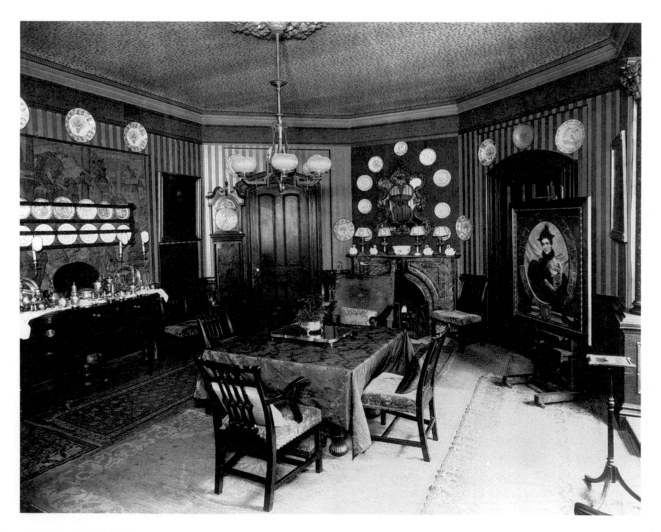

offered in interior decoration, so it was difficult to obtain formal training. If formal coursework was unavailable or too expensive for some, they learned from magazines or books.

"Interior decorator" became the most recognized title for those who planned surface embellishments of interior spaces. These individuals were concerned with the decorative arts, i.e., ornamentation, finishes, furnishings, and furniture, and dealt primarily with existing spaces.

After World War I, as the middle class became more prosperous, interest in professional interior decoration increased. The sale and manufacture of home furnishings flourished. Department stores, such as Macy's and Marshall Field, designed elaborate "vignettes" to display their merchandise. In the 1920s the art deco style revolutionized both the exterior and the interior design of office and other commercial buildings. Until that time, men had executed most of the interior design in commercial structures. Dorothy Draper (1889–1969) was one of the first American women decorators to specialize in commercial design. Her commissions included hotels, clubs, restaurants, shops, and hospitals.

After World War II, interiors of buildings demanded more than just decoration of the spaces. As commercial building industries flourished, their interiors became increasingly complex, requiring more attention to the functional needs of the users. Focus began to shift from the decorating of surfaces to establishing functionalism and activity-related support systems. There was also a shift from the exclusive involvement of high-income residential decorating to planning for commercial spaces.

FIGURE 1.6 In 1898, Elsie de Wolfe redecorated the same dining room in her brighter and lighter style.

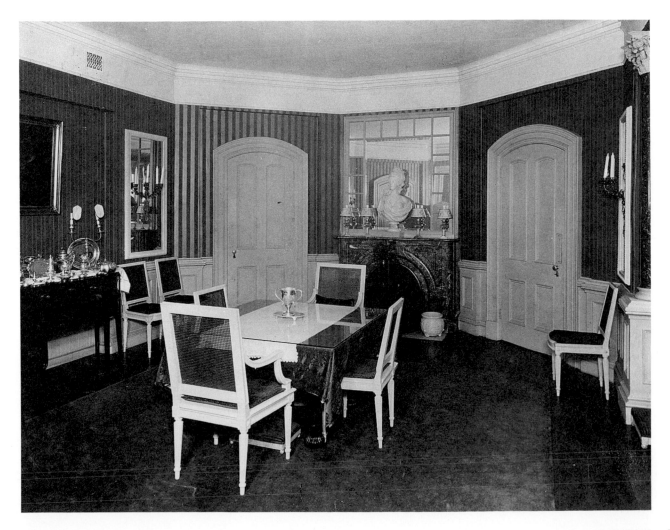

Today, the role of the interior designer has expanded to reflect the highly complex problems that environments pose in our continually changing technological society. Office buildings, hospitals, shopping centers, restaurants, schools, airports, residential communities, entertainment centers, hotels, and public buildings are but a few of the areas in which highly skilled interior designers team up with architects, engineers, planners, and developers to create better environments for a better quality of life.

INTERIOR DESIGN AS A PROFESSION

Interior design has grown rapidly and undergone many changes since the 1960s. It is a distinct, creative professional field closely allied with other design professions. One of the most exciting and expanding professional fields for dedicated students to enter, interior design is becoming more important every day as we remodel and build more interior environments. Interior designers of today and tomorrow must take up the challenge of creating more exciting and more technologically advanced environments in less and less space.

The Interior Designer

An interior designer is a creative person who develops ideas into objects and environments—for other people to use or interact with. Although this may seem simplistic; the act of designing is a complex combination of art and science. Interior design is involved with creating or modifying interior environments, including the structure, the life-support systems, the furnishings, and the equipment. In addition, the interior designer must deal with the experiences, needs, and personalities of the people (or users) within. Working with lighting, color, materials, human behavior, and accessories, the interior designer plans and organizes interior spaces to serve specific needs.

The term *interior designer* has been defined and endorsed by many professional societies, schools, accrediting agencies, and states and provinces. At this writing, according to the National Council for Interior Design Qualification, the definition of an interior designer is as follows:

The Professional Interior Designer is qualified by education, experience, and examination to enhance the function and quality of interior spaces. For the purposes of improving the quality of life, increasing productivity, and protecting the health, safety, and welfare of the public, the Professional Interior Designer:

- analyzes the client's needs, goals, and life and safety requirements;
- integrates findings with knowledge of interior design;
- formulates preliminary design concepts that are appropriate, functional, and aesthetic;
- develops and presents final design recommendations through appropriate presentation media;
- prepares working drawings and specifications for non-loadbearing interior construction, materials, finishes, space planning, furnishings, fixtures, and equipment;
- collaborates with professional services of other licensed practitioners in the techni-

cal areas of mechanical, electrical, and loadbearing design as required for regulatory approval;

- prepares and administers bids and contract documents as the client's agent;
- reviews and evaluates design solutions during implementation and upon completion.

Interior design is practiced by interior designers, architects, space planners, and decorators. Each has a particular viewpoint and expertise, and the role and merit of each viewpoint will continue to be debated in the schools, the professions, and the professional societies. These debates promote self-evaluation and, hence, advancement of the field of interior design.

Interior design is an integral part of the built environment, which in turn is an aspect of environmental design (Figure 1.7). Environmental design encompasses the entire natural and built environment, both interior and exterior spaces.

FIGURE 1.7 There are many areas or fields of design. The basic theories and principles are the same; however, the scale may change.

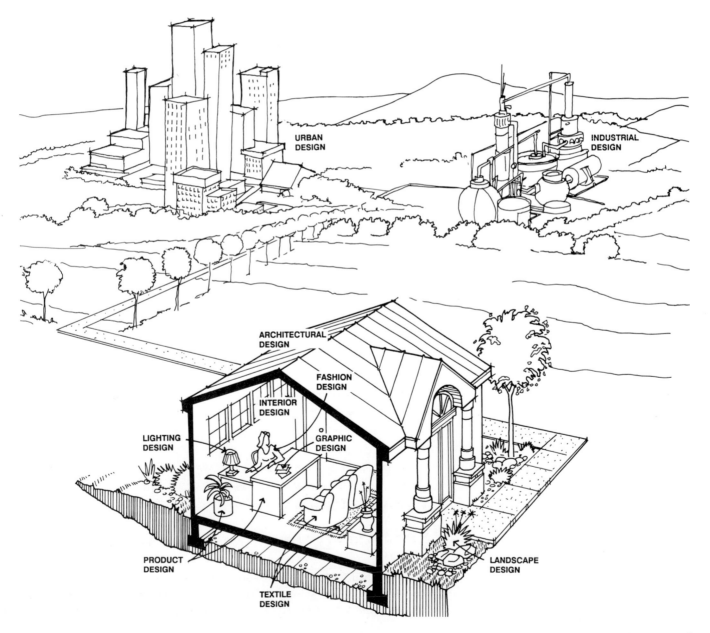

URBAN DESIGN

INDUSTRIAL DESIGN

ARCHITECTURAL DESIGN

FASHION DESIGN

INTERIOR DESIGN

LIGHTING DESIGN

GRAPHIC DESIGN

PRODUCT DESIGN

TEXTILE DESIGN

LANDSCAPE DESIGN

Allied Professions

Interior design is closely related to architecture and other professions. Specialists in these other fields work with interior designers in a team effort to create environments that serve users and enhance the quality of life.

DECORATOR

As discussed earlier, the decorator's role evolved over time, and today the decorator provides many services in the design field. Although the public often uses the term to refer to interior designers, there are differences between the decorator and the designer. Decorators are involved mostly with decorative surface treatments, accessories, furniture, and furnishings.

ARCHITECT

The architect today has been educated, served an internship, and been tested by exam to become registered (licensed). The title "architect" and the practice of architecture are protected and regulated by law. Architects design buildings, including the structural, electrical, mechanical, and other systems. Some architects also provide interior design services, including selection of furniture and other furnishings. However, many of these interior services are done by interior designers who are consultants to the architect or are part of an interior design department within the architectural firm.

The field of architecture has produced a series of specialized areas of expertise and practice: specification writers, systems architects, and interior architects, who primarily design the interior of a building. Some architects choose to practice in all areas of architecture, and others focus on a specialized area, such as residences, hospitals, or schools.

LANDSCAPE ARCHITECTURE

Landscape architecture is a separate profession concerned with the exterior environment and has its own licensing laws. Landscape architects are involved primarily in site planning and design and in exterior landscaping.

OTHER PROFESSIONALS

Industrial designers work integrally with the interiors industry to produce furniture and other accessories. Sometimes interior designers create these designs, and sometimes they hire industrial designers to design specific objects for the spaces.

The design of large corporate offices often requires the services of facility planners or managers to oversee the spatial needs of corporations as their personnel and equipment requirements change. A large number of these people are interior designers, yet some positions are filled by management and business graduates who in turn hire interior designers as part of the team.

The engineer also is a part of the team designing environments. Engineers are licensed and generally specialize in such areas as electrical, mechanical, structural, or acoustical engineering.

Professional Societies

Professional societies and organizations are established to serve and advance the various professions and to represent designers to the public. They provide information, resources, re-

search, continuing education, codes of ethics, lobbying efforts, and many other services for their memberships. Each has its own requirements for and levels of membership. Several societies to which interior designers and design educators belong are listed below. Some belong to more than one.

AMERICAN SOCIETY OF INTERIOR DESIGNERS (ASID) One of the largest interior design organizations is ASID, which has more than 31,000 members. It was formed in 1975 by a merger of the American Institute of Interior Designers (AID), founded in 1931, and the National Society of Interior Designers (NSID). ASID serves to advance the profession of interior design, inform and protect the public, promote design excellence, and strengthen interaction with related professions and industry. ASID provides educational materials and seminars, conventions, newsletters, and related design activities—including student chapters.

INSTITUTE OF BUSINESS DESIGNERS (IBD) IBD is an organization (more than 3,500 members) composed primarily of nonresidential designers. See Figure 8.3 for a complete listing of these practice specializations. IBD was formed in 1969 as a development of the National Office Furnishings Association (founded in 1963). Like ASID, IBD also provides many programs and services to the profession, public, and students.

INTERIOR DESIGNERS OF CANADA (IDC) IDC is an umbrella organization of professional designers who belong to various provincial associations. It was founded in 1972 to assist these associations in maintaining a national forum for common experiences and concerns. IDC has more than 1,700 members and promotes design excellence, education, research, information, and liaison with the public.

INTERNATIONAL FEDERATION OF INTERIOR ARCHITECTS/INTERIOR DESIGNERS (IFI) IFI was founded in 1963 in Denmark and is made up of worldwide design institutions and associations. It provides many of the services that other societies provide, but it functions primarily as an international forum for national associations and members (more than 18,000 professional members).

INTERIOR DESIGN EDUCATORS COUNCIL, INC. (IDEC) IDEC was founded in 1967 and serves to improve the quality of education and research in interior design. IDEC (more than 450 members) seeks to strengthen communication and education among the other related professions and in schools. It publishes the *Journal of Interior Design Education and Research* (JIDER), a design research journal.

FOUNDATION FOR INTERIOR DESIGN EDUCATION AND RESEARCH (FIDER) FIDER was established in 1970 to evaluate and accredit interior design programs in the United States and Canada. It is composed of a board of trustees made up of representatives from ASID, IBD, IDC, and IDEC.

NATIONAL COUNCIL FOR INTERIOR DESIGN QUALIFICATION (NCIDQ) NCIDQ was started in 1972 and establishes standards for the qualifications of interior designers. NCIDQ gives an exam twice a year across the United States and Canada to maintain these standards. Its membership is made up of organizations, not individual members. Passing the exam is often required to achieve the highest level of membership in some interior design societies. It is also the qualifying exam for those states that have licensing or registration laws governing the interior design profession.

INTERNATIONAL SOCIETY OF INTERIOR DESIGNERS (ISID) ISID was founded in 1979 and has a worldwide membership. It promotes design communication on an international level and supports education and legal recognition of professional interior designers.

AMERICAN INSTITUTE OF ARCHITECTS (AIA) AIA was founded in 1859 and has more than 50,000 members. Although the organization is composed primarily of architects,

many interior designers are also architects and belong to this organization in addition to others. The AIA has several national and state committees on interior design that are open to both interior designers and architects. These cooperative committees also help many of the other professional organizations communicate with each other.

ENTERING THE FIELD OF INTERIOR DESIGN

To become a professional interior designer, a person should have the proper academic training and a period of work experience in the professional field. In addition, in states that have passed a licensing act, the interior designer must pass the National Council for Interior Design Qualification exam and be registered with a state board. As interior design becomes more complex and technologically advanced, an academic preparation is of prime importance.

Academic Preparation

Many colleges, universities, and design schools in the United States and Canada offer academic programs for the education of interior designers. Today, more than 400 such programs are offered, ranging from four- or five-year baccalaureate degrees to two- and three-year degrees with varying titles. However, most programs are for four years and lead to either a Bachelor of Arts or a Bachelor of Science degree.

Interior design curricula are ever changing to accommodate the vast amount of knowledge and training needed for an expanding and complex profession. The introduction (in 1970) of an accrediting body serves the needs of standardizing the educational content of these programs.

FIDER The Foundation for Interior Design Education and Research (FIDER) has established a set of minimum basic accreditation criteria for interior design programs and has become the officially recognized accrediting agency for interior design education. FIDER establishes guidelines for educational institutions to follow to apply for membership and to be reviewed for accreditation. These institutions' programs are then accredited if they meet the FIDER standards. The agency also has set procedures for periodic reviews of member schools' programs and schedules revisits as necessary to ensure that the schools adhere to FIDER standards. The names and locations of FIDER-accredited schools can be obtained from the national headquarters of FIDER, which is based in Grand Rapids, Michigan.

UNIVERSITY AND COLLEGE PROGRAMS Interior design education at institutions of higher learning is generally offered in one of three basic programs: art and design, home economics, or architecture. Within each of these basic areas, some variance exists about how the program is structured, administered, and philosophically based. For example, an interiors program might be a subcomponent of an architectural department or school. The emphasis of such an interiors program then might be parallel to the education of an architect. Or one might find an interiors program, along with industrial and graphic design, as a part of the "applied" arts. Interiors programs can also be associated with home economics. However, most home economics

programs have been restructured to emphasize today's consumer and the behavioral sciences rather than homemaking skills.

There is no one way to teach interior design, and both FIDER and interior design educators recognize this. In fact, the FIDER guidelines allow for the various programs to provide a particular emphasis and vary their curricula, yet meet the required FIDER standards.

PRIVATE AND SPECIALIZED INSTITUTIONS Four- and five-year programs at institutions of higher education (often state supported) are not the only means available for a student to prepare for the design profession. Numerous two- and three-year programs in community colleges or at technical, vocational, and even specialized private institutions also provide a basic foundation in interiors. Some students begin their preparation in these places and continue their baccalaureate studies elsewhere. Some graduates of these two- and three-year programs become paraprofessionals, technical assistants, or eventually, professional designers.

Work Experience and Apprenticeships

An interior designer must have not only an academic preparation but also work experience before becoming qualified to sit for the NCIDQ exam. Usually this means post-educational employment with an established interior designer or related professional, such as an architect. Entry-level experience should include exposure to and guidance in all the various aspects of an interior design practice—not just drafting or some other narrow focus of professional practice. The length of experience varies in accordance with the educational background, type of firm, and the particular tasks the designers perform.

Some schools recognize a need for exposure to professional practice before a student graduates. These schools arrange intensive apprenticeships in a design or related firm to give their students valuable insight and a hands-on educational experience that cannot be duplicated in the academic setting.

Some schools offer a co-op (cooperative education) work experience. These programs alternate between on-campus coursework and off-campus work experiences to provide a balance of academic and practical work preparation.

Career Opportunities

Many career opportunities are available for the graduating interior design student. Interior design firms, architectural firms, furnishings dealers (residential and nonresidential), and retail establishments all employ interior designers. Positions are also found with in-house design services of various corporations, hospitality businesses, institutions, government agencies, and healthcare facilities. In addition, design careers are found in education, research, historic preservation, and many other specialized areas.

Students can enter the interiors field at junior-level positions and advance to senior designers, management positions, and even a principal of a firm. Salaries and benefits vary greatly in the interiors field, depending on the type of services offered, location, volume of business, and reputation of the designer.

LICENSING INTERIOR DESIGNERS

Many professionals are licensed by the states, which test and monitor these individuals to protect the health, safety, and welfare of the public.

Licensing (sometimes referred to as registration) is also a means to protect the title and control the qualifications for practicing a particular profession—especially educational prerequisites, experience requirements, and ethical standards. The interior design profession has moved toward licensing for the protection of the title and, in some states, the practice of the "interior designer." Most of the activities that interior designers are involved with, such as space planning, interior construction and detailing, lighting, drawings and specifications, project management, building code regulations, and on-site inspection, are concerned with the health, safety, and welfare of the public. Based on their services, interior designers are obligated to act in a professional manner and accept liabilities related to their work. The main reason for licensing interior designers is to assure standard qualifications and competence for people performing work in the profession.

Licensing acts are on a state or provincial basis and consist of two main types: a title act and a practice act. A title act is concerned with protecting the use of certain "titles" for individuals who have met specific qualifications and who have registered with a state board. This type of licensing act assures the public that anyone using the title has professional qualifications. A practice act restricts what an individual may or may not do in the "practice" of a profession. Anyone engaging in a profession with a practice act must also meet certain professional qualifications and be registered with a state board.

The major intent of either act is to indicate to the consumer and general public which individuals are qualified to practice according to specific criteria of education, work experience, and tests. However, a title act does very little to limit who can engage in practice, whereas a practice act can make such limitations.

At this writing, several states have enacted either a title act or a practice act for the interior design profession. It is clear that the profession will become more and more complex, require more knowledge of the technical aspects of interior design, and become more accountable for the environments the designers create, as indicated by the increased number of lawsuits involving design projects.

No doubt in the future we will see more states pass title and/or practice registration acts and require licensing as interior design gains recognition for protecting the public's health, safety, and welfare. Interior designers who are "certified" as a result of these acts will enjoy increased legal and public recognition.

REFERENCES FOR FURTHER READING

Abercrombie, Stanley. *A Philosophy of Interior Design*. New York: Harper & Row, Publishers, 1990.

Beecher, Catherine E., and Harriet Beecher Stowe. *The American Woman's Home*. New York: J.B. Ford & Co., 1869.

de Wolfe, Elsie. *After All*. New York: Harper & Row, 1935.

Hitchcock, Henry Russell, et al. *The Rise of American Architecture*. New York: Praeger Publishers, Inc., 1970.

Interior Design Educators Council. *Interior Design as a Profession*. Richmond, Va.: Interior Design Educators Council, 1983.

National Council for Interior Design Qualification. *NCIDQ Examination Guide*. New York: National Council for Interior Design Qualification, 1989.

Piotrowski, Christine. *Professional Practice for Interior Designers*. New York: Van Nostrand Reinhold, 1989, pp. 1–15.

Smith, C. Ray. *Interior Design in 20th Century America: A Concise History*. New York: Harper & Row, Publishers, 1987.

Veitch, Ronald, et al. *Professional Practice*. Winnipeg, Manitoba, Canada: Peguis Publishers, 1990, pp. 1–25.

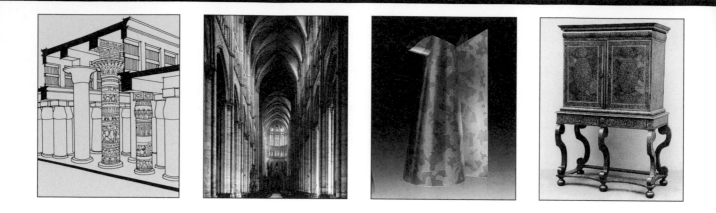

THE
ORIGINS
OF
DESIGN

The word *design* means different things to different people, but a common belief is that design is an active, planned process with a purpose, or a meaningful outcome. Design can also mean creating physical form from a mental image. Webster's dictionary says design is (1) "to plan and make with skill, i.e., as a work of art"; (2) "to form or make in the mind; conceive; invent"; and (3) "the organization of all elements into a unified whole."[1]

Design can be related to small, simple objects or large, complex ones. We speak of the design of a piece of pottery, the design of the clothes we wear, even the design of a large city. In nature, we can see the minute designs of small plants, animals, or fish—and on a grand scale, we can appreciate the complexity of the design of the universe.

Design influences every aspect of human endeavor, from the visual arts to industry, communications, and transportation. It is a unique combination of art, science, technology, and human intuition, collecting information from diverse areas and applying it to a specific situation.

We speak of a design for living, statistical design, architectural design, pictorial design, interior design, graphic design, textile design, and other kinds of design. In each "field" of design, we are referring to design as order or organization or as a plan for something, the first step in the creative process. Even in an aesthetic sense, design is the organization of elements and forms in a particular manner to fulfill a specific purpose or need. Design is an intrinsically conscious

process, and whether utilitarian or aesthetic, it is the deliberate act of forming materials and ideas to fit a certain function, need, or composition.

The impact of a design will depend on its successful organization of ideas or elements into unified wholes—the use of materials, the manipulation of form, aesthetic sensitivity, and satisfying a need. Design involves bridging the gap between people and things, improving human accommodation with physical surroundings, and increasing the safety and satisfaction of interactions between people and their environments. Design can increase efficient use of objects and spaces and act as a means of enhancing communication.

The established principles and criteria that determine the success of a design are based on the relationship between human needs and the efficiency of the design solution to meet these needs. Design principles apply to all fields or related areas of design (Figure 2.1), although the scale and application may change.

In this chapter we shall look at design from a theoretical viewpoint, that is, how its fundamental concepts have evolved over the centuries. In order to appreciate, understand, and apply the purposes of design, it is necessary to have some awareness of what has gone before in design movements and some idea of the direction design may take in the future.

THE MEANING AND ESSENCE OF DESIGN

What are the underlying fundamentals in "design"? One functional relationship is derived from nature. Human beings seem to possess an innate appreciation of design in nature, perhaps because we are an integral part of the natural environment. We can recognize the rightness, order, and beauty of objects and living things that please us, for example, the beauty of a blooming flower (Figure 2.2) or the majesty of snow-capped mountain peaks.

It can be said that "order" is the essence of any design. Order, or organization, can seem to occur spontaneously in nature. We can observe relationships, sequences, or correspondences in the environment that seem to exhibit some underlying system or cause-and-effect principle. In the built environment, order is often planned through a systematic use of materials, spaces, and objects. For example, the classical architectural orders of the Greeks and Romans exhibit aesthetically balanced proportion, mass, and scale (see Figure 2.12).

Human beings instinctively feel that most things in the natural environment "fit" or have a sense of rightness, but there are also things that we do not perceive to be beautiful or good—certain insects, snakes, or other creatures that appear to be harmful or annoying (Figure 2.3). Yet,

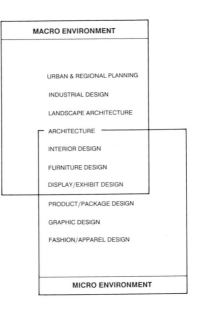

MACRO ENVIRONMENT

URBAN & REGIONAL PLANNING

INDUSTRIAL DESIGN

LANDSCAPE ARCHITECTURE

ARCHITECTURE

INTERIOR DESIGN

FURNITURE DESIGN

DISPLAY/EXHIBIT DESIGN

PRODUCT/PACKAGE DESIGN

GRAPHIC DESIGN

FASHION/APPAREL DESIGN

MICRO ENVIRONMENT

FIGURE 2.1 Design can be categorized into related fields of specialization on large and small scales. However, in practice many of these areas overlap or are closely allied.

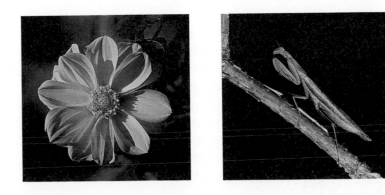

FIGURE 2.2 FAR LEFT This flower, like most things in nature, is a pleasing visual image to us.

FIGURE 2.3 LEFT Although at first glance the praying mantis is a fearsome sight, its design has a sense of order and function.

these creatures and elements are a part of the overall design scheme and natural order of things in the universe, and our negative perception of them doesn't mean they are poorly designed. Many designers are inspired by natural forms and their relationships.

On the other hand, some people find man-made, or "artificial," designs ugly or poorly designed—automobiles, buildings, and even cities. They may just be different from, or run counter to, the general design trend at the time (Figure 2.4). After time passes, these same objects may seem attractive to us, reflecting a response to something that may no longer be available or is considered rare, scarce, or an antique. The design itself has not changed, but society's judgment about it has.

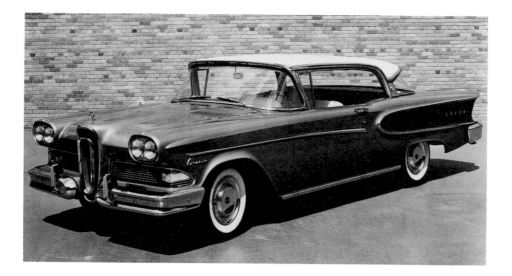

FIGURE 2.4 The Ford Edsel's design was not well accepted by the general public at the time of its introduction; it appeared too radical.

Primitive people often imitated things in nature that seemed to have some sense of order. The grass huts in Figure 1.1 reflect the natural ability of leaves or tightly bunched thatch to repel water and provide basic shelter. Igloos and tents are also refinements of basic natural shapes and effects. Primitive man used design also; he used natural materials and shapes to create and form tools to meet specific needs.

Design moves through time and is influenced by time. The designs of nature have survived, disappeared, or changed according to the natural process in which characteristics held fast, evolved, or became extinct in response to various forces.

Originality in Design

Originality in design is generally associated with the uniqueness of expression or in the problem solving of the designer. Originality in design is the creation of something totally new.

Many people might say that nothing is new, that everything has been invented, expressed, or created before and that we are merely reinterpreting. This is a futile argument, for all things change, including our perceptions of established truths or ideas. Interpreting history changes history (from our viewpoint) as we attempt to redefine it; so it is with design. In any case, while most design today is probably re-design or re-interpretation, such as in the "design" of plates, silverware, and glasses, there are no exact former working models or examples in history for designing micro-circuitry, lasers, compact disk players, space travel hardware, and so forth.

excite, please, shock, intrigue, attract, or even repel a viewer. If the creation evokes the intended response, it must be considered an effective design.

Primitive people's shelters, tools, and even weapons were a utilitarian form of functional design that served their immediate needs for survival. The visual aspect of these pieces reflects their workings. In other words, the objects look like what they should do, with no ornamentation or aesthetic intent. In these objects, function has a direct influence on design.

To some designers, functional design requires an "integrity" or unity in the designer's idea and "honesty" in the method of transforming that idea into reality. This design integrity, from the Latin *integritas,* meaning state or quality of the overall whole, can be expressed in three areas: function, form, and materials.

Integrity in function is stated in the design axiom "form follows function," usually attributed to the American architect Louis Henry Sullivan and closely linked to the Bauhaus, a design school founded about 1919 in Weimar, Germany (see Chapter 3). One of the avenues the Bauhaus explored was using designs that could be produced by machine for furniture, textiles, and even architecture. These designs were simplified to the essential form that represented the function they were to support.

In fact, Sullivan applied ornamentation to his buildings, so his designs cannot be said to be strictly functional. However, we must consider his practice of using ornamentation in reference to his time, when most designers and architects were applying elaborate decoration and stylistic features to their designs. It was not until the 1920s that functionalism became a concept that many designers and architects followed.

Today, we must carefully scrutinize the concept that "form follows function" since there often exists more than one way to express function or solve a problem in function. A window can be a simple glassed opening in a wall to let in light and air, or it can be elaborately embellished, yet serve the same purposes. Function is important, but functional design is not necessarily inherently successful or beautiful.

THE DEVELOPMENT OF DESIGN

The development and the history of design are important to the interior design student. They serve as the foundation for understanding the way architecture, interior design, and furniture evolved through time. Designers create forms and elements that may seem new to us, but many of these are really copies or adaptations of, or references to, historical styles. In some cases, however, we do see something that does not seem to have a historical precedent. This uniqueness often occurs because of a new building material, manufacturing process, construction method, or other technological innovation. Nonphysical influences, such as the inspirational beliefs that gave us the towering Gothic cathedrals, can also set the stage for major design movements.

By studying the origins of design, architecture, interiors, and furniture, today's interior designers can create forms that might incorporate great achievements of the past or reinterpret them to suit current needs and practices. History helps us understand what caused the invention of the wheel, its development, and ways we can improve and use it today—without having to reinvent it. The same is true for design: It is helpful to understand the impulses that created major design movements and style changes and to use those findings in the context of our needs and aspirations today.

It is not feasible to include here more than a basic outline of the history of design. This chapter treats only the most important movements and people in the development of design from

The creation of something that has never existed before (so that we can have no preconception of how it should look) might be considered the "most honest" or "purest" form of design. The tablets of the Sumerian civilization show us that a chair has been something to sit on since 4000 B.C., but an electronic space probe fired into outer space to send information about our universe back to Earth is totally new.

Functional and Visual Design Concepts

Basic concepts governing the practice of design can be expressed as functional and visual. Functional design deals primarily with physical needs (Figure 2.5), and visual design is basically aesthetic in nature and might not serve a physical purpose (Figure 2.6). The two concepts are often interrelated; many functional designs are visually satisfying, and many visual designs may be functional (Figure 2.7).

In functional objects, such as furnishings, automobiles, or cooking utensils, the purpose of the design is usually clear. Visual designs—paintings, sculpture, and other art forms—are created to elicit a response from the viewer and are mostly nonfunctional. An artwork can be created to

FIGURE 2.5 Although these creamers are primarily functional in design, they also have an aesthetic composition.

FIGURE 2.6 This sculpture, suspended from the ceiling with PVC-coated cable, fills the eight-story hotel lobby. The theme of water and fall leaves is depicted through the use of color and form in these twisting and cascading pieces made from 100% nylon sheer and fiberglass.

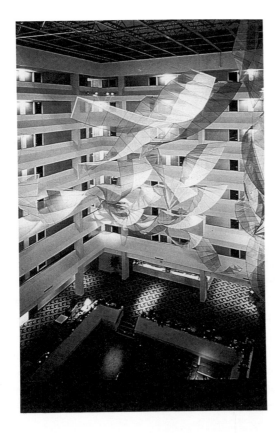

FIGURE 2.7 These light dimmer switches (top) and four-switch plate are designed as both visual and functional forms.

antiquity to the Victorian era. The Modern movement, beginning in the late nineteenth century, is covered separately in Chapter 3. Other books deal exclusively with the histories of architecture, design, interiors, and furniture, and most interior design and architectural schools have several courses devoted entirely to those subjects. Museums and surviving historical examples of architecture and furniture also can provide more detailed studies.

Context, Container, and Contents

In this chapter, we shall look at design movements as an integrated or contextual part of society, technology, and the process of constructing buildings (containers) and their interiors and furniture (contents). Interior design is an interrelated part of the built environment, thus demanding that we look at buildings and their interiors in the context of the whole. Context refers not only to the immediate surroundings of a building but to the region—the city, the nation, and other geographical influences that shape the container. We also speak of a building's context in relation to historical, political, sociological, and other forces that have an impact on the structure. In turn, the interiors and furniture (contents) of that building (container) have a contextual relationship to the physical and nonphysical characteristics of the enclosed space. Interiors and furniture are not just beautiful spaces and objects but necessary parts of the overall fabric that serves our human needs and aspirations. The contents of a space do not always follow the design of the structure that houses them, for interior and furniture design has a direct relation to, and is often a result of, the social, political, and economic conditions of a particular period of time.

Unfortunately, there is not ample space in this book to address all the interrelationships of the context, container, and contents of each era. Only the major periods and influences can be touched on. The student is encouraged to refer to the excellent sources listed at the end of this chapter and of Chapter 3.

Design and Style

It is difficult to talk about interior design or architecture without addressing the concept we often term *style*. Style can be defined as a specific or characteristic manner of expression, execution, construction, or design, in any art, period, work, or employment, such as the Byzantine style or Modern style. Like the word *design*, style can mean many different things. Style is associated with various social graces, literary productions, personal expressions, and mannerisms. We also speak of "life-styles," which reflect a complex relationship of trends and their influences on the way an individual or group lives.

In architecture and interior design, style is generally associated with an individual, a time, or a philosophy. It can refer to an aspect of a cultural period, such as the Victorian style. It can be more specifically associated with countries or regions that expressed that style uniquely; for example, certain churches and medieval furniture using the pointed arch can generally be classified as Gothic (Figure 2.8). However, the proportions and shape of Gothic structures in England differ from those found in France, resulting in English and French Gothic styles.

Social and technological influences have also produced individual stylistic interpretations. Examples can be seen in variations of furniture styles that reveal the artisans of the period and

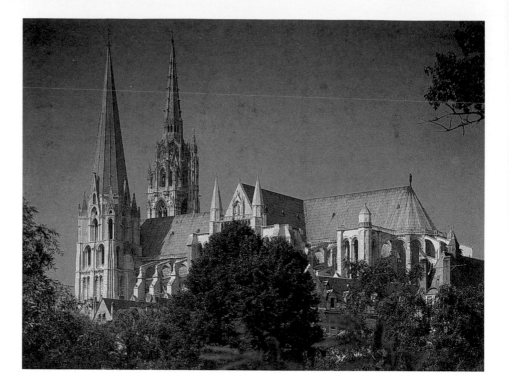

their methods of crafting furniture. Their materials and technology produced certain stylistic forms.

The development of styles can be more easily understood set in a wider frame of reference. We can summarize the development of architecture and interior design into three concepts in terms of space and style. The first theory was typified by the ancient architecture of Egypt and Greece, where interior space was defined by the interplay between objects or volumes. For example, Greek sculpture, art, architecture, and philosophy were interrelated.

The second concept encompassed the theories of architecture and arts of the Roman, Byzantine, Romanesque, Gothic, Renaissance, and Baroque periods. This concept is characterized by the development of the interior spaces through techniques such as the vaulted ceiling. The Renaissance is also considered to be the age of realism and individualism, which in turn created new forms of architecture and interiors.

The third concept is the Modern movement, which began about the end of the nineteenth century and is covered in Chapter 3. Its theory evolved from the first two, for each concept has been built on the foundation of previous thought and development. But new materials and technologies in our century have allowed an integral relationship between inner and outer space. Technological and social influences have permitted us to manipulate materials, construction methods, manufacturing methods, and even our way of life.

DESIGN HISTORY

A successful designer must have a good working knowledge of the development of design and its stylistic counterparts. The foundation of interior design is imbedded in the historical development of society, architecture, fine arts, and the crafts of the past.

Ancient Design

To understand how the design of interiors evolved over the centuries and how the various changes influence our ideas today, it is necessary to look back to our earliest built environments.

Not a lot of building history remains from the prehistoric, primitive, or ancient worlds. However, some secular buildings, such as huts and storage buildings, give us an indication of how early people adapted their local materials for shelter and other needs. The uncovering of various ceremonial temples and shrines has helped us to identify the way architecture and interior spaces advanced through the use of better material and better construction techniques, as well as through the intellectual pursuit of "planning" these structures and their groupings.

EGYPTIAN, 3100–311 B.C.

Egypt is a good starting point for our understanding of ancient design since many Egyptian building materials and the remains of Egyptians' tombs, art, and hieroglyphics have lasted through the millenia to give some insight into that civilization.

The Egyptians used their understanding of the world as they built structures and furniture for their daily needs. They built with mud bricks and stone and created design motifs based on their native vegetation—lilies, lotuses, reeds, date palms, and papyrus. They grew enough foods to consume and store, controlled the flooding of the Nile, domesticated animals, and traded profitably with other peoples.

The pyramids exemplify the Egyptians' architectural and engineering achievements (Figure 1.2). The pyramids, as well as the Egyptians' tombs and temples, were built of stone and fitted together with extreme precision. All these structures were developed with a sense of geometry, axis of circulation, and strong ceremonial concepts, which are still used today, as seen in Figure 2.9. The Egyptians developed post-and-lintel (trabeated) construction to span their roofs and interior spaces. Their columnar hypostyle halls allowed them to create larger interior spaces than were possible in earlier times (Figure 2.10).

The Egyptians constructed their sun-dried brick houses around small courtyards and gardens with systems of running water, pools, and interior sanitary facilities. The interior spaces were minimally furnished but decorated in brightly painted colors.

Egyptians took pride in the craftsmanship of their furniture, developing joints that we still use today, such as the mortise and tenon. Wood was scarce and had to be imported from

FIGURE 2.9 ABOVE **The Trans America Building in San Francisco has often been compared to the ancient Egyptian pyramids due to its similar shape.**

FIGURE 2.10 LEFT **The Hypostyle Hall, part of the Great Temple of Amon at Karnak, consists of many symmetrically placed columns. This post-and-lintel construction features a raised center section with clerestory windows for interior lighting.**

other areas. The lumber they obtained was small scale and had to be jointed to create larger pieces. Egyptian furniture is characterized by animal-shaped legs. The stool, designed in the form of an *X*, was the most common piece of furniture.

GREEK, 650–30 B.C.

The Greeks achieved a high level of order in their architecture, art, and design (Figure 2.11). Their architecture and art have served as models for other civilizations to copy and refine for centuries. The many gods the Greeks worshipped served as inspirations for their temples and were a major influence in Greek architecture and art.

FIGURE 2.11 The Parthenon (447–432 B.C.) at Athens is one of the best-known examples of Greek architecture. It displays a high sense of order, proportion, and symmetry.

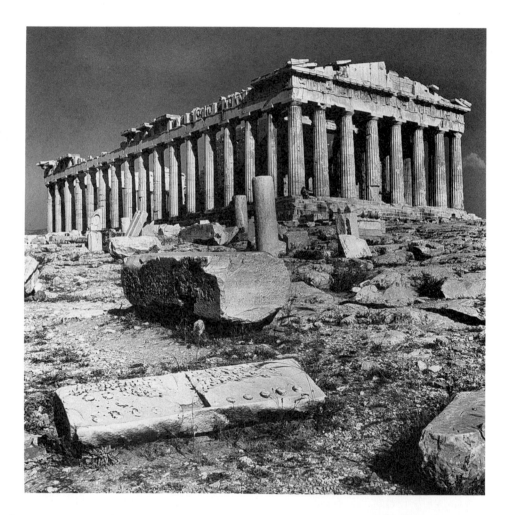

The Greeks standardized their architectural forms, developing "orders" to govern position, shape, and components. They had three major orders—Doric, Ionic, and Corinthian—of column design (Figure 2.12). Greek masonry techniques improved upon the Egyptians' stonework, with a precision method of fashioning hairline joints without mortar. The Greeks also developed the wooden truss, building extensions called the portico and the colonnade, and the pediment (Figure 2.13). Ornamental forms were taken from vegetation and interlocking geomet-

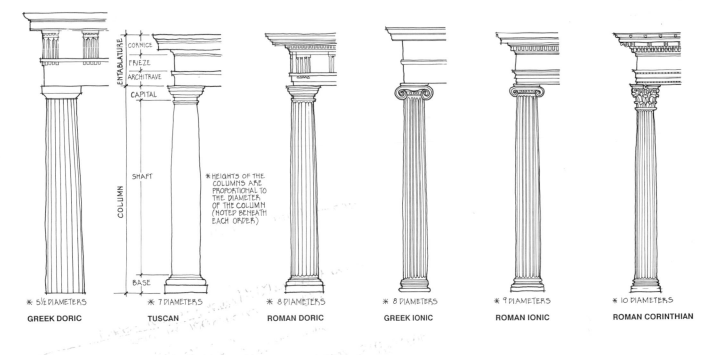

FIGURE 2.12 ABOVE This illustration compares the Greek and Roman orders. Note the proportional changes in the columns and entablatures.

FIGURE 2.13 BELOW Pediment arches developed from the simple Greek origin to broken ones and later more stylistic ones using scrolls.

PEDIMENT BROKEN PEDIMENT BROKEN SCROLL PEDIMENT

ric patterns. Many buildings and interiors today are inspired by these Greek forms, as seen in Figure 2.14.

The Greeks used simple, sparse furniture, most of it carved from wood and decorated with paintings or inlays of metal and ivory. The construction was highly refined, matching that of the Egyptian era. The klismos chair shown in Figure 2.15 was developed by the Greeks and has been copied by many other cultures throughout history.

ROMAN, 753 B.C.–365 A.D.

The Romans organized and ruled much of Europe, the Near East, and northern Africa. They built roads throughout their empire, most of which lead back to Rome as the center of authority. The Romans were for several hundred years a well-disciplined civilization, with orderly conduct of legal and public affairs. As with the Greeks, some public activities required large, specialized, and stately buildings—such as the Coliseum (Figure 2.16).

FIGURE 2.14 The columns in Giancarlo's Pizza restaurant by the Rowland Associates are inspired from classical Greek and Roman architecture.

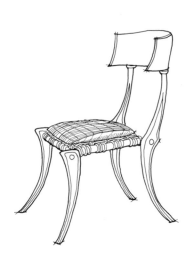

FIGURE 2.15 The Greek klismos chair features concave back and splayed legs.

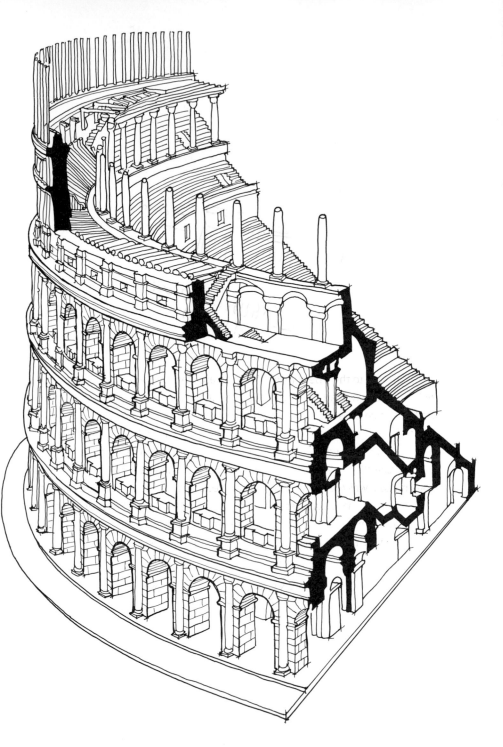

FIGURE 2.16 The Colosseum (72–80 A.D.) in Rome was the largest amphitheater in Roman times. Its elliptical form was 160 feet (48.5 m) tall and 510 feet (170 m) by 618 feet (206 m). It seated approximately 60,000 spectators.

Roman architecture copied and further developed Greek forms and, in their desire for large-scale buildings, developed the dome, vault, and niche. Much of Roman architecture, like the large-scale arch in Figure 2.17, can still be experienced today.

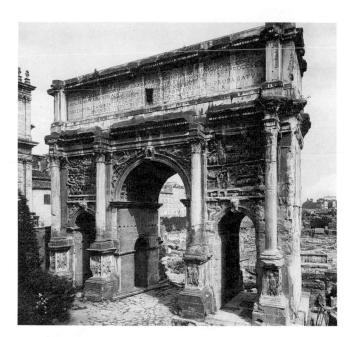

FIGURE 2.17 The Arch of Septimus Severus at the Forum in Rome (203 A.D.) is a typical Roman monument that bears inscriptions telling of an Emperor's conquest. These triumphal arches were constructed throughout the Roman empire.

One of the keys to the development of Roman architecture and interiors was the use of concrete, which strengthens masonry construction and allows for the span of great structures. It was also used as setting beds for tile, brick, and other finishes. The Romans utilized the Greek orders but made them lighter in proportion and added the Tuscan and Composite orders (Figure 2.12). As the Romans strove for grandiose spaces, their interiors became more distinctively Roman. The Pantheon (Figure 2.18) is a famous example of Roman architecture dominated by the dome construction, which is still used as a major design element today. From the preserved Roman wall paintings, we have examples of furniture designs and usage. Styles were borrowed and adapted from Greek pieces, but are generally heavier in scale and proportion, and the Romans used more veneering techniques and inlays of exotic woods and metals.

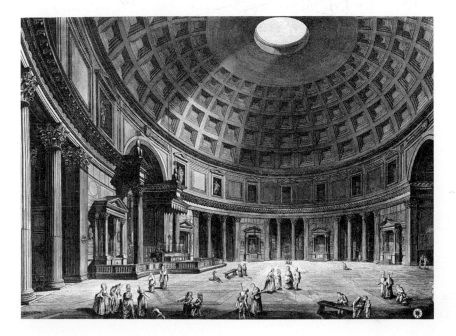

FIGURE 2.18 The Pantheon (120–124 A.D.) in Rome was twice destroyed by fire in ancient times and rebuilt. The temple's spherical space is approximately 143 feet (8.7 m) in diameter and in height.

The Middle Ages

The fall and breakup of the Roman empire threw Western Europe into a period of upheaval. Widespread poverty and ignorance dominated the land in this period, often called the Dark Ages. Most people lived in crude homes on feudal estates, and the development of interiors and furniture made little, if any, progress. Pieces from former civilizations were owned by the wealthy few, but it was the monks in monasteries who stored and recorded much of what remains, both physical and pictorial, of former civilizations. And it was during this period that churches began to serve as centers for religion, education, and social life.

BYZANTINE, 323–1453

In the Byzantine period the important architecture and interiors belonged to religious structures. Very few of the domestic buildings of this time have survived to give us a clear picture of the day-to-day life.

During this time the pendentive dome was developed. This system of thrust and counter-thrust transmitted weight loads from the dome to four heavy pier supports. Well-known Byzantine structures include the famous Hagia Sophia, built about 530 A.D. in Constantinople (Figure 2.19).

FIGURE 2.19 The Church of the Hagia Sophia (532–537) in Istanbul (formerly Constantinople) has an architecturally heavy massive exterior that is contrasted by an interior open main vault that is richly decorated in mosaic tile patterns.

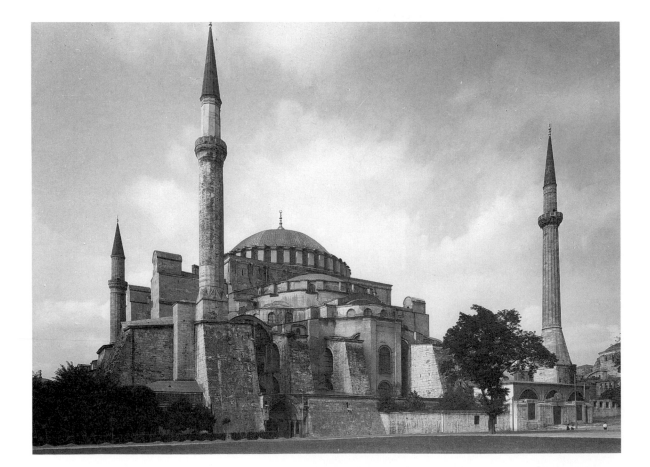

Interiors of the churches house the best remaining examples of Byzantine mosaic techniques. Small pieces of colored marble or glass were pressed into wet cement to create elaborate decorative scenes or designs.

The few Byzantine furniture pieces were usually simple and utilitarian. However, the rich had furniture elaborately inlaid with precious metals and ivory.

ROMANESQUE, 800–1150

The Romanesque period is perhaps best known for stone structures featuring semicircular arches and horizontal lines. The period was influenced by Byzantine architecture, yet rough interpretations of Roman architecture were adapted, primarily to create churches, castles, monasteries, and fortresses.

The Romanesque period produced simple, heavy, and defendable buildings with thick walls, vaults, arches, and buttresses (Figure 2.20). Many of these massive structures survive today because of their solid construction. The Norman conquest introduced large "great" halls, which were the centers of activity. Simple in decoration, the dark interiors had stone floors, small window openings, and fireplaces for cooking and heating.

The few pieces of furniture in these interiors were generally simple in construction and carved of wood. Some of the furniture was demountable. Rulers took it with them as they moved from castle to castle to control their territory.

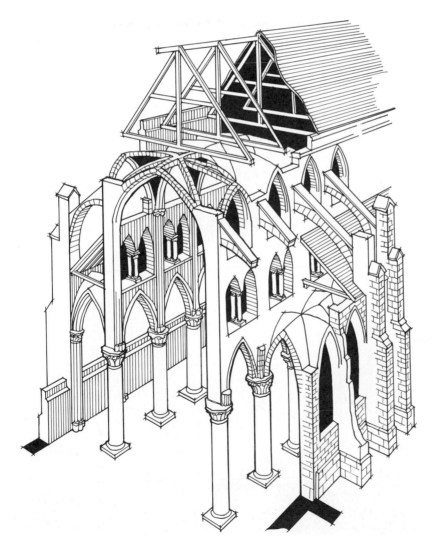

FIGURE 2.20 Sketch illustrating the functional character and structural support of ribbed vaulting and flying buttresses that counteract the horizontal thrust of the vertical arches.

GOTHIC, 1150–1500

As people congregated in towns built around castles, centers developed as trading places, creating the demand for more building activity. Churches became large, important architectural statements of power and wealth. Gothic style emphasized the vertical line in design, architecture, furniture, and ornamentation. Trade routes carried the Gothic style throughout many lands, and each—Italy, Germany, England, and France—developed its own interpretation.

Gothic cathedrals are perhaps the greatest architectural achievements of these times (Figure 2.21). The pointed arch and vault made it possible to create towering interiors and tall expanses of glass windows. Stained glass windows were surrounded by a skeletal stone cage, or lacelike ornamentation, known as *tracery*. Along with Gothic vaulting techniques, the flying buttress was used to transfer the load of the tall, pointed vaults to the ground.

The pointed arch forms were used throughout the interiors, appearing in window and door openings, moldings, and even furniture. Clerestory windows, gargoyles, and cubiform

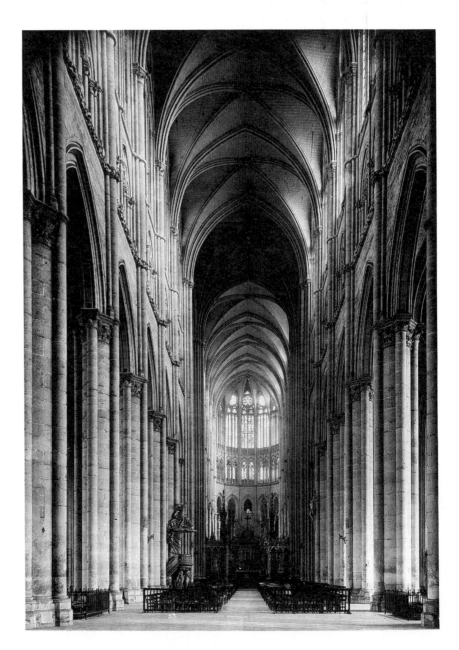

FIGURE 2.21 The Cathedral of Notre-Dame (1220–1269) at Amiens is an excellent example of French Gothic architecture. The towering interior vault is 140 feet (43 m) high and 490 feet (150 m) long.

capitals on Gothic columns decorated these soaring spaces. The Gothic influence is still seen in modern buildings and interiors (Figure 2.22).

Gothic furniture was heavy and highly carved, echoing the vertical lines of the cathedrals (Figure 2.23). The massive horizontal chest was used universally for storage, a table, a seat, and even for sleeping. Chests were made of panel construction and carved with various motifs. Beds were constructed with massive carved canopies and draped curtains that could be drawn for warmth and privacy.

FIGURE 2.22 Some modern buildings today have characteristics of the Gothic influence.

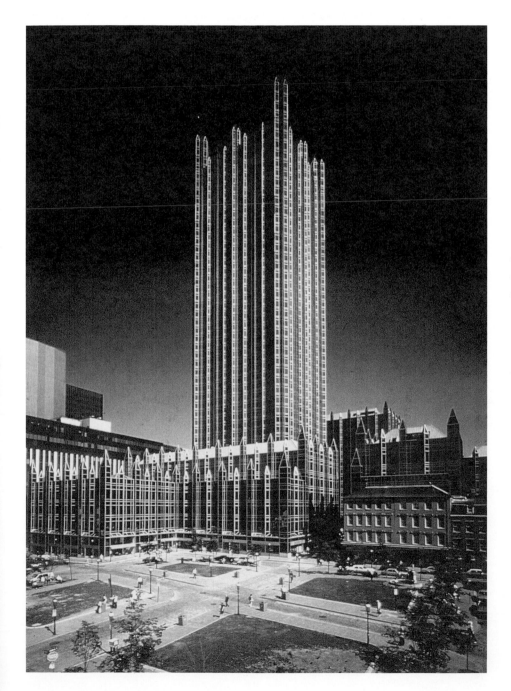

FIGURE 2.23 This chair exhibits characteristics of tracery, pointed arches, and buttresses similar to the Gothic architecture of that period.

The Renaissance, 1400–1700

The Renaissance, which literally means rebirth, was characterized by a new way of life. Thinkers and artists saw expansion in all dimensions of human activity. The awareness of the individual and the study of nature gave inspiration for exploring new developments. Rediscovered classics preserved from ancient times kindled a new awareness and expansion of the arts, literature, and architecture.

Architecture flourished, combining the classical orders, entablatures, and arches with simple, geometrical buildings. Renaissance architecture sharply contrasted with the preceding towering Gothic forms. Elaborate interiors and furniture began to appear, echoing the former intellectual designs of the classic ages. The Renaissance encompassed several distinct stages and regional interpretations.

ITALY, 1400–1580

The Renaissance began in Italy where the remains of Roman civilization provided a stimulus. The medieval castle with its defense architecture gave way to new styles. The invention of the printing press allowed the rapid spread of new knowledge to other lands. A realistic art and sculpture developed, and linear perspective was introduced in painting.

Florence was the seat of the Italian Renaissance in architecture and design. The principles of formalized and symmetrical planning can be seen in its villas, public buildings, and town centers. Early Renaissance buildings exhibited an experimental and reserved use of classical elements, while High Renaissance styles developed sophisticated design theories derived from the classics. One person who systematically incorporated classical detail and orders into his architectural practice was Andrea Palladio (1508–1580) (Figure 2.24). His writings and designs, along with those of Leon Battista Alberti (1404–1472), served as sourcebooks for many architects who followed.

FIGURE 2.24 Andrea Palladio's Villa Rotonda (1550) on a hill near Vicenza has a central domed salon that is symmetrically flanked on four sides by identical porticoes.

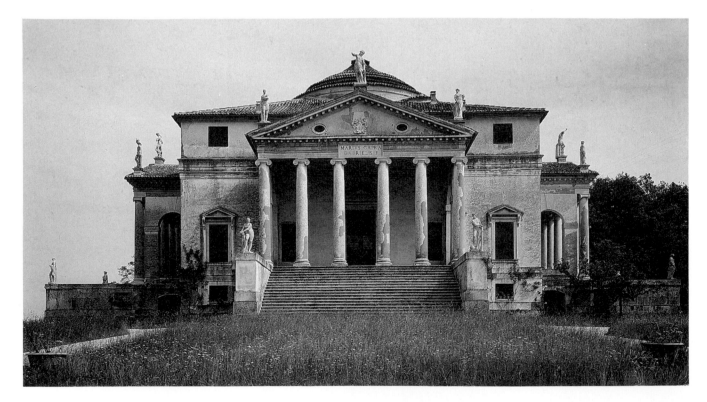

Renaissance interiors were painted, inlaid with wood, or finished in neutral tones and accented with bright draperies or accessories. A typical interior from this period can be seen in Figure 2.25. Coffered and flat ceilings, brightly painted, were used, as were flat, decorative columns, called pilasters. Floors were constructed with brick, tile, or marble laid in geometric patterns.

In the Early Renaissance, interiors were sparsely furnished with functional wood furniture that harmonized with the architectural designs. A variety of seating, such as stools, armchairs, and benches, was used for social interactions. In the Renaissance, *cassone* chests, the *cassapanca* (Figure 2.26), and several variations of the *X*-shaped chair, such as the Savonarola, were introduced (Figure 2.27). The refectory table and the credenza storage unit were also characteristic of this period.

FIGURE 2.25 **This bedroom in the Palazzo Davanzati at Florence during the 15th century has tiled floors, richly painted walls, and a carved wood ceiling.**

FIGURE 2.27 **The Savonarola is an X-chair derived from the folding stools of the Egyptians, Greeks, and Romans. This Italian example is from the 15th century and is constructed of beechwood.**

FIGURE 2.26 **The large cassone storage chest and cassapanca seating bench are examples of 16th century Italian furniture.**

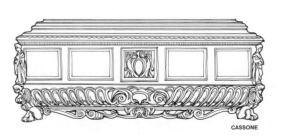

CASSONE

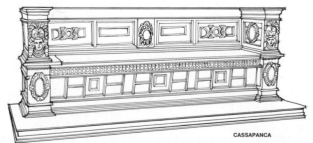

CASSAPANCA

FRANCE, 1490-1650

French military campaigns into Italy brought the influence of the Italian Renaissance to the French nobility. However, French artisan guilds resisted the change from Gothic styles to the new Italian motifs, so the Early Renaissance saw a curious mixture of Renaissance ornamentation and the pointed, arched Gothic styles. Gothic exterior elements such as pointed roofs, towers, and dormers slowly gave way to Renaissance influences. Gradually, the French developed their unique style in the Renaissance, and it flourished later during the baroque period.

Little ornamentation was used in the interiors or on the furniture in the Early Renaissance period in France. Later, however, pieces were elaborately carved and inlaid with a variety of metals, marble, and shells. The French introduced the armoire, a clothing wardrobe piece still used extensively today. As the Renaissance advanced, furniture was crafted with ebony veneers and hidden construction joints. Fabric covering of furniture became popular, and marquetry (the inlaying of contrasting veneered materials) was developed.

SPAIN, 1400-1600

The Renaissance in Spain was influenced by the objects and art brought from Italy in political and military expeditions. Spain was strongly influenced during its Renaissance period by the tradition of Moorish decoration, since the Moors had been a strong force there for 800 years.

The Renaissance in Spain can be divided into several periods that vary in the degree of Italian influence. The most notable periods were the Early, or Plateresque (referring to the work of silversmiths), and the Desornamentado (unornamented), which adhered closely to the Italian style of austere simplicity.

The Moorish geometrical and decorative elements had a great impact on Spanish buildings. Interiors were simply plastered but detailed with mosaic-tile work, wood, wrought iron, and wood-paneled ceilings. Doors were generally of heavy wooden construction and recessed, like the windows, which were adorned with wooden shutters, iron grilles, and blinds. Floors were covered with rugs, and tooled leather pieces hung on the walls.

Spanish furniture, influenced by the Italians, was simple and was either placed along the wall or built in. Many chairs were covered with tooled leather, with Cordovan leather being much in demand. The *sillon frailero,* or monk's chair (Figure 2.28), is typical. The Spanish developed the *varqueño* writing cabinet (Figure 2.29), a chest of drawers with a hinged writing surface that when open revealed many cubbyholes, some of them secret compartments.

FIGURE 2.28 LEFT Monk's chair from the Spanish Renaissance, with a leather seat, back, and fretted front splat.

FIGURE 2.29 FAR LEFT The Spanish Renaissance varqueño is a writing and storage desk made in wood with iron hinges and lock.

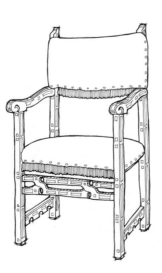

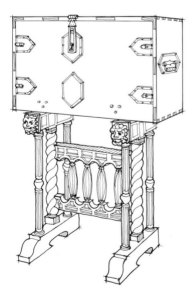

ENGLAND, 1485-1689

The Renaissance seemed to come more slowly to England; however growing trade, economic stability, and the throne pushed the country into new prosperity and introduced Renaissance principles throughout the region. The English Renaissance can be broadly divided into four periods, the Tudor, Elizabethan, Jacobean, and Restoration.

TUDOR PERIOD, 1485-1558. The Tudor period saw the slow ending of the feudal system and the development of towns. The Gothic style of architecture began to be modified with intricate patterns in an English style that used large, closely spaced windows and tracery. The Tudor Gothic style, which used a flatter arch, was introduced. Brick became preferred to stone.

In early times, English houses were constructed with an all-purpose space called the great hall, which had a central open hearth for cooking and heating. During the Tudor period, other smaller, more private, rooms were developed, and additional fireplaces were built into the walls. However, the main hall, in its long gallery form, still served as the primary activity center. The interiors were framed with beams, some exhibiting a fan-vaulted ceiling decorated with hanging pendants. Oak became the most popular building material and could be seen in wall paneling and furniture.

Furniture in the Tudor period was fairly sparse, large, and heavy. Pieces included chairs (Figure 2.30), benches, massive tables, canopied beds, and storage pieces, such as the cupboard, the food storage ambry, chests, and the press storage unit.

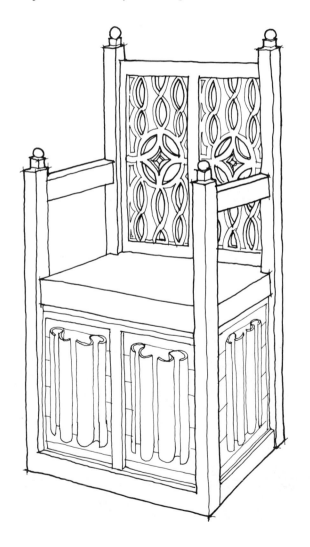

FIGURE 2.30 This Tudor chair is constructed in simple lines with a linenfold carving at the back and seat front.

ELIZABETHAN PERIOD, 1558–1603. The Elizabethan period saw an increase in building activity, particularly in residential sectors. Houses were symmetrical in proportion, and in the interiors, plastered ceilings were developed and stairways became focal points. Large estates were constructed for the wealthy, and the use of brick and stone increased. In turn, these materials inspired the use of additional classical features on exteriors.

Carved Elizabethan furniture was more refined and abundant. Although oak was still the most popular wood, others, such as walnut, were occasionally used. Chairs were still fairly straight and uncomfortable since they were not proportioned to fit the human body. Some beds were monumental in size and construction (Figure 2.31), using various types of ornamented canopies. Bulging "melon" shapes were often carved on furniture legs and other vertical members during this period.

FIGURE 2.31 This massive Elizabethan bed from the 16th century has an assortment of intricately carved pedestals that support a canopy with closable hangings. (The Metropolitan Museum of Art. Gift of Irwin Untermyer, 1953.)

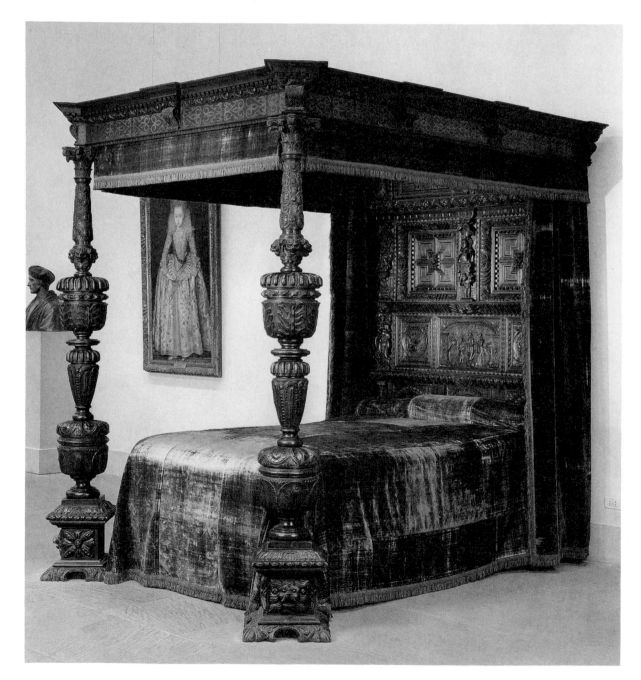

JACOBEAN PERIOD, 1603–1649. The Jacobean period was named after the first of the Stuart monarchs, James I. The architecture of this time was influenced by the architect Inigo Jones (1573–1652), who had studied Italian architecture and executed many royal and public buildings. English architecture of this time saw an increase in the use of standardized bricks and Italian features.

Jacobean interiors were more regular in scale and comfort, with symmetry becoming more popular. The great hall's height decreased, and additional specialized rooms were developed. Ceilings were of decorative plaster, and more classical elements were used. The furniture, still fairly simple, was lighter and more comfortable. Panel-backed chairs were decorated, and ornamentation began taking on classical features. The gate-leg table is one of the most notable furniture pieces of this time (Figure 2.32).

FIGURE 2.32 Jacobean gate-leg table that can be folded out for additional table surface. This one is decorated with columnar legs and contains a storage drawer.

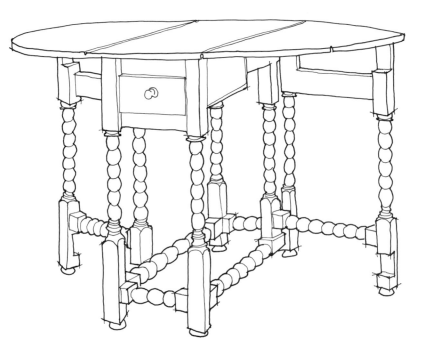

RESTORATION PERIOD, 1660–1702. The Restoration period began when Charles II took the throne (1660–1685) and introduced much of French style and architecture to England. This period overlapped the baroque and rococo periods, which are discussed later in this chapter. Symmetry was still dominant, and ornamentation with urns, pilasters, and finials was popular. Red brick and portland stone were a favorite combination of building materials.

Interiors were symmetrical, with stairs, corridors, smaller fireplaces, and small rooms located around the great hall. Walls and carvings of oak or walnut and decorative plastered ceilings adorned the rooms. Floors were tile, marble, flagstone, and oak.

During the Restoration period, walnut became popular and was used in veneer, often inlaid with other woods. Skilled craftsmen constructed furniture that was curved and padded and thus more comfortable. The furniture became more decorative, influenced by French and Dutch styles. Beds, which continued to be one of the most important items of furniture, were quite large and canopied.

Baroque and Rococo, 1580–1760

The seventeenth century in Europe was a period of many conflicts, opposites, and irregularities characterized by a political stability imposed by a monarchy. Great wealth poured into Europe because of international trade, but only to a few rulers who gained power and dictated all aspects of life to their subjects.

Art and architecture expressed this age of power. The baroque originated in Italy as a style of religious expression, then spread to France, where it emerged as a style of royalty and grandeur, particularly in public buildings, churches, and palaces. Its name was derived from *barocco*, a Portuguese term meaning imperfect pearl of irregular shape.

ITALIAN BAROQUE, 1580–1750

The baroque style began in Rome and spread rapidly throughout the rest of Italy. A strong feeling of competition prevailed among European rulers to acquire the best artistic works available.

The architectural elements of Italian baroque, such as pilasters, pillars, entablatures, and round arches, evolved from classical Roman elements but were arranged in a new way to convey the feeling of dynamic movement. Pillars were frequently oriented diagonally, and architraves broke into pediments. Fireplaces were treated with elaborately carved details in high relief and often had the curvilinear contours of the period's doors and windows. The latter elements were generally elaborate structures, as high as the cornice of the ceiling and dominated the entire room. Stairways were created as a visual and emotional experience, with pillars, pilasters, arches, and niches filled with oversized statues that often projected beyond the plane of the wall. Baroque ceilings were very high, containing dramatic effects, such as large figures. Although baroque interiors adhered to the classical orders, they were enlarged in scale and full of dynamic energy and movement.

Baroque furniture, mostly of walnut and very large, was designed for monumental and magnificent interior settings. Applied ornamentation consisted of figural silhouettes, swirling curves, deep undercutting of shapes, and three-dimensional projections. In some cases the decoration was so profuse that it could be difficult to identify the structure of the piece.

Chairs had heavily carved gilded frames, with the arms constructed of scrolling curves extending to large scrolled feet with diagonal stretchers. Chairs were upholstered in velvets and silks, generally in a large pattern of strong, contrasting colors (Figure 2.33).

Classical-interpretation console tables, set against the wall and supported by heavily carved bases with dolphin, cherubin, or mermaid motifs, were typical. The commode, or large chest of drawers, had an excessive amount of decoration and was used for storage as well as the display of art objects. Very large mirrors with heavily carved gilded frames became popular.

FRENCH BAROQUE, 1643–1715

Louis XIV (1638–1715) assumed the throne of France in 1661 and developed his court into an international leader in fashion and the arts. He saw the arts as a way to restore royal prestige and power. Under his rule, the finance minister, Jean Baptiste Colbert (1619–1683) established the Academies of Architecture, Fine Arts, and Music. Many factories that produced furniture, tapestries, and accessories were given royal encouragement by Colbert and supervised by Charles Le Brun (1619–1690), the art director of France. The French baroque style, which grew out of exaggerated Roman forms, was one of grandeur. It evolved as a national style, called *le grand siécle* (or "the grand century"), and was associated with Louis XIV.

The French baroque was a monumental interior style of rooms and furnishings. Symmetrical, lavish ornamentation and rich color contrasts expressed the pomp and formality of court life

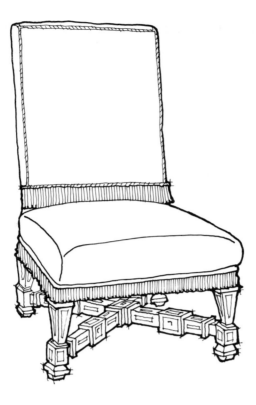

FIGURE 2.33 This baroque upholstered chair has an X-shaped stretcher, fringe trimming, and heavy, square, tapered legs.

during this period. Classical architectural details, such as columns, pilasters and entablatures, rectilinear outlines, and vast scale characterize the period. Cornices and deep-relief sculptural moldings, often with cherubs and foliage, were used around doors and windows.

The palace of Versailles was built for Louis XIV under the direction of Colbert, who assembled architects, artists, designers, and master craftsmen. Versailles covers more than 6,000 acres and was built to house 10,000 people. It has 67 stairways, more than 300 chimneys, and approximately 2,100 windows. Every room in the palace appeared to be a public space because of its enormous size and proportion, as well as its lavish decoration. Walls were generally constructed of wood and ornamented with gilded carvings and light-colored paint (Figure 2.34). Furniture was placed on the perimeter against the walls because pieces were designed for elegance rather than comfort and were generally too heavy to be moved. The motifs of the period ranged from foliate patterns and abstract swirls to shells, nymphs, and sphinxes.

Seating was designed as part of a ceremonial ritual, with a throne for the king, armchairs for princes, and stools and other chairs for nobility of lesser rank. Large chairs upholstered in velvet, silk, or tapestry had rectangular backs, heavily carved arms, and stretchers in flowing s-curves. In 1673, confessional chairs to be used by priests were designed with wings to hide a sitter's face. The sofa and chaise lounge were also developed during this period.

André Boulle (1642–1732) was appointed master cabinetmaker to Louis XIV in 1672. Boulle employed 20 cabinetmakers, along with his four sons, and made furniture for the king, other nobility and foreign courts in his louvre workshop. Boulle perfected the use of ormolu, an alloy of copper and zinc with the luster of gold, used for moldings and decorative motifs.

Storage pieces, such as the cupboard, bookcase, commode, and armoire, were very large, elaborate, and generally ornamented with Boulle marquetry. Tables with tops made of marble, stone mosaic or wood were usually massive and gilded or inlaid. Tables for special purposes, such as the writing table or the bureau, began to appear at this time. The cabaret table was the first tea table.

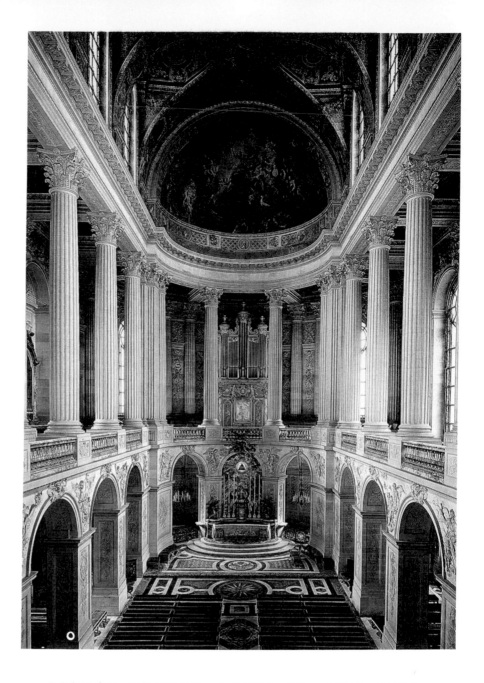

FIGURE 2.34 The Chapel at Versailles (1689–1710) is two stories in height and lavishly decorated with a marble floor and carved white stone ornamentation.

FRENCH ROCOCO, LOUIS XV, 1715–1774

With the reign of the new king, Louis XV, social life began to shift from the grandeur of the court to luxury for the nobility and wealthy upper classes. Derived from the French word *rocaille*, meaning rockwork, the term *rococo* referred to the fanciful treatment of ornament. More important than the ornamentation, the rococo style developed a new approach to the planning of interior space.

Building facades became simplified, with less ornamentation. Much less emphasis was placed on classical pilasters, columns, and entablatures. Windows were larger, with simple moldings and delicate cornices. Interiors were planned for specific functions, and separate rooms varied in size and shape. Hollow interior walls constructed of light materials to reduce the scale of individual rooms replaced the heavy walls of marble and stone from the previous period. Walls were generally painted in pastel colors, with applied ornament in flowing curvilinear forms.

The furniture of the rococo style was comfortable, light, graceful, and contoured to fit the human body. Soft, curved lines were predominant in chair backs and legs, commodes, and textile patterns. Chairs of this period generally had padded arms that were set back to accommodate women's clothing. Two important chairs of this period were the fauteuil (Figure 2.35), which had padded arms open underneath, and the bergère (Figure 2.36), which was larger in scale and had enclosed sides. The emphasis on comfort and conversation also produced several sofas during this period.

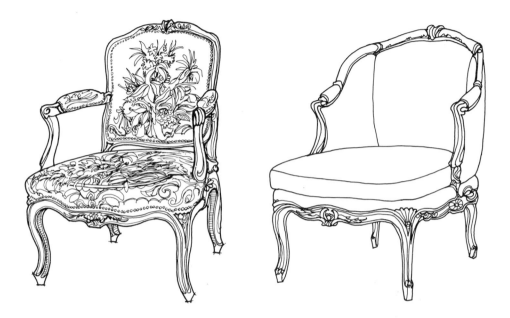

FIGURE 2.35 FAR LEFT **The fauteuil chair has open sides and cabriole legs.**

FIGURE 2.36 LEFT **The bergère chair of the rococo period is characteristic of furniture exhibiting cabriole legs with upholstered enclosed sides beneath the arms.**

ENGLISH BAROQUE AND ROCOCO, 1660–1760

When Charles II assumed the English throne in 1660, he sought to imitate the lavishness and extravagances of the French court under the rule of his first cousin Louis XIV. Echoing the turbulent politics of this period, architectural styles were also in conflict. In fact, the English baroque and rococo periods can be broken into distinct styles reflecting who occupied the throne.

Charles II was succeeded by his son James II, who reigned from 1685 to 1688, and continued a policy of autocratic power. This provoked the nobility of England, and the crown was then offered to William of Orange, who was married to Mary, the daughter of James. This reign (1689–1702), known as the period of William and Mary, was characterized by simplicity, prosperity, and economy.

Queen Anne reigned from 1702 until 1714, and George I reigned from 1714 to 1727. In these periods England enjoyed an increase in trade and great wealth. New ways of thinking created an atmosphere of comfort and culture.

Social development continued under the leadership of George II and George III. The period from 1727 through 1760 is known as the Early Georgian Period.

Furniture historians disagree about whether the William and Mary style or the Queen Anne style is transitional between baroque and rococo. However, they almost always classify the early Georgian and Chippendale furniture styles as rococo, even though the exterior architectural design, as well as many interior architectural details, depicted the baroque and/or Palladian idiom.

Sir Christopher Wren (1632–1723) was an important architect who became a leader in the artistic life of the period. He was strongly influenced by Andrea Palladio, an Italian architect,

and by French architects. Wren designed several churches, including St. Paul's Cathedral in London, in the baroque style (Figure 2.37). Generally, these English baroque exteriors were restrained in design and constructed of red brick with stone pilasters; they were large, simple rectangular shapes, with pitched roofs and dormer windows.

Interior walls were wood paneled to the ceiling, either of naturally finished oak or of painted white pine with gilt accents. Ceilings were generally elaborately painted, with illusionistic effects. Fireplaces and doors were carved and elaborately ornamented.

Another architectural style emerging during the Queen Anne period was the Anglo-Palladian, inspired by the architecture of Palladio and Inigo Jones. The Anglo-Palladian plan of Chiswick House (Figure 2.38), designed in 1725 by the Earl of Burlington, reveals a square, symmetrical shape with a circular hall in the center, reminiscent of the Villa Rotonda by Palladio. The influence of Jones can be seen in the richly decorated ceilings and fireplaces. Baroque elements, such as broken pediments over doors, rich ornament, and elaborate furniture, were still present. Even though English baroque interiors were large, sprawling, and ornate, they never displayed the dramatic effects of the baroque period in Italy or France.

Georgian interiors were elegant, refraining from lavish ornament. Wood paneling was painted white to blend with the plaster ceiling and simple moldings. Fireplaces continued to be framed with a broken pediment and other decorative details. French wallpaper featuring East Asian scenes and flocking, a textured surface used to imitate wall fabrics, sometimes adorned the

FIGURE 2.37 St. Paul's Cathedral (1675–1711) in London was designed by the noted architect, Sir Christopher Wren. The classical features of the building attest to the baroque influence on architecture during this time.

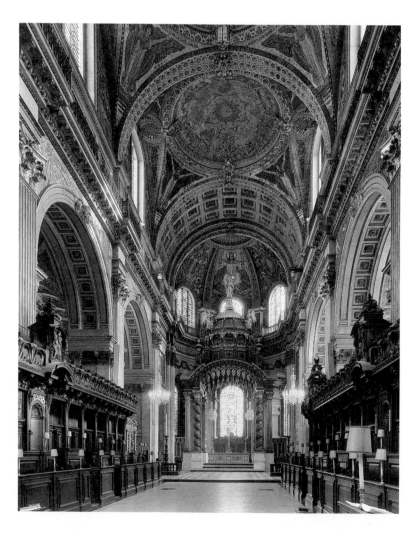

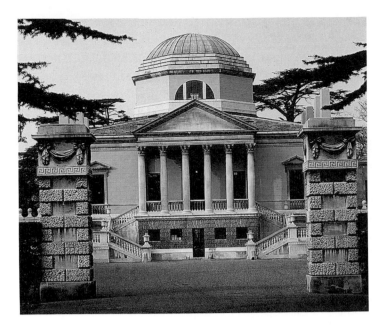

FIGURE 2.38 The Chiswick House (1720–1725) in Middlesex was constructed by Lord Burlington and based on Palladio's studies of Roman baths. It combined classical motifs and had a highly decorated interior.

walls. However, plain surfaces began to appear, as did an interest in balancing all elements of the interior.

The furniture of the English baroque and rococo period also exhibited a variety of influences, as follows:

LATE STUART PERIOD, 1660–1668. The main characteristic of this period was deep carving of *c*- and *s*-curves in flowing, dynamic shapes. Spiral turnings were popular in tables and high-back chairs. Walnut replaced oak as the main wood for furniture. Two new forms of furniture, elongated chairs, called *daybeds,* and chests of drawers on stands (Figure 2.39), were developed.

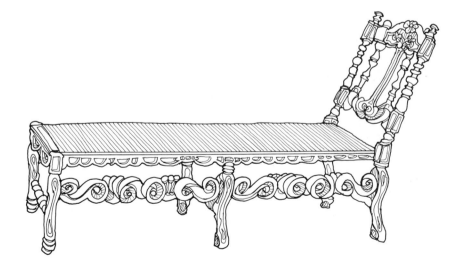

FIGURE 2.39 Example of late Stuart Period daybed.

WILLIAM AND MARY, 1688–1702. Furniture became smaller in scale and more comfortable. Wood veneers and marquetry with intricate, interlacing patterns became common. New types of case goods, including the writing desk, dressing table, and highboy, a chest of four or five drawers supported by a table (Figure 2.40), were introduced.

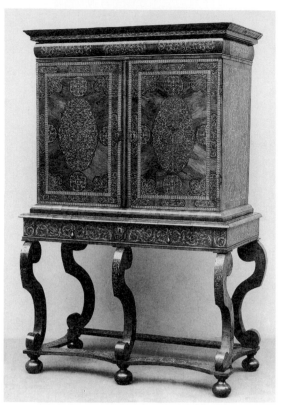

FIGURE 2.40 This walnut cabinet is indicative of the furniture styles during the William and Mary period (1688–1702). It is supported by broken-S-curved legs that rest on ball feet. The surface is overlaid with decorative marquet. (The Metropolitan Museum of Art. Bequest of Annie C. Kane, 1926.)

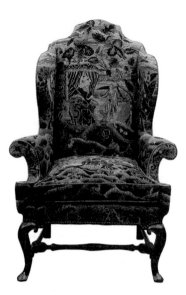

FIGURE 2.41 This walnut wing chair from the Queen Anne period (1702–1714) is upholstered with patterns of plants, figures, and other landscaping features. (The Metropolitan Museum of Art. Gift of Irwin Untermyer, 1955.)

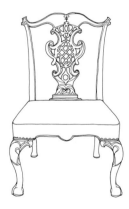

FIGURE 2.42 This mahogany side chair is typical of the style and strength of furniture made under Thomas Chippendale's direction.

QUEEN ANNE, 1702–1714. Comfort and elegance were considerations of the early 1700s. Queen Anne furniture was sturdy, with flowing, curved shapes; the cabriole leg; and very little applied ornament. China cabinets and small, low tables for serving tea were introduced, as was the fully upholstered wing-back chair (Figure 2.41).

EARLY GEORGIAN, 1714–1760. Thomas Chippendale (1718–1779) was the leading furniture maker of the early Georgian period. His designs were created by combining the curves of the French baroque and rococo styles with Gothic influences, Chinese fretwork, and the gracefulness of the Queen Anne style. In 1754, he published *The Gentleman and Cabinet-Maker's Directory*, which featured his designs and construction methods (Figure 2.42).

Early American Architecture and Interiors

The development of American architecture, interiors, and furniture was heavily influenced by English styles. As the colonies began to develop, colonists started to manufacture their own necessities, and their dependence on England began to diminish.

Although the main stylistic influence came from England, other countries exerted some design influence. In the late sixteenth century, the Spaniards created thick-walled houses around open courtyards in Florida and the Southwest. French styles were evident in French settlements along the St. Lawrence River, the Great Lakes, and the Mississippi. As a result of various climatic conditions, regional American styles also began to appear. For example, because of the damp climate and dense underbrush, buildings in Louisiana were designed with raised ground floors and

roofed outdoor galleries for protection from rain and heat. In the northern colonies, the Dutch constructed buildings with high-pitched roofs to shed snow.

American architecture and furniture from the 1600s to the 1900s are generally divided into two distinct styles: the early colonial and the colonial Georgian.

EARLY COLONIAL, C. 1630–1720

Because the early colonists were faced with Indian battles, the elements, sickness, and accidents, there was not much time or energy to cultivate the arts. Agriculture was the basis of the economy, though gradually other trades and industries, such as fishing, lumbering, iron manufacturing, and shipbuilding, were developed. The colonists' rough dwellings had to be constructed quickly; indeed, sometimes they lived in caves or crude shelters of mud and branches. A typical house consisted of a simple, single room where all the basic activities took place. As the economy improved, a second room was added and sometimes a second story or loft area for additional sleeping space. The interior spaces were small and rectangular, with low ceilings. The main feature of each room was the thick-walled fireplace, used for heating and cooking (Figure 2.43). Beams and structural supports were left exposed and unpainted. The spaces between the supports were generally plastered and painted white.

The furniture of the early colonial period generally served multiple needs. Local craftsmen created their own interpretations of medieval, Elizabethan, and early Stuart styles. Influences from the Renaissance period were evident in architectural motifs, such as spindles and turned posts.

Chests were the most important pieces of furniture; they were used for storage, travel trunks, tables, or seating. Gradually, drawers were added, and the chest evolved into a chest of

FIGURE 2.43 A typical hall in an early colonial house built about 1684 shows how a single room was used for living, cooking, eating, and sleeping.

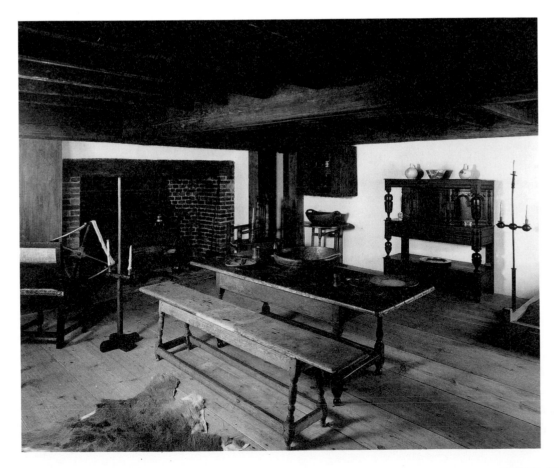

drawers on legs. The court cupboard of the seventeenth century was richly carved, with blocky proportions and "melon bulb" turnings on the legs, reminiscent of the English Elizabethan style. The storage and display cupboard evolved into the highboy, a high, one-piece chest on a waist-high stand (Figure 2.44).

Chairs of the early colonial period were reminiscent of those made in Europe. They had stick backs, cane seats, and simple, turned cylindrical arms and legs, as exemplified in the Carver chair (Figure 2.45).

FIGURE 2.44 **The early colonial highboy is made of veneered walnut and has William and Mary inverted-cup legs.**

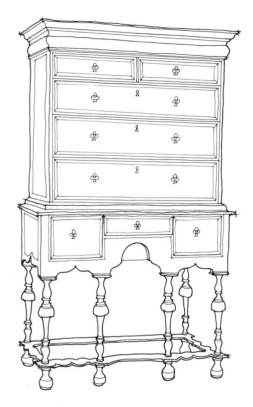

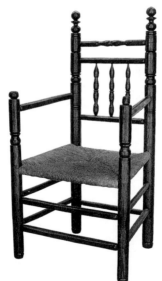

FIGURE 2.45 **This Carver armchair is typical of the early colonial period, with a rush seat and a minimum of turned embellishments. (The Metropolitan Museum of Art. Gift of Mrs. Russell Sage, 1942.)**

Since space was limited, furniture was designed for flexibility and convenience. The chair-table had a hinged top that could be lifted to form the back of an armchair. Tables with swinging gate legs or butterfly supports had drop leaves that were extended for meals.

COLONIAL GEORGIAN, C. 1720–1790

As America became more settled, increased trade brought closer contact with European styles. Colonial craftsmen depended heavily on the illustrated books on architecture and design published in England during the eighteenth century. Sir Christopher Wren and Palladio exerted strong architectural influences.

Although some regional differences existed in colonial America, from Maine to Florida the architecture was similar: symmetrical, with the front door in the center, generally flanked by pilasters and a pediment or a small porch (Figure 2.46); rectangular; and two or three stories in height. Rooflines were accentuated by projecting cornices that eventually became flatter and were topped by a balustrade.

FIGURE 2.46 An example of a colonial Georgian dwelling showing strong symmetry with a central projecting entrance and triangular pediments. The hipped roof is topped with a balustrade and bracketed by two balanced end chimneys.

Interior spaces consisted of four or five rooms with a fireplace in each and a large, central staircase. A spacious hallway ran from the front of the space to the rear. Large, tall rooms were based on the severe, classical Palladian and the Louis XV styles. Doors and windows were trimmed with classical architectural details, such as architrave moldings and triangular pediments. Walls were either paneled or papered. Wallpaper was first imported from China, but after 1786 it was produced in America.

By 1750, colonial furniture had become lighter in construction and had more curves. Craftsmen in Boston, New York, and Philadelphia produced distinctive furniture designs that could be identified with those population centers. Mahogany and walnut were the favored woods, and variations of Queen Anne and Windsor chairs were commonly used. Storage pieces included the lowboy, as a side table, and the highboy unit. Cabinets, chests, and large beds with fabric enclosures were used throughout the colonies.

Although colonial furnishings were basically copied from European predecessors and handbooks, American interpretations differed from the originals in ornamentation and proportions.

The Neoclassic Period and Other Revivals

As a reaction against the baroque and rococo styles, a movement called neoclassicism, or romantic classicism, began about 1750 and reached a peak in the middle of the nineteenth century. This age of rationalism, revolution, and industrialization revived the styles of the past. Not only were classical styles of architecture being imitated, but a new appreciation grew for the Gothic and other earlier styles from Europe, China, and the Near East.

Generally, the neoclassic style was simple and stable. It consisted primarily of straight lines and right angles. There were, however, distinct differences in various countries' early and

late phases. Early neoclassicism was essentially an imitation of former styles characterized by dignity and restraint. In France it was the Louis XVI style; in England, a late Georgian or Adam style; and in America, the Federal style.

Late neoclassicism began about 1790 and was strongly influenced by Greek and Roman architecture and furniture. In France the style centered around Napoleon's empire. In England neoclassicism was called the Regency style; in America, the Greek revival or Empire style.

FRENCH NEOCLASSICISM, 1750–1850

Louis XVI's name is associated with the early neoclassic style, which developed as a reaction to the rococo style. During his reign (1804–1815), as emperor, Napoleon created the late neoclassic style in France.

LOUIS XVI STYLE, 1750–1792. The architecture of the period from 1750 to 1792 was restrained and devoid of ornament. The interiors again were large, with high ceilings, tall doors and windows. With the return of cornices, a distinction was made between the walls and the ceiling. Straight lines and right angles were emphasized, creating a dignified atmosphere (Figure 2.47). Wall paneling was generally painted white or off-white and framed by straight, thin gilded moldings.

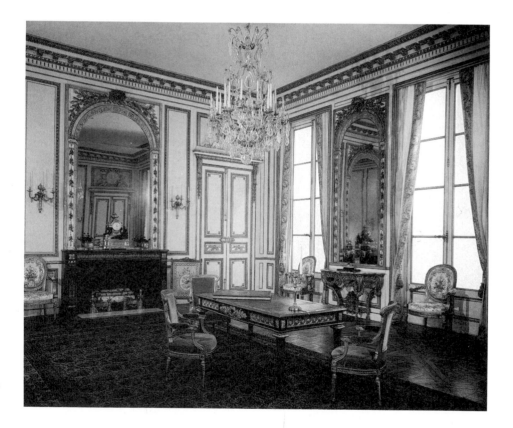

FIGURE 2.47 A room in the Hotel de Tesse, Paris (1770), is an example of the dignified refinement of the French neoclassic style. Tall windows and white walls are trimmed with gold leaf. (The Metropolitan Museum of Art. Gift of Mrs. Russell Sage, 1909.)

This period also saw a dramatic reaction in its furniture. The furniture was produced in light and delicate proportions, but straight lines and rectangular silhouettes began to dominate. The distinguishing feature was the furniture supports. The cabriole leg began to straighten out, and by 1770, all pieces of furniture had straight and tapered legs, either round or square, and with vertical or spiral flutings. Mahogany was used more extensively because of the increased popularity of grained wood.

EMPIRE STYLE, 1804–1815. The Empire period illustrated the growing awareness

of archaeological knowledge in the correctness of classical styles. Napoleon, who traveled to Egypt in 1798, was strongly influenced by ancient Egyptian designs, as well as by the monumental style of ancient Rome. The Empire style was characterized by its large scale and emphasis on flat planes. Walls featured flat pilasters and were generally painted in strong Pompeian colors, such as bright reds, yellows, greens, and deep blues. Walls and ceilings also featured painted decorations of stylized vegetable motifs in geometric patterns. Elaborate draperies covered the windows and sometimes extended across an entire wall.

Furniture designers of this period were more concerned with integrating antique design motifs—winged figures, sphinxes, eagles, and swans—than with human comfort. Pieces were heavy, solid; generally made of mahogany, ebony, and "ebonized" fruitwoods; and smothered with metal ornament. Case pieces and tables were strictly rectangular, but chairs and sofas combined gentle curves with straight lines. Beds and daybeds were treated in a monumental manner, with tentlike canopies, massive platforms, and elaborate scrolled headrests and footrests (Figure 2.48).

FIGURE 2.48 Reminiscent of the furnishings of the Greeks, Romans, and ancient Egyptians, this bedroom in the Chateau Malmaison, near Paris, was refurnished for the Empress Josephine in 1810.

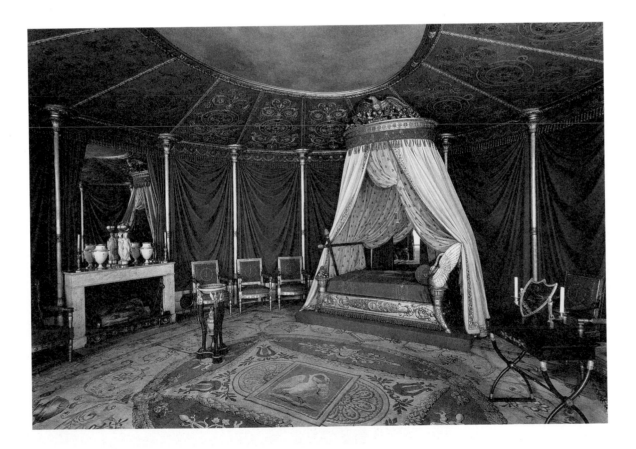

ENGLISH NEOCLASSICISM, 1760–1830

In England, the Anglo-Palladian movement had already separated itself from the baroque and rococo styles of France. The early neoclassic style, under the leadership of architect Robert Adam (1728–1792), interpreted classic architecture in a light and graceful manner until the 1790s. Then the late neoclassic period experienced a renewed interest in French styles, culminating in heavier proportions and literal interpretations of ancient styles.

LATE GEORGIAN, 1760–1800. The late Georgian period was largely influenced by Adam's strong contribution to interior design. He traveled extensively and was influenced by

French and Italian architects and their theories of neoclassicism. The monuments of Rome and the excavated ruins at Pompeii and Herculaneum made great impressions on his designs. He created his distinctive styles based on what he saw on his travels, as well as on current books on Greek and Roman architecture.

The most notable feature of this period was that it was the first time a conscious effort was made to unify all elements within a single space or room. Adam designed not only the walls and ceiling of a room but every piece of equipment, including furniture, light fixtures, floor coverings, textiles, silver, pottery, and metal work. Architectural effects were created by his monumental treatment of classical columns, pilasters, entablatures, arch forms, domes, and panels ornamented with classical motifs. Roman prototypes could be seen in many of his rooms through the use of semicircular, segmental, or octagonal end walls treated with architectural orders. Adam preferred pastel plaster walls to emphasize the finely molded white stucco relief. Fireplace mantels and doors became smaller in scale, and interest in ceiling decoration increased.

Adam's emphasis on the unity of his interiors led him to design furniture that would also be complementary in scale and decoration. His interior motifs reappeared in his furniture. He was particularly noted for the development of the English sideboard, as we know it today, as well as his side tables, settees, cabinets, and bookcases. His sideboard is characterized by its bow front and satinwood frieze across the top, with urns, acanthus, and a plaque showing griffins on either side of a portrait medallion (Figure 2.49).

FIGURE 2.49 This bow-front commode was designed as one of a pair by Adam in 1773. It was designed for the drawing room at Osterly Park in Middlesex, England, and features decorative motifs inlaid in various woods.

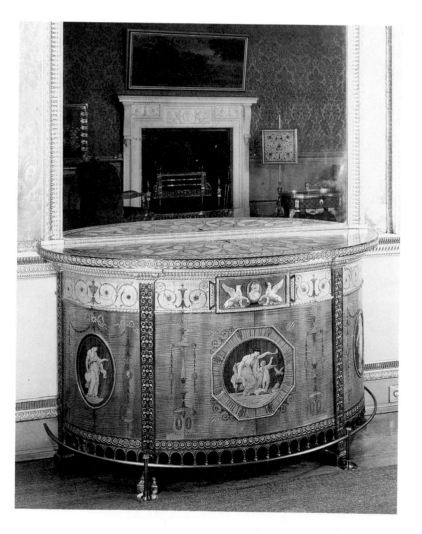

Two of Adam's followers were George Hepplewhite (d. 1786) and Thomas Sheraton (1751–1806) (Figure 2.50). Hepplewhite is best known for his chair designs featuring straight legs of round or square sections that tapered toward a thimble or spade foot, with heart-, oval-, and shield-shape backs. Hepplewhite gained an international reputation after his widow published a book of his furniture designs in 1788. Thomas Sheraton's *The Cabinet-Maker and Upholsterer's Drawing Book* and *Cabinet Dictionary* established his reputation. He was influenced by Hepplewhite's use of straight legs, slender forms, moderate scale, and marquetry or painted decoration. Sheraton, however, refined the use of the straight line, right angle, and short, simple curves. These elements are best expressed in his chair backs, which exhibit a great deal more surface detail than Hepplewhite's. Sheraton also is credited with the development of the tambour desk, writing desk, and kneehole desk.

FIGURE 2.50 Two designs for Hepplewhite's shield-back chairs (a) resemble the delicate Adam style. Thomas Sheraton's side- and armchair (b) illustrate his use of the straight line, right angle, and short simple curves.

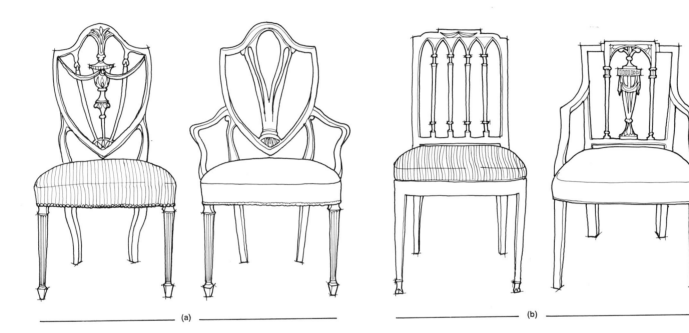

(a) (b)

REGENCY STYLE, C. 1800–1837. Architecture drew little interest during the English Regency period, in part because of the Industrial Revolution and the increase of wealth available to the middle class, which was not interested in cultivating new artistic styles. Interiors were generally open, incorporating large folding doors to separate rooms. To extend the interior space, bow and bay windows were used. Interiors as a whole became plainer, with less emphasis on rich ornamentation and more on flat surfaces. Ceilings were white plaster; walls were generally painted in strong colors with contrasting white pilasters or gilded fixtures. Fireplaces, which became less important, were framed with simple white or black marble mantels.

Regency furniture was very large in scale, severe, and simple in design. It imitated Chinese, Greek, Roman, Gothic, and Egyptian forms and ornaments. *X*-shape supports, as well as animal forms, such as lions, sphinxes, and chimeras, were used for chairs and stools. Case goods generally were very heavy and used architectural supports and moldings. One of the most important pieces of furniture of the Regency period was the adaptation of the "Grecian" sofa with scroll-shaped head and footrest (Figure 2.51).

Thomas Hope (1769–1831) was one of the most important designers of the Regency period. He traveled extensively and in 1807 published a book of his designs entitled *Household Furniture and Interior Decoration* (1807).

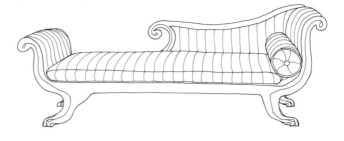

FIGURE 2.51 An example of a "Grecian" sofa illustrates the influence of Greek, Roman, and Egyptian forms in its splayed legs with lion feet and scroll-shaped head and foot rest.

AMERICAN NEOCLASSICISM, 1790–1860

Neoclassicism in the United States began about 1790, when the ancient Roman buildings and contemporary French and English neoclassic buildings were used as models for American architecture and interiors. The Federal style—the early phase of American neoclassicism—was characterized by formal public buildings that were based on Roman, Renaissance, and contemporary European models. However, domestic interiors and furniture relied on the restrained neoclassicism of Adam and his followers.

The late neoclassic period began after 1820, when the architectural style turned from Roman to Greek models. In America this period is referred to as the Greek Revival or Empire style, because it was strongly influenced by the French Empire and English Regency styles.

FEDERAL, 1790–1820. Independence and patriotism in America developed during the Federal era, which included the American Revolution, the War of 1812, and westward expansion.

Architecture during this time was rooted in classicism and symmetry. Thomas Jefferson, on his return from Europe, remodeled Monticello, his home, and produced designs for the University of Virginia in the new Federal style. That style, with its symmetry and attention to detail, soon became the most popular for new buildings across the land. Entries were often pedimented, flanked by columns, and placed symmetrically on the facade. Chimneys were moved to the ends of the building, and roofs were flat or hipped, topped with a balustrade (Figure 2.52).

FIGURE 2.52 The federal style produced a refinement of classical taste in American architecture. Symmetry, an entry portico, classical elements, and a roof topped by a balustrade are typical of this style.

Generally, residences had simple rectangular rooms, but some were combined with circular, octagonal, or oval spaces and ornamented with delicate surface embellishments. Walls were plastered and painted in white or pastels with classical motifs around center chandeliers hanging from the high ceilings. Floors were crafted in various woods and often covered by large carpets. Doors and windows were tall. Fireplaces were constructed of marble and flanked by pilasters.

Federal furniture styles came to America primarily through the influence of pattern books and can be classified as early (Sheraton, Hepplewhite, and Duncan Phyfe) and late (Empire). Hepplewhite's sideboard and shield-back chair were popular. Furniture in the early period had simple legs and feet. Proportions were small in scale.

Duncan Phyfe (1768–1854), a New York furniture designer, varied the Sheraton style in producing furniture bearing his unique stamp of individualism and style (Figure 2.53).

The late Federal style of furniture exhibited French and English influence. These pieces were of heavy proportions, primarily made from dark mahogany, and highly ornamented with a variety of motifs. Wardrobes were monumental; chair legs were embellished with motifs of animal feet in both wood and metals.

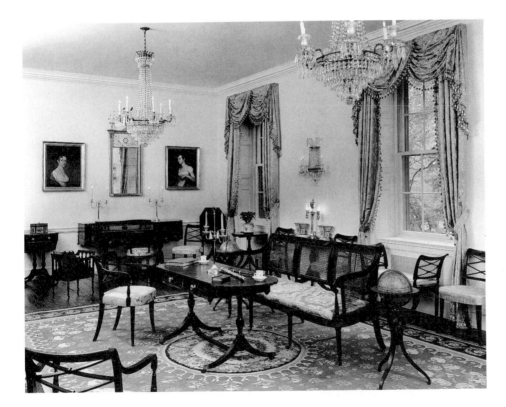

FIGURE 2.53 Examples of Duncan Phyfe's earlier work is shown in this typical room of the Federal period. The elegant simplicity of the square-back chairs is reminiscent of the Sheraton style.

GREEK REVIVAL OR EMPIRE STYLE, 1820–1860. About 1820, architects returned to earlier periods, to the monumental classics of Greek and Gothic structures, for models to copy. It was a time of using historic styles in a variety of design movements. **Eclecticism** reigned, incorporating historical pieces and parts of classic buildings, rather than the entire composition, into new buildings.

The Greek style became popular in America for architectural motifs. Large commercial buildings, as well as private homes, incorporated pediments, porticos, columns, and various details from the classic structures of the past. Sympathy for the Greek wars of independence and the urging of American statesmen for federal buildings in classic styles caused architectural designers

to produce this revival. Temple-style buildings using Greek orders began to appear everywhere, particularly in the large mansions of the South.

Empire-style homes were spacious in their interiors and filled with large proportioned furniture. Geometric designs and vivid colors, especially in carpets, curtains, and upholstery, added a richness to the American Empire interiors.

The Victorian Era, 1830–1901

The Victorian era is generally identified with the reign of Queen Victoria. Many architectural, interior, and furniture styles of the past, including the Greek, Gothic, and subsequent movements were adopted. The period produced heavily decorated and stylistic varieties in the architecture, interiors, and furniture.

Society developed into middle- and upper-class stratifications, each demanding more social functions. Inventions flourished, the automobile appeared, and immigrants flowed into America. All this variety and industrialization produced some interiors that were not orderly in their arrangement and used unrelated carvings and patterned surfaces excessively.

The Gothic revival style overlapped the Greek style and was inspired by the Gothic designs still being produced in London. Although the Gothic revival did not produce exact copies of existing buildings, the style was seen as proper for churches as a testament to Christianity.

The Victorian era also produced an abundance of residential varieties. These wood interpretations of earlier styles each had its own characteristics. Soon, however, residences began to be interpreted in the Gothic style. A series of cottage dwellings by Andrew Jackson (1815–1852) and A.J. Davis (1803–1892), as seen in Figure 2.54, exemplify the Carpenter Gothic, or ginger-

FIGURE 2.54 In this Carpenter Gothic-style cottage the windows are tall and arched. Adding to this vertical effect are pointed gables with a scalloped verge board.

bread, style. Its machine-cut scrollwork on gables became a popular motif. Gothic interiors of carved, arched wooden panels and corresponding furniture were given contemporary proportions, in many cases resulting in awkward appearances.

After the Gothic style came the Italian villa, mansard, Victorian eclectic, and Queen Anne styles. Machine saws capable of intricate carving produced a variety of shapes in trimwork, shingles, posts, and windows.

A pivotal event in the Victorian era was the Great Exhibition, held in London in 1851. Art, crafts, and machines were exhibited in the Crystal Palace (Figure 2.55), a structure of prefabricated iron and glass components that could be assembled and dismantled at the site. This was the beginning of an age of new materials and advanced technology. Interestingly, as the industrial and machine age progressed, turning out better materials and methods of mass production, the designs of the time remained deeply rooted in historical copies. For example, an outdoor garden seat, formerly produced in wood could be made in the new malleable cast-iron material, but it continued to be molded in the old naturalistic vine pattern, with grapes and leaves. This contrast of new materials and old designs continued until the twentieth century, when finally architects and designers began to explore the integrity, meaning, and functional aspects of new materials and processes. This direction was to produce distinct styles that had no predecessors.

FIGURE 2.55 The Crystal Palace, designed by Joseph Paxton, was a prefabricated iron-and-glass structure that housed the first world fair, the Great Exhibition of 1851, was over 1,600 feet (500 meters) long.

NON-EUROPEAN ARCHITECTURE AND INTERIORS

There have been non-European influences, direct and indirect, on Western architecture and interiors since ancient times. Only the most important of these contributions can be discussed here, but the reader is encouraged to consult books from the bibliography and other sources for more details of these cultures and their influence on design. As we become more global in our culture, it is important for the interior designer to understand the beginnings and current traditions of these peoples and their lands.

China

Chinese architecture and interiors developed over a long period and involve the art of creating space, as well as the unique use of materials and construction techniques. The architecture was a traditional, homogeneous blend of buildings that was repeated throughout the centuries, with origins more than 4,000 years ago. Construction and designs varied with the dynasties and regions of the country.

Chinese buildings and towns were based on cosmos imagery and a careful ordering of space. Designs emphasized a regularity of structure and modular proportions. These formulas are evident in both simple, small buildings and grandiose ones because similar materials and methods were used for both. Structures were usually wooden frameworks of beams and columns placed on a platform (Figure 2.56). Non-loadbearing latticework and screens were placed between the columns for privacy and space separation while permitting air circulation. Stone and brick were used mostly in fortifications, tombs, bridges, and pagodas, where more durability was required.

FIGURE 2.56 The Chinese timber technology can be seen in the Confucian Temple located in Teipei, Taiwan. The temple was built in 1854, destroyed in 1895, and rebuilt in 1925.

Many Chinese houses were designed with an integral landscaped garden that provided a scenic walk or place for meditation. The gabled, tile-covered roof of the house often was steeply pitched, curving upward. Wide overhangs were supported by multiple brackets, often complex in their design. This roof construction evolved over the centuries, producing well-crafted geometric forms that interlocked into tight joints, eliminating the need for nails or bolts (Figure 2.57).

Buildings were designed as primary rectangular spaces that were increased by the addition of lesser bays and lower roofs, creating a pavilion style. Most arrangements were laid in axes of primary and secondary spaces.

Influences of Chinese architecture can be seen throughout the world, particularly in the Victorian era, where many Chinese buildings and stylistic forms were copied in new construction.

FIGURE 2.57 The evolution of Chinese roof construction shows that the early designs (1) consisted of narrow eaves and span. To increase the size of a room, more pillars were added (2), which caused the interior to become cluttered. A system of brackets was then developed that would reinforce the structure and open up the interior space (3). Since the 8th century, cantilevers were designed to fit within the brackets that supported more brackets (4).

Japan

Japanese architecture and interiors were strongly influenced by the Chinese techniques that reached Japan primarily through Buddhism and through temple building by way of Korea. However, Japan has its own distinct style of architecture.

In Japan dissymmetry, as contrasted to the Chinese symmetrical patterns, was introduced. Traditional Japanese architecture relies on wood as the primary building material and uses horizontal wooden frameworks, set upon a platform and infilled with windows, doors, and sliding partitions (Figure 2.58) that are often made of wood frame and paper. Hipped roofs are tiled and curved upwards on complicated bracket forms.

FIGURE 2.58 The most notable and influential building that characterizes Japanese form is the Katsura imperial palace, built about 1620. The palace is a group of buildings with entrance gates and tea houses surrounded by gardens and lakes.

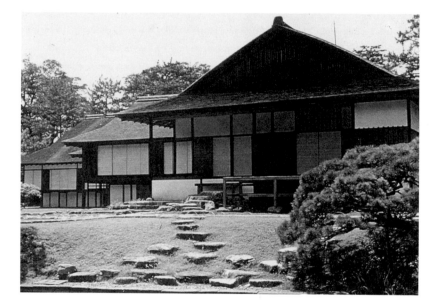

Japanese architecture is closely connected with the environment, with walls and spaces opening onto the exterior, providing a strong tie between external and internal spaces. This sense of harmony and relationships and of open internal space had an influence on the residential buildings and interiors of modern Western architecture.

Japanese houses are often designed on a modular tatami system; tatami are standardized (six feet six inches by three feet) mattresses of compressed straw. Room dimensions were established in the tatami proportions, and shoji (translucent screens) panels were placed between columns for light and view control.

India

Much ancient Indian architecture has been lost because the structures' wood construction has not survived. Most that do remain are temples that were constructed of brick and stone (Figure 2.59).

Indian craftsmen were very adept at rock carving techniques, hollowing out niches, forms, elaborate carvings, and entire buildings from the stone. Large Buddhist monasteries and temples were carved from the rock faces of cliffs, creating an exciting sculptural form of space and structure.

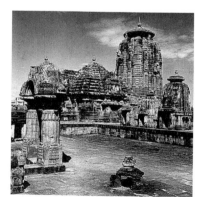

FIGURE 2.59 The temples of Orissa, at Mukteshvara, Bhubaneswar, dating around the beginning of the 9th century, epitomizes the form and exceptional carvings in medieval Indian architecture.

Some of the best-known architectural monuments in India are the Taj Mahal (c. 1640) in Agra and the Fatehpur Sikri.

Pre-Hispanic America

The architecture of pre-Hispanic America was established in Central America and related regions. The rich complexity of the cultures in those areas produced many Mayan cities and Incan fortresses throughout the region. Many of the structures were in the form of pyramids, markets, ball courts, and other building groupings.

Although most of these structures are gone or overgrown with vegetation, those that do remain exhibit distinct style, ornamentation, and construction methods (Figure 2.60). Mexican and southwestern American design motifs often are based on these previous civilizations and their buildings.

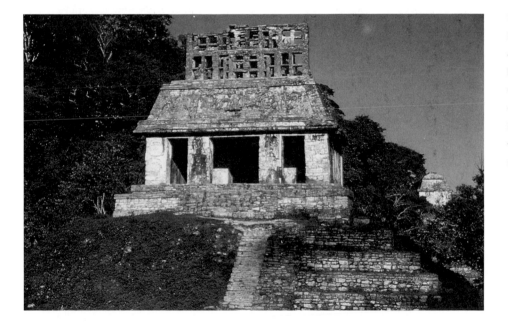

FIGURE 2.60 The Temple of the Sun, Palenque, was built at the end of the 7th century and belongs to a group of buildings that includes the Temple of the Cross and the Temple of the Leafed Cross. The architecture of these buildings is very subtle and appears simple, yet they contain, especially on the interior, numerous decorative elements.

NOTES TO THE TEXT

1. David B. Guralnik, Editor-in-Chief, *Webster's New World Dictionary of the American Language,* 2nd College Edition. New York: Simon and Schuster, 1984, p. 382.

REFERENCES FOR FURTHER READING

Ball, Victoria K. *Architecture and Interior Design.* 2 vols. New York: John Wiley & Sons, 1980.
Bellinger, Louise, and Thomas Broman. *Design: Sources and Resources.* New York: Van Nostrand Reinhold, 1965.
Bevlin, Marjory. *Design Through Discovery.* New York: Holt, Rinehart and Winston, 1985.

Boger, Louise Ade. *The Complete Guide to Furniture Styles*. New York: Charles Scribner's Sons, 1969.

Chippendale, Thomas. *The Gentleman and Cabinet-Maker's Director*. New York: Dover Publications, Inc., 1966.

Faulkner, Ray, LuAnn Nissen, and Sarah Faulkner. *Inside Today's Home*. 4th ed. New York: Holt, Rinehart and Winston, 1975.

Fitzgerald, Oscar P. *Three Centuries of American Furniture*. Englewood Cliffs, N.J.: Prentice-Hall, Inc., 1982.

Giedion, Sigfried. *Space, Time, and Architecture*. Cambridge, Mass.: Harvard University Press, 1976.

Hepplewhite, George. *The Cabinet-Maker and Upholsterer's Guide*. New York: Dover Publications, Inc., 1969.

Itten, Johannes. *Design and Form*. New York: Litton Educational Publishing, Inc., 1975.

Lauer, David. *Design Basics*. New York: Holt, Rinehart and Winston, 1979.

Lucie-Smith, Edward. *Furniture: A Concise History*. New York: Oxford University Press, 1979.

McCorquodale, Charles. *A History of Interior Decoration*. New York: Vendome Press, 1983.

Sheraton, Thomas. *The Cabinet-Maker and Upholsterer's Drawing Book*. New York: Dover Publications, Inc., 1972.

Trachtenberg, Marvin, and Isabelle Hyman. *Architecture, From Prehistory to Post-Modernism*. New York: Harry N. Abrams, Inc., 1986.

Whiffen, Marcus, and Frederick Koeper. *American Architecture 1606–1976*. Cambridge: MIT Press, 1981.

Whitton, Sherrill. *Interior Design and Decoration*. Philadelphia: J.B. Lippincott, 1974.

Yarwood, Doreen. *The Architecture of Europe*. London: Batsford, 1974.

———. *The Architecture of Britain*. London: Batsford, 1976.

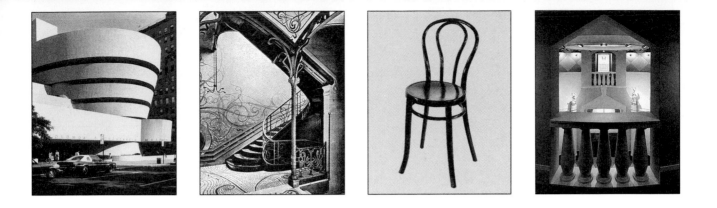

C H A P T E R 3

THE
EVOLUTION
OF
MODERN
DESIGN

he evolution of modern architecture and design was characterized by the rapid transformation of Western civilization beginning in the late eighteenth century. One of the most important developments was the Industrial Revolution, which changed the old order of society. New technology in transportation and communication (telephone, radio, movies) made people more aware of each other, important events, and the availability of commercial products. Living and working conditions for all people improved because furniture and other items could be mass produced rather than handmade. This development permitted the growing middle class, rather than just the wealthier upper class, to become consumers of the products of industry.

Further, theories of evolution and relativity, along with other scientific discoveries, made people question basic concepts of humanity and of the world around them.

NEW TECHNOLOGY— INNOVATIVE DESIGN

The Industrial Revolution and the introduction of new materials and technology caused architecture and interior design gradually to emerge from mere imitation of styles of the past. A new style of architecture emphasizing iron, wood, and glass appeared. Another important innovation was the development of new structural members made of iron that allowed greater spans between cast-iron columns. The use of freestanding columns supporting iron girders and timber roofs created flexible, open spaces that allowed a fluid interpenetration of spaces, as opposed to the rigidity of the typical closed-box arrangement.

The tremendous space the iron frame could span was exhibited by the Crystal Palace at the London Exposition in 1851. This structure demonstrated that a frame could be self-sustaining and that nonstructural materials, such as glass, could be used as exterior surfaces for admitting natural light. The same structural iron large-span construction was also used for department stores, libraries, railroad stations, exhibition halls, and other specialized public and commercial buildings.

For decades, there was a definite division between art and technology. New technology and materials challenged a few innovative designers, but the majority were content to draw inspiration from historical styles.

Michael Thonet, 1796–1871

Michael Thonet was an innovative Austrian designer who designed and produced in the 1830s what is considered to be the first modern furniture. He invented a process for steaming and bending hardwood by machine that is still used. The result was gently curved shapes that could be used for sturdy, lightweight, and relatively inexpensive furniture. His furniture was shown internationally at the London Exhibition and was accepted immediately at all social and economic levels. It became widely popular in Europe and the United States both for home and public use, notably in cafes and ice cream parlors (Figure 3.1). Thonet also created the bentwood rocker, whose rounded arms and swirling curves seem to imitate the chair's swaying motion.

FIGURE 3.1 This Vienna cafe chair (1876) was mass produced by Michael Thonet. The back and legs are formed from a continuous section of bent wood. This styled chair is still in production today. (Thonet Brothers. "Vienna Cafe Chair." Bent beechwood, 33½" high. Collection, The Museum of Modern Art, New York)

Shaker Furniture, 1747–c.1860

The Shakers were members of a communal religious sect who came to the United States from England in the second half of the eighteenth century. Their belief in order and utilitarian objects produced plain furniture devoid of carved ornament, moldings, or veneers. It was generally delicate in its proportions, though sturdy, and exhibited only the essentials of form to achieve maximum efficiency. This concept that true beauty rests on the suitability of the article to its purpose, that form should follow function, is one of the most important founding principles of modern design.

The interiors of Shaker houses consisted predominantly of built-in cupboards, chests, and drawers, each designed for a specific storage purpose. Shaker furniture became popular around

1860 and remains so because of its simple, sparse lines and functional quality that can be successfully combined with a variety of other styles.

The Arts and Crafts Movement, 1860–1900

The early part of the nineteenth century produced attempts to imitate handmade products with machine methods. However, most mass-produced objects exhibited poor quality in design and construction. A conscious revolt against machine-made objects was begun in England as early as the 1840s by John Ruskin (1819–1900), a writer who condemned machine-made objects and the use of one material to simulate another. In his book *The Seven Lamps of Architecture* (1849), Ruskin urged a return to honest craftsmanship, particularly that of the Gothic period. A.W.N. Pugin (1812–1852) expressed similar feelings when he wrote in *Contrasts* (1836) that true beauty of design was attained if the design fit the purpose for which it was intended. This reaction against machine-made products was called "the arts and crafts movement" and was headed by William Morris (1834–1896), a designer who advocated a return to basic honesty and simplicity in handmade furniture.

Morris and his company produced wallpaper, textiles, and furnishings (Figure 3.2). However, the firm's handcrafted products were more expensive than the mass-produced products of industry and thus the movement failed to spread to all levels of society.

The arts and crafts movement attracted a number of followers, including artists, architects, designers, and critics, who continued Morris's ideas although they moved away from the heavy, medieval influences he favored.

FIGURE 3.2 This refreshment area (1867) of the South Kensington (now the Victoria and Albert) museum in London was designed by William Morris and Philip Webb.

In the 1890s, Charles F.A. Voysey (1857–1941), one of Morris's most important successors, designed houses featuring honest, uncluttered interiors, as well as his own wallpaper, textiles, and furniture. Voysey's furniture showed a Japanese influence in its light, simple design.

Henry Hobson Richardson (1838–1886) was an American architect who revolted against the Gothic revival and turned to the round-arched Romanesque style. His personal style also featured exteriors of local stone or weathered wooden shingles, and towers that harmonized with the natural setting. Richardson's interior space was laid out in an asymmetrical plan with a generous amount of space flowing around the entrance hall and stairway (Figure 3.3). The use of interior space, rather than a concern for exterior symmetry and regularity, also dictated the size and placement of windows. Richardson's interiors emphasized his concern for expertly crafted woodwork and built-in furniture. His interpenetration of spaces was an influence on the work of Frank Lloyd Wright.

In California, the Greene brothers, Charles Sumner (1868–1954) and Henry Mather (1870–1957), integrated the arts and crafts techniques with shingle-style architecture and Japanese decoration and detailing. The craftsmanship of Greene and Greene's interiors and furnishings emphasized perfectly integrated woodwork in every detail. Julia Morgan, the first woman architect registered in California, also worked in this integrated tradition of paneled woodwork and furnishings.

FIGURE 3.3 Henry H. Richardson designed this staircase for the R. T. Paine house (1884–1886) in Massachusetts.

Art Nouveau, 1890–1905

The art nouveau movement appeared during the 1890s throughout Europe and the United States almost simultaneously. This movement opposed excessive overloading of interiors with unnecessary applied ornament and furnishings. It was believed that the beauty of an object was derived from natural forms, simplicity, and good craftsmanship. Artists of this period tried to create a new style based on leaves, flowers, branches, and sweeping curves. Art nouveau is characterized by sinuous, organic lines ending in a whiplash curve like the bud of a plant. Art nouveau was the first truly original style since the French rococo (1715–1774).

Art nouveau was popularized in Europe by many designers from the early 1880s until about 1900. Victor Horta (1861–1947), a Belgian architect, fully developed the art nouveau style through the use of meandering ribbon patterns that appeared molded in the iron handrails of stairways, painted on walls, and inlaid in floor mosaics. An example of his work is the Hôtel Tassel in Brussels (1892–1893) (Figure 3.4). Before Horta, exposed iron was used mostly for bridges and engineering works, not as an interior material.

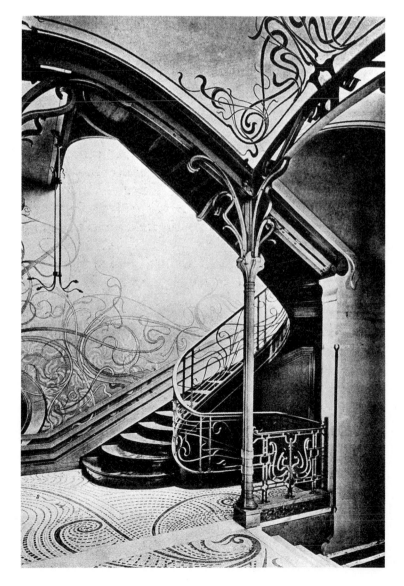

FIGURE 3.4 Victor Horta designed this dynamic, flowing iron staircase in the Tassel House, Brussels, Belgium (1893). (Photograph, courtesy of the Museum of Modern Art, New York.)

In France, Hector Guimard (1867–1942) was an architect noted for carrying the art nouveau style mainly into his interiors. He designed furniture, fixtures, lamps, doorknobs, and even special nailheads with long, sensuous lines that were included as part of a totally unified interior.

Unaware of what was being done in Brussels and France, Antonio Gaudi (1852–1926) worked in Barcelona, Spain, and was one of the most creative and inventive architects in the art nouveau movement. Gaudi's sculptural forms seem to be in constant motion (see Figure 4.5). His interior spaces appear to have been pulled askew, leaving strange, organically shaped windows that seem hollowed out by the wind. The same sensuous, fluid shapes appear in his furniture and fixtures.

Charles Rennie Mackintosh (1868–1928), a Scotsman, was the only inventive architect working in the art nouveau style in Great Britain. Mackintosh's designs consisted mainly of rectilinear shapes with delicate swirls of linear patterns. His furniture was formal and elegant and featured tall (some were more than six feet high), straight backs with slender vertical elements.

In the United States, there were only two major art nouveau designers: Louis Sullivan (1856–1924), a Chicago architect who designed commercial buildings, applying a stylized, flowing floral design to the exteriors (Figure 3.5), and L.C. Tiffany (1848–1933), who developed new techniques of working with glass and metal. He is best known for the swirling decorative patterns and vivid colors in the flowers and trees of his stained glass windows and lampshades.

FIGURE 3.5 Louis Sullivan designed this tracery around the street-level windows of the Carson Pirie Scott store in Chicago (1901–1904). His designs reflected the art nouveau influence of nature-based motifs.

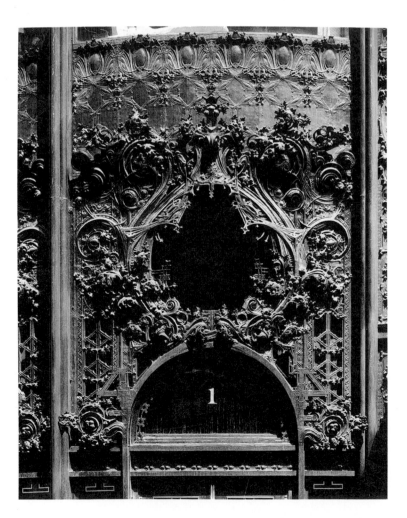

The Vienna Secession Movement, 1897–1911

At the turn of the century, the Vienna secession movement was led by protesting groups of young designers and artists, including architects Otto Wagner(1841–1918), Adolf Loos (1870–1933), and Josef Hoffmann (1870–1956). This movement was the Viennese parallel to the arts and crafts reform movement and protested design approaches, such as art nouveau, that focused only on surface ornamentation and visual effects. In 1903, Hoffmann and Koloman Moser (1868–1918) formed the Wiener Werkstaette (Vienna Workshop) to produce utilitarian objects handcrafted by fine artists. Their goals were to produce functional art that would be viewed as aesthetically significant and would link the public, designer, and worker through objects of everyday use. Hoffmann, the most brillant of the Viennese decorative arts modernists, is best known for the design and furnishings of the Palais Stoclet, a lavish residence in Brussels. It is an example of the unique Viennese total work of art, integrated inside and out with luxurious materials and elaborate decorative objects, paintings, mosaics, and furnishings. Later, Hoffmann and Wagner became known in the United States for their furniture designs, which are still manufactured today.

Although the Vienna secession movement had no strongly identifiable design effects on American interior design, it did contribute to the foundations of the Modern design movement.

THE TWENTIETH CENTURY

In the twentieth century several important designers pioneered in the development of the Modern style of architecture and design. When they began their innovative practices, American and European designers and architects were still using historical or eclectic styles, and architects who attended the French Ecole des Beaux-Arts were "borrowing" pseudoclassical elements for their building vocabularies.

Pioneers of Modernism

Louis Sullivan was an important architect not only as a pioneer in the development of modernism but also as mentor to Frank Lloyd Wright. Sullivan adopted the phrase "form follows function" as the principle defining the way in which architectural and design elements expressed their structure, rather than concealing it with eclectic ornamentation.

Frank Lloyd Wright (1867–1959) developed the theory of "organic" architecture, which states that a building should grow from the inside out, blending into the landscape. Wright believed architecture should be uplifting, going beyond the needs of comfort and shelter. In his home designs, he used the open-plan concept, breaking away from many boxlike, closed interior spaces. Wright developed the "Prairie" house (Figure 3.6), which expressed his concern for the freedom of movement available in the wide open spaces of the American Midwest.

Wright had firm design control over all his buildings, including the interiors and the furniture (Figure 3.7). He used natural tones in the plaster work and natural finishes on wood.

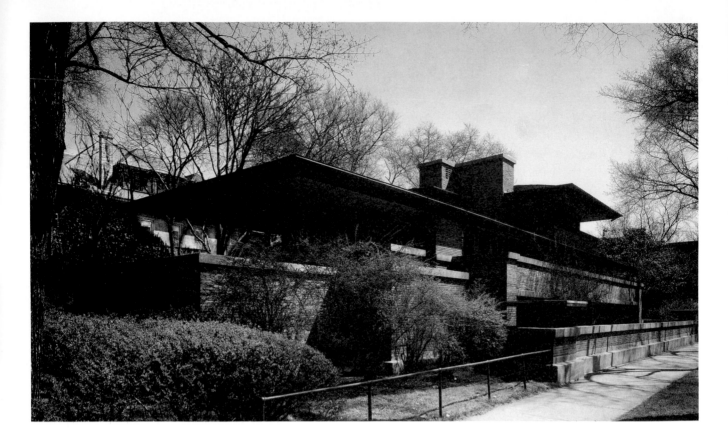

FIGURE 3.6 Frank Lloyd Wright's design for the Robie house (1909) in Chicago exhibits long horizontal flowing forms extended from a central fireplace core.

FIGURE 3.7 Wright employed rich materials that helped to define shape and direction, spatially linking major areas within the interiors—as seen in Taliesin East (1925), Spring Green, Wisconsin.

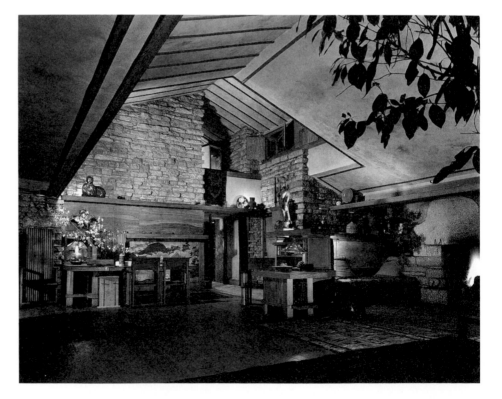

His interiors abounded with geometrical designs, diagonal motifs, stained glass inserts, and asymmetrical arrangements.

Wright's seating designs were geometric and fairly uncomfortable, for he felt sitting was an unnatural body position, and standing and reclining were natural. Many items were built in and were integrated with the architecture.

Le Corbusier (1887–1965), a Swiss architect and designer whose given name was Charles Edouard Jeanneret-Gris, was an early French Modernist who used simple, Cubist style designs. He believed that a house was a "machine for living," whereas Wright's concept held that house and landscape were one. Corbusier's designs, which exhibit geometrical abstractions, were founded on principles of mathematical, orderly modules. His best statement of Modernism in architecture is the simple, boxlike Villa Savoye, built in 1929 in the Paris suburb of Poissy (Figure 3.8).

Corbusier worked with furniture designer Charlotte Ferriand and designed tables, chairs, and built-in storage units. His chromium-plated tubular steel chairs were designed for comfort, conversation, or reclining.

FIGURE 3.8 Le Corbusier (Charles-Edouard Jeanneret), with Pierre Jeanneret, designed the Villa Savoye (1929–1930) in Poissy, France (near Paris) in the simple, geometric forms of the modern style. The main living area of the house is raised above the ground-level garage and entry foyer. The roof is provided with a patio and protected by a windscreen. (Photograph, courtesy of the Museum of Modern Art, New York.)

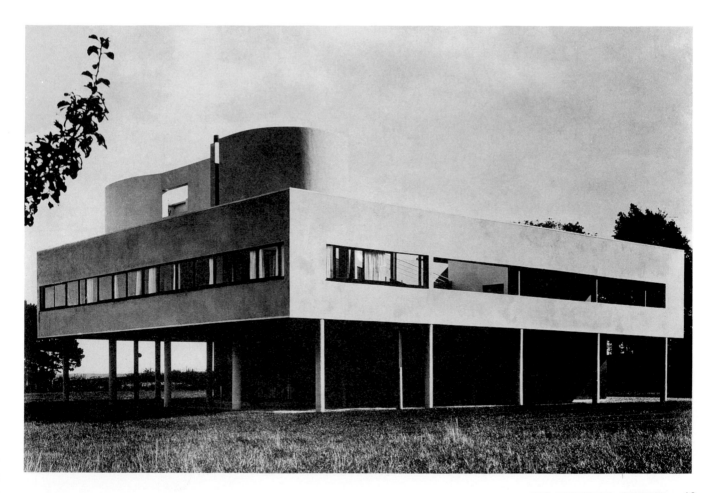

Later in Corbusier's career, he abandoned many of his simple, geometrical shapes, creating a more sculptural form of architecture with concrete and plaster, as exemplified in the church at Ronchamp in 1950 (Figure 3.9).

FIGURE 3.9 The Chapel at Ronchamp (1950–1954) in southern France by Le Corbusier is an expressionistic free-form sculptural building. The interior sloping walls were heavily stuccoed and penetrated by a variety of sized and patterned windows. (Esra Stoller © Esto.)

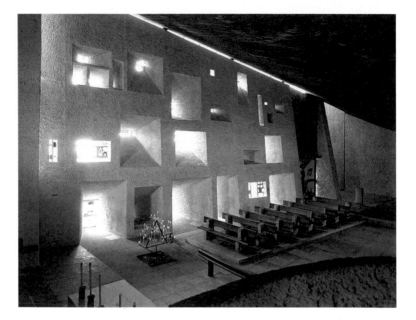

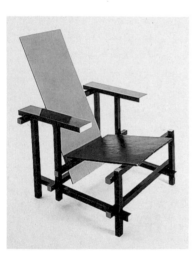

FIGURE 3.10 Gerrit Rietveld's "Red and Blue Chair" (c. 1918) represented a major break from traditional furniture design. The seat is painted blue, the back red, and the other parts black with white accents on the ends. (Painted wood, 34⅛ × 26½ × 26½". Collection, The Museum of Modern Art, New York. Gift of Philip Johnson)

de Stijl, 1917–1931

A group of artists and architects in Holland originated the de Stijl movement, which favored geometrical and abstract designs. Although some historians also call this movement constructivism, that was an art movement originating in Russia in the 1920s. Painters, such as Piet Mondrian (1872–1944); sculptors; architects; and designers, such as Gerrit Rietveld (1888–1965), used basic elements to compose their works. Mondrian restricted his paintings to abstract geometric lines, shapes, and primary colors with black and white. In turn, architects and designers turned to flat planes, geometry, and simple forms to echo the de Stijl principles.

Perhaps the most noted design of the movement was Rietveld's Red-Blue Chair (Figure 3.10). The handling of the flat planes, simple joinery, hiding the natural woods with paint, and sharp edges all allude to the aesthetics and precision cutting of machine manufacturing, as opposed to the crafted furniture of earlier eras.

Bauhaus, 1919–1933

One of the most influential movements in modern architecture and design came from the Bauhaus, a German school of design. Under the initial direction of Walter Gropius (1883–1969),

the Bauhaus philosophy was to simplify the design of objects so that functionalism, material usage, and construction techniques were evident in the finished piece. Ornamentation was seen as surface decoration, not part of the integrity of the design; hence it was banned. The Bauhaus celebrated prefabricated and standardized parts in design stemming from the age of machine manufacturing.

Gropius, a German architect, studied in Berlin. With Adolf Meyer (1881–1929) he designed some of the first modern buildings of his time, including the Fagus factory at Alfeld (1911–1913) and the Deutsche Werkbund Pavilion at the Cologne Exposition (1914). He became the first director of the Bauhaus school and designed its new facilities in Dessau, one of the most important examples of Modern architecture. In 1928, Gropius retired as the Bauhaus leader; the school closed in 1932. Gropius then worked in Europe and America, becoming the head of the architecture department at Harvard University in 1937.

The German architect Ludwig Mies van der Rohe (1886–1969) succeeded Gropius as the director of the Bauhaus and was one of the most influential pioneers of the machine-design styles. His German Pavilion for the International Exposition in Barcelona, Spain, in 1929 (Figure 3.11)

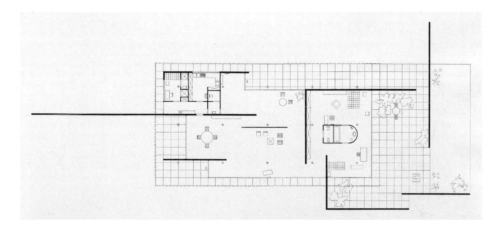

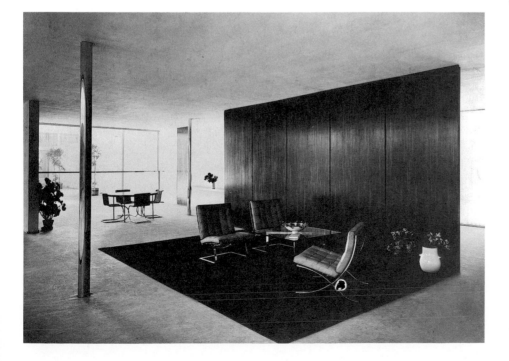

FIGURE 3.11 Ludwig Mies van der Rohe provided free-flowing spaces and designed chairs, tables, and other furniture that have become classics. TOP Plan of *House, Berlin Building Exposition,* 1931. Ink on illustration board 30 × 40". (Collection, Mies van der Rohe Archive, The Museum of Modern Art, New York. Gift of Ludwig Mies van der Rohe.) BOTTOM Photograph of *House, Berlin Building Exposition,* living room, no longer extant. (Courtesy of the Mies van der Rohe Archive.)

is considered a masterpiece of design. He used free-flowing space, planes for walls, and thin steel columns under a low, flat roof. As part of the exhibition, he also designed the classic Barcelona chair (see Figure 16.5), which has become one of the most significant chair designs in history.

Mies coined the phrase "less is more," which reduces design to its most elemental essentials, then refines the details to near perfection. He moved to the United States to head the Illinois Institute of Technology architectural school in 1938 and influenced many of the steel-and-glass-enclosed high-rise buildings of the 1950s and 1960s.

Another member of the Bauhaus was the architect Marcel Breuer (1902–1981), who designed several important modular-unit furniture pieces in the machine style. His tubular steel chair of 1925 (Figure 3.12) and the Cesca chair of 1928 (Figure 3.13) are copied today and have become international classics. Breuer also became world famous for his architectural works, such as the UNESCO Secretariat building (1957–1958) in Paris and the Whitney Museum (1966) in New York.

FIGURE 3.12 Marcel Breuer designed this chrome-plated tubular steel armchair with canvas slings (1927–1928). His classic design continues to be produced and is used in many contemporary settings today. (*Armchair (B3)*. Late 1927, early 1928. 28½ × 30¼ × 27¾. Collection, The Museum of Modern Art, New York. Gift of Herbert Bayer)

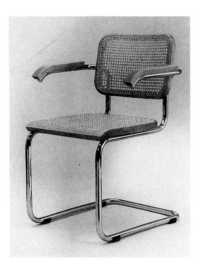

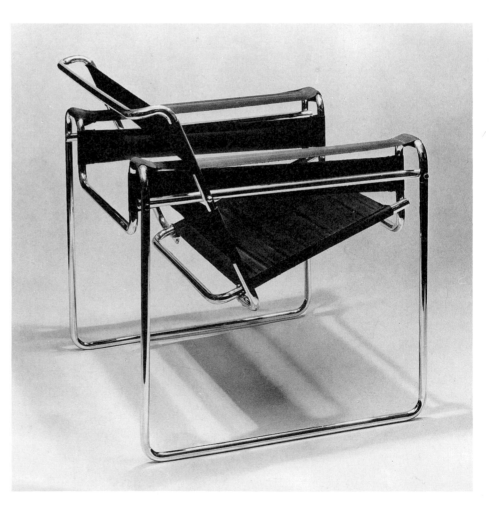

FIGURE 3.13 Marcel Breuer's "Cesca Chair" of 1928 is made in simple lines of chromed tubular steel with a caned back and seat. It is still manufactured today.

International Style

In 1932, Philip Johnson (1906–) and Henry Russell Hitchcock (1903–) organized an International Exhibition of Modern Architecture and coined the term *international style*. This style used ferroconcrete and glass in an unadorned and modular form to produce stark, simple structures. The international style emphasized free-flowing interior spaces, as opposed to structure as a mass, and decoration was eliminated to create sleek lines. Regularity, asymmetry, and volumes defined by light are typical of the international style. Many of the buildings were white, exhibiting a stark contrast to the landscape—glorifying the building as a machine-made entity.

Art Deco, 1925–1940

Modern design spawned the art deco style in the late 1920s and 1930s. It was named after the 1925 Paris Exposition of Decorative Arts, which exhibited design styles fashioned after machine productions. Art deco used aluminum, shiny metals, plastic, mirrors, and glass walls. Geometric shapes and bold colors were used freely in contrasting patterns and surfaces (Figure 3.14). Images such as lightning bolts, zigzags, sunbursts, and triangles were used in dynamic patterns.

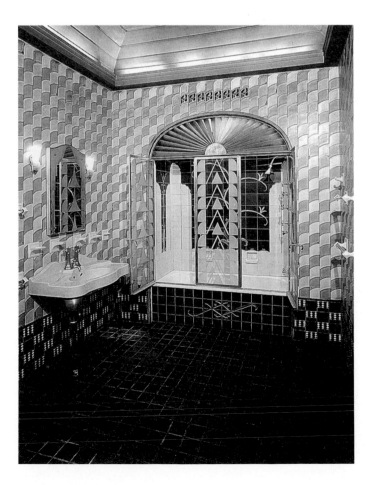

FIGURE 3.14 The art deco style can be seen in this private office bathroom as designed in 1929 by Jacques Delamarre. Popular motifs of sunbursts, dynamic patterns, and hard materials are used throughout.

Art deco quickly spread to America through the many department store buyers who had attended the 1925 Exhibition, bringing back various products crafted in the innovative style. Buildings and furniture were designed with straight, machinelike exactness, and the emphasis on streamlining was seen in aircraft, trains, automobiles, and many consumer products.

Influenced by the Paris Exposition, Eileen Gray (1879–1976) exemplified the art deco style with her highly decorative interiors. However, she later became interested in the Modern movement, seen in her use of glass and tubular steel, and abandoned the art deco style.

MODERNISM

The influences of Mies, Corbusier, and Gropius led Modernism and the international style into the forefront of design. Development in the 1930s of plexiglas, thermosetting plastics, plastic laminates, nylon, and fluorescent lighting added to the clean, functional look of Modern styling.

Although there are some typical characteristics of Modernism, there is also variety within it. Generally, however, Modern style is functional, is simple in form, and lacks ornamentation.

Early Modernism, 1930–1950

By the 1930s, Modernism had spread throughout America. Although it is difficult to list all the key people who contributed to the development of Modernism, we will mention major contributors to this style in architecture, interiors, and furniture.

Buckminster Fuller (1895–1983) was the architect, engineer, inventor, and futurist who developed the dymaxion house in 1927 (Figure 3.15). Although Fuller is not considered a true

FIGURE 3.15 Buckminster Fuller's Dymaxion House (1927) applied technological features such as a hexagonal enclosure of plastic and metal suspended from a central mechanical core.

Modern stylist, his work with both machine fabrication of materials and functionalism places him as a Modernist. He invented geodesic domes (see Figure 4.2), which have been built throughout the world.

Alvar Aalto (1898–1976), a Finnish architect, was an international designer of buildings and furniture. Aalto's concerns for acoustics and lighting produced some distinctive interiors. His innovative stacking chairs are widely copied today and exhibit the machine-made simplicity of the Modernists—although he worked primarily in plywood, utilizing laminating and bending techniques (Figure 3.16), rather than metals, as did most Modernists.

Charles Eames (1907–1978) was an innovative furniture and interior designer whose impact is still seen in today's products. The leg splint he designed of molded plywood for the Navy in the 1940s led the way to the development of his famous plywood chair (Figure 3.17) of 1946. He also designed a molded plastic chair with Eero Saarinen (1910–1961) and one of polished aluminum, both of which are considered classics.

FIGURE 3.16 BELOW, LEFT **Alvar Aalto's Paimio chair (1931–1932) is typical of his designs using laminated and bent Birch plywood. These contrasted with the modern-style tubular steel furniture of the same period.**

FIGURE 3.17 ABOVE, RIGHT **Molded plywood chair (1946) by Charles Eames and Ray Eames. These production chairs were cut from sheets of plywood and formed into various structural, flowing forms.**

Eames and his wife, Ray, started designing furniture for the Herman Miller Company in 1946, producing a series of noteworthy pieces still being copied. Eames not only designed furniture but also was involved in architectural design and movie-making. His own house, a forerunner of the use of factory-made components, was constructed in 1949 of lightweight steel (Figure 3.18).

Eliel Saarinen (1873–1950), a Finnish architect who settled in America, in 1932 became director of the Cranbrook Academy of Art, which educated many design leaders of the 1950s and 1960s. Although Saarinen is not considered a pure Modernist in his architectural designs, his influence through the Cranbrook education system had great impact on modern designers, such as Harry Bertoia (1915–1978), Harry Weese (1915–), and Jack Lenor Larsen (1927–).

FIGURE 3.18 Charles Eames built his own home (1949) near Los Angeles of modular lightweight steel framing members. These systems allowed a great flexibility in placement of windows, walls, and other components. (Copyright © Julius Shulman, HON, AIA.)

Eero Saarinen (1910–1961), the son of Eliel, was an architect who worked with Eames designing innovative furniture. Saarinen designed the womb chair (Figure 3.19) in 1946 and a pedestal chair in 1958. Later, he produced many major works of architecture, including the Trans World Airline building at Kennedy Airport (Figure 3.20) and St. Louis's Gateway Arch (see Figure 14.6), one of the most innovative examples of contemporary architecture and a unique interior space.

FIGURE 3.19 LEFT Eero Saarinen created his famous Womb chair designs in 1948. They were constructed of molded fiberglass-reinforced plastic shells.

FIGURE 3.20 BELOW Eero Saarinen's TWA Terminal at JFK International Airport (1962) is one of the most sculptural buildings constructed. Structure, interior space, and materials all flow integrally throughout the building. (Esra Stoller © Esto.)

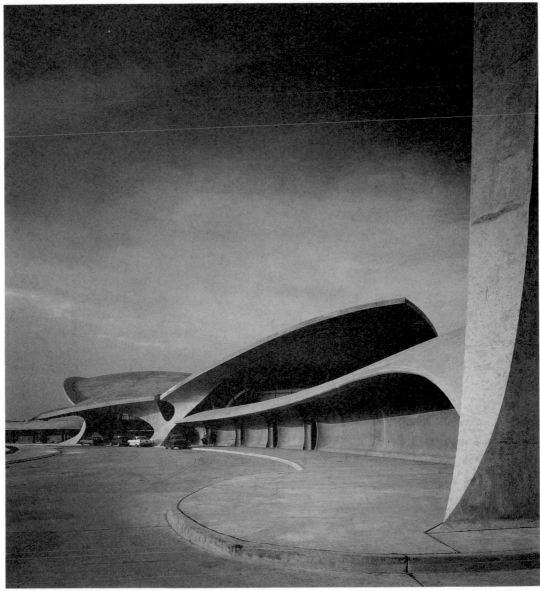

Richard Neutra (1892–1970) was a Viennese architect who established himself in California and worked with Wright. In 1929 he designed the Lovell house, which utilized steel and glass in large grid patterns. This house became the prototype for all-glass residential structures, such as the Nesbitt house (Figure 3.21) in 1942. His houses were linked with nature and often had dramatic cantilevers.

Hans Knoll (1914–1955) in 1938 started Knoll Furniture, which set the standards for modern, durable furniture. He and his designer-wife, Florence Schust Knoll (1917–), produced pieces by several noted designers, such as Eero Saarinen and Pierre Jeanneret from France. Knoll Furniture is still a leader in modern furniture products.

George Nelson (1908–1986), an architect and author, worked for the Herman Miller Company and in 1947 set up his own industrial design office. Nelson designed the *L*-shaped desk (Figure 3.22) in 1949 and the slat bench in 1948.

FIGURE 3.21 J. B. Nesbitt house (1942) in Brentwood, California, was designed by Richard Neutra. The plate glass walls slide open to connect the interiors with an outdoor terrace. (Julius Shulman, HON, AIA.)

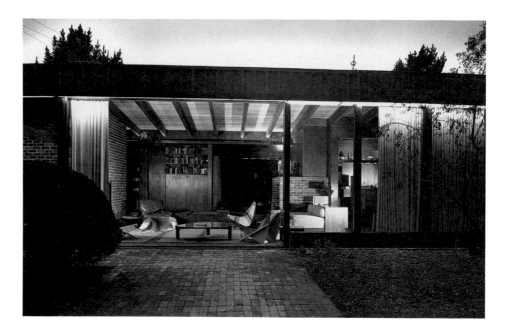

FIGURE 3.22 L-shaped desk (1949–1950) from the Executive Office Group by George Nelson for Herman Miller.

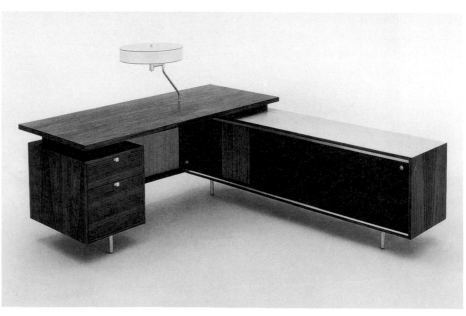

Philip Johnson graduated from Harvard and studied architecture under Gropius and Breuer. In the Miesian style, Johnson designed himself a transparent glass and steel house in New Canaan, Connecticut, that brought him into the limelight. Johnson continues to produce award-winning designs, such as the AT&T Building (1978) in New York (see Figure 3.28) and the Republic Bank building in Houston. Although he worked originally in the international style, his later works are primarily Post-Modern.

Middle Modernism, 1950–1970

The 1950s brought a wave of technological advances, such as air-conditioning, low-cost furniture, improved plastics, suspended ceiling assemblies, and synthetic fibers. Master architects—Mies, Wright, Johnson, Eero Saarinen, and Neutra—continued to refine style as an expression of honesty in materials and construction. An example of this functionalist expression, characterized by not concealing the mechanical system in the ceiling, is seen in the United Nations General Assembly building (1952) in New York City.

In this period, large, sleek skyscrapers abounded, and corporate clients required large, multiple floors of interior planning and design. Several firms, such as Skidmore, Owings, and Merrill (which started in 1936), provided comprehensive design services for the architecture, interiors, and engineering of many of the major buildings constructed in this era and today.

Bruce Goff (1904–1982) was not a true Modernist in architectural style, but his influence and designs are significant. Primarily working in Kansas and Oklahoma, he produced two well-known houses in Oklahoma—the 1950 Bavinger House in Norman and the 1956 Price House in Bartlesville. Goff explored free-flowing interior spaces and used a variety of materials, styles, and techniques bordering on eclecticism.

Alexander Girard (1907–) is an architect noted in the late 1940s for his restaurant and cafeteria designs, which were popular far into the 1950s. Girard's Modern style used simple materials and colors to express his vision of unadorned interiors as honest statements. He and his wife, Susan, collected primitive and folk art that influenced many of his design ideas. Today, these artifacts reside in the International Museum of Folk Art at Santa Fe.

BRUTALISM

Brutalism is an architectural and design style that contrasted with the international style, which was developed primarily in Europe. Brutalism exhibited a monumental style of large mass, rough textures, and bold colors. Sculptural exteriors were punctured with openings to allow light to shoot into the interiors, much like cannons, as Corbusier explained.

Paul Rudolph (1918–) is an architect who studied under Gropius and produced noteworthy residential structures in Florida. His interiors were simply furnished in the Modern style. In 1963, Rudolph finished the controversial Yale University Art and Architecture Building, which used a ribbed concrete texture outside and throughout the interiors. This innovative building integrated structure, space, and the mechanical systems in inventive ways. Yet, the people who used the spaces complained about the lighting and various functional problems. In 1969 a fire destroyed the upper three floors of the building, and in the mid-1970s the interiors were almost totally remodeled into new spaces.

Louis Kahn (1901–1974) influenced architecture and interiors with his sculptural handling of materials and space. Kahn designed a series of buildings primarily in concrete or brick that exhibited a new richness and understanding of these earthy materials. Among his most famous buildings are the Richards Medical Center in Philadelphia and the Kimbell Art Museum in Fort Worth, Texas (Figure 3.23).

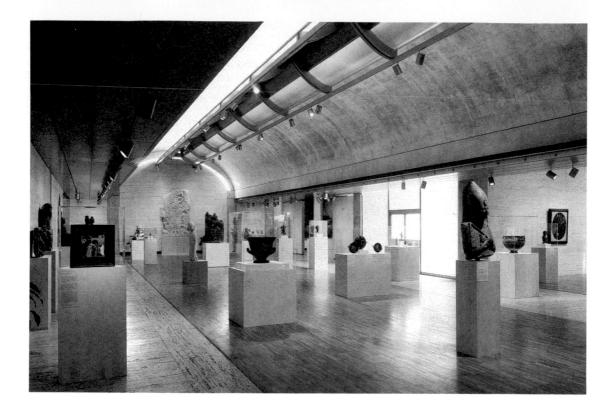

FIGURE 3.23 The Kimball Art Museum in Fort Worth is one of the best known buildings by the architect Louis Kahn.

THE MINIMAL STYLE

Ward Bennett (1917–) began to design furnishings and interiors in the 1950s, gaining international prominence in commercial work for the headquarters of the Chase Manhattan Bank. He is a major influence with his furniture and textile designs, particularly for the Brickel Corporation between 1963 and 1988. He and other designers, such as Nicos Zographos and Benjamin Baldwin, became caught up in the "minimalistic style" for their interiors, reducing spaces to elemental necessities and using plain surfaces, sparseness, no ornamentation, and minimal furniture.

Other important designers producing significant works during the 1960s were Angelo Donghia, Barbara D'Arcy, Edward Zajac, Peter Andes, and Richard Callahan. Although these designers were not producing pure Modern-style interiors, their projects influenced many other designers and the general public. Later, in the 1970s, Joseph Paul D'Urso continued the minimalistic movement.

Reaction to Modernism

The 1950s and 1960s saw the emergence of buildings and interiors with more sculptural qualities than those geometric structures of Mies and Gropius. Concrete and plaster were molded into shapes representing the plasticity of the materials. Wright's Guggenheim Museum (Figure 3.24), Oscar Niemeyer's (1907–) parabolas in Brasilia, Brazil, Le Corbusier's Chapel at

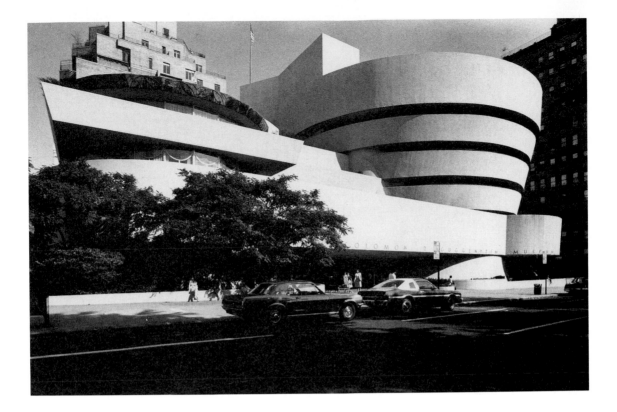

FIGURE 3.24 The Solomon R. Guggenheim Museum (1956–1959) in New York by Frank Lloyd Wright. This fluid, reinforced concrete structure is dominated by the creation of the large central spiral ramp.

Ronchamp, and Saarinen's TWA terminal represent Modern architects' explorations beyond the rectilinear forms of the international style.

In the 1960s, criticisms arose that the pure functionalism and austere appearances of Modernists' buildings and interiors lacked a sensitivity to the users and the general public. At this time, several designers rebelled against the styles of pure Modernism and embraced ornamentation and the historicism of earlier styles.

Robert Venturi (1925–) is a leading architect who had worked for Eero Saarinen and Louis Kahn. Venturi expressed the contradictions, ambiguity, and duality of contemporary life in his book *Complexity and Contradiction in Architecture* (1966). He set the wheels in motion for other architects and designers to throw off the purity of Modern styles and look back to history. Venturi's work used classical forms, such as the Palladian arched window, in rather whimsical fashion. He did not copy them exactly or put them in their proper classical composition but juxtaposed elements almost playfully to demonstrate contradictions in form. His floor plans and interiors broke the rectangular patterns of the Modern style with diagonals to reflect human movement. Venturi's award-winning firm, Venturi, Ranch, and Scott-Brown, includes his talented wife, Denise Scott-Brown.

Venturi's philosophy stated that, since the world is complex and contradictory, there is no "good" or "bad" design. He coauthored *Learning From Las Vegas*, in which he expounded the idea that the "ugly and the ordinary" are an integral part of modern society. He applauded Las Vegas, Nevada, with the mobility, diversity, and visual delights this city represents, as an example of the symbolism of our times. Venturi's ideas were radical when the book was published in 1972, but many designers emulated his ideas about the representation of societal patterns and historical

references. Thus, the seeds of the rejection of Modernism, or what is now termed *Post-Modernism*, were planted.

Charles Moore (1925–) received his doctorate from Princeton University under Louis Kahn and began both a teaching career and an architectural practice. Like Venturi, Moore began to rock the established Modernists by playfully interjecting ornamentation and historicism in his works. His 1962 house in Orinda, California (Figure 3.25), was a simple rectangular plan with a different facade on each elevation and four large interior columns. The furnishings were typical of the new design movement—they were personal pieces representing historical memories of his travels and associations with the past.

FIGURE 3.25 A perspective section of the Moore House, Orinda, California, 1962.

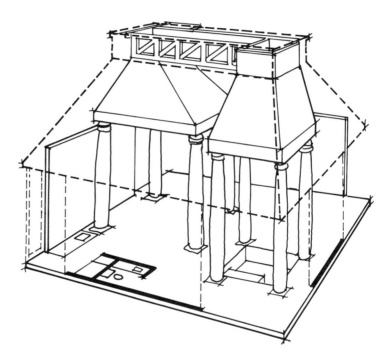

By the late 1960s, this concern with historical context and a desire for urban renewal set the stage for the next steps in design. The preservation and restoration movement began to save and celebrate old buildings. The recycling of architecture and interiors, such as the Ghirardelli chocolate factory in San Francisco, sparked a new interest in and reuse of those treasured old buildings.

Late Modernism and Post-Modernism, 1970–1990

In the 1970s, the United States went through a period of slow building activity and high inflation. The energy crisis in 1973–1974 curtailed new construction and initiated energy conservation measures in building design. Preservation, conservation, recycling, and solar design came to the forefront in design during this decade.

As the nation and designers looked to the historicism of buildings, architects developed the concept of contextualism (Chapter 2): the idea that new and old buildings were an integral part of history, that location and adjacency to other buildings were important factors when considering a building site. Designers looked to historical examples for those meanings that the Modern or international style had lost.

In the mid-1970s, a group of architects began to label this new movement *Post-Modernism* and attacked Modernism's principles with a fury. Perhaps one of the most prominent architects identified with this movement is Robert Stern (1938–), who studied history at Columbia University and architecture at Yale University, establishing his own practice in 1969. He designed a series of residences in the 1970s that brought back the familiar Palladian details, gables, shingles, and other applied ornamentation. Both his exteriors and his interiors embraced historicism, particularly from the classical periods. Today, his architectural work continues to explore the concepts of Post-Modernism (Figure 3.26).

Michael Graves (1934–) studied architecture at the University of Cincinnati and at Harvard. He later spent time in Europe drawing and making studies in the Ecole des Beaux-Arts traditions. By the late 1970s, he had produced many houses, galleries, and museums in the Post-Modern style. Graves's use of color relates to what he calls the "cultural references" of nature, such as blue for the sky, yellow for sunlight, and green for plants (Figure 3.27).

FIGURE 3.26 Classical elements are apparent in the interior of the Casting Center, Lake Buena Vista, Florida, by Robert Stern. (Peter Aaron/Esto.)

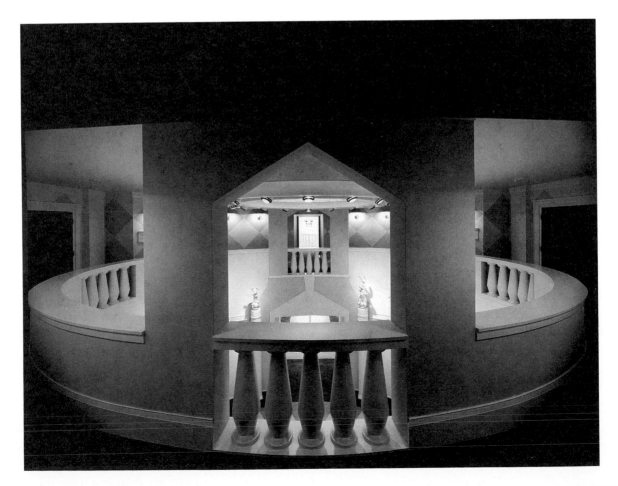

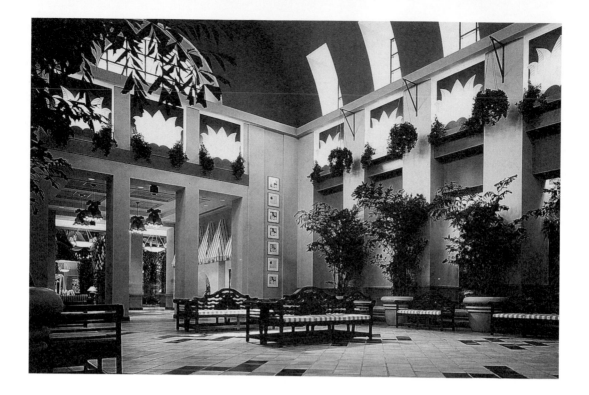

FIGURE 3.27 The entrance foyer to the Walt Disney World Dolphin Hotel in Lake Buena Vista, Florida, exhibits Michael Graves' use of color and form in the Post-Modern style.

FIGURE 3.28 The 1978 AT&T building in New York, by Johnson and Burgee, is said to be loosely derived from the design of Chippendales's highboy. (Courtesy of John Burgee Architects, N.Y. © Richard Payne AIA, 1988.)

Post-Modernism caught up many established architects into new ways of thinking about design, as evidenced by Johnson's AT&T skyscraper (Figure 3.28) and Moore's Piazza d'Italia in New Orleans (Figure 3.29), which features classical Roman details crafted in modern metals.

The Post-Modern style can be seen in many illusionistic buildings that reflect historicism and contexturalism such as Johnson's skyscrapers and Charles Pfister's (1939–) interiors. We see examples as designers sought to outdo one another with stylistic adaptations. Graves continues to explore the movement in his various building designs throughout the land (Figure 3.30).

HIGH TECH

Not all interior design and architecture since the 1970s has been primarily a reaction against Modernism. For example, the Pompidou Centre in Paris (1977), executed by architects Richard Rogers (1933–) and Renzo Piano (1937–), is a prime example of the high tech movement. The mechanical and other service parts of the building are exposed on the exterior, attesting to the machine-age beauty of support systems. High tech emphasizes and displays materials and principles used in science, machines, and other technological advances. In interior design, the hi-tech movement is exemplified by Joseph Paul D'Urso (1943–), who used metal fencing and **stainless steel** sinks as prime interior elements within his apartment and other buildings.

MEMPHIS STYLE

In the 1970s, modern Italian design was challenged by several avant-garde designers, such as Joe Columbo (1930–1971), who began rejecting the Modernism style. In 1981, the Italian-based Memphis Group exhibited at the Milan Furniture Fair. Their brightly colored furniture uses an abundance of plastic laminates. The pieces are often in unconventional shapes and are

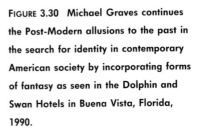

FIGURE 3.29 The 1978 Piazza d'Italia in New Orleans by Perez Associates and Charles Moore is criticized for its seemingly classical Roman allusions. The piazza was designed to provide the small Italian–American population of New Orleans a place to hold its annual feast and celebration of St. Joseph. (© Norman McGrath, 1978.)

FIGURE 3.30 Michael Graves continues the Post-Modern allusions to the past in the search for identity in contemporary American society by incorporating forms of fantasy as seen in the Dolphin and Swan Hotels in Buena Vista, Florida, 1990.

based on mass culture appeal. The Memphis style had major influences on many products and interiors, particularly fast-food restaurants and upscale retail shops.

DECONSTRUCTIVISM AND DECONSTRUCTIONISM

In 1988, the Deconstructivist Architecture show was held at New York's Museum of Modern Art. This controversial exhibition gave a public viewing of what is called deconstructivism and deconstructionism. The two terms are often used interchangeably; however, there are some differences. Deconstructivism portrays a reflection of society's involvement with turbulent times, when war, rampant crime, terrorism, and other problems are at the forefront.

Deconstructionism can be traced to theories of literary criticism of European philosophers who teach that opposing ideals are equally important and that the taking apart, or deconstruction, of ideas will lead to new theories. In architecture and interior design, deconstructionism takes apart the elements, attempting to alter perception and instill physical dislocation—often by the use of jagged edges. The work of SITE Projects, Inc., Peter Eisenman, and Eric Moss are representative of this movement.

FUTURE DEVELOPMENTS

As we move into the late stages of Post-Modernism, we are seeing change and variety in architecture and interior design. As occurred in many periods and styles before our time, new directions and references to the past will create other design movements. Each will seek to impel design in a new direction until a new major stylistic form representing our societal patterns emerges.

Many individuals and groups, such as the American Institute of Architects (AIA), are pursuing future visions. The 1988 AIA report, *Vision 2000: Trends Shaping Architecture's Future,* calls for a new awareness and participation by the general public in shaping our built environment. This public, or user-generated, architecture has been called "process design" by Charles Moore and William Turnbull (1935–). Process design involves the people, soliciting their *hands-on* involvement not only in the design stages but in the construction phase as well. This idea is particularly important in the works of Christopher Alexander, as explained in his book *A Pattern Language,* and several others.

Redevelopment work and urban renewal projects in city districts are a great opportunity for user design inputs. Some of these participatory sessions are conducted "live" before television cameras or in front of meeting hall assemblies of concerned people.

REFERENCES FOR FURTHER READING

Banham, Reyner. *Theory and Design in the First Machine Age.* 2nd ed. Cambridge: MIT Press, 1980.

Bayer, Herbert, Walter Gropius, Andise Gropius, eds. *Bauhaus: 1919–1928.* New York: The Museum of Modern Art, 1975.

Faulkner, Ray, LuAnn Nissen, and Sarah Faulkner. *Inside Today's Home.* 5th ed. New York: Holt, Rinehart and Winston, 1986.

Garner, Philippe. *Twentieth-Century Furniture.* New York: Van Nostrand, 1980.

Gueft, Olga. "Two Decades of Interiors: 1940–1960," *Interiors,* November 1960.

Jencks, Charles. *The Language of Post-Modern Architecture.* New York: Rizzoli, 1977.

Massey, Anne. *Interior Design of the 20th Century.* New York: Thames and Hudson Inc., 1990.

Pehnt, Wolfgang (ed.). *Encyclopedia of Modern Architecture.* New York: Abrams, 1964.

Russell, Beverly. *Architecture and Design.* New York: Harry N. Abrams, Inc., 1989.

Smith, C. Ray. *Interior Design in the 20th Century.* New York: Harper & Row, Publishers, Inc., 1987.

Trachtenberg, Marvin, and Isabelle Hyman. *Architecture From Prehistory to Post-Modernism.* New York: Harry N. Abrams, Inc., 1986.

Venturi, Robert. *Complexity and Contradiction in Architecture.* New York: The Museum of Modern Art, 1966.

————, Denise Scott-Brown, and Stephen Izenour. *Learning From Las Vegas.* Cambridge: MIT Press, 1972.

Whiffen, Marcus, and Frederick Koeper. *American Architecture 1606–1976.* Cambridge: MIT Press, 1981.

Whitton, Sherrill. *Interior Design and Decoration.* Philadelphia: J.B. Lippincott, 1974.

THE BASIC THEORIES OF DESIGN COMPOSITION

Design theories and applications are as numerous as designers, projects, and historical examples. Although at first glance they may seem quite different, design theories do have some commonalities and basic premises. Theories are underlying principles, guiding forces, speculations, or ideas that people share about how things exist or operate. For example, believing that the earth was flat once was a theory. The Bauhaus movement (Chapter 3) was a theory about how resources, technology, art, and society should interact that set the parameters for the work of many artists, designers, and technicians.

Design theories are developed to enable designers to formulate, apply, and evaluate essential design elements and principles to meet human needs and fulfill human aspirations. Design composition is traditionally taught as a theoretical base for constructing, viewing, and judging the interrelationships of objects, space, and materials. These compositional theories primarily address the physical arrangement of elements in the environment as perceived by humans when they interact with them. Design theories should also take into account human psychology and behavior, correlating people's needs and desires as they interact with one another and the environment.

This chapter will explain the basic theories of design composition. Counterpart concepts for addressing human behavior and the needs for security, comfort, stimulation, variety, and complexity will be discussed in Chapters 6 through 9. The issues of privacy, community, and territory are detailed in Chapter 7.

DESIGN APPROACHES

All professional fields of design, such as architecture and industrial, graphic, fashion, and interior design, utilize theories of design composition. Particular design theories can be fairly simple, yet complex at the same time. It can be difficult to separate all the concepts of design into specific components, for there is no limit to the flexibility, relationships, and application of how design is carried out.

In Chapters 2 and 3, we discussed the origins and development of design through the ages and looked at various examples of how it was applied.

We shall now discuss several common design approaches, purposes, and applications (Figure 4.1). Examples will be given of how various designers express them and how people view or evaluate them. Although most people consider structural and decorative design to be the basic approaches, other types can also be major influences. Many combinations of all these approaches, discussed below, are evident in design theory.

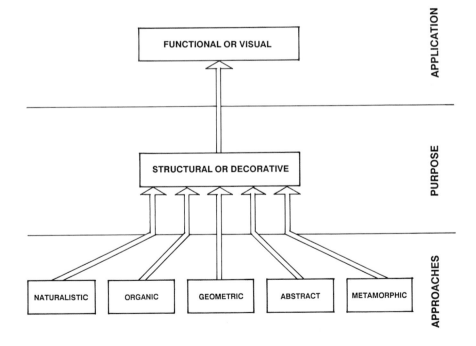

FIGURE 4.1 Several design approaches designers commonly use.

Structural Design

Structural design is the underlying framework, or structural component, and is usually expressed in the final visual form. The design is not an embellishment added to the form but

rather an integral part—such as the ancient pyramids in Egypt (Figure 1.2) with their stacked and exposed stonework as the structural support and Buckminster Fuller's geodesic domes (Figure 4.2). Looking at nature, we find the design of a beehive, the shape and composition of the bones in a bird's wing, or those of a spider's web to be structural in form. Structural design in furniture can be seen in modern designs that use tubular steel, such as Marcel Breuer's chair of 1925 (Figure 3.12). Simplicity is one of the characteristics of most structural design.

FIGURE 4.2 The framework of Buckminster Fuller's geodesic domes is established by mathematical proportions and structural analysis. This is a good example of the structural design approach.

Decorative or Applied Design

Decorative design implies that ornamentation is applied to structure. Patterns printed on wallpaper or fabrics are not intrinsic to the structural makeup of the material and are referred to as applied design. The Victorian era saw much of this type of ornamentation in architectural design and in furniture. One of the important furniture designers of the Victorian era was John Henry Belter (1804–1863), who made chairs, sofas, and case pieces with elaborate openwork designs and fruit, flower, and foliage carvings applied to the structural forms of his furniture (Figure 4.3). In Victorian interiors, elaborate carvings, cornices, and moldings were added to the basic structural components of the walls and ceilings.

A fascinating example of decorative design applied to structural design can be seen in the evolution of the automobile. The early models consisted of the basic functional elements of engine, chassis, wheels, and passenger compartment. Later development has seen decorative additions to the body, using chrome, brass, colors, and custom features or gadgets. Even the basic body shapes have been streamlined to imply speed, as seen in Figure 4.4.

Decorative design should be applied logically and sensitively, for it makes a powerful and personal design statement. Applied decoration can harmonize with an object's form, function, and materials or become a contrast.

FIGURE 4.3 This sofa (c.1850) by John Belter exhibits an elaborate imagery of leaves, vines, fruit, and acorns in the fabric and carving of the rosewood. (Virginia Museum of Fine Arts, Richmond. Gift of Mrs. Hamilton Farnham.)

FIGURE 4.4 Streamlining was an applied design for the bodies of early automobiles to give them the appearance of speed and sleekness.

Naturalistic Design

Naturalistic design utilizes shapes found in our natural environment, such as rocks, hills, ocean waves, and clouds, instead of artificial or manufactured objects. Living organisms, such as plants and animals, are, of course, also found in nature but are referred to as organic designs. It is feasible, however, to include both living and nonliving things in naturalistic design and in organic design. Can we say, for example, that the ocean is not "alive" in composition or its movements?

Organic Design

An approach related to, or derived from, living things, such as a person, an animal, or a plant, is organic. Organic design is not based on precise geometric form but rather on flowing, undulating curves and forms. Organic design in architecture is closely linked to the work of Antoni Gaudi (Figure 4.5). His organic structures illustrate solutions to the problem of linking a geometric structure to organic forms. Organic design, like naturalistic design, reflects our existence as an integral part of our natural environment and the universe.

FIGURE 4.5 The fantastic architecture of Antoni Gaudi is based on organic principles. He believed straight lines do not exist in nature and building designs should reflect nature's organic patterns.

Geometric Design

Geometric design is related to straight lines, circles, squares, triangles, rectangles, cubes, spheres, and other mathematically precise shapes. The Greeks often are credited with perfecting the geometric approach of design in both their architecture and their ornamental motifs (Figure 2.13). Geometric forms were also characteristic of the early periods of contemporary architecture and design. In the de Stijl movement (1917–1930) several Dutch artists restricted design to the basic elements, primary colors, and arrangements of two-dimensional lines and geometric shapes on a flat surface. Gerrit Rietveld, a furniture designer and architect, translated these principles into three-dimensional forms, as seen in his Red-Blue Chair (Figure 3.10) in 1917. Other examples of geometric design can be found in wall coverings, floor coverings, and upholstery fabrics printed in strong, geometrical patterns (Figure 4.6).

FIGURE 4.6 The designs of the wall quilt composition and most of the interior features and furniture are based on geometrical design principles.

Abstract Design

Abstract design can be derived from natural, organic, or geometrical shapes, but it distorts or stylizes them to create a new meaning or essence. The original object is transformed into something different and may or may not be recognizable (Figure 4.7). This type of design, frequently characterized by simplification of form, can be seen in the work of Pablo Picasso (1881–1973), who often reinterpreted shapes into Cubist abstract motifs, as seen in Figure 4.8.

FIGURE 4.7 The "Reclining Figure" (1945–1946) in elmwood by Henry Moore is an abstracted art form based on the human figure.

FIGURE 4.8 Pablo Picasso's "Three Musicians" (1921, summer) in the cubist motif is an abstraction of people, objects, and space. (Oil on canvas, 6'7" x 7'3¾" [200.7 x 222.9 cm]. Collection, The Museum of Modern Art, New York. Mrs. Simon Guggenheim Fund.)

Metamorphic Design

Metamorphic design refers to the changing, varying forms or shapes within a design. It is an alteration of the basic premises, evolving as it progresses. In nature, the changing of a caterpillar into a butterfly is a good example of a metamorphosis. Some wall coverings and fabrics whose patterns seem to change and evolve from a basic form exhibit metamorphic design (Figure 4.9). In drawing, the examples of M.C. Escher (1898–1970) (Figure 4.10) exhibit changing, metamorphic designs that delight the eye.

FIGURE 4.9 This quilt art by Leslie Carabas exhibits some metamorphic design qualities as the images appear to evolve into different shapes.

FIGURE 4.10 Many of the works of M.C. Escher—such as "Relativity" in 1953—are based on visual illusions and designs that metamorphically change throughout the space. (Haags Gemeentemuseum—The Hague.)

THE ELEMENTS OF DESIGN

As traditionally taught in schools, theory of design composition has been defined under the generic term *basic design*, which in turn is divided into two major areas, elements and principles (Figure 4.11). The seven elements can be thought of as the vocabulary in design language, and the eight principles can be likened to the grammar, or rules for applying those elements.

FIGURE 4.11 Basic design compositional theory is traditionally divided into the elements and principles of design.

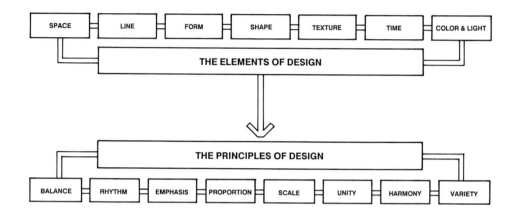

The "Elements of Design" are space, line, form, shape, texture, and time, discussed below, and color and light, discussed in Chapter 5. Although some textbooks do not include time as a basic element, the authors will illustrate how it is an integral part of the other elements. The "Principles of Design" utilize the seven elements and consist of balance, rhythm, emphasis, proportion, scale, unity, harmony, and variety. The principles can be thought of as a funnel that directs or focuses the elements to achieve a particular effect or solution.

The elements and principles of design are the foundation and vital tools that a designer manipulates to create a strong solution to a given problem situation. A good grasp of basic design theory is essential no matter whether an individual plans to become a professional interior designer; to work in related fields of architecture, graphic design, product design, or fine art; or simply to use the knowledge to enhance day-to-day living.

The elements and principles of design should not be thought of as fixed rules and formulas but rather as guidelines to encourage the creation of successful designs. Different combinations of elements and principles can produce different results or characteristics in the final design. By understanding these basics of design theory, the designer can set up certain criteria to evaluate what we commonly refer to as *good design*.

Space

Space is perhaps the most important and complex of the basic elements in design theory and application. It can be thought of as an endless vacuum relating to our universe, or "outer" space. Space can also be expressed as a complex relationship of our feelings and impressions, for example, as we view a painting by Picasso that represents objects and the space around or through them—all in the same Cubist drawing (Figure 4.12). To the interior designer and the

architect, space is the essence of what our natural and man-made environments are all about. Space has physical, visual, emotional, psychological, implied, functional, planned, and aesthetic connotations. Various theories analyze the essence of space and how it affects us or, conversely, how we affect it. Such an integral relationship exists between human beings and the spatial environment that it is difficult to define the line between the two.

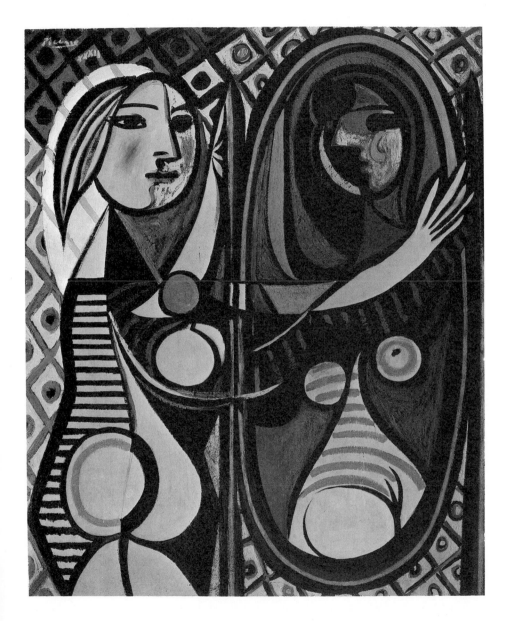

FIGURE 4.12 "Girl Before a Mirror" (Boisgeloup, March 1932) by Pablo Picasso represents objects and space around them in the same multi-view work. (Oil on canvas, 64" x 51¼" [162.3 x 130.2 cm]. Collection, The Museum of Modern Art, New York, Gift of Mrs. Simon Guggenheim.)

Space is spoken of in relationships—to people, their occupancies, and the time period in which they exist. Webster's dictionary defines space not only as an area where things exist and move but also as a period of time. The "subelements" of space are physical objects, nonobjects, movement in three dimensions, and time. The fabric that holds these together is the human unit and its interaction with them all. When we discuss space as a basic element of design, we are more appropriately talking about "spatial" concepts and relationships than about "space" as a distinct entity. We shall use the word *space* interchangeably with *spatial* in the following discussions.

TIME–SPACE PERCEPTION

To the interior designer, the boundaries of floors, walls, and ceilings of a room seem physically to mold, define, and articulate space in that environment. People and objects within the space also influence the way space exists and how we perceive it. Space is not static but invites people to change it as they move through it bodily, visually, or psychologically. Although we cannot walk into space, our sight and other senses can experience it, and our minds can interpret its impact on us. The phenomena of time and movement play an important part in our perception and use of space, because unless the environment is very small, we cannot perceive all of it at once. We must take time and move through it little by little, gradually accumulating impressions until a sense of the whole and its relationships has been assembled.

As we move through an interior environment, its space(s) become a sort of space/time continuum, and often our impressions change from our initial perceptions. The key here is that space is indeed perceived and changed by how we move through it, thus giving space a sense of "kinetics" or nonstatic existence. If we stand still in the environment, our movement of vision (focusing and refocusing on objects or the space) will create changing relationships, both physical and psychological. So space is not static, although the structure forming it or the fixed viewpoint of the observer appears to be. Examples of the kinetic aspects of space can be seen in the architectural sculptures found in parks, plazas, and shopping malls. People can walk around, under, through, and perhaps even on space, as illustrated in Figure 4.13.

We speak of space being divided into "positive space and negative space." Positive space refers to the area that is filled or occupied by mass, forms, or objects. The empty space that surrounds these areas or that is surrounded by the objects is called negative space. The two are directly related and can be balanced or contrasted, depending on the design aspects. Despite what its name might imply, negative space is of equal importance to positive space and sometimes is even more significant.

Look closely in this book at the photographs of environments and the spaces they present. A designer should ask, can I go beyond the fixed viewpoint of the camera and experience the space? Can I see myself in it, moving through it, seeing it from different viewpoints? Will these change my initial impressions of the space? It is important to begin looking beyond the fixed view of the photograph—which was also fixed in time—and try to see what the designer was creating and how people will experience the space. Designers are constantly using our perceptions of space, such as color or texture, to modify a space or heighten its impact on us. A designer should put himself or herself in the space and move around in it—even while creating it.

SPATIAL RELATIONSHIPS

The understanding and effective use of space and its many relationships have a major effect on successful design, because space forms the basics of architecture and interior design. The success of an environment is often determined by the function and quality of the space, for it is after the use and the form of the spatial environment have been established that the material, surface, color, and texture of the objects are considered.

To create form or to define boundaries of spaces, physical and nonphysical spatial concepts must be organized to achieve particular results. The overall relevance of space becomes clearer if space is considered unlimited until the architect or interior designer defines it by erecting walls, floors, and ceilings or adding other shapes.

Building structures and interiors generally consist of a number of spaces that are related by function, location, or circulation. These relationships are defined as spatial concepts. Spaces flow into one another vertically, horizontally, and in many other ways to create coherent shapes and patterns that meet specific needs and make aesthetic statements. Some important basic concepts of spatial relationships, shown in Figure 4.14, are described as follows:

FIGURE 4.13 A shopping mall offers an abundant variety of views, objects, and stimulus as one moves through the space.

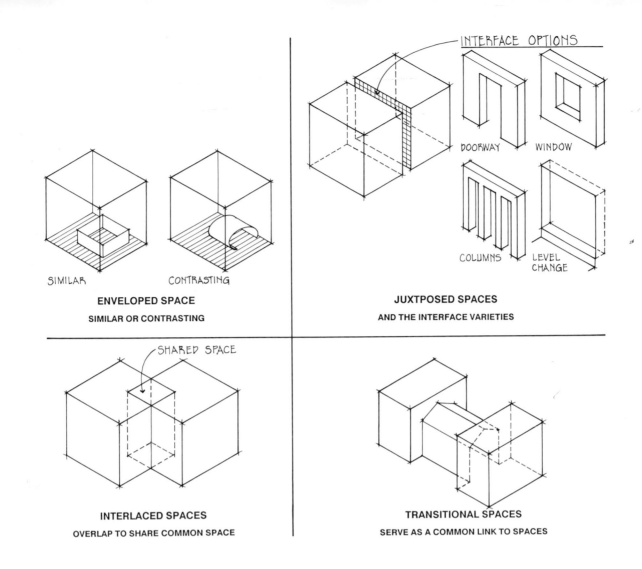

SIMILAR **CONTRASTING**

ENVELOPED SPACE
SIMILAR OR CONTRASTING

INTERFACE OPTIONS

DOORWAY WINDOW

COLUMNS LEVEL CHANGE

JUXTPOSED SPACES
AND THE INTERFACE VARIETIES

SHARED SPACE

INTERLACED SPACES
OVERLAP TO SHARE COMMON SPACE

TRANSITIONAL SPACES
SERVE AS A COMMON LINK TO SPACES

FIGURE 4.14 Basic spatial relationships can be defined as enveloped, juxtaposed, transitional, and interlaced.

ENVELOPED SPACES. Enveloping refers to smaller spaces that are contained within a larger volume of space. The smaller and the larger spaces generally have their own identities, thus promoting a distinct relationship between the two. The smaller space may reflect the shape of the enveloping space, emphasizing their similar forms, or it may contrast with the larger space for emphasis on form or function (Figure 4.15). Also, the spaces might be similar in form yet oriented differently to create distinctive shapes.

JUXTAPOSED SPACES. A common type of spatial relationship is juxtaposition, or comparing spaces side by side (adjacent). Each space is defined in its own unique form, which is related to its functioning, symbolic, or structural requirements. The juxtaposed spaces might be similar, exactly the same, or contrasting—the degree of relationship depends on the interface (and resulting plane/penetration) between the two. The separation element between the spaces then might (1) restrict physical and visual access between them (a door); (2) be a distinct element between them (columns or freestanding wall); (3) restrict physical but not visual access (window or opening); or (4) be implied through change of levels (ceiling or floor-level changes), color, or surface textures.

LINEAR ARRANGEMENT

WITH DIRECT OR COMMON LINK

NUCLEUS ARRANGEMENT

HAS A COMMON CENTER

MODULAR ARRANGEMENT

RANDOM OR GEOMETRICAL

GRID ARRANGEMENT

REPETITIVE SYSTEM OF UNITS

FIGURE 4.16 Spatial arrangements can be categorized through several basic ordering systems.

TRANSITIONAL SPACES. A common or intermediate space linking other spaces is called transitional. This intermediate space, such as a hallway, can link other, sometimes more important, spaces. It can also become an important space in itself, and even be the dominant space, such as a center atrium or courtyard, linking other spaces. Transitional space can be similar in size, form, and orientation to the spaces it links or can differ from them. Transitional spaces are often used to heighten people's senses in anticipation of moving into another space. For example, after being confined to the tighter, smaller space of a low, long entry to a large auditorium, people tend to perceive the auditorium as larger than it really is.

INTERLACED SPACES. Two spaces that connect so that the form or shape of one affects the other in a zoned or shared configuration is termed *interlaced space.* Interlaced space can be seen as part of one of the spaces or it can gain its own distinct identity as a link for the original spaces. The overlapping of these spaces and resulting shared form can be physical or implied.

SPATIAL ARRANGEMENTS

Architecture and interior design represent the art and science of enclosing space for human habitation or to suit a particular purpose for human use—the skyscraper, the igloo, the hospital, and the tent, for example.

Space can be arranged in several basic ways to define the specific functional and visual requirements it is to satisfy (Figure 4.16), such as accessibility, privacy, or orientation. The following spatial arrangements are the basic methods of ordering space conceptually.

FIGURE 4.15 The circular display unit within the Lenox Store in Palm Beach Gardens, Florida, is an example of a contrasting enveloped space.

LINEAR ARRANGEMENT. A linear configuration of space is comprised of a series of spaces placed next to each other in a direct line that can be straight, curvilinear, or segmented. These spaces can also be directly linked through a separate common space.

NUCLEUS ARRANGEMENT. A plan that consists of a central, dominant space with supporting spaces grouped around it or extending from it is called a nucleus arrangement. These supporting areas can be in geometric or organic shapes and can extend from the nucleus in a linear or a radial manner. These areas can be similar or contrasting in shape and function.

MODULAR ARRANGEMENT. An organization of space where related functions and/or purposes are grouped to form a unit is a modular arrangement. Two or more modules can then be organized into one cohesive pattern or plan. Modular spaces can be arranged around a central axis, such as in an entry to a building or a courtyard, to help unify the overall plan and articulate the circulation from one module to another.

GRID ARRANGEMENT. A grid arrangement is created by a regular pattern of points located at the intersections of two sets of parallel lines being laid perpendicular or at an axis to each other. The grid creates equal, repetitive units of space. Various spatial configurations can evolve within the grid while maintaining a constant reference to the grid pattern. For example, in a large industrial building, structural bays (or spaces) may be subdivided into smaller units, but with the grid pattern still evident in the column and beam spacing. In architecture, structural systems are usually designed in a grid pattern to use fewer materials, to provide better structural qualities, and to simplify construction methods (Figure 4.17).

These various arrangements of space are not meant to be "absolute" spatial configurations but instead can be modified or combined to create a multitude of configurations based on the spatial needs of a problem situation and the needs of the individuals using the space.

FIGURE 4.17 The State of Illinois Center by Murphy/Jahn and Lester B. Knight is based on structural systems that are grids formed and exposed for visual expression.

PSYCHOLOGICAL AND EMOTIONAL SPACE

Designers must also carefully consider the psychological and emotional qualities of space. Everyone has a personal sense of space; sometimes the size of a particular space or the arrangement of furniture is not in harmony with a person's sense of what should occur in the space. Each individual has a sense of "territory," which is often referred to as "personal space" or as a "space bubble." This natural characteristic of humans and animals is referred to as *territoriality*, a term coined by Dr. Edward Hall (see Chapter 7).

Dr. Hall, a professor of anthropology, is credited with the original theories of people's perceptions and uses of space, which vary among individuals and within specific groups and cultures. People's invisible bubble of space is their defensible, or territorial, space. If they allow a few other individuals to penetrate these bubbles, it is usually only for a short duration. Outside forces, such as other people, objects, and the immediate environment, can expand or contract these space bubbles. In turn, this invasion of space can affect individuals' feelings about and reactions to everything around them. Although these spaces are seemingly nonphysical in substance, they are very real to each individual. Designers work with physical-spatial relationships but also must be aware of the impact of emotions on those spaces.

Line

Line is one of the most basic elements of design theory. Throughout civilization—from cave dwellers' doodlings to scientific diagrams of electronic circuits—people have used lines to connect points or express relationships. Even televisions and computer video equipment utilize many varieties of lines on their screens to create. We can perceive as lines the spider's web, the veins in a leaf, or the horizon as seen on the ocean. Some of these lines, such as the "line" between the sky and the earth that we perceive as the horizon or the junction between mountaintops and the sky, do not actually exist in nature but are implied or abstractly interpreted.

When asked to draw something, we often draw the outline of it. That is, we tend to see or infer a line that separates the various planes of the object from the surrounding spaces or other objects. This contour line defines the shape or form of the object (Figure 4.18).

Line is classified as straight, curved, vertical, horizontal, or diagonal—depending upon how the viewer uses or perceives it. These categories imply that line has direction and can project emphasis by the apparent path it takes. For example, horizontal lines can seem to elongate a plane or space, while vertical lines can give an impression of height (Figure 4.19). We can also think of lines as having character, emphasis, or quality of expression. We can further distinguish lines as thick, thin, jagged, smooth, flowing, or tapering. Line is used in interiors with other principles, so we must view the overall use of the line and its relationship to the design, the users, and their inner feelings. It is not enough simply to say that horizontal lines always elicit responses of relaxation and that vertical lines are strong or formal or increase height awareness. Instead, it is the quality and the context of the line in its surroundings that establish both how we "feel" about the line and what it seems to imply.

Form

Although form is often used synonymously with shape, there are distinctions. When we speak of shape, we are often referring to the outline of an object, such as the shape of a human

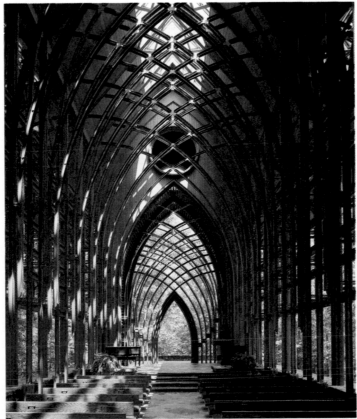

FIGURE 4.18 ABOVE This interior drawing by Gary Saxton primarily uses line to represent objects and textures. However, line is also used in the design of the structure, furniture, and material representation.

FIGURE 4.19 LEFT The structural shapes in the M. B. Cooper Memorial Chapel by E. Fay Jones, FAIA, are designed as vertical sweeping lines that accent the height of the space.

body, a piece of furniture, or a building. Form, however, can be compared to mass, which is three dimensional and exhibits volume. The manipulation of space creates form, and, in turn, form gives space dimension and mass. Generally, we speak of furniture and other objects used in interior design and architecture having physical form. However, form can mean more than just a physical or substantive mass. The term is also used abstractly by designers to express the essence and inspiration behind a design concept. For example, we can say that a sculpture was created in the form of a bird, thus speaking of the abstract approach the designer was creating versus the physical form, as illustrated in Figure 4.20. Also, the physical form of an island and the form of a concept based upon an island are not necessarily the same thing.

FIGURE 4.20 Brancusi abstracted the "essence" of a bird in his highly polished bronze sculpture "Bird in Space". (Constantin Brancusi, 1928. Bronze [unique cast], 54 x 8½ x 6½". Collection, The Museum of Modern Art, New York. Given anonymously.)

Form can include substance (such as solid or liquid form), vaporous elements (gases), or internal structure (the skeletal framework for an airplane). A form can also exhibit implied or apparent weight; a box painted flat black will seem to most people to weigh more than a clear plastic box. A dark upholstered chair next to a white wall will have more apparent weight or dominance than a chair of similar scale that is covered with a light-colored fabric and placed in a light-colored environment (Figures 4.21 and 4.22).

FIGURE 4.21 The light-colored wall behind these chairs and their dark finish/fabric visually give more weight and dominance to them in this office.

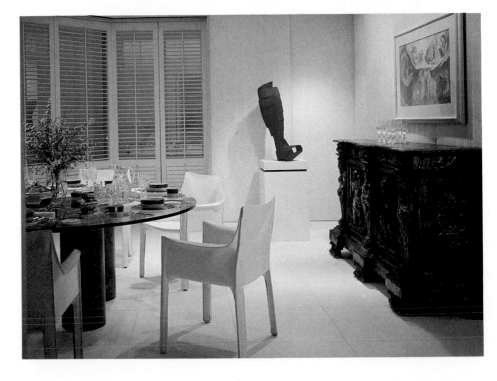

FIGURE 4.22 These chairs would appear visually heavier or more dominant if they were a darker color. Their off-white color and simple lines complement the lightness of this interior within the Capital Bank, Miami, Florida.

Shape

Although many designers often use the word *shape* interchangeably with *form*, shape is defined as the outline, or identifiable contours, of an object. Geometrically speaking, we can refer to the basic shapes of rectangles, circles, squares, and triangles. In turn, these shapes might be expressed as curved, angular, or rectangular. Geometric shapes are derived from mathematics and seem to dominate our built environments.

The effective use of shapes in design, whether such shapes are derived from geometric or naturalistic sources, depends on how they are applied to a particular situation. Shapes can be manifested in a very precise, regular manner or in an irregular or organic way. Not all shapes are used in their purest form, such as a perfect circle, square, or triangle, but most are derived from one or more of these pure shapes.

We generally use shapes with specific characteristics in conjunction with similar shapes. For example, curved shapes might be used with other circular, flowing curved forms to create an overall harmony. However, we seldom find interiors totally made up of a single category of shape, since creative designers combine and mix shapes to accent and balance the overall interior environment (Figure 4.23). Shapes elicit a particular response from people when they see the inher-

FIGURE 4.23 **The Rowland Associates repeated a circular shape throughout this restaurant as an accent with the furniture, structural shapes, and accessories.**

ent relationships of the object; for example, the straight geometrical lines in a table and chairs constructed of similar geometrical features, plus other groupings of straight geometrical pieces, will seem harmonious due to the unifying rectangularity of their shapes. A curved element introduced into that space might contrast with the straight, geometrical forms and become a focal element (Figure 4.24).

FIGURE 4.24 This curved wall opening provides an excellent sculpture niche that emphasizes shape and harmonizes with the other linear forms, yet provides a focal point in the space. (Copyright © Norman McGrath, N.Y., 1983. Designer: Centerbrook Architects.)

Shapes are applied to interior spaces through any of the design approaches to create exciting environments. Today's designers are shaping internal space with a new freedom by redefining the concept of stability and repose previously linked to the square, triangle, and circle. Some common qualities attributed to these shapes are listed below. Remember, however, that these qualities are not absolute.

Based on their orientation, size, proportion, color, and placement within a space, rectilinear shapes can create different effects. Tall, rectilinear shapes usually convey a feeling of clarity, stability, and formality (Figure 4.25). If the longer side of a rectangular shape is horizontal, it can

FIGURE 4.25 The tall, rectilinear shapes and lines in this reception area convey a sense of formality, stability, and procession.

connote a restful feeling. However, if a rectangle, square, or cube is placed on end, it becomes a very dynamic shape (Figure 4.26).

Triangular shapes seem to imply direction as they reach toward a terminal peak and are very dynamic because of their nonperpendicular sides (Figure 4.27). Structurally, triangles are considered very stable because they cannot be modified without bending or breaking one of the sides. This stability is apparent with the broad base of a triangle at the bottom, but if the apex of the triangle is reversed and at the bottom, the triangle becomes very unstable.

Curvilinear shapes tend to imply movement by creating a feeling of continuity, motion, and change. Curvilinear shapes and forms can be very pleasing, for they reflect nature and natural objects (Figure 4.28). Because of their continuous character, they tend to express unity. Compared to other shapes, circles or spheres also can enclose more space using the least amount of area and surface, making them very economical in design.

FIGURE 4.27 The triangular shapes in this wall-mounted glass sculpture "Convergence" exhibit very dynamic shapes and contrasting angles. It emphasizes shadow and illusion, integrating the elements of light, shape, and form to punctuate environments.

FIGURE 4.28 The chambered nautilus shell is composed of curved shapes that form a visually flowing natural design.

Texture

Texture refers to the visual or tactile characteristics of natural and man-made objects or materials. The terminology used to describe textural characteristics is associated with both sight and touch. Tactile or "actual" textures, such as bricks, sandpaper, or a wool carpet, can be physically felt and represent three-dimensional qualities. Visual textures, also called simulated or illusionary, can be smooth to touch but visually appear to have textural qualities similar to real ones (Figure 4.29).

FIGURE 4.29 The illusionistic murals painted on this wall by Timothy and Andrea Biggs have an illusionary texture that is done with paint. This entire wall is smooth—the forms and textures are artificial.

A strong relationship exists between the tactile sense of touching and the visual sense of seeing. People respond to seeing something by wanting to feel it. Textural qualities are further classified as soft or hard, rough or smooth, dull or shiny, dark or light.

Perception of texture can be influenced by the quality of light and how the form or surface reflects or absorbs the light. Because very rough textures tend to absorb light, they can create interesting contrasts of light and dark shadows (Figure 4.30). On the other hand, a very shiny, smooth surface will create design interest with the amount of light it reflects (Figure 4.31). The use of concentrated light and shadows can emphasize texture. Diffused light, such as that produced by overhead fluorescent lamps, tends to soften textural qualities.

Variation in texture can contribute to physical and emotional comfort in our surroundings. Smooth textures generally seem "cold" when they dominate space, whereas rough textures, associated with plush fabrics and carpeting, uneven wall surfaces, and live plants, can create a sense of warmth. Contrasting of textures can allow the eye and hand to experience changing sensations. A space with smooth walls and floors, for example, might be furnished with a strong textural quality (carved wood), soft fabrics, and leafy plants for an interesting contrast.

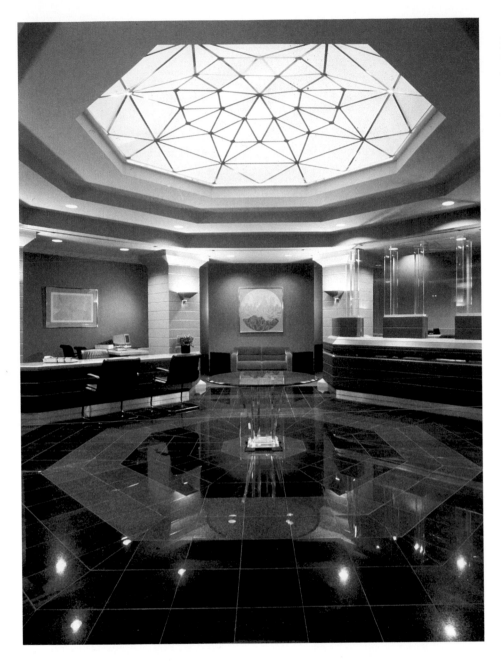

FIGURE 4.30 The rough texture in the wall of this restaurant are further exaggerated by spot-lighting them at a low angle, creating shadows and highlighting edges.

FIGURE 4.31 The shiny, smooth surfaces in this bank reflect light and other elements, creating a variety of interest and sparkle.

The scale of texture is also an important factor. If it is used inappropriately, such as by placing large masonry blocks in a small, intimate space, a visually uncomfortable space will result. An environment with too many and overly powerful textures, used without a sensitivity to the contribution of each, may contribute to this disturbing feeling also.

Acoustical control is another important quality of textural surfaces. Smooth, hard surfaces will reflect and magnify sound, whereas soft, uneven, rough surfaces will absorb it. These characteristics are particularly important in planning commercial environments, where sound control must be a strong consideration.

Patterns of texture can be produced by "repetitive forms," such as wood flooring, wall siding, floor tiles, bricks, plant leaves, or woven fabrics. The overall texture created by the repeated shapes causes more emphasis than does the individual object.

Two-dimensional patterns are also used to simulate the visual effect of actual three-dimensional texture. Examples include paint, plastic laminates, wallpaper, or marbleized tile (Figure 4.32).

The integrity of materials is directly related to the quality of textures and how they are used. Most people appreciate the natural quality of wood, its texture, and its pattern. This quality can be brought out through using finishing processes that emphasize the wood rather than high-gloss finishes that overcoat or hide the material. Exposing ordinary materials, such as the old brick of many buildings being renovated and rehabilitated, can give much visual delight (Figure 4.33).

No matter how aesthetically pleasing, exciting, or honest a particular texture might be, it must be appropriate to the use of the space, since maintenance of the finish can be a problem. A high-traffic area, such as a building lobby, would not be an appropriate place for a deep, textural pile carpet that would wear out very quickly. Sometimes, also, maintenance and building codes limit the choice of materials and textures that can be used.

FIGURE 4.32 The patterns and texture of this "Faux Marble" are created with paint by the EverGreene Painting Studios.

FIGURE 4.33 The old, exposed brick at the entry to this restaurant is complemented and accented by modern materials and finishes.

Time

Under "Time-Space Perception" above, the close relationship between time and space was discussed. Moving through space at various time intervals produces varying impressions of the space.

The elements of design discussed previously have been expressed as two- and three-dimensional concepts—that is, as fixed design entities. However, they are not fixed in existence, since time will have a marked influence on their ability to withstand nature's forces, such as rain and extreme cold affecting the texture of a brick or adobe wall over many years. Colors will fade, textures might erode, forms will evolve, and shapes might change, yet some of these occurrences can be planned for. For example, some exterior woods will eventually be bleached by the sun to a soft, silver or gray patina (Figure 4.34).

FIGURE 4.34 **The untreated wood siding, trim, deck, and handrail of this house will eventually age to a gray patina due to weathering effects.**

Time is the fourth-dimensional design element that designers should plan for with their ideas and proposals. They should be of aware of what time might physically do to the project and should even consider how people's attitudes and impressions may change with time.

THE PRINCIPLES OF DESIGN

The scientific world speaks of the elements of matter that in turn compose larger or holistic forms. In design, as previously mentioned, we also speak of the elements or basic components and how they in turn are applied through the use of the principles of design (see Figure 4.11). However, we may find that many designs do not follow these specific categories exactly. They seem to violate or intermix the principles but still produce pleasing or strong, exciting characteristics. The experienced designer understands the principles of design, yet can go beyond the basic rules (or principles), break those rules, and create successful interiors.

Balance

From childhood, when we learned to stand upright, walk, and ride a bicycle, we were aware of balance and its importance. This is *physical* balance and it relies on natural principles of gravity and equilibrium. Our inner-ear functions allow us to perceive unstable balances and attempt to counteract them.

The designer speaks of *visual* balance, which is often related to the apparent perceived relative weights of objects in architecture and interiors. These relationships are determined by the psychological impact they make on the individual experiencing them. Balance does not always reflect a state of repose; it can be in an ever-changing state of equilibrium—seeking to counteract instability. Referring to physical balance again, an example would be the minor weight shifting we use to overcome the forces of gravity while riding a bicycle. The same principle holds true when the visual or apparent balance of a room changes as a person moves through it. It is important to note that a magazine photograph of a "balanced" interior might not have the same effect if a person could move into the space and view it from another angle. These movements in space can be anticipated and taken into account in the designer's overall scheme.

The discussion below concerns the three basic types of balance: symmetrical, asymmetrical, and radial.

SYMMETRICAL BALANCE. Symmetrical, or bilateral, balance refers to the arrangement of objects that seem to have an imaginary mirror placed along a central axis that bisects the form and presents each half as a mirror image of the other. In nature, the human body, various plants, and animals exhibit these forms. This type of balance is the one that designers most readily perceive and most frequently use—perhaps because it appears naturally in our environment. Symmetrical compositions of objects and furniture, such as seen in Figure 4.35, appear to most viewers as stable, static, dignified, and calm. Many buildings, particularly historic public buildings with entry doors placed directly in the center of the facade and windows set equidistant on either side (Figure 4.36), exhibit symmetry. Historically, the classic periods in architecture produced many symmetrical buildings and interiors that created formal, stately impressions. It seems that people desire symmetry in their environments; however, too much formal symmetry can result in dull, static arrangements.

ASYMMETRICAL BALANCE. In asymmetrical balance the visual arrangements or weights are neither identical, mirror images nor equivalent images but do tend to stabilize one another. Two unequal people (a small child and an adult) on a seesaw is an example of arranging the locations of the objects (people) to balance in physical equilibrium. In design, brightly colored objects can visually balance the use of a dull color, and a large object can be balanced by a

FIGURE 4.35 The lobby of the Inn at Semiahoo, Washington, is arranged in a symmetrical balance design where objects are almost mirror imaged along the axis to the fireplace. (Copyright © Dick Busher, 1987. Seattle, WA.)

FIGURE 4.36 The City Hall in Sandwich, Illinois (converted to an opera house) has a symmetrically balanced facade typical of many historic public buildings.

FIGURE 4.37 In this example of asymmetrical balance, the sofa, end table, and wall pictures are balanced on the left with a chair, end table, and lamp. The windows and door placement and shape reinforce a sense of balance and stability.

RADIAL BALANCE. Radial balance is similar to symmetrical balance but has a central point, or core, from which elements extend outward, or radiate. Radial balance can also seem to exhibit circular, expanding movement. A wagon wheel, rose windows in churches, a daisy, or the planets revolving about the sun are forms of radial balance. However, if we removed a petal from the daisy or a spoke from the wagon wheel, the radial balance would seem incomplete or unbalanced. We see radial examples in interiors (Figure 4.38), furniture arrangements, and circular objects, such as lighting fixtures, plates, and even flower arrangements.

Balance can be expanded to include more than just the physical arrangement or shapes of objects. Specifically, we can speak of balance in the elements of design, such as balance of texture, color, line, and space. Balance can also be a fluid relationship, such as that of dancers moving in space as well as through time, complementing one another and the essence of their movements in the routine.

FIGURE 4.38 The interior of the Conrad Sulzer Regional Library in Chicago is designed around a radial skylight with columns placed at the outer perimeter.

Rhythm

Rhythm can be thought of as organized movement, regular intervals, or recurrence, such as the pattern of a heartbeat or of water dripping from a faucet. Visually, it can be seen in the repetitive use of brick forms in a wall, columns in a Greek temple, or repeated forms of leaves in a tree. Rhythm can be accomplished through repetition, alternation, and progression.

REPETITION In repetition, the most basic pattern of rhythm, elements or concepts are repeated in a structured, organized manner. In interiors, this repetition can also be utilized to carry the eye throughout the space by repeating simple forms, textures, or colors (Figure 4.39).

FIGURE 4.39 The simple repetitive pattern of the wood planks, set in a curved shape, carries the eye through this dining area at Paramount Pictures in Hollywood, California. The curvilinear shapes are also repeated on the ceiling.

ALTERNATION. Alternation of rhythm can create a slightly more complex system of design by alternately changing the elements of the design. Fabric with a pinstriped pattern creates an alternating rhythm, as do more naturalistic alternations such as the zebra's black and white stripes.

PROGRESSION. Progression of rhythm suggests movement and draws the eye into directional sequences. Examples include the rhythmic progression of a series of light colors to dark colors or of small objects to large objects and the progression of patterns in various wallpaper designs.

Emphasis

Emphasis is employed as a design principle when certain elements are accented more than others, creating a relationship of dominance and subordination. Emphasis gives a variety and character to interiors by creating focal points and centers of interest through dominant and subordinate use of forms, colors, textures, and lines (Figure 4.40).

FIGURE 4.40 **The large purple columns in this library provide an emphasis in color and form to the rest of the space and elements.**

The dominant forms have the greatest impact or importance; the subdominant are secondary and complement the former. Yet all are visually necessary, and each should be visually strong and exciting in itself as a part of the design concept.

In interiors, designers might use important features, such as a fireplace, a large bookcase, a picture window, or even a plant, as the point of emphasis or center of interest in a space. The emphasized element should be carefully selected and balanced by or contrasted with other elements.

Proportion

Proportion as a principle of design is often closely associated with scale, because both express concepts of relative size and magnitude. Proportion is defined as the relationship of the parts to one another or to the whole, whereas scale refers to the size of a thing in relation or comparison to other things. We often speak of scale as related to the human body in architecture and interior terms, whereas proportion is thought of as the relationship of parts contained within the object. Scale is the relationship in size of the object and a scalar unit of measure outside the object.

Proportion can be expressed as matters of width in relation to length with which designers seek to balance or relate the parts to one another to create an aesthetic composition. The Greeks set down some of the basic principles of proportion when they devised the "golden section" axiom. The system they derived sought to set down pleasing proportions in architecture and sculpture (Figure 4.41). The progression of numbers 1,2,3,5,8,13,21,34 . . . demonstrates

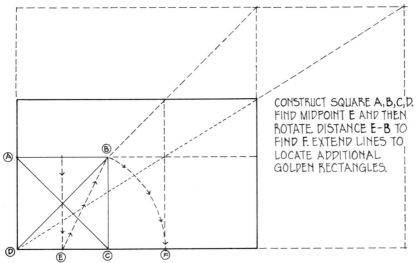

CONSTRUCT SQUARE A,B,C,D. FIND MIDPOINT E AND THEN ROTATE DISTANCE E-B TO FIND F. EXTEND LINES TO LOCATE ADDITIONAL GOLDEN RECTANGLES.

ONE METHOD OF DERIVING THE GOLDEN SECTION AND RECTANGLE.

FIGURE 4.41 The Greeks developed some of the basic principles of proportion. They proposed the golden section, the golden rectangle, and the golden mean.

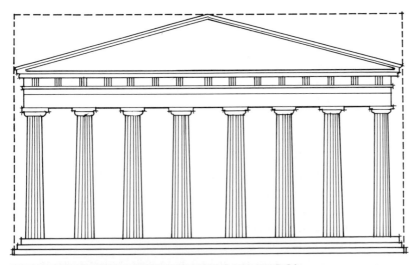

THE FACADE OF THE PARTHENON AT ATHENS (447-432 B.C.) FITS ALMOST EXACTLY IN THE GOLDEN RECTANGLE.

the relationship of the "golden section" in which each number is the sum of the two preceding ones. Designers have applied this progression to produce pleasing results.

The Greeks also developed the "golden rectangle," with its sides as a ratio of two parts to three. The golden rectangle represents the division of a form or line in which the side of the smaller portion in relation to the larger is identical, as the side of the larger part is to the whole. The "golden mean" represents the division of a line between one-third and one-half of its length, which produces a pleasing proportion, versus an exact division of the line.

Scale

We have discussed the fact that scale is usually closely related to proportion, except that scale is primarily viewed as a relative standard or measure outside of an object and related to some constant unit. In architecture and interior design, when we speak of scale, we are comparing the size of an object or an environment to man. For example, the ancient pyramids are of such a gigantic scale that man appears to be a small insect when compared in size to them. If we doubled the size of one of the pyramids and kept its proportions the same, it would be unchanged except much larger. However, if we compared it to man, it would be doubled in scale.

Scale can refer to small or diminutive, as well as to large or grand, size. Models of objects, interiors, or buildings are usually made small in scale. However, most model makers will often establish a unit of relative measure (man) by placing appropriately scaled figures, cars, or other readily perceived objects in or on the model for scale unit measure. In turn, we can then relate to the scale of the model.

FIGURE 4.42 The repetition of line, texture, and pattern in the Galleria for the Riverside Convention Center (Rochester, New York) gives the interiors a sense of unity and order. (Copyright © Peter Aaron/Esto.)

Unity and Harmony

Unity is primarily defined as oneness, or the state of being one. It also refers to the totality of the related parts. As designers, we often look for compositions, objects, or spaces that have unifying elements because they appear less chaotic or haphazard to us. Unity is all around us in the natural world. For instance, people look different as individuals, but as human beings, they represent a unity of composition and form.

Unity is established in designed compositions in many ways. One of the most fundamental approaches is the use of repetition in shape, form, pattern, or texture (Figure 4.42). Color also can be used to mold seemingly different objects or spaces into a unified whole. In fact, it is difficult to speak of unity and variety without discussing them in terms of harmony. Harmony results from a composition fitting together, from a correct combination and balance of unity and variety, and provides a sense of belonging, consonance, or oneness. It is the basic principle that holds the components of a design together, in a harmonious relationship, but that design could become dull or monotonous without a sense of variety.

Variety

Variety abounds throughout our natural and man-made environments. Designers use interesting things that capture our attention by their uniqueness or simply by being different to create excitement and interest in otherwise static, dull compositions. However, variety should be combined with some degree of unity or harmony, for it could create discord if used to excess.

REFERENCES FOR FURTHER READING

Abercrombie, Stanley. *A Philosophy of Interior Design.* New York: Harper and Row, 1990.

Allen, Phyllis. *Beginnings of Interior Environment.* Minneapolis: Burgess Publishing Company, 1985.

Belvin, Marjorie Elliott. *Design Through Discovery.* New York: Holt, Rinehart and Winston, 1985.

Ching, Francis. *Interior Design Illustrated.* New York: Van Nostrand Reinhold Company Inc., 1987.

Faulkner, Ray, LuAnn Nissen, and Sarah Faulkner. *Inside Today's Home.* 5th ed. New York: Holt, Rinehart and Winston, 1986.

Grillo, Paul. *Form, Function, and Design.* New York: Dover, 1975.

Itten, Johannes. *Design and Form.* New York: Litton Educational Publishing, Inc., 1975.

Lauer, David. *Design Basics.* New York: Holt, Rinehart and Winston, 1979.

Maier, Manfred. *Basic Principles of Design.* New York: Van Nostrand Reinhold, 1977.

Pile, John F. *Design Purpose, Form, and Meaning.* New York: W.W. Norton and Company, 1979.

———. *Interior Design.* Englewood Cliffs, N.J.: Prentice-Hall and New York: Harry N. Abrams, Inc., 1988.

Wong, Lucius. *Principles of Two-Dimensional Design.* New York: Van Nostrand Reinhold, 1972.

Young, Frank. *Visual Studies: A Foundation for Artists and Designers.* Englewood Cliffs, N.J.: Prentice-Hall, 1985.

Zelanski, Paul, and Mary Pat Fisher. *Design: Principles and Problems.* New York: Holt, Rinehart and Winston, 1984.

COLOR
AND
LIGHT

After the design element of space, color and light are probably two of an interior designer's most powerful design tools. Color and light can alter the use and perception of a space since they can be manipulated for effect or emotion. Color can be used to define form and give a sense of scale rather than merely provide a background. Color is an integral part of the world around us. Color can be used to create an illusion or to emphasize a dramatic architectural form. Color cannot be explained as just a scientific theory, an art, or an emotional reaction to our environment, because it is an integral part of all of these. The need for color is often a reaction to an otherwise drab world.

Color is usually associated with commonplace physical objects, such as brightly colored flowers, multicolored leaves in autumn, the sky at sunset, or a painting. In design, color is generally thought of in terms of objects and surfaces, such as walls, carpets, cars, and buildings. Color affects, and is crucial to the success of, the design of an environment. Color is a mood-setting and emotion-producing tool (Figure 5.1). Putting together a color scheme for an interior design project is a very pleasurable and rewarding aspect of design work. Working with color is a science as well as an art. Developing skill in using colors begins with the study of color systems, which are based on the scientific principles of light and color.

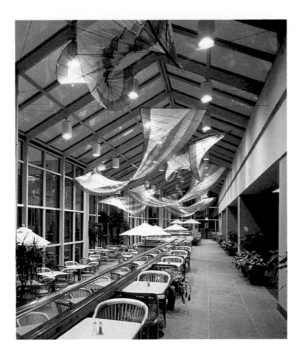

FIGURE 5.1 These panels, with a slight twist, soften the glass atrium environment and bring visual warmth and cheer to this corporate dining facility through the use of color.

HOW WE SEE COLOR AND LIGHT

Color is not a physical part of objects we see, but rather is the effects of light waves bouncing off or passing through the objects. In fact, if there were no light, there would be no color. Therefore, light and color are inseparable. For a designer to use color, it is important to know first how light affects color. We perceive colors because of the way light strikes objects and by the way our brains translate the messages our eyes receive (Figure 5.2). Other factors that

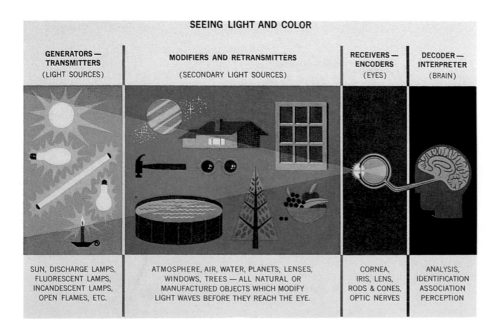

FIGURE 5.2 Light and color perception are influenced by the many variables and factors categorized under one of the four columns in this illustration.

determine how we perceive the color of a given object are the light source under which it is examined, the material the object is made of, and the physical condition of the viewer's eyes.

Light Sources

FIGURE 5.3 The human eye responds to that very small portion of the electromagnetic spectrum known as the visible spectrum. However, it does not respond uniformly, as it senses the yellow–green region as the brightest and the red and blue regions as the darkest.

Light is a form of radiant energy that exists in the shape of repeating wave patterns emanating from a source in straight paths and in all directions. An example of this radiant energy is the sun and its projecting rays. Light is considered to be a radiant energy wave and a part of our larger wave spectrum, referred to as the *electromagnetic spectrum* (Figure 5.3). Figure 5.3 shows that the visible spectrum, which is responsible for color, is a very small part of the overall spectrum of radiant, electromagnetic energy. The eye distinguishes different wavelengths of this radiant energy and interprets them as different colors. The longest wavelength in the visible spectrum is red, followed in descending order by orange, yellow, green, blue, and violet, the shortest visible wavelength. Wavelengths are measured in nanometers, each one-millionth of a millimeter, and range from 380 to 760 nanometers. Wavelengths shorter or longer than this range, such as ultraviolet and infrared light, do not stimulate the receptors in our eyes; hence, we cannot see them.

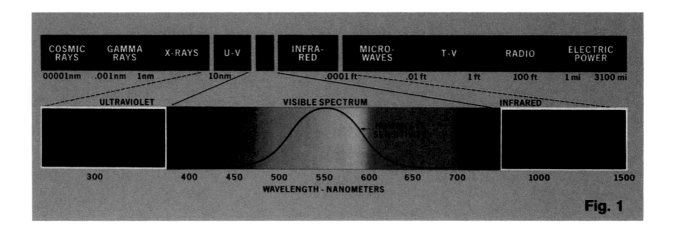

In the 1600s Sir Isaac Newton (1642–1727) demonstrated that color is a natural part of sunlight or white light. When he passed a beam of sunlight through a prism of transparent material, he found that as the light emerged from the prism, it had dispersed, separating the individual wavelengths into different colors. These colors arranged themselves according to the colors of a rainbow—red, orange, yellow, green, blue, and violet (Figure 5.4). Newton carried his experiment one step further by utilizing a second prism to mix the waves back into sunlight. This verified the fact that color is basically made up of light and that when "colored" lights are mixed, the result is white light.

When a light source emits energy in relatively equal quantities over the entire visible spectrum, as in the case of the sun or a bright light bulb, the combination of the colored light will appear white to the human eye. However, if a light source emits energy over only a small section of the spectrum, it will produce that corresponding colored light. Examples can be seen in our electric light sources, such as the high-intensity discharge mercury lamp that produces a blue-green light or the deep yellow low-pressure sodium lamp commonly used on freeways.

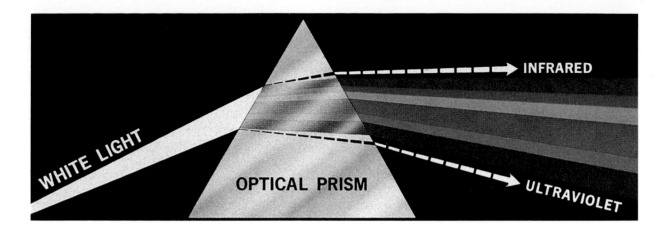

Modifiers of Light

Indeed, color cannot exist without light, because colors are actually other names for various mixtures of radiant, electromagnetic energy. But how then do we explain colors in actual objects? The colors that we see in objects are the result of light waves that reach the eye after the object has selectively absorbed some of the wavelengths and either reflected or transmitted the others. In other words, the color, or pigmentation, of an object absorbs all colors of light except its own color, which is either reflected or transmitted to the eye. For example, if white light falls on a red surface, that surface will absorb all the wavelengths except the red ones, which are reflected back to the eye, allowing us to perceive the color red, as illustrated in Figure 5.5.

FIGURE 5.4 The effect of passing rays of white light through a prism is to bend the shorter wavelengths more than the longer wavelengths, thus separating them into distinctly identifiable bands of color.

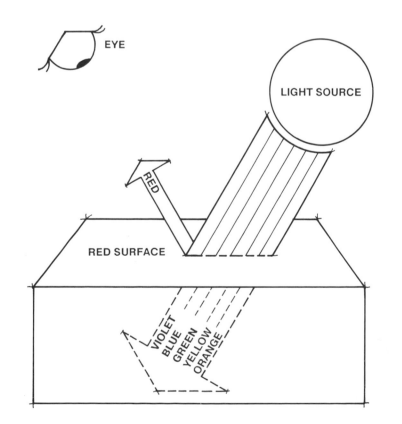

FIGURE 5.5 Only red light waves are reflected back to the eye after all other wavelengths are absorbed by the red surface.

Similarly, if a white light is passed through a transparent surface, such as a piece of green glass, the transmitted wavelengths will appear green because the other wavelengths were absorbed. An object or surface will appear black when light is totally absorbed.

The material or texture of an object will also influence how much light is absorbed, reflected, or transmitted. When light falls on an unpolished (diffuse) surface, light waves are reflected in all directions (Figure 5.6) because of the overall even surface. Smooth, shiny surfaces reflect more light, and dull or matte surfaces absorb most of the light waves, thus modifying the visual appearance.

FIGURE 5.6 Selective spectral reflectance occurs when light falls on matte or diffuse surfaces such as sandstone (a). Spectral transmission occurs when a light falls on a transparent surface or object (b).

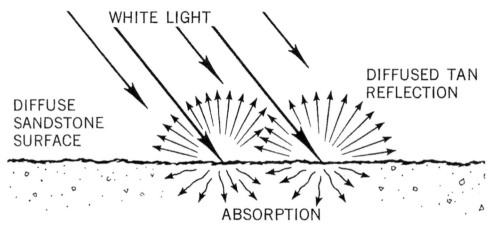

EXAMPLE OF SELECTIVE SPECTRAL REFLECTANCE

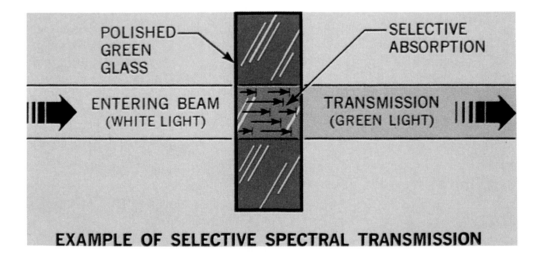

EXAMPLE OF SELECTIVE SPECTRAL TRANSMISSION

Human Vision and Perception

Because light and color are related to vision, it is necessary to understand how the human eye works. The human eye is a delicate and complex instrument that functions in many ways like

a camera. Both the eye and the camera have a light-sensitive plane on which a lens focuses an image; in the eye this plane is the retina, and in the camera it is the film. In each, the amount of light entering the lens can be controlled—by the iris in the eye and by the diaphragm in the camera (Figure 5.7).

FIGURE 5.7 Comparison of a human eye to a camera.

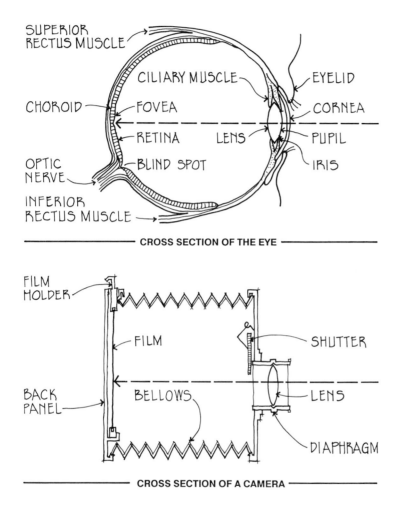

For light to be visible, it enters the eye through the pupil, whose size is controlled by the iris. The pupil expands or contracts in response to the stimulus of the optic nerve to control the amount of light entering. The light then passes through the lens and focuses to form an image on the retina. The optic nerve then transmits the visual message by electric impulses to the brain to create the mental picture we see. The image perceived is dependent on the central portion of the eye, which is located near the fovea and contains light-sensitive cells called cones because of their shape. These cones are responsible for the ability to see color and to discriminate fine detail. There are three kinds of cones in our eyes that are each sensitive to a certain wavelength area. The peaks of the three spectral sensitivity curves in Figure 5.8 correspond to the spectrum's short, middle, and long wavelength areas, which respectively give us the color sensations blue, green, and red. Cones discriminate detail primarily because they are connected to their own nerve ends. The muscles allow the eyeball to rotate until the image is focused and falls on the fovea. Cone vision is referred to as photopic, or daytime, vision.

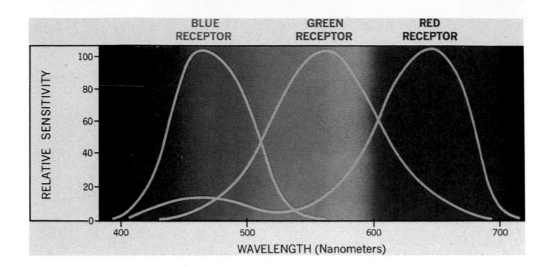

FIGURE 5.8 Relative sensitivity of the cone mechanisms within the eye correspond to the blue, green, and red wavelength areas of the visible spectrum. The sensitivities of the three receptor peaks are not necessarily equal, as the eye perceives the yellow–green region as the brightest.

The rod, a second type of cell within the eye structure, is also named after its shape. These cells are extremely sensitive to low levels of light, enabling the eye to see at night or under extremely low lighting conditions. However, rods lack color sensitivity, which accounts for the fact that in very dim light (rod vision), we have no color perception. Also, since several rods are connected to a single nerve end that provides a general picture of the field of view, rod cells cannot discriminate fine detail. Rod vision is referred to as scotopic, or night, vision.

As the eye focuses on individual objects, what it actually sees depends on the quantity and quality of light available. As light bounces off objects and is reflected back to the eye, variations in brightness, color, size, shape, distance, and texture are recorded on the retina and then translated into a picture that we learn to understand as the appearance of whatever we are viewing. Human vision and the perception of color and light vary widely according to factors such as aging, experience, and behavioral perceptions. These concerns are addressed in Chapter 12 under "Lighting Needs and Application."

COLOR THEORY AND SYSTEMS

To understand the effects, relationships, and applications of color, it is helpful to organize color into a systematic classification or theory. Before any of the color systems can be described, however, it is essential to understand the relationship between the primary colors of light and the primary colors of pigments and how these are mixed to produce other colors.

Additive Method of Mixing Light

The first method of mixing light is called an additive process (Figure 5.9). The three primary colors of light are red, green, and blue. When two of these are added together, they produce secondary colors of light—magenta (red plus blue), cyan (blue plus green), and yellow (green plus red). If a secondary color of light is mixed with its opposite primary, that is, the

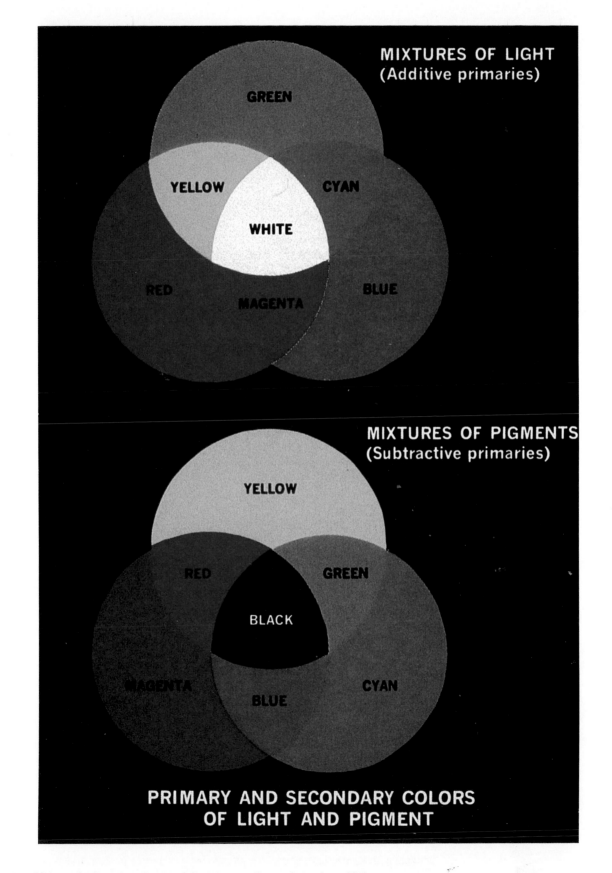

FIGURE 5.9 Additive and subtractive mixtures of the primary and secondary colors of light.

primary color not part of the mixture, white light will be produced. For example, a mixture of cyan and red light will result in white light. Thus, cyan and red are complementary colors of light. Other complementary colors of light are yellow and blue, and magenta and green. When all three colors are overlapped, white light is produced from the three additive primaries. This process of mixing light consists of adding "energy" on top of "energy," thus creating lighter colors.

The mixing of colored light is generally used in theaters for stage lighting. However, it has also been used in some interior spaces, such as in retail and restaurant environments, to create stage effects. Care should be taken in the use of colored lights, especially where color selections are important, because these lights can distort real color and cause eye fatigue or irritation.

Subtractive Method of Mixing Light

The other method of mixing color through light is a subtractive process. It involves mixing transparent colorants, such as dyes, inks, stained glass, and water colors. In the subtractive method, the primary colors are magenta, yellow, and cyan (the secondary colors of light). When overlapped, magenta and yellow produce red, yellow and cyan produce green, and cyan and magenta produce blue. When the three subtractive primary colors are overlapped, all color is absorbed or subtracted from white light, producing black.

Paint-Color Mixing

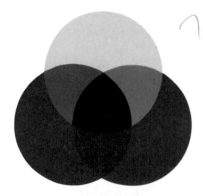

FIGURE 5.10 Paint-mixing method of combining primary and secondary colors.

When dealing with opaque pigments, such as paint, the theories of mixing light do not apply. However, mixing paint colors is closely related to the subtractive method of mixing light. The color of an object or a material absorbs, or subtracts, all the colors of light except the color of the object, which is reflected to the eye. The three primary colors of opaque pigments are red, yellow, and blue. When two primaries are mixed, that is, yellow plus blue, red plus blue, and red plus yellow, they produce secondary colors of green, violet, and orange, respectively. When the three primaries are mixed, they produce black (Figure 5.10).

Harald Kuppers recognized that the additive and subtractive mixtures of light did not apply to paint or opaque pigments and came up with a new law of mixtures called the "integrated mixture." In his book *Color: Origin, Systems, Uses,* published in 1972, Kuppers identifies eight "integrated" primary colors—white, yellow, magenta, cyan, blue, green, red, and black. He feels these are "pure" colors and cannot be produced by any other colors. His complete color system will be discussed later.

Color Properties

To describe a color with reasonable accuracy, three basic properties have been designated to identify the dimensions, or qualities, of color: hue, the name of a color; value, the lightness or darkness of a color; and intensity, or chroma, the degree of purity or strength of a color.

HUE

Hue is the name, such as red, blue, or yellow, given to each color to distinguish it from the other colors. It refers to the color in its purest form, that is, with no blacks or whites added.

VALUE

Value designates the darkness or lightness of a color. Figure 5.11 shows the values between black and white, that is, all the gray values in between. This gray scale of values can be broken down into perhaps more than 100 gradations. However, in most color systems the gray scale is usually expressed in approximately nine steps, often called the achromatic scale. This means it is free of any color, consisting of only black and white.

Values can be expressed by shades, tints, and tones (Figure 5.12). Shades are produced by the addition of black to a color, which will darken the hue; tints are determined by how much white is added to a hue, which lightens the color; and tones are produced by adding gray to a hue.

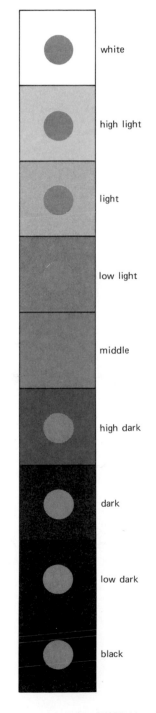

FIGURE 5.11 Seven gradations of a gray value scale between white and black. The dots (all of a middle value) appear darker against a light background and lighter against a dark one.

white

high light

light

low light

middle

high dark

dark

low dark

black

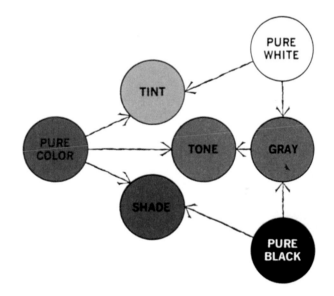

FIGURE 5.12 Tints, tones, and shades can be produced by adding white, gray, or black to a pure hue.

CHROMA

The chroma of a color is the purity, saturation, or amount of pigment it exhibits. Colors that exhibit a high degree of chroma are those that are not grayed but rather are at their ultimate degree of vividness. Adding black or white to a color can lower its intensity, or vividness. Adding a complementary color can also lower the saturation of a color.

Color Systems

As Sir Isaac Newton continued his experiments with light and the color spectrum, he recognized that a relationship formed between each color and its adjacent color. By joining the

end colors, red and violet, to form a circle, he found that the bands of color flowed together in a continuous spectrum. From these early experiments, the color circle or color wheel was developed and further refined into color systems. Several color systems have evolved since Newton's early experiments, each one based on a different group of basic, or primary, colors. We will look at some of the most commonly used systems.

12-PART COLOR SYSTEM

The most familiar and simplest color system is based on the work of Johannes Wolfgang von Goethe (1749–1832). His color circle (Figure 5.13) was made up of the three primary colors of red, yellow, and blue and the three secondary colors of orange, green, and purple. Goethe's theory was expanded to the common 12-part color wheel (Figure 5.14), often credited to Herbert E. Ives, David Brewster, and Prang. It is often referred to as the "standard color wheel." This system is based on paint-color mixing properties and the belief that the three primary colors cannot be mixed from other colors or be broken down into component pigments. Secondary colors are formed when two of the primary colors are mixed in equal parts: red and yellow mixed together will produce orange, yellow and blue will produce green, and blue and red will form violet. This process can be expanded by mixing equal parts of a primary color and a secondary color to create six tertiary, or intermediate, hues. These resulting colors are yellow-green, blue-green, blue-violet, red-violet, red-orange, and yellow-orange.

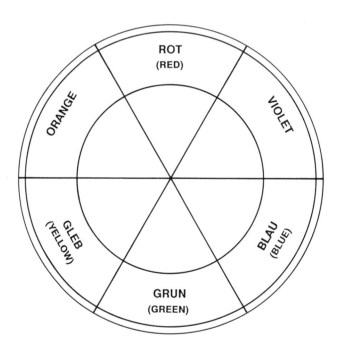

FIGURE 5.13 Goethe's color wheel of 1793 had six equal color designations.

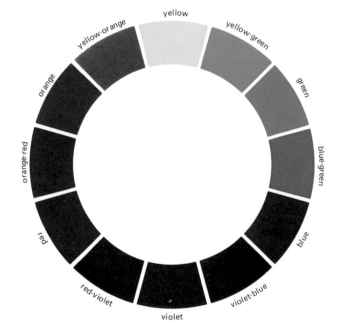
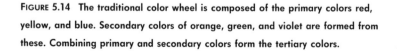

FIGURE 5.14 The traditional color wheel is composed of the primary colors red, yellow, and blue. Secondary colors of orange, green, and violet are formed from these. Combining primary and secondary colors form the tertiary colors.

The 12-part color system may appear too simplistic or limited to some people, but it is only a beginning. An infinite number of variations can be produced by combining adjacent hues or varying the proportions of other added colors, as well as by adding black, white, and gray. Also, the visual quality of a color can be further modified by the effects of background colors and light, to be discussed later.

THE MUNSELL COLOR SYSTEM

One of the most widely used systems of color notation is the Munsell color system. It was developed, at the turn of the century, by Albert Munsell (1858–1918), an American artist and art teacher. His theory of color is based on five principal hues—red, yellow, green, blue, and purple—and five intermediate hues—yellow-red, green-yellow, blue-green, purple-blue, and red-purple (Figure 5.15). Each of these principal and intermediate hues is then subdivided into 10 equal

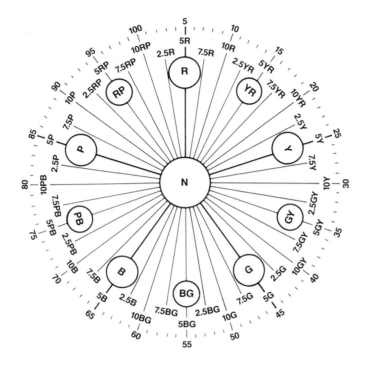

FIGURE 5.15 The Munsell color system divides the spectrum into five principal and five intermediate hues which are indicated by a letter. These ten hues are then divided into 10 additional hues indicated by a letter and a number, thus creating 100 hues in the circle.

parts, totaling 100 different hue variations. These hue variations are designated by capital letters, such as *R* for red, *Y* for yellow, and *YR* for yellow-red, preceded by a number. The principal and intermediate hues are designated by the number *5,* which signifies that it is the "pure" color of that particular hue family. In addition to the part numbered 5, each hue family is divided into three other equal parts, designated by 2.5, 7.5, and 10. When these numbers are combined with the letters symbolizing a particular color, such as 2.5R, that combination designates the exact hue variation. For example, 2.5R indicates a color toward red-purple, whereas 7.5R is toward yellow-red. Further gradation refinement is then possible, to create the total 100 hue variations designated by the numbers on the outer circle.

This two-dimensional circle of hues is then extended into a three-dimensional form where "value" is the vertical axis (Figure 5.16). Munsell's value scale is divided into nine steps, ranging from 0 for black to 10 for white. Thus, a color can be identified according to its degree of lightness or darkness based on its position on the value scale.

The horizontal axis of Munsell's three-dimensional solid represents the chroma levels, or saturation possibilities, of each hue. The chroma levels extend from 0 for the neutral axis to 10 or more steps for the more vivid hues. As colors vary in saturation, some hues extend as far as 16, while others may only extend to 6, thus creating a solid that is not symmetrically balanced.

Munsell also developed an intricate method of classification to further identify each color within his system. The letter-number combination exactly locating each hue on the 100-hue color wheel is followed by the value level and the chroma level written as a fraction. For example, 5R

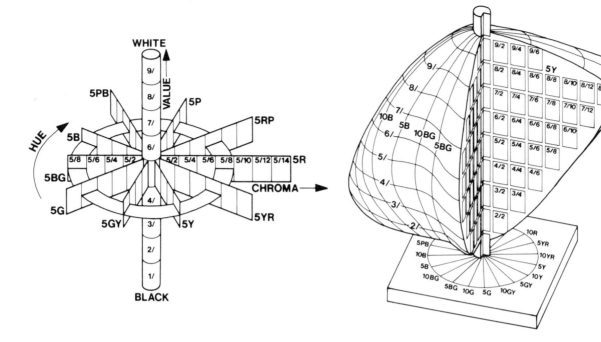

FIGURE 5.16 LEFT Chroma (or saturation) scales radiate in equal steps from the neutral axis outward to the periphery of the color model. RIGHT Increasing steps of chroma are indicated in Munsell notations by degree of departure from the neutral gray of the same value.

5/10 designates "pure" red at the middle value level (5) and maximum chroma level (10). A very grayed (low value) yellow would be designated as 5Y 3/2. Based on this notation system, Munsell also developed a standardized way to "harmonize" colors. If two or more hues are to harmonize, they must be in the same hue family or at the same value or same chroma level. For example, if a "pure" blue (5B) were to harmonize with "pure" red (5R 5/10), the selected blue would need to be at the fifth value level or the tenth chroma level, for example, 5B 5/8 or 5B 6/10. Thus, it becomes simple to plan a color scheme if the following relationships exist:

1. Any two colors of the same hue family will go together (harmonize).
 Example: 5R 5/10
 2.5R 8/4
2. Any two colors of the same value level or with the same amount of "gray" in them will harmonize.
 Example: 5Y 6/8
 5G 6/10
3. Any two colors at the same chroma level will harmonize.
 Example: 5B 3/6
 5YR 5/6

THE OSTWALD COLOR SYSTEM

Wilhelm Ostwald (1853–1932), a German physicist and chemist who won the Nobel Prize for chemistry in 1909, also developed a color system. His system (Figure 5.17) is based on four primary colors—red, green, blue, and yellow—and four intermediate colors—orange, purple, green-blue (turquoise), and yellow-green (leaf green). Each primary and intermediate hue has two auxiliary hues, one added to each side, for a total of 24 hues around his color wheel. Each hue is then designated by a number from 1 to 24.

FIGURE 5.17 The Ostwald color wheel is based on four primary hues of green and blue and four intermediate hues of orange, purple, turquoise, and leaf green.

Similar to the Munsell system, Ostwald's color system also takes the form of a three-dimensional solid but is shaped like a double cone rather than a sphere (Figure 5.18). In this system, the 24 pure hues are grouped around the equator, with the eight value steps from white to black in the form of a central vertical axis.

Ostwald's system is based on the theory that any color can be mixed from combinations of black, white, and a pure hue. This system makes no distinction between value and chroma. Similar to the standard color triangle in arrangement, Ostwald's gray scale ranges from white (lettered A) at the top to black (lettered P) at the bottom. Then mixtures of white, black, and pure hue are added to form 28 variations of each of the 24 hues in terms of lightness or darkness; the results are similar to tints, tones, and shades of the standard color system. Ostwald's complete solid contains a total of 672 chromatic hues and 8 neutrals.

FIGURE 5.18 Ostwald's three-dimensional color system takes the form of a solid double cone (partially cut away here to illustrate relationships). The most saturated hues are at the equator of the cone and become neutralized as they move to the central axis of the gray scale. A triangle, at the right, illustrates how 28 variations of each hue are produced.

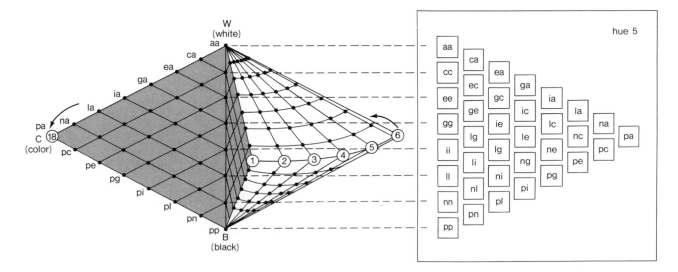

Like Munsell, Ostwald also developed his own hue notation system for use in selecting color harmonies. Ostwald's system specifies the number of the hue (from 1 to 24) followed by two letters, for example, 14 ea. The first letter indicates how much white is added, and the second letter, how much black. Intermediate values are noted as *c, e, g, i, l,* and *n.* For example, the Ostwald notation for a tint of red would be 8 ca. To find a color that would harmonize with that hue, either the hue must be the same number, such as 8 le, or the following letters must be identical, such as 15 ca. These "harmonizing" hues are located according to geometric relationships within the various parts of the color solid.

THE GERRITSEN COLOR SYSTEM

In 1975, Frans Gerritsen developed a color system that is based on the laws of perception and explained in his book *Theory and Practice of Color.* Gerritsen began his training in the Netherlands in art, photography, graphic arts, and education. He then went on to work as a designer and consultant and on occasion worked with Le Corbusier on his pavilion for Expo 1958 in Brussels.

Gerritsen's color system (Figure 5.19) is based on six basic colors—yellow, cyan, magenta, green, red, and ultramarine blue. These six colors are made up of three "eye" primaries—blue, green, and red (as discussed under cone vision)—and three "eye" secondary colors—yellow, magenta, and cyan. In Gerritsen's theory, when we activate two eye primaries simultaneously, we perceive the secondary color sensations; that is, red and green activated at the same time produce the color sensation yellow, red and blue produce the color sensation magenta, and green and blue produce the color sensation cyan.

Gerritsen's color tone circle can be separated into infinite divisions of the basic colors. The circle surrounding the basic colors consists of two in-between colors next to each basic color, which totals 18 colors. The more the colors are divided, the smaller the sections of the basic colors become. As the colors are divided, they are still "pure" and are not neutralized or modified

FIGURE 5.19 Gerritsen's color system is based on six basic colors, three "eye" primaries of blue, green, and red. There are also three "eye" secondaries of yellow, magenta, and cyan.

by any other color. The second ring on the circle, which consists of 54 colors (3 × 18 = 54), only illustrates the transition to the outside circle of infinite divisions. The Gerritsen color circle is divided by systematically activating one of the eye's two sensitivities for spectral light, as illustrated by the perception schemes shown for the 18 colors in the middle ring.

The value scale in Gerritsen's system also is based on spectral sensitivities and color-perception qualities of the eye. The brightness axis (Figure 5.20) ranges from white through various grays to black, with the perception schemes placed next to each step. The highest possible brightness (white) can be produced only by activation of all three spectral sensitivities (blue, green, and red) simultaneously. The perception schemes show that all three spectral sensitivities are equal and none dominates. This is Gerritsen's definition of neutral, and he has named the steps of the value scale "special" tertiaries, which are coded from white to black with the letters *A* through *J*. Color with optimum saturation is fixed at 100, and color fixed at 0 has no color and is neutral.

Gerritsen's color theory is also illustrated by a three-dimensional form that shows the relationship between value and saturation levels for all colors. Each basic color is placed on the outside of a cylinder wall according to the same lightness found on the value axis. Since the value level is different for the basic colors—yellow is at the C level, red at G, magenta at E, ultramarine blue at H, cyan at D, and green at F—an irregular, zigzag line results when these points are linked. This irregular color form organizes all full colors by hue and their own inherent lightness, according to the laws of color perception.

In his book *Evolution in Color* (1988), Gerritsen says that the color circle Newton introduced in the 1600s was irregular, because the basic colors of magenta and cyan were missing. He explains that the color wheel based on the mixing properties of paint, with red, yellow, and blue as the primaries, is misleading and outdated. He says that magenta, cyan, and green are spectral sensitivities that cannot be produced by mixing any other colors. Another major difference between Gerritsen's color system and those of others is his complementary color pairs. In his system, because they lie opposite each other on his color circle, ultramarine blue and yellow, green and magenta, and red and cyan are the complementary color pairs.

THE KUPPERS COLOR SYSTEM

Harald Kuppers, a partner in the printing firm of Wittemann-Kuppers K.G., explains his color theory in his book *Color: Origin, Systems, Uses.* In an effort to identify the primary colors, Kuppers explains that the monochromatic colors of the spectrum are what he felt were "original" colors and make visible everything that we see. To progress from the original colors of the visible spectrum to the primary colors necessary for the laws of color mixture, Kuppers theorizes that the color spectrum (Figure 5.21) contains the five regions of blue, cyan, green, yellow, and red. He also explains that although magenta is not present in the spectrum as a monochromatic color, it is produced by superimposing the red and blue spectral regions. Therefore, his color system is based on those six primary colors.

The Kuppers color circle corresponds to the arrangement of the colors of the spectrum (see Figure 5.3). He feels that a color circle is really a spectrum that has been bent into a circle, with magenta used as a transition. The outer ring of his color circle illustrates how one color merges into the next without a break. The middle ring shows certain hues isolated from the continuous color spectrum. This particular arrangement shows 24 isolated hues (also called a 24-sector color circle, using the same colors as in the Ostwald system). Kuppers explains that his color circle can consist of an infinite number of isolated hues as it is expanded outward toward infinity (which is the continuous spectrum). None of the mixed colors consists of more than two primary colors.

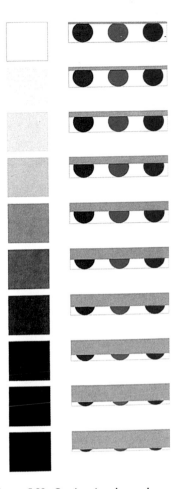

FIGURE 5.20 Gerritsen's value scale ranges from white to black, with the color perception schemes placed next to each step.

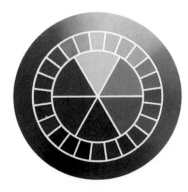

FIGURE 5.21 Kuppers color system is based on the visible spectrum that has been bent into a circle, with magenta used as the transition. It is produced by superimposing the red and blue spectral regions as illustrated in the outer ring.

His three-dimensional system for mixing color is based on a rhombohedron. The rhombohedron is a geometrical form that has six faces and resembles a cube but differs in that the two diagonals of a face are not of equal length (Figure 5.22).

FIGURE 5.22 Kuppers three-dimensional system for mixing color is illustrated here by two color photographs of the rhombohedron. The gray axis passes through the body from the black point in the lower base to the white point in the top. A 180 degree rotation around the gray axis has taken place between A and B.

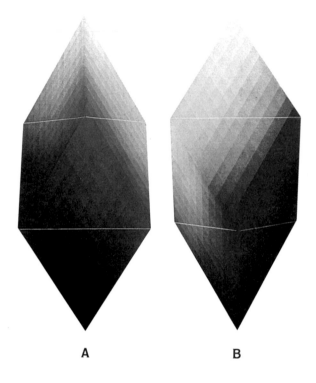

A B

Both Kuppers's and Gerritsen's color systems are based on updated theories that include green, cyan, and magenta as primary colors along with red, yellow, and blue. They both agree that Newton and others who considered only red, yellow, and blue as primaries were inaccurate because in those earlier days no pigments of present-day standards of purity were available as magenta and cyan.

Color Schemes

The concept of color harmony is the basis of understanding the theories of arranging colors into practical color schemes. Just as the Munsell and Ostwald color systems use a systematic approach to determine harmonies, guidelines for arranging colors based on other systems

have also been developed. Designers establish color schemes to set a basic guide, or rule of thumb, to build upon. The schemes that follow are exactly that—a foundation of color principles to build upon. They can be interpreted differently or modified according to the situation. In fact, some designers' color schemes do not seem to follow any of the basic schemes, yet work very well. A successful color scheme is not necessarily determined by which concept was followed but by how it was applied and to what proportions.

Color schemes can be applied to the standard 12-part color wheel (Figure 5.23) or to other color systems, such as Gerritsen's color tone circle, as illustrated in Figure 5.24. These

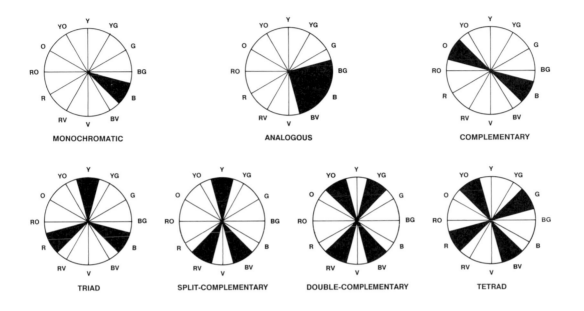

FIGURE 5.23 Seven basic color schemes can be composed on the 12 part color wheel.

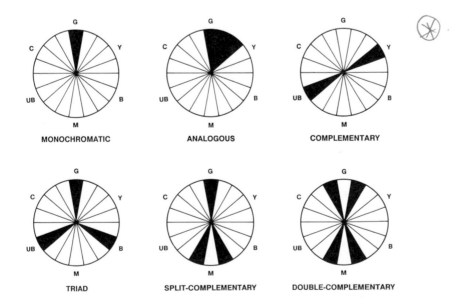

FIGURE 5.24 Six basic color schemes can be composed on Gerritsen's 18-part color wheel.

schemes are based on the organization and harmonizing effects of colors, irrespective of the number of hues in a color circle. These color schemes can be placed in two general categories, contrasted or related (analogous). Contrasting schemes are those made up of hues opposite or far apart on the color wheel. Designers tend to use these hues as accents in a color scheme. Related color schemes are made up of adjacent hues on the color wheel. When a designer wants to express harmony or unity through the use of color, these schemes often are the easiest route.

MONOCHROMATIC SCHEMES

The monochromatic is perhaps the simplest and most basic of the color schemes. A single hue is varied throughout in tints, tones, and shades. The one-color combination seems to assure some unity or harmony through color application (Figure 5.25). However, designers should consider that some colors lend themselves to monochromatic schemes better than others and that certain monochromatic concepts can become rather monotonous. Some variety in intensities, textures, and forms should be used to give life to the interior.

drawback

FIGURE 5.25 A monochromatic color scheme is used on this station that serves as a work station for nurses and doctors to work on patients' charts.

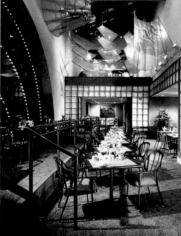

FIGURE 5.26 Panels and fan shapes in an analogous color scheme add color and elegance to the Greenhouse Restaurant through the use of lyrical form with hand-dyed nylon sheer.

ANALOGOUS SCHEMES

The analogous color scheme uses colors (often three or more) that are adjacent on the color wheel. Analogous schemes offer more variety than the monochromatic schemes, yet are harmonious (Figure 5.26). The hues are intermixed in varying proportions, values, and intensities to provide successful interiors. Many designers select one of the colors as a dominant theme and accent with the other analogous hues.

COMPLEMENTARY SCHEMES

The complementary color schemes offer an even greater variety in contrast or accent by using colors that are directly opposite on the color wheel. When these colors are in their purest form and placed next to one another, because they contrast with one another, they appear more intense than if viewed separately. These brilliant contrasts are frequently used in graphic design when a forceful visual impact is needed. In interiors, however, the hues are generally toned down, reduced in amounts, or varied in value and intensity to lessen the harsh visual statement.

TRIAD SCHEMES

Any three hues that are equidistant on the color wheel comprise a triadic color scheme. These colors might be the basic primary or the basic secondary colors. Sometimes, pure primary hues are used in interiors, perhaps in playrooms or child-care centers, to provide visual excitement and contrasts for sensory stimulation. However, for most interior schemes they are toned down or varied in value and saturation.

OTHER COLOR SCHEMES

NEUTRALS. A simple color scheme can be created by using black, white, gray, off-white, beige, tan, or brown. Interiors with neutral, or achromatic (meaning without color), schemes tend to visually expand a space and make good backgrounds for colorful furniture, artwork, and accessories. In most neutral color schemes, one or two chromatic hues are added for accent. Neutral backgrounds are advantageous in that they are flexible; it is easy to change color schemes through varying accent colors rather than changing wall and floor colors.

SPLIT AND DOUBLE COMPLEMENTARY. A split-complement scheme resembles a narrow-armed Y on the color wheel rather than exact opposites or complementary colors. Such a scheme thus provides three colors instead of the two of complementary combinations, thereby offering a wider range of color selection. The split-complement scheme can be expanded to a double complement on the color wheel, taking the shape of an X with its legs and arms adjacent to each other.

TETRAD. Four colors equidistant on the standard 12-part color wheel form a tetrad scheme. The tetrad scheme does not present itself equally and is therefore not valid in the Gerritsen color system or other systems unless the color circle is extended to include 24 hues. This scheme can also be thought of as a balanced double-complement color scheme, though the colors are not adjacent.

COLOR INTERACTION

Color never appears visually as it physically is supposed to, for color is perceived in relation to the total environment, rather than by itself. Color can even deceive the eye, for it has the ability to change or influence other colors. These visual illusions are very important to interior designers, as their desired color effect can change due to the interaction of hues on one another.

SUCCESSIVE CONTRAST OR AFTERIMAGE. In all color systems, two hues directly opposite each other are called complementary colors. When complementary hues are placed next to each other, they produce a strong contrast and vibrancy, referred to as successive contrast. For any given color, the eye requires balance from the complementary color and will generate the complement spontaneously if it is not present.

If a person looks at a particular hue, such as a red surface, for a period of time and then suddenly shifts to a white or gray surface, his or her eyes usually will visualize the color green (or cyan) instead of white or gray. The phenomenon of "seeing" the complementary color is called afterimage (Figure 5.27). A practical example of the importance of understanding the afterimage is the hospital operating room, where walls, cover sheets, and surgical gowns used to be white. When surgeons and nurses looked up from their work, after concentrating on red blood and

tissue, they would see green spots before their eyes. Today, most gowns, walls, and cover sheets are green or blue-green to act as a background to neutralize these afterimages and eye fatigue. By understanding the concept of afterimage, designers can prevent such undesirable color relationships and visual perceptions.

SIMULTANEOUS CONTRAST. Color is rarely seen in isolation, especially in interior environments, where different colors are usually viewed together. This creates an optical effect referred to as simultaneous contrast, a perceived change of a color as the result of the influence of a surrounding contrasting color.

Simultaneous contrast is an illusion of color, since one color can be made to appear as two different colors when it is placed against two different backgrounds (Figure 5.28). To make one

FIGURE 5.28 Simultaneous contrast is a perceived change of color when one color appears as two different colors when placed on different colored backgrounds.

color look different, the backgrounds or surrounding environment can be contrasted to it. Designers should be aware that large color masses influence smaller ones and that the stronger the contrast of the backgrounds, the more the center color will change in visual appearance. For example, if two areas of a neutral gray are surrounded by a larger area of white and black, respectively, the gray surrounded by the black will appear to be brighter and lighter in value than the gray surrounded by the white. This happens because the adaptation of the eye is less sensitive to low brightness and will evaluate the gray area as being very bright (Figure 5.29). The same kind of contrast will occur between most other colors, not just between black and white, if a strong contrast exists. For example, a neutral gray placed against a surrounding red background will appear to have a tinge of green (the complement of red).

FIGURE 5.29 Simultaneous contrast in value. The gray spot surrounded by white appears to be of a lower (darker) value due to the bright surroundings. When the background is black, the eye is less sensitive to the lower value of black and perceives the gray spot to be lighter or of a higher value.

The visual illusion of simultaneous contrast can be effectively applied to interior design: A colorful accent can be made to appear stronger by placing a contrasting color or object next to or around it.

REVERSED GROUNDS. The illusion of simultaneous contrast can be expanded by making three different hues appear as only two. This is done by selecting the mixture of two background colors to be the middle color. When this middle color is placed on each of the two background colors, it produces the visual illusion of the other background color (Figure 5.30).

FIGURE 5.30 Reversed grounds. The illusion of making three different hues appear as two.

SUBTRACTION OF COLOR The background color "absorbs" or "subtracts" its own hue from the center color. This process is referred to as the subtraction of color and can be used to create still another illusion involving the use of color, making two different colors look the same (Figure 5.31).

It has been demonstrated that color changes are caused by two factors, hue and light, generally by both simultaneously. Recognizing this, we can visually affect the appearance of a color by "pushing" its hue and/or lightness away from its first appearance toward opposite qualities, using contrasting backgrounds, in other words, by adding opposite qualities or by subtracting the qualities of color that are not wanted.

FIGURE 5.31 Subtraction of color is an optical effect that makes two different hues appear as one.

By experimenting with colored objects on colored backgrounds or in colored environments, we find that a ground will subtract, or absorb, its own hue and thus project the remaining hues. A blue-green sofa against a blue background will make the sofa appear "green" because the blue ground absorbs the "blue" from the "blue-green" color. The lightness or darkness of a color will also be absorbed in the same way that its hue is. Thus, light colors on light backgrounds will appear darker because the light ground subtracts the lightness of the center object's color.

PSYCHOLOGY OF COLOR

Interior designers must understand the perception and use of color and its resulting effects on human behavior. Studies have shown that color can create excitement, relaxation, calmness, or cheerfulness and can even increase productivity in working environments. The way a person interprets or feels about color can vary according to experiences, education, and cultural association with color. Color association, or symbolism, is generally based on a person's individual

innate personality or cultural background. For example, in Western cultures, black generally symbolizes death and mourning, whereas in Eastern civilizations, the symbolic color of death is white. Some common color associations in Western societies include:

Red is associated with battle, blood, fire, passion, love, and excitement. Historically it represents royalty, majesty, and triumph.

Orange symbolizes friendliness, pride, ambition, warmth, and relaxation and is stimulating to the appetite.

Yellow symbolizes sunlight and is associated with springtime, cheerfulness, and optimism. Yellow also connotes safety because it is easy to see.

Green represents nature and the feeling of calmness, friendliness, and freshness.

Blue stands for the truth, honesty, loyalty, and integrity. It also is associated with coolness, repose, and formality.

Purple or violet is the color of royalty and has religious significance.

Many studies have attempted to identify the emotional impact of color on people, but most of the studies cannot determine whether the reactions are cultural or emotional.

Color response also differs according to the context in which it is experienced. For example, red is commonly associated with love and passion, yet it can also evoke a feeling of danger.

Colors are also commonly associated with a psychological "temperature" and are divided into warm and cool categories (see Figure 5.14). Reds, oranges, and yellows produce a warm and active feeling. They also appear to advance toward the eye because they seem nearer than they actually are. A chair or sofa in an intense red fabric will generally appear larger than the same piece in a cool color, such as blue. Also, if the walls of a room are painted the same intense red, the walls will appear closer, decreasing the apparent size of the room.

The cool colors are blues, greens, and violets. Tints of these colors create a restful and soothing feeling unless they are too intense in chroma. Cool colors are also known as receding hues since they appear farther away than they actually are. The apparent size of a room will increase when these colors are applied to the walls, but furnishings using cool colors will seem smaller.

A major factor in the determination of advancing or receding colors is intensity. A very intense, bright cool color will seem to advance, but a dull warm color will recede. Whether a color psychologically advances or recedes depends on the hue (warm hues advance, cool hues recede), value (high or light values recede, low or dark values advance), and intensity (bright advances, dull recedes). Studies on the psychological effects of color have revealed that people actually feel warmer in red and orange spaces than they do in blue and green spaces, although the temperature is constant in both environments.

People attach all kinds of different meanings and emotional responses to color. We all have heard about "feeling blue" or being "tickled pink." One hypothesis is that people respond to color with their emotions rather than their intellect. We do not experience color in isolation but in relation to the total environment. Thus, color alone does not affect our behavior and emotional state, but in relation to the objects, patterns, texture, light, and so on within an environment, it does affect us.

The complex area of the effect of color on people is still being researched. Interior designers should be aware of some of the emotional effects color can create—especially in isolated environments.

COLOR PERCEPTION

Color and Space

The effect of color on space perception, (the apparent, versus the actual, size and distance of objects) and their distance from a viewer is a very complex relationship and will vary with different users.

When hues are placed closer to the viewer, they will appear more brilliant and darker than the same hues placed at a greater distance. More intense and darker colors will appear less demanding when used in very large spaces than in small spaces. Spaces with white or very light, cool colors on the walls generally appear more spacious than those with darker warmer hues.

Colors also appear more intense, or stronger in chroma, when covering large areas. For this reason caution should be used when selecting wall colors based on very small samples or color chips, for the color will often appear darker when applied to large areas.

Color and Texture

The textural quality of an object or surface will also affect the visual appearance of color. Rough-textured materials will generally appear darker because they absorb light and color rather than reflect it, as do shiny surfaces and materials. Also, textured materials, such as nubby fabrics, pile carpet, and velvets, will cast small shadows within themselves and appear darker than a smooth material of the same hue, value, and chroma.

Color Distribution

Color distribution is important in creating a feeling of unity within an interior environment. Every color plan should ideally include some light, some dark, and some median values to create the desired effect.

There are primarily two popular methods utilized for color distribution. The first specifies that the backgrounds (floors and walls) should be the most neutral colors, the large pieces of furniture should be in middle values, and the strongest chroma should be used in the accents, such as accessories or small furniture items. The second method is to put the darker values, or stronger chroma, in the backgrounds (floors and walls) and the small accent items and use more neutralized tones for the major furniture items.

The choice of one method over the other depends on personal preference and what is to be emphasized in a space—the background or the objects in it. Light values against dark values produce the strongest contrast. Then as values become closer to each other, such as a light-value chair against a light-value wall, the shape of the object will tend to merge with its background. A dark-value chair placed against a light background will produce a dramatic effect but be less pronounced in contrast than a light-value chair against a dark background.

Generally speaking, most successful spaces are planned around one dominant color and two subordinate colors that are varied in value and intensity. These colors do not have to be present in every piece of furniture, but they should be repeated at least once to create a unified feeling. Remember, however, that an even distribution of color could become boring and create a monotonous feeling.

COLOR APPLICATION IN INTERIORS

Color is a design tool. Its practical application ranges from using luminescent colors for safety in highway signs and markers to using specific colors for hunting gear, life jackets, and reflectors for bicycles in order to be seen instantly.

A number of studies have been done on using color so that it is conducive to activities designed for specific interior environments. For example, hospital interiors have been painted in specific colors because studies have shown that particular colors can affect behavior and personality. The following discussion mentions some examples of color usage in commercial spaces.

Offices

Job performance is closely associated with satisfaction in the working environment. Because the work environment has a direct relationship to employee efficiency, drab offices can be counterproductive. It is important to design office spaces that will lift spirits, not depress them. Off-white, buff, and gray surroundings are not very stimulating if additional color is not used effectively. Earth colors can be comforting in an office environment, and yellow has been found to create a cheerful atmosphere and improve work concentration.

Greens and blues are thought to be calming, but that effect depends on the value and saturation level of the hues. Too much white in a workplace can produce too much glare. More-saturated colors, such as deep green or purple, are often used as accents, especially in executive or reception areas, to give a feeling of status and dignity. Another way to express prestige and status is through the use of natural materials, such as marble and wood.

In some office environments, creating a corporate image is important. Black, gray, and white with one or more accent colors might be used, for example (Figure 5.32). However, the brightness contrast ratio needs to be proportionate. Because white reflects 80 percent of light, and black approximately 5 percent, a brightness contrast ratio of 16 to 1, there could be physical eye discomfort.

Gray can be ideal for desk tops and working surfaces since it is a neutral color and not distracting. And because it creates a good balance in contrast between black and white, gray is able to keep the eye at a comfortable and uniform brightness level.

FIGURE 5.32 Accents of startling colors provide a corporate identity for this showroom of this independently owned Herman Miller furniture dealership.

In offices where a great deal of concentration is necessary, cool hues tend to be a better choice. In general office areas, either warm or cool hues can be used, depending on users' preference. High-stress environments can use color to achieve a calming atmosphere. Low-reflective surfaces should be used in areas where workers must use their eyes a great deal for visual tasks. Also, to ease the strain of working long hours at a computer terminal, flat, absorptive colors can be effectively used.

Educational Facilities

Traditionally, a pale green has been thought to be a good color for school walls because it creates a quiet mood that enhances concentration. However, pale green can also create a very monotonous environment and should be used for specific situations, not a general scheme for all spaces.

Warm, bright color schemes are thought to be a good choice for preschools and elementary grades since children in these age groups tend to be more extroverted. Such schemes also can reduce anxiety and stimulate activity.

In secondary schools, beige, light greens, and blue-greens are often used to create a more passive effect while enhancing the ability to concentrate. Brightly colored accents can add cheerfulness and encourage participation among students. Using a different color for the front walls in classrooms where students face a specific direction not only draws attention to the front of the room but creates an effective contrast with visual aids, such as chalkboards and bulletin board materials, to allow students to relax their eyes when looking up from their desks. Visual monotony can be lessened also by adding a contrasting color to the front wall. The side and back walls then could be more neutral, such as tan or beige.

Medical Facilities

The correct application of color in medical facilities contributes to the well-being of the patient and the efficiency of the staff. In the study "Effects of Color,"[1] M.N. Bartholet hypothesizes that color could be used to motivate sick people to get well and, possibly, to improve nursing care. It was also concluded that since green is frequently associated with sickness and nausea, patient rooms should not be painted this color. After doing research into color preferences of a depressed group, Dr. Deborah T. Sharpe reported in *The Psychology of Color and Design* that the group members had a strong preference for bright, gay colors.

In general, warm neutrals, light greens, and blues are used in health-care environments. Blue walls create a calming effect and give an impression of expanded space that will help keep patients from feeling confined. This does not necessarily mean, however, that all walls should be blue. Medium tones of green or blue-green are recommended for operating rooms, as discussed under "Successive Contrast or Afterimage."

Large expanses of yellow used in hospital patient areas can give patients a sickly pallor. Pure white is seldom used for hospital walls because it is highly reflective and harsh on the eyes. Even though white has been traditionally associated with sterile environments, such as hospitals and health-care facilities, it, too, can make a patient appear sickly. Gray is not a good color to use in large applications for health-care facilities, for it appears cold and harsh. Purple or lavender can produce a yellow-green afterimage and disturb the eye's ability to focus.

Public areas of health-care facilities, such as waiting rooms and corridors, generally use more brightly saturated colors to create a cheerful atmosphere.

Restaurants

Color is a major factor in our evaluation of the freshness, ripeness, and palatability of food. Experimental studies show that people's appetites are stimulated by viewing food under normal light. When colored light is substituted, unnatural food colors are produced, such as dark-gray meat or violet potatoes. Even though people knew the food was edible, many would not eat it and indicated a feeling of nausea.

Other studies on appetite and color reveal certain trends to stimulate appetites. Red, red-orange, and orange tend to produce the most favorable appetite sensations. Blue-greens, such as aqua and turquoise, can be used successfully as backgrounds for food displays because their afterimage of red-orange enhances these colors. Green salads will appear greener on cool pink backgrounds.

Another consideration for color in restaurants is the use of color flattering to human complexions. An elegant atmosphere uses pink or warm lights to shine on warm neutrals or soft reds and oranges. However, in a fast-food establishment, bright, stimulating colors and light tend to encourage rapid eating and movement.

Retail

Color can also be an important element in the marketing and selling of merchandise. We are bombarded daily by a huge variety of colors on products and in those retail outlets that sell them. Yellows and reds are used for aggressive, attention-grabbing messages. Earth tones are often used for subtler product messages.

Brighter, more saturated hues are often used for store identification, traffic patterns, and shopping bags to assist in image making and ease of purchasing.

Industry

Color is important in industrial plants and related manufacturing areas. Using intense colors for warnings in hazardous areas or on potentially dangerous machinery and products emphasizes safety. Light colors (except stark white) can be used overall to reflect light and can be accented with bright, cheerful colors.

Eye fatigue can be lessened by reducing contrasts and afterimage effects of dark and saturated colors. Matte surfaces are also preferred over shiny, reflective ones where workers must concentrate on a specific task or product.

Color can also be used to create a sense of place in industrial areas or to identify position on an assembly line. Color coding can be more effective than words to designate specific work or storage areas and to break up a large area into smaller spaces.

COMMUNICATING COLOR DECISIONS

After understanding the theory of color and proposing a suitable scheme for a particular project, designers must communicate these decisions to others. An effective way to do this is through the preparation of sample boards.

Color Samples

Designers must first have readily available many paint chips, upholstery and drapery fabric swatches, and samples of carpets, wallcoverings, and accessory colors. With these color samples at hand, the designers can put together several trial schemes for client viewing.

Most manufacturers will supply large "memo" samples of fabric, carpet, plastic laminate, wall vinyls, and wood panels. It is sometimes a good idea to see a larger sample of patterned objects because their appearance may change drastically from the small sample.

It is important to select colors under lighting conditions that approximate those in the actual project space. As light directly affects color, a variance in light conditions where colors are chosen and where they are applied can create color discrepancies. This phenomenon, known as metamerism, means that colors look different under different lighting systems (Figure 5.33). Many designers have several types of lighting (incandescent, fluorescent, and natural) available in their offices to use when matching colors.

(a) **(b)**

FIGURE 5.33 An example of metamerism is illustrated where the same textile samples appear to be different colors when viewed under incandescent light (a) and fluorescent light (b).

Sample Boards

Samples of actual materials, along with color samples representing paint or other solid colors, are then arranged and attached to a sturdy sample board. The actual board color should be neutral and not distract from the colors of the material samples. These are presented as an overall "palette" in small projects or are detailed with a key to a floor plan in more complicated or larger projects (Figure 5.34). Careful attention must be given to making sure the sample material is not outdated or has not been discontinued by the manufacturer. Most designers maintain an updating system in their resource libraries to weed out outdated material samples. A record is made of each sample attached to the board unless the manufacturer's identification is readily apparent. This record later serves as a guide for the actual specifying and ordering of materials and furniture.

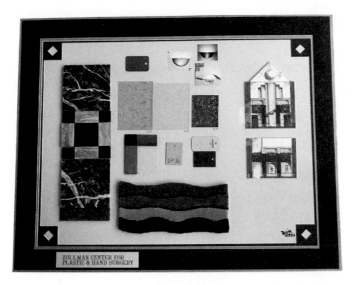

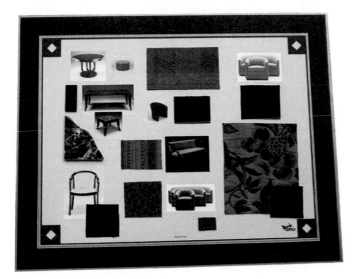

FIGURE 5.34 Sample boards are created to convey ideas of materials, color, and finishes of the interior spaces, furniture, and furnishings.

Ideally, large areas of color or texture, such as walls and floors, should be represented by large samples, and small samples or swatches should represent smaller areas or accents. However, it is not always possible to obtain samples in the desired proportions. Sometimes larger than proportional samples are needed to show accurately how a particular pattern or texture would look. In some projects, sample boards are not used for presenting color selections to a client. For example, a large fabric sample might be draped over a client's existing sofa for color selection.

Presentations

The sample boards are presented to clients to explain the designers' overall color and materials concepts. When approved, the boards and the color chart can then become a record of the final selections. In small projects, the sample board can be used directly as an aid to the installer or painter. In larger projects, additional color specification charts or floor plan keys are made to assist in getting the selected colors to the proper location.

NOTES TO THE TEXT

1. M.N. Bartholet, "Effects of Color," *Nursing Outlook* (Oct. 1968): 51.

REFERENCES FOR FURTHER READING

Albers, Josef. *Interaction of Color.* New Haven, Conn.: Yale University Press, 1963.

Birren, Faber. *Color and Human Response.* New York: Litton Educational Publishing, Inc., 1978.

————. *Light, Color and Environment.* New York: Van Nostrand Reinhold Company, Inc., 1982.

Gerritsen, Frans. *Theory and Practice of Color.* New York: Van Nostrand Reinhold, 1975.

————. *Evolution in Color.* West Chester, Pennsylvania: Schiffer Publishing Ltd., 1988.

Gerstner, Karl. *The Spirit of Colors.* Cambridge: The MIT Press, 1981.

Itten, Johannes. *The Art of Color.* New York: Reinhold Publishing Corp., 1961.

————. *The Elements of Color.* New York: Van Nostrand Reinhold Company, Inc., 1970.

Kuppers, Harald. *Color: Origin, Systems, Uses.* London: Van Nostrand Reinhold Company, Ltd., 1972.

————. *The Basic Law of Color Theory.* New York: Barron's, 1980.

Ladau, Robert F., Brent K. Smith, and Jennifer Place. *Color in Interior Design and Architecture.* New York: Van Nostrand Reinhold, 1989.

Libby, W.C. *Color and the Structural Sense.* Englewood Cliffs, N.J.: Prentice-Hall, Inc., 1974.

Mahnke, Frank H., and Rudolf H. Mahnke. *Color and Light in Man-Made Environments.* New York: Van Nostrand Reinhold Company, 1987.

Munsell, A.H. *A Color Notation.* Baltimore: Munsell Color, 1981.

Ocvirk, Otto G., et al. *Art Fundamentals Theory and Practice.* Dubuque, Iowa: William C. Brown Publishers, 1981.

Ostwald, Wilhelm. *The Color Primer.* New York: Van Nostrand Reinhold Company, Inc., 1969.

Porter, Tom. *Architectural Color.* London: The Architectural Press Ltd., 1982.

Sharpe, Deborah T. *The Psychology of Color and Design.* Chicago: Nelson-Hall Co., 1974.

Verity, Enid. *Color Observed.* New York: Van Nostrand Reinhold, 1980.

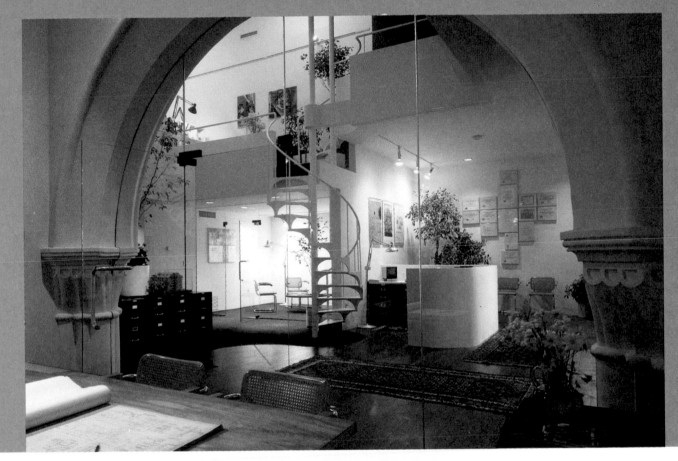

PLANNING RESIDENTIAL AND COMMERCIAL SPACES

PART TWO

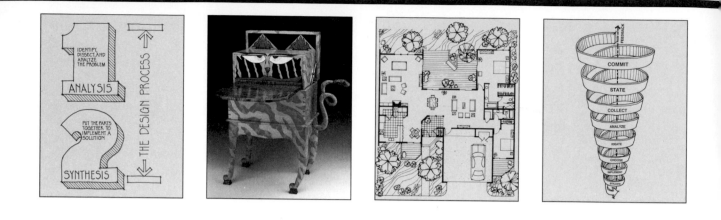

DESIGN AS A PROCESS

The process of designing interiors involves defining problems within interior environments, generating and evaluating alternatives, and implementing solutions.

Design can be viewed as a strategy of problem solving in which creative ability utilizes art and science to generate solutions to problem situations. Good interior design does not just happen; it is a process planned to yield interiors that perform well and are aesthetically pleasing—when designers, clients, consultants, and builders join in organized, creative problem solving.

Designers solve problems in many different ways. Frequently, however, they go through a pattern or sequence of steps that they have previously found effective for achieving their designs from conception to completion. The process may be a conscious or subconscious effort the designers use on almost every project.

Many studies have been written on design methodologies. These studies critically analyze, evaluate, compare, and propose alternative methods for creative problem solving to help designers understand their own style and to offer new alternatives for achieving solutions. It is generally believed that an improved design process will lead to an improved design.

Some designers use a subconscious, intuitive approach, feeling their way through the problem and arriving at a solution. This may involve mulling over and seeking solutions to a problem without a clear understanding of the problem or how to proceed in solving it. These

designers go through a series of actions that seem right until, after a period of incubation, a solution suddenly appears. They do not realize exactly how they arrived at that particular solution or the design process used to achieve it. The interior design field demands a more conscious and systematic approach to achieve solutions that not only are aesthetic but serve the needs of the users of the spaces involved. Interior design is a professional field, not a frivolous occupation for those who may dabble as designers.

By identifying and utilizing a design process, designers attempt to get to know and understand the whole problem or situation, not just their particular view or unique area of concern. A process also helps designers see themselves moving toward a result as they go from one step to the next. This allows more flexibility in design decisions by permitting trade-offs that address the scope of the user's needs. For example, an interior designer might choose carpet material manufactured for longer wear (although it is more expensive) and eliminate fabric wall coverings in favor of paint (a less expensive choice). In this way, the designer might offer a more utilitarian solution based on the client's maintenance and budgetary needs rather than a pure aesthetic choice of "pretty" materials that do not meet the stated needs.

There are several approaches to designing or creative problem solving. The key word is *creative*, which implies that designers not only solve problems or make designs but create things where they did not previously exist. To be creative is also to be conscious of one's self, actions, and place in the environment.

All design processes, simple or complicated, propose that the designer must be aware of the problem or situation before it can be tackled. Generally stated, a design process can be thought of as two phases. In the *analysis phase* the problem is identified, researched, dissected, and analyzed (Figure 6.1). From this phase, designers come up with ideas or proposals about how to proceed in solving the problem or changing the situation. The second phase in the process can be labeled the *synthesis stage*, where the parts are pulled together to form a solution that is then implemented.

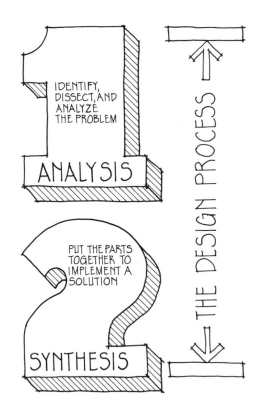

FIGURE 6.1 Design processes can be broken down into two simple phases: analysis and synthesis.

THE DESIGN PROCESS:
THE SEQUENTIAL STEPS

This two-phase design process can be further broken into eight specific steps, as seen in Figure 6.2. These steps do not necessarily have to be linear but could instead be cyclic, as illustrated in Figure 6.3, or even take the form of a spiral (Figure 6.4). An easy way to remember the steps of the process is to use the first letter of each step to make up a catchy sentence (Figure 6.5).

FIGURE 6.2 The design process is a series of sequential steps with feedback to all former steps.

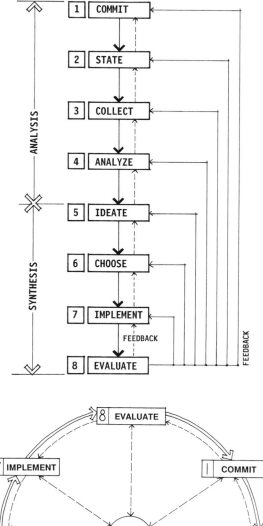

FIGURE 6.3 The design process can also be seen as cyclic steps with feedback across the axis.

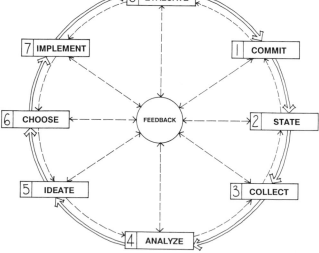

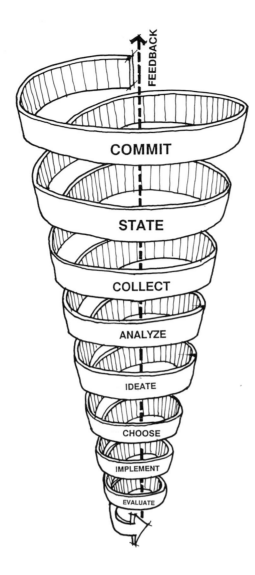

FIGURE 6.4 The design process can also be seen as a spiral or funnel that focuses into a solution. Feedback then occurs along the central axis.

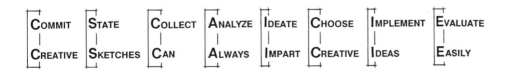

Commit	State	Collect	Analyze	Ideate	Choose	Implement	Evaluate
Creative	Sketches	Can	Always	Impart	Creative	Ideas	Easily

FIGURE 6.5 The design process can easily be remembered by taking the first letter of each step and making a sentence from all of these.

No specific design process will solve every problem or be useful to every designer. The model of design processes shown in Figure 6.6 demonstrates one approach interior designers can use to achieve solutions to problems. This model breaks down complicated problems into simple steps for project development and methods of communication.

THE DESIGN PROCESS	ANALYSIS				
	COMMIT	STATE	COLLECT DATA	ANALYZE	IDEATE
PURPOSE	*Accept the Problem *Involvement *Start *Get into the Situation	*Set Goals *Establish Objectives *Define the Issues	*Gather Facts *Research	*Clarify Goals *Break It Down *Scrutinize	*Find the Essence *Formulate Concepts *Alternate Options
DESIGNER'S TERMINOLOGY	Retainment of Services	Feasibility	Programming	Analyze	Conceptualize/ Schematic Design
PROJECT DEVELOPMENT	Proposal/Contract → Secure Contract Client Contact	Feasibility Study	Programming Scheduling Budgeting Client Approval	Analyze	Schematics Concepts Feedback
METHODS OF COMMUNICA-TION	*Telephone Contact *Referrals *Interview *Letters of Inquiry *Prior Experience *Proposals *Contracts	*Graphic *Written *Verbal	*Bar Graphs *Matrix *Flow Charts *Diagrams *Interviews *Statistics *Surveys *Written Info. *Pattern Searching *Photographic	*Diagrams *Matrix *Charts	Bubble Diagrams *Sketches *Symbols *Written Information *Conceptual Models

FIGURE 6.6 Relationships between the design process and phases of a project. Note the column at the left that defines the purpose, professional terminology, phases of a project, and the various forms of communication.

SYNTHESIS

CHOOSE AND REFINE | IMPLEMENT AND CONSTRUCT | EVALUATE

*Decide Best Way to Proceed
*State in Clear Specific Manner
*Obtain Approval

*Obtain Approval

*Detail and Specify the Specifics
*Set Performance Criteria
*Assign People/Tasks

*Put Plan into Action
*Synthesize
*Giving Form to the Idea
*Translate into Reality

*Appraising
*Talking it Over
*Grading
*Criticizing
*Future Application

Design Development | Final Design Presentation | Construction Documents | Bidding or Negotiating; Selecting Contractor | Construction | Occupancy (move-in) | Follow-up

*Formal Drawings
Orthographic Dwg's.
　Plans
　Sections
　Elevations
　Details
Perspectives
Axonometric
*Finish Models
*Verbal Information
*Renderings
*Presentation Model

*Orthographic
　Drawings
　Plans
　Elevations
　Sections
　Details
　Lighting plans
　Finish schedules
　Mechanical plans
　Structural plans
　Electrical plans
*Specifications
*Installation Plans
Furniture & Equipment Spec's.

*Verbal Info.
*Written Info.
*Cost Estimates

*Written Info.
Punch lists
Field orders
Change orders
Field observations
Payment requests
Purchase orders
*Schedules
*Revisions
*Drawings
*Verbal Info.

*Interviews
*Surveys
*Observations

Commit (Accept the Problem)

Recognizing a design problem and committing to it is the first step a designer undertakes in the design process (Figure 6.7). To get motivated, the designer must first accept the problem as a personal assignment and jump in with heart, soul, and both feet. Partial involvement leads to partial solutions.

Some students and designers often procrastinate when given an assignment or problem to solve. One of the reasons is that they have not really dedicated themselves to the situation. Time management problems, such as outside activities, personal time commitments, displeasure with the assignment, or a multitude of other factors might be preventing them from getting started. The process of designing also involves a commitment to deadlines or due dates, a commitment that can be as crucial as the act of designing. The designer could be fired, or the student penalized, if the process does not move in a timely manner.

COMMIT · STATE · COLLECT · ANALYZE · IDEATE · CHOOSE · IMPLEMENT · EVALUATE

FIGURE 6.7 Techniques for commiting to a problem can be listed as prioritization, reward concept, or personal values.

TECHNIQUES FOR COMMITTING TO THE PROBLEM. Methods for designers to apply in taking on a problem might be listed as prioritization, reward concept, or personal value analogies. The first of these, prioritization, concerns time management and requires listing priorities and determining involvement with the project in terms of personal time available. The time estimated for solving the problem is compared with the actual time available. Adjustments must be made as necessary so that the designer can devote more of himself or herself and more time in order to solve the problem while meeting deadlines.

In another method, called the reward concept, basically the designer asks, "What's in it for me? What do I expect to gain or how will I be rewarded from involvement with this problem?" The designer then lists these rewards as tangible assets, such as money, recognition, or skills to be gained.

As its name suggests, personal value methods can be thought of as ways to make the problem more personally valuable. This value may not have a monetary basis but can be rich in personal satisfaction, such as knowing a problem has been solved in a unique and creative way. For the professional designer, the personal value might be the signed contract that indicates the client's confidence in the designer and commitment to hiring him or her.

State (Define the Problem)

As stated previously, a problem or project must be identified or stated before a designer can effectively deal with it (Figure 6.8). Good designers try to approach new problems with a fresh outlook; that is, they do not let preconceptions of previous problem solutions cloud the new solution. Creative designers must constantly remind themselves that each problem is unique and may have a unique solution. How clearly the problem is defined in the early stages can have a tremendous impact on how it is solved.

This defining step generally involves establishing the problem requirements, constraints, limitations, and assumptions with which the designer is operating. If a program is to be formally written, it will generally state the goals and objectives to be resolved (discussed in more detail in Chapter 7). This would then be considered the problem statement. If the program is not prewritten, the designer defines the key issues of the problem and continually asks, "What really is the problem? What am I trying to resolve? Does my solution truly resolve the situation?"

FIGURE 6.8 Techniques for problem statement can be through check lists, perception lists, visual diagrams, or a printed program.

TECHNIQUES TO PERCEIVE, DEFINE, AND STATE THE PROBLEM

CHECKLIST. The designer devises a checklist of precisely what needs to be resolved to solve the problem, listing all aspects (physical, social, psychological and economic) that can be considered in order to better understand the overall problem.

PERCEPTION LISTS. A perception list names everyone with an opinion about the problem. The designer tries to perceive the situation as these people might see it, perhaps by asking questions of the client or other "experts," such as architects, designers, or consultants. Their points of view could offer different insights into the problem.

VISUAL DIAGRAMS. If a program has been supplied, it might list the goals, objectives, and problem statement in diagrammatic form. This generally helps the designer to visualize the information.

If no program is supplied, a simple chart or sketch should visually list all the components of the problem, which can then be rated according to their importance and relationships to one another.

Collect (Gather the Facts)

Once the designer has a clear understanding and definition of the problem, pertinent information should be gathered (Figure 6.9). This stage is generally referred to as "programming" and involves collecting data that are categorized and presented as a published program. (This step involves a great deal of research and is explained in more detail in Chapter 7.) However, additional information may be needed if not fully supplied in the program. For example, the program may have stated that seating is required in an auditorium-type setting. At this time, the designer may have to gather additional information on various types and sizes of appropriate seating.

TECHNIQUES FOR COLLECTING INFORMATION. If no program has been furnished with background information, the designer can use research, interviews, and surveys to gather that information. See Chapter 7 for specific examples.

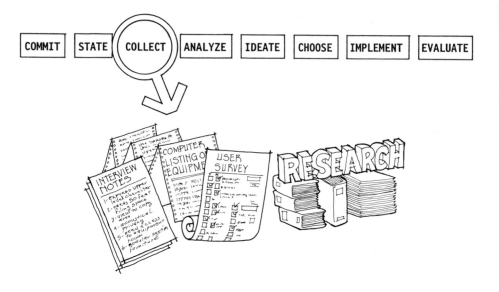

FIGURE 6.9 Techniques for collecting information can be achieved through interviews, user surveys, and research of published accounts.

Analyze

A designer must now look over all the gathered information about the problem and organize it into related categories (Figure 6.10). This is particularly helpful when an abundance of data and facts prevents a designer from drawing any direct conclusions or easily seeing the relationships within the information. The designer sifts through the data and notes those items that are primary to effecting the final solutions and may have a direct bearing on the problem. For example, if the givens for an examination room in a doctor's new medical offices include natural daylight and a low-maintenance floor, the lighting data have greater impact on the final design solution since the room must have a window or a skylight. A number of alternative coverings can be suggested for the flooring, which is a secondary concern.

TECHNIQUES FOR ANALYSIS. Among the many ways to break a complex problem or a mass of data into smaller, more manageable parts is using charts or matrices (see Chapter 7

FIGURE 6.10 Techniques for analyzing information can be through the use of conceptual sketches, matrices, pattern searching, and categorization.

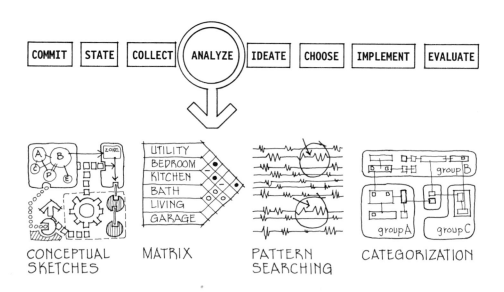

for more details). As the individual parts are scrutinized, overall relationships can often be found that lead in the direction of solving the problem or give meaning to all the data collected.

At this time, the designer begins to generate simple visual sketches of the plan, by developing it from conceptual diagrams to final design plans. This design sequence, as illustrated in Figure 6.11, continues through to the implementation step.

FIGURE 6.11 Typical design sequence for visually developing a floor plan from the conceptual stage to a final plan.

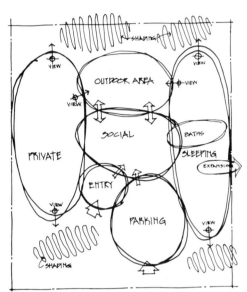

CONCEPTUAL DIAGRAM

- OFTEN CALLED "BUBBLE DIAGRAM"
- INDICATES FUNCTIONAL AND SPATIAL RELATIONSHIPS
- IDENTIFIES MAJOR SPACES, AREAS, AND OTHER
 IMPORTANT FEATURES
- BUBBLE SIZE IS NOT DRAWN TO SCALE AT THIS TIME

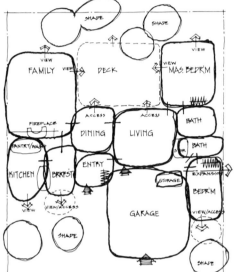

SCHEMATIC PLAN

- INDICATES SPATIAL AND CIRCULATION RELATIONSHIPS
- SCALE AND SHAPE OF SPACES BECOME EVIDENT
- IMPORTANT FEATURES ARE DELINEATED
- SEVERAL SCHEMES ARE QUICKLY SKETCHED FOR STUDY

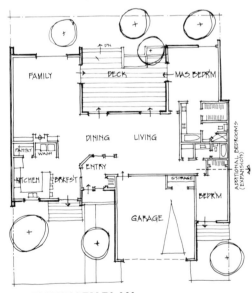

PRELIMINARY PLAN

- SCALED PROPORTIONS OF SPACES AND ELEMENTS
- ADDITION OF INTERNAL ARCHITECTURAL DETAILS
- WALLS, WINDOWS, AND BUILT-IN ITEMS ARE SHOWN
- FURNITURE MIGHT BE INDICATED IN SOME AREAS

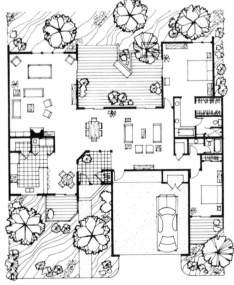

FINAL PLAN

- FULLY SCALED DRAWING DEPICTING SPACE, OBJECTS, AND USAGE
- DETAILS SUCH AS DOORS, WINDOWS, COUNTERS, ETC., ARE SHOWN
- FURNITURE OFTEN SHOWN TO INDICATE HOW A SPACE IS USED
- TEXTURES OFTEN DRAWN TO SHOW SURFACE OF MATERIALS

CONCEPTUAL DIAGRAMS. Conceptual diagrams are the beginnings of visualizing functional relationships for the problem. These abstract sketches help to reinforce a design concept. Ideas are sketched into abstract forms that represent program activities and physical circulation patterns (see Figure 6.12).

FIGURE 6.12 Conceptual diagram of a proposed medical suite for three physicians. This sketch shows some possible activities, circulation, and relationships required by the users.

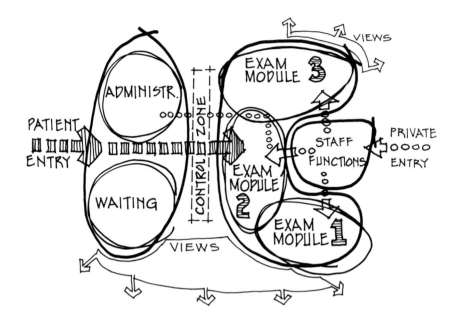

These conceptual sketches are often called bubble diagrams and identify major spaces or areas. The bubbles are not drawn to scale, since at this stage these reflect general relationships, as opposed to actual sizes or shapes (see Figure 6.13).

FIGURE 6.13 Bubble diagrams indicate spaces, relationships, circulation, and other important features. The areas can also be further separated into individual zones.

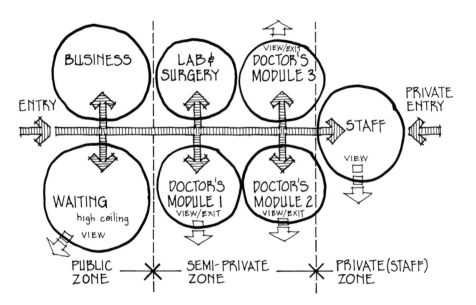

Ideate

The ideation step is perhaps the most exciting and creative segment of the design process. Ideation, as a concept used in the book *Universal Traveler*,[1] means generating as many ideas or alternatives for achieving the solutions to project goals as possible. It is seeking different creative ways of solving the problem situation and establishing the overall design concept. However, ideas should be generated only after gaining thorough understanding of the problem, as outlined in the earlier steps.

The process of ideation involves two distinct phases: a drawing phase, referred to as schematics, and a concept statement, expressed in a written or verbal form.

SCHEMATICS

The designer's imagination is stretched to find as many creative alternatives as possible that can be generated to solve the problem's givens. These alternatives are then sketched or recorded to build a series of different ways the problem can be resolved. Creative designers force themselves to look at the problem from many different viewpoints, attempting to resolve these into one strong solution. This phase involves the drawing of diagrams, plans, and sketches that express spatial and functional requirements, as well as the image, feeling, or character of the environment (Figure 6.14).

FIGURE 6.14 In the conceptual stages of a project, designers also execute exploratory sketches that express imagery and character in addition to functional requirements.

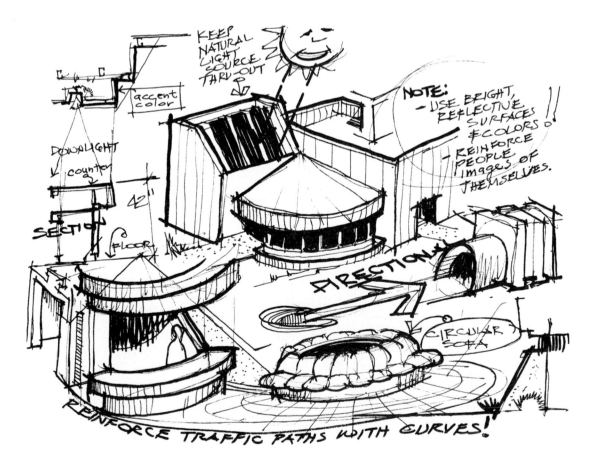

Schematic sketches are further refinements of the bubble diagrams. They are generally drawn in proportion to the size or square footage of each area and begin to suggest boundaries, circulation systems, and articulations. Important requirements, such as views and storage, are delineated. See Figures 6.15 and 6.16 for examples.

FIGURE 6.15 Schematic sketches can be regularized in order to begin refining spatial relationships and approximate sizes.

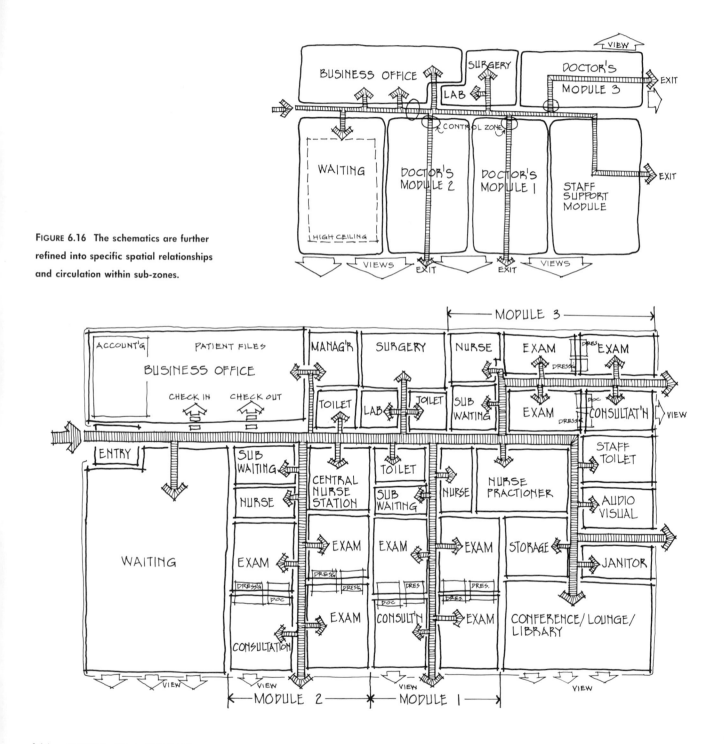

FIGURE 6.16 The schematics are further refined into specific spatial relationships and circulation within sub-zones.

CONCEPT STATEMENT

At this same time as visually exploring the alternatives, the designer begins to develop a concept of how to achieve the problem objectives. These ideas are stated or written as the concept statement, which establishes the underlying principles that the resulting physical designs will address. This statement should be written in simple, declarative sentences that concisely describe the principal ideas, both functional and aesthetic, behind the proposed design. The concept statement should discuss the methods that bring about results; it does not state what those results will be.

The design concept should relate to the needs and special requirements of the situation. For example, a concept statement might say, "The multipurpose room will be designed to be flexible in use by providing . . . " or "Physically impaired people require spaces that allow them"

TECHNIQUES FOR IDEATION

The complexities and magnitude of some interior environments, particularly large-scale interiors, such as office buildings, often demand more design expertise, time, and idea generation than one designer can offer. In these cases designers may form design teams to tackle a project. Decisions are made to ensure that all team members and aspects of the problem are represented. Any conflicting views or opinions must be worked through before proceeding to the next step of implementing.

In his book, *Methods of Architectural Programming*, Henry Sanoff[2] describes the following five group decision-making strategies that are helpful in generating ideas (Figure 6.17).

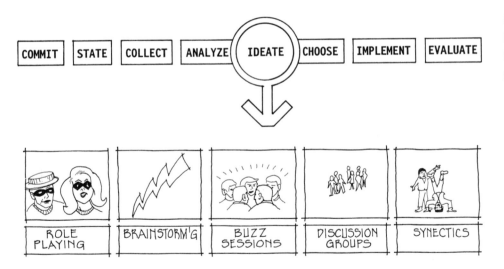

FIGURE 6.17 Techniques for ideating can be done through role playing, brainstorming, buzz sessions, discussion groups, and synectics.

ROLE-PLAYING. In role-playing, a group participation to generate ideas, designers simulate client or user situations in an unrehearsed scenario. One or more of the team members assume a designated role and give input from the point of view of that client (or user). The intent is to stimulate the designers to look into new attitudes and biases about the project that will ultimately affect the use of the spaces. The designers try to understand how others would perceive the problems at hand.

BRAINSTORMING. Brainstorming is an idea-generating process whereby a designer or group of designers express their thoughts in a freewheeling, informal way to produce as many ideas and alternatives as possible. Spontaneity and innovation, as well as fantasizing about rela-

tionships of the problem, are encouraged. It is desirable for sessions to be rapid-fire to stimulate group enthusiasm and release ideas that individuals may be holding back or subconsciously censoring. This censorship might inhibit reaching a unique solution to the problem.

BUZZ SESSIONS. A fast-moving group activity, buzz sessions discuss a specific topic and propose alternatives for design strategies. The goal is to establish a body of people to critically analyze ideas related to the specific problem within a designated time limit. These groups promote understanding of all the participants' viewpoints but seek to arrive at a consensus on specific points.

DISCUSSION GROUPS. In small discussion groups, participants share knowledge, develop new attitudes, and attempt to arrive at well-thought-out decisions. Unlike quick buzz sessions, these sessions are held over a prolonged time period and are closely coordinated by a group leader who guides the participants through to a decision-making process. This technique is sometimes used by a design team in solving a complicated client problem with many variables.

SYNECTICS. Synectics involves a group activity that attempts to make the unfamiliar look familiar and the familiar appear unfamiliar. This fresh way of looking at a problem increases the probability of a creative and unique solution. Symbolic and fantasy analogies are utilized to delve into the project to allow team members to interact creatively and achieve a novel solution not possible by using other methods.

The storage desk in Figure 6.18 is an example of a unique design stemming from synectics. The designer could have been asking, "How is a desk like a cat?" The answer would be, "They

FIGURE 6.18 Kattmose II. A study in form, fantasy, and function, by Michael Creed. This storage and desk cabinet demonstrates a novel approach to the design of a functional furniture piece.

both have four feet and a tail." "What happens if you pull the tail?" The answer: "The eyes and mouth open, revealing the tongue." The desk shown here opens by cranking the tail, revealing storage and a writing surface (the tongue).

Choose (Select the Best Option)

Some designers find the selection stage of the design process difficult (Figure 6.19). However, if the established goals, objectives, and problem-solving methods have been defined, this step can be fairly clear-cut. The designer chooses the most appropriate or "best" option by going back to see how the selected concept fits the client's budget, needs, objectives, and desires. If the selected option satisfies the criteria, has a creative approach, and produces a functional and exciting solution to the problem, it is the right choice. If it does not, the designer should reevaluate the alternatives and select another option. After all the schematic drawing options have been explored and one has been selected, the designer begins preliminary drawings.

FIGURE 6.19 Techniques for selecting the best solution can be done by personal judgement, comparison, or by soliciting a consultant.

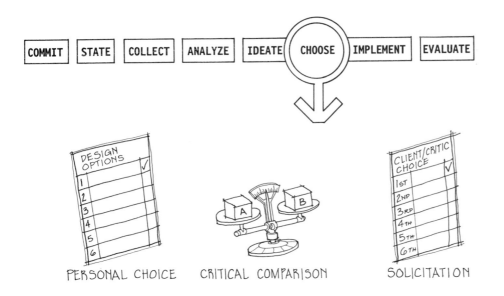

PRELIMINARY DRAWINGS

The schematics are refined in scale and proportion to represent the actual square footages of the spaces. Details begin to evolve, showing walls, circulation routes (corridors), views (windows), and the usage of the spaces. Sometimes at this stage, furniture, equipment, and built-ins (such as cabinets) are indicated (Figure 6.20). The drawing is still fairly sketchy and may have been drawn freehand. The designer is still refining details and does not want to laboriously make very accurate drawings at this time. These preliminaries are generally presented to the client for feedback and then revised or further developed into the next phase of design drawings. At the same time the preliminary plan is being developed, designers are also preparing preliminaries or building sections and elevations to indicate vertical spaces (Figure 6.21). (See Chapter 18 for further discussion of communicating in design.)

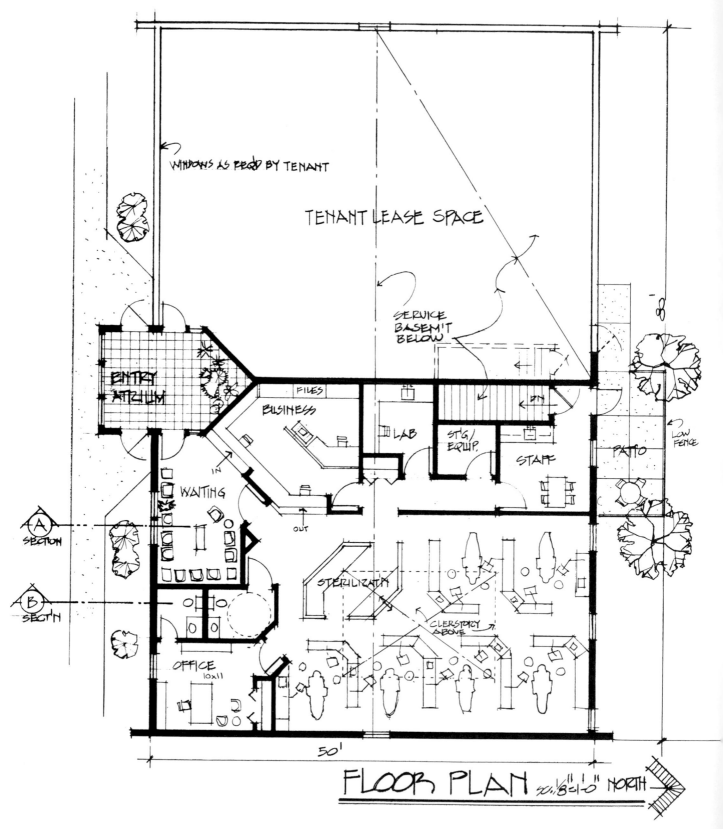

FLOOR PLAN SCA. 1/8"=1'-0" NORTH

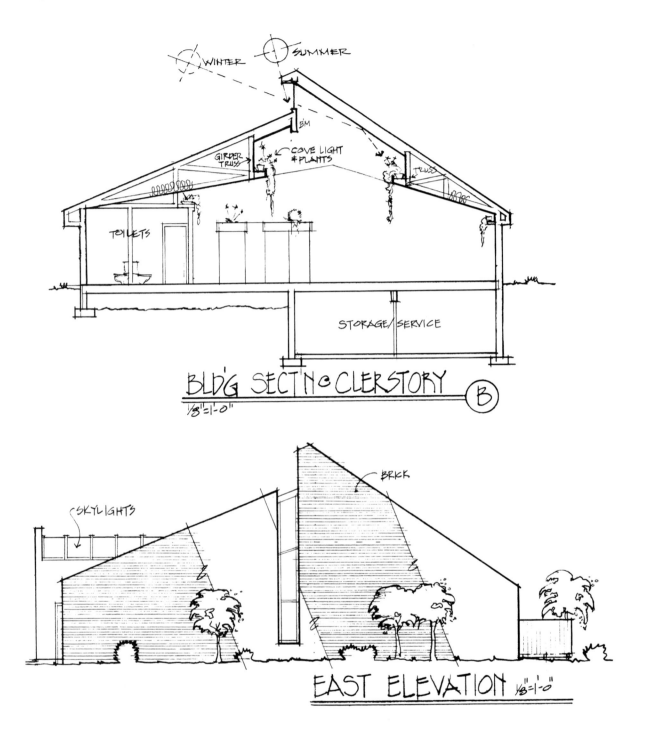

WINTER SUMMER

BM

GIRDER TRUSS

COVE LIGHT & PLANTS

TRUSS

TOILETS

STORAGE/SERVICE

BLD'G SECT'N @ CLERSTORY B
1/8"=1'-0"

SKYLIGHTS

BRICK

EAST ELEVATION 1/8"=1'-0"

TECHNIQUES FOR DECISION MAKING

PERSONAL JUDGMENT. Most designers make decisions based on personal judgment. They carefully compare each choice against the others and decide which option satisfies the problem objectives. This is a decision-making process in which the designer relies on his or her past experiences and confidence in making proper choices.

COMPARATIVE ANALYSIS. Although the personal judgment method is effective, decision making can be improved by carefully itemizing, ranking, and weighing the options in a hierarchical manner to determine why one solution is better than the other. Criteria are carefully listed for each idea and weighed against other options. Judgment can then be made, based upon a total point or weighing system of pros and cons, rather than by "feeling" which decisions might be best, based on a personal bias.

CONSULTANT OR USER DECISION. Another method is to let the clients, consultants, or users make the decisions. Often the people who are going to utilize the solution are asked for their input or decision; this is called user selection. However, users' decisions might be biased because of the way they perceive the solution, so the designer should always structure the alternatives for the users and suggest implications each choice might present.

Implement (Take Action)

Implementation refers to executing or taking action on the selected idea and giving it physical form (Figure 6.22). This step communicates the idea through final drawings, plans, renderings, and other forms of presentation to the client. The design process does not stop with a creative idea or solution but continues in this action stage to bring the ideas into reality. To the student in the classroom, this step might involve executing final presentation drawings, renderings, models, and so forth for presentation and evaluation by the instructor(s). To a professional designer, this step involves the strategy of getting final approval from the client.

TECHNIQUES FOR IMPLEMENTATION

FINAL DESIGN DRAWINGS. At this time the preliminary drawings are further developed into final design drawings, including plans, sections, elevations, and other details. (See Chapter 18 for examples of more detailed drawing types.) The final plan is drawn to scale and depicts all spaces and objects, including architectural details, such as doors, windows, and built-in cabinetry.

Once these drawings are approved, construction drawings must be made, a contractor must be hired, and workers have to be supervised before the client can eventually move in.

TIME SCHEDULES. To move ahead effectively on the chosen idea, it is best to have a clear view of the major tasks, activities, people, materials, and time involved to execute the idea. The designer can simply list all these or can develop time schedules, calendars, graphs, and other charts to assist in methodically moving ahead on the project.

CONSTRUCTION DRAWINGS. Construction drawings, sometimes called working drawings, are prepared to detail all the particulars of a project. They are drafted to show what is to be constructed (or supplied), where it is to be placed, and how it relates to other parts of the project. These drawings include scaled plans, elevations, sections, details, notes, schedules, and other directives that will guide contractors who do the work. (See Chapter 18 for detailed descriptions and examples of these drawings.) Careful coordination is needed between the structural, architectural, mechanical, electrical, finish, and furniture drawings to ensure that the project is completed correctly and in a coordinated effort by the workers.

In some cases, "as-built" drawings must first be prepared if none are available for an existing facility. The designer measures all the physical features of the built environment and prepares scaled drawings to show what exists (Figure 6.23).

SPECIFICATIONS. Specifications are written instructions to the general contractor and vendors for the materials, performance standards, and method of construction or installation

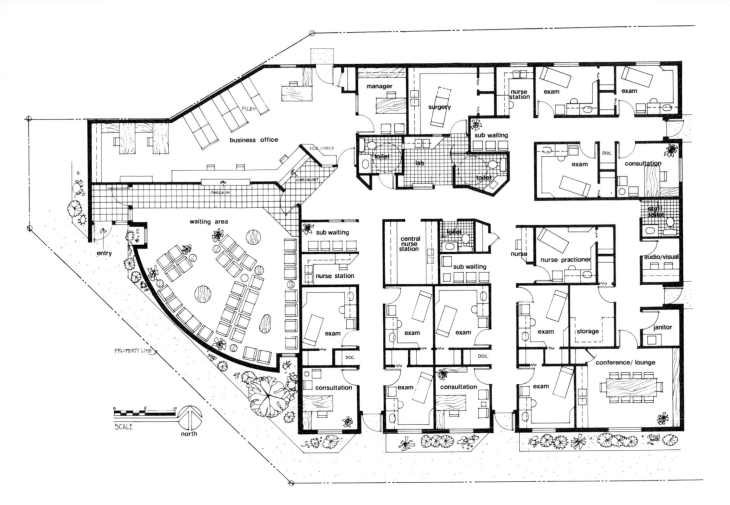

FIGURE 6.22 Final presentation floor plan of the medical suite explored in Figures 6.12 to 6.16. This plan is drawn accurately to scale and detailed to the specifics within each space.

to be utilized. Specifications are written in technical terms and usually include what is to be done, how it is to be done, who is to do it, and the standards of materials and performance to be met. In the design field, these specifications, the accompanying construction drawings, and various legal contracts direct the various parties in implementing the solution into physical reality.

CONTRACT ADMINISTRATION. The designer or a representative often has to oversee the implementation of ideas from conception to physical reality. In interiors, this means overseeing the project to be constructed or installed. The designer assists the client in the administration of the contract to implement the designer's solution. These stages of implementation are usually broken down into the following steps:

1. *Contractor Selection.* Contractors are selected to execute the work. In some instances, just one contractor is negotiated with, but usually bids are received from several contractors interested in doing the project. The bids are based on the designer's drawings and specifications. The designer and the owner select a contractor based on the estimated cost and the reputation of the builder.

2. *Supervision.* During the construction process, the designer checks on a regular basis for quality, to be sure the budget is being met, to make certain the time schedule is being followed, and to check subcontractors' shop drawings against the designer's drawings for conformity.

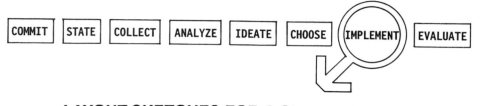

LAYOUT SKETCHES FOR A SMALL SET OF CONSTRUCTION DRAWINGS

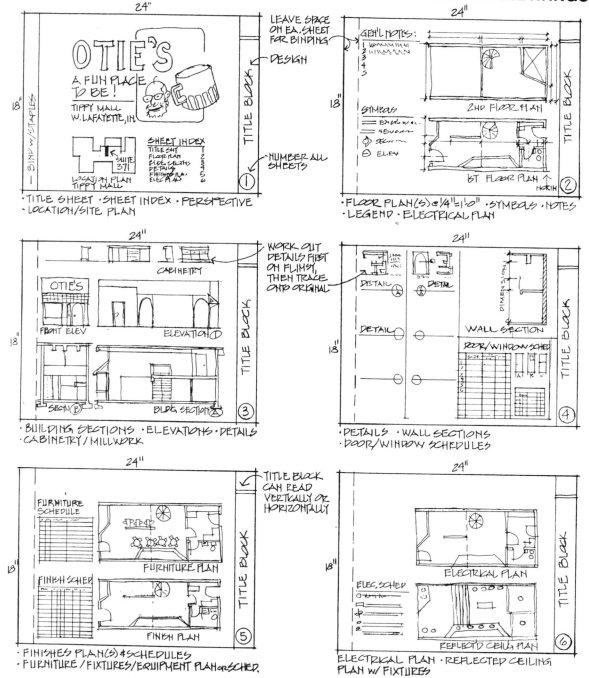

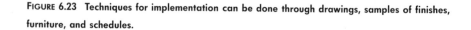

FIGURE 6.23 Techniques for implementation can be done through drawings, samples of finishes, furniture, and schedules.

3. *Move-in or Occupancy.* The designer assists the owner and the contractor in coordinating the move-in and the installation of furniture, furnishings, and equipment. (See Chapter 19 for further explanation.)

4. *Punch List.* The designer develops a list of substandard or incomplete items that must be corrected by the contractor. Although it is preferable to do this step before move-in, it often occurs during or after this process, at the time when the owner is ready to occupy the project.

Evaluate (Critically Review)

The evaluation stage (Figure 6.24) of the design process reviews and makes critical assessment of what has been achieved to see if it does indeed solve the original problem situation. The evaluation stage is also a review to see what was learned or gained from the experience and what the effects or results of the design activity were. This stage is also part of the self-improvement of the designer and the design process used and is intended to achieve closure on a problem.

It is important for the interior designer to work continually to understand and improve his or her own method of design process for arriving at solutions. This can be difficult, but it is imperative for all designers to look back to see how they got to the end of the problem and to attempt to assign a value to the results achieved. They can then refine their methods for application to future situations.

FIGURE 6.24 Techniques for evaluating a design solution can be done through a variety of methodology.

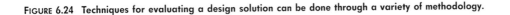

TECHNIQUES FOR EVALUATION

There are many forms of evaluation that measure quality and quantity of design decisions. They all attempt to measure the effectiveness of the design solution and the designer's process of designing; evaluation serves as a learning tool for future problem solving.

SELF-ANALYSIS. Designers often measure their achievements in terms compared to the initial objectives. To accomplish this, they evaluate themselves and their actions honestly and critically.

SOLICITED OPINIONS. Another method involves evaluation by an outside, independent source. These outside judgments can assist the designer in seeing the solution to the problem from another viewpoint. This can provide valuable insight for the designer to measure the effectiveness of his or her own proposals and the way others perceive those proposals. However, these opinions must be scrutinized to determine whether they are an accurate assessment of the situation and are indeed aimed at helping the designer improve the design process.

STUDIO CRITICISM. In the classroom, a common form of evaluation is the studio criticism, or the "critique". This is an evaluation of the project and the student's performance. These critiques can be done periodically or as a final at the end of the project. In turn, they might be done individually by the instructor or in conjunction with a peer review "jury" where the student presents his or her designs before the instructor, class, and invited critics (often professional designers).

Critique sessions provide an excellent form of critical evaluations and are most effective when the communication is two-sided—that is, questions and explanations flowing freely between the student, instructor, and others who might be participating. Students should be aware that instructors are providing "constructive" criticism, not "destructive" criticism. Design is often a trial-and-error process where learning occurs from making mistakes. A student should realize this and build from the critique, creating better design results and methods.

POSTOCCUPANCY. Many interior designers use an evaluation technique termed postoccupancy evaluation, which is a formal process to determine whether the designer's solutions did indeed solve the client's problem. This analysis seeks to find out how well the interior environment satisfies the performance, behavior, and psychological needs of the users. Does the final design satisfy the original program requirements? By going back to a project later and carefully examining everything, the designer can learn what worked and what did not. The designer can then improve ideas and problem-solving processes on the next project. These postoccupancy evaluations are often done as a walk-through observation and/or through a questionnaire answered by the users of the facilities.

FEEDBACK

Feedback is the term many designers use for the systematic evaluation at each step of the design process, using former, or previous, steps. It includes looking back, after the process is completed, to the very first step to compare what resulted with what was in place when the project began. It is characteristic of the design process that the entire operation is cyclic—it keeps repeating itself, looping back to former stages, as illustrated in Figures 6.2 to 6.4. If feedback is used after each step and the information gained is fed to the former step, the new inputs might produce some new results. In other words, if the output of each step is fed to the input of the former step, the information gained can often change the current step's results.

NOTES TO THE TEXT

1. Don Koberg and Jim Bagnall, *The Revised All New Universal Traveler.* Los Altos, Calif.: William Kaufmann, Inc., 1981.
2. Henry Sanoff, *Methods of Architectural Programming.* Stroudsburg, Pa.: Dowden, Hutchinson & Ross, Inc., 1977, pp. 14–16.

REFERENCES FOR FURTHER READING

Alger, Jean, and Carl V. Hays. *Creative Synthesis in Design.* Englewood Cliffs, N.J.: Prentice-Hall, 1964.

Arnheim, Rudolf. *Art and Visual Perception.* Berkeley, Calif.: University of California Press, 1965.

Diekman, Norman, and John Pile. *Drawing Interior Architecture.* New York: Whitney Library of Design, 1983.

Hanks, Kurt, and Larry Belliston. *Draw! A Visual Approach to Thinking, Learning and Communicating.* Los Altos, Calif.: William Kaufmann, Inc., 1977.

————. *Rapid Viz.* Los Altos, Calif.; William Kaufmann, Inc., 1980.

Huchingson, Dale. *New Horizons for Human Factors in Design.* New York: McGraw-Hill, 1981.

Hurlburt, Allen. *The Design Concept.* Cincinnati: Watson-Guptill, 1981.

Jones, J. Christopher. *Design Methods.* New York: Pergamon Press, 1970.

Koberg, Don, and Jim Bagnall. *The Revised All New Universal Traveler.* Los Altos, Calif.: William Kaufmann, Inc., 1981.

Preiser, Wolfgang. *Post-Occupancy Evaluation.* New York: Van Nostrand Reinhold, 1988.

Sanoff, Henry. *Methods of Architectural Programming.* Stroudsburg, Pa.: Dowden, Hutchinson & Ross, Inc., 1977.

Tate, Allen. *The Making of Interiors.* New York: Harper and Row, 1987.

Zeisel, John. *Inquiry by Design: Tools for Environment-Behavior Research.* New York: Cambridge University Press, 1986.

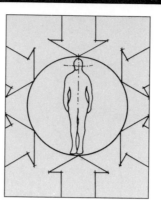

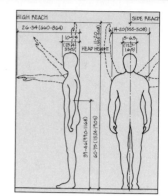

C H A P T E R 7

PROGRAMMING INTERIOR SPACES

To design requires talent,
but to program requires genius.[1]
Le CORBUSIER

Before a designer can actually design a space for someone, he or she must anticipate how that person will function in the space. Knowing the user's present and future needs, activities, conditions, equipment, special allocations, and other particulars makes the organization and design of space an easier task. Background information must not only be organized and planned but gathered in a systematic manner. This methodology constitutes planning or establishing a plan of action. Often referred to as programming in the design profession, it is the "collect" step (Figure 7.1) in the design process, as discussed in Chapter 6.

Many designers and other professionals use the terms *programming* and *program* in several different ways. In the design field, a program generally takes the form of a written or graphic document in which background information, analysis of facts, evaluation, goals, and conclusions relevant to the problem situation are documented and presented in a clear, organized manner, facilitating communication between user and designer. The program establishes the basic goals and objectives for the designer during the design phase.

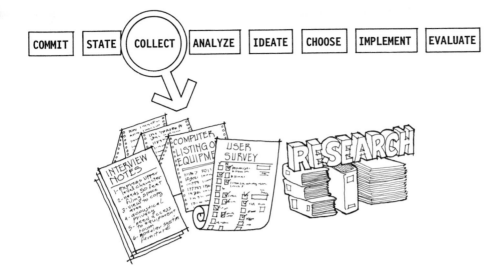

FIGURE 7.1 Programming in the design profession is the "collect" step in the overall design process. The collection of background information and facts are then organized in a systematic manner.

Programming is not a totally separate profession but rather is actually part of the overall process for designing and building environments, establishing the initial steps in designing for the built environment (Figure 7.2). Programming can be thought of as the predecessor to examining or analyzing the problem, whereas designing can be thought of as solving or synthesizing the problem from the program specifics (Figure 7.3). To analyze means to dissect the parts of a problem to discover the interrelationships; to synthesize means to pull all the parts into an integral and meaningful whole to develop a design solution. As William Pena summarized it, "Programming is problem seeking, and design is problem solving."[2]

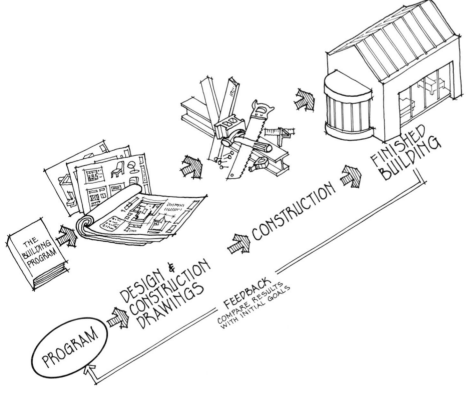

FIGURE 7.2 Programming is the initial step in planning, designing, and constructing interiors and architecture.

The specific content and format of a program may change from project to project, depending on the scope and complexity of the problem situation. For example, the same program cannot always be used for every restaurant. A program might need to be developed for a physical change in a new or an existing building or for a nonphysical change, such as improving operational efficiency within an established organization.

FIGURE 7.3 Programming is an integral part of the overall design process, but can be seen as a separate phase preceeding the design phase.

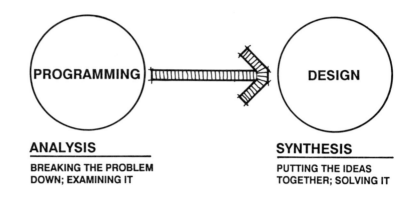

ANALYSIS

BREAKING THE PROBLEM DOWN; EXAMINING IT

SYNTHESIS

PUTTING THE IDEAS TOGETHER; SOLVING IT

The program serves as a tool for recording client and user needs, expectations, and decisions. It establishes specifics to be met in the design stages before the actual construction begins. The designer continually looks back to the program to ensure that the designs will satisfy all those stated specifics.

Programs are recognized today as an essential part of the planning process for most design situations in architecture and interior design. Interior designers are being required to take more responsibility for detailed programming and planning before the design and sketching process begins. Designers are often faced with the task of designing environments that accommodate functions and activities that they know little about; thus a program becomes a key to the design phase. More is also being demanded of interior environments in terms of performance and operations. Merely gaining a "pleasing" environment is no longer sufficient justification for a client to incur design, construction, and maintenance costs. The programming phase is crucial to the interior designer as the initial step in ensuring that the environment "performs" as it is designed to, serving the client's needs. Programming is done by a design professional, such as an interior designer or architect. This professional is referred to as the programmer in this chapter.

When a large amount of information must be programmed, a model, or paradigm, is an effective method for organizing, analyzing, and presenting this information. Whether for the most complex office environment or a small house, a programming paradigm generally consists of six basic steps: establishing goals, gathering and analyzing facts, specifying needs, evaluating the program, organizing, and presenting conclusions relevant to the problem situation (Figure 7.4). This paradigm process is simple enough to be generally repeatable and applied to different types of facilities, yet comprehensive enough to cover the wide range of factors and details that influence the design of complex buildings or interior environments.

FIGURE 7.4 Programming has six distinct steps that are sequential.

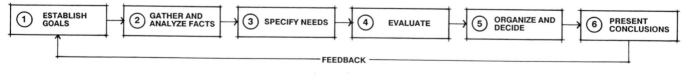

VALUES IN PROGRAMMING

It is important to understand that the programmer interjects into the program certain values and attitudes that in turn will influence the problem solution.

The programmer must seek and carefully state the values of the user, client, and society and of their interrelationships. In turn, the resulting program statements and performance criteria should clearly direct the designer toward creating a viable environment that not only responds to the client/user needs but establishes the resulting environment as a space promoting the healthy existence of those people and their functions in the overall society. Interior designers should be aware of environmental issues and be responsible for protecting the health, safety, and welfare of the public as well as for preserving global life.

Throughout the programming process (and into the design phase), to establish the "quality" toward which the program will direct the resulting designs, a conscious effort must be made to understand the meanings or values of the information gathered on user needs, goals, space requirements, and so forth. Recognizing and stating values will ensure a smooth transition from the program goals to the resulting solution.

THE PROGRAMMING PROCESS— THE SEQUENTIAL STEPS

Establish the Goals
(Figure 7.5)

Goals are the desired result of what is to be achieved. They could also be termed the mission, aspirations, or purpose of the project. The goals of a project state what the client wants to accomplish and why; they involve trying to ascertain the client's values and needs, including physical, social, economic, and psychological.

Design is a difficult process because it often attempts to satisfy several goals simultaneously. Goals for a particular problem situation may include creating a space that is safe and healthy, enables users to perform their functions without causing discomfort, and is aesthetically pleasing, all at the same time. However, these goals are not equal and must be tested for usefulness, integrity, and relevance to the problem situation. The programmer or designer should set priorities, specifying those goals believed to be most crucial.

Understanding the relationship between goals and objectives will help determine their relevance to the overall program. A goal is a broad generalization; an objective is a more detailed description of how to achieve the goal. Goals indicate what the client wants to achieve; objectives indicate how to achieve the goals and to what degree. The designer should state the goals and objectives in his or her own words to ensure that there is a clear understanding of the situation. For example, if a client's goal is to increase the number of customer transactions in a banking facility, a design objective could be to add tellers (or lengthen the bank's operating hours).

FIGURE 7.5 The first step in programming is to establish the goals.

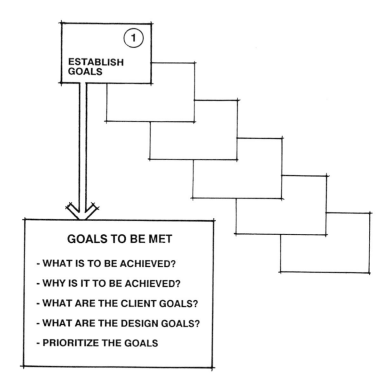

Gather and Analyze Facts
(Figure 7.6)

GATHER FACTS

Facts are existing or actual conditions. They are pieces of information that have reality or truth. The designer should collect and categorize only facts that are pertinent to the goals of the specific problem situation. Important facts in a program include descriptions of user characteristics, economic data, and statistical projections. Other facts might include local, state, or federal regulations concerning deed restrictions, zoning, and health, safety, fire, and building codes. Facts also generally involve numbers, for example, how many people will occupy the space and the space requirement per person, such as 15 square feet (1,393 square millimeters) per dining seat or 1,000 seats in a movie theater.

After collecting the necessary facts, the designer can use them as a basis for discussion, making calculations, or reasoning.

INTERVIEWS OF USERS. To elicit information that is perhaps intimately known only by the users of a space, product, or system, the programmer may find it necessary to interview those people. This direct method encourages the users to describe and to demonstrate any aspects of their activities that are important to them (Figure 7.7). The interviewer should record critical, factual, and circumstantial information to identify the users' relevant needs and attitudes. Users can add some very important information in an interview, including their biases—which may not be the same impressions the designer or co-users have. A potential problem arises in that some people do not say exactly what they mean. In these cases, the interviewer should carefully scrutinize their comments to determine the users' meaning.

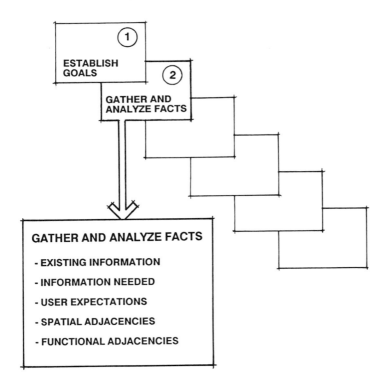

GATHER AND ANALYZE FACTS

- EXISTING INFORMATION

- INFORMATION NEEDED

- USER EXPECTATIONS

- SPATIAL ADJACENCIES

- FUNCTIONAL ADJACENCIES

FIGURE 7.7 BELOW Notes are made of the programmer's interview with a client, generally referred to as a "user needs analysis."

PROJECT Dr. Smith's Clinic		PAGE 7 of 21	DATE 10-91	
SPACE Dr. Smith's office		USER Dr. Smith / interview		

ACTIVITIES	FURNISHINGS AND EQUIPMENT	SPACE NEEDED	ADJACENCIES	COMMENTS
· Consults with patients · Meet with staff · Meet with doctors, other professionals	· chair · Seating for 2 patients · Desk · Bookshelf · Coat Closet · Telephone · Computer Console	· approx. 120 separate feet · View to the outside · accoustical privacy	· exam rooms · nurse station · private entry (not thru patient area) · private toilet	· wants low lighting except at work area · furniture scaled to make patients comfortable

GENERAL REMARKS wants to display some of his Kachina doll collection

The interviewer can solicit information from several users who represent different norms and compare their comments to see if they all agree. For example, an interview with managers and executives can be compared to those with office workers. Sometimes the results are the same, but sometimes the interviews can provide a startling contrast between the impressions and data furnished by each group.

USER SURVEY. A useful tool in gathering data to support functional problem solving and planning is the user survey or written questionnaire to determine the needs and desires of those who will occupy or use the space. The development of user surveys and questionnaires and the programmer's analysis of the replies are very important and must be designed very carefully in order to be useful to the problem situation. The documents should attempt to identify the real needs of the user by asking the "right" questions. An example of a questionnaire can be seen in Figure 7.8.

SITUATIONAL RESEARCH. The programmer might consult available publications and other professionals, including experts who have dealt with similar problem situations to find out how those problems have been solved. Sources such as magazines, books, and other research

FIGURE 7.8 Example of a written questionnaire that is filled out by a user.

INTERVIEW QUESTIONNAIRE

Page 1 of 3 Date _____

Company _____ Department _____

Person Interviewed _____ Title _____

Job Description _____

Telephone No. _____ Supervisor _____

Interviewed by _____ Reviewed by _____

1. Briefly describe the functions of your department.

2. Briefly outline the flow of work through your department.

3. List (in order of importance) the departments with which you have frequent contact: both physical and work flow.

4. Describe any conferencing facilities needed by your department. List types, frequency, length, and number of people involved in these.

5. List other people, their titles, and functions in your department.

6. Describe your current work surface (size) and equipment needed. Do you anticipate any changes?

7. List the files/storage/supplies you need to perform your tasks. Are they needed at your station or in a central location?

8. What furniture (desks, chairs, etc.) do you have to perform your work? Any changes needed?

9. Describe any special equipment/needs required for your tasks.

material can provide considerable data, including pictures, about similar situations and their relationship to the current problem. We can learn a great deal from history rather than "reinventing the wheel" for every new problem or situation that arises.

ORGANIZATIONAL PROFILES. Most companies have some form of hierarchical organizational profile or chart showing the relationships of the employees and their functions (Figure 7.9). It can be a very simple chart for a small company with a few employees or a complex graphic analysis of a large company with hundreds of employees. The programmer utilizes these organizational profiles to gain a clear understanding of the working relationships of the company, its communication procedures, its departments, and the interrelationships among them. If no hierarchical chart exists, the programmer works with the administrative unit of the organization to develop one.

FIGURE 7.9 **Example of a company's organizational chart.**

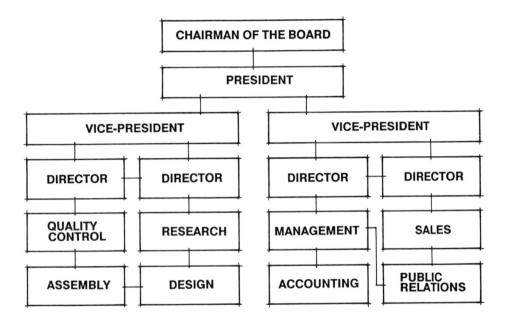

An informal structure that often does not agree with the official, formal chart may also exist. The informal structure may be more representative of how the organization really functions—with its allowances for the peculiarities of personnel, functions, abilities, and communication networks. It is necessary for both the programmer and the client to recognize this informal structure in the program.

COMMUNICATION MODES. It is essential for the programmer to scrutinize the way the organization communicates as work is being performed. The communication patterns may be in the form of paper transactions, telephone systems, computers, or face-to-face meetings. These interactions can occur between staff members or between visitors and the staff. They may be formal or informal, which could influence the physical arrangement of interior space to maximize layouts to improve communications and work-flow efficiency.

FUNCTIONAL ADJACENCIES. The programmer should analyze the organization in terms of both how it operates and the physical proximity of its parts. The functional relationships are defined in terms of the physical and spatial needs of each individual and of each group (or department), as well as the interactions of the whole organization. How much space each individ-

ual needs to perform assigned tasks is determined, as is the necessary proximity to coworkers. Then the groups or departments are diagrammed according to their functional and adjacency needs (Figure 7.10).

FIGURE 7.10 Functional adjacency diagram of departments within a company.

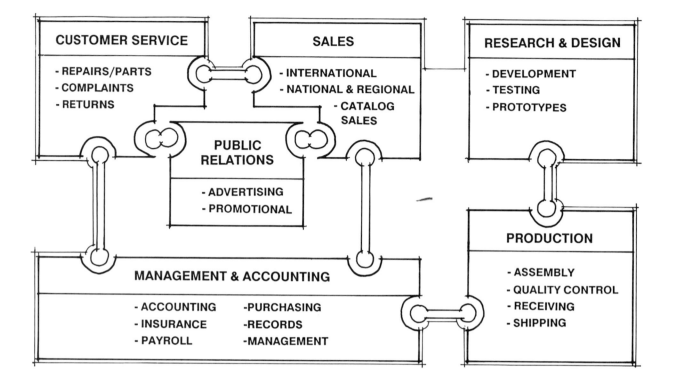

FURNITURE, FURNISHINGS, AND EQUIPMENT INVENTORY. Whether the space to be designed is new or is to be remodeled, the furniture, furnishings, and equipment must be efficiently and aesthetically integrated into the future plans. The programmer must consider whether the client is reusing existing items, purchasing new ones, planning to replace them in the near future, or using a combination of these. A careful inventory must be made of existing items, indicating their type, size, color, finish, and physical condition, if they are to be reused. (Refer to Chapters 16 and 17 for more specific information.)

In this inventory, furniture includes the typical support items, such as desks, chairs, tables, sofas, and credenzas, found in work spaces. Equipment is primarily the nonfurniture items, such as telephones, computers, video equipment, copy machines, and kitchen equipment, needed to execute the work. All other items, such as plants, rugs, privacy screens, and artwork, are classified as furnishings.

ANALYZE FACTS

To analyze facts means to take the materials and ideas that have been gathered and break them down into categories identifiable by similar attributes. This allows the programmer to scrutinize these groupings rather than try to look at all the information at one time. The data might be categorized into groups such as physical, social, psychological, and economic, allowing the programmer to organize them for careful analysis. This information can be in the form of written documentation or visual charts. The programmer compares the collected groupings of facts to the stated goals, refining those that meet the criteria and rejecting those that do not.

CHARTS AND MATRICES. Among the many ways to research, examine, and classify materials about the problem or situation being investigated is simply to list all the questions that can be generated about the problem and seek information that may address these inquiries.

A chart or matrix is an effective way of studying interrelationships. In the matrix form, elements or components are listed in a grid and the relationships are determined by a dot or preset value mode. The matrix helps clarify and make simpler the complexity of all areas/components and their relationships. See Figure 7.11 for a typical interior design problem stated in a visual matrix form for analysis.

FIGURE 7.11 Example of a programming matrix for a restaurant.

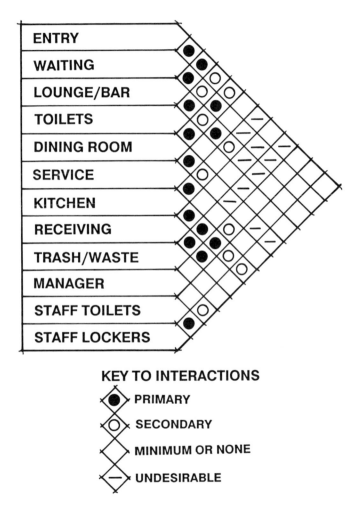

PATTERN SEARCHING. Pattern searching scrutinizes individual parts of a problem to see if some components have similar characteristics or connections. These identified small subsets of patterns are then grouped into larger bodies and in turn are analyzed to see if larger patterns might exist. In this way, the programmer seeks to relate smaller parts of a problem to larger components. For example, a programmer analyzing a bank lobby to be redesigned might observe and record the pattern a bank teller goes through while performing daily work tasks and compare this pattern to that of other tellers to discover common movements among all tellers. This analysis would then enable the designer to plan traffic patterns accurately.

Specify Needs
(Figure 7.12)

Some of the needs of the problem situation are fairly simple to define, such as the amount of money the client wants to spend on the project. Other needs, such as the psychological impact the resulting environment may have, can be more difficult to determine. Therefore, in the programming phase the designer tries to establish the "real" needs of the problem. The program then serves as a guide for both the designer and the client (or user) for the situations addressed in the design phase that follows.

FIGURE 7.12 The third step in programming is to specify the needs.

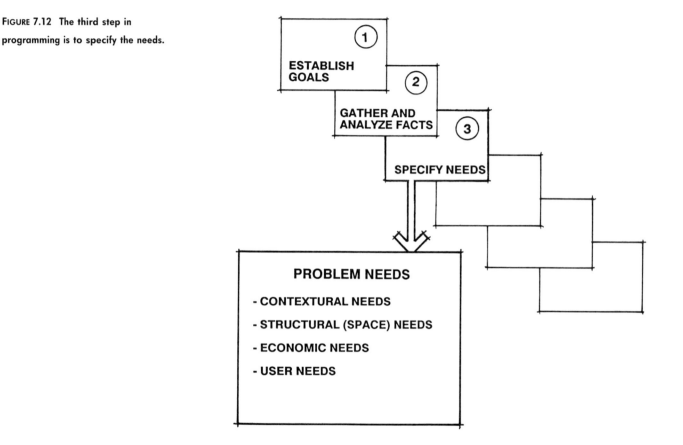

Although the program specifies the needs of the problem, they are dynamic and can change. The users of the space may change, as may the original purpose of the space. For example, as people grow older and experience some physical changes, their individual needs may change. Likewise, as time passes, the usage of a space or building may also change. If some changes can be anticipated, such as the client's need for additional space at a future date, the program should address those issues.

In trying to determine the needs of a problem situation, four areas should be considered: user needs, structural needs of the space, contextual needs, and economic needs.

USER NEEDS

The program defines the needs of the people who will ultimately use the space. Although we tend to consider the client to be the user of the final design there may be "intermediaries" between program and user who either have hired the designer or make the final decision for the

user. Business executives might in a sense be the user by virtue of being a client for a new office space, but these individuals rarely if ever use a work station in the secretarial pool. Likewise, developers and managers of mass housing units are not really the end users. The programmer should attempt to address the needs of the people who will indeed be the "real" users. To do so, the programmer must consider physiological, psychological, and sociological needs, as well as structural, contextual, and economic needs (Figure 7.13).

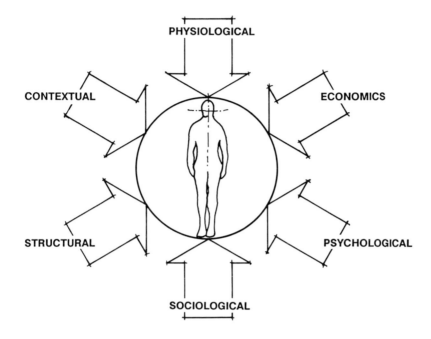

FIGURE 7.13 People have many specific needs that must be met when designing environments for them.

PHYSIOLOGICAL. Physiological needs are physical in nature and relate to human and body requirements. Physiological planned spaces must support basic human physical functions. The planned spaces must also be designed for comfort in terms of things the body senses: noise, light, temperature, humidity, and ventilation. Physiological spaces relate to human scale—thus the need for an environment to be designed to fit a person, not an insect or an elephant. This may seem obvious, but how many spaces or objects have you encountered that seemed too small or too large?

Winston Churchill once noted that we build our buildings first, then they shape our lives. It is actually the converse of this statement that should be the guiding principle in planning interior space for human habitation. Ideally, interior spaces should reflect and fulfill rather than control the functions enclosed. Our lives should shape the buildings, not be shaped by them.

Anthropometrics. The measurement of the size and proportions of the human body is called anthropometrics (Figure 7.14). This discipline is involved with measuring the physical requirements of human beings as users. Over the years, a large quantity of anthropometric data has been gathered, often by the military, on body sizes as related to sex, age, race, occupational groups, and socioeconomic influences. Today many publications supply this information.

It is, of course, not enough merely to obtain the data on the human body; the importance is in understanding the field and the complexities of applying these facts to design situations. The data often represent averages, norms, and ranges of human bodies, not exact dimensions. Also, consideration must be given to the body in motion in interior spaces, for its proportions and needs can change or be variable. The designer should be aware of the specific situation he or she is designing for and use some common sense in applying anthropometric data.

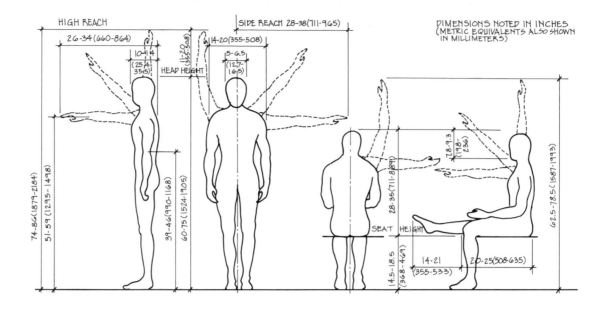

FIGURE 7.14 Anthropometrics is involved with body measurements that are useful to the interior designer.

Ergonomics. The study of the relationships between human beings and their functions in the environment is termed *ergonomics.* It is the applying of anthropometrics for optimum human/environment relationships. The thrust of most of the previous work in ergonomics, or human engineering, was associated with complex technological situations and machine interactions, such as in aircraft cockpits, space capsules, and military applications. Now, however, many of these studies of human factors are applied to automobile design, electronic/computer applications, and furniture design, involving the human body as a user of equipment and environments. The designer should be aware of the specific situation when applying ergonomics since needs may vary considerably depending upon the application; that is, the needs of a population of users that is numerous and mixed will be quite different form those of a specific single user.

PSYCHOLOGICAL AND SOCIOLOGICAL. We have discussed some of the physiological needs, which are basically measurable components that can be programmed rather easily since they are physical in nature. Bodies and their functions can be measured and studied so that appropriate furniture and spaces for circulating can be designed. But such physical data do not take into consideration the user's feelings and interactions with other users.

People need a certain amount of psychological space surrounding them, which we call personal space. It can be thought of as a bubble that can vary in size and shape depending upon the user's psychological make-up and the activity the user is trying to perform. Good friends engaged in a conversation may be within touching distance, but this would be too close for two business associates conducting a formal meeting. A classic example of personal space "bubbles" can be seen when people ride in an elevator of a high-rise building. Many of them go through all sorts of postures and efforts not to touch one another, speak, or break into those personal spaces. At such a close distance, most of these people will attempt to stand perfectly still and stare into blank space. Psychologically, they need more space. Designers must be aware of these personal space bubbles when designing interiors. Consequently, the program should attempt to state the individual's psychological needs and the relationships between those needs.

Proxemics. In his book *The Hidden Dimension,* Edward T. Hall[3] discusses the interrelations, use, and perceptions of space. These theories of man's spatial relationships have been coined proxemics. Hall divides this spatial territory into four zones—the intimate, personal, social, and public (Figure 7.15). These zones specify distances that govern activity and the relations formed during that activity, and these facts can be useful guidelines for the interior designer.

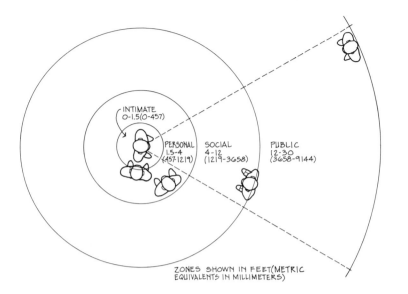

ZONES SHOWN IN FEET (METRIC
EQUIVALENTS IN MILLIMETERS)

FIGURE 7.15 The four zones
of proxemics.

The "intimate" zones allow actual physical contact and generally exist from skin surface to a distance of approximately 1½ feet (457 mm). If a stranger penetrates an individual's intimate zone, actual discomfort may be experienced—sometimes by both parties.

From approximately 1½ to 4 feet (457 to 1,219 mm) is the area defined as the "personal zone." This space allows friends of an individual to come close to, but not to penetrate, the inner limit. If they do penetrate this zone, it is only briefly, such as for a handshake or a passing social contact. This distance also allows conversations to take place at a little below a normal voice level.

The "social zone" ranges from about 4 to 12 feet (1,219 to 3,657 mm) and is the spatial zone conducive to informal, social, and business transactions. Voice levels range from the normal level within the 4-foot (1,219 mm) distance to a raised level near the outer limits of 12 feet (3,657 mm). The arrangement and placement of furniture within this social distance can also affect relationships of people in the space. For example, a visitor's chair placed across from a desk generally places the visitor approximately 9 feet (2,743 mm) from the person behind the desk and creates a more formal atmosphere. In contrast, a chair at the side of the same desk places the visitor about 4 feet (1,219 mm) away and appears to be more conducive to an informal meeting.

The space that extends beyond the 12-foot (3.65 m) limit of the social zone is the "public zone." This distance tends to stimulate formal behavior and hierarchical relationships. Individuals of prominence or status within this zone tend to automatically have approximately 30 feet (9,144 mm) around them. Voice levels become generally louder, and enunciation is clearer and more formal, within this zone.

Proxemics is also concerned with individual differences and perceptions of space as applied to specific groups and cultures. Hall further notes that proxemic classifications are indeed approximate and applicable only to the group of individuals studied. People's perceptions and uses of space vary from culture to culture, and therefore their proxemic patterns also vary. It is important to recognize that even though general zone patterns exist, the interior designer must be cognizant that personal space requirements differ.

Emotions can also be affected by spaces of unusual proportions or those to which one is not accustomed. Large spaces with very high ceilings may create a feeling of awe or make some people feel insignificant or threatened. Yet in some public environments, such as cathedrals with their soaring, uplifting spaces, we can appreciate and even desire high vertical spaces. In contrast, small spaces may cause a feeling of discomfort due to a cramped feeling (claustrophobia).

Much of our daily life depends on interaction and cooperation between individuals—in the neighborhood, on the streets, and in the workplace. If in designing spaces the designer takes into account characteristics that make cooperation convenient and easy for the users, they can function more effectively and congenially.

We are increasingly finding that limiting our space to some degree is essential since space is fast becoming a precious commodity. The economy affects our ability to build new living and working environments, transportation systems (highways, airports, and the like), and recreational areas because of rising costs of materials and labor. Population growth and a finite limit to available land also create the necessity to conserve on space usage.

STRUCTURAL NEEDS

Structural needs of a planned space must be considered in terms of protection, health, safety, and welfare and must be documented in the program. Protection of both the occupants and the contents must be specific in terms of weather, including water, cold, heat, high wind, earthquakes, and fire. (See Chapters 10 and 11 for specific information.) The arrangement of the space must allow for logical and convenient entrance and exit of both people and objects. The program must also define needs for the distribution of energy, information, equipment, and materials. The space must be structurally sound, that is, designed and engineered to stand up under its own weight, and must accommodate objects and people placed in it. The space must have structural considerations, such as walls, floors, and ceilings, to hold it together. If an existing space is being designed, structural elements must be noted, for they might influence the new design. For example, an existing stairway location could affect the design concepts and may have to be removed or brought up to new code standards. Environmental comfort of the immediate space must be maintained through appropriate lighting, comfortable air temperature and humidity, and adequate air circulation.

CONTEXTUAL NEEDS

A building or space within a building is not an island isolated from its surroundings. If it does not work in harmony with the surroundings, it will work against the environment. Among the programming contextual needs of the space (and its inhabitants) are the cultural aspects of the immediate area, along with its historical, religious, and political elements. Physical contextual concerns that also need to be addressed in the program include how outside systems, such as electric power sources, communication modes, and water, sewer, and transportation units, are linked to the environmental situation. After the contextual needs are determined and listed, the programming process projects into the future to determine how those needs might change in years to come.

ECONOMIC NEEDS

In terms of the client's budget, the major design considerations are that the space must be economically feasible to construct, serve the needs of the users, and take maintenance costs into account. These maintenance costs are projected over the expected life of the project to determine what is called life-cycle costs. (See Chapter 16 for a more detailed explanation.) Most people (and clients) cannot afford to do everything they desire. It is important for the programmer to distinguish between the needs and the wants of a client. What a wealthy person considers necessities, someone else would see as luxuries. Clients often desire more from an interior environment than they can actually afford. The programmer and the client have to come to an agreement concerning how much money is to be spent for the quantity and quality of construction, furniture, and equipment. This agreement must be stated in the program. This phase of determining economic needs defines the amount and kinds of funds the client has to work with and whether his or her expectations match this amount. Preliminary cost estimates and project

budgets are generally set in the programming phase, to be adhered to in the design phase that follows.

Evaluate
(Figure 7.16)

The evaluation stage of the program attempts to determine the relative importance, and to appraise the value, of the program. Evaluation can actually occur at various stages throughout the programming process since the programmer can evaluate the whole or its parts. In either case, the programmer must have some criteria for judging the relative importance of the data to this point. The whole program might be judged by totally different criteria than a part would be.

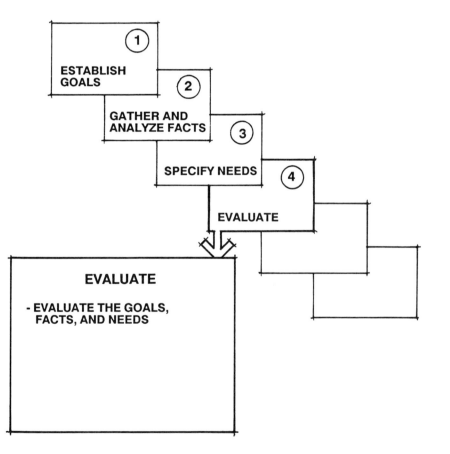

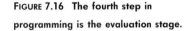

FIGURE 7.16 The fourth step in programming is the evaluation stage.

The programmer makes evaluations not only about objects but about their "value" in relation to the goals to be achieved. Using question sets as evaluative criteria is a good way to see if the original goals are being met. Some questions that should be asked include: What are the important issues? What value will you assign the various data? What alternatives should be pursued further? Have the goals been met? The evaluation step offers feedback immediately about decisions that may affect the whole process. In a complex situation involving a large number of facts, it sometimes helps to assign numerical ratings to the criteria for evaluation and to

express the relative importance of the facts in the form of a hierarchy. This will help to clarify in the feedback to the client and in the communication to the designer the value range assigned to problem determinants. A good program format for evaluating a design will also be a good design tool. Another tool is postoccupancy evaluation, which is discussed in Chapter 6.

Organize and Decide
(Figure 7.17)

The organizational and decision-making process in programming occurs after, and builds upon, the analysis and evaluation stage. Although organization takes place throughout the whole programming process, it is defined here as a formal step that generally occurs after the goals have been established and the data have been collected, analyzed, and evaluated.

FIGURE 7.17 The fifth step in programming is to organize all of the parts into a whole meaning and form conclusions.

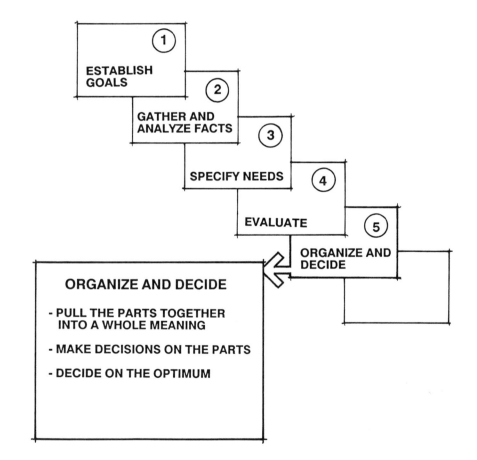

The organization step is the facet of the program in which the client's needs and their relationship to the overall information collected, analyzed, and evaluated are translated into a format that the designer can utilize to reach decisions.

The organizational step begins to formulate the decision-making stage in programming, which in turn leads to conclusions. Commitments about relationships and priorities begin to be made. Conclusions, alternatives, and recommendations are developed about what should be achieved in the design process and what the result should be. Projection of future circumstances and how they might be achieved should also be stated.

The conclusions and recommendations should be presented in as graphic and diagrammatic form as possible. Diagrams often have direct implications on physical form or suggest obvious pattern relationships. The programmer's ability to organize visual, graphic, and verbal data will help translate programming facts into the formation of a physical space.

To be an effective guide, the order of the program and the form in which it is presented must relate to the way the designer will use the program. Its format must be well organized, have established priorities, and state recommendations.

Present Conclusions
(Figure 7.18)

The last step of the programming process is to present or communicate the findings to the client and other parties involved in the situation. An end product or document, usually in the form of a printed publication containing both written and graphic information, must evolve from the programming process for the ideas to become reality. Although some programmers tend to rely on written presentation, a program should also seek to communicate data graphically. The finished program can be one sheet or a bound publication of many pages, or it can assume a different visual mode, presenting the program as a continuing process, not a final conclusion. For example, the designer might use a kinetic programming or active feedback system that allows and encourages participants at the presentation to modify the conclusions. This might include the

FIGURE 7.18 **The sixth step of programming is to present the conclusions.**

"story board" technique often employed by the motion picture industry for developing movies and cartoons (Figure 7.19) or might use a series of large work sheets pinned to the walls. Both of these formats place all the information in view of many participants at one time to encourage immediate responses.

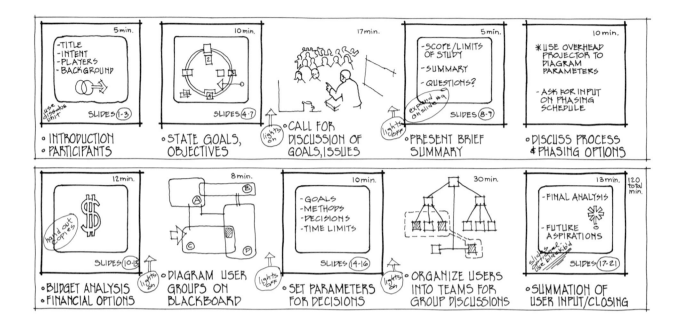

FIGURE 7.19 Using the storyboard technique can be an effective method for visually organizing information and involving participants.

No matter in what form the program is presented, the intent is the same. A program is an effective design tool that finds, organizes, selects, and sets goals into a written and/or graphic document that in turn will be used by a designer. Figure 7.20 shows a fairly standard outline for a programming report that serves as a general guide for the presentation of material. The outline shown here can vary according to the complexity of the situation and the uniqueness of the problem; however, it contains certain basic categories applicable to most programs.

FIGURE 7.20 Typical outline for a program report.

1. PREFACE
 Introduction
 Participants/Clients
 Acknowledgements
 Table of Contents

2. SCOPE
 Limits of Study
 Philosophy/Purpose
 Summary

3. GOALS
 Client and Operational Goals
 Project Goals
 Programming Goals
 Programming Methodology
 Client Background and
 Information

4. DATA
 Assumptions/Givens
 Client Organizational Structure
 Existing Conditions/Facilities
 User Needs/Descriptions
 Summaries of Projections

5. SCHEDULES/BUDGETS
 Budget Analysis
 Phasing of Project
 Time Schedules

6. CONCLUSIONS
 Spatial Needs/Requirements
 Recommendations

7. APPENDIX
 Detailed statistical Data
 Exhibits
 Bibliography

NOTES TO THE TEXT

1. Le Corbusier, *The Radiant City.* New York: Orion Press, 1967.
2. William M. Pena, *Problem Seeking.* Boston: CBI Publishing, 1977, p. 82.
3. Edward T. Hall, *The Hidden Dimension.* New York: Doubleday, 1966.

REFERENCES FOR FURTHER READING

Alexander, Christopher. *Notes on the Synthesis of Form.* Cambridge, Mass.: Harvard University Press, 1964.

————, et al. *Houses Generated by Patterns.* Berkeley, Calif.: Center for Environmental Structure, 1969.

Bennett, Corwin. *Spaces for People.* Englewood Cliffs, N.J.: Prentice-Hall, 1977.

Chermayeff, S., and C. Alexander. *Community and Privacy.* Garden City, N.Y.: Doubleday, 1963.

Deasy, C.M., in collaboration with Thomas E. Lasswell. *Designing Places for People.* New York: Whitney Library of Design, 1985.

Gutman, Robert, ed. *People and Buildings.* New York: Basic Books, 1971.

Hall, Edward T. *The Hidden Dimension.* Garden City, N.Y.: Doubleday, 1966.

Lang, Jon, et al. *Designing for Human Behavior.* New York: McGraw-Hill, 1974.

Palmer, Alvin E. *Planning the Office Landscape.* New York: McGraw-Hill, 1977.

Panero, Julius, and Martin Zelnick. *Human Dimension and Interior Space: A Sourcebook of Design Reference Standards.* New York: Whitney Library of Design, 1979.

Pena, William, with S. Parshall and K. Kelly. *Problem Seeking.* New York: AIA Press, 1987.

Perrin, Constance. *With Man in Mind.* Cambridge: MIT Press, 1970.

Preiser, Wolfgang. *Programming the Built Environment.* New York: Van Nostrand Reinhold Company Inc., 1985.

Sanoff, Henry. *Methods of Architectural Programming.* Stroudsburg, Penn.: Dowden, Hutchinson & Ross, Inc., 1977.

Sommer, Robert. *Design Awareness.* San Francisco: Rinehart Press, 1972.

————. *Personal Space.* Englewood Cliffs, N.J.: Prentice-Hall, 1969.

————. *Social Design.* Englewood Cliffs, N.J.: Prentice-Hall, 1983.

White, Edward T. *Introduction to Architectural Programming.* Tucson: Architectural Media, 1972.

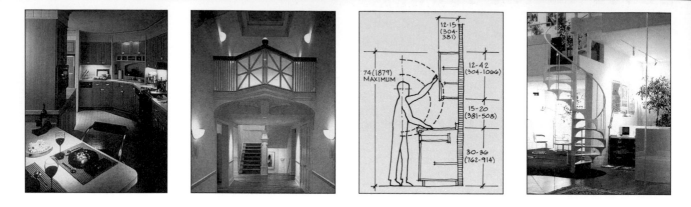

SPACE PLANNING OF RESIDENTIAL INTERIORS

INTRODUCTION TO SPACE PLANNING

Once the building program has been established, presented, and approved by the client, the interior designer develops the information into physical reality. The designer now has the goals, data, objectives, and other pertinent guidelines to proceed with creating spatial concepts and interrelationships that will be responsive to the users' needs.

This phase of the design process is space planning, which means arranging the spaces to satisfy the program and the needs of the client. We speak of "planning" the space rather than "designing" the space since the primary concern at this point is solving the functional, physical, and psychological needs of the client. This phase goes beyond addressing the aesthetic or visual issues of texture, color, or fabric. Although it is difficult to shape and manipulate spatial concepts for use by human beings without thinking of all the elements in a holistic "design" sense, this first stage of the design process is intended only to establish order and functional relationships of the space and its inhabitants.

Space Planners and Interior Design

Space planning based on building programs can deal with small, simple spaces or large, complex ones. In fact, large-scale space planning of office interiors in large buildings has become so complex and such a lengthy process that many interior designers (and others) call themselves space planners. This title usually connotes that they are planning specialists who work primarily in this phase of the design process in commercial interiors. They might work from a program established by another firm or generate the program as part of their own services. Space planning implies an ordered, methodological approach a designer utilizes to create an interior environment responsive to and in harmony with its users. Although the term *space planning* is almost exclusively applied by designers to office planning, in the true sense it can be applied to the planning of all spaces, whether they are in offices, residences, factories, retail stores, or institutions. All interior designers are space planners.

Space planning involves developing concepts in two-dimensional plan drawings and other sketches to explain basic relationships (Figure 8.1). Other graphic material, such as equipment lists, flow diagrams, analysis, circulation, and horizontal (and vertical) relationships, is added to assist in presenting the designer's basic premises for solving the problem.

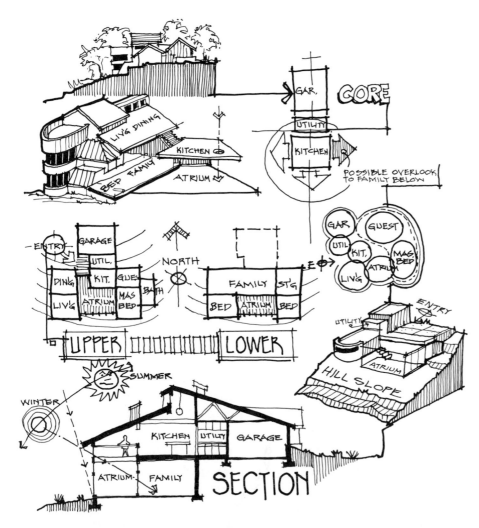

FIGURE 8.1 A designer's sketches for space planning explore basic concepts and relationships in a variety of drawing techniques.

These schematics are refined through bubble diagrams (Chapter 6, Figure 6.11), preliminary floor plans, and final design plans (Figure 8.2). From these drawings, more detailed studies and construction drawings are made to direct contractors in building the designs. (See Chapter 18 for a more in-depth description of the types of drawings used in these processes.)

FIGURE 8.2 Space planning evolves from basic schematics and bubble diagrams to final design plans.

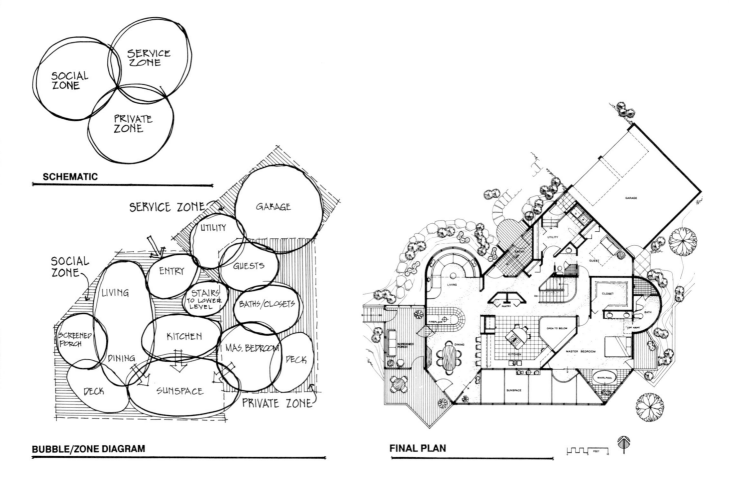

SCHEMATIC

BUBBLE/ZONE DIAGRAM

FINAL PLAN

Categories of Interior Spaces

Interior environments are very important because we spend the major part of our lives inside a variety of artificial or man-made interior spaces. We experience and talk about the natural environment, but many people have little or no direct contact with it on a hourly or even daily basis. For most of us, our immediate space is man-made. How this interior space is created, is shaped, and functions becomes crucial to our existence and psychological well-being.

RESIDENTIAL AND NONRESIDENTIAL DESIGN

Many designers, design schools, and the general public separate the field of interior design into two distinct categories: residential and nonresidential, or commercial (Figure 8.3). The

RESIDENTIAL

ENVIRONMENTS FOR LIVING, OR WHAT
IS GENERALLY CALLED HOME

A. SINGLE FAMILY OR MULTIFAMILY
1. Detached Houses
2. Apartments, townhouses
3. Condominiums, dormitories
4. Manufactured housing units
5. Mobile homes (trailers)
6. Specialized

NON-RESIDENTIAL

(sometimes called contract or commercial)
ENVIRONMENTS THAT ARE RELATED TO THE BUSINESS WORLD,
ENTERPRISES, PUBLIC DOMAIN, OR SPECIAL PURPOSES.
NOT DIRECTLY RELATED TO LIVING QUARTERS.

A. OFFICES

B. FINANCIAL INSTITUTIONS
Banks, Savings & Loan, Credit
Unions, Trading Centers

C. RETAIL
Stores, Shops, Shopping Malls,
Showrooms, Galleries

D. HOSPITALITY (AND
ENTERTAINMENT)
Restaurants, Eateries, Hotels,
Motels, Inns, Resorts, Clubs,
Theaters, Concert Halls,
Auditoriums, Arenas,
Convention Centers

E. RECREATIONAL
Gymnasiums, Bowling Alleys,
Swimming Pools, Health and
Sports Centers

F. HEALTH CARE
Hospitals, Clinics, Nursing
Homes, Doctors' Offices

G. INSTITUTIONAL
Schools, Colleges, Universities

H. PUBLIC AND GOVERNMENT
Libraries, Museums, City Halls,
Courthouses, Legislative, Post
Offices

I. TRANSPORTATION
Airports, Terminals, Airplanes,
Space Vehicles, Motorcars,
Buses, Trains, Boats, Ships,
Motorhomes, Campers

J. INDUSTRIAL
Factories, Manufacturing,
Laboratories, Garages,
Warehouses, Workshops

K. SPECIALIZED
Set Design for TV/Theatre/Film,
Studios, Exhibition Design,
Kiosks

FIGURE 8.3 Interior design is often categorized into two distinct areas: residential and nonresidential.

practice of interior design is also categorized by the particular kind of space, such as work space, living space, institutional space, special purpose space, and other spaces being planned. This categorization is really involved more with defining the specialty of practice or expertise of an interior designer than with the type of spaces people occupy. Although interior designers work with many different kinds of space, some specialize in either the residential or the nonresidential area.

Although we categorize types of interior spaces, it does not necessarily follow that total environments are specifically of one category or the other. Living and work spaces can be and often are combined in the same interior environment. In fact, they can be within the same "room" or space—not being divided by conventional means of walls or doors. This multiuse of space is becoming more apparent as computerization and technological advances create additional options for people to work and live in the same environments. The name given to the space is not necessarily the definer of that type of space—the inhabitants (or users) of the space and what

they do or how they interact with the space give the space its name. The physical makeup of the space may be constantly changed to reflect the occupant's performance, thus theoretically changing the space's usage and resultant category.

The distinction between residential and nonresidential spaces is often not very distinct. The theories and practice of interior design are utilized in all areas, not just in residential or nonresidential. Interior design is a holistic approach to creating all environments—not a specialty of interests or places.

It is not the authors' intent to distinctly categorize every kind of interior space or to create new niches for defining types of interiors. The categories presented in Figure 8.3 will serve to illustrate that indeed interior spaces can basically be called either residential or nonresidential. Under nonresidential, it is further possible to list spaces under general headings of office, retail, hospitality, institutional, and so on. The specifics categorized here are generally accepted by most designers; however, some individuals will take exception where the authors have listed types of space. So be it; interior design, like other professions, is composed of individuals—designers, educators, and students—who have different points of view and interpretations and that provides a healthy forum in which creative people can interact.

PLANNING RESIDENTIAL SPACES

Civilization has evolved from a simple society where residential activities, such as eating, socializing, sleeping, and playing, took place in one area of space. We now have a very complex society in which we perform different activities in many different physical buildings or spaces.

In its broadest sense, living space now refers to any shelter built for human habitation. People today tend to refer to residences rather than living spaces. The term *residential* is generally accepted to mean an environment to "house" an individual or a social set formed by a family (or group of unrelated people living together who form a congenial unit). This "living environment" is a space that has great influence on our interaction and relationships with one another and that reflects our personalities and our life goals.

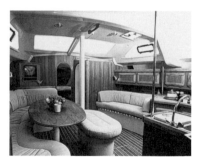

FIGURE 8.4 **A residence might be a yacht that people use as their home while traveling throughout the vast oceans and seas.**

We might also classify apartments, condominiums, and retirement homes as part of residential design, defining them simply as any place where one spends one or more nights. We could expand this theory to any place one dwells in for an extended amount of time or that a person calls his or her residence, such as a trailer, mobile home, or yacht (Figure 8.4) that moves from port to port. No matter what form living spaces take, what they might be called, or where they might be located, the importance in designing them is to meet the needs of the people who will use them as a living environment.

Planning Guidelines

In planning a new residence or remodeling an existing one, the designer should address certain basic issues. These are usually provided in the program, as outlined in Chapter 7. These issues for design decisions include:

• The users' needs, characteristics, aspirations, and activities;

- The context of the residence—location, orientation, and relationship to the physical and societal patterns;
- The economics or budgeted money for the project;
- The aesthetic influences with respect to beauty and character that the designer and the client exert.

With the economic need to conserve land and square footage in our living environments, designers have also made more economical and creative use of vertical spaces and stacking of floors. Exciting and dramatic spaces are created by high, sloping ceilings with mezzanine or balcony effects (Figure 8.5). The use of vertical space allows a departure from the standard eight-foot (2,438 mm) ceiling and helps to alleviate our feeling of constriction and our awareness of smaller floor area. On a larger housing design scale, utilizing vertical space planning in multileveled plans allows the opportunity to design well-separated zones of activity over a relatively small land area, thus economically and effectively saving our precious resource, land. Population growth in this country and others has created the need for more and more housing, but less space for it. We designers are faced with the necessity to do more with less space.

Buckminster Fuller's dymaxion house (see Figure 3.15) was a concept for designing a living environment in a very limited space. His concept is similar to today's "compact" house, in which spaces are shared for a variety of activities and the mechanical areas and support spaces are grouped together to maximize efficiency in the use of space and materials. The arrangement, quality, and use of space (or space planning) have become much more important than the quantity of space. Multipurpose areas have solved the problem of limited space.

Designing for a residence involves planning for human needs and life experiences by dividing the space for specific or numerous activities and defining these with elements such as walls, doors, windows, other openings, or furniture. A floor plan is the end result of space planning and indicates the location, size, and shape of the various spaces and often the ways in which the furnishings might be arranged. This overall floor plan evolves from the program and translates user needs and desires into areas of specific sizes, shapes, and functions. Living patterns and circulation then become expressed through the placement of areas, doors, windows, walls, and different floor levels.

FIGURE 8.5 **Designers often create overlooks between floor levels of a building, accenting the spatial relationships and features that can be shared by more than one level. (Copyright © H. Durston Saylor, New York.)**

SPACE ORGANIZATION

There are two design approaches to spatial organization and planning for activities within an interior environment, whether we are discussing residential or nonresidential design. They are commonly called the closed and the open plan concepts. Each derives its name from the organization and creation of spaces within spaces—as defined primarily in plan arrangement.

Closed Planning

About the nineteenth century, floor plans for housing began to reflect particular activities and were labeled accordingly, such as music room, sitting room, library, card room, and drawing room. This concept, called the closed plan led to compartmentalization of specific spaces, with separate rooms often being joined by hallways. Today many houses continue to have spaces labeled kitchen, bedroom, living room, and so on, to reflect the living patterns and life-styles of

the occupants. The last decade, however, primarily because of economic considerations, has seen smaller residential units that utilize spaces for multipurpose activities.

Changing life-styles have influenced a corresponding trend reflected in homes where there are fewer "formal" rooms strictly for socializing. Although we still see many formal living rooms, they are often smaller than their predecessors. Living patterns have also transformed kitchens and formal dining rooms into combined areas that accommodate both functions in a more informal atmosphere.

Closed plans have some distinct features and advantages not possible in the open plan concept. The use of walls and doors provides visual and acoustical privacy for the occupants. This type of planning also allows for varying types of activities that ordinarily might be in conflict to occur simultaneously. For example, with proper acoustic control of walls, a game room and a library might be placed side by side for simultaneous use in the closed plan, whereas an open plan would not permit this. Many people, particularly families, often prefer the closed plan, which allows segregation or control of various family activities by generations, such as children's sleeping areas being undisturbed while the parents or older children are engaged in other activities.

Closed plans produce some distinct physical disadvantages as compared to open plans. For example, climate control by heating, ventilating, or air-conditioning becomes more involved, with extra ducting or conveyances being needed for each room or space. On the other hand, special mechanical systems can provide more control of separate rooms by zoning the microclimate of specific rooms to meet the occupant's needs. Closed planning can offer some energy-saving alternatives in that portions of a home that are not in use can be zoned off and not heated or cooled.

Open Planning

Some of our residential design and planning has cycled from the open plans of early civilization through the closed planning of the nineteenth and twentieth centuries and seemingly back to the open plans once again.

Some houses are being designed with one central space or with fewer spaces that flow or combine into other spaces and eliminate the "physical" segregation of activities. Changing life-styles of families away from formalized social activities have created the demand for more spaces with multipurpose functions. The open plan might have spaces, such as an entertaining area or a great room, that are derived from a combination of activities.

The open plan as we know it today was influenced by Frank Lloyd Wright with his prairie house designs and by the innovations of Le Corbusier and Ludwig Mies van der Rohe. Their contributions to residential design emphasized greater flexibility in the use of space through planning, volume, lightness, and an open, informal integration with the immediate environment.

The designs of modern furniture and equipment that are modular, compact, and even portable have also added to the multiuse of spaces for different activities. Overall, open plans exhibit a minimum of spatial separation or compartmentalization. Segregation of activities can be accomplished by furniture arrangement, level changes, and partial walls or screens. Interaction of activities and groups between spaces is often encouraged, as is the use of adjacent spaces to flow into one another for flexibility.

In residential design, the open plan offers some cost savings in the reduction of interior walls. Also, in passive solar design, the open spaces encourage natural heating of all the space versus using ducting systems to circulate warm or cool air to individual rooms (Figure 8.6).

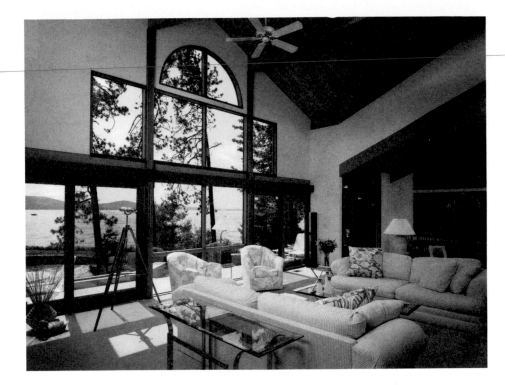

FIGURE 8.6 **In passive solar design, interior spaces are often open to one another to encourage the natural flow of heat throughout the building.**

INTERIOR ZONING

In residential design, spatial organization should be viewed as a whole. Its elements, products, procedures, equipment, people relationships, and environmental aspects are interdependent and should be planned integrally. Space planning begins with an analysis of the activities to take place within the environment, the furnishings and equipment needed to carry out those activities, the relationship to adjacent activities, and the spatial and structural needs to accommodate those activities and accompanying furnishings.

Activities can be grouped into zones according to their similarity in function and the degree of privacy or interaction required. These are termed group (or social) zones, private zones, and service (or support) zones (Figure 8.7). The designer should refer to the program for specific user needs to be met and activities to be accommodated.

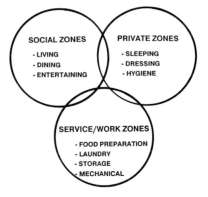

FIGURE 8.7 **Typical activity zones of a residence.**

Group/Social Spaces

The group, or social, spaces within a living environment are areas where family members, friends, and guests gather for activities such as conversing, watching television, listening to music, playing games, and entertaining in general. These spaces should provide an atmosphere conducive to the occupants' life-style and values. The group/social areas of a residential environment have been traditionally identified as the living, dining, and family areas. The number and the size of

these areas are determined by specific user needs and resources and can vary widely from a multiuse studio apartment to a large, formal space. In some residences two or more separate living spaces, such as a formal living room for adult conversation and entertainment and an informal recreation room for family and/or children's activities, are needed. In others, a large space, sometimes referred to as a great room, accommodates several activity areas. These areas might be subdivided by changing the floor levels, furniture arrangements, or floor coverings to create visual rather than physical wall separations.

The relationship of one area to another influences the way space will function. Group spaces should be located for easy access for both occupants and guests from the primary entrance or parking facilities. Since group conversation is often accompanied by serving meals, eating areas should be adjacent or close to the living area for entertainment and multiactivity purposes. These eating areas can be planned as either one area or two or more separate spaces, such as a dining room and a breakfast area (Figure 8.8). Of course, the eating area or areas should also be adjacent to the food preparation area, with the location of the main eating area (where the meals are served most frequently) taking precedence over that of secondary dining areas (where an occasional meal is served).

FIGURE 8.8 This kitchen designed by Gay Fly incorporates an eating counter for convenience and to facilitate social interaction with the food preparation activities.

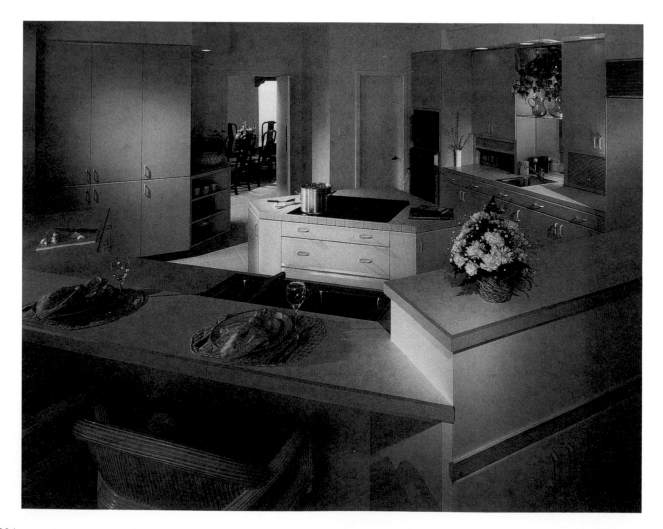

LIVING AREAS

When designing a new residence, the designer should not be limited by the tradition that the living area must always be at the front of the house. Some sites are actually more conducive to having the living area overlook the back or side yard. This might be more desirable than to have the living area overlook the street or the neighbors' houses.

Even the smallest of living areas benefits by having the spaces separated into sections for different activities. Within the living space, three activity areas might be a primary seating/conversation area, a secondary seating group, and an entertainment center. The functions of these areas can also overlap rather than being distinctly separated.

The primary seating area is usually the major conversation space, with the furniture grouping or a focal point (such as a fireplace) being the dominant element. One of the arrangements most conducive to conversation is a grouping that places a maximum distance of about 8 to 10 (2,438 to 3,048 mm) feet between people. This distance allows people easily to see facial expressions and body language and to hear. To interact comfortably, people generally prefer to sit opposite each other or at a slight angle. If there is too much distance between them, they will then tend to sit side by side. Well-planned seating areas avoid having traffic pass directly through. Doorways or entrys should be grouped in a corner or be located across from each other to avoid cross-circulation problems (Figure 8.9).

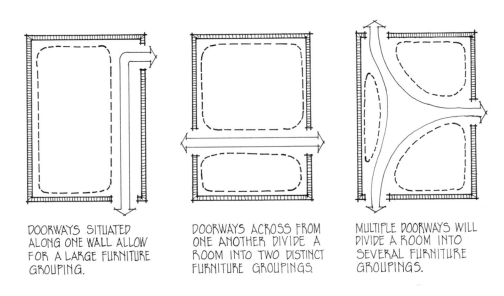

DOORWAYS SITUATED ALONG ONE WALL ALLOW FOR A LARGE FURNITURE GROUPING.

DOORWAYS ACROSS FROM ONE ANOTHER DIVIDE A ROOM INTO TWO DISTINCT FURNITURE GROUPINGS.

MULTIPLE DOORWAYS WILL DIVIDE A ROOM INTO SEVERAL FURNITURE GROUPINGS.

FIGURE 8.9 Doorways and entrys into a space should be placed in a manner that avoids traffic patterns through the center, which could disrupt the effective use of the space.

If space permits, additional seating areas can be planned within the living area to accommodate one to four people for a secondary conversation area or for reading, games, or music activities. This secondary area could be in the form of a window seat, game table with chairs, or large lounge chair. Furniture used in living areas is categorized as built-in (or fixed) and movable. Much of the movable furniture on the market today is modular and encourages rearrangement.

The electronic entertainment center has evolved from spaces, referred to as dens in the 1950s, that primarily featured a TV console. A decade later this became the family room, with a

color TV and a hi-fi system. The 1970s brought space called the media center, which contained both visual and audio electronic equipment. Today, this home entertainment center is often integrated into the overall design of the living environment for entertaining, information, comfort, and aesthetics. It includes everything from a color TV, video recorders, and total sound system to a computer and related equipment. The placement and the design of these entertainment centers depend on the life-style of each family. For instance, some clients feel that televisions are too conspicuous or not very attractive and, hence, want to hide them behind cabinet doors or place them on portable carts.

A total storage and media wall or center provides a good solution for incorporating audiovisual equipment by making the area easily accessible, as well as making a strong design statement (Figure 8.10). The entertainment center should be located so it is convenient to the primary and secondary seating groups, especially if it includes a TV. Major concerns in locating the entertainment center are good seating and viewing angles, light and sound control, and some separation for those who do not want to participate.

FIGURE 8.10 This freestanding media center incorporates many electronic features and becomes a focal point within the space. Note the skylight behind the center.

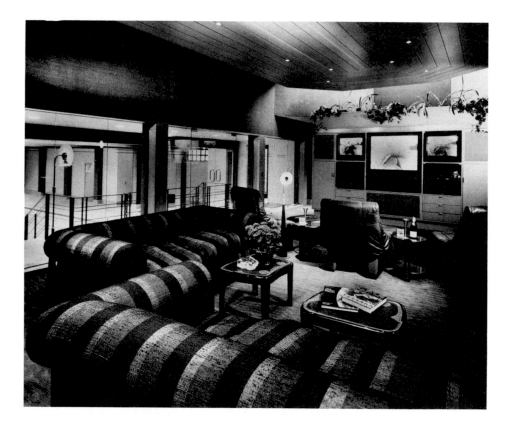

As personal computers become common household items, they are incorporated within almost any area, depending on the users' needs. Whatever the location, adequate space for a keyboard, video display terminal, printer, other hardware, and software is important to the operation of these units. Proper height of the keyboard, angle of the screen, adjustable seating, and good lighting are also important for the comfort of the users.

Permanently placed musical instruments, such as pianos, need enough open space around them for effective acoustics and for a small audience to gather. Upright pianos can be placed flat against a wall or sometimes used as a room divider to partition off an area. Grand pianos are usually placed so the curvilinear side faces into a room for the best sound dissemination. Pianos

should not be placed in areas that might subject them to significant temperature and humidity changes, such as next to a heating unit or sunlit window.

EATING AREAS

To some people, eating is merely a necessary function to replenish the body. To others, it may be a time of social pleasures and communicating with family or friends. The ways, times, and locations where people eat in a residence can vary according to the personal values of the occupants, their lifestyles, and the available space. People eat just about everywhere—the kitchen, the family room, outdoors, in front of the television, and even in bedrooms. The designer should analyze the particular situation to determine users' needs.

As people become busier with work and activities outside the residence, eating areas are often less formal and more flexible to serve other activities. Also, because we are more aware of the need to conserve space, we tend not to set aside an enclosed space that will be used only approximately three hours a day for the specific activity of eating. Instead of one isolated dining room, we often see two or more eating areas that merge into other areas, such as a kitchen and living space that can be planned and used as circumstances dictate (Figure 8.11). "Breakfast"

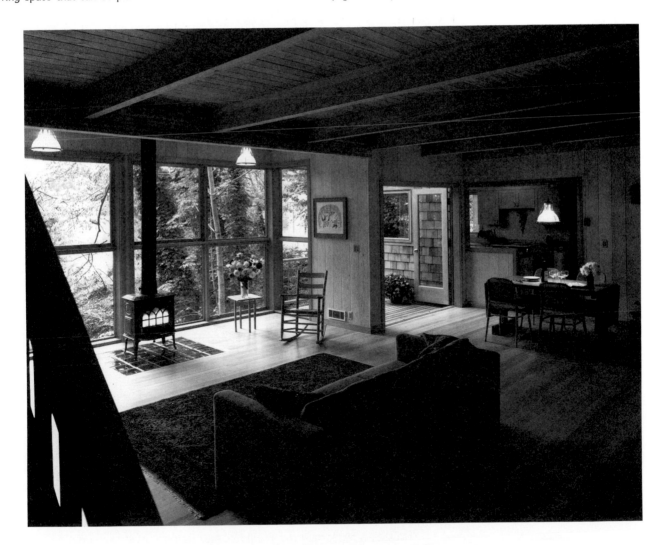

FIGURE 8.11 This small house does not have a dedicated dining room. This provides flexibility in arrangement and size between the living and dining functions. (Copyright © Peter Aaron/Esto.)

areas or eating counters, which can be designed in a number of ways within the kitchen, are also very popular, primarily for quick meals (Figure 8.12). The occupants' living patterns should dictate whether the eating areas will be formal or informal, how much space should be made available, and the type of equipment to be utilized, and what furniture to select. For instance, dining tables and chairs are of various sizes and shapes and can be arranged in many ways (Figure 8.13).

FIGURE 8.12 Eating counters adjacent to or within kitchen areas are popular for breakfast, quick meals, and social interaction with the cook(s).

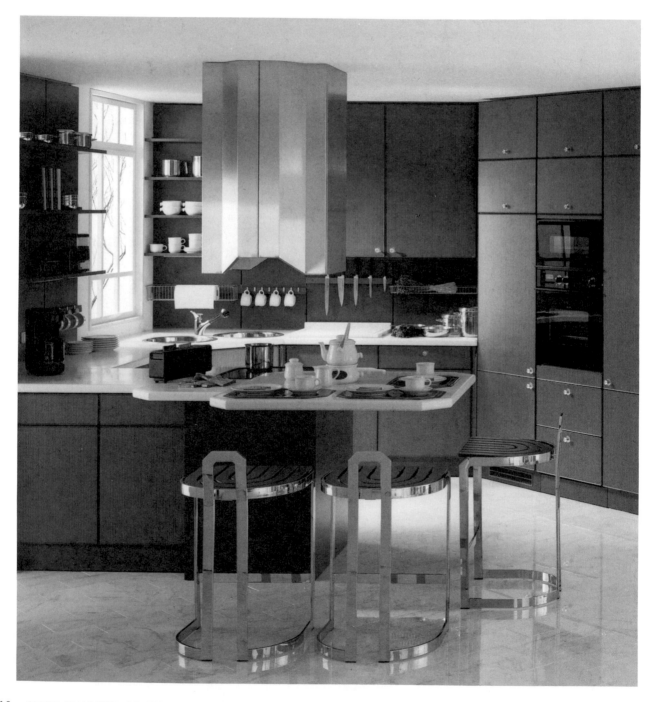

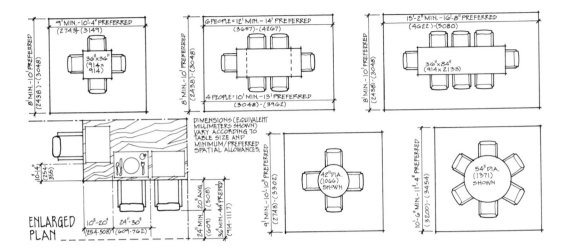

Private Zones

SLEEPING SPACES

In addition to allowing us to meet the basic biological necessity of sleeping, the bedroom provides a place for quiet meditation or rest, for retreating from the pressures of everyday life—work, the outside world, and even family interactions. The space is often used for reading, contemplating, and sexual expression. The bedroom has further become associated with being a very personal or private area where people keep their intimate or personal items, such as jewelry, important papers, money, and other valuable or memorable keepsakes. In fact, the bedroom (and adjacent dressing/bathing areas) has become a "retreat" to many people because of its furnishings, size, and separation from the rest of the house. This is not the case, however, in many other cultures and other parts of the world where the sleeping area is an integral part of the living spaces. In Japan, for instance, many families roll out mats on the floor for sleeping, roll them up in the morning, and store them out of the way so that other activities can take place in the same space.

The bedroom has undergone many changes throughout history. The sleeping platform, or bed, has actually been around since Egyptian times. Since then, the bed has taken almost every shape, style, dimension, and importance imaginable. During some periods, such as the fifteenth and seventeenth centuries, beds were not only very elaborate but were also used by the host or owner to receive guests and even conduct business. Now we have beds filled with water, air, foam, and springs. We also now have available specific types of beds, such as adult beds, children's beds, bunk beds, cribs, daybeds, convertible beds, and even beds built into the structure of a room.

Bedrooms or sleeping areas are often isolated from the rest of the house or zoned into "quiet" areas to maximize privacy and the needs associated with sleeping. Residences are usually classified as one, two, three, or more "bedrooms," denoting the number of sleeping spaces the structure has. Some dwelling units have no "formal" bedrooms but instead have designated sleeping areas, such as lofts. Other small dwellings may have convertible beds, such as the Murphy bed, that are pulled out specifically for sleeping and put away when other activities are taking place (Figure 8.14).

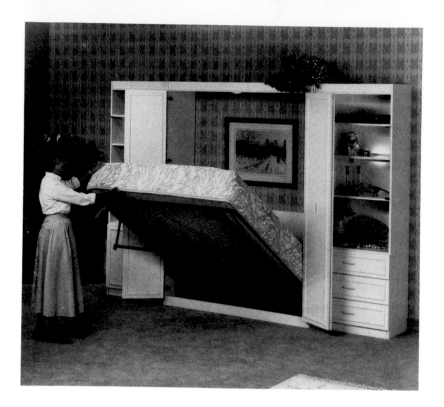

FIGURE 8.14 This foldout queensize bed provides additional floor space in a small room when it is put away into its cabinet.

Sleeping spaces have some basic requirements. Physically, the sleeping area, including the bed and related furniture, should be comfortable for the specific activity of sleeping and should be conducive to relaxation. Sometimes, the room needs to take on an almost opposite character in the morning, when the occupant is ready to rise and "jump out of bed" to start the day, perhaps by performing calisthenics. The visual makeup of the room and even its outside views (where possible) should be restful/peaceful to the eye or controllable. It should have the appropriate environmental controls for isolating noise, temperature, and light, both natural and artificial. Psychologically, the sleeping area can take on other attributes, such as providing us with intimate privacy and even individualistic expression. It is important to realize that a client may select interior furnishings that seem quite irrational or very different from what the designer proposes; this is often a result of a person's individualistic desires and private sleep-related needs or routines.

Bedrooms or sleeping areas can vary in size and physical layout. Consideration should be given to the number of people, their ages, and the various functions the space will serve other than just sleeping. Today's trends toward smaller dwellings, more efficient use of space, and modular furniture have influenced a move toward smaller bedrooms. Several housing and government authorities have specified minimum sizes for bedrooms; however, it is not the size of the space that is important but how effectively it is planned. In general, the area or room should be large enough for the bed, circulation around it, making the bed, and appropriate clearances for other furniture (Figure 8.15) and activities. Every sleeping room should have at least one window for fresh air and to be used as a fire escape. Most building codes require this for the health and safety of the occupant.

Bedrooms are also used as studies or small offices by some people. Inclusion of a working space with chairs and even a desk can make the bedroom more than just a sleeping space. We also find today's bedrooms serving a multitude of other functions, such as exercising or aerobic workouts (Figure 8.16).

FIGURE 8.15 Minimum clearances recommended around bedroom furniture and standard bed sizes.

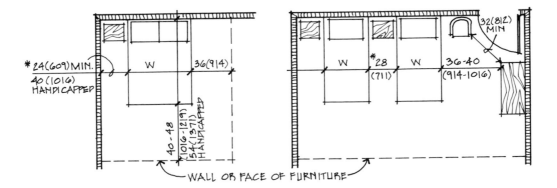

BED SIZES*				
TYPE	WIDTH		LENGTH	
	IN	MM	IN	MM
CRIB	30	762	53	1346
DAYBED	30	762	75	1905
TWIN	39	990	82	2082
DOUBLE	54	1371	82	2082
QUEEN	60	1524	82	2082
KING	72	1828	84	2133

* DIMENSIONS GIVEN IN INCHES.
(METRIC EQUIVALENTS SHOWN IN
MILLIMETERS).

MATTRESS HEIGHT FROM FLOOR
VARIES 14-18 INCHES (355-457 MM).

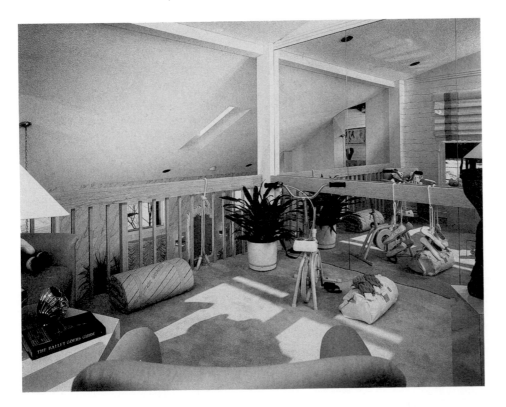

FIGURE 8.16 Many homes today have rooms or areas designated as exercise centers to support our needs for physical and mental well being. (Copyright © 1988 Norman McGrath.)

DRESSING AND CLOTHES STORAGE

Storage for clothing items is often located within a sleeping space or is readily available in an adjacent dressing area which also might contain lavatories. Typically, this storage is in a closet near the room entrance. Location of the closet needs to be convenient for all-day use.

Clothing closets are usually designed as either the linear type or the walk-in type, although variations of these basic styles exist. Each type has some minimum size and layout standards (Figure 8.17). Unfortunately, most closets in our dwellings are inefficiently designed and waste a lot of space by using just one hanging rod and a shelf. Such closets can be modified in many creative ways to better serve the users.

FIGURE 8.17 Closets can be designed as reach-in or walk-in enclosures and have many functional variations of shelving and hanging assemblies.

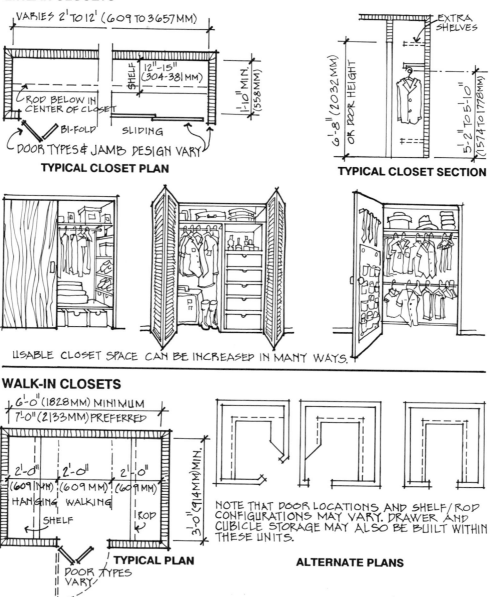

LINEAR CLOSETS

VARIES 2' TO 12' (609 TO 3657MM)

SHELF 12"–15" (304-381MM)

1'-10" MIN. (558MM)

ROD BELOW IN CENTER OF CLOSET

BI-FOLD SLIDING

DOOR TYPES & JAMB DESIGN VARY

TYPICAL CLOSET PLAN

EXTRA SHELVES

6'-8" (2032MM) OR RDR HEIGHT

5'-2" TO 5'-10" (1574 TO 1778MM)

TYPICAL CLOSET SECTION

USABLE CLOSET SPACE CAN BE INCREASED IN MANY WAYS.

WALK-IN CLOSETS

6'-0" (1828MM) MINIMUM
7'-0" (2133MM) PREFERRED

2'-0" (609MM) HANGING
2'-0" (609MM) WALKING
2'-0" (609MM)

SHELF ROD

3'-0" (914MM) MIN.

TYPICAL PLAN

DOOR TYPES VARY

NOTE THAT DOOR LOCATIONS AND SHELF/ROD CONFIGURATIONS MAY VARY. DRAWER AND CUBICLE STORAGE MAY ALSO BE BUILT WITHIN THESE UNITS.

ALTERNATE PLANS

As noted, some sleeping spaces provide a separate or distinct clothes storage area and dressing space, but generally the space for a person to dress or undress is near the closet or even in it. However, dressing is a distinct and separate activity that the designer should plan for—often in direct relation to the personal hygiene and grooming needs of an individual. The basic requirements of a dressing area are proper lighting, easy access to garments, space to dress either standing or sitting, and amenities related to dressing, such as mirrors, hooks, and a place to put on makeup or to wash. In fact, many master bedroom suites now place such importance upon dressing, grooming, and convenience of washing that these areas are often located in a distinct space between the sleeping area and the personal hygiene, or bathroom space.

Another important factor when planning dressing areas and clothes storage is the distinction between soiled and cleaned clothes and the handling of them. Clean clothing is organized and placed for retrieval, whereas soiled items should be placed in a convenient storage area (often a clothes hamper) or laundry chute for routine removal to the laundry area.

PERSONAL HYGIENE: BATHROOMS

Personal hygiene areas, or bathrooms, seem to have evolved more from an economic consideration than from psychological or anthropometric needs. For a long time, most dwellings had an economy bathroom with three fixtures: the lavatory (correct term for a bathroom sink), water closet (correct term for toilet), and bathing tub (or shower combination) in a room approximately five feet by seven feet (Figure 8.18). This classic example is still evident today in most

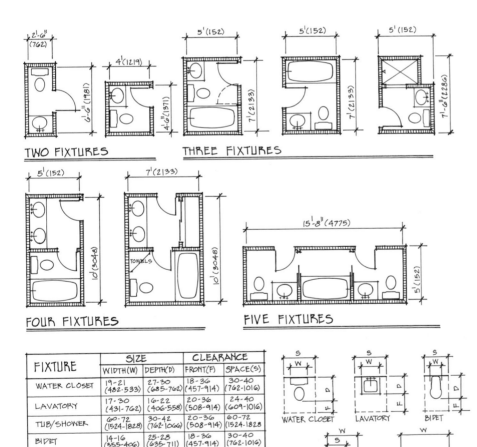

FIGURE 8.18 Basic bathroom and plumbing fixture arrangements.

FIXTURE	SIZE		CLEARANCE	
	WIDTH(W)	DEPTH(D)	FRONT(F)	SPACE(S)
WATER CLOSET	19-21 (482-533)	27-30 (685-762)	18-36 (457-914)	30-40 (762-1016)
LAVATORY	17-30 (431-762)	16-22 (406-558)	20-36 (508-914)	24-40 (609-1016)
TUB/SHOWER	60-72 (1524-1828)	30-42 (762-1066)	20-36 (508-914)	60-72 (1524-1828)
BIDET	14-16 (355-406)	25-28 (635-711)	18-36 (457-914)	30-40 (762-1016)
SHOWER	32-42 (812-1066)	32-48 (812-1219)	18-36 (457-914)	30-42 (762-1066)

DIMENSIONS SHOWN IN INCHES (AND MILLIMETERS)

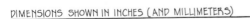

dwellings, with the fixtures all on one wall (to save plumbing installation costs) or rearranged in several ways depending upon the relationship to and size of the dwelling. Today, many individuals are fascinated with adding whirlpool baths, soaking tubs, hot tubs, saunas, and spas to their bathrooms, all of which encourage an appreciation of our bodies, the enjoyment of bathing, and the relaxation it can provide. Therefore, we find bathrooms becoming larger to accommodate more than the basic hygiene needs (Figure 8.19). Also, bathroom design has become more flexible and can accommodate more than one person at a time by compartmentalization.

FIGURE 8.19 Today's bathrooms receive a lot more attention and design than just serving our body needs.

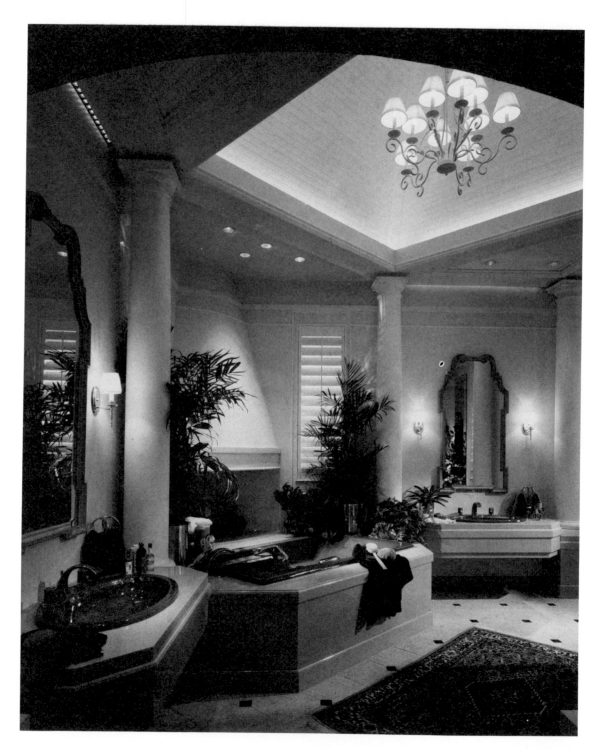

If a dwelling is to have only one bath, it is customary to locate it between group and private zones so that it can be reached from either area with a minimum of disruption. Most dwellings, however, have two or more bathrooms. The number of people occupying the dwelling and economic considerations vary the number. Some have half baths or three-quarter baths, which have two or three fixtures (substituting a shower for a tub) and are used in areas other than bedroom suites (Figure 8.20). Moreover, a wide variety of fixture arrangements is used, depending upon the function of these baths within the dwelling and upon available space.

FIGURE 8.20 Half and three-quarter baths are conveniently used in residences to provide more than one fully equipped restroom facility.

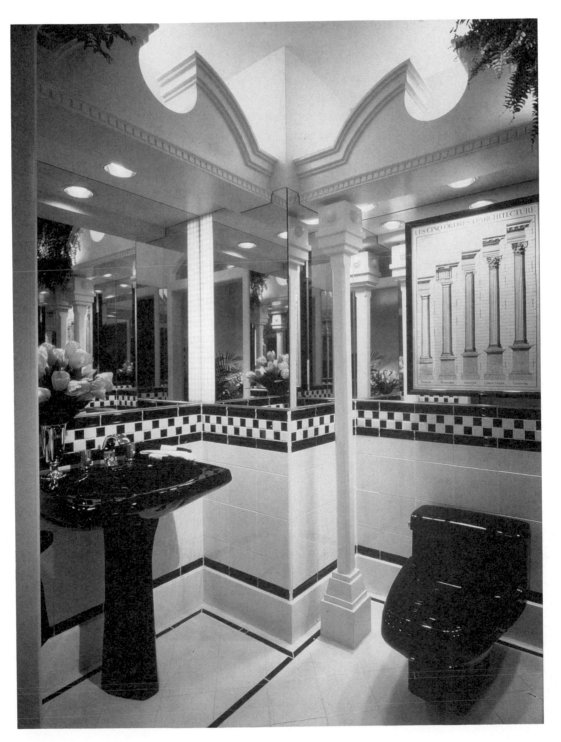

The doorway to the bathroom should be designed to visually shield the room if the door is left open. The room should have a window for natural light and ventilation; however, many building codes permit artificial light and mechanical exhaust fans if a window is not possible. Storage is also needed within the room for items related to grooming and hygiene. Bathroom fixtures are now made in all colors and shapes for individual preference.

Support/Service Areas

The support and service areas are the work areas of a residence. They are designed for food preparation, general storage, clothing care, and mechanical equipment storage. These areas are usually called the kitchen, laundry facilities, mechanical space (for heating and cooling equipment), and utility or storage space. The amount of space designated for these functions seems to have been decreasing over the last few decades because of increased construction costs and new technological developments in equipment. Much of our support equipment today is smaller, quieter, and cleaner than in the past. We can even find a laundry area that is similar to a closet and centrally located. The heating and air-conditioning equipment is also being put in a smaller space incorporated within the garage, crawl space, or unfinished basement.

ENERGY CONSERVATION, EFFICIENCY, AND RECYCLING

Of paramount importance in today's society and environments are the needs of energy conservation, efficiency, and recycling. Adding insulation to prevent heat loss and designing with energy-efficient heating and cooling systems can aid in reducing the amount of energy expenditures. The use of energy-efficient appliances and the recycling of food, packaging, and other seemingly "waste" materials can help preserve the environment and protect our future resources.

The support and service areas within residences can be designed and utilized to aid in the harmonious relationship with our micro- and macroenvironments. For example, today's utility areas and kitchens can be planned to include recycling bins and other features to help with the use and reuse of materials that can be effectively and efficiently recycled.

Because of increased construction and energy costs, service areas should be centrally located and grouped if possible. Plumbing fixtures for kitchens, baths, and laundry facilities should be placed back-to-back or stacked in multistory units whenever possible. It is also energy efficient to locate hot-water-producing areas close to the hot-water supply, since the shorter the run of piping, the more economically and the faster hot water is produced. These facilities are often grouped into a utility core. In some manufactured housing modules, the utility core contains all the equipment necessary to support the functions of cooking, bathing, laundry, heating, air-conditioning, and water heating. These modules are produced in standard sizes, shipped to the site in one unit, and installed.

LAUNDRY

The laundry area is sometimes placed close to the source of soiled pieces and the storage of clean ones. However, it should be located where it is most convenient for the user to do the work during normal routines.

The laundry area should be designed with convenient and functional space for the washer and dryer—if so equipped. It is ideal to provide a sink, counter space for folding clothes, and

storage cabinets for detergents and miscellaneous items. Many laundries also serve a number of other activities, such as ironing and sewing (Figure 8.21).

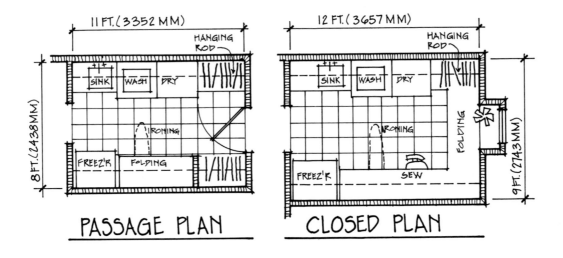

FIGURE 8.21 Laundry rooms can serve more functions than their name implies. Ironing, sewing, and storage can also be incorporated into this space.

FOOD PREPARATION AREA

In its earlier development the purpose of a kitchen was for the preparation of food and for family members to keep warm in front of a big open fire during winters. The kitchen often served as center of family life, accommodating family gatherings and being used for entertaining visitors and other activities.

With technological advancements, different sources of heat for the entire house were developed and new heat sources were created solely for the preparation of meals. The kitchen then became an isolated room designed for the specific function of preparing food. In the eighteenth century the kitchen stove was developed; it was the standard cooking mechanism until the arrival of the iron coal range. About the nineteenth century the icebox and water pumps were placed inside, and by the end of the century the kitchen was generally located at the back of the house. During this time the kitchen was generally considered a place that only the food preparer or servants used and was to be sheltered from the view of guests and even the owners.

In 1841, Catherine Beecher published a study on domestic kitchen planning in which she pointed out that domestic services should be compacted to utility cores for convenience and time-saving efficiency. From this point on, the kitchen developed into the center of family activities—efficient, an electric powerhouse, and a status symbol that many homeowners are proud to show. Most kitchens today are large enough to accommodate two or more cooks at one time so that food preparation duties can be shared. Manufacturers are continually redesigning kitchen appliances and equipment to make them more efficient and attractive (Figure 8.22). Studies have also been conducted on tasks performed in the kitchen, as well as on the location of work centers, their design, and their relation to changing life-styles. A well-planned kitchen can save time and energy and enhance the value of a house.

The kitchen should be located near the areas where food may be served. The kitchen should also be accessible from the service entry, parking area, or garage for the convenience of transporting food items to and from the area.

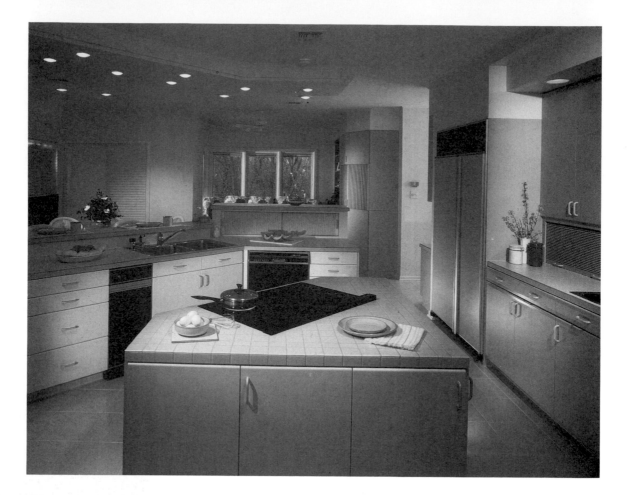

FIGURE 8.22 Gay Fly designed this kitchen with several activity centers in order to accommodate more than one cook. It is also open to the breakfast and dining areas to encourage socializing during meal preparation.

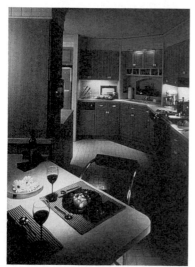

FIGURE 8.23 Ample counter space is provided between the refrigerator and sink in this kitchen to facilitate the food retrieval, preparation, and re-storage sequence.

ACTIVITY CENTERS How efficiently a kitchen functions depends on the placement of its activity centers. These centers are governed by the activities that are to take place and the major appliance that will be utilized in the task. Activity centers used to be confined to the sink/clean-up center, the cooking center, the cold storage center, and the mixing center. With technological developments (along with changes in living patterns), the design and functions of the kitchen have changed drastically. For example, with the popularity of microwave ovens, cooktops, and double ovens, there may be several cooking centers instead of just one.

The *refrigerator/food storage center* (Figure 8.23) is generally both the first and the last in the food preparation sequence; that is perishable food is taken out of the refrigerator or storage center first and is put back in during the cleanup task. In addition to the refrigerator (and freezer), this center requires at least 18 inches (457 mm) of counter space on the latch side of the refrigerator door for placing food items. If a freezer is incorporated within the kitchen, it would also be located in the refrigerator center. Generally, however, large freezers are placed in a storage or utility room, basement, or garage, since they may not be used on a daily basis and can occupy valuable space that could be more efficiently used.

The *sink center* (Figure 8.24) is the area utilized for washing food and utensils and providing water. The sink center is usually placed between the cooking and the mixing centers. On

the other hand, the sink center is also closely related to the refrigerator center, generally where fruits and vegetables are stored before being brought to the sink for cleansing. It is important for the sink center to be close to the dish storage area for ease of putting dishes away. Because of all the activities related to the sink center, sometimes two sink centers are used. The needs of this center or these centers are:

- A sink or sinks, the design depending upon the size and needs of the family and upon the available space. Sinks are available in single, double, or triple units, with a central compartment for the waste disposal equipment. If space is limited and a dishwasher is incorporated, a large single sink will usually suffice. Sinks are made of enameled metal (cast iron or steel) or stainless steel.
- Counter space should be provided on both sides of the sink and be at least 18 inches (457 mm) wide in a small kitchen with limited space, although 24 to 36 inches (609 to 914 mm) would be more efficient.
- A dishwasher is almost as standard an item today as a sink. It should be located as close as possible to existing water supply, drainage, and the sink and should be easily accessible to dish storage. Personal preference and space availability will dictate whether it is placed to the left or right of the sink.

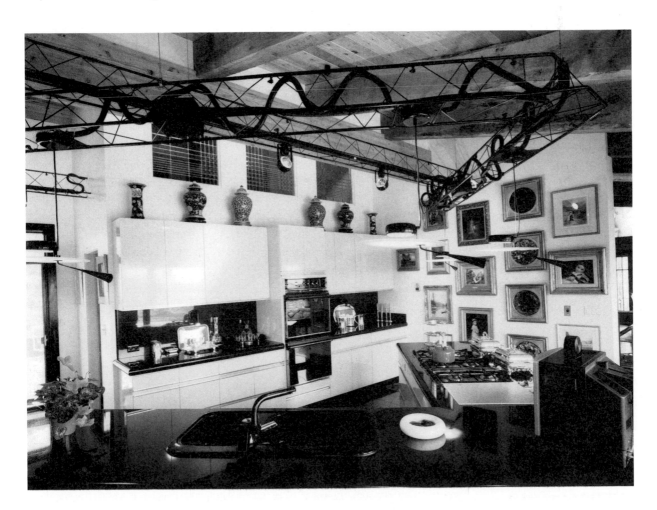

FIGURE 8.24 Today's kitchen sinks are designed to incorporate a number of activities beyond washing utensils and foods.

- Storage space is also necessary for equipment such as cleaning, cutting, and peeling utensils. The storage space should also have provisions for dish storage nearby.
- Trash and garbage needs, including a waste disposal in one of the sink compartments and possibly a trash compactor or recyclable bin, must also be considered.

The *cooking center* (Figure 8.25) is probably the most active center in the kitchen and should be located near the sink and mixing center and convenient to the eating area. With the development of new equipment the cooking center has often expanded to two or more areas, such as a main cooking area where the oven(s) and surface cooktop are located and another area that includes a microwave for quick cooking and/or thawing. The cooking center(s) should include:

FIGURE 8.25 The cooking center in a kitchen should provide for a variety of surface, oven, and microwave cooking needs—as well as adequate counter area and exhaust/ventilation needs of the equipment. (Reproduced with permission of the copyright owner: General Electric Company.)

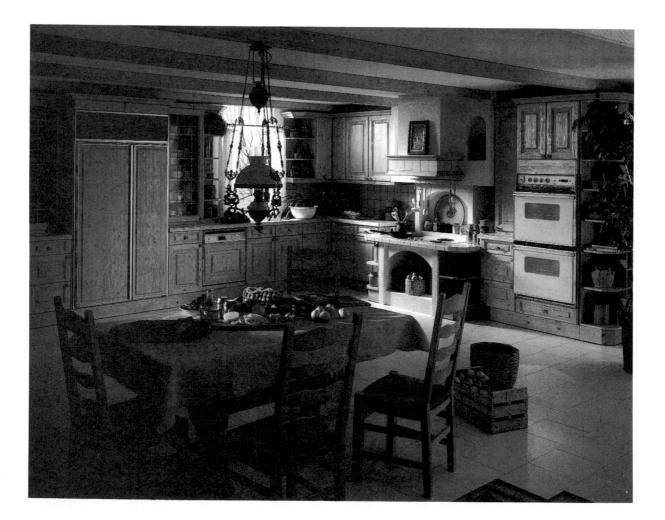

- Surface cooktop units, either incorporated into a range or installed separately. Cooktops are available with gas, electric, or magnetic induction burners. Developments in cooktops include a smooth, ceramiclike top with conventional electric resistance heat. Quick cleanup is an advantage to these units; spilled liquids or food is easily removed.

Another development is the cooktop that incorporates a barbecue grill or a griddle. Two-, four-, and six-element units are available, along with useful extras, such as a rotisserie or a wok.

- An oven or ovens can either be incorporated below the surface units or separate from the cooking surface. Ovens can be built in over the cooking units or in the wall to eliminate stooping. Convection cooking ovens, in which warm air is continually circulated around the food by a small air-moving device, offer the benefit of operating at a lower temperature.
- Microwave ovens are available in many forms and sizes and can be a portable unit that sits on the counter, or on a cart or can be built in as a wall unit. These ovens might even be incorporated within a conventional range/oven unit and located above the surface cooking units.
- Counter space for conventional ovens with surface units or separate surface cooktops should be 18 to 24 inches (457 to 609 mm) on each side. If a separate built-in wall oven(s) is incorporated with this center, 24 inches (609 mm) of counter space should be provided on at least one side.
- Adequate ventilation must be provided for the cooking surface, whether by an exhaust fan to the outdoors or by a recirculating/cleansing unit.

The *mixing center* consists primarily of counter space and storage space and could be located between the sink and refrigerator or adjacent to the cooking center (Figure 8.26). It should incorporate:

- Uninterrupted counter space at least 36 inches (914 mm) wide and from 30 to 36 inches (762 to 914 mm) high, depending on personal needs and physical limitations of the user(s) (Figure 8.27);
- Wall and base cabinets to provide storage for various packaged food, cookbooks, small tools, bowls, pans, and small appliances used in mixing.

FIGURE 8.26 The mixing center in a kitchen should provide abundant counter space, storage of equipment, and adequate lighting.

FIGURE 8.27 Dimensions within a kitchen are based on the height and reach of average-sized individuals who would use the room most frequently.

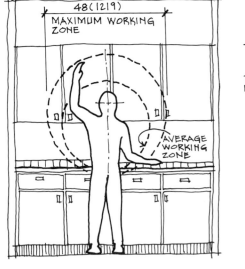

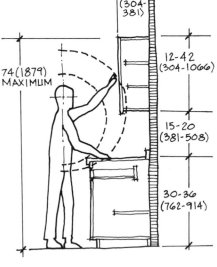

ELEVATION

SECTION

PLAN

The *serving center* is often integrated with the cooking center and should be located near the eating area. The serving center consists mainly of storage and counter space as follows:

- Ample cabinet space for items, such as dishes, flatware, and linen, that go directly to the eating area;
- A 24-inch-wide (609 mm) counter to facilitate serving.

Other activities that may be incorporated within the kitchen (depending on personal needs, preference, and life-style) include a planning or study area. This area may need adequate storage space for cookbooks, recipes, and perhaps even a personal computer.

ARRANGEMENT AND LAYOUTS. The most appropriate organization of the activity centers within a kitchen depends primarily on the work habits of those using it. However, some basic plans and guidelines have been developed and researched for efficiency and time-saving energy. An average meal generally requires six steps: planning, storage, preparation, cooking, serving, and cleanup. The work triangle was developed to help plan a convenient layout (Figure 8.28) for meal preparation. It is an imaginary line drawn between the three main activity

FIGURE 8.28 Of the four basic kitchen layouts, the U-shape is generally the most efficient and not disrupted by unwanted traffic into the work space.

LINEAR PLAN

LINEAR PLANS TAKE UP MINIMUM SPACE, BUT CAN REQUIRE A LENGTHY WORK TRIANGLE. THEY CAN BE CONCEALED BEHIND FOLDING DOORS.

CORRIDOR PLAN

CORRIDOR PLANS CAN PROVIDE EFFICIENT WORK CENTERS, BUT MIGHT HAVE UNWANTED TRAFFIC THROUGH THE WORK AREA.

U-SHAPE PLAN

U-SHAPED PLANS ARE USUALLY THE MOST EFFICIENT AND CAN KEEP UNWANTED TRAFFIC OUT OF THE WORK AREA.

L-SHAPE PLAN

L-SHAPED PLANS CAN BE MORE COMPACT IN THE WORK AREA THAN LINEAR PLANS AND DIVERT UNWANTED TRAFFIC.

centers within the kitchen: refrigerator/food storage, sink/cleanup, and cooking. The triangle concept is meant to be used as a general planning guide, not a hard-and-fast rule. Studies have found that the most frequently traveled path is between the sink and the range. Therefore, it follows that this leg of the work triangle should be the shortest, from 4 to 6 feet (1,219 to 1,828 mm), to save time. The next most traveled path is between the refrigerator and the sink, and the least traveled path is between the range and the refrigerator; therefore, it is generally best to locate the sink between the range and the refrigerator. The built-in oven and microwave do not really fit within the work triangle. However, they should be located so they are easily accessible to and not too far away from the cooking center. The basic kitchen arrangements are one-wall (or pullman), two-wall (or corridor), L-shape, and U-shape. Variations of these include the island and peninsula arrangements.

Distances between the activity centers should be kept short and as direct as possible so that time and energy spent while working will be minimized. The work triangle is recommended to be no more than 22 feet (6,705 mm) for the total of the three legs, with a maximum of 12 feet (3,657 mm) and a minimum of 4 feet (1,219 mm) per leg. Traffic (other than the cook or cooks) should be routed around or outside the work triangle. For this reason, the L-shape and U-shape arrangements are considered the most efficient.

HUMAN PERFORMANCE SPACE. If the quality of interface between the user and the components of the kitchen is to be adequate, the components must be responsive to the physical limitations of the human body. Of critical importance in work comfort are the height of a kitchen counter, the clearance between cabinets and appliances for use and circulation, the accessibility of overhead or undercounter storage, and proper visibility.

Standard manufactured cabinets with an attached countertop are usually 36 inches (914 mm) high, but this standard height is not necessarily comfortable for all users and all tasks. Shorter people may find the upper shelves in wall cabinets completely inaccessible. Flexible or adjustable kitchen cabinets could be more usable not only for the shorter or the taller person but also for the handicapped and the elderly. Figure 8.27 shows the amount of space necessary to perform comfortably within the kitchen. As discussed later in this chapter, most multifamily housing is now required to have one or more units either specifically designed for the handi- capped or built as "adaptable."

Transitional Spaces and Circulation

The entry into a residence is one of the transitional spaces that connects the outdoors to the indoors. This area can make a powerful statement about the architecture of the space and the inhabitant's values (Figure 8.29). Unfortunately, most residences tend to simply have a front door, which opens immediately into the living space and creates intrusion each time the door is opened. A properly designed entry should accommodate not only the inhabitants but friends and strangers (such as a delivery person).

ENTRY AREAS

Entries are classified as primary (or, more commonly, front) and secondary. The primary entry is mostly for guests and strangers. In fact, it may be seldom used by the occupants, who might instead use a secondary entry from the side or garage. To provide a sense of security and to prevent surprises, most entries have either a window or a peephole to peer out of. To conserve energy, many homes are being designed with an air lock or entry vestibule to prevent the harsh

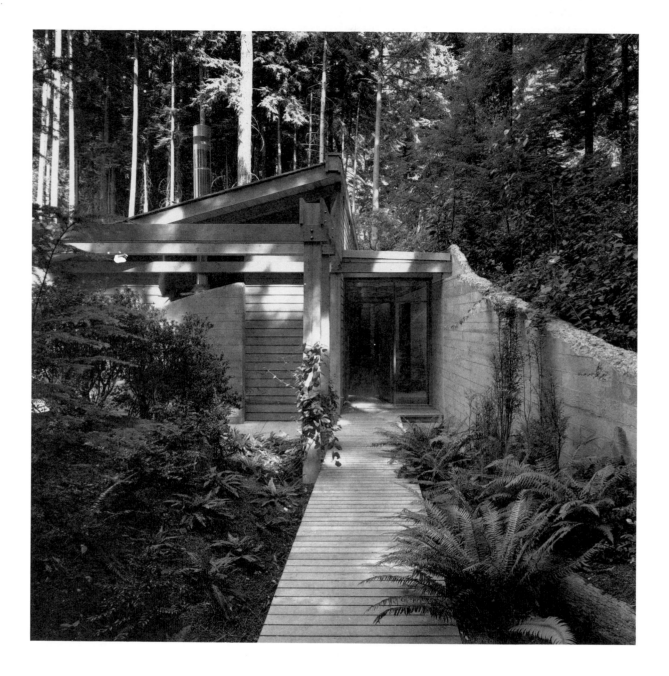

winter cold or summer heat from entering the residence each time the door is opened (Figure 8.30). Either within these vestibules or close by, closet space and a settee can be made available to place outer garments and remove muddy shoes.

Secondary entries are located to provide convenient access from support or work spaces. Formerly called service entrances because they were used primarily by servants, today these secondary exits can also double as emergency escape routes directly to outdoor areas.

FIGURE 8.30 Energy efficient homes are often designed with a vestibule (used as an air lock) to minimize heat transfer between the interior spaces and exterior each time the front door is opened.

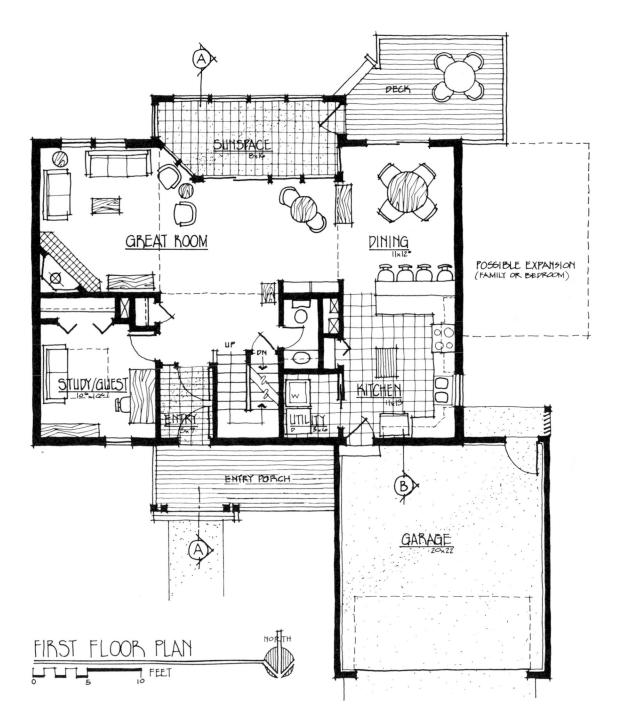

FIRST FLOOR PLAN

0 5 10 FEET

NORTH

HALLWAYS AND STAIRS

Circulation between areas in a residence is accomplished in a number of ways. Hallways or corridors often function as horizontal connections between areas. In poorly designed floor plans, these become long, narrow avenues to go from one space to another. Many of these halls are created primarily because the designer has not solved the relationship of spaces. Hallways should not be added to solve a circulation problem; they are a distinct kind of space and should be

treated as an experience to travel down—not as a tunnel leading to various spaces. The addition of windows, lights, ceiling changes, artwork, and even sitting areas can increase the pleasantness of a hallway (Figure 8.31).

Although primarily a functional element for circulation between floor levels, a stairway can be designed to supplement the architecture and spatial feelings experienced when traversing between floor levels (Figure 8.32). Stairway design is discussed in Chapter 15.

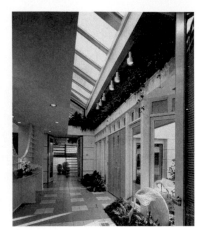

FIGURE 8.31 The entry foyer at the Pella Idea House is also a corridor that connects several spaces. In addition to its function, it also incorporates many design features that make it a striking interior.

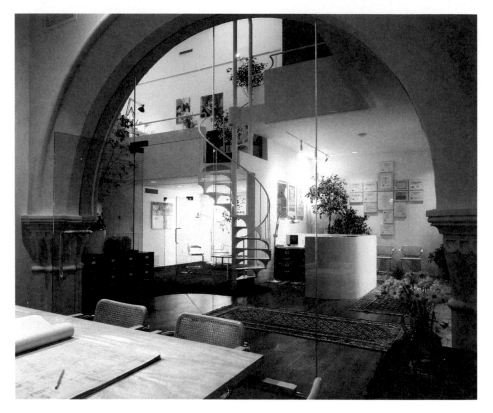

FIGURE 8.32 Stairways are primarily functional in nature but can also be a major design statement within an interior. (Copyright © 1983 Steve Rosenthal Photographer. Architect: John Sharratt Associates, Inc. Stair: Boston Design Corporation.)

Ancillary Spaces

Many ancillary or specialized spaces in residences can be placed in the social, private, or service zones. Although these special-purpose areas are not a basic necessity to every residence and person, they can add to the quality of life and enhance the use of the residence. If a designer has not planned for them, many inhabitants will make space for them or create them within existing areas. They are categorized here and might include:

- Screened porches and sunspaces for relaxing or socializing (Figure 8.33). These can incorporate hot tubs or spas.
- Hobby rooms or workshops. These come in every imaginable fashion, size, and location, depending upon the occupants' needs.
- Game rooms for small or large groups. These can accommodate table tennis, billiards, other table games, and a variety of other activities.

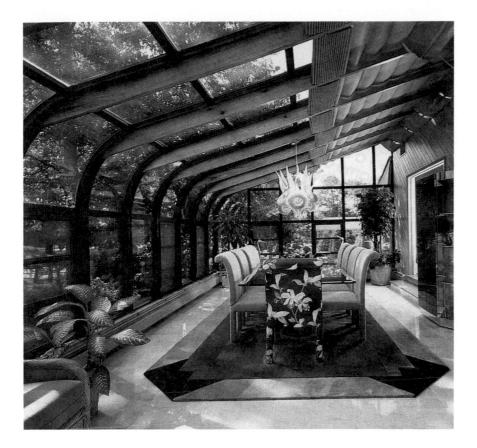

FIGURE 8.33 Sunspaces can be an effective way to extend interior spaces to the outdoors yet provide control for daily and seasonal fluctuations in the natural climate.

FIGURE 8.34 Outdoor spaces can be designed to provide many amenities to a residence by extending the living spaces visually and functionally to the exterior.

- Garages for one or more vehicles. These spaces can also house bicycles, boats, snowmobiles, workbenches, and the like.
- Outdoor spaces. These can be as simple as a small deck (Figure 8.34) or balcony or as large as a backyard patio including a swimming pool.

SPECIAL HOUSING TYPES

Our discussion of space planning for residences has centered primarily around the "average" person. In today's society, we know that that person comes in many sizes, ages, and physical abilities. A concentrated effort is now being made to address the specific issues of designing for the handicapped (including for individuals with temporary disabilities), the elderly, and other special populations. (See Chapter 10 for more specifics on barrier-free access.)

Many of the dimensions, spaces, floor changes, and materials we discussed do not serve all the needs of these special groups. For example, doors, hallways, and floor-level changes need to be designed to accommodate people in wheelchairs and other physically disabled people. Countertops need to be lowered (28 to 30 inches, or 711 to 762 mm) and clear space provided beneath them for wheelchairs or other seating units. Storage, light switches, and other items need to be lowered and specifically designed to match the physical ability or impairment of the user.

Accessibility and Adaptable Housing

Accessibility in housing and other buildings refers to the physical features that allow those structures to be accessible to and usable by people who have physical disabilities. Accessible buildings allow a handicapped person to enter, use, and escape (in an emergency), which requires special design considerations. Typically, accessible housing designed for the physically disabled person was constructed with all the dimensional and material requirements in place. To make a large proportion or an entire multifamily building in this manner could be limiting both in economics and marketability. Today, we see many residential units designed as "adaptable" housing. These environments contain the mechanical and structural features that allow the units to be readily converted for use by disabled occupants and back again if necessary.

Many adaptable and conventional housing units are similarly designed, making a commonality that is easily marketable. The American National Standards Institute (ANSI) has produced publications that set residential and commercial standards for accessibility and usability for the physically handicapped. Some of these that apply are illustrated in the Appendix.

Housing for the Elderly

Housing for the elderly should be located where there is activity and in areas suitable for residences. In the past, too many of these facilities have been isolated or located in places not conducive to the elderly for everyday activities, such as shopping, walking, socializing, and other community involvement.

Many dwelling units for the elderly are designed to be accessible and are similar to environments for the physically disabled. Many elderly residents of housing projects have some degree of financial or physical inability to maintain a single-family home or to continue their daily routines without some assistance. Housing for the elderly ranges from full-care nursing homes to facilities that provide minimum monitoring or assistance, such as retirement homes.

REFERENCES FOR FURTHER READING

Allen, Phyllis A. *Beginnings of Interior Environment.* 5th ed. Minneapolis: Burgess Publishing Co., 1985.

American National Standard for Buildings and Facilities—Providing Accessibility and Usability for Physically Handicapped People. A117.1-1986. Washington, D.C.: U.S. Department of Housing and Urban Development, 1986.

Ching, Francis D.K., and Dale E. Miller. *Home Renovation.* New York: Van Nostrand Reinhold Co., Inc., 1983.

Conran, Terence. *The Bed and Bath Book.* New York: Crown Publishers, Inc., 1978.

———. *The Kitchen Book.* New York: Crown Publishers, Inc., 1984.

Curran, June. *Drawing Home Plans.* New York: McGraw-Hill, 1979.

Faulkner, Ray Nelson, et al. *Inside Today's Home.* New York: Holt, Rinehart and Winston, 1986.

Faulkner, Sarah. *Planning a Home.* New York: Holt, Rinehart and Winston, 1979.

Hoke, John Ray, Jr., ed. *Ramsey/Sleeper Architectural Graphic Standards.* 8th ed. New York: Wiley, 1988.

Keiser, Majorie Branin. *Housing: An Environment for Living.* New York: Macmillan, 1978.

Kicklighter, Clois E., and Joan C. Kicklighter. *Residential Interiors.* South Holland, Ill.: Goodheart-Wilcox Company, Inc., 1986.

Kira, Alexander. *The Bathroom.* 2nd ed. New York: Viking Press, 1976.

Nielson, Karla J., and David A. Taylor. *Interiors: An Introduction.* Dubuque, Iowa: Wm. C. Brown Publishers, 1990.

Panero, Julius, and Martin Zelnick. *Human Dimensions and Interior Space: A Source Book of Design Reference Standards.* New York: Whitney Library of Design, 1979.

Reznikoff, S.C. *Interior Graphic and Design Standards.* New York: Whitney Library of Design, 1986.

St. Marie, Satenig S. *Homes Are for People.* New York: Wiley, 1973.

Weale, Mary Jo, et al. *Environmental Interiors.* New York: Macmillan, 1982.

SPACE PLANNING OF COMMERCIAL INTERIORS

Space planning for both residential and nonresidential spaces is similar in process, but unique characteristics of planning are needed in each area.

Commercial spaces generally are defined as those that serve a user in carrying out a job or making a living. The commercial world is a complex place where people are employed in a variety of different kinds of work, often totally within interior spaces. These spaces include offices, banks, retail, hospitality, healthcare, institutional, and public, as shown in Figure 8.3.

In discussing residential design (Chapter 8), we noted that the designer and the client work closely to develop a personal environment that serves the functional needs and personal tastes of the occupant (the client). In commercial design, the client may not necessarily be the user; executives, employees, and other workers utilize the space. Commercial interiors also tend to be larger and more complex—sometimes ranging to multilevels and thousands of square feet. It becomes very important, then, to plan these projects after a systematic and careful analysis of the users' needs and the creation of a design that in turn supports the business activity and "image" of the client.

OFFICE DESIGN

Let's first select the area of office planning as a model to illustrate the steps in space planning. This is a good example to begin with since more than half of the interior design firms are involved in office planning and design, compared to those executing residential work. This trend will continue to grow as the need for office space increases along with growth in population and business activities.

Space planning and office design has become complex and is rapidly evolving, reflects the changing relationships of the organization occupying the space and the technology used to carry out the work. When people hear the word *office*, no longer do they associate it with the open bullpens of the past, with typewriters and telephones clattering throughout the spaces and desks lined up in seemingly endless rows. Today's office (Figure 9.1) is conceived as a total environment

FIGURE 9.1 Today's offices are designed not only to serve basic business functions but also to provide an environment that meets the users' human needs and aspirations.

and is very different from past examples. We now find office workers and executives in modern, efficient, and unique "workspaces" and better-designed environments. The restructuring of business organizations and computer technology have further revolutionized the working and design of offices. The computer, with its ability to quickly process, store, and transmit information, has changed the way people do business—doubling and tripling their business transactions and productivity. More workers are now moving into white-collar and management positions, producing and processing information or providing services rather than goods or products.

These rapid changes in work patterns and environments will present more complex situations to interior designers as they seek to provide well-designed work environments responsive to people and their machines. As the automobile changed and shaped our cities and lives, so has the computer modified our offices.

Historical Development

Office planning has undergone several conceptual and physical changes in using interior space throughout history. At the beginning of the century, most management and executive offices were enclosed, with each accommodating one person. These individual offices multipled throughout the industrial period to include staff and administrative people.

One of the most common historical concepts in office planning was the bullpen, or pooling, effect, which centralized the work force. People were placed in rigid rows of identical desks in large, open spaces. This gave some sense of order to the staff and no doubt reflected the authoritarian control of business managers. Administrative personnel were segregated into closed offices with windows to the outside and even windows overlooking the bullpen areas for visual monitoring of the staff. This separation of management and staff has existed for a long time in the office environment, and we can still find examples of these arrangements.

About the mid-1950s a concept emerged that reversed the typical approach that window status directly related to executive status. The administrators were shifted into offices near the center of the building (with windows facing the staff), and the other personnel were arranged in open spaces around the building's perimeter. This concept is still used today (Figure 9.2). This not

FIGURE 9.2 The Pacific Bell Administration Complex by SOM is designed for office workers to maintain a link with the outdoor spaces.

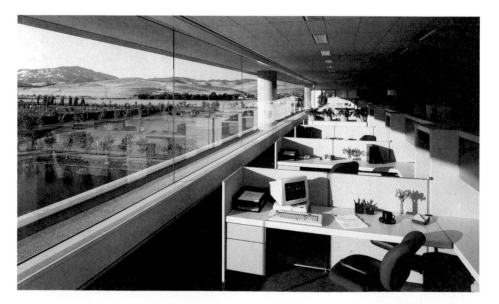

only was a shift in planning to bring more light into the building but primarily was an attempt to elevate the status of the staff worker and temper the elitist perception of the administrative staff. At about the same time, modular panel wall construction was developed, allowing some degree of flexibility in relocating offices. Although entire walls and windows could be dismantled, moved, and reassembled in another location, that was not a quick and easy task to accomplish.

OPEN PLANNING

The next phase in office planning was taking away walled offices and placing executives and staff in an open plan—strategically scattered around the building floor (Figure 9.3). However, a lot of these plans fostered the reemergence of executive status, with executives usually occupying the areas closest to the windows or at the corners of the windowed building. The open

FIGURE 9.3 Gensler and Associates created this office as open individual work areas without using full height walls. Offices at the perimeter are enclosed for privacy but incorporate glazing to permit exterior light to enter the building's center.

plan developed with an increased use of partitions and modular furniture. These open arrangements offered two important changes over former closed office plans. It was easier and cheaper to move furniture than to tear down private office walls and rebuild them; and this flexibility in arrangement also allowed for easier managerial controls in personnel replacement or changes or in regrouping workers periodically into "team" structures for increased work productivity.

OFFICE LANDSCAPE PLANNING

Office "landscape planning" was a concept introduced about 1959 by a consulting firm in Germany. The Quickborner Team specialized in the organization of paper materials and of products such as filing systems and furniture. The team members studied the workings and interrelationships of offices. They realized that the elements and the performance of an office are interrelated and should be dealt with concurrently in office planning. Office landscape planning is an approach that encompasses an organization's elements and interrelationships, both physical and nonphysical. The Quickborner group theorized that the placement of workers and their furniture (including equipment) is dictated by the flow of all types of communication as the office carries on its business activities. They believed communication among workers is easier in a physically open, partition-free space than in separate cubicles or offices. In turn, the decrease of emphasis on the status accruing to individual offices is said also to increase the overall office morale.

Designers often interchange the concepts of the open plan office with those of the office landscape; however, landscape planning is distinctly different. Open planning stemmed from opening up the traditional office, whereas the landscape approach defines physical space and people as functions of the organization's workings.

Office landscape planning often takes place as an interdisciplinary team approach. A planning team of representatives/consultants of the disciplines involved, as well as the users of the space, is organized. Teamwork becomes a critical factor to ensure that the process runs smoothly and satisfies all the organization's needs.

FIGURE 9.4 Comparison of a conventional closed office layout (left) and a landscape plan (right).

The office landscape's physical layout can seem confusing when a person first experiences it (Figure 9.4). Furniture, privacy screens, and equipment appear to be randomly scattered throughout the interior, with no apparent visual order or geometric rhyme to the arrangement. Circulation paths seem to have no clear avenues from one point to another. However, upon closer scrutiny, it becomes apparent there is indeed an underlying pattern relating directly to the communication flow within the office. As with the open plan, landscape planning's effectiveness is highly dependent upon the flexibility of the furniture for rearrangement, thus supporting

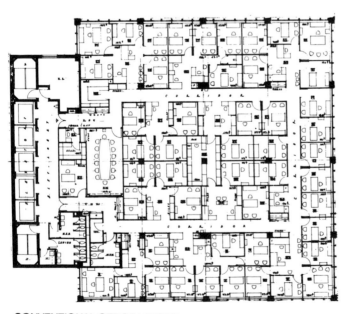

CONVENTIONAL OFFICE LAYOUT
FOR DU PONT'S FREON DIVISION;
WILMINGTON, DELAWARE

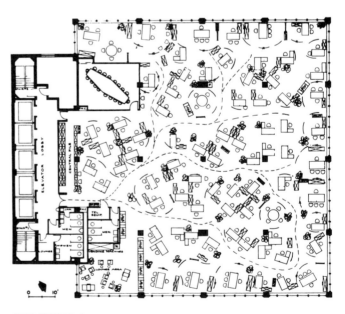

THE QUICKBORNER TEAM'S
OFFICE LANDSCAPE PLAN FOR
THE SAME PROJECT

changes. Landscape planning requires careful study by designers since noisy machines (and people) and loss of privacy can create havoc. In fact, acoustical considerations are of paramount important in these environments and in open planning.

Office landscape planning has had some acceptance by business organizations and designers. However, the introduction of the "action office" by the American researcher Robert Propst in the 1960s is probably more influential in creating the open plans today. His component system of writing surfaces, storage units, and other units replaced the traditional desks and credenzas.

Although open and landscape planning are widely used in office spaces, more conventional closed plans are also used. Paradoxically, the computer has not only changed office workers' patterns but has also often demanded more uninterrupted attention by the user—which leads to needs for increased privacy that are met through more acoustical and visual controls or simply by moving people back into closed offices. Office personnel can also communicate with one another through electronic devices rather than meeting face-to-face. In some cases, personal contact may occur only during breaks when employees gather for social interaction rather than business transactions.

Some prophets of electronic wizardry say that there is no future for office planning since offices are becoming obsolete. They believe that the increased use of communication, as well as wider use of computerization at the workplace, will allow a more decentralized work force and society. Workers can work just about wherever they choose, such as at home, in cars, or even on beaches. Their link to others would be through a computer/satellite communication network. We will undoubtedly see communication modes in the future that seem impossible to us today. Yet, people still require face-to-face communication. Offices will not disappear; they will become more adaptable to a particular life-style, merging the user and the environment.

Spatial Organization

Let's look at some of the specific steps of the design process in the space planning of a typical office interior. We will assume at this point that the program (discussed in Chapter 7) for our office example has already been generated and published for the designer's use as a guide for goals to be met in the design. The space planning step will be concerned with applying the program and generating schematic drawings to show the interrelationships of the business organization, its needs (physical and functional), and the shaping of the interior space necessary to accommodate the office organization.

The interior designer provides services to corporate clients in many different ways when planning office spaces. The client may have already selected or bought a building space. Sometimes, to assist in locating a potential existing interior space that appears to be appropriate, the interior designer provides the initial feasibility studies for a client. The interior designer might also be retained in the initial stages of designing new buildings to team up with other design professionals, such as architects and engineers, to plan a building that will have functional interior spaces.

The interior designer first analyzes the existing or proposed building's interior and makes note of inherent characteristics and square footages. Locations of building "cores," which include elevators, stairs, restrooms, communication links, and utilities, are noted. Today, we find available office space and shapes or footprints of buildings in almost every size and configuration imaginable (Figure 9.5). Spatial configurations, window placement, and available floor-to-ceiling heights of the building are studied to determine strengths and weaknesses. Another important character-

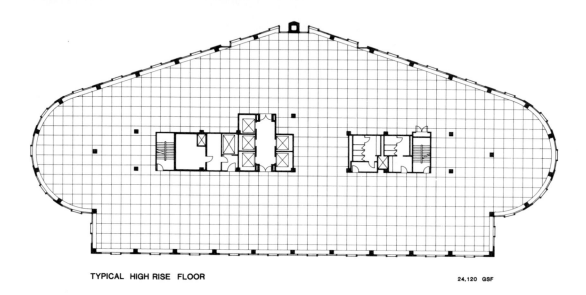

TYPICAL HIGH RISE FLOOR

24,120 GSF

FIGURE 9.5 The uniquely shaped floor plan of this office building by Kohn-Pedersen Fox Associates provides for some creative interior spaces not available in simple, rectangular building plans.

istic the designer looks for is the ability of the building space to accommodate possible expansion. Many buildings are constructed on a structural module that is subdivided into smaller units of one- to five-foot increments. Corresponding interior office sizes, and even the furniture size, are often matched to this module.

ADJACENCY AND CIRCULATION ANALYSIS

After the building's characteristics have been identified and studied, the designer begins to relate the client's program to the floor plan. He or she makes graphic drawings to represent the physical relationships of the office needs. Then adjacencies and functional relationships are diagrammed and eventually transposed into physical space containers. Three graphic tools the designer uses at this stage are the matrix, the bubble diagram, and the zoning diagram. These diagrams address concerns such as the circulation network and the need for spaces to be near one another. Spatial adjacency and circulation patterns involve factors such as the movement of people, material, and information.

MATRIX. A matrix diagram (explained in Chapter 7) is often used to determine relative importance or proximity of spaces to one another in the facility (Figure 9.6). If two different

FIGURE 9.6 A matrix can be an effective tool to prioritize required relationships within an office during the initial stages of design. These can be expressed by comparing the symbols where two areas intersect.

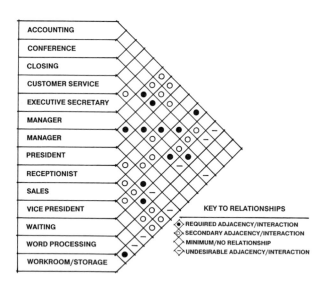

ACCOUNTING
CONFERENCE
CLOSING
CUSTOMER SERVICE
EXECUTIVE SECRETARY
MANAGER
MANAGER
PRESIDENT
RECEPTIONIST
SALES
VICE PRESIDENT
WAITING
WORD PROCESSING
WORKROOM/STORAGE

KEY TO RELATIONSHIPS

◆ REQUIRED ADJACENCY/INTERACTION
○ SECONDARY ADJACENCY/INTERACTION
✕ MINIMUM/NO RELATIONSHIP
⬦ UNDESIRABLE ADJACENCY/INTERACTION

spaces cross in the grid, the importance of their adjacency can be noted. It should be noted that sometimes the programmer has already translated much of the data into matrix diagrams and presented them in the written program. In this case, the designer refers to the program to assist in the drawing of the floor plan.

BUBBLE DIAGRAM. The bubble diagram translates the decisions recorded in the matrix into a more visual form. As discussed in Chapter 6, this diagram is made up of bubbles that represent each interior area, with lines connecting the bubbles that need direct linkage to each other (Figure 9.7). The bubbles do not attempt to scale the size of the spaces but represent a distinct unit and its working relationship to others. Although designers sketch bubbles as two-dimensional circular shapes on paper, the real concept implies a three-dimensional space. Students often have difficulty translating their two-dimensional bubble diagrams into three-dimensional space—because they were not visualizing in three dimensions in the first place. They were attempting to solve the function of the floor plan, not of the three-dimensional space.

The thickness of the lines connecting the bubbles can indicate the relative type or intensity of the connection between the activities in the spaces.

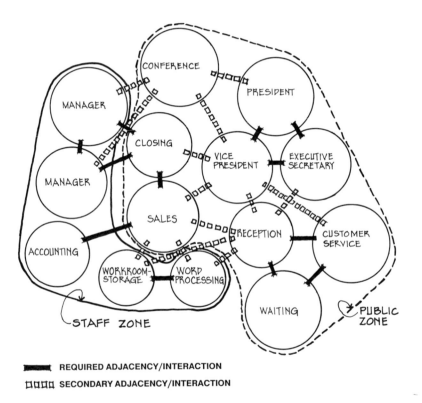

FIGURE 9.7 The relationships established in the matrix (Figure 9.6) are expressed in this bubble diagram.

ZONING DIAGRAM. The designer locates and identifies major areas or zones where various departments of a business might be located. In zoning diagrams, additional information is superimposed over the bubble diagram. The designer sketches several alternative layouts of zones to scale on the building plan and notes the advantages and disadvantages of each (Figure 9.8). For example, spaces can be grouped into noisy and quiet zones or public and private zones. Each time spaces are connected using a different grouping criterion, a new zone is made. In the design process (covered in Chapter 6), this is the ideation stage, looking for many different ways to lay out the overall office onto the building plan. The main and secondary circulation routes for people, equipment, and other communication avenues are defined.

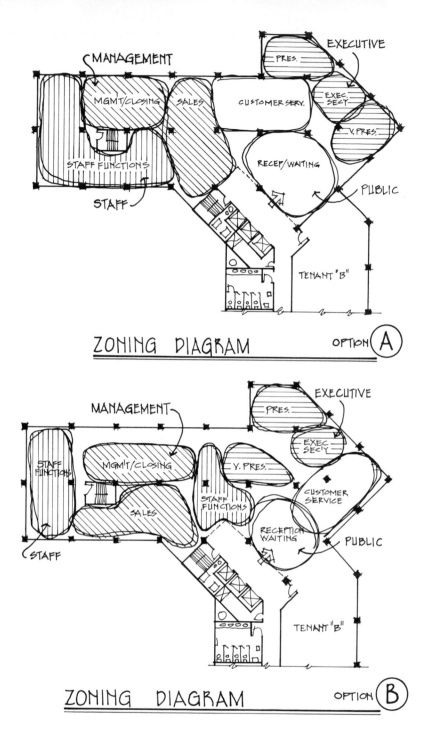

FIGURE 9.8 Zoning diagrams are made to explore comparative departmental layouts on the building's floor plan.

The zones are blocked out for each floor level, and an overall three-dimensional stacking diagram can be prepared for multilevel buildings. Such a stacking diagram is often prepared over a scaled building section to indicate which floors are grouped together for similar zones or adjacency needs.

Each zone of the plan is refined and detailed, with its interdepartment relationships and individual workspaces defined with regard to needs. These schematics are then translated into scaled preliminary plans to indicate how the interior space is to be utilized within the building (Figure 9.9).

FIGURE 9.9 A scaled preliminary floor plan is drawn to define the spaces, walls, openings (doors and windows) and functional relationships of the office. Furniture and other design features can also be added to assist the designer in presenting concepts to the client.

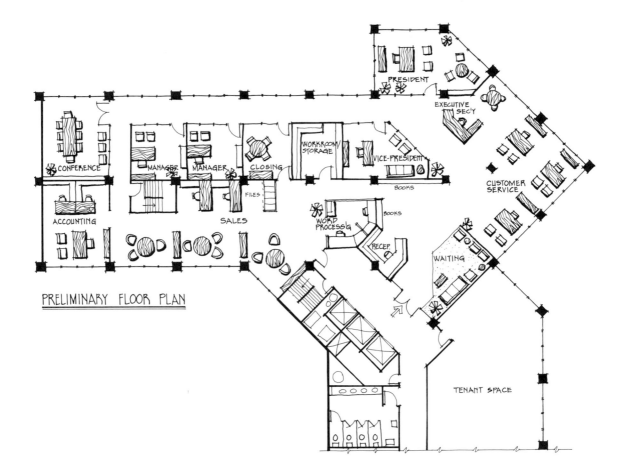

PRELIMINARY FLOOR PLAN

COMMUNICATION ANALYSIS

In a communication analysis, the interior designer produces diagrams representing the office's activities, paper-flow routes, filing systems, furniture/equipment allocations, and various other aspects from the program (Chapter 7). The purpose of this analysis is to track communication patterns to use as a basis for the layout, ensuring workflow and communication efficiency.

With the development of office technology and computers, communication and storage needs have changed in form. As automated equipment, such as word processors, microcomputers, laser printers, and electronic filing, becomes standard, the interior designer needs to address the ongoing challenge of integrating this hardware into the office environment.

Computer-aided design has permitted many design firms to quickly execute preliminary space planning on video screens and printouts. Computers in design offices are also programmed to move into the next phases of design development drawings, construction drawings, and even cost estimating as the plans are being drawn. Clients often seek the interior designer who can do tenant development planning and can produce design solutions in quick turnaround time to get a business office into a building. The computer has given the designer a tool to keep pace with the demands of office developments.

We have discussed how an interior designer analyzes a client's program, develops graphic concepts, and produces scaled drawings. Designers must also deal with other concepts, such as the

image or aesthetic appearance of the new space. A design might function very well but be visually unexciting or lack visual cohesion. With the efficient planning of the space, a designer must also search for the unique overall concept, or thread, that holds the idea together. For example, we might have a concept based on maximizing view and natural light for all employees in the space.

Typical Office Areas

Although each business office is a unique entity, there are some common denominators. The typical spaces are called areas rather than rooms. This is important since in today's open and closed office planning, a conference area can be a room or a modular group of furniture set within an open area of the building.

ENTRY AND RECEPTION

The entry to an office and the reception area are important design features that can project immediate impressions about the company and its interior spaces (Figure 9.10). The image of the firm is often set at this front entrance. Entries are usually designed around several functions that serve both visitors and staff. In addition, the entry must provide security and meet fire and handicapped access codes.

These spaces can be formal or informal depending upon the "face" the firm wishes to present to visitors. By greeting, providing directions for, and seating visitors, the receptionist exercises a control aspect that is an important ingredient in providing the office some degree of privacy and a minimum of disruption by outside forces. The reception area can be a convenient place for visitors to leave their coats and, if equipped with a table and chairs, it can serve as a small conference area.

FIGURE 9.10 The entry to an office establishes the image of the business and sets the design character of the spaces beyond.

CONFERENCE

Holding meetings is a necessity in business organizations, whether among the staff or with visitors. A firm may have one central space that everyone uses on a rotating basis, or there may be a series of smaller conference areas (Figure 9.11).

Conference spaces can be very formal or informal in arrangement and finishes to reflect the particular type and level of business discussions. For basic functioning, conference areas consist primarily of a table and chairs for two or more people. Other items, such as credenzas, storage, audiovisual equipment, sinks, bars, and lecterns, can be included to serve additional needs. Most conference areas require a high degree of audio privacy; that is, people in adjacent areas should not be able to overhear. However, if meetings are not expected to require total privacy, these spaces might be constructed as open or semiopen conference spaces.

FIGURE 9.11 The central conference room at Steelcase, Inc., in Tustin, California, establishes a strong identity for the firm. Its curved motif is accented by decorative neon tube lighting and recessed curved doors.

FIGURE 9.12 The executive office in this firm was designed by Gensler and Associates to reflect executive functions and status. The glass wall at the right provides acoustical privacy but allows light to enter the building's interior spaces. (Copyright © Peter Aaron/Esto.)

EXECUTIVE AND MANAGEMENT

The executive or management area is where policies are set and decisions made. This space is reflective of executive needs, and many times is spatially suited to the status of executives within the company organization (Figure 9.12). Executives may be spaced throughout the floor plan of a building or grouped together for efficiency of function and communication. Executive areas are supported by conference rooms or boardrooms, with space for executive secretaries within the suite. Interior budgets are usually increased for these spaces to project an executive image to visitors or to staff members. Depending upon the individuals and their needs (or desires), private washrooms, bars, and dining and entertainment facilities may be provided.

CLERICAL OPERATIONS

The workers' space or clerical operations areas should be designed to assist employees in performing their functions efficiently in a pleasant working environment (Figure 9.13). Some tasks may be repetitive and monotonous, but the space does not have to be. Office workers should be given some degree of control over their environment and a sense of "personaliza-

FIGURE 9.13 Clerical operations in the design offices of Haines Lundberg Waehler are set in a lighted open space. This allows the staff visually to interact with other office activities and to be adjacent to the management personnel.

tion." Breaking down large pools into smaller clusters can improve clerical areas and increase productivity.

WORK CENTER

At the heart of many business offices is the all-purpose area designated as the work center or workroom. Typically, these spaces are closed off since they frequently are cluttered and/or house noisy equipment, such as copy and mailing machines. These spaces can also contain the central files, paper and other office equipment supplies, and a general workspace. In smaller offices where there are no designated employee lounges, the workroom becomes the employee break area or socializing space.

RESOURCES

Resource areas might include a library or communications room. The library can house books, films, tapes, video cassettes, or slides. In architects' and interior designers' offices, these resource areas house manufacturers' catalogs and material samples (Figure 9.14).

AMENITIES

Employees are often given some "special" areas that may not seem directly related to their jobs but are crucial for their well-being. Socializing and an escape from the daily routine are provided in these areas, such as a coffee-break space or an employee cafeteria (Figure 9.15).

Other amenities provided in some office environments are child-care centers and employee recreational or exercise spaces. All of these are important ingredients in the office environment and are designed to increase employee satisfaction and productivity.

FINANCIAL INSTITUTIONS

Financial institutions, including banks, savings and loans, credit unions, and trading centers, provide a multitude of financial transactions and services. Although their business operations differ, some similarities are apparent in their planning. The daily routines of these facilities and their customer relations dictate the functional layout of the spaces.

The image of financial institutions can vary from the formal and traditional look (Figure 9.16) to the modern and visually dynamic. Many financial institutions project customer-friendly attitudes, and their interiors offer patrons a comfortable, relaxed atmosphere (Figure 9.17). Let's look at a banking facility to illustrate how financial institutions are planned.

FIGURE 9.16 Design Plan Inc. created this bank teller line around existing columns and set a strong image with wood and metal-banded motifs for the Union Savings Bank in Indianapolis.

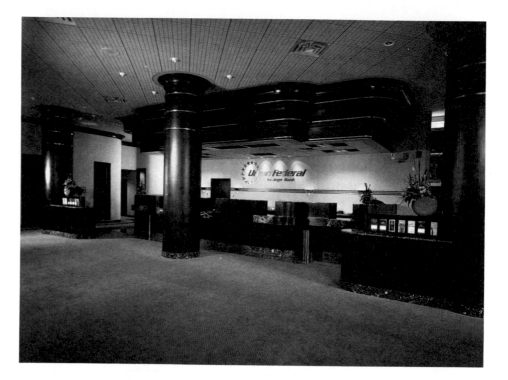

FIGURE 9.17 This octagonal-shaped banking space is very open to provide visual access between the tellers and managers. It is topped by a skylight and accented by cove lighting.

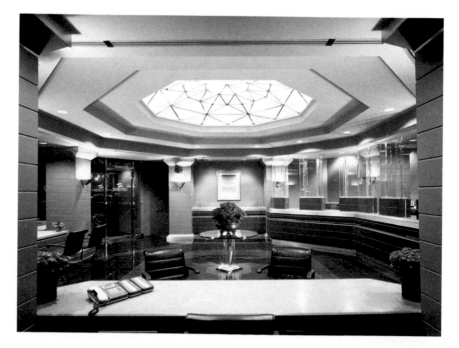

Spatial Organization

Banks are organized into public, semipublic, and ancillary zones (Figure 9.18). The customer enters the public area (which includes the teller line) for most daily transactions and can cross into the semipublic spaces, such as safety deposit areas. Usually included in the public areas are the offices of bank officers and sometimes of executives. These public interiors are designed to be spacious and to direct the customer to the appropriate place. Finish materials are selected to withstand the wear of numerous people using the space. Banks also have convenient drive-up windows that connect directly to a teller station or use pneumatic delivery systems.

FIGURE 9.18 Banks are organized into public, semi-public, and ancillary zones, as seen in this schematic drawing.

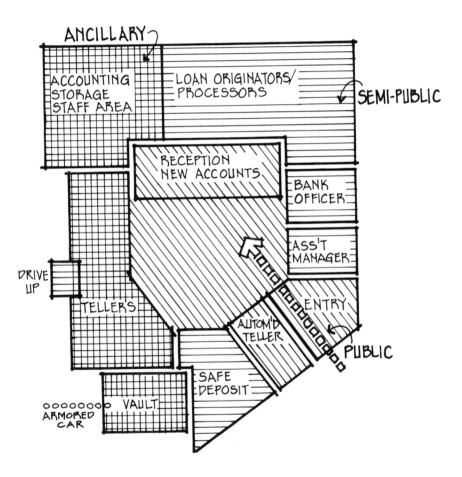

ADJACENCY AND CIRCULATION ANALYSIS

The bank's entry leads directly to the main banking floor and related offices (Figure 9.19). Here we might find the teller stations, information desk, and loan offices. Adjacent to the public space are the secondary spaces, such as the safety deposit area. Behind both of these spaces the behind-the-scenes workings of the bank take place. Patrons are not generally allowed in these areas, which are *secured* spaces. These include the main bank vault and armored car delivery area. The ancillary areas of the bank are the employee lounge, central files and storage, and other clerical areas.

FIGURE 9.19 The entry into a bank sets the stage for the spaces and services available on the main banking floor.

COMMUNICATION ANALYSIS

Bank operations and workflow are highly computerized. Although money and other legal tenders are exchanged and stored, many transactions are electronic. Data are fed into the bank's main computer, which may be in the same facility or a remote main terminal. Today there are sophisticated automated teller machines and even at-home banking. One of the main design concerns of a bank is the security and monitoring of financial transactions through cameras and alarms.

RETAIL DESIGN

Some of the most exciting interior spaces in our built environment are commercial retail facilities, such as stores, shops, shopping malls, showrooms, and galleries (Figure 9.20). The buying, selling, and customer service aspects of retailing pervade our daily lives through aggressive advertising and specially built environments to lure us into spending our money. The marketing strategies and the design of these spaces are controlled by the location, the type of service or products to be sold, the price, and the targeted customer profile. Retail outlets range from conservative, low-illumination high-end stores to stimulating and playful shops (Figure 9.21). Some stores are geared to deal in quantity of goods and efficient handling of customer movement

FIGURE 9.20 The North Pier shopping center in Chicago is a visually exciting complex created in an old multi-level brick warehouse.

FIGURE 9.21 This shoe store has a playful, yet strong design image to draw customers into the shop and provide a unique experience for its patrons.

and buying. Others are geared toward leisure shopping and high levels of customer service. Some specialty shops, such as beauty and other salons market services, rather than products. Other specialty shops include computer stores, catalog showrooms, optical centers, and gourmet food stores.

In retail designs, through the effective combination of lighting, color, and physical setting, the environment is created to display merchandise and cajole the customer into buying.

Shopping centers are designed for destination buying; that is, the combination of specialty stores attempts to lure customers to the retail complex to do all or most of their shopping. Although most shopping centers and malls contain a large center court, many are constructed as vertical malls, festival malls, and factory outlet centers (Figure 9.22). These indoor and outdoor commercial centers are popular for socializing as well as buying. The shopping mall attempts to balance a series of specialized shops with a few large all-purpose retail outlets to round out consumers' choices.

FIGURE 9.22 The Food Court in the Town Center at Boca Raton, Florida, provides an oasis refreshment center for the shoppers.

Showrooms are designed as specialty outlets primarily aimed at the intermediary between the manufacturer or distributor and the customer. For instance, many manufacturers of interior products and materials cater to interior designers and architects (Figure 9.23). These showroom spaces are often well designed and stimulating to the senses in order to show the goods in a most flattering or "applied" manner. A design professional usually must accompany a client to a showroom. Showrooms are found also in other fields, such as the apparel industry.

Galleries as defined here are those special retail places used to exhibit and sell works of art. Gallery design serves primarily as a backdrop to the works being displayed (Figure 9.24).

FIGURE 9.23 This entry to a showroom by Irvine and Associates incorporates a curved lattice form and accent lighting to create a distinct design image for the company.

FIGURE 9.24 Lighting and custom exhibit bases set the stage for this private gallery to bring out the best features and viewing angles of the art.

Proper lighting, viewing angles, people circulation, and security are important factors. These environments should be conducive to leisure shopping, allowing customers to appreciate the works exhibited.

Spatial Organization

Retail outlets (shops and stores) are designed to attract the customer, display the merchandise, and assist in making purchasing decisions, closing the transaction, and servicing the customer after the sale. The design of the establishment should be targeted toward a specific group of customers. The design should display a clear image to the shopper, reflecting the type and quality of goods offered. Some franchised shops use a distinct image that can be repeated in other locations (Figure 9.25).

The facility should be designed to meet the needs of the shopper: imminent buying, routine purchases, major purchases, or social shopping.

Most retail establishments are separated into distinct areas, such as entries, merchandise areas, cashier/transaction areas, product storage and receiving, dressing rooms (if applicable), and restrooms (Figure 9.26). Depending upon the variety of products, customer service, and other

FIGURE 9.25 The design theme of this shop is that of a whimsical neighborhood seen from a child's point of view.

FIGURE 9.26 Floor plan of the shop shown in Figure 9.25. Note that it is divided into customer sales area, product storage, and employees' restroom.

needs, additional spaces can be created. The entry of the shop motivates the customer to come in and begin the inspection and browsing process. Circulation paths are defined according to the targeted buying habits for quick or impulse purchases. Other layouts may entice a buyer to move more slowly and be introduced to highlighted merchandise.

Good visual control of the merchandise and signage is important in store design for security, customer assistance, and proper display.

HOSPITALITY DESIGN

Hospitality interiors are designed to facilitate entertainment and socializing and to otherwise provide for the physical needs of guests. A person seeks these places to fulfill a physical need of nutrients (restaurants and other eateries), to provide a resting place while traveling (hotels, motels, and inns), or to be entertained and informed (theaters, auditoriums, convention centers). In all of these, however, the guest usually seeks socializing and a sharing of experiences with other people.

We do not dine out just to eat or stay in a hotel just to rest. For the price of a meal or admission, hospitality facilities will provide much more than just satisfaction of basic human needs. Space does not permit the authors to touch on every type of hospitality facility, but a few that are most commonly designed by interior designers will be discussed below.

Restaurants

Dining out is a big business today, and restaurant design is probably one of the most innovative arenas for creating interior environments (Figure 9.27). Some restaurants are actually designed as trendsetters; they either do not expect to be long-lasting environments or will need periodic remodeling. Restaurant design can also be difficult, for eateries are specifically designed for a target market. The interiors should provide an appropriate atmosphere for the serving and eating of food. Even if great interiors are created, however, the eating establishment may be doomed to failure if the marketing, management, and service to the customer falter.

In addition to serving food and providing an ambient atmosphere, restaurants also furnish an arena for the "see and be seen" needs of social life. People who eat out generally fall into one of four target groups. First, there is the "eat and run" type, who usually wants to eat quickly and may find service and time savings more important than the price and quality of the food. Second is the "food connoisseur," who wants excellent food. Price, time, and speed of service are not quite as important as being able to experience the quality of the meal. Third are "comparative" diners, who expect a balance of good food, price, and service. These people tend to dine out informally dressed and often have children with them. The fourth type is the "socialite," who perceives dining out as primarily a social or business event. This can range from a quite intimate couple to a ceremonial, theatrical production. In turn, the design of the eating establishment should correspond to the needs of these four target groups. It should be pointed out, however, that some establishments cannot be neatly categorized into one of these types. Some might cater to more than one group or might change their service delivery, that is, might set up buffet style sometimes but have waitstaff serving tables at others.

FIGURE 9.27 The Backstreet Restaurant in New Haven, Connecticut, utilizes curved custom millwork and curved neon accent lighting to present food as a strong design image. (Copyright © 1980 Norman McGrath. Designer: MGH/Centerbrook Architects.)

Successful restaurant operations are based on research and analysis of (1) the market to be served; (2) the type and style of food service; (3) the menu; (4) the location; (5) the competition; (6) the cost of original construction and start-up; and (7) the cost of daily operations.

THEME VS. CONTEXTUAL CONCEPTS

Many restaurant designs fall under one of two basic design concepts: theme or contextual. Theme restaurants are created around a selected image or idea that appeals to our visual and intellectual senses of places, persons, things, events, or experiences. The design is created with the theme, for example, a nostalgic western saloon, as the underlying guiding principle around which everything else evolves. Unfortunately, many theme interiors can be overdone to the point of triteness or can quickly become outdated as a passing fad. Some theme designs can be very successful and a delight to experience. These are often rather subtle in their design, leaving one's imagination to make strong thematic connections.

Contextual restaurant design concepts are based on good design principles and materials. The interior spaces and finishes are supportive of the dining experience and do not create an artificial or theatrical atmosphere. No distinct theme guides the planning—just good design conducive to the act of dining (Figure 9.28).

FIGURE 9.28 The cafe on the square in the San Francisco Hilton provides a sidewalk cafe atmosphere for guests seeking a casual meal.

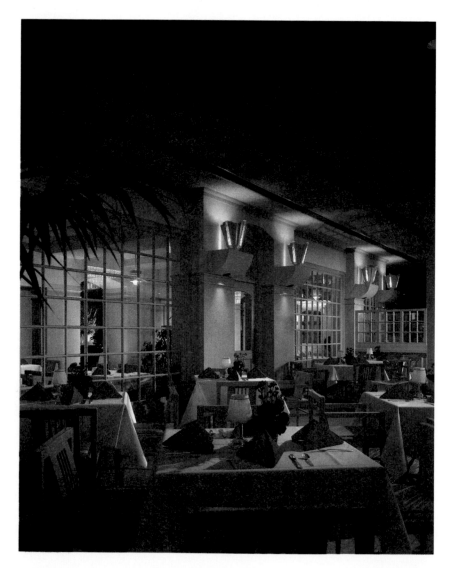

SPATIAL ORGANIZATION

Restaurants are organized into a "front" and "back" relationship. The design atmosphere is created in the front for customers, while food preparation, services, and management occupy the back. However, in some situations, such as fast food establishments, the two areas often overlap or are at least exposed to one another.

Restaurants and other eateries are generally divided into entry/waiting areas; dining and/or drinking areas; food preparation areas; and service/delivery spaces (Figure 9.29). Other

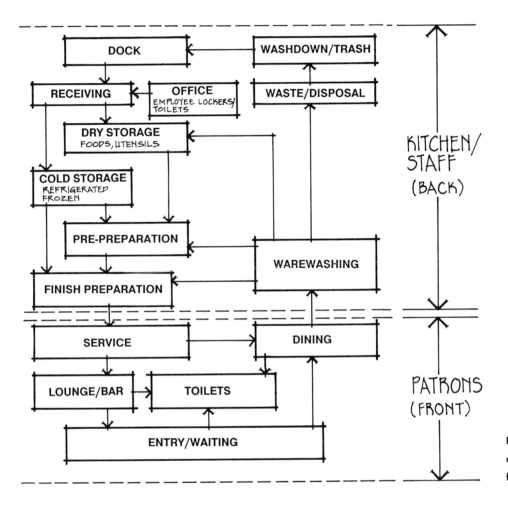

FIGURE 9.29 Diagram of typical restaurant space adjacencies and flow of materials/people.

facilities, such as employee locker rooms and management offices, might also be provided. The entry and waiting areas frequently give a glimpse of the dining spaces and experiences within. In some cases, these are designed as comfortable environments themselves; in others, they lead directly to a lounge that can be used for waiting and socializing. Dining spaces are visually oriented outward to a view, inward to a focal point, socially to other views of diners, or compartmentalized to more intimate or small group dining.

Transitional zones exist in several spaces within restaurants. For example, the interface between the waiting areas and the dining areas should provide proper separation, yet heighten the patrons' anticipation as they move from one zone to the other. The transition zone (service) between the kitchen and the eating area must be designed with maximum efficiency of use by the servers and provide audio and visual controls to prevent undesirable factors from entering the dining area from the kitchen.

Circulation and seating of the patrons should be well planned to minimize confusion and interference with the servers. Seating arrangements fall into several categories based on the number of diners. These arrangements are planned for socializing, privacy, and flexibility of groupings, the latter to accommodate varying numbers of people and their desire to interact. Typically, dining rooms are designed with an average of 10 square feet allowed per person for fast food service to 16 square feet per person for quality table service.

The food preparation areas can vary as much as do the meals served. In most cases these areas are hidden from the patrons by doors or halls; in some, however, part of the preparation and cooking areas are visible to the diners, especially in participatory cooking centers that provide theatrics for patron enjoyment. The food preparation area, or kitchen, is the heart of a dining establishment and generally is about one-third the size of the dining area in square footage. Most commercial kitchens are divided into areas for receiving and storage, hot food preparation, cold food preparation, beverage preparation, serving, and washing (Figure 9.30). Variations from this basic planning arrangement are seen in fast food enterprises, cafeterias, and participatory dining establishments.

FIGURE 9.30 The floor plan of a restaurant and its kitchen reflects the logical flow of customers, employees, food, beverages, and the many other components necessary for service.

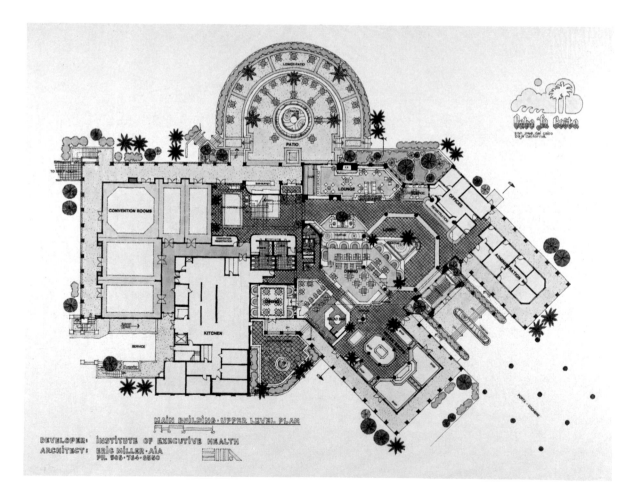

It is well worth remembering that although design of dining interiors can be very creative, the underlying principle is similar to that of retail design—the price and service must match the customer's expectations. Eating establishments must generate profits if they are to be successful and remain in business.

Hotels, Motels, and Inns

Today's overnight accommodations are certainly more than a place to rest or sleep. Hotels have become cities within cities and offer numerous amenities to their guests. These guests come from varying backgrounds and might be vacationers, businesspeople, or conventioneers.

Hotels fall under the basic types of resort, convention oriented, urban, or airport, the latter being travel related. Sometimes there is a mixture of the types, such as the urban downtown hotel that serves a convention function. Whatever the type of hotel, generally the design is related to a locale's outdoor environment, or an interior focal setting is created.

Hotel (and motel) guest rooms are grouped according to the number and type of beds provided. The room sizes and amenities increase proportionately from the single to the double to the suite. Floor plans of hotel rooms vary to accommodate the convenience of the guest and can be a simple layout with one bed to a kitchenette unit with a separate dining area. Of paramount importance to all plans is the protection of the guests, including egress routes in case of a fire or other catastrophe.

SPATIAL ORGANIZATION

Hotels are composed of a series of activities: housing, services, housekeeping, and sometimes eating, exercise, rentals, and entertainment. Although hotels can exhibit individuality by their amenities, several commonalities prevail. There are two distinct worlds in a hotel: that of the guests and that of the staff. Designs should cater to the guests' expectations, and the service should support those needs.

The entry and the lobby (Figure 9.31) provide the first impression of a hotel. This can be an impressive ceremonial expression to beckon the public in or it can be designed in a manner to

FIGURE 9.31 The lobby of this hotel sets the design image of the facility and provides seating for social interaction that occurs in these large-scale places.

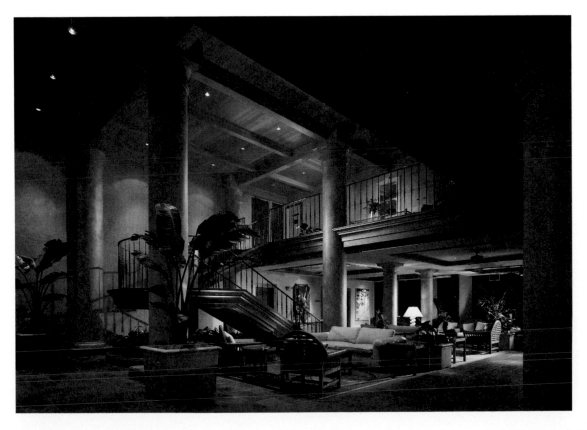

keep unwanted people at arm's length. The lobby and reception area is a multifunctioning space that oversees guests arriving and departing and is controlled by a reception desk/component. Traffic patterns from corridors, elevators, and baggage handling all traverse this central clearinghouse. Many of these lobbies are grand showplaces to exhibit the hotel's uniqueness and character.

A hotel is usually multifloored to lessen the building area and to compact services. The forms can vary from towering skyscrapers or several sprawling floors in a resort setting. Goods, services, guests, and employees create a series of traffic patterns through a hotel. In turn, related activities and spaces are grouped together to form spatial zones (Figure 9.32).

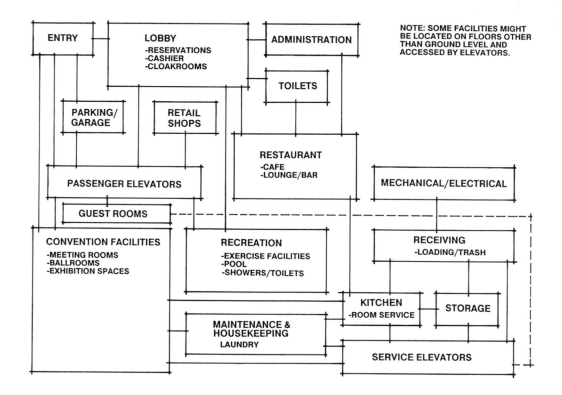

FIGURE 9.32 Diagram of the spaces and circulation routes of a typical hotel.

Motels serve the automobile traveler on either a business or a pleasure trip. Motel design provides for quick, easy-to-reach services, such as a convenient parking spot. The traveler who arrives at the motel as an end point of the journey is more interested in the surroundings or recreation and entertainment facilities than in whether the location is convenient. In this case, the motel design must fulfill the traveler's needs for comfort and convenience, which might include restaurants, lounges, game rooms, or even a kitchenette.

HEALTHCARE DESIGN

Healthcare has undergone quite a few changes in the last decade. Trends have developed to prevent disease and keep people healthy and mentally in tune with themselves, rather than just treating physical problems or disease.

Healthcare design involves more than merely understanding interior finishes and space allocation. A designer must have some familiarity with medical procedures and specialized medical equipment and must have an appreciation of current medical philosophies.

Design for healthcare facilities includes working on hospitals, physicians' medical offices, dental care facilities, nursing homes, and various specialized clinics. However, we will limit our discussion on space planning to a small office occupied by a general practitioner. This will allow us to look at the basic functions and flow of a typical medical office.

Although medical offices can vary in their functional layout and services offered, they generally contain three distinct areas: administration, patient care, and support services. Within these, there are specific spaces and functions particular to the type of physician's practice (Figure 9.33). The diagram in Figure 9.33 shows how a patient enters the office and checks in with the receptionist, then takes a seat in the waiting room or is led to an examining area. The check-in is often termed a "hello" window, and the check-out, a "goodbye" area. The check-out window is situated so that all patients exiting the examination rooms must pass it before leaving. This provides control for payments, medications, and future appointments. Many physicians prefer these windows to be somewhat separated to provide privacy and ease of circulation yet want them controlled by one staff member.

FIGURE 9.33 Schematic diagram of a typical suite for a general practice physician.

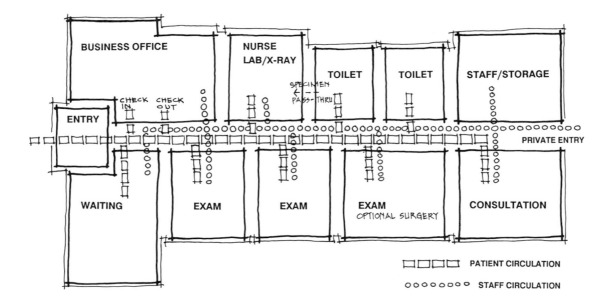

The waiting room serves as the design image of the physician's office and manner of practice (Figure 9.34). This space should provide a sense of comfort and appeal. Magazine racks, coat storage, and other amenities, such as a children's area, are often included. Ideally, the receptionist should have visual control over the entire space for monitoring. In some cases, a drinking fountain and toilet are located within the area or close by, depending on the physician's preferences.

The business office contains the patients' medical records and deals with appointment scheduling, billings, bookkeeping, insurance record work, and other clerical duties. It is usually staffed by one to three people, depending upon the size of the practice. In larger practices, a business manager might work within this area but in a private office.

FIGURE 9.34 The waiting room for a physician's office should accommodate the needs of the patients and establish the image of the physician's facilities and practice.

In small practices, the nurses' station is often located near the business office to facilitate both communication with the business staff and receiving patients from the waiting room. Nurses' stations can be small alcoves or combined with a laboratory for various medical workups. Depending on whether the physician wants to perform tests within the office or have the work done elsewhere, labs and X-ray rooms may be included in a medical office.

Examination rooms are placed close together to lessen the extra steps a physician must take. These rooms are approximately 8 feet by 12 feet (2,438 by 3,048 mm). They contain an exam table, dressing area, guest chair, physician's stool and writing area, built-in cabinets with sink and storage, and miscellaneous small medical equipment. Preferably, these rooms are designed to be functionally the same; that is, they should not be mirror images. The physician should be able to work in matching rooms and not have to deal with layouts and equipment being "opposite handed" from room to room. Whether to have a window in the exam rooms is up to the physician, for natural light is not a necessity for examinations.

One exam room or an additional room is often designated a minor surgery or treatment room. It is basically a large exam room with additional equipment so that casts can be applied and minor surgery can be performed.

The consultation room serves as a private office for the physician to consult with patients. The use depends on the doctor's practice and philosophy of patient/doctor relationships. Of prime importance to the overall medical suite is a private entry so that the doctor can arrive or leave the suite without going through the waiting room.

For planning purposes, a physician's office requires about 1,000 square feet (92.9 m^2) per doctor. A partnership of two doctors would be approximately 2,000 square feet (185.8 m^2), and three doctors need about 2,500 to 3,000 square feet (232.2 to 278.7 m^2). The facilities that can be shared, such as the business office, waiting areas, nurses' stations, or staff break room have a bearing on the total amount of space needed in a multiphysician practice.

INSTITUTIONAL, PUBLIC, GOVERNMENT, AND OTHER FACILITIES

Interior designers are involved in the designing of many other kinds of interiors, both small and large scale. This section will provide a brief survey of some of the most typical.

Schools, Colleges, and Universities

Interior design in schools, colleges, and universities includes spaces such as classrooms, lecture halls, dining facilities, libraries, dormitories, laboratories, and other specialized educational facilities (Figure 9.35). Although these facilities are institutional in function, the design should not be the bland look of past years.

FIGURE 9.35 Educational facilities should be designed to support the learning process and visually to stimulate the eye/mind relationships.

Public and Government

Libraries can be part of other facilities, such as schools and offices, or large public buildings supported by municipalities and counties. All of these must provide easy access and proper storage/protection of the records kept there. Acoustics and lighting are very critical to provide the users with a supportive environment to do their work.

Museums are most often public buildings that provide exhibitions on a permanent or temporary basis. Museum design involves the careful planning of function, security, and crowd control—as well as dramatic settings for specific displays.

Government facilities, such as post offices, city halls, and courthouses, have traditionally been designed in historical styles. However, their designs now often reflect an understanding of functionalism and user needs, as well as creating exciting architectural features. Although these public-related buildings are often controlled by tight budget restraints, innovative designs can create some distinctive buildings.

Recreational, Industrial, and Transportation

Recreational interiors include health clubs, bowling alleys, swimming pools, tennis clubs, golf resorts, and a myriad of others. Although most involve physical exercise, they also serve as entertainment and socializing centers. Many are combined with other facilities, such as schools, hotels, and offices.

Industrial spaces include those of manufacturing plants, factories, utility suppliers, and other facilities. They can be towering, giant spaces, such as power plants and automobile plants, or small, specialized spaces, such as electronic facilities. Although these are highly specialized in their functional requirements, the designs can provide worker comfort, support productivity, and create a good work environment for the users.

Transportation design involves interior spaces that are both permanent (terminals and stations) and transitory (trains, airplanes, buses, and ships). There is an overlap of interior design and industrial design when doing many of the vehicle interiors. Most of the interior work in the transportation field is done on the terminals and stations. Some are new facilities, but most are the renovation or expansion of existing spaces.

Specialized Interiors

Interior designers execute many other specialized or miscellaneous spaces. A large number of these, such as atriums, greenhouses, studios, kiosks, and workshops, frequently are an integral part of another facility. Others, such as motor homes, are highly specialized in function and generally are considered a part of transportation or other categories of spaces.

Some specialized interiors such as set designs for the theater, television, and film are unique to entertainment spaces and are designed in conjunction with designers in the fields of electronics, industrial design, and theatrical productions.

REFERENCES FOR FURTHER READING

Baraban, Regina S., and Joseph F. Durocher. *Successful Restaurant Design.* New York: Van Nostrand Reinhold, 1988.

Barr, Vilma, and Charles E. Broudy. *Designing to Sell.* New York: McGraw-Hill Book Co., 1990.

Birchfield, John C. *Design and Layout of Foodservice Facilities.* New York: Van Nostrand Reinhold, 1988.

Cohen, Aaron, and Elaine Cohen. *Planning the Electronic Office.* New York: McGraw-Hill, 1983.

Editors of Interiors Magazine. *The Interiors Book of Shops and Restaurants.* New York: Whitney Library of Design, 1981.

End, Henry. *Interiors 2nd Book of Hotels.* New York: Whitney Library of Design, 1978.

Gosling, David, and Barry Maitland. *Design and Planning of Retail Systems.* New York: Whitney Library of Design, 1976, pp. 2–17.

Green, William. *The Retail Store.* New York: Van Nostrand Reinhold, 1986.

Harris, David A., et al. *Planning and Designing the Office Environment.* New York: Van Nostrand Reinhold, 1981.

Ketchum, Morris. *Shops and Stores.* New York: Reinhold, 1957.

Klein, Judy Graf. *The Office Book.* New York: Facts on File, 1982.

Konz, Stephen. *Facility Design.* New York: Wiley and Sons, 1985.

Malkin, Jain. *The Design of Medical and Dental Facilities.* New York: Van Nostrand Reinhold, 1982.

Palmer, Alvin E., and Susan M. Lewis. *Planning the Office Landscape.* New York: McGraw-Hill Book Co., 1977.

Peglar, M. *The Language of Store Planning and Display.* New York: Fairchild Publications, 1982.

Pile, John. *Interiors Third Book of Offices.* New York: Whitney Publications, 1976.

————. *Open Office Planning: A Handbook for Interior Designers and Architects.* New York: Whitney Library of Design, 1986.

————. *Open Office Space: The Office Book Design Series.* New York: Facts on File, 1984.

Pulgram, William L., and Richard E. Stonis. *Designing the Automated Office.* New York: Whitney Library of Design, 1984.

Reznikoff, S.C. *Interior Graphic and Design Standards.* New York: Whitney Library of Design, 1986.

Rutes, Walter A., and Richard Penner. *Hotel Planning and Design.* Cincinnati: Watson-Guptil, 1985.

Russell, Beverly, ed. *The Interiors Book of Shops and Restaurants.* New York: Watson-Guptill, 1981.

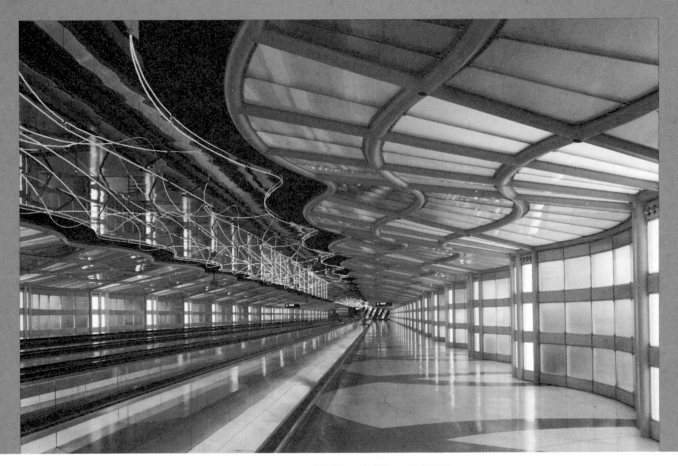

THE EXTERIOR AND
INTERIOR ENVIRONMENTS

PART THREE

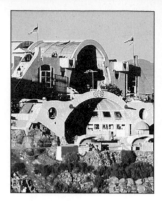

ENVIRONMENTAL CONCERNS, CODES, AND REGULATIONS

THE TOTAL ENVIRONMENT: INFLUENCES ON INTERIORS

Why should interior designers be concerned with the total environment or even the environment beyond the immediate spaces they are designing? Other than through windows to view the outside and permit sunlight to illuminate the interiors, and doors to gain access, what impact does the "outside" have on the "inside"? Interior design is an integral part of the environmental context, and that correlation implies an orderly plan of the way the built environment is constructed in harmony with the natural environment. Designers consider the total picture and its many interrelationships when solving problems. Interior design looks at the contents of a structure and at the building as a container, within the context of the environment and society. This chapter focuses on environmental concerns affecting the built environment, such as (1) the impact of natural and man-made elements; (2) the importance of codes and the regulatory environment, including accessibility for all people; and (3) preserving our historical heritage.

A designer is first a human being and part of the overall physical and societal world. Our daily lives are interwoven with and shaped by relationships and interdependencies on these influ-

ences. We may develop sophisticated and technological minienvironments that function seemingly independent of the natural environment, but these enclosures are subject to the natural forces that affect our planet and the universe. As people seldom function in isolation from the total environment, interior designers cannot effectively develop interior spaces without considering external influences. For example, it is difficult to develop an interior primarily illuminated by natural lighting techniques if the project is located in a region that is mostly overcast and rainy. And a designer must consider what the effect on an intimate restaurant atmosphere will be if each time the entry door opens the room is flooded with harsh light, noise, and perhaps automobile fumes. It is the designer's responsibility to be aware of external conditions that will affect an interior space and its occupants.

Today, many clients are looking for designers who can offer a spectrum of design services that includes the exterior and the interior of a project. Firms offering those services generally consist of a team of specialists who can design projects that take full benefit of environmental perception and human behavior. These firms produce projects that exhibit direct linkages between the exterior and the interior, neither being spaces isolated from the other. Successful interiors make good buildings, and successful buildings make good interiors—the two are interrelated.

The interior designer must understand the exterior influences, both physical and nonphysical, that will impact the interiors. Designers must be aware of the overall environmental planning and regulatory process that involves external forces, whether natural or man-made. Sometimes, it is beneficial to incorporate some of these forces into the interiors, while others will need to be separated from them (Figure 10.1).

FIGURE 10.1 The interior of the Canoe House Restaurant becomes open to the external elements by the use of large glass doors and sliding glass panels.

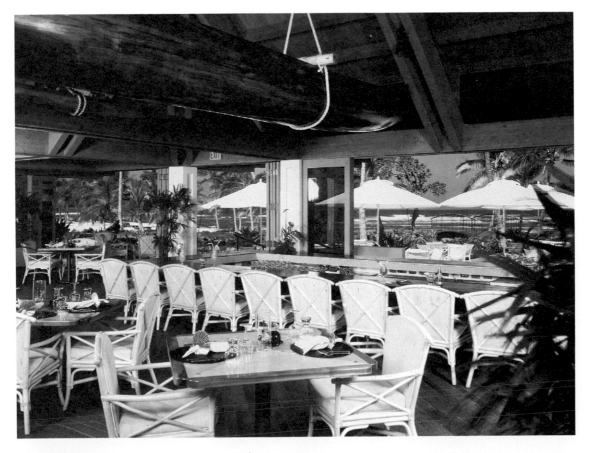

Environmental Planning

Environmental planners seek to understand and design for both macro (large) and micro (small) worlds simultaneously and to respect their interrelationships. Although specialization is increasing, there is a growing trend for designers to be aware of all environmental forces and their impact on the design process.

The natural environment is composed of the ocean, sky, land, plants, animals, weather, and all those other attributes we call Mother Nature. People seek to enrich their lives through direct relationships with their world or to create man-made devices to help interact with these elements. Many of these creations fall into the categories of harmony, contrast, or adaptability when considered in terms of the natural environment. However, the complexity of the world situation, with increasing populations and rapid growth in technology and consumption, is taxing our resources both in a global and in a backyard arena.

A great need exists for careful, thoughtful evaluation and planning of man-made and natural resources, in terms of both current and future usage. Cities, towns, buildings, and other land usage must be carefully planned for people and the total environment. Environmental analysis and planning not only includes designers working together but also incorporates input from the users of these developments to achieve solutions.

Flexibility, adaptability, restoration, preservation, and reuse are terms that relate to concepts of designing for today's structures and interiors. These concepts consider the environment as a part of the whole and view civilizations in the context of time—past, present, and future. We perceive and use these environments from the past and pass them on to future generations. Laws, codes, and the enforcement of both help to protect and preserve our environments from short-sighted viewpoints. However, these rules must be humanistic, capable of modifications for the good of all people and the environment.

LAND USE AND DEVELOPMENT

Land use indicates the way people adapt or change the land to suit their everyday functions. Specifically, the term refers to planning for the best use of the landscape to suit the needs of the individual, society, and the environment.

The term *community* can mean society in general, a group of people living together, or people living in a particular district within a city. Cities encompass communities of citizens and are centers of population larger than towns or villages. Throughout the centuries, cities evolved around people's activities, needs, and wants and around the usable spaces they developed. A city is a complex, living, dynamic organism made up of many physical and nonphysical intricacies. As occurs in a biological organism, each of these parts contributes to the whole, even though the specific component may be specialized or seemingly self-supporting. Smaller units (such as neighborhoods, commercial districts, and industrial areas) interreact to produce a pattern and a character that make that city distinct from others.

Planners speak of a city's having a "fabric," which implies the interweaving of physical and nonphysical attributes, such as a historic district and its cultural makeup, giving it an identity and functioning as a force. Changes in any of these "filaments" of the fabric can have a direct

impact on the city as a whole. Changes can be positive, such as the redevelopment of a city's inner core, which can draw suburbanites back into the heart of the city to revitalize it.

More than half of the population of the United States dwell in urban areas that account for perhaps one percent of the available land. Suburban living has been a response to crowded cities. People moved to tracts of land developed as small centers or villages within commuting distance of the city centers. Attempts are made in these satellite communities to regulate the orderly growth of these new "cities" through zoning laws.

Transportation has a direct influence on the shaping of our cities and communities, new or old. As people and goods moved from space to space, the impact of vehicles and the avenues they traveled became the connectors of our centers. Historically, transportation has been one of the most influential plan generators of our cities because most growth took place around railroads, streetcars, and more recently, the automobile.

The automobile has its conveniences, yet can cause heavy polluting and traffic gridlocks in large cities. Furthermore, as we continue to use more land to build roadways, we decrease the available land for people and buildings.

Urban Planning

Throughout history many designers and planners have conceived of urban centers that would solve the problems of the populace, such as overcrowding, sprawl, poor working conditions, crime, and pollution. These utopian schemes tried to satisfy the social and physical needs of individuals and to consider the overall good of the community.

In the 1920s and 1930s, Le Corbusier and Frank Lloyd Wright each proposed a scheme for city planning, though neither was constructed. Le Corbusier proposed that approximately 600 acres be cleared in the center of Paris and that sixteen 60-story towers be erected to house people, office facilities, and shopping. Streets and parks between these structures would create beautiful garden settings for all to use.

Wright proposed his "Broadacre City," which followed a decentralized scheme in which people were to live in single houses on an acre of leased land where they would grow their food. In his concept of a "garden city," apartments and highrises would be carefully placed and elevated arteries would be used for public and private transportation. Community facilities and other services would be placed beneath these routes. Actually, some of Wright's ideas have been realized in larger cities where services have been constructed beneath elevated freeways and rail systems.

In the 1960s, the term *megastructure* was given to a large, single-entity structure that sought to house large communities within it. These communities in turn were to be small cities within cities and would offer a variety of services, habitats, and workspaces. During the same decade, Peter Blake published a series of conceptual megastructures that received a great deal of interest at the time, although they were never built.

In the Arizona desert, Paolo Soleri (1919–) has envisioned what he has termed "Archecology"—a unified mixture of ecology and architecture. He proposes large, three-dimensional complexes of great population densities and mixed community experiences (Figure 10.2). He has expanded the concept of a megastructure to a city scale, designed for varying geographical locations and population sizes. Modular living units are stacked in layers around large commercial, civic, and industrial facilities. These gigantic structures are envisioned as preserving the land from the two-dimensional sprawl by concentrating buildings and people into three-dimensional layers.

FIGURE 10.2 Paolo Soleri and his associates are constructing one of his visionary cities "Arcosanti" in Arizona.

Cluster Planning

Traditionally, suburban developments were laid out in straight rows in a grid to facilitate access in an organized fashion. These developments sprawled across the land, each residence having its own lot. The cluster plan was developed to prevent this sprawl and gridlock form, while minimizing the area of the lots. This clustering concept has been of particular help in multifamily developments, where open space, pools, parking, and views can be shared by all.

PLANNED UNIT DEVELOPMENT

Originally a housing development concept, the planned unit development (PUD) is being increasingly used for other zoning types, such as commercial zones and even the intermixing of several zones. For example, a PUD might contain several office buildings, restaurants, a small shopping center, and some apartment buildings all in close proximity or within the same buildings. PUDs vary in scale and are based on the principle that if a development is carefully planned, it can produce a beneficial and efficient use of land and amenities not otherwise available in traditional zoning.

Specialized Planning

Some developments or communities, such as retirement or vacation communities, are designed for specific groups or a particular clientele. These developments include such amenities as recreational areas, clubhouses, increased security, and other shared benefits. Vacation communities are designed for short-term use on a year-round basis. Ski resorts are a good example of seasonal communities that reach their peak in winter (Figure 10.3); however, sunny, southerly developments also reach a pinnacle of popularity in the winter as people seek the warmer climates and lower energy costs.

FIGURE 10.3 This ski resort in Utah was designed primarily for winter skiing, but also offers many activities throughout the year. (© Peter Aaron/ Esto.)

Zoning

Each state, county, and city and many subdivisions have passed zoning laws to regulate controlled growth and provide desirable amenities and infrastructure for the populace. Zoning laws govern land use, specifying what kind of facility can be constructed and for what specific uses. This zoning of land not only regulates the basic category of development—commercial, residential, industrial, or agricultural—but also dictates lot and building size, setback distances to the street, height of the structure, required parking, and sometimes even the character of the building.

Zoning districts within urban developments vary according to their location but can be broken down into the basic categories listed above. Within these categories, more definitive areas are outlined with regard to specific sizes and uses of those districts.

The commercial district is composed primarily of businesses and stores from small neighborhood corner groceries to shopping center developments to large groupings of major stores and offices in a downtown city core. These might be further defined as Local Business (LB), downtown or Central Business (CB), or Highway Business (HB), rather than just Commercial.

Residential zoning encompasses dwellings where people live. It is divided into low-density, single-family residences; medium-density, two-family residences; multiple-family residences, and so on, depending on the specific housing type and square footages (or square meters) permitted.

Industrial zoning (I) is divided into light and heavy. Facilities that produce a minimum of noise, fumes, traffic, or other intrusions upon the environment, such as small electronic assembly plants, are considered nonnuisance and fall under the light manufacturing category. Heavy manufacturing includes businesses, such as steel and aluminum plants, that store and distribute large amounts of nuisance materials. Sometimes industrial zoning is concentrated in industrial parks and intermixed with related offices.

If a zoning ordinance creates a hardship for an individual or an organization wishing to do something in a zone contrary to the regulations, a variance can be filed. The community's zoning commission or similar body hears the plea for a change in the regulation and acts to allow the exception or deny it.

FORM DETERMINANTS FOR BUILDINGS

It is important for the interior designer to be knowledgeable about the process of designing a building for a particular site. Understanding this process enables the designer to see why and how an architect generates a particular form for a building, the way it relates to its surroundings, and how zoning or other regulations influence the final solution. Often a direct link connects the visual and physical interdependencies of the interiors with the external spaces. An interior designer should be cognizant of these and be able to capitalize on them.

It is generally accepted that the geology, location, hydrology, topography, climate, vegetation, and cultural use of the site will indeed have a major influence on the design of a building, open spaces, and the interiors. Some major elements, such as mountain slopes, rivers, lakes, and existing buildings, cannot be readily changed on a site and generate strong design determinants

and constraints. Other natural forces—winds, temperature, erosion, and sunlight—also become prime influences on the planning process.

Site Planning

Site planning is the process of harmoniously relating buildings and other structures to the environment and to one another. The professions of architecture, landscape architecture, engineering, and urban planning are all involved in the site planning process. This planning is not limited to buildings and the immediate site but encompasses parks, highways, and other elements in the macroenvironment. Site design also must take into account zoning, utilities, traffic circulation, historic uses, culture, and existing structures on and adjacent to the immediate site. Usually a direct relationship exists between the interiors of a building, its exterior design, and the site

FIGURE 10.4 A Site Analysis Checklist is made to analyze all the aspects that can have positive or negative influence on the site design.

SITE ANALYSIS CHECKLIST

ITEM	POSITIVE OR NEGATIVE DETERMINANTS
CLIMATE	Wind, precipitation, temperatures, solar availability and orientation. Possibilities for energy efficiency and outdoor use.
HISTORIC IMPLICATIONS	Historic or archaeological features to be presented.
SOCIAL CONTEXT	Relationships and impact of people and their activities to the site or adjacent to it.
ZONING AND LAND USE	Existing, proposed and possible variances needed for any development. Restrictions on building height, setbacks, lot coverage.
TOPOGRAPHY	Ground surface changes, slopes, geology, and hydrology resources.
VEGETATION AND ANIMAL LIFE	Species, number, location, size, and age of existing and implications of site development to these.
UTILITIES	Existing and new electricity, gas, water, sewer, communication, and other utility needs.
SENSORY IMPACTS	Sounds, smells, and views generated on and adjacent to the site.
ACCESS	Transportation onto the site for pedestrians, vehicles, and goods. Circulation patterns within the site.
MAN-MADE STRUCTURES	Existing buildings and other structures to be removed, left, or remodeled.
LEGAL	Existing and proposed ownership, leases, rights-of-way, uses, taxes.

surrounding it. Most successful architects and interior designers use these relationships to create a concept encompassing all of them.

Site Analysis

The process of site planning begins with an analysis and understanding of the particular site and its relationship to the proposed or remodeled building. A program and subsequent design recommendations are then made to guide the eventual construction of a building or any reconstruction of existing features. A thorough investigation of both the site and the impact of a structure to be constructed on it is necessary to achieve harmony between the two. The best site design is usually one that requires the least amount of reconstruction to the site.

Site analysis involves a careful investigation of the physical and nonphysical characteristics on and surrounding the site. These site data are compiled with a site analysis checklist, as seen in Figure 10.4. The information is then graphically sketched on the site plan to provide a visual study that depicts the most important information (Figure 10.5).

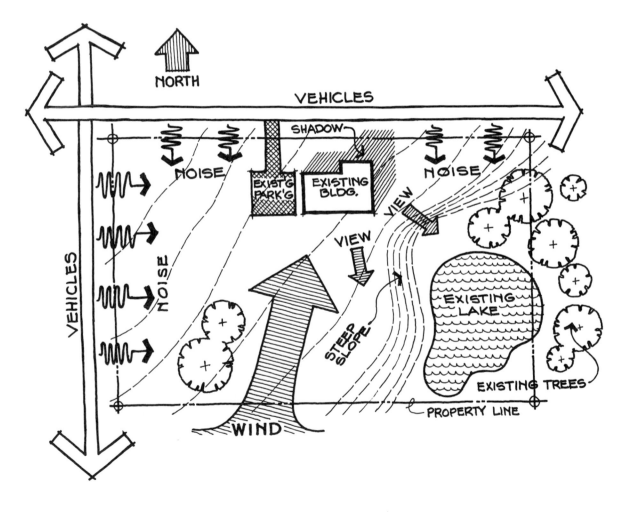

FIGURE 10.5 The site is studied for its unique features that have possible advantages and disadvantages for development.

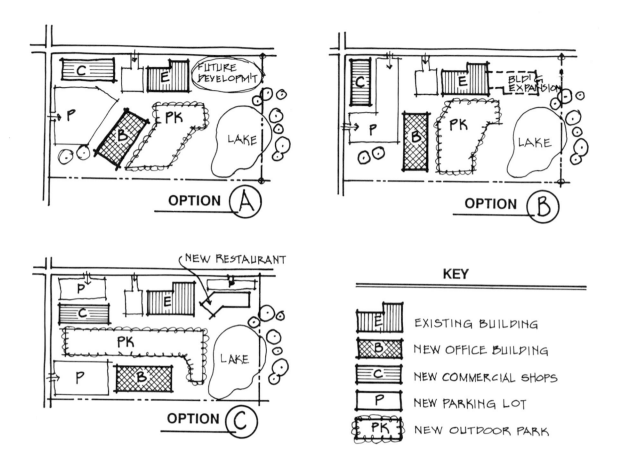

FIGURE 10.6 The site use is studied by exploring several alternative layouts. The advantages and disadvantages are listed for each option and compared to one another.

KEY

EXISTING BUILDING

NEW OFFICE BUILDING

NEW COMMERCIAL SHOPS

NEW PARKING LOT

NEW OUTDOOR PARK

Building Siting and Design

With the site analysis complete and the building program finished, the optimum placement of the building is determined; this is accomplished through a series of preliminary studies examining alternative arrangements and locations on the site. Advantages and disadvantages are weighed until the best solution is derived (Figure 10.6). This integration seeks to determine whether the building and site are compatible.

The building design is also controlled by a number of other variables: function of the building, style of the structure, materials and structural systems, budget constraints, the occupants' uses, and building codes. The site coverage, or the "footprint" the building makes on the site, is governed by the zoning restrictions, floor area, number of floors, and configuration of the structure.

BUILDING CODES

Building codes are regulations established to set minimum performance and/or prescriptive standards for design, materials, and methods of construction for new or remodeled struc-

tures. Earlier codes were written for the protection and preservation of human life and property from losses, such as caused by the great Chicago fire in the 1800s. After some of these tragedies, various codes were established to attempt to prevent these widespread occurrences. In 1905, a national building code was established. Building codes now are set at the federal, state, and local levels to protect and promote the health, safety, and welfare of people in all kinds of structures . Codes set guidelines and minimum standards for electrical, mechanical, and structural systems and for plumbing, lighting, stairs, exits, windows, and materials, as well as for complying with requirements to aid the physically impaired.

Most cities, counties, and states adopt a standardized national code and modify it as needed to fit local conditions. A governing agency, such as a building department, is set up to administer and enforce the codes through checking drawings and inspecting construction. Cities and counties also establish districts of varying fire zones according to density, construction, and heights of buildings and required fire stations to cover the areas in which the buildings are located. Approximately 70 percent of the codes are directly or indirectly related to fire issues.

In the past, architects, engineers, and contractors were the people usually involved with code compliances of projects. Today, however, interior designers also must be involved with codes and their designs must specify flame-spread characteristics of materials, exit requirements, features to aid disabled people, and many other items in the building's interior.

Building Codes and Interiors

Although the numerous codes governing the construction of buildings and their interiors vary across the states and even from county to county, most states have adopted one of three national model codes: (1) the Uniform Building Code; (2) the Basic/National Building Code; and (3) the Standard Building Code. Canada has adopted the National Building Code of Canada. Even if all the codes applying to interiors could be listed here, each local building department interprets the codes slightly differently for its region and allows for variances. However, most building codes follow some general guidelines that are comparable in scope and intention, and those guidelines will be mentioned here.

OCCUPANCY REQUIREMENTS

Existing, remodeled, and new buildings are classified according to their usage or general character, such as residences, schools, stores, offices, garages, hospitals, and auditoriums. This classification is the "occupancy group" and is directly related to potential fire hazards and required egress, or escape, routes. Based on the number of people in a building or the type of potentially flammable materials stored, each group is subdivided into less hazardous occupancies. For example, an assembly area (such as an auditorium) is distinguished from a residence or an automobile repair garage. In turn, the occupancy load that is set determines the number of people and concentration of floor loads permitted for the specific groups (Figure 10.7). In some cases, one building might incorporate more than one use or occupancy group. For example, a building might contain a basement garage, retail shops on the first floor, offices on the next floors, apartment floors above the offices, and a restaurant at the top. In these instances, each use and floor of the building must be studied individually for code compliance and proper fire separations (such as fireproofing) provided between each group.

BUILDING LOCATION ON PROPERTY

How property lines, streets, alleys, and other buildings relate to the spread of fire from one structure to another determines the specifications for the setbacks of the structure. These

OCCUPANCY GROUPS, FLOOR LOADING, AND OCCUPANT/EGRESS REQUIREMENTS

USE OR OCCUPANCY (1)	FLOOR LOAD (2)	OCCUPANT LOAD (3)
ASSEMBLY Auditoriums Dance Floors Stadiums, Stages Churches, Chapels	50–125	7
DWELLINGS	40	300
HOTELS, APARTMENTS	40–100	200
HOSPITALS, NURSING HOMES	50–100	80–100
MANUFACTURING	75–125	30
OFFICES	50–100	100
PARKING GARAGES	100	200
RETAIL STORES	75–100	20–50
SCHOOLS	40	20
ALL OTHERS	50–125	35–200

(1) The terminology and specific uses listed vary according to the specific building code used.

(2) Floor loads are the weights of people, furnishings, and equipment as expressed in pounds per square foot (or square meter)

(3) Occupant load factor (in square feet or meters) is a number that the total floor area used is divided by to determine how many exits are required-according to the particular code. The higher the resultant number, the more exits required.

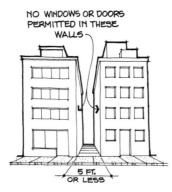

NO WINDOWS OR DOORS PERMITTED IN THESE WALLS

5 FT. OR LESS

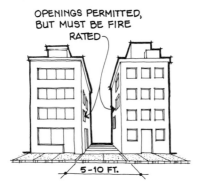

OPENINGS PERMITTED, BUT MUST BE FIRE RATED

5-10 FT.

FIGURE 10.8 Building codes set minimum distances between buildings where any openings must be fire-rated or not permitted.

distances are set so that they are proportional to the fire-resistant construction of the exterior building materials. The number and size of door and window openings, as well as the fire protection requirements concerning them, are governed by the setback code. As a preventive measure to keep fire from spreading, no door or window openings are permitted (in most codes) between buildings that are closer than 5 feet (1524 mm) (Figure 10.8).

FLOOR AREA

The maximum allowable floor area permitted for buildings depends on the fire zone, type of construction, and occupancy use. Wood-frame buildings are generally limited to less than 10,000 square feet (929 square meters), whereas concrete and steel structures can be larger. Increases in floor area of buildings are sometimes permitted if more fire-resistive construction or sprinklers are added and if strategically located fire-resistive separation walls within the building are provided.

TYPE OF CONSTRUCTION

Structures are classified by type of construction, which refers to the materials, construction methods used, and known fire-resistive qualities. Categories (usually five) range from wood-frame residences with very little fire resistance (Type V) to steel skyscrapers with highly fire-

resistive coverings (Type I). Supplemental coverings can be added to the building's structural system to upgrade the building's fire-resistance qualities.

HEIGHT

The number of stories or a maximum height is specified, depending on the type of construction and occupancy group. For example, a wood-frame building could be limited to 4 floors, although a concrete and steel one could be more than 60 floors. A structure's height is allowed to be increased in some cases if sprinklers are installed. Codes are specific about fire-resistive construction, required exits, and fire-protection systems in buildings of more than 3 floors.

Fire Resistance, Safety, and Fire Protection

Interiors can become harmful environments if there is an accident or an outbreak of smoke and fire. Building codes and other national standards, such as those of the National Fire Protection Association (NFPA), have established and monitor various requirements in the design of buildings to protect life, the building's contents, and its structure. These regulations also govern the placement and performance of fire-fighting equipment. These rules come into effect when new structures are built or old buildings are remodeled.

FIRE-RESISTIVE CONSTRUCTION

Buildings are designed and constructed with fire-resistive materials to protect people and contents and to keep the structure from collapsing. Generally, the more people in a building (higher occupancy load), the larger the building. The particular usage of the building (for instance, manufacturing versus offices), dictates how stringent the fire-resistive requirements are.

Fire-resistive barriers, that is, specially constructed walls, doors, ceilings, or floors, are placed throughout a building to slow the spread of a fire. These barriers are given fire ratings of one or more hours, depending upon the materials and construction used. This rating implies the length of time an assembly can be expected to contain a fire or smoke; this period of time allows occupants to escape and fire fighters to do their job. Sometimes spaces between floors that include stairways and other openings must also be protected by closing off each floor separately to slow the vertical spread of fire.

Codes also govern flame spread, toxicity levels, and smoke ratings. Interior finishes, furniture, and furnishings are regulated according to their abilities to withstand fire or to prevent the spread of smoke, toxic fumes, and flames.

The following code regulations apply primarily to commercial buildings but some also have direct applications to residential structures.

EXITS AND STAIRS

Exits are designed primarily according to their use in an emergency. Exits and their locations are determined by a number of variables in the building, such as occupancy load and fire resistance of the structure. Codes for corridors and doors along exitways govern their minimum width, maximum length to prevent dead-end corridors, direction of door swing, and other features (Figure 10.9). Codes also provide details for the tread and riser sizes, handrails, landings, construction, and other items used in conjunction with stairways serving as exitways.

Fire codes in commercial buildings generally specify at least two separate exits per floor for use in an emergency. If one becomes blocked, the other can be used as an alternate escape

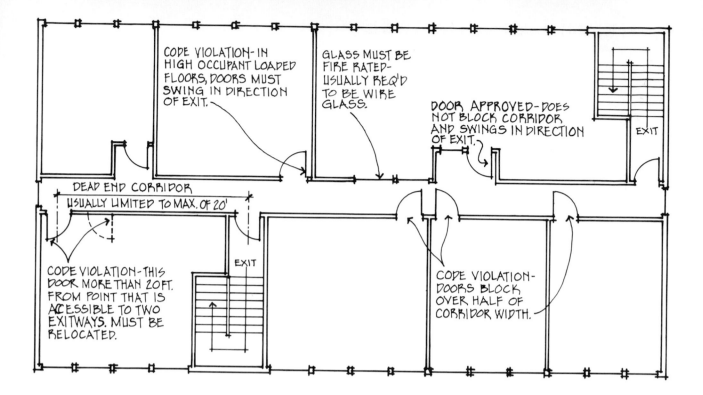

FIGURE 10.9 "Dead-end" corridors, minimum hall width, direction of door swings, and number of exits are specified by building codes—and can vary from code to code.

route. Doors and hardware may be required to be "panic" type, opening outward with a minimum of handling. Exits must be clearly marked and, in most cases in commercial buildings, are lighted with emergency power.

Residential structures are governed by fewer detailed exit specifications, but there are requirements for size, location, and minimum width and height of escape windows; in addition, the maximum distance from the window sill to the floor is spelled out for sleeping areas. Every building, whether commercial or residential, should have an evacuation plan. In government and most commercial buildings, it must be posted along the emergency route.

FIRE DETECTION

Smoke and fire detectors are required in all new and remodeled buildings to give the occupants an early warning of the possibility of a fire hazard. Most of these signal with an audible alarm, and some transmit a signal to the fire department or a manned security system. Some of these devices automatically close fire doors or dampers in a building to prevent the spread of fire and smoke.

FIRE-SUPPRESSION

High-rise and other large buildings have elaborate systems of fire extinguishers, piping, and hose cabinets to fight fire. As will be discussed in Chapter 11, wet and dry standpipe water sprinkler systems designed to fight a fire at its source in various ways can be used throughout a structure. All sprinkler heads can be activated to spray water; however, most installations are fused to activate only the one detecting the fire's heat. Although most are water filled, some systems use carbon dioxide or other gases to fight the fire more efficiently and even prevent water damage. These special gas systems are used in computer installations where large amounts of water could be devastating to the equipment.

BARRIER-FREE ACCESS

Barrier-free access is very important for the interior designer to understand and use as a design parameter. Freedom of access is perceived to be an individual right for Americans, particularly since the passage of the Americans with Disabilities Act. However, a significant number of people in our society have not been accorded freedom of access because of architectural barriers, such as narrow doorways, corridors and stairs that prevent wheelchair access . Physically impaired people have had extreme hardships in working, living, and enjoying our environment for a long time. However, new social concerns and legislative actions have changed the way handicapped people are perceived. Now they are being given access to what most of us take for granted.

In addition to permanently disabled people, there are also those who experience physical impairment through accidents and illnesses. These disabilities might include mobility limitations, sensory (sight and hearing) limitations, cognitive function limitations, or extremes of physical size. The built environment has many obstacles for these people, making it difficult for them to carry out their daily activities. These physical barriers are also a problem to the elderly, who might have difficulty in walking or seeing hazards in their paths.

Laws have been passed at the national, state, and local levels to promote better access for physically impaired people. Voluntary cooperation of many concerned citizens is also helping to create new structures or adapting old ones for access by disabled individuals. Many books and articles have been published on general guidelines for designing for barrier-free access. The publication *Specifications for Making Buildings and Facilities Accessible to and Usable by Physically Handicapped People* (American National Standards Institute document—ANSI A117.1) has become a standard guide, widely adopted, for creating barrier-free environments.

Sometimes designers execute ideas around the "average person" as the user of a facility, basing anthropometric measurements around these "typical" people. There is, however, much variety in physical size and ability throughout the population. Children, the elderly, and the physically impaired can outnumber the "typical" population; their needs also should be addressed in a design scheme. Special interiors can be created for these population groups, but all interiors should be designed to be sensitive to and to accommodate their many physical variations.

Designers are responsible for planning the built environment, the materials selected, and the ability of these spaces to be accessible to and for the physically impaired. Building codes are established for disabled compliance, and although the particulars can vary, certain standards apply to all and are briefly discussed here.

General Guidelines

Regulations and requirements for barrier-free design can vary from state to state, as well as between public/commercial facilities and private/residential facilities. Although private/residential structures are less controlled than public-sector buildings, most housing projects that include three or more units are required to have at least one "accessible" or "adaptable" unit for the physically impaired.

The following guidelines detail some of the requirements for designing for the physically impaired in commercial and public facilities. These are presented in the order of the route of travel a person would take upon arriving at the building site.

PARKING, WALKWAYS, AND RAMPS

Convenience, an adequate number of spaces, and proximity to the building are of prime importance for parking. The designation for handicapped parking must be clearly identified and the area must be policed.

The pathway from the parking lot or street must be a hard surface, free of obstructions, wide enough to accommodate a wheelchair, and otherwise made safe for the user. Ramps must have handrails and minimum grade changes: slopes of a 1-foot (304 mm) rise to a 12-foot (3657 mm) run. Low-sloped ramps are also a benefit to the elderly and those using crutches or other assisting devices.

BUILDING ENTRY

The entry must be accessible to a physically impaired individual with regard to the floor area adjacent to the door, the threshold of the door, and the clearance through the doorway. Narrow or revolving doors do not permit access for the physically impaired. Also, adequate maneuvering clearances must be maintained on both sides of the doorway.

CORRIDORS AND DOORS

Once inside the building, a disabled person must be able to gain access to various rooms, including restrooms. Some buildings are classified as "accessible buildings," with the facilities designed for wheelchair travel in many areas, that is, in most spaces, in corridors, and through doors. Although each year more structures are being constructed with full accessibility, some buildings have only "accessible routes" to the entry, exits, and restrooms. Proper clearances must be allowed on both sides of a door, depending on direction of approach (Figure 10.10).

FIGURE 10.10 Minimum clearances are required at doors encountered along accessible routes. These are dependent upon which way a disabled person approaches the door.

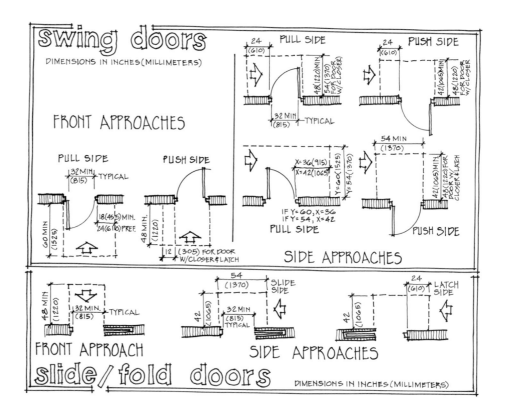

RESTROOMS

Almost every commercial building today must provide the physically impaired with access to a restroom facility. Depending on the number of visitors and employees, additional restrooms for each sex must be provided, particularly if a physically impaired employee is hired. Restrooms and bathrooms for the disabled can be arranged in many different patterns, but all must meet minimum spatial requirements and provide convenience features such as grab bars (Figure 10.11). A clear space 60 inches (1525 mm) in diameter is required for a wheelchair to make a 180-degree turn.

FIGURE 10.11 Toilet facilities for the physically disabled require minimum spatial features and equipment.

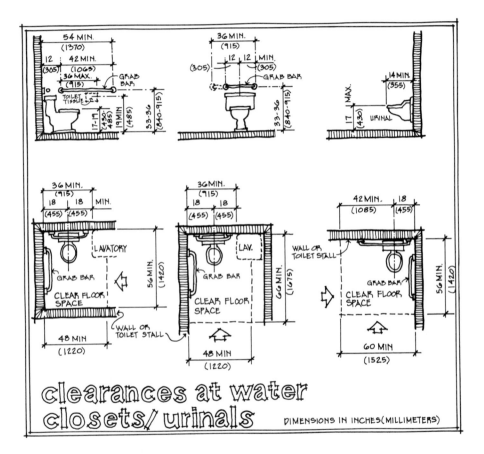

STAIRS

Building codes usually specify minimum and maximum riser and tread dimensions, handrail requirements, and stairway widths. These should meet fire exit requirements and the needs of the physically impaired. (See Chapter 15 for more information.)

SPECIAL FEATURES

Water fountains, signs, telephones, counters, and emergency devices must be designed for the physically disabled. These items must meet clearance, height, and materials requirements, among others, for easy use by the physically impaired. (See Appendix 1 for some examples of these items.)

HISTORIC PRESERVATION, RESTORATION, AND ADAPTIVE REUSE

FIGURE 10.12 The old Allenberg Cotton Building in Memphis was remodeled by the Hnedak Bobo Group for new use as a professional office building.

Of increasing interest in our environment is the preservation, restoration, or adaptive reuse of historic areas and buildings (Figure 10.12). Historic buildings are an important part of our nation's background and culture; they not only remind us of the past but serve the present and the future. Old buildings and interiors serve as focal points and add variety to our streets and interior spaces.

Preservation is an often used generic term, but it has specific meaning: using methods to sustain an existing structure's materials, form, and integrity to ensure that it does not deteriorate or cease to exist in the future. The process of preservation can be undertaken at any time in the structure's history but is ideally begun when it is built. Historic preservation is a specialized field including a comprehensive undertaking quite different from the design and construction of new buildings or the remodeling of existing ones. Many historians, scientists, architects, museologists, engineers, archaeologists, and experienced craftsmen are jointly involved in the preservation process. The saving and protection of our nation's landmarks and buildings maintains tangible evidence of our history and culture.

Restoration means to carefully return a structure to its original appearance and integrity. This can be accomplished by removing later additions and modifications that were not authentic to the original intention or materials. Any missing earlier work is restored and repair work to the structure is hidden.

Renovation or *rehabilitation* is involved with upgrading or altering existing buildings to extend their useful life and function. Although repairs might be major, any historical, cultural, or architectural features of the building are generally preserved (Figure 10.13).

Adaptive reuse is concerned with modification of an existing structure to enable it to serve a useful purpose today. Although the character of the original structure often remains, the new use can be entirely different from the original use. For example, a former train depot might be modified to become a new shopping center, or an old house adapted to become a restaurant.

FIGURE 10.13 The facade of the original James Whitcomb Riley Hospital for Children (Indianapolis) was renovated into the interior design of the new structure, creating a welcoming front door.

Background

Preservation was first undertaken in Europe in the 1800s; the impetus spread to the United States, where the movement has become very important. A considerable amount of literature exists showing both how earlier periods saw the need to preserve buildings and the methods they used.

In the United States, a private group was organized in 1853 to save the home of George Washington; eventually, in 1966, the National Historic Preservation Act was established, setting historic preservation as a national policy and providing incentives for preservation activities. Now, the National Register includes national, state, and local historic sites and buildings. Guidelines are published for rehabilitating historic buildings and must be followed to achieve National Register designation.

The "National Standards for Rehabilitation," published in a section of *The Secretary of the Interior's Standards for Rehabilitation and Guidelines for Rehabilitating Historic Buildings*, "are used to determine whether a rehabilitation project qualifies for Federal consideration and funding."

Landmarks: Districts and Buildings

Historic preservation involves historic landmarks, whether they are districts, buildings, or both. For example, a building located in a historic district might not qualify for inclusion on the National Register if it is not itself of historical significance in its construction or place in history. On the other hand, a building could have historical significance but not be located in a historic district.

Historic Buildings and Interiors

The preservation of a historic building involves two main areas: the historical character or context of a building in time and the building's historical materials. If these two can be saved, the structure will continue to serve as a historical testament. The historical character of a building is its individuality or integrity exhibited in its physical form and its reference to historical times. The building's original materials are either those that were used when it was constructed or their remains that have stood weathering by elements, use, and repair.

Interior historic preservation has been an important part of preserving the overall building, but many interior designers were not involved until the last decade. Now, however, we see historic restoration being undertaken by teams of interior designers and architects who specialize in this type of work and are sought nationally because of their expertise.

REFERENCES FOR FURTHER READING

Allen, Edward, and Joseph Iano. *The Architect's Studio Companion.* New York: John Wiley & Sons, Inc., 1989.

American National Standards Institute, Inc. *Specifications for Making Buildings and Facilities Accessible to and Usable by Physically Handicapped People.* ANSI A1117.1. New York: American National Standards Institute, Inc., 1986.

Haviland, David, ed. *The Architect's Handbook of Professional Practice.* New York: American Institute of Architects, 1988.

Kemper, Alfred M. *Architectural Handbook.* New York: John Wiley and Sons, Inc., 1979.

Ramsey, Charles G., and Harold R. Sleeper. *Architectural Graphic Standards.* 8th ed. New York: John Wiley and Sons, Inc., 1988.

Reznikoff, S.C. *Specifications for Commercial Interiors.* New York: Whitney Library of Design, 1979.

U.S. Department of the Interior. *The Secretary of the Interior's Standards for Rehabilitation and Guidelines for Rehabilitating Historic Buildings.* Washington, D.C.: U.S. Dept. of the Interior, National Park Service, 1979.

 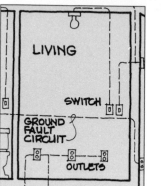 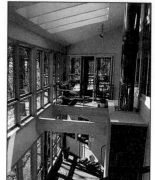

C H A P T E R 1 1

INTERIOR ENVIRONMENTAL CONTROL AND SUPPORT SYSTEMS

nterior environmental control and support systems are important parts of a building, providing thermal, sanitary, power, electrical, and other, sensory aids essential for the comfort, utility, and convenience of the users (Figure 11.1). In turn, these systems are designed as an integral part of the building's structural and enclosure systems.

Although architects and engineers are primarily responsible for the design and remodeling of most control systems, interior designers should be aware of the systems and their functioning, since these systems have a direct influence on the quality of the interior environment and affect the aesthetic considerations of the spaces. Interior designers need a basic understanding of these systems in order to consult with the various professionals and workers to provide for the coordination and proper selection of these interior support systems and their components.

All the systems illustrated in Figure 11.1 are discussed in this chapter except lighting, which appears separately in Chapter 12 because of its uniqueness and complexity within the interior environment.

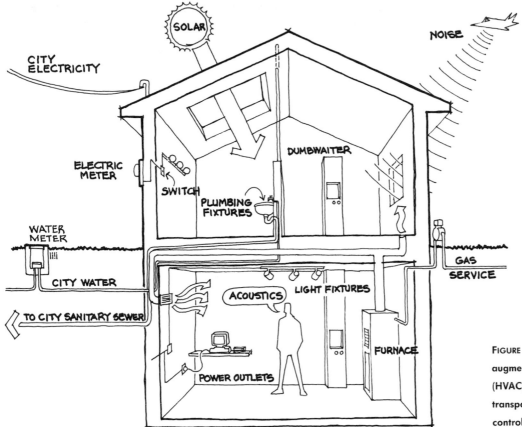

CITY ELECTRICITY

SOLAR

NOISE

ELECTRIC METER

DUMBWAITER

SWITCH

PLUMBING FIXTURES

WATER METER

CITY WATER

GAS SERVICE

TO CITY SANITARY SEWER

ACOUSTICS

LIGHT FIXTURES

FURNACE

POWER OUTLETS

FIGURE 11.1 Interior environments are augmented by electrical, mechanical (HVAC), and plumbing systems. Vertical transportation equipment and acoustical control methods can also be employed.

CLIMATE CONTROL AND ENERGY CONSERVATION

The interiors of our buildings should provide an ideal environment in which occupants can function well and appreciate the quality of life. Depending upon the location of the structure and its harmony or disharmony with the local environment, this ideal environment can be accomplished by using external factors in a direct relationship to the interiors or by relying on artificial methods of control and support.

Architectural design and energy concerns attempt to minimize energy consumption in a structure by integrating the building with its surroundings and taking into account local climatic conditions. In most cases, a beneficial blending of the interior and exterior spaces can be accomplished. However, excessive odors, noises, or temperature extremes may have to be regulated or blocked from reaching the occupants. The designer creates interior and exterior control and support systems to assist in making the environment better serve the users and their equipment.

Energy conservation and the efficient use of our natural resources have received widespread attention, particularly since the 1970s, when rising costs of fossil fuels and the oil embargo drastically affected our living, working, and transportation patterns. Today, concern for the natural environment and high replacement costs of energy sources have shifted our attention to conservation and recycling on a global basis. How we obtain, use, and conserve energy today will have a direct impact on current and future generations.

Design for energy conservation in buildings aims to minimize energy dependency and provide optimum comfort in the interiors. These goals are achieved through good site planning, orientation, massing of structure, the building's envelope (such as windows, other exterior materials, and insulation), and interior systems responsive to exterior influences. In turn, many of these design approaches, such as passive solar design, have created stimulating environments quite different from former building types that rely mostly on mechanically heated and cooled interiors. Buildings and interiors designed for energy conservation may become more regionalistic in appearance and function as they are influenced by local climatic conditions and cultural preferences.

The Human Comfort Zone

Acceptable climatic conditions for human comfort vary from culture to culture and individual to individual, depending upon each person's activity, metabolic composition, and psychological adaptation to his or her environment. This comfort range can also vary seasonally as individuals go through their daily functions. This human comfort zone has definite boundaries in temperature, ventilation, and humidity beyond which some physical and psychological stress might occur.

The comfort zone of the majority of the people in the United States lies approximately between 68° and 78° Fahrenheit (20° and 25.5° Centigrade) with about 20 to 80 percent relative humidity. Our interior environments are designed to fall within these ranges through natural or artificial conditioning for local climatic conditions and season of the year.

Heating, Ventilating, and Air-Conditioning of Interiors

Heating, ventilating, and air-conditioning (commonly called HVAC) of a building's interior spaces are necessary in most climates to provide environmental comfort for the occupants. Machinery and electronics have been developed that provide an automatically balanced comfort zone. Some of these systems are fairly simple and controlled by the user, but others are elaborate and operate automatically. The building's HVAC system controls the following aspects of the interior environment:

1. Surrounding air temperature;
2. Mean radiant temperature of the surrounding surfaces;
3. Relative humidity of the air;
4. Air movement;
5. Air quality or purity (odors, dust, or pollen).

The first four of these factors make up the "thermal environment," which is modified as necessary by the HVAC system to condition the interiors according to the degree of human activity and comfort in the space. The system controls seek equilibrium to adjust for users' bodily heat loss as they perform their various functions.

Architects and engineers are primarily responsible for the design and inspection of HVAC systems, and contractors install and operate them. However, the interior designer of today is

increasingly required to understand the basics of the HVAC and the way they affect interiors. For example, a designer should know that if many incandescent lights and people are added to a small space, the resulting heat load will increase and could become uncomfortable if not addressed by the mechanical system. A designer should also be able to read the basic blueprints of HVAC systems (particularly the ceiling plan) because the placement of light fixtures and other elements he or she adds must be coordinated with the HVAC elements, such as grilles, air registers, and required clearances (Figure 11.2). The interior designer should also take care that furniture, furnishings, and equipment do not obstruct parts of the HVAC system. Many books and articles on the design and performance of HVAC systems have been written, and several are listed at the end of this chapter.

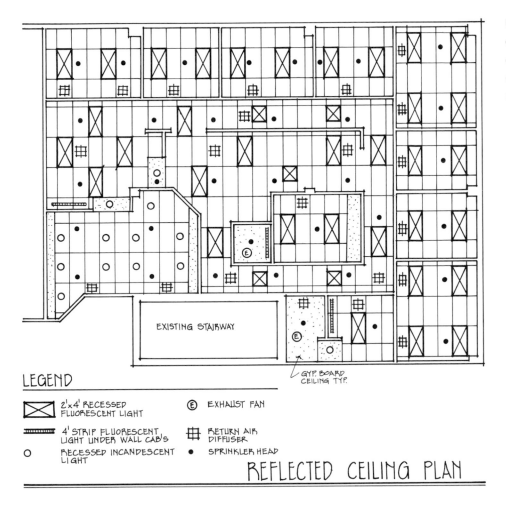

FIGURE 11.2 The interior designer assists in coordinating the placement of lights, mechanical system devices, and other elements as seen in this reflected ceiling plan.

LEGEND

⊠	2'x4' RECESSED FLUORESCENT LIGHT	Ⓔ	EXHAUST FAN
▭	4' STRIP FLUORESCENT LIGHT UNDER WALL CAB'S	⊞	RETURN AIR DIFFUSER
O	RECESSED INCANDESCENT LIGHT	•	SPRINKLER HEAD

REFLECTED CEILING PLAN

SOURCES OF ENERGY FOR HVAC SYSTEMS

Buildings can utilize a number of different primary energy sources to control their thermal microclimates. Some of these sources, such as wood (in a fireplace), can be used directly to heat an interior; others, such as oil, must first be refined and then burned in a furnace for radiant energy. Currently there is also an interest in using more renewable energy sources, such as solar, wind, hydroelectric, biomass, and wood, as opposed to nonrenewable ones, such as oil and coal, which have fixed and limited reserves. The advantages, disadvantages, and costs vary according to region and availability. Some of the common energy sources are discussed here.

FOSSIL FUELS. Fossil fuels are those natural resources, such as coal, oil, and gas reserves, that lie beneath the earth's surface. These are extracted directly and burned (coal), refined (heating oil and gas), or used indirectly (burned in large generating plants) to produce electricity.

NATURAL MATERIALS. Today, wood is often a secondary heat source in airtight stoves or fireplaces. However, many people are less concerned about heat output from these materials than with the visual or aesthetic aspect of a fire. Wood-burning equipment has become more efficient; however, in some cities "no burn days" and other restrictions are being placed on wood-burning devices to help reduce air pollution.

ELECTRICITY. Electricity is an excellent and universal source of energy generated by hydroelectric (water), fossil fuel, wind, photoelectric, or nuclear plants and distributed to our buildings.

GEOTHERMAL. The earth's crust covers large amounts of trapped heat that can be tapped for steam and hot water in some areas for generating geothermal heat sources. Similarly, deep-well drilling near a building can be coupled with a water-driven mechanical heater to use groundwater as a source of heat. This will be discussed later.

SOLAR ENERGY. Since the oil crisis in the mid-1970s, solar energy has been looked upon as possibly one of our most renewable energy sources for the future. Depending upon the location of a building, it is possible to replace 30 percent to 80 percent of the energy required for heating needs by utilizing principles of solar energy design.

HEATING INTERIORS

Heating interior environments can be achieved in two different ways—directly, by burning fuels within a space, or indirectly, by transferring a heated medium (such as hot air) to the space from a central plant. The particular method used is dependent upon several variables, such as the exterior climate, desired comfort level of the users, and availability of fuels. The costs of the system's installation and operation are also of prime importance.

A building's potential heat losses are due to its materials, its shape, and the local climatic conditions, all of which must be taken into consideration when a heating system is designed. The heating plant is sized to replace heat losses to a level that will maintain a comfortable interior climate for the occupants. Engineers and architects also take into account heat generated by the occupants, lighting, and equipment in the space. There are four basic methods by which this heat loss in buildings, called heat transfer, occurs (Figure 11.3).

FIGURE 11.3 Heat is lost or transferred from one medium to another in four basic ways.

CONVECTION — HEAT TRANSFERS THROUGH THE ATMOSPHERE BY THE MOTION OF COOL OR WARM AIR CURRENTS ACROSS A SURFACE.

RADIATION — HEAT TRANSFERS THROUGH SPACE, SUCH AS HEAT RADIATED FROM THE SUN, A FIRE, OR A PERSON.

CONDUCTION — HEAT TRANSFERS DIRECTLY THROUGH MATTER, AS FROM A WARM MATERIAL TO A COOLER MATERIAL.

EVAPORATION — HEAT IS LOST THROUGH THE PROCESS OF MOISTURE TURNING INTO A VAPOR.

ENERGY AND HEAT CONSERVATION. Buildings are designed today to use less energy than in the past, because more emphasis is now placed on heat conservation and efficient heat utilization. Structures are designed to slow heat loss to the exterior during cold periods, resulting in the heating system having to generate less new heat, thereby increasing efficiency. For example, more heat is needed from a furnace to heat a poorly insulated building than a well-insulated one. Standards are now set and enforced by most building codes to help conserve the amounts of energy we use to heat our buildings. Most people are aware of the need to caulk, insulate, and turn down thermostats in homes and workspaces to help conserve the world's energy sources.

Insulation is used in buildings to slow the loss of heat to the exterior in cold seasons and help buffer the interiors from high heat in hotter seasons. The choice of insulation depends on a material's resistance to heat flow, physical characteristics, and purchase and installation costs. Generally, the greater the resistance (R) value, the better the material serves as an insulator.

HEATING SYSTEMS

Heating systems function primarily by warming a particular medium, such as water, air, or steam, and delivering it to the various building spaces. Other methods, such as electric radiant heating elements or electric coils, transfer their energy directly to the surrounding air to warm a space. Air can be force blown over these elements or allowed to circulate in natural patterns.

A thermostat automatically monitors the temperature of a space and switches the furnace accordingly, controlling both the air-conditioning system and the heating system. The thermostat is placed in a location free of drafts and direct sunlight, since these can influence the accuracy of its readings.

WARM AIR HEATING. Most heating systems include furnaces that use air as the medium to transfer heat to interiors by delivering it with fans or gravity feeds. The latter type uses the natural principle of the tendency of heated air to rise, then fall as it cools, and was used before forced-air systems were developed. In mechanical systems, the air is moved through proportionately sized ducts and enters registers, which are outlets through floors, walls, or ceilings (Figure 11.4). These devices are designed to direct the warm air to different parts of a

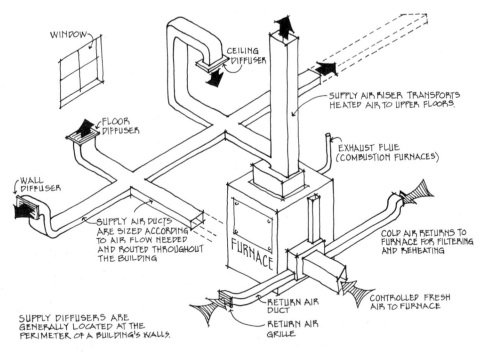

FIGURE 11.4 Warm air heating systems use a furnace to heat the air and deliver it through a system of supply and return air ducting.

WINDOW

CEILING DIFFUSER

SUPPLY AIR RISER TRANSPORTS HEATED AIR TO UPPER FLOORS.

FLOOR DIFFUSER

EXHAUST FLUE (COMBUSTION FURNACES)

WALL DIFFUSER

SUPPLY AIR DUCTS ARE SIZED ACCORDING TO AIR FLOW NEEDED AND ROUTED THROUGHOUT THE BUILDING

FURNACE

COLD AIR RETURNS TO FURNACE FOR FILTERING AND REHEATING

CONTROLLED FRESH AIR TO FURNACE

RETURN AIR DUCT

RETURN AIR GRILLE

SUPPLY DIFFUSERS ARE GENERALLY LOCATED AT THE PERIMETER OF A BUILDING'S WALLS.

space. Their size, number, and location depend on the expected heat loss of the space, its size, heat-producing equipment, and activities within the space. The air then finds its way back to the furnace through individual return air grilles and ducting or is drawn through a large, centrally located return air grille to be heated again. These furnaces can be gas or oil fired, use electrical heating coils, or use a combination of compressors and heat pumps (discussed later in this chapter).

Heating ducts are designed in relation to the velocity of the warm air delivered to create a "balanced" system of the various interior spaces. These ducts are constructed of metal, fiber-board, or plastic and are rectangular or round, depending on the design and material used. Their cross-sectional area is in relation to the cubic feet per minute (CFM) of air needed for the spaces and to the permissible velocity the engineer specifies in the duct. The ductwork branches out to deliver a specific volume of air to the respective spaces, corresponding to their size, shape, desired temperature, and use. These layouts can be designed as an underfloor perimeter or branch system, an above-ceiling system, or an exposed arrangement.

Warm-air heating has some advantages over other systems, since humidifiers and filters can be added to the system for conditioning the air. The same system of ductwork can also be used during warm seasons to ventilate or to provide air-conditioning.

HOT-WATER HEATING. In contrast to warm-air heating, hot-water (hydronic) heating uses water to transfer heat from the furnace (called a boiler) to interior spaces via piping. Although hot-water heating can be more expensive to install, it has some advantages over warm-air systems: Piping requires less space than air ducts, does not cause air drafts, and tends to maintain a more even temperature.

A boiler heats water to a predetermined temperature, circulating it by electric pumps through piping to individual radiators or "fintubes." Air flows over these radiators naturally or is blown by a fan, picking up heat and warming the space. This type of heating uses several different layouts—the series perimeter loop, the one-pipe system, or the two-pipe system (Figure 11.5).

In some cases, the hot water is circulated through radiant heating pipes imbedded in a concrete floor. This system has two advantages: It eliminates cold floors, and it uses no space in the interior for radiators. However, this system can be difficult to repair if it breaks.

FIGURE 11.5 **Hot water systems boil water to a high temperature and deliver it to radiators to heat spaces. Although there are many piping methods, there are three basic methods.**

HOT WATER HEATING SYSTEMS

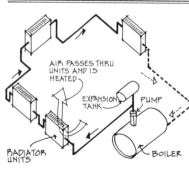

PERIMETER (SERIES) LOOP

- PIPING REQUIRED IS MINIMAL
- INDIVIDUAL UNIT CONTROL IS LIMITED
- MOST ECONOMICAL TO INSTALL

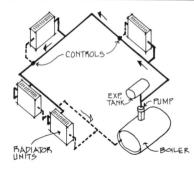

ONE-PIPE SYSTEM

- LESS PIPING REQUIRED THAN IN THE TWO-PIPE SYSTEM
- VALVES CAN BE USED AT EACH UNIT FOR TEMPERATURE CONTROL

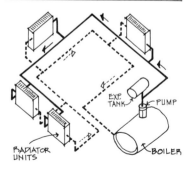

TWO-PIPE SYSTEM

- VALVES NEEDED AT EACH UNIT
- WATER TEMPERATURE AT ENTRY TO EACH UNIT IS THE SAME
- PRODUCES MOST EVEN TEMPERATURES

STEAM HEATING. In a steam heating system, water is heated to a high temperature until it changes into steam, which is then sent through insulated piping to the individual radiators. As the steam cools and condenses to water, a separate gravity-return pipe delivers it back to the boiler for reheating into steam. Steam heating and hot-water systems have some advantages over air in that they can be piped into zones, which allows individualized control of different rooms and areas of the building.

ELECTRIC HEATING. Electric heating is generally the least expensive of all systems to install but often costs more to operate because of its higher electrical demand. However, it can easily be zoned, with separate wiring or a thermostat at each unit, to allow great flexibility. There are several ways to use electricity to supply heating. The most common method is installing electric baseboard strips or wall units in a space. The wiring creates a resistance to the flow of electricity, causing it to heat up and transfer to the surrounding air. Fans can also be added to help circulate air throughout the space.

HEAT PUMPS. Heat pumps are a hybrid system that combines some of the features of all the formerly mentioned systems, yet are unique in their operation. A major feature of these devices is that with the flick of a switch, they can heat in the winter or, by reversing the fluid that goes through them, can cool in the summer. By using a reverse-cycle refrigeration system, the electrically driven system can be utilized in a variety of building types—and, unlike other systems, it does not require a flue to exhaust spent gases. The heating and cooling can be accomplished by reversing the flow of the refrigerant in the system (Figure 11.6). These units derive their heat

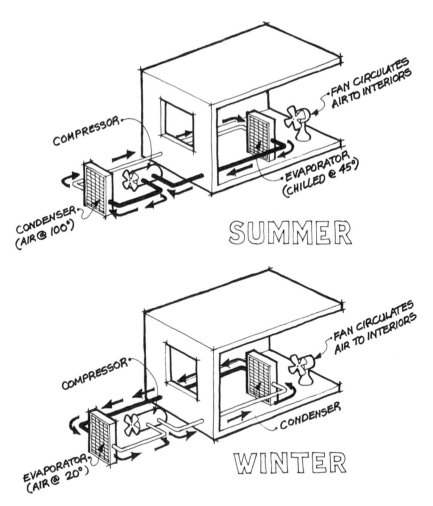

FIGURE 11.6 A heat pump reverses the flow of a refrigerant to produce a cooling or heating mode as needed for the interior spaces.

from outside air or a water source, such as a geothermal well in the earth. The air systems are very efficient in their operation for heating when outside air temperatures are above approximately 34°F (1.11°C). Below these temperatures, the outdoor part of the system has difficulty drawing heat from the surrounding air. In these cases, the electric resistance heating inside the furnace takes over, decreasing the unit's efficiency because it is operating like straight electrical resistance heating.

UNIT HEATERS. Most of the previously described systems utilize one or more central heat plants, depending on the size of the building. Sometimes unit heaters might be used instead. These heaters can be thought of as a decentralized system in which furnaces are placed within or adjacent to the space being served. Unit heaters eliminate the need for a lot of ductwork or piping and can be located in specific areas for more independent control. Most of them combine air-conditioning and a fan to help distribute air. Because of their versatility in comfort control for heating and cooling, these units are popular in hotels, motels, and other spaces requiring individualized climate control.

AIR-CONDITIONING

Air-conditioning is a process that removes heat from a space by delivering air cooler than the air existing in the space. Although air-conditioning is sometimes called cooling, air-conditioning really refers to year-round climate control, whether it is cooling, heating, or ventilating air. When air is dried by removing water vapor from it, the lessened relative humidity promotes an evaporative effect on our bodies that results in a feeling of coolness. Humidity control is an important comfort factor, and some forms of cooling simply remove humidity without introducing chilled air.

Cooling of air can be accomplished in two ways—the evaporative method for arid climates or the refrigeration method for high-humidity areas. Evaporative coolers will not cool as well in areas where the air has greater humidity levels. The evaporative system, which involves cooling by water, introduces more humidity, which can be tolerated in the Southwest but not in areas such as the Midwest, since the higher humidity adds to the heat gain. Refrigeration systems operate like household refrigerators and heat pumps. They draw heat out of the refrigerator (house) and dump it into another space (outdoors), using a refrigerant under pressure, rather than water, to create the cooling effect. Various refrigerants are used in these systems, and efforts are being made to discover new ones to ensure that any leakage of these gases will not be harmful to the environment and atmosphere, particularly by depleting the earth's ozone layer.

COOLING BY WATER, AIR, AND HEAT PUMPS. Cooling and the conditioning of air can be accomplished by sending chilled water through piping and radiators to a space, similar to the way hot-water systems work. The lower temperature of the water will absorb the heat from the air, transfer it to the water, and carry it back to the central plant.

Cooling by air-to-air transfer utilizes the refrigeration principle of compression, condensing, and evaporation, as is used in the household refrigerator. The heat in the room air is literally transferred to the outdoors by being absorbed in the refrigerant. Air is conditioned by its exposure to chilled or heated refrigerants in the system, rather than to water. Cooling units are placed in the furnace room and have an outside compressor (Figure 11.7).

VENTILATION

Interiors can be maintained at the desired temperature by tempering the air in the space with some of the heating and cooling methods described above. However, at some times of the year it may be possible either to exhaust air out of the building or to introduce air into the building from the outdoors. If the outdoor air is cooler or warmer than the interior, this outdoor air can be used directly for the desired effect. This process, called ventilation, involves moving the air either through the heating or cooling system or just transferring it separately by individual

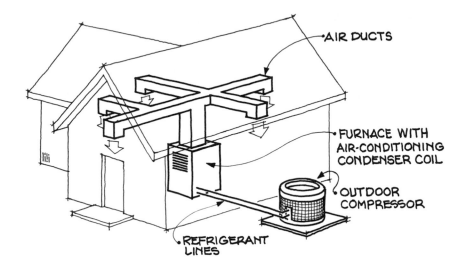

AIR DUCTS

FURNACE WITH
AIR-CONDITIONING
CONDENSER COIL

OUTDOOR
COMPRESSOR

REFRIGERANT
LINES

FIGURE 11.7 Cooling of building interiors can be done with a refrigeration system that transfers interior warm air to the exterior, thus cooling the building space.

ducts or vents. Moving air through the interiors can help maintain uniform temperatures and be coupled with other air improvement modes, such as humidity and filtering controls.

NATURAL AND FORCED VENTILATION. Air is either moved through buildings by natural convection or air currents or it is pushed and pulled by mechanical means. A natural method is the simple opening, closing, or regulating of windows and doors. Breezes from the exterior can be captured by these openings and funneled through interiors. While most of this movement is horizontal, air can also be moved vertically by adjusting the openings at different heights within a space or multileveled building. For example, a combination of first-floor and second-floor windows can be opened to prevailing winds to create a vertical air movement that can cool the interiors. This principle can also be used in rooms with cathedral ceilings and other vertical spaces to help circulate air through natural air currents as hot air rises.

Forced ventilation uses electrical fans to move air through ducts to adjacent building spaces. Generally the fan is located in a central plant, although other remote locations can also be employed. Ceiling fans, exhaust fans, and "whole house" fans are used in many interiors to push or pull air for the desired effects.

SOLAR ENERGY AND INTERIORS

The sun floods the earth with abundant energy that can be a viable resource for heating, cooling, and generating electricity for our needs. Solar energy is not newly discovered; for many centuries, it was used by our ancestors, who discovered that cave and building wall openings oriented in the direction of the sun would be heated and illuminated on cold winter days.

Historically, the Greeks designed their homes around central courtyards and oriented buildings to take advantage of the sun's rays. Even today in the Mediterranean, houses are whitewashed to reflect the hot summer sun. The autumn rains then wear away the whitewash to expose the structure's darker colors, which tend to absorb winter solar energy as heat. In the United States, southwestern Pueblo structures and New England saltbox house designs are evidence of the effective use of the sun. By understanding the sun's path, cliff dwellers in the Southwest also used solar principles to capture heat and create cooling (Figure 11.8).

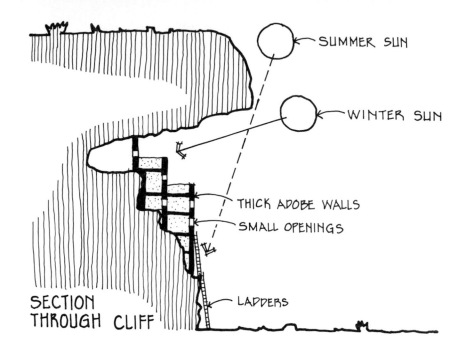

SUMMER SUN

WINTER SUN

THICK ADOBE WALLS

SMALL OPENINGS

LADDERS

SECTION
THROUGH CLIFF

FIGURE 11.8 The hot summer sun is blocked by the cliff overhang in this ancient cliff dwelling. Low winter sun strikes the adobe or massive stone walls, storing heat for the occupants.

At the 1933 World's Fair in Chicago, a glass structure was exhibited that had a large expanse of south-facing glass to admit winter sun, which would heat interior masonry surfaces. In the evening, the stored heat warmed the interiors. In the same decade several projects attempted to capitalize on the principles of solar energy, creating a new interest in solar heating. Since that time, many individuals and organizations have designed, built, and tested structures to use solar energy for heating and cooling.

When energy prices are fairly stable, the interest in solar design is not as apparent as during energy crises, such as the oil embargo of the 1970s. However, there is indeed a need for this technology as we deplete our world's natural resources in the quest for energy.

The interior designer today needs a knowledge of the principles of solar energy and their effects on interiors. The use of additional open spatial plans within buildings to encourage solar heating and distribution can directly affect the design of the spaces and materials used. In recent years clients have been asking for more sunspaces, greenhouses, and glassed dining spaces. The designer must understand the effects and functions of these solar rooms; overheating and the fading of colors by sunlight can be of great concern.

Various regions in the world are better than others for utilizing solar energy for heating, depending upon the amounts of sunlight hours and radiation available. For example, because of the number of cloudless days with more direct sun, the Southwest of the United States is better suited than the Northeast for harnessing a high percent of solar energy.

Many books and charts give detailed information on the sun's path across the sky for different seasons, times of day, and geographical locations. These data are used by architects to determine when, where, and how much of the sun's rays will strike a building and penetrate the interiors. The interior designer can use these findings to design for "daylighting" techniques (Chapter 12) to supplement artificial lighting and ascertain the likelihood of interior materials fading.

Generally, windows in cold and temperate climates can be oriented southward to receive the sun's rays during winter and be shielded from hot summer sun with various screening devices. North windows can be small to reduce winter heat loss, with west windows designed to be shielded from low, hot summer sun. East windows are designed to fall between these extremes.

Methods of Solar Heating and Cooling

The use of solar design effects a high level of energy conservation. Most heating and cooling systems in solar structures are not capable of providing the instant high and low temperature control of conventional methods. Effective insulation can help the building conserve the heat generated; and to help block the sun's energy effectively when cooling is needed, various shading devices that help store or deflect heat are needed. Some of these are in the form of movable elements that can be adjusted for proper times of the day and seasons (Figure 11.9).

Cooling with solar energy uses shading of a building and its windows, air ventilation, and other methods for natural cooling. Cooling can also be done using the refrigeration principles discussed earlier. In these, solar collectors are used to heat a liquid to a high temperature, and the liquid then becomes the refrigerant to draw heat from surrounding spaces.

There are two approaches to designing for solar heating and cooling: active systems or passive systems. These can be found in both residential and commercial structures, although residential use is more common because the spaces generally are smaller, requiring less output from the solar source.

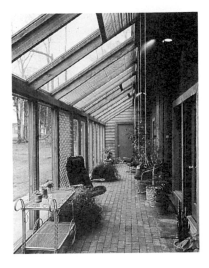

FIGURE 11.9 The window blinds in this residence by the Tennessee Valley Authority can be raised, lowered, or tilted for desired sun control throughout the day and seasons.

ACTIVE SOLAR SYSTEMS

Active solar systems use technological hardware and mechanical equipment to collect solar radiation and convert it to thermal energy, which then heats water, air, or other fluids to warm or cool interiors. These systems, which can usually be recognized by the solar collection panels on the building's exterior (Figure 11.10), are often more expensive to install than passive

FIGURE 11.10 This energy-efficient building utilizes active solar system collectors on the roof to provide heat and domestic hot water.

systems. However, because these units are small and have become more economically feasible, one of the most common active systems found today is that used for heating domestic hot water. In some cases, the initial installation costs can be offset by the payback of lower operating costs over a short period of time. An active system has six basic components: collectors, transport medium, distribution, storage, backup source, and controls (Figure 11.11).

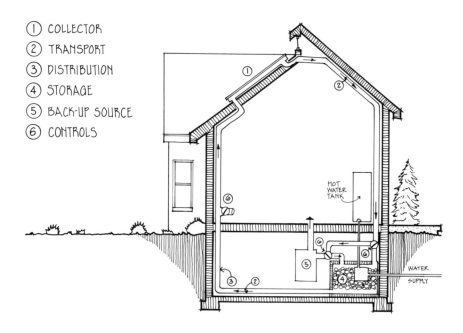

FIGURE 11.11 Active solar systems have a variety of unique features. However, there are six basic components to all: (1) collector, (2) transport, (3) distribution, (4) storage, (5) backup source, and (6) controls.

① COLLECTOR
② TRANSPORT
③ DISTRIBUTION
④ STORAGE
⑤ BACK-UP SOURCE
⑥ CONTROLS

COLLECTORS. Collectors capture the sun's rays by means of panels facing toward the south and the sun. These collectors can be the nonfocusing type (flat collectors), absorbing an equal amount of energy across their surface, or they can be focusing, such as a parabolic louver that concentrates the sun's energy into a small area, increasing the intensity of the sun and of the heat generated. Inside the collector, a material heats up and transfers energy to a liquid or air medium.

TRANSPORT MEDIUM. The transport medium that passes through the collector can be a liquid or air, depending upon the type of system designed. Most of the liquid systems use water, except in climates where the nighttime temperatures can cause freezing at the exposed collector. In these cases, an antifreeze solution is used. The transport delivers the heat to the next stage by gravity, fans, or pumps.

DISTRIBUTION. Through ducts or piping, depending on whether air or liquid is used for transport, the distribution system carries the heated transport medium from the collectors either directly to the space that requires it or to the storage center for later use. The distribution system also delivers heat from the storage area to the spaces and recycles the transport medium back to the collectors. It can be natural in its operation or use pumps and fans for forced circulation.

STORAGE. The transport moves the collected heat to a storage reservoir if the interiors do not need the heat directly. It can be transferred in the storage facility to rocks, water, or other materials to hold for use at a later time. This storage might provide heat for a few hours or for several days, depending on its size, insulation, and degree of initial heat.

BACKUP SOURCE. A backup energy source is needed to take over heating requirements if the solar system cannot produce enough heat, such as on cloudy days, at night, or when

stored heat is depleted. These sources can be wood stoves, fireplaces, or the other conventional furnace systems.

CONTROLS. Active solar systems require more controls than just a simple thermostat. Several types of thermostats, sensors, and other monitoring devices work in stages to control the operations of an active system. Some are automatic, and others require some direct involvement by the user.

PASSIVE SOLAR SYSTEMS

Passive solar systems use natural or passive means to transfer energy from the sun and use little or no mechanical equipment. These systems take advantage of the physical laws of heat transfer within the building's design and materials. Passive solar concepts make energy conservation and natural energy modes an integral part of the building's design (Figure 11.12). However, passive solar can demand active participation by a user, such as periodically opening and closing window shades, windows, and other devices. Temperature variations can become uncomfortable

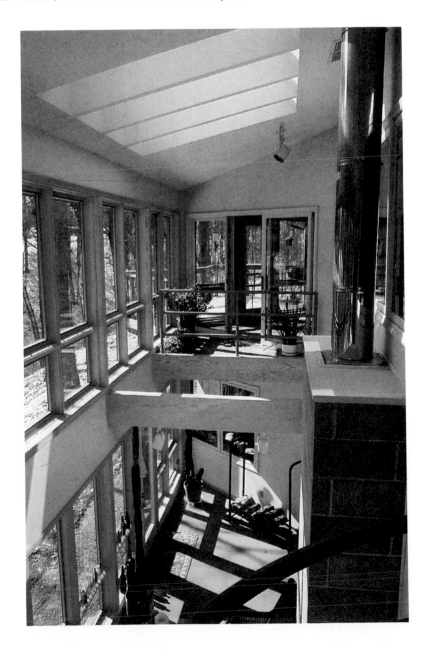

FIGURE 11.12 Passive solar design concepts of large south glazing, massive wall storage, and earth berming on the north create the unique appearance of this residence.

in some cases because greater fluctuations in temperature levels can occur. Some spaces might overheat while others become too cool. The three ways to achieve passive design are through direct, indirect, and isolated gain (Figure 11.13).

FIGURE 11.13 Passive solar design involves three basic approaches. Each is studied for its winter, day and night, heating needs and its summer cooling features.

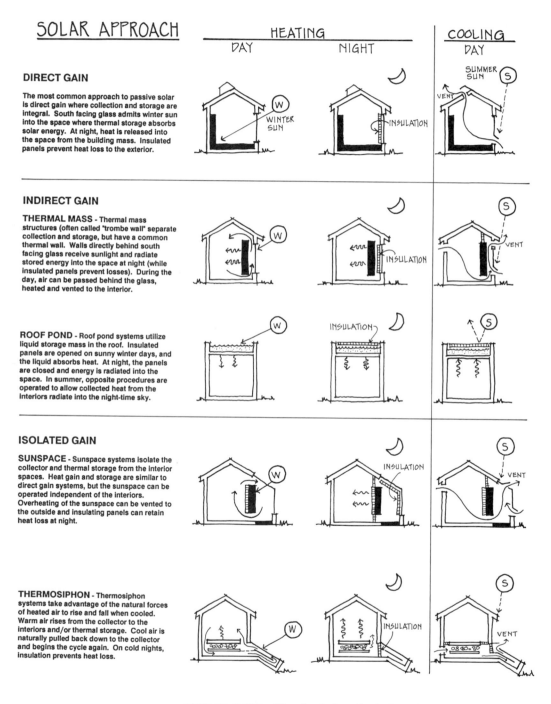

DIRECT GAIN

The most common approach to passive solar is direct gain where collection and storage are integral. South facing glass admits winter sun into the space where thermal storage absorbs solar energy. At night, heat is released into the space from the building mass. Insulated panels prevent heat loss to the exterior.

INDIRECT GAIN

THERMAL MASS - Thermal mass structures (often called "trombe wall" separate collection and storage, but have a common thermal wall. Walls directly behind south facing glass receive sunlight and radiate stored energy into the space at night (while insulated panels prevent losses). During the day, air can be passed behind the glass, heated and vented to the interior.

ROOF POND - Roof pond systems utilize liquid storage mass in the roof. Insulated panels are opened on sunny winter days, and the liquid absorbs heat. At night, the panels are closed and energy is radiated into the space. In summer, opposite procedures are operated to allow collected heat from the interiors radiate into the night-time sky.

ISOLATED GAIN

SUNSPACE - Sunspace systems isolate the collector and thermal storage from the interior spaces. Heat gain and storage are similar to direct gain systems, but the sunspace can be operated independent of the interiors. Overheating of the sunspace can be vented to the outside and insulating panels can retain heat loss at night.

THERMOSIPHON - Thermosiphon systems take advantage of the natural forces of heated air to rise and fall when cooled. Warm air rises from the collector to the interiors and/or thermal storage. Cool air is naturally pulled back down to the collector and begins the cycle again. On cold nights, insulation prevents heat loss.

DIRECT GAIN. The simplest method of passive design is the direct gain method, in which the occupied interior space serves as the collector. This method requires large expanses of south-facing glass and some means to restrict sunlight or exhaust heat, either by shading with

roof overhangs or by using vents. Insulation properties of windows or movable insulation must also be considered to prevent major heat loss.

The most successful direct gain systems use a thermal mass, such as concrete, brick, or other dense material, to trap the sun's heat and release it later into the space. These masses are located within the space to receive direct sunlight in order to gain maximum heat input from the sun's rays. Direct gain techniques can result in the fading of materials and other damage to furnishings and furniture from the excessive amounts of direct sunlight.

INDIRECT GAIN. Indirect gain involves receiving the sun's energy and heat in a place separate from the occupied spaces. The sun strikes the thermal mass of concrete, stone, brick, or water in these remote spaces. The heat is then transferred to the occupied space, allowing the collector and storage to be operated separately. In this method, excessive heat buildup or heat loss can be better regulated for the occupant's comfort. Indirect gain can use several different ways of collecting, storing, and heating interior spaces.

The Trombe wall system of indirect gain, named after the French scientist who developed the technique, utilizes large expanses of south-facing glass with a dark-colored thermal mass set a few inches behind. The mass receives the sun's heat, stores it, and slowly releases it into the adjacent occupied space for a lengthened heating effect throughout the day and even at night. Vents are placed low and high in the Trombe wall mass to take advantage of the natural convection loop of hot air rising in the interiors, drawing the cooler, heavier air back into the lower part of the wall as the air is returned from the occupied space.

A roof pond system of indirect gain locates the thermal mass on the roof of the building to obtain heat from the sun's rays and distribute it to the occupied spaces. These systems are more commonly found in moderate climates, such as California's, where the liquid medium is not subject to extreme heating and freezing temperatures.

ISOLATED GAIN. Sunspaces (used for solar gain) or greenhouses (used for growing plants) are examples of isolated gain systems of solar heating. These are very popular and are used both in residences and a variety of commercial buildings, particularly restaurants. They not only can add heat to interiors but are a bright, cheerful extension to an interior space. Sunspaces work most efficiently when coupled with thermal mass storage and movable insulation/shading devices to prevent major heat loss or overheating.

Thermosiphoning is an isolated gain principle that uses a convective loop system based on natural forces. The system and collector are independent of the occupied space. The heat flows through the medium of either water or air; as it is heated in the collector, the transfer medium rises to the occupied space and at the same time pulls cool air or water to the collector for reheating.

ELECTRICAL SYSTEMS FOR BUILDINGS

Electrical systems for buildings usually are designed and installed by electrical engineers or licensed contractors who handle the technical aspects, since they are aware of the many codes and restrictions that govern electrical devices and power supplies. However, the interior designer does get involved in planning for electrical systems, particularly switch locations, dimmers, outlets, and an increasing variety of lighting circuitry and types. Computers and other specialized devices have placed a greater demand on the interior designer to understand the functioning of

electrical systems in the interior environment. The designers must be able to read, and frequently to draw, an electrical or lighting plan using the symbols that indicate the placement of lights, switches, electrical outlets, telephones, and basic circuits. The interior designer is also involved at the beginning of a project in analyzing and specifying electrical and communication needs.

Electrical Theory and Terminology

Electricity can be thought of as the flow of a current, such as water through pipes. Electricity uses various sizes of wiring and circuitry to produce usable energy when it is tapped. Electricity can be in the form of alternating current (AC) or direct current (DC). AC is primarily used for higher voltages, to run electrical equipment and general lighting; DC mostly powers smaller energy devices, such as telephones, signal equipment, automobiles, flashlights, and specialty low-voltage lighting.

AMPS AND VOLTS

A certain amount of electrical current flows past a particular point in the wire or conductor at any given moment. The measure of the rate of flow is termed *ampere,* or *amp* (A). Just as we can measure flowing water in gallons per minute, we can measure electrons as amps per second.

Volts (V) represent the unit of electrical potential of the flowing electrons created by causing a higher electrical charge to exist in one end of a conductor than in the other. The potential difference, or voltage, is the effect—similar to the pressure difference caused in a hydraulic system.

OHMS, WATTS, AND POWER

Just as the flow of a fluid in a pipe is slowed by friction, the flow of electrical current in a conductor meets resistance. Whether AC or DC current is used, the resistance measurement is the ohm, abbreviated R. Materials that have a lesser resistance to the flow of electric current are termed *conductors.* Wires and circuit boards, made of metals such as copper and aluminum, are conductors of electricity. Glass, rubber, and other synthetics are more resistive to current and are termed *insulators.* These materials are used to insulate electric conductors.

The watt (W) is the unit of power in electrical theory that is the measure of one volt causing one ampere of current to flow. In a formula ($W = A \times V$), the power (watts) is derived by multiplying the current (in amps) by the pressure (in volts). For example, if a light bulb uses approximately .5 amps when burning and is connected to a 120-volt electrical line, the power consumed is 60 watts ($.5 \times 120 = 60$). Light bulbs and other devices are rated according to the amount of power (watts) they draw and are labeled by wattage to assist in selecting the proper device and determining how much energy is being used.

Electrical companies sell electricity based on the amount used and the length of time it is used. Electrical consumption is usually expressed in kilowatt hours (kwh), each of which represents 1,000 hours. Buildings today are metered to establish how much electricity is being used and how many hours should be billed to the consumer. Most of the public is aware of the need to conserve energy by turning off lights and equipment when not in use. The designer should also be more aware of conservation in specifying energy-efficient appliances, lighting, and other devices.

Distribution of Electricity

Electric companies route electricity as high-voltage alternating current to our buildings from overhead or underground. Transformers are periodically installed in the high-voltage system on utility poles, in boxes placed on the ground, or within buildings to serve branch circuits from main feeder lines. These transformers lower or raise voltages according to the building's needs.

Electrical service wiring enters a building through an electrical meter and a main disconnect switch that can interrupt power in an emergency or to service the system. From here, wiring is distributed throughout the building (Figure 11.14).

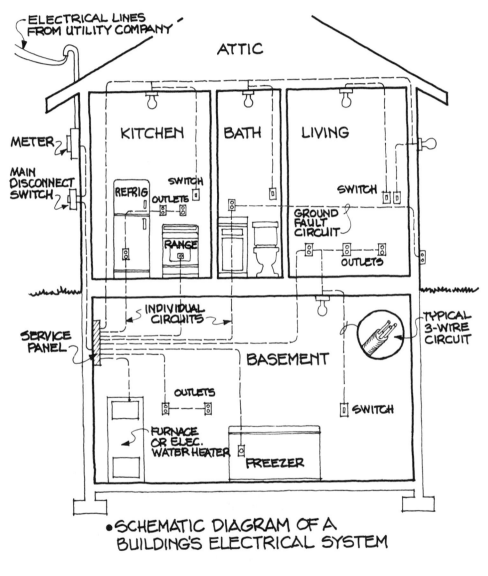

•SCHEMATIC DIAGRAM OF A BUILDING'S ELECTRICAL SYSTEM

FIGURE 11.14 Electricity is delivered by wiring into a building and connected to a service panel. It is then routed in designated circuits throughout the structure for various needs.

SERVICE PANELS, CIRCUITS, FUSES, AND BREAKERS

Exterior electrical lines are connected to a distribution or service panel within the building. From this panel, wiring is fed to the various parts of the structure through separate circuits. These circuits serve equipment, the HVAC system, light fixtures, and other electrical convenience

outlets. Each circuit is wired separately to the service panel to differentiate it from other circuits. Each circuit is designed and calculated with the proper size of conductors based on the anticipated loads that will be placed upon that circuit. Each is protected by a fuse or a circuit breaker from overloading or short-circuiting within that branch. These protection devices are rated in maximum amps to handle the attached electrical loads and to trip off or burn through when overloaded. The maximum circuit load in amps is determined by dividing the total wattages of devices on that circuit by the available current. For example, twenty-four 100-watt light bulbs placed on a 120-volt supply would require a minimum 20-amp circuit. The equation for this is amps equals watts divided by volts ($A = W \div V$), or 2,400 divided by 120 = 20 amps.

Electrical circuits that contain switches and convenience outlets in wet locations, such as bathrooms and outdoors, are termed ground fault interrupter circuits (GFIC). These contain very sensitive circuit breakers that trigger immediately to prevent electrical shock to people.

Panels, breakers, wiring, and all other electrical devices are strictly standardized and manufactured to specific codes. The National Electrical Code sets most local, state, and national requirements for electrical systems. When specifying electrical devices or lighting, the designer must be aware of those codes that directly affect the equipment, such as clearances, finish coverings surrounding electrical devices, and the like.

Interior Wiring

Electricity is distributed through a building generally as a two- or three-wire system, although specialized currents, such as telephone and computer systems, can be carried with multiwires or even fiber optics. Wiring is sized in diameter according to (a) how much electricity it can safely carry at a maximum operating temperature and (b) the ability of the insulation to protect it.

Service wiring is distributed throughout a building in three forms: insulated wire (used mostly in walls of residential installations), insulated wire in closed feeders (metal conduits and underfloor raceways), and insulated wire in closed special feeders (such as premade metal conductors or other special types). Wiring within commercial office panel systems is another example of specialized wiring concealed in hidden raceways (Figure 11.15).

FIGURE 11.15 Some office furniture panel systems contain hidden raceways for distributing electrical power, telephone, and computer wiring.

Wiring can be routed in a building through the walls, floor, or ceiling, according to the specifics of the system and the type of installation needed. Although wiring runs have been standardized over the years, computer and communication needs, energy conservation, and flexibility of use have created new wiring systems, such as low-voltage wiring and flat undercarpet systems (Figure 11.16). New forms of electrical wiring are being developed to interface with

FIGURE 11.16 Example of electrical flat wire cable system as installed under carpeting.

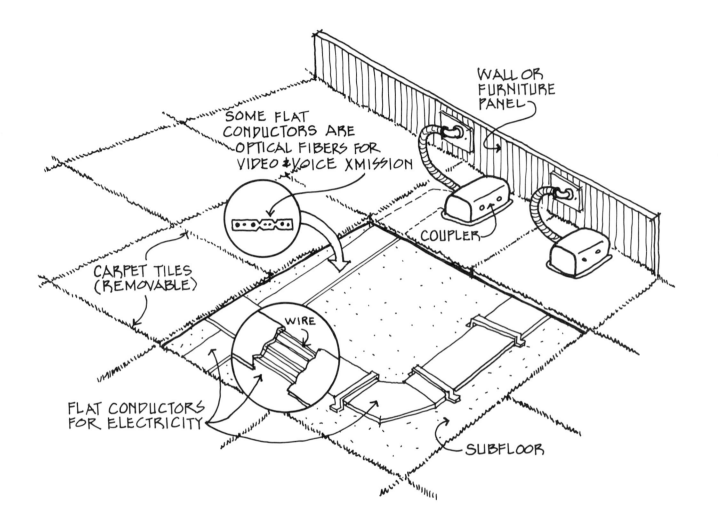

today's increasing technologies. These systems, such as the "smart house" development (endorsed by the National Association of Home Builders (NAHB) and other commercialized "intelligent" networks, locate all the electrical systems in one computerized control package. In turn, these systems are tied directly to fire alert, security, HVAC, and other monitoring devices to produce an interrelated "brain" that controls all these devices (Figure 11.17).

Electrical outlets and light switches are carefully located for the convenience and safety of the user. Most residential electrical codes require that outlets are no more than 12 feet (3657 mm) apart, measured along the floor line. Outlets are a standard 12 inches (305 mm) above the floor or 48 inches (1219 mm) above cabinetry, although variances are used for special needs. Commercial building locations of outlets range from floor level to ceiling level, depending upon specific uses. However, in most cases, requirements are similar to those for residences.

Specialized Electrical and Communication Systems

A number of specialized electrical and communication systems other than the main power sources are used in a building. Although these systems require electricity to operate, they are often of a specialized electrical nature, independent of the primary electrical distribution. Some are permanently installed, such as emergency lighting, doorbells, and intercoms, but others can be unplugged and moved, such as telephones and computer connections.

Methods and equipment for communication are constantly changing. The expanding fields of electronics, fiber optics, light-wave technology, low-voltage circuits, and satellite links are creating whole new modes of communication. These are increasingly being handled in our buildings as a communication system that is networked with many of the other building support systems. Communication systems now utilize mobile and cellular telephones, computer/telephone modems, facsimile transmissions by wire and satellite, and video satellite/cable hookups for teleconferencing and entertainment over great distances.

Traditional forms of paper flow and large storage files are being replaced with electronic media, decreasing the amounts of physical space necessary for storage and equipment. The interior designer is being called upon to assist in specifying and designing around these communication systems as they shape interiors and the human interface.

TELEPHONES AND INTERCOMS

The telephone system normally enters a building as the electrical system does but consists of an independent, low-voltage source. Specialized telephone wiring or fiber optics are placed throughout the structure, terminating in outlets (telephone jacks) where telephones can be plugged in or in a special station device that allows cordless phones to be free of wiring by employing radio waves. In other instances, the phone can be combined into an intercom system, or an independent communication network can be installed in the building.

COMPUTERS AND VIDEO

Many computers and electronic video devices, such as televisions and video cameras, use their own independent network of electrical distribution. These can be tied together within the building or tied into a global network by employing satellites or other transmission modes outside the building. These and the telephone system can combine with facsimile machines, computer modems, and other teleconferencing equipment. (Refer to Chapter 19 for specific information on communication systems.)

OTHER SYSTEMS

A number of other specialized electrical systems can be found in a building. Security systems detect unauthorized entry, monitor a space, and/or sound an alarm when required. These systems can be in the form of hard-wired sensing devices or can use infrared and ultrasonic waves or light waves for their operation.

Fire-alert electrical systems are composed of detection devices and an alarm device that emits a loud warning sound or calls the fire department. These can be linked with heat-sensing devices that emit an extinguishing agent, such as water, to contain a fire outbreak and are generally backed up with an emergency power supply in case of the disruption of the building's main power.

WATER USE IN BUILDINGS

Water has been used abundantly and sometimes wastefully over the past decades because people took for granted its low cost and seemingly endless supply. Fortunately, growing concern for water conservation and water quality is helping to regulate this precious resource.

However, as the population increases and the need for more water arises, stress can be placed on the resources and systems that deliver potable, or drinkable, water. International and local programs are actively seeking alternatives. Just as in space technology, these studies are looking into ways of turning waste water into pure water for drinking and domestic purposes. In some communities and rural areas, gray water from sinks, lavatories, showers, and dishwashers is being used to water lawns and for other practical purposes. The increased utilization of these alternative water systems will have a direct bearing on the current design of plumbing systems within buildings, as well as on the environment.

Water sources are classified as hard or soft, depending on the environment and the conditions of the soil from which the water is drawn. Dissolved impurities and minerals affect the quality and taste of the water, as well as the type of piping it is delivered through. Since hard water can cause low suds for washing and leave spots on drinking glasses, some buildings (particularly residences) incorporate water softener equipment to temper the water into a softer, or demineralized, state.

Water is used within a building for three basic functions—human or domestic use, sanitary drainage systems, and mechanical systems. Each has its own distribution system and governing codes.

Although the interior designer does not become directly involved in the design or repair of these systems, he or she must have a working knowledge of them for selecting fixtures or specifying locations for water use equipment in relation to plumbing walls. The designer is often called on for preliminary advice for remodeling or providing new kitchens, bathrooms, wet bars, and other water facilities. Consideration must also be given to the location of access doors, or

access panels, and piping runs that need periodic adjustment, inspection, or repair. The interior designer seeks to make access to these devices an integral part of the design of the interior environment.

Cold-and Hot-Water Distribution

Water enters a building in large piping systems below ground and is piped throughout a building (Figure 11.18). Because of the depth of the pipe to prevent freezing in cold climates, the water is usually cold or cool to the touch (53° to 70° F or 11.7° to 21° C). It is delivered at a pressure of about 40 to 50 pounds per square inch in most locations of the building. Since this pressure can diminish in tall buildings, the piping is augmented with additional pumps or piped to a large, separate tank high above the ground (for gravity-fed systems). Both a water meter and a shutoff valve are installed for each building.

FIGURE 11.18 Schematic of a typical domestic water supply system in a building. The size of the piping is determined by the water pressure and flow required at each fixture.

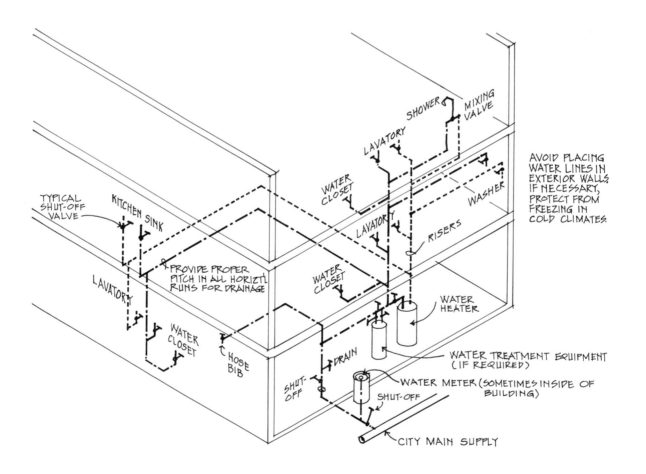

Pipes are sized to ensure adequate pressure and quantity of water for the appropriate fixtures and equipment. Pipes are usually made of copper or plastic, depending upon the building codes. Piping is concealed within walls, above ceilings, or below the floor where possible, except

when access or economics dictates exposed piping. An interior designer must have knowledge of which walls and columns contain plumbing when calling for a modification or locating a fixture that is not adjacent to these runs of piping. These locations are often called "wet walls" or "wet columns."

In humid climates, the cold-water piping is sometimes wrapped with an insulation and vapor barrier to keep the pipe from sweating, which is caused by the condensation of the surrounding warm air when it comes in contact with the cold pipe. Insulation is used to keep the water at a cool temperature as it is delivered throughout the building.

Water is piped to a water heater to have its temperature raised before being delivered as hot water to the appropriate fixture in a separate piping system. To conserve heat, these pipes might also be wrapped with insulation. In some systems, small preheaters are added adjacent to the fixture location rather than using hot water piped from a central heater. This can be an economical method, depending on the amount and frequency of hot water needed, since long runs of piping and constant heating can be expensive.

Domestic Use of Water

Water systems that serve human functions, such as drinking, cooking, washing, and bathing, are termed *domestic* water systems. These usually include both the cold- and the hot-water supplies and are sanitized for human ingestion. As each fixture that dispenses water has its own pressure requirements, the piping must be carefully sized to ensure a balance in the system and proper delivery at the outlet.

An average domestic system in a residence uses approximately 50 gallons (189 liters) per day per person, and a large hotel might use 100 gallons (378.5 liters) per person because of a multitude of water requirements in cleaning, food preparation, and occupant use.

Sanitary Drainage Systems

A building's sanitary drainage system uses gravity piping to drain fluid wastes and water. Waste water is discharged into a city collector system for treatment or into septic tanks in rural areas. Waste water is classified as black water if carrying materials from body wastes or as gray water if containing material from sinks, lavatories, showers, and washing machines. In most cases one sanitary system collects both varieties of waste water; however, in some rural areas the different types are handled separately, since the gray water might be used for outdoor watering needs.

Many buildings have storm drainage systems that rid the roof or other areas of heavy rainfall. These are fed into storm sewer drainage systems separate from the sanitary systems.

DRAINS AND VENTS

The sanitary drainage system is composed of various drain piping, traps, and vents (Figure 11.19). The traps, vents, and vacuum breakers prevent gases and odors from decomposing materials from escaping into the occupied spaces as fluids and wastes are drained away. Venting of the gases into the atmosphere is provided through *soil* and *waste* stacks (vertical plumbing runs) that extend to the roof of the structure. Vacuum breakers and air gaps are installed at the fixtures to prevent any accidental and deadly cross-connection between the fresh-water and

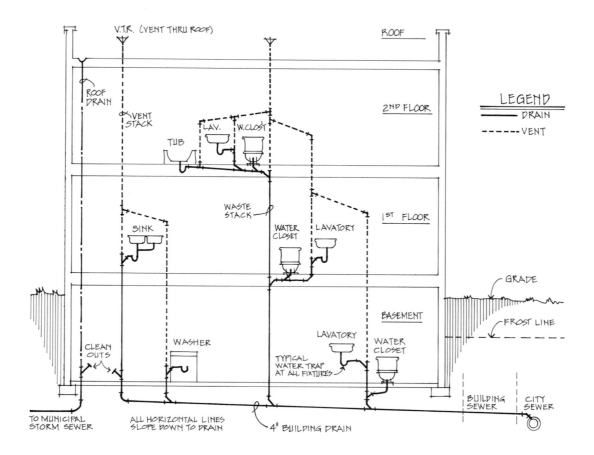

sewage systems. The plumbing system is composed of varying sizes of pipes that get larger where they connect to the main drain in order to handle the branching series of drains that feed them.

The designer may not be involved with the design, details, and intricacies of the sanitary plumbing systems but must be aware of their basic functions and space requirements. For example, if a sink is to be added on a wall, the designer should be aware of the location of the available drains and vents in order to ascertain whether the installation is possible. Since the drainage system is controlled primarily by gravity flow, piping runs and sizes must be designed with certain maximum limitations on distances and vertical drops. Plumbing walls are aligned vertically between floors, where possible, to keep the runs straight and to decrease costs by angling between floors. Fixtures are installed on common plumbing walls, where possible, to reduce the amount of piping needed to connect fixtures. Piping for drains and vents range in size from 1¼ inches (32 mm) to 4 inches (102 mm), which might require additional wall thicknesses to accommodate them.

Fire Protection Systems

As discussed in Chapter 10, fire protection is an important issue in the design, construction, and occupancy of buildings. Fire detection, protection, and suppression are integral parts of

the fire-safety systems in a building. Most structures use water as a fire extinguishing medium and distribute it through an independent system of pipes and sprinkler heads. Water is held in a pressurized state in the piping and released automatically to the interiors through a sprinkler head that detects a high temperature of 135°–160° F (57°–71° C). This system is commonly called a wet pipe system. There is also a dry standpipe system, which is filled when necessary by the fire department during an emergency.

The interior designer may not be directly involved with the mechanics of these systems but often has to design around them when placing light fixtures or deciding on ceiling treatments, finishes, and other items that must accommodate the sprinkler pattern system. Generally, the sprinkler system is drawn on the reflected ceiling plan and coordinated with architectural soffits, lighting fixtures, finishes, and other ceiling elements, as seen in Figure 11.2.

MECHANICAL CONVEYING SYSTEMS

Buildings sometimes contain mechanical conveying systems to move people and other objects vertically and horizontally. Elevators, escalators, automated ramps, and dumbwaiters are powered by electrical or hydraulic means to move people or objects, depending on their functions.

Elevators and Escalators

Elevators and escalators are automated vertical transportation systems used as auxiliaries to stairways. Elevators might stop at each floor of a building or operate as a high-speed express to specific upper floors. These arrangements of low- and high-speed elevator groupings allow for more efficient transporting in very tall structures. They can also be designated as passenger or freight elevators or a combination of the two. Elevators are either fully enclosed or have glass walls for view and emphasis. Designers are involved with the elevator cab finishes, call buttons, and lighting, as well as with lobby design if elevators are grouped.

Elevators are powered either by electrical motors and cables or by hydraulic piston lifts, depending on the height of the building and the speed required. Electrical types are used in tall buildings; hydraulic lifts are usually limited to about five stories. The equipment to run electric elevators is either in the basement or on the roof of a building. Hydraulic operating equipment is located in a pit or basement below the cab.

Elevators can be dangerous in case of a fire. Their operation is affected by smoke, flames, and excessive temperatures, which can cause stalling or opening to a burning floor. For these reasons, elevators are not classified as escape routes and must be backed up by stairways.

Another type of elevator is the dumbwaiter, a small cab used only for moving freight. Dumbwaiters can be electrically driven or manually driven, such as the one Thomas Jefferson invented for Monticello. Dumbwaiters are often used for transporting food and soiled dishes in multilevel restaurants.

Escalators are moving staircases for passengers and can be strong design elements in a space (Figure 11.20). These units are generally installed in pairs, one up and one down. Escalators

FIGURE 11.20 Escalators and elevators are primarily transportation devices but can be designed as exciting visual elements in a space.

are restricted in widths and runs, according to the various building codes, and must have stair-ways as a backup escape route in case of an electrical failure.

Moving Ramps and People Movers

Moving ramps and people movers can transport people and equipment efficiently and quickly either horizontally or on gradual inclines. Many examples of these can be seen in airports and large manufacturing plants. The Westinghouse headquarters in Grand Rapids, Michigan, uses a specially designed computer-guided vehicle to transport as many as 12 people throughout the building.

ACOUSTICAL CONTROL

Controlling acoustics is not usually perceived as a system, but floor or ceiling assemblies (Chapter 14) can be designed in such a manner that they will provide acoustical or sound blockage from floor to floor.

The interior designer is concerned with controlling sound in a space by eliminating (or reducing) unwanted noise and preserving (or enhancing) desirable noise. The designer becomes involved with acoustics in specifying finishes, furniture, equipment, and specially designed assemblies to control sound waves.

Air is the most common medium for sound waves, although they can also move through building materials. A sound wave is kinetic energy that radiates spherically from a vibration source until it hits an obstacle or surface. Sound waves are then absorbed or reflected, depending on the surface and density of the material. Generally, soft, porous materials absorb sound, and hard, rigid ones reflect it. Examples of absorbing materials include carpets, rugs, drapery, fabrics, and special products, such as acoustical ceiling tiles. Hard materials, such as wood floors, ceramic tile, glass, plastered walls, and brick, tend to reflect sound. However, thick, dense, and heavy materials also will tend to block sound traveling through them.

To control unwanted sound, we can (1) isolate it at its source; (2) locate the source far away from the desired "quiet" environment; and (3) eliminate the paths of airborne or material-borne sound waves. The first method involves selecting quiet operational equipment or sources, which can be enhanced by using special isolator mountings and connections to reduce transmission of excessive noise, particularly from machinery. The second method deals with the design of the building and the separation of "loud" and "quiet" zones through basic planning of the building configurations. Closets and corridors can be used as sound buffers between zones of conflicting acoustics. The third method can be accomplished by selecting heavy, rigid materials to resist sound transmission or by reducing the continuity of the construction assembly to transmit sound. Generally, the greater the mass of a material (concrete, stone, brick, and so forth) that is impervious to air, the more the material serves as an effective sound barrier.

SOUND RATINGS. The sound energy of a given source is represented by a number on the decibel (dB) system of measurement. This decibel scale is a logarithmic ratio of sound pressures. A jet airplane might generate 140 dBs, a lawnmower can produce 100 dBs, and a whisper can be about 10 dBs. Sound levels above 130 dBs can cause pain and discomfort, while those below 0 are beyond the threshold of hearing.

To help designers control unwanted sounds, various materials have been tested and rated with a noise reduction coefficient (NRC) (Figure 11.21). The higher the NRC rating, the more a material absorbs sound. For example, carpet (NRC of approximately 0.15 to 0.65, depending on its composition and the padding used) is more effective than a concrete floor (NRC of .05) in absorbing noise. However, the carpet NRC in this case is not as important as the fact that carpet reduces noise at the source—a chair scraping or shoe soles clicking. When the sound absorption coefficient of a material exceeds 0.5, it is generally considered an effective sound absorber.

FIGURE 11.21 Various building materials and components have been tested and assigned NRC ratings to assist in selection for acoustical control.

NOISE REDUCTION COEFFICIENTS (NRC) OF VARIOUS MATERIALS*

Marble or glazed tile	0
Concrete, brick, concrete block	.05
Glass, heavy plate	.05
Gypsum board, 1/2 inch thk.	.05
Wood flooring	.10
Fabric, light	.15
Plywood paneling, 7/8 inch thk.	.15
Carpet, heavy	.45
Carpet, heavy on pad	.55
Heavy drapes	.60
Ceiling, acoustical	up to .90

*An NRC rating of a material (.00 to 1.00) indicates the effectiveness of it to absorb sound. Material with a .90 rating or higher is a very efficient absorber, 0.5 and above is effective, and lower than .05 reflects sound back to the space.

FIGURE 11.22 Manufacturers publish sound transmission class (STC) ratings and drawings of their products as used in various building construction assemblies.

Sound transmission from one space to another can be controlled by using a particular building assembly (walls, floor, ceiling, partitions) to prevent the transfer of the noise. Various assemblies have been designed, tested, and rated for their ability to prevent noise transfer. They are assigned an STC (Sound Transmission Class) rating according to their individual composition of materials and construction (Figure 11.22).

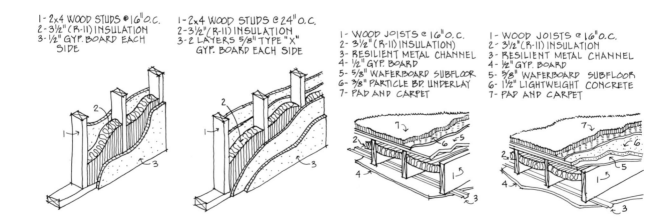

1- 2x4 WOOD STUDS @ 16" O.C.
2- 3½" (R-11) INSULATION
3- ½" GYP. BOARD EACH SIDE

1- 2x4 WOOD STUDS @ 24" O.C.
2- 3½" (R-11) INSULATION
3- 2 LAYERS 5/8" TYPE "X" GYP. BOARD EACH SIDE

1- WOOD JOISTS @ 16" O.C.
2- 3½" (R-11) INSULATION)
3- RESILIENT METAL CHANNEL
4- ½" GYP. BOARD
5- 5/8" WAFERBOARD SUBFLOOR
6- 3/8" PARTICLE BD. UNDERLAY
7- PAD AND CARPET

1- WOOD JOISTS @ 16" O.C.
2- 3½" (R-11) INSULATION
3- RESILIENT METAL CHANNEL
4- ½" GYP. BOARD
5- 5/8" WAFERBOARD SUBFLOOR
6- 1½" LIGHTWEIGHT CONCRETE
7- PAD AND CARPET

Acoustical problems or desirabilities can be caused by the shape of an interior space (Figure 11.23). The principles of size and shape of space can be combined with materials and assemblies to achieve "good" acoustical control. Architects, interior designers, and acoustical consultants work together in theaters, ballrooms, concert halls, and large meeting rooms to

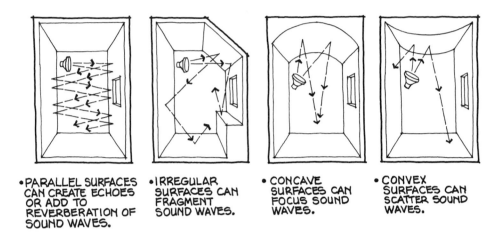

• PARALLEL SURFACES CAN CREATE ECHOES OR ADD TO REVERBERATION OF SOUND WAVES.

• IRREGULAR SURFACES CAN FRAGMENT SOUND WAVES.

• CONCAVE SURFACES CAN FOCUS SOUND WAVES.

• CONVEX SURFACES CAN SCATTER SOUND WAVES.

FIGURE 11.23 The shape of reflective surfaces in an interior space will direct sound waves in a number of different directions.

produce environments that manipulate sound for better results (Figure 11.24). In some installations where sound amplification is needed, an assortment of microphones, electrical amplifiers, and other electronic equipment to boost, filter, and direct the sound is used. Movie theaters, large lecture halls, and spaces for musical performances use these devices to help the ear appreciate the level and quality of sound.

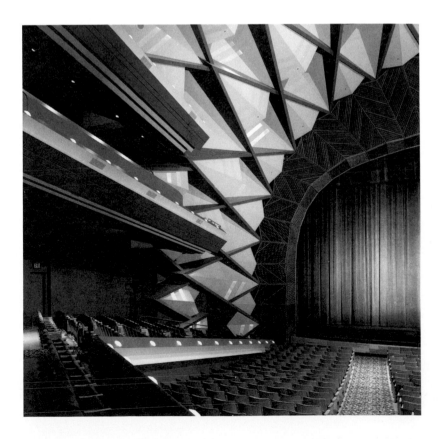

FIGURE 11.24 Concert Hall of the Anchorage Performing Arts Center by Hardy Holzman Pfeiffer Associates. The multiplicity of the ceiling facets in the Alaska center creates an effective distribution and diffusion of sound waves in the auditorium.

A.I.A. Research Corporation. *A Survey of Passive Solar Buildings.* Stock no. 023-000-00437-2. Washington, D.C.: U.S. Government Printing Office, 1978.

————. *Solar Dwelling Design Concepts.* Stock no. 023-000-0034-1. Washington, D.C.: U.S. Government Printing Office, 1976.

American Society of Heating, Refrigerating, and Air Conditioning Engineers. *ASHRAE Handbook of Fundamentals.* New York: ASHRAE, 1981.

Anderson, B., and M. Riordan. *The Solar Home Book.* Harrisville, N.H.: Brick House Publishing, 1976.

Brown, G.Z. *Sun, Wind, and Light.* New York: John Wiley and Sons, 1985.

Egan, M. David. *Architectural Acoustics.* New York: McGraw-Hill, 1988.

Flynn, John E., A. Segil, and G. Steffy. *Architectural Interior Systems.* 2nd ed. New York: Van Nostrand Reinhold, 1988.

Huntington, Whitney Clark. *Building Construction.* New York: John Wiley and Sons, 1981.

Loftness, Robert L. *Energy Handbook.* New York: Van Nostrand Reinhold, 1978.

Mazria, Edward. *The Passive Solar Energy Handbook.* Emmaus, Penn.: Rodale Press, 1979.

McGuinness, William J. *Mechanical and Electrical Equipment for Buildings.* New York: John Wiley and Sons, 1980.

Motlock, John L. *Introduction to Landscape Design.* New York: Van Nostrand Reinhold, 1991.

Olgyag, Victor. *Design With Climate.* Princeton, N.J.: Princeton University Press, 1963.

Ramsey, Charles G., and Harold R. Sleeper. *Architectural Graphic Standards*, 8th ed. New York: John Wiley and Sons, 1988.

C H A P T E R 1 2

LIGHTING
FOR
INTERIORS

ight brings interiors to life and is important to our activities and perception of the world around us. By controlling and designing with natural and artificial light, the interior designer can create striking design concepts in interior spaces and provide for the visual needs of user activities.

Light is important as a form of art and design. It is similar to the other basic design elements of space, line, form, color, and texture, since it stimulates our perception of these elements. Light not only guides our seeing for visual tasks but affects our behavior and attitudes. Lighting contrasts of brightness and darkness can create dramatic effects and emphasize certain characteristics within a space or on objects (Figure 12.1). Bright light is stimulating, and low levels of illumination can be quieting and soothing. Warm-colored light tends to be cheerful, and cool-colored light, restful.

Lighting design is a combination of an applied science and an applied art. It is necessary then to discuss its scientific properties as well as its aesthetic qualities in order to understand how light can be manipulated within an interior space.

Light is a form of energy, a special segment within a range of electromagnetic energy capable of stimulating receptors in the eye that permit vision. This range is called visible energy (Figure 12.2). Light and vision are dependent upon each other, since one cannot see if there is no light. Light is not visible by itself, but light falling on an object or color makes that object or color visible. The appearance, definition, and character of objects and spaces are greatly affected by the kind of light that makes them visible. When it strikes an object, light may be reflected, absorbed,

FIGURE 12.1 This Bernhardt showroom uses dramatic lighting effects and forms to create a striking interior and image for their products.

or allowed to pass through, depending on the degree of transparency or opacity in the material and on its surface qualities. For example, light reflected from smooth surfaces, such as polished metal, is bright and sharp, compared to light reflected from dull surfaces, such as brick, that produce more diffuse light. The shape of objects can also be emphasized or subordinated according to the strength and direction of the light source—sharp and bright or dull and diffuse.

Good lighting design also incorporates the conservation of energy by utilizing more efficient lamps and fixtures in combination with switching controls and systematic maintenance programs. The interior designer can make a difference by educating clients about energy efficiency and conservation. Numerous options are available to reduce energy demands without sacrificing the quality of light within an interior space.

FIGURE 12.2 The visible energy of the electromagnetic spectrum lies between 380 and 780 nanometers.

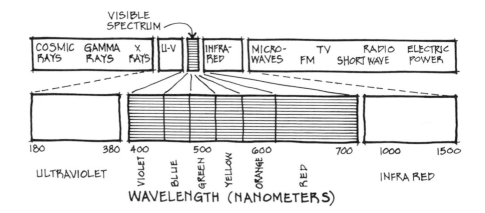

The designer needs to understand the different kinds of light available and how to control them efficiently. To do this, he or she should study the luminous environment, which can be divided into two categories, natural light and artificial light.

NATURAL LIGHT

Our primary source of natural light is the sun. People derive great physical and psychological pleasure from sunlight, since it is our principal source of Vitamin D and full-spectrum light. Sunlight contains all visible wavelengths of radiant energy plus invisible infrared (heat) and ultraviolet wavelengths. Some research has proposed that a wide variety of health problems are linked to the lack of full-spectrum light and the absence of ultraviolet light in some artificial light sources.

There has been a renewed interest in harnessing natural light. Daylight is viewed as a free source of light, offsetting escalating energy costs and health concerns. Learning to control free light is important, since it generally is accompanied by excessive heat and glare. Discomfort within an interior space can be caused by too much heat or glare due to excessive contrast. Direct sunlight can also cause interior fabrics and materials to deteriorate and colors to fade.

Another form of natural light is combustion light, which can be produced from gas lights, fireplaces, and candles. However, gas lighting has almost become obsolete except for decorative purposes. The flickering flames from candles and fireplaces can be used to create low-lit atmospheres, particularly in restaurants and residences.

Controlling Daylight

In order to control daylight, it is first necessary to understand the pattern of the sun's movement, which is related to the time of day and year and to the latitude of the observer. In the summer in northern latitudes, the sun comes up toward the northeast and arcs high in the sky, setting in the northwest. Days are longer and there is a greater amount of daylight available in the summer months than in the winter. The winter sun rises south-southeast, is low in the sky, and appears to set quickly in the south-southwest. By understanding these solar principles, a designer can utilize maximum penetration of light and heat into the interiors during the winter season and constrict it in the summer (Figure 12.3).

The quality of daylight is also affected by its compass direction. North light is generally a cool and consistent light that casts few shadows, making it desirable for artists' studios. East light is strong and bright in the morning but becomes less brilliant and more neutral as the day progresses. South light is generally the most favorable in terms of brightness, pleasantness, and control. It is more consistent throughout the day but may need to be controlled during the summer months. West light is usually very strong in the late summer afternoons; from the exterior it can be controlled by plants, awnings, or trellises and in the interior can be moderated by window treatments or can be filtered by tinted glass. Careful planning and control of sunlight is the basis for the design of solar energy buildings that optimally capture or repel the sun's energy.

Another way to maximize daylight is to manipulate it to penetrate deeply into an interior space, which can be accomplished by various types and placements of windows and skylights

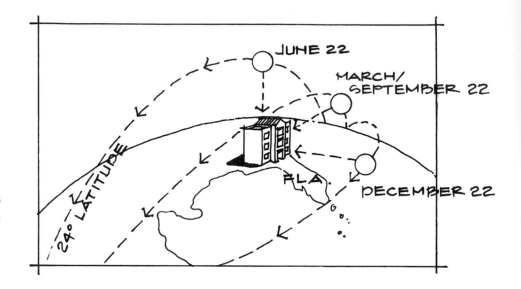

FIGURE 12.3 Most south-facing windows in the northern part of the United States will receive a deeper penetration of sunlight than this southernmost location in Florida.

(Figure 12.4). By using light colors as reflectors, such as putting a high-reflectance, matte white finish on ceilings and walls, the window's light will be reflected and distributed more evenly and deeply into the interiors.

FIGURE 12.4 The diagrams below illustrate how different sizes and shapes of windows can control the amount of light that enters an interior space.

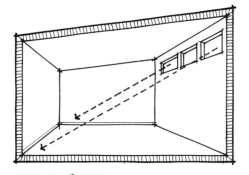

CLERESTORIES: CLERESTORY WINDOWS PLACED HIGH ON A WALL WILL CREATE DEEP LIGHT PENETRATION IN THE ROOM.

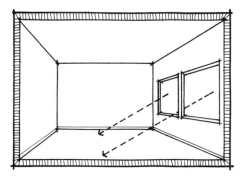

HORIZONTAL WINDOWS: WIDE WINDOWS WILL PROVIDE THE MOST EVENLY DISTRIBUTED ILLUMINATION IN A ROOM.

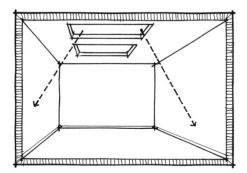

SKYLIGHTS: SKYLIGHTS PROVIDE ILLUMINATION THROUGHOUT A ROOM, BUT CAN PRODUCE BRIGHT CONTRASTS ON THE CEILING PLANE.

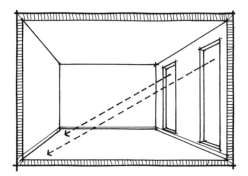

VERTICAL WINDOWS: TALL WINDOWS PRODUCE GOOD LIGHT PENETRATION DEEP INTO A ROOM, BUT CAN PRODUCE A DARK WALL AND FLOOR AREA BETWEEN THE WINDOWS.

ARTIFICIAL LIGHT

Artificial light is generally associated with electric light. In the 1800s, several inventors developed incandescent lamps, but the first to use a high-resistance carbon filament vacuum was Thomas Alva Edison in 1880. Since that time a wide variety of electric light sources and lighting systems have been developed. When well planned, artificial illumination enables us to see at night, helps prevent accidents, and contributes to the overall character and mood of an interior space. Artificial light is extremely important to the interior designer, since it affects the brightness, placement, color, and quantity and quality of the light in an interior environment. Varying the light can change the mood of a space from intimate to formal, as well as visually expand or shrink a space. Objects or areas within an interior can be highlighted or deemphasized with the placement and quantity of light.

When lighting is designed in relation to the architecture, activities, furnishings, and people in a space, it can become dynamic. Theaters have long used artificial lighting as a mood setter for dramatic productions. Techniques such as dimming and increasing light, using footlights and colored lights, and providing differing degrees of sharpness and diffusion to focus attention where it is needed create exciting lighting effects. These techniques can also be used within many other types of interior environments.

The Measurement of Light

To effectively design with light, the designer must understand some of the basic principles and terminology used in measuring light. There are four basic units of measurement for light: footcandles, footlamberts, lumens, and candelas.

FOOTCANDLES
The amount of light falling on a surface is measured in footcandles (fc), the basic unit of illumination. One footcandle is equal to the amount of light falling on one square foot of surface one foot away from a candle flame. Footcandles can be measured by a standard light meter. The actual illumination level (amount of footcandles) that should be provided depends on (1) the age of a worker/user (as the eye ages, it requires more light for visual tasks); (2) the importance of the task (how critical speed and accuracy of seeing are); and (3) the difficulty of the task (what the size and contrast of the details are).

For example, in interior spaces where visual tasks are only occasionally performed, such as lobbies, reception areas, corridors, stairs, or washrooms, only 10 to 20 footcandles would be necessary. However, in areas that require performance of visual tasks of low contrast or very small size, such as drafting or reading poorly printed matter, 100 to 200 footcandles would be necessary.

The Illuminating Engineering Society (IES) has developed some recommended ranges of footcandle levels needed for many standard seeing tasks, activities, and general illumination of spaces (Figure 12.5). More complete data are available in IES handbooks (IES, 345 East 47th Street, New York, NY 10017).

FOOTLAMBERTS
A footlambert (fL) is the basic unit of measurement for brightness or luminance; that is, it measures the amount of light reflected from a surface. Since the majority of what we see is due to reflected light from surfaces in a space, footlamberts reveal the nature of the

IESNA RECOMMENDED LIGHT LEVELS

ILLUMINANCE CATEGORY	TYPE OF ACTIVITY	RANGES OF ILLUMINANCES IN FOOTCANDLES
A	Public spaces with dark surroundings	2–3–5
B	Simple orientation for short temporary visits	5–7, 5–10
C	Working spaces where visual tasks are only occasionally performed	10–15–20
D	Performance of visual tasks of high contrast or large size	20–30–50
E	Performance of visual tasks of medium contrast or small size	50–75–100
F	Performance of visual tasks of low contrast or very small size	100–150–200
G	Performance of visual tasks of low contrast and very small size over a prolonged period	200–300–500
H	Performance of very prolonged and exacting visual tasks	500–750–1000
I	Performance of very special visual tasks of extremely low contrast and small size	1000–1500–2000

SPECIFIC ACTIVITY	ILLUMINANCE CATEGORY
HOTELS	
Bathrooms	D
Bedrooms	D
Corridors/stairs	C
Front desk	E
Lobby	
General	C
Reading	D
MUSEUMS	
Nonsensitive art	D
Circulation spaces	C
FOOD SERVICE FACILITIES	
Dining areas	
Cashier	D
Cleaning	C
Dining	E
Kitchen	E

SPECIFIC ACTIVITY	ILLUMINANCE CATEGORY
BANKS	
Lobby	
General	C
Writing areas	D
Tellers' stations	E
CONFERENCE ROOMS	
Conferring	D
DRAFTING	
Vellum	
High contrast	E
Low contrast	F
Light table	C

SPECIFIC ACTIVITY	ILLUMINANCE CATEGORY
MERCHANDISING AREAS	
Dressing areas	D
Fitting areas	F
Sales counters	E
RESIDENCES	
General	
Conversation	B
Passage	B
Specific tasks	
Dining	C
Grooming/shaving	D
Kitchen counters	
Critical seeing	E
Non critical	D
Reading	
Printed matter	D
Handwriting	E
Table games	D

Source: John E. Kaufman, ed., IES Lighting Handbook Applications Volume 1981 (New York: Illuminating Engineering Society, 1981) 2.2–2.19.

space and objects within it. The amount of light leaving any surface is a product of the footcandles reaching this surface multiplied by the percentage of light reflected by it (fL = fc × % reflectance). For example, if 100 footcandles reach a surface and the surface is painted with an 80 percent reflective color, 80 footlamberts will be reflected from the surface (fL = 100 × .80, which equals 80 footlamberts). To find the percentage of reflectance of a surface, divide footlamberts by footcandles. For example, if 80 footcandles reach a surface and 40 footlamberts are reflected from it, the reflectance value will be 50 percent (40 fL ÷ 80 fc = .50, or 50 percent).

Brightness ratios or luminance relationships in the visual field of a person performing a task are important for efficiency, comfort, and safety. The visual field for a task consists of three zones: Zone one is the precise area in focus or the task itself (such as a printed page), zone two is the area immediately surrounding the task (such as the top of a desk or a work surface), and zone three is the general surrounding area (the walls and floor). For an effective lighting design, the designer should follow the optimum contrast ratios between these zones. IES recommends that optimum comfort is achieved when the task is only slightly lighter than the surfaces that immediately surround it (zone 2). Zone 3 should be no more than five times, and no less than one-fifth, as bright as zone 1. The longer the task takes to complete, the more critical this luminance relationship becomes. In spaces where critical visual tasks are never performed, higher brightness ratios are acceptable. The percentage of reflectance of major surfaces in a space is important in achieving desirable luminance ratios. See Figure 12.6 for recommended surface reflectances.

FIGURE 12.6 Recommended room surface reflectances.

IMPORTANCE OF SURFACE REFLECTANCES

The right room surface reflectances are essential to obtain the brightness relationships required for visual comfort.
These are the recommendations for various surfaces:

SURFACE	REFLECTANCES
CEILING	.70 to .90
WALLS	.40 to .60
FURNITURE TOPS	.25 to .45
OFFICE MACHINES & EQUIPMENT	.25 to .45
FLOORS	.20 to .40

LUMENS

Lumens are the amount of light output produced by a lamp or light source; lamp manufacturers rate their lamps in lumens. Lumens are also used to determine the efficacy, or efficiency, of a light source. Efficacy is equal to the number of lumens of light produced per watt of electricity consumed. Since fluorescent lamps produce more light than incandescent lamps of the same wattage, the fluorescent lamps would have a higher efficacy.

CANDELAS

The candela measures candlepower, the luminous intensity of a light source or fixture in a particular direction. The candlepower measurement is the footcandle reading that describes how intense the light output will be at a certain point. A candlepower distribution curve is a graphic representation of the shape and direction of the light coming from a light source or fixture (see Figure 12.7). The candlepower distribution curve can be used to estimate how much light from a lamp or fixture will arrive at a specific location.

RECESSED INCANDESCENT DOWNLIGHT

PHOTOMETRIC DATA OF THIS LIGHT SOURCE AND LUMINAIRE

FIGURE 12.7 An example of a light distribution curve for a lamp and luminaire.

The Illuminating Engineering Society of North America (IESNA) has identified six categories of beam shapes to describe the light distribution and direction of a light source or fixture (Figure 12.8). To carry out a good lighting design, it is important to understand the pattern and orientation of the beam spread. This information is critical for delivering brightness to specific surfaces and objects within an interior space. Distribution curves are available from lamp and fixture manufacturers.

TYPE	LIGHT DISTRIBUTION	CHARACTERISTICS

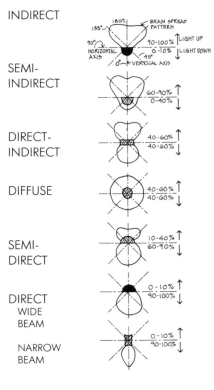

INDIRECT

Most light output is directed upwards to ceiling. Can prevent dark ceilings and create feeling of height.

SEMI-INDIRECT

Although most light is directed upwards, a translucent luminaire can direct some downward, softening shadows.

DIRECT-INDIRECT

Light output is approximately equal to the ceiling and floor, with little to the sides. Direct glare is reduced.

DIFFUSE

Equal light is provided in all directions. Diffuse enclosures can prevent direct glare.

SEMI-DIRECT

A small amount of light output is directed upwards, softening shadows from direct light downwards.

DIRECT
WIDE BEAM

NARROW BEAM

Direct light can be used for emphasis by highlighting. Some background illumination on surfaces such as walls, ceilings, and other planes can prevent high brightness ratios.

FIGURE 12.8 **This chart shows various lamp and luminaire beam spread patterns and the percentages of light directed towards the ceiling or floor.**

ARTIFICIAL LIGHT SOURCES

Before a designer can plan an effective lighting design, he or she must understand what kind of light sources are available. There are two main sources of electric light: incandescent lamps and electric or gaseous-discharge lamps. Lamp is the correct term for what is commonly called the light bulb. The bulb is the actual housing or enclosure of the filament and gases. Lamps come in a wide variety of types, sizes, shapes, and colors. They are designed for an equally wide variety of purposes and effects. For the designer to select the correct lamp for a given situation, he or she must consider energy consumption, efficiency, length of life/hours expected, quantity of light produced, and qualitative factors such as color and brightness. Functional, decorative, or psychological effects must also be considered. Because the two categories of light sources produce light in such different ways, the properties of each will be discussed individually.

Incandescent Lamps

In the incandescent lamp, light is produced by heating a material (usually metal) to a temperature at which it glows. Most incandescent lamps have a tungsten filament or other material vacuum sealed in a glass bulb that becomes hot and intensely bright when electricity is passed through it. See Figure 12.9 for a diagram of a typical incandescent lamp.

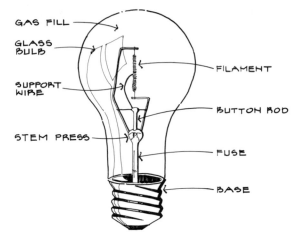

FIGURE 12.9 Typical parts of an incandescent lamp.

The glass enclosure, generally made of common lime glass, comes in a variety of shapes and is identified by a letter (Figure 12.10). A number following the letter indicates the size or maximum diameter of the lamp. To determine the diameter of the bulb in inches, the number is divided by eight. For example, a lamp designated by A-21 indicates a standard bulb shape with a maximum diameter of $2\frac{1}{8}$ or $2\frac{5}{8}$ inches. A PAR-38 would be a parabolic aluminized reflector lamp with a maximum diameter of $3\frac{8}{8}$ or $4\frac{3}{4}$ inches.

The finish of the glass bulb determines the brightness and appearance of the light produced. Standard lamps are generally available in clear or frosted finishes. In clear lamps, the light is intense and bright, and the filament is visible. Frosted lamps (also known as soft white) are coated on the inside with a silica powder that diffuses the intense brightness, giving the appearance of a uniformly illuminated bulb. However, light output from a frosted bulb is approximately one percent less than that from clear bulbs.

Since incandescent lamps are the oldest and most familiar, they have been the preferred source. They produce a warm light, similar to sunlight, since they consist of a continuous spectrum that includes all colors of light to form white. However, this white light contains more red and yellow wavelengths, and less blue and green, than daylight. Because this warm light tends to be flattering to human skin, suggesting feelings of comfort and warmth, incandescent lamps are preferred for make-up mirrors and most home environments.

FIGURE 12.10 Lamps are available in a variety of styles to serve various functions. The size and shape of a bulb (not actual sizes) is designated by a letter or letters followed by a number. The letter indicates the shape of the bulb while the number indicates the diameter of the bulb in eights of an inch.

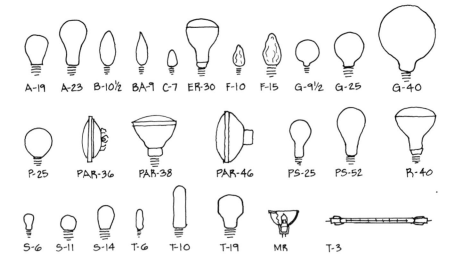

Incandescent lamps are also a point or near-point source, tending to form bright high-lights and cast sharp shadows useful to emphasize objects, textures, shapes, and forms. The variety of wattages available and the ability to dim incandescent light make it easy to control its quality and quantity.

Generally, incandescent lamps and fixtures cost less than fluorescent lamps. However, they have a low efficiency factor in terms of producing light related to the amount of energy consumed. Because their light is produced by heat, a considerable amount of heat is transferred to the air and can create extra loads on air-conditioning and energy consumption demands during warmer seasons. Incandescent lamps have a short life expectancy (750–1,000 hours), and ex-posed lamps can provide an uncomfortable source of glare.

Incandescent lamps are rarely used in large offices, factories, or other large buildings for uniform lighting because they require large amounts of electricity. However, because of their point-source characteristics, they are used in retail establishments, where the light is attractive for the merchandise and can be used to highlight displays. In restaurants, the warm light makes the food more appetizing and flatters people's complexions.

Incandescent lamps can be divided into two basic groups—the standard incandescent and the halogen lamps. Standard incandescent lamps use nitrogen or argon gas and operate on 120 volts. These lamps can be general service, rough service, silver or white bowl, or a complete optical system with built-in reflectors. Examples of the latter include the elliptical reflector (ER), reflector (R), and parabolic reflector (PAR).

Halogen lamps use halogen gas and are the next generation of incandescent lamps. They may be operated at regular voltage (120 volts) or low voltage (12 volts) that requires a trans-former. Halogen light is whiter than standard incandescent light, due to the halogen gas, which makes it burn at a very high temperature. The halogen gas reacts with the tungsten filament to regnerate itself so that it doesn't burn out as fast as a standard incandescent lamp.

It is not possible to cover all the many different types of incandescent lamps available in the scope of this book. However, a few warrant mentioning in detail, and Figure 12.11 lists the most common types and their characteristics.

INCANDESCENT LAMPS

FIGURE 12.11 Most common types of incandescent lamps and their characteristics. (Continued on the next page.)

TYPE	WATTAGE	CHARACTERISTICS
STANDARD		
A and PS	15–1500	General service lamps are available with clear or frosted bulbs. These are the most economical incandescent lamps.
RR, R, PAR	15–750	Elliptical reflector (ER), reflector (R), and parabolic reflector (PAR) lamps are manufactured with built-in reflectors to better direct light. They are available in a wide variety of beam spreads for different lighting purposes. The wide-beam or flood lamps provide a more uniform light without producing "hot spots," these are suitable for general or wall-washing purposes. Spot lamps have narrow beam patterns and are

TYPE	WATTAGE	CHARACTERISTICS
RR, R, PAR *(cont'd)*		primarily used to highlight a specific object or to concentrate light. Generally, PAR lamps have a more precise control of light than the R or ER lamps. The ER lamp is more efficient than the R lamp since a great amount of light emitted by the R lamp is trapped inside the luminaire and is wasted, as illustrated. These lamps cost three to four times more than general service lamps of the same wattage.
TUBULAR	6–750	Tubular lamps are long and cylindrical. They also are available in the "showcase" model with a single screw base at one end or in the "lumiline" model that has one disk at each end. Tubular lamps are available in various lengths and diameters. The lumiline is similar to a small fluorescent lamp and can be used where linear light sources are needed.
LOW-VOLTAGE	20–75	Low-voltage lamps are designed to operate at 5.5 to 12 volts rather than the standard 120 volts. They use a much smaller filament that offers superior light control, longer life, and somewhat higher amounts of light per watt. Low voltage PAR lamps are very small and can project a "pin spot" of a brilliant and very precise light at a great distance. They are excellent for display lighting, downlighting, and spotlighting. They generate less heat than standard lamps, but require a transformer to step down standard voltage.
HALOGEN		
TUNGSTEN-HALOGEN	50–5000	Tungsten-halogen lamps (also known as Quartz) produce up to 20 percent more light than standard lamps. The bulb is a narrow quartz cylinder that generates and operates at high temperatures. The lamp is filled with halogen gases that regenerate the filament, keeping the lamp clean so the bulb doesn't blacken and burn out, giving it a longer life. These lamps are generally very small to prevent the hard quartz bulb from cracking under extremely high temperatures.
HALOGEN PAR	20–90	Available in compact Par 20, 30, and 38. Well-defined beam spreads in

TYPE	WATTAGE	CHARACTERISTICS
HALOGEN PAR (cont'd)		narrow spots to floods. These are very popular for retail applications due to their excellent color rendition. The Halogen Par lamps have a second glass envelope to project light better and protect the quartz envelope inside.
LOW-VOLTAGE HALOGEN	20–75	Low-voltage halogen lamps such as the MR-16 generally incorporate a reflector to focus a very small beam. These lamps produce the whitest halogen light with the longest life and least heat. They require a transformer.

Electric Discharge Sources

Electric or gaseous discharge lamps produce light by passing an electric current or arc through a gas vapor sealed in a glass tube. These lamps are filled with different kinds of gases and are kept at either a low or a high pressure. The type of light produced is "cold," or "luminescent," meaning not produced by heat. All these types of lamps require a ballast, which regulates the amount of current used and provides the proper starting voltage. This ballast is generally installed between the power line and the lamp. The most common types of electric discharge lamps used in interior environments are fluorescent, high-intensity discharge (HID), and neon.

FLUORESCENT LAMPS

Fluorescent lamps were developed in the 1930s and are the most popular of the low-pressure electric discharge lamps. They became popular very rapidly because they had a much higher efficacy in terms of light output in relation to energy consumed than did the incandescent lamp. Fluorescent lamps are economical for use in large offices, factories, schoolrooms, and other areas where low operating costs are important.

The typical fluorescent lamp (Figure 12.12) is a long glass tube filled with vaporized mercury and argon gases under low pressure. When electric current activates the gases, invisible ultraviolet light is produced. So that the invisible light rays can become visible, the inside of the tube is coated with phosphors that fluoresce, or transform the ultraviolet rays into visible light.

Fluorescent lamps are coded to designate wattage, shape, diameter in eighths of an inch, color, and type of lamp circuiting. For example, F40T12/WW/RS indicates a fluorescent lamp of 40 nominal watts, a tubular bulb of $12/8$ or $1\frac{1}{2}$ inch diameter, warm white color rendition, and rapid-start circuiting (Figure 12.13).

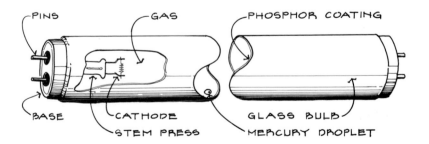

FIGURE 12.12 Typical components of a fluorescent lamp.

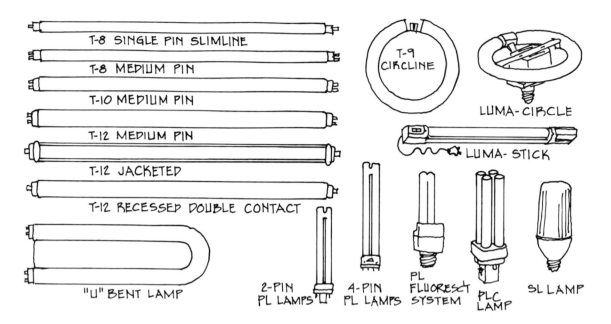

FIGURE 12.13 Fluorescent bulb shapes (not actual sizes). The size and shape of a bulb is designated by a letter or letters followed by a number. The letter indicates the shape of the bulb while the number indicates the diameter of the bulb in eighths of an inch. For example, "T-12" indicates a tubular shaped bulb having a diameter of 12/8 inches, or 1½ inches.

The most common fluorescent bulbs are straight glass tubes; other popular shapes include the compact, U-shaped, and circular (see Figure 12.14 for their characteristics). Tubes range in length from 8 inches to 8 feet and vary in diameter from ⅝ to 2⅛ inches. The most commonly used fluorescent lamps are 4 feet (1219 mm) long, placed inside a 4-foot (1219-mm) fixture of varying widths. However, the 2 × 2 foot (610 × 610 mm) luminaire is becoming more popular in commercial applications and can be fitted with U-shaped bulbs or two 2-foot (610-mm) straight bulbs.

The color of a fluorescent lamp is produced mainly by the phosphor used inside the bulb; light that phosphor produces is full-spectrum, with all colors present. However, the gases in the tube emit light of a single color. The combination of the phosphor coating and gas causes our color perception to be off balance. Although fluorescent light gives the illusion of normal white light, in reality it distorts the natural color of many objects. To alleviate this distortion, fluorescent lamps are available in a variety of colors, such as cool white, deluxe cool white, warm white, deluxe warm white, white, and daylight. Generally, cool white, warm white, white, and daylight lamps are weak in red wavelengths and appear bluish-green. Deluxe lamps are improved in red tones but have a lower efficacy. However, with advanced phosphor technology, fluorescent lamps are available with a tri-phosphorous coating that combines excellent color rendition with high light output. When putting together a color scheme for an interior environment that will be illuminated with fluorescent lamps, it is important to match the color of the lighting with the materials and finishes. Generally, cool color schemes, such as blues or greens, should use lamps in the cool spectrum or a tri-phosphorous lamp (with the good color rendition).

Fluorescent lamps are further classified by one of three types of circuiting used for their starting operation: preheat, instant start or slimline, and rapid start.

PREHEAT. Fluorescent lamps with preheat circuiting require a starting circuit for preheating the cathodes to aid in starting the lamps. This method is the oldest and the slowest.

FLUORESCENT LAMPS

TYPE	WATTAGE	LENGTH	CHARACTERISTICS
STANDARD F40 T12 FLUORESCENT LAMP	40	4'–8'	The standard four-foot rapid start fluorescent is the most widely used lamp in large commercial projects. They are the most practical source because they offer low brightness, high efficiency, long life, low overall cost of light, and a variety of colors.
ENERGY-EFFICIENT FLUORESCENT LAMPS	25–34	2'–8'	Lower wattage lamps that are used to achieve energy cost savings. They often have a light reduction comparable to the wattage reduction.
U-SHAPED T-12	35–4	2'	Most popular choice for 2' × 2' fixtures. Available in 3" or 6" leg spacing. Outperform straight tubes in terms of light output, energy-use, and longevity.
CIRCLINE LAMPS	20–40	6½"–16" diameter	Mainly used with circular or square luminaires. Also available with screw-in adapter ballast for use with incandescent fixtures.
T-8 TRIMLINE	17–40	2'–5'	This one-inch diameter lamp is more efficient than the traditional T-12 lamp when used on electronic ballasts.
COMPACT LAMPS	40	16½"–22½"	Higher efficiency, higher light output, and lower cost of light in 2 × 2

FIGURE 12.14 Most common types of fluorescent lamps and their characteristics. (Continued on the next page.)

TYPE	WATTAGE	LENGTH	CHARACTERISTICS
COMPACT LAMPS *(cont'd)*			fixtures compared to T-12, T-8, and U-shaped fluorescent lamps. The T5 tube (⅝" diameter) does not drop in light output due to the warm temperatures found in luminaires, as do larger diameter lamps. Available in wide variety of colors.
LOW-WATTAGE COMPACT LAMPS	5–26	4⁵⁄₃₂"–9"	Used primarily in downlights, wall sconces, or task lights. With special adapters they can replace incandescent lamps for higher efficiency.

INSTANT-START OR SLIMLINE. The fluorescent lamps that are the quickest to start have an instant start or slimline circuiting, and have a single pin at each end. They do not need the starter and starting circuit; however, they are slightly more expensive to operate.

RAPID START. Fluorescent lamps with rapid-start circuitry are the most widely used for commercial applications. They incorporate the principles of both the preheat and the instant-start circuits, although starters are not required. These are the only kind of fluorescent lamps that can be dimmed or flashed.

Fluorescent lamps have several advantages compared to the incandescent lamp. Fluorescent lamps last 10 to 15 times longer; produce about 4 times as much light per watt, which conserves energy; and produce almost no heat. Because the light source of fluorescent lamps is considerably larger, it gives off diffuse, shadowless light and produces less glare.

However, there are some drawbacks to fluorescent lights: Because they produce diffuse light, which promotes good vision, they also tend to create a flat, monotonous lighting effect; some of the color renditions of fluorescent lamps are not complimentary to skin tones and can make people and objects appear sallow and unattractive; and fluorescent lamps can be annoying if they flicker and/or hum. However, the newer electronic ballasts have eliminated this problem. Some manufacturers rate ballasts on the amount of sound produced. For example, ballasts with an *A* rating are quieter than those rated *B* or *C*. For areas that require minimum external sound, the ballast may have to be installed in an adjacent area. A designer must also be aware that ballasts (both fluorescent and HID lamps) produce heat. Sometimes it is necessary to install a ventilation system to constantly remove the ballast heat from the space.

In spite of these problems, fluorescent lamps remain a good, economical lighting choice. New tubes of improved color characteristics are being developed. Mixing fluorescent light with incandescent light or daylight can make a satisfactory lighting environment.

HIGH-INTENSITY DISCHARGE LAMPS

High-intensity discharge lamps produce light in much the same way as fluorescent lamps, by establishing an arc between two electrodes. The main difference is that the HID lamp is similar in shape to an incandescent bulb but is generally much larger (see Figure 12.15). Also, the two

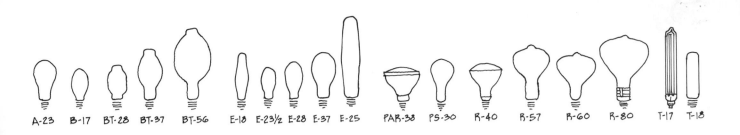

A-23 B-17 BT-28 BT-37 BT-56 E-18 E-23½ E-28 E-37 E-25 PAR-38 PS-30 R-40 R-57 R-60 R-80 T-17 T-18

contain different types of gases under a high pressure. In general, HID lighting combines the advantages of incandescent and fluorescent light. HID lamps have a high efficacy—up to twice the output of fluorescents, and 10 times that of incandescents. They have long lives, ranging from 15,000 to 24,000 hours. Their greatest disadvantage has been poor color rendition. They lack a well-balanced spectral distribution of color, which results in color-perception problems. They give a point or near-point light but can cause intense glare and uneven light patterns. Compared to fluorescent lighting systems, their ballasts are noisier and they have a very slow start-up time, 5 to 7 minutes (10 to 15 minutes for restrike after being turned off). HID lamps can be dimmed but are slow to respond.

HID lamps can be classified according to the type of gas vapor and phosphor coating used and are commonly available in three types—mercury vapor, metal halide, and high-pressure sodium. See Figure 12.16 for characteristics and uses of each type. In the past, HID lighting was

FIGURE 12.15 Some of the more popular High Intensity Discharge (HID) bulb shapes and sizes (not actual sizes).

HIGH INTENSITY DISCHARGE LAMPS (HID)

FIGURE 12.16 Common types and characteristics of High Intensity Discharge (HID) lamps.

TYPE	WATTAGE	EFFICACY—LUMENS/WATT	CHARACTERISTICS
MERCURY VAPOR	40–1,000	22–60 (efficacy increases with wattage)	Blue-green color rendition; deluxe white & warm deluxe white have improved color, but still low in red rendition. Mainly used for exterior landscape lighting.
METAL HALIDE	30–1,500	100	Well-balanced color rendering properties. Higher light output and smaller size for precise control. Used in office, retail, and public interiors.
HIGH PRESSURE SODIUM	50–1,000	50–127	Most efficient HID lamp; provides excellent optical control due to linear shape. Light output is yellow-tinted, thus affecting color rendition qualities.

used primarily for industrial applications and outdoor lighting because of its poor color rendition. However, new developments are rapidly improving HID lighting, and it is now being used extensively in public spaces, offices, and retail spaces. It is particularly useful in spaces with very high ceilings and as indirect lighting sources.

OTHER LIGHT SOURCES

Other light sources have been developed for specialty and decorative lighting needs. These types permit the interior designer to create a variety of special effects and a type of light not possible with the above-mentioned units. These specialized types include neon, cold cathode, fiber optics, and laser light.

NEON. Neon lights are another type of low-pressure electric discharge lamp used primarily for display or decorative purposes. They have a very long life, are available in a full range of colors, can be bent to any shape, and can be mounted on walls or ceilings. A neon lamp produces a low amount of uniformly distributed light throughout its length. Neon lamps are low energy consumers and can be dimmed and flashed but are fragile, requiring a special ballast for starting at high voltage and for staying lit. The ballast for a neon lamp is about 1.5 to 2 times as large as that of a fluorescent and can be noisy unless mounted in a remote or concealed area. Neon lamps have endless potential for creative interior lighting, since they can be shaped to fit any contour. They can be used for special visual effects, decoration, highlighting, and dramatization or as lighting sculptures (Figure 12.17).

FIGURE 12.17 Movement is the theme of this dynamic light sculpture that travels the length of the pedestrian corridor in the United Airlines Terminal 1 Complex at O'Hare International airport.

COLD CATHODE. Cold cathode lamps operate like instant-start fluorescents but are similar to neon in that the tube can be bent to conform to any shape. Cold cathode lamps have a very long life and are generally used where long, continuous runs of light are required, such as in built-in structural lighting.

FIBER OPTICS. Fiber optics are thin, cylindrical glass or plastic fibers that do not produce light by themselves. However, when a ray of light is passed through one end and emerges from the other in a process called total internal reflection, intense pinpoints of light are produced. Typically, a large number of fibers (50 to 1,000,000) are bonded into bundles at one end. The ends of the bundle are then bonded together, ground, and highly polished to minimize interference in the path of light. When a light source is placed in a precise location at the input end, the optic fibers and bundles will produce intense points of light. Fiber optics are used to create decorative effects, such as starlight patterns in the ceiling, under the treads of a staircase, or interlaced through plants to create three-dimensional shadows that crisscross over adjacent walls and ceilings. Because the light from fiber optics travels only a short distance once it has left the fiber, this type of lighting has been used in decorative, rather than functional, ways (Figure 12.18).

LASER LIGHT. The term *laser* means "light amplification by stimulated emission of radiation." A laser is a device containing a crystal, gas, or other substance in which the atoms are stimulated by focused light waves, amplified, and concentrated, then emitted in a narrow, very intense beam. Laser beams were formerly used only in scientific and medical fields but are now being used for a variety of purposes. Although laser beams can be dangerous, since a high-powered beam can burn the skin or can damage the retina of a person who looks directly into its beam, they can be applied effectively in special interior and theatrical environments. Lasers can be used to produce moving, three-dimensional objects in space or on a screen, as well as to move like a pencil in space, drawing figures in the air with a continuous line. For the interior designer or lighting designer, laser light offers the opportunity to produce and direct a cast of light beams, creating physical planes or sheets of light in midair. Laser light opens up a whole new field of visual experiences and communications.

Color Appearance of Light

The perceived color of materials and finishes within an interior space varies depending on the type of light source used. The best choice of lighting is one with good color-rendering properties and a moderate color temperature.

Two measures of light source color have been established and are commonly used to describe color characteristics of lamps. These are color temperature and the Color Rendering Index (CRI). Color temperature, measured in kelvin degrees, describes the actual appearance of the light produced in terms of its visual warmth or coolness. Kelvins range from 9000K (which appears blue) down to 1500K (which appears as orange-red). See Figure 12.19 for a comparison of natural and artificial light sources expressed in kelvins. Color temperature is related to the tasks that will be performed in an interior. For example, in residences, lamps of 2,700K to 3,000K should be used; office environments should range between 3,500K and 4,000K. A space with lots of available daylight, such as an atrium, can use lamps with 4,000K to 5,000K.

The color rendering index is a measure of how well colored objects appear under different light sources. The CRI is a number (from 0 to 100) representing how color samples appear when compared to a reference light source with the same color temperature. Generally, the

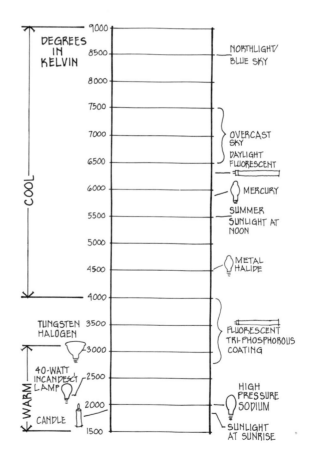

FIGURE 12.19 Color temperature is measured in degrees Kelvin and ranges from 9000K (which appears blue) down to 1500K (which appears orange-red). Light sources fall in between these ranges with those of a higher color temperature, 4000K or more, appearing more blue or "cool" and those 3100K or less considered to be "warm" as they appear more orange-red.

higher the CRI number, the better the color appearance. An incandescent lamp generally has a CRI close to 100. Fluorescent lamps (2700K to 6300K) vary in CRIs from 48 to 90. See Figure 12.20 for some general light sources and their effect on color.

FIGURE 12.20 Color-rendering properties of a lamp are an important influence on the color appearance of an object. Generally, the higher the CRI, the less distortion of an object's color by the lamp's light output. However, CRI values should only be compared between lamps of similar color temperatures.

LIGHT SOURCE	COLOR TEMPERATURE	COLOR RENDERING INDEX (CRI)	CHARACTERISTICS	EFFECT ON COLOR
STANDARD INCANDESCENT	2750–3400K	95+	• Warm, inviting light • Standard light source • Relatively inefficient	• Brightens reds, oranges, yellows • Darkens blues and greens
TUNGSTEN HALOGEN	2850–3000K	95+	• Brighter, whiter light than standard incandescent • More efficient than regular incandescent	• Brightens reds, oranges, yellows • Darkens blues and greens
FLUORESCENT	2700–6300K	48 to 90	• Wide selection of phosphor colors—select warm to cool lighting atmosphere • Generally high efficiency • Much longer life	• Wide range of color temperatures and CRIs to light effectively any (basically indoor) area with a "warm" to "cool" environment as decor or task dictates
HIGH INTENSITY DISCHARGE Metal Halide, High Pressure Sodium Mercury	 2700–4000K 2100K 4400 to 4	 60 to 70 21 32	• Different gases and phosphor colors create a variety of atmospheres • High efficiency • Very long life	• Metal halide lamps provide excellent color rendering. Mercury and High Pressure Sodium provide poor color rendering. Mercury gives a blue-green coloration and High Pressure Sodium imparts an orange-yellow color

LIGHTING NEEDS AND APPLICATION

The first step in lighting design is to analyze lighting needs in terms of the user(s) and the activities that will take place in the space. Good lighting depends on careful planning, beginning with an analysis of needs, the selection of lighting fixtures and lamps to suit those needs, and a drawing indicating the location of the fixtures to achieve the lighting levels and effects desired. The drawing is discussed later under "Interior Applications of Lighting."

As human vision differs widely, a designer must analyze user needs according to age, experience, and perception in terms of brightness, color, and satisfaction. The primary way we see is through sensitivity to contrast. The human eye can adapt to an enormous range of brightness and still distinguish fine detail. However, the perception of space is interpreted differently depending on many factors, especially age and experience.

Lighting for Special Groups

The fastest growing segment of our population is the elderly. As people grow older, they experience a great many changes in their lives that are affected by the interior environment. As a person's eyes age, that individual's color vision, depth perception, visual acuity, peripheral vision, glare and flicker tolerance, and size of the visual field all change. When these changes in vision begin to occur (generally, a reduction in a person's visual ability begins about the age of 40), eyeglasses can help to improve vision, but generally more light is needed for performing detailed visual tasks. A good designer must be in tune with the life process of aging and design in a subtle and visually harmonious way so that older people do not feel segregated or degraded because of their physical disabilities.

Designers can help compensate for visual loss through creative and flexible lighting design, such as adding special accent lighting to keyholes, public telephones, switches, and electrical outlets. Other lighting techniques can be designed to warn and guide the elderly at doorsills, steps, and pathway obstructions. Designers can also plan for higher light levels than normally recommended and provide dimmers so individuals can adjust the light level for their particular situation. Elderly fingers can manipulate slide dimmers fairly easily or push buttons on master switching systems.

Aging eyes also cannot distinguish colors very well. As the cornea of the eye begins to yellow and cloud, things begin to appear more amber. The sensitivity to contrast declines and the ability to discern simultaneous contrast, which is important in distinguishing color vibrancy, is decreased. The elderly need highly saturated primary hues in contexts of high contrast. Also, blues should be used sparingly because the ability to see blue and mixtures containing it is reduced with aging.

General or Ambient Lighting

Lighting for visual functions or activities can be categorized as (1) general or ambient; (2) task; and (3) accent or special-emphasis lighting.

General or ambient lighting brightens an entire space fairly uniformly. It provides a comfortable level of light, allowing people to find their way around, locate objects, and be able to see other people or objects easily. General illumination also provides a soft background or glow throughout a space.

General or ambient lighting can be produced by either a direct or an indirect method. Direct lighting means that light shines directly from the luminaire downward, generally from recessed, ceiling-mounted, or suspended fixtures. Indirect light shines against a surface, usually the ceiling, and is reflected down into the space indirectly. Indirect light generally produces a softer effect than direct light. Indirect light can be provided by suspended fixtures, wall sconces, or architectural built-in lighting systems, such as coves that are placed high on a wall with the light concealed. General lighting can also be achieved by perimeter lighting that outlines the perimeter of a space, as seen in Figure 12.21.

High levels of general lighting can make an area seem lively and cheerful, causing the people within to be inclined toward activity. However, uniform lighting can be monotonous and is seldom bright enough for reading or close work unless a high level of illumination is used. When

the general/ambient lighting level is low, a feeling of restfulness, relaxation, and intimacy is created. However, the lighting should be strong enough to avoid excessive brightness contrast between the general illumination and bright task lighting.

Task Lighting

Task lighting is direct, functional lighting that provides illumination for specific visual tasks or activities. Adequate and suitable light must be provided for every activity that takes place within a space. Typical tasks that may require special lighting considerations include reading, writing, drafting, preparing food, eating, and grooming. Task lighting is used in most environments such as offices, factories, medical facilities, retail establishments, museums, galleries, theaters, recreational facilities, or residential interiors.

Direct light is the best type for task lighting. However, proper placement is also very important to avoid the generation of shadows and glare. Task lighting can be placed high or low and can be mounted or portable, such as in floor, desk, or table lamps.

Accent or Special-Emphasis Lighting

Accent lighting is used to highlight art objects or special structural features within a space (Figure 12.22). Low-voltage halogen lamps or other types that produce narrow beam spreads are a good choice for these effects. Special effects can also be created by fixtures that break light into many small, bright spots. Accent lighting can take the form of a candle on a restaurant table or flexible strips of miniature lights that can bend and conform to any shape.

Special-emphasis lighting can be used to create interesting pools of light within a space and attract people to a certain area or to break up a large room into smaller islands of space. It can also be used to direct traffic or to set a mood or illusion.

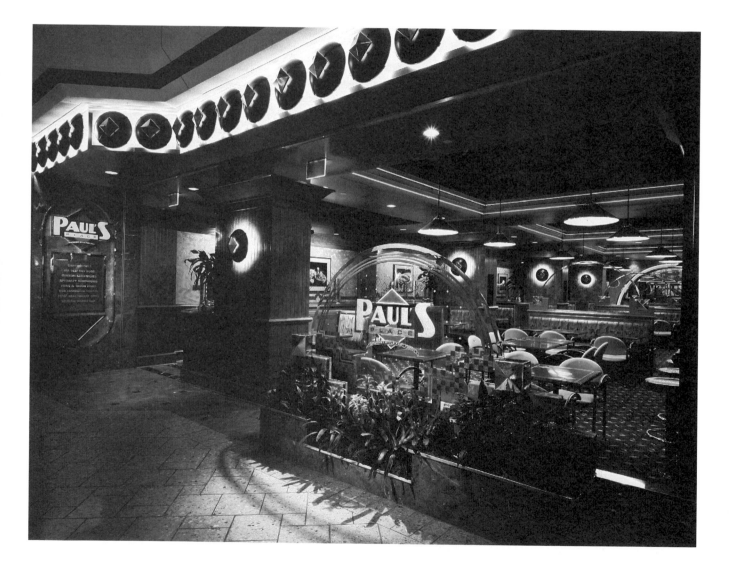

FIGURE 12.22 Neon spots, down lights, wall sconces, and pendant lighting are used in this restaurant by Victor Huff Design Partnership, Inc. These highlight the structural features, elements, and areas within the space.

LIGHTING FIXTURES AND TECHNIQUES

The lighting fixture, called the luminaire, is the housing for the lamp and is an integral part of a building's electrical system, transforming energy into usable light. Luminaires are available in a variety of shapes and sizes that can determine the shape and direction of the light beam. Since there are thousands of luminaires on the market, it is helpful for a designer to know what criteria to look for when making a selection. The first consideration is that the fixture must be suitable to the particular purpose or activity. Luminaires should be scaled to the overall design of a space in terms of size, proportion, and character. Luminaires can become focal points within a space or be subordinate and concealed.

Manufactured Luminaires

The best way to determine what kind of luminaires to select for a particular purpose is to consider the desired direction of the light beam and the method of mounting. The form of the light beam can be generally classified as point, linear, and volumetric sources. Point sources are used to give focus to a space by providing areas of brightness. They are also used to highlight an area or object of interest and can be arranged to create rhythm or sparkle. Linear sources can be used to emphasize the perimeter of a space, outline an area, or provide direction. If linear sources are placed parallel to each other, they create a plane of illumination. Volumetric sources are diffuse point sources that have been expanded by the use of translucent materials to create illumination patterns in the form of spheres, globes, or other three-dimensional forms.

Five common types of mounting methods for manufactured luminaires determine the direction of the light beam: recessed, ceiling mounted, wall mounted, suspended, and track mounted (Figure 12.23).

RECESSED

Recessed luminaires provide direct light. They are mounted above the ceiling line, the bottom generally flush with the ceiling. These are popular luminaires for general lighting using all types of lamps. They can also be used for wall washing or accent light.

CEILING MOUNTED

Ceiling mounted luminaires produce direct light and are very efficient, impeding neither light nor heat. This type is mounted directly on the ceiling; its light beam can be directed in a wide pattern. Installation and relamping are generally easy and relatively inexpensive. One disadvantage is that ceiling-mounted fixtures can lower the effective height of a ceiling.

WALL MOUNTED

Wall-mounted fixtures, often called sconces, provide direct, indirect, diffuse, or direct-indirect light. These fixtures are used mainly for decorative purposes and tend to bring down the line of sight in a space with a very high ceiling. If a ceiling is very low, however, the clearance for passersby may be impeded with a wall-mounted fixture. Some wall-mounted luminaires incorporate a reflector plate against the wall to reflect any lost light and to create a focal point of brightness.

FIGURE 12.23 Luminaires can be mounted by five basic methods.

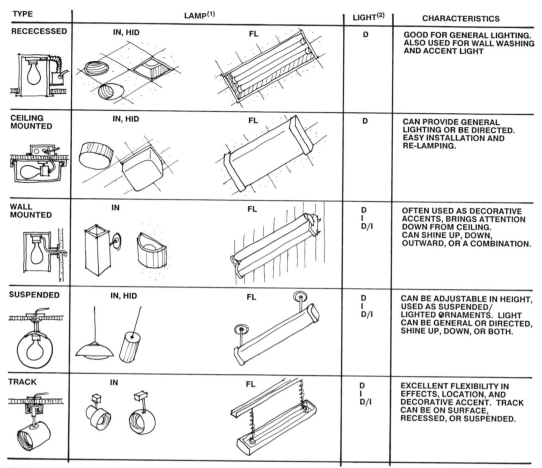

TYPE	LAMP[1]		LIGHT[2]	CHARACTERISTICS
RECESSED	IN, HID	FL	D	GOOD FOR GENERAL LIGHTING. ALSO USED FOR WALL WASHING AND ACCENT LIGHT
CEILING MOUNTED	IN, HID	FL	D	CAN PROVIDE GENERAL LIGHTING OR BE DIRECTED. EASY INSTALLATION AND RE-LAMPING.
WALL MOUNTED	IN	FL	D I D/I	OFTEN USED AS DECORATIVE ACCENTS, BRINGS ATTENTION DOWN FROM CEILING. CAN SHINE UP, DOWN, OUTWARD, OR A COMBINATION.
SUSPENDED	IN, HID	FL	D I D/I	CAN BE ADJUSTABLE IN HEIGHT, USED AS SUSPENDED/ LIGHTED ORNAMENTS. LIGHT CAN BE GENERAL OR DIRECTED, SHINE UP, DOWN, OR BOTH.
TRACK	IN	FL	D I D/I	EXCELLENT FLEXIBILITY IN EFFECTS, LOCATION, AND DECORATIVE ACCENT. TRACK CAN BE ON SURFACE, RECESSED, OR SUSPENDED.

(1) **IN** = INCANDESCENT; **HID** = HIGH INTENSITY DISCHARGE; **FL** = FLUORESCENT
(2) **D** = DIRECT; **I** = INDIRECT; **D/I** = DIRECT/INDIRECT

SUSPENDED

Suspended, or pendant, luminaires can produce direct, indirect, diffuse, or direct-indirect light beams. These fixtures are suspended below the ceiling and can be adjustable, depending on the ceiling height. One major advantage of these fixtures is their appearance—they become lighted ornaments when suspended in an interior space. Some large suspended luminaires may also form a canopy effect. Some building codes require large suspended fixtures to have "earthquake" hangers so the fixtures will sway but not fall in the event of an earthquake or other disaster.

TRACK MOUNTED

Track-mounted luminaires can provide direct, indirect, or direct–indirect light. A track-mounted lighting system consists primarily of two parts: the track and the luminaire. This type of lighting system is very popular because it offers optimum flexibility in a vast range of lighting effects and can be economical. The track itself is an electrical raceway that supplies power to the luminaires. The luminaires can be mounted anywhere on the track and moved horizontally or vertically. The track can be surface mounted, recessed in the ceiling or attached to a wall or can have pendant fixtures hanging from it. Track-lighting systems come in a variety of sizes and shapes and can be mounted practically anywhere to serve a multitude of purposes.

Spatially Integrated Lighting Systems

Spatially integrated lighting systems can be defined as lighting that is built in and integral to the construction of a building. This type is relatively invisible and can be controlled to enhance the brightness within a space without creating glare in the field of view. Figure 12.24 shows some of the more common types of integrated lighting systems used in both residential and nonresidential facilities.

CORNICE LIGHTING

Cornices are mounted at or near the ceiling and direct light downward, either to give dramatic emphasis to textured walls, such as stone, brick, or wood, or to create an interesting lighting effect. Cornices are used to conceal the actual light source and provide a reflected ambient effect for a space.

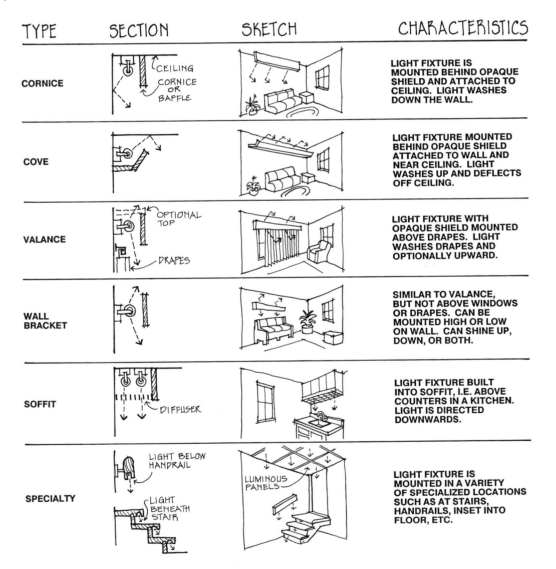

TYPE	SECTION	SKETCH	CHARACTERISTICS
CORNICE	CEILING / CORNICE OR BAFFLE		LIGHT FIXTURE IS MOUNTED BEHIND OPAQUE SHIELD AND ATTACHED TO CEILING. LIGHT WASHES DOWN THE WALL.
COVE			LIGHT FIXTURE MOUNTED BEHIND OPAQUE SHIELD ATTACHED TO WALL AND NEAR CEILING. LIGHT WASHES UP AND DEFLECTS OFF CEILING.
VALANCE	OPTIONAL TOP / DRAPES		LIGHT FIXTURE WITH OPAQUE SHIELD MOUNTED ABOVE DRAPES. LIGHT WASHES DRAPES AND OPTIONALLY UPWARD.
WALL BRACKET			SIMILAR TO VALANCE, BUT NOT ABOVE WINDOWS OR DRAPES. CAN BE MOUNTED HIGH OR LOW ON WALL. CAN SHINE UP, DOWN, OR BOTH.
SOFFIT	DIFFUSER		LIGHT FIXTURE BUILT INTO SOFFIT, I.E. ABOVE COUNTERS IN A KITCHEN. LIGHT IS DIRECTED DOWNWARDS.
SPECIALTY	LIGHT BELOW HANDRAIL / LIGHT BENEATH STAIR	LUMINOUS PANELS	LIGHT FIXTURE IS MOUNTED IN A VARIETY OF SPECIALIZED LOCATIONS SUCH AS AT STAIRS, HANDRAILS, INSET INTO FLOOR, ETC.

FIGURE 12.24 Spatially integrated lighting systems are those that are built into the building as an integral part of the architecture.

COVE LIGHTING

Cove lighting is concealed in a continuous trough that is usually directed toward the ceiling. Coves are a good choice to give a feeling of height or to emphasize a cathedral or vaulted ceiling. Cove lighting provides a soft, uniform, nonglaring light and is best used as a supplement to other lighting.

VALANCE LIGHTING

Valances are traditionally located directly above windows, usually with draperies or other window treatments. They provide both direct and indirect light to emphasize the texture of the window treatments and to reflect light off the ceiling into the rest of a space.

BRACKET LIGHTING

Bracket lighting is similar to valance lighting, but it is not located over windows. It can provide both direct and indirect light and can be placed high or low on a wall. Bracket lighting can be used for general ambient lighting, task lighting, or a combination of the two. Brackets can be placed above work areas, beds, or shelving units for emphasis.

SOFFIT LIGHTING

Soffit lighting is common and inexpensive. It is often used in a dropped or "furred-down" area of a ceiling and can provide a high level of direct light. It is generally placed over work areas, such as a kitchen sink or a mirror in a dressing room. It also can be placed around the perimeter of a room or along one wall to visually expand a space or draw attention to it. Either fluorescent or incandescent lamps can be installed in a soffit with a suitable diffuser or louver at the bottom.

SPECIALTY LIGHTING

Specialty lighting, such as luminous panels can be used on ceilings or walls. A continuous diffusing or louverlike material with light sources mounted above might cover all or most of the ceiling. Generally, fluorescent light sources are used to produce an evenly distributed, diffused, soft light. The luminous panel system is practical for general light if it is installed 8 to 10 feet (2438 to 3048 mm) above the floor; if placed above 10 feet (3048 mm), it becomes mostly decorative. Luminous panels can be used to simulate a skylight effect in interior environments, such as in restaurants or shopping malls.

Luminous wall panels or columns are based on the same concept as luminous ceilings but are fluorescent lamps placed within the wall surface or installed inside columns and covered with a translucent panel. Both applications are used for decorative purposes or graphic displays. These panels and columns can be most effective in drawing attention to a display or defining structural elements within a space, since they produce an ambience of natural light.

Other types of specialty lighting can be incorporated into handrails, stairs, or floors.

Portable Lighting Fixtures

Portable lighting fixtures are available in an infinite variety of sizes, shapes, and styles (Figure 12.25). Portable fixtures originated in the home as floor or table lamps to provide working light close to a task. However, in the 1970s the concept of task lighting was modified and adapted to the office environment in the form of portable workstations that incorporated task lighting under a shelf unit and indirect ambient lighting mounted above the shelf in a desk unit (Figure 12.26). Miniature and powerful fluorescent, incandescent, and HID lamps have become stylish floor and table portable fixtures in homes and office environments across the nation.

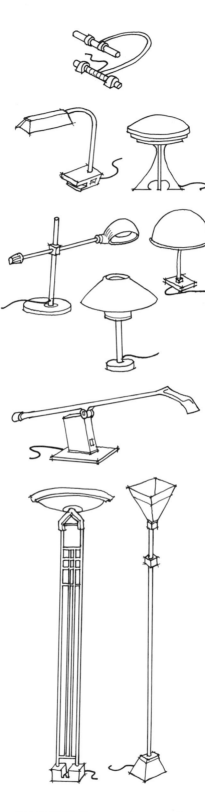

FIGURE 12.25 Some popular types of portable light fixtures.

FIGURE 12.26 Under-shelf task lighting incorporated within a workstation.

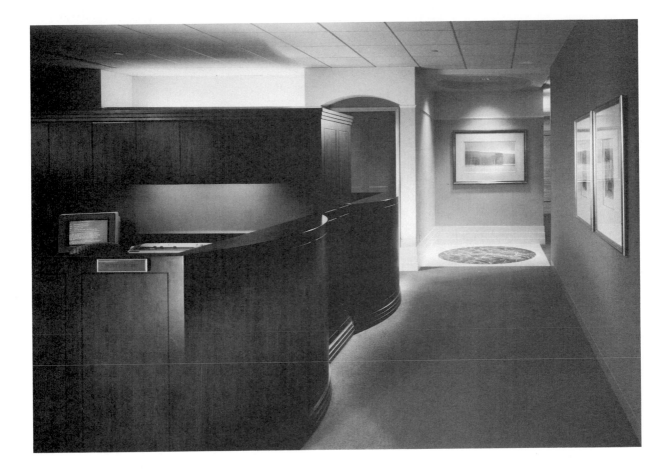

ELECTRICAL CONTROLS
FOR LIGHTING

A lighting system must have electrical controls for turning light off and on, dimming it, or moving it. Traditionally, lighting controls have been provided to allow lighting flexibility or dramatic lighting effects. However, today's lighting control is also being used for energy management. The most common method of switching control is the manually operated wall switch; however, other types, such as the push-button, slide plate, photocells, presensing systems, and electronic control, are available.

Dimming a light source, which controls the electrical input, is an excellent way to provide the required amount of light within a space without wasting energy. Dimmer controls can adapt the level of light to a particular task or mood and offer great flexibility to the lighting designer. The key to proper application of lighting controls is the selection of the proper control device, as well as the careful planning of how the control is to be used. Several dimming methods are available today, depending on the type of lighting system to be produced. See Figure 12.27 for the most common types and characteristics of electrical controls.

Good lighting control in residential applications requires every space or area to have a light switch adjacent to the door or access. Depending on the type of space and activities, more

ELECTRICAL CONTROLS FOR LIGHTING

TYPE OF SWITCH	CHARACTERISTICS	COMMON USES
TOGGLE/ SNAP	Most common and least expensive. Connection made by snapping one metal contact to another.	Typical for most residential and commercial applications.
MOMENTARY CONTACT	Switch opens or closes a circuit. Actually a push button switch.	Often used as elevator call button: Generally accompanied with an integral light to indicate if circuit is on or off.
DIMMER	Allow variable voltage to a lamp circuit, producing dimming effect.	Used in most residential and commercial applications to dim light fixtures.
ELECTRONIC	Variety of switching methods triggered by heat, sound, touch, motion, radio waves, and light.	Used for security installations, switching for daylight/nighttime phases.
MERCURY	Vial of liquid mercury is tilted and conducts electricity between contacts. Often called "silent action switches."	Used in thermostat controls and as silent action switches.

than one switch is sometimes required for lighting flexibility. In commercial applications, lighting control systems may be controlled by individual switching, or in large facilities, by the use of a time clock or other sensitive switches. However, where possible, individual switching is generally preferable in spaces so the users can turn off lighting where and when it is not needed.

For safety purposes, stairs should have switches at the top and bottom, and hallways should have them at both ends. The mounting height of switches should be no higher than 48 inches (1220 mm). However, for better access by the handicapped, some codes recommend that switches should be mounted 30 to 40 inches (762 to 1016 mm) above the floor, with 36 inches (914 mm) preferred by wheelchair users.

INTERIOR APPLICATIONS OF LIGHTING

Lighting design involves selecting and locating the appropriate lamps and fixtures to satisfy stated needs. The designer develops a concept to determine what the lighting should be not only to satisfy the needs but also to complement the occupants, the architectural features, and the character of the interior space. After exploring several alternative sketches, the designer should develop a lighting plan to accomplish those goals. A lighting plan is part of the construction drawings (Chapter 18) and is sometimes referred to as an electrical or reflected ceiling plan. However, each of these has distinct characteristics.

A lighting plan is used in residential and small commercial projects to show types and locations of light fixtures and controls (Figure 12.28). It is often used to communicate the concepts of the lighting design to the client and the contractor.

A reflected ceiling plan (Figure 12.29) is used primarily in large commercial work or complex ceiling systems that have several changes in elevations, materials, and soffits. It also shows such items as HVAC registers and sprinklers and can indicate where switches are located.

An electrical plan (Figure 12.30) is a floor plan that shows wall and floor electrical outlets, telephone outlets, and other devices using power. Service panels, electrical line diagrams, and light-control switches can be added. In residential and small commercial projects, the electrical and lighting plans can be combined into one drawing (see Figure 18.22).

FIGURE 12.28 Example of a lighting plan.

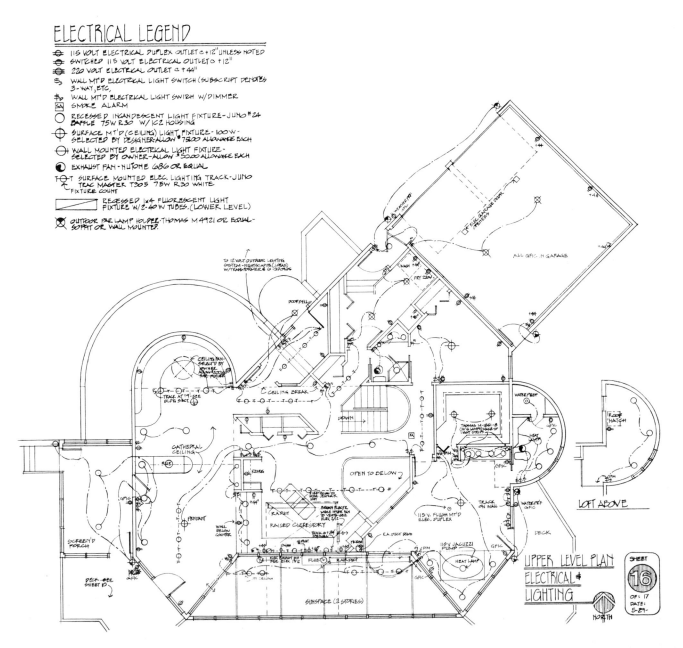

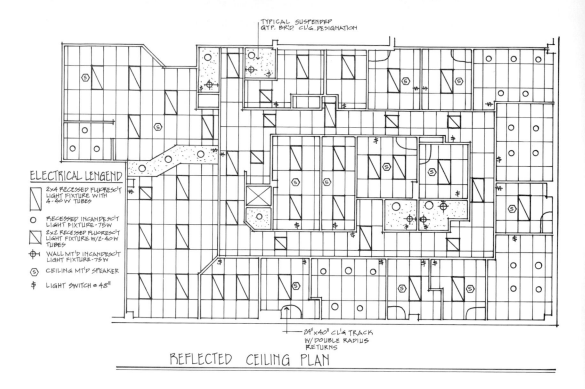

ELECTRICAL LEGEND

- ☐ 2x4 RECESSED FLUORESC'T LIGHT FIXTURE WITH 4-40 W TUBES
- ○ RECESSED INCANDESC'T LIGHT FIXTURE - 75W
- ☑ 2x2 RECESSED FLUORESC'T LIGHT FIXTURE W/2-40W TUBES
- ⊕ WALL MT'D INCANDESC'T LIGHT FIXTURE - 75W
- Ⓢ CEILING MT'D SPEAKER
- $ LIGHT SWITCH @ 48"

TYPICAL SUSPENDED GYP. BRD CLG. DESIGNATION

24"x40" CLG TRACK W/ DOUBLE RADIUS RETURNS

REFLECTED CEILING PLAN

FIGURE 12.29 Reflected ceiling plan for a commercial space.

FIGURE 12.30 Example of an electrical plan.

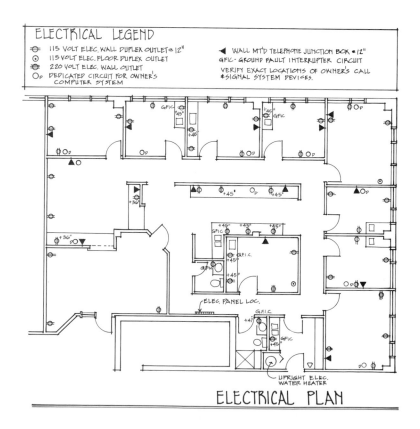

ELECTRICAL LEGEND

- ⊖ 115 VOLT ELEC. WALL DUPLEX OUTLET @ 12"
- ⊙ 115 VOLT ELEC. FLOOR DUPLEX OUTLET
- ⊕ 220 VOLT ELEC. WALL OUTLET
- O_D DEDICATED CIRCUIT FOR OWNER'S COMPUTER SYSTEM

- ◀ WALL MT'D TELEPHONE JUNCTION BOX @ 12"
- GFIC - GROUND FAULT INTERRUPTER CIRCUIT
- VERIFY EXACT LOCATIONS OF OWNER'S CALL & SIGNAL SYSTEM DEVICES.

ELEC. PANEL LOC.

UPRIGHT ELEC. WATER HEATER

ELECTRICAL PLAN

A lighting detail (Figure 12.31) is drawn whenever more precise information is needed to explain the light fixture or how it is to be installed.

Although every lighting project and situation is different, we can look at some guidelines for a few specific applications in commercial interiors.

FIGURE 12.31 Examples of lighting details.

FIGURE 12.32 Successful office lighting incorporates more than one type of system for interest and visual relief, as illustrated in this office interior. (Courtesy of Gensler & Associates. Copyright © Peter Aaron/Esto.)

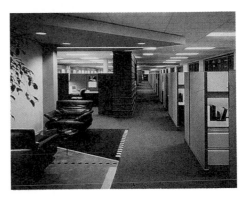

Office Lighting

Research has shown that improved lighting is directly related to increased worker productivity and efficiency. Lighting should be designed to make worker tasks as efficient and enjoyable as possible. Generally, successful office lighting must provide quality task lighting at the task surface, glare-free ambient lighting, and interesting perimeter or other lighting for visual relief. More than one lighting system should be incorporated, with regular or dimmer switches available at each task area in order to create visual balance when necessary (see Figure 12.32). Direct glare can be minimized by using low-glare-producing lens, such as parabolic louvers in fluorescent luminaires (Figure 12.33).

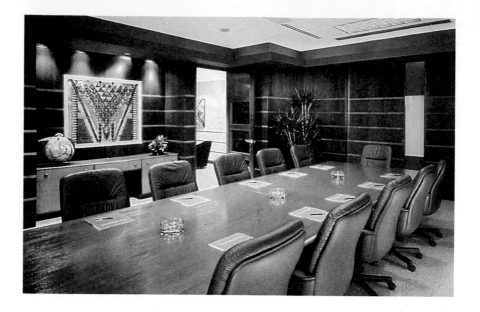

FIGURE 12.33 Parabolic louvers are used with these fluorescent fixtures to minimize glare and to control the light output.

A variety of meetings and associated activities might take place in conference rooms, creating the need for a flexible lighting system. Quality task lighting should be available directly on the conference table, with a separate switch for its control. To create a pleasant environment, perimeter lighting is a good choice for wall-washing effects. Supplementary lighting, on a separate dimmer switch, should be provided for presentations or displays on or near a predetermined wall.

Retail Lighting

Good lighting is a positive sales tool that can help attract customers and sell merchandise by enhancing the retail environment. Whether focusing attention on specials in the aisles or highlighting primary display areas, effective lighting can produce a pleasant atmosphere that will foster both spontaneous and repeat sales in a variety of commercial settings. It is critical that buyers in retail spaces must be able to see the color of the merchandise accurately and with enough light.

Three basic categories of lighting are needed in a store environment to provide efficient and comprehensive store lighting: general, accent, and perimeter (Figure 12.34). General lighting is needed to provide optimum quantity, distribution, and light direction of appropriate color to establish overall visibility and character. Accent lighting is needed to add visual impact to displays and to draw the customers' attention to them. Perimeter lighting is used to draw attention to wall displays as well as contribute to the pleasantness of the store's environment. The level of light to accent merchandise is usually three to three and one-half times as high as that for general circulation areas. For featured displays, this level should be five times higher than that for general merchandise.

Recommended illumination levels depend on the type of store and its activity level. As illustrated in Figure 12.35, activity level can be categorized as high, medium, or low.

Fluorescent, incandescent, and high-intensity discharge light sources can be used for retail lighting; however, each has unique characteristics and should be chosen to fit the lighting, merchandising, and economic objectives.

FIGURE 12.34 General, accent, and perimeter lighting are needed in retail spaces to provide efficient and comprehensive viewing as shown here in Marshall Field's Men's Department in the company's flagship store in Chicago.

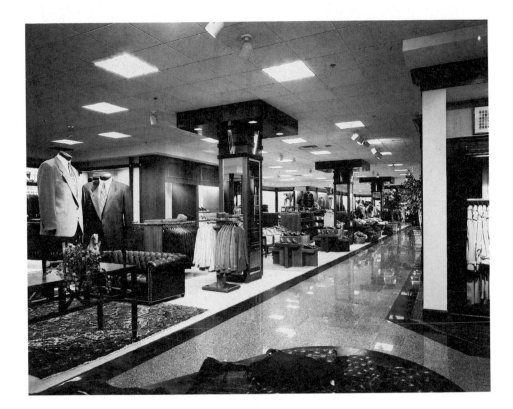

RECOMMENDED ILLUMINATION LEVELS (FOOTCANDLES)	MERCHANDISE	FEATURED DISPLAYS
DISCOUNT/MASS MERCHANDISING STORES: "HIGH ACTIVITY"—Where merchandise displayed has readily recognizable use. Evaluation and viewing time is rapid, and merchandise is shown to attract and stimulate the impulse buying decision.	100	500
FAMILY STORES: "MEDIUM ACTIVITY"—Where merchandise is familiar in type or use, but the customer may require time and/or help in evaluation of quality, use, or for the decision of buying.	70	300
UPSCALE STORES: "LOW ACTIVITY"—Where merchandise is displayed that is purchased less frequently by the customer, who may be unfamiliar with the inherent quality, design, value, or use. Where assistance and time is necessary to reach a buying decision.	30	150

FIGURE 12.35 Recommended levels (footcandles maintained) for merchandising areas.

Restaurant Lighting

Lighting for restaurants must fulfill the two major requirements of function and mood. Diners must have enough light to read the menu comfortably and to see their meal and each other; employees must have adequate lighting to serve the diners. Lighting also must enhance the mood established by the overall design concept and the type of food service offered. For example, in fast food restaurants a fast-paced atmosphere is created by bright light, whereas a leisure dining restaurant would use subdued lighting to foster a slow and relaxing pace (Figure 12.36).

Although the mood or atmosphere may differ, functional lighting for serving counters, workstations, and public facilities is generally the same. To create a specific mood, the designer must consider the type of food served, the type of accommodation, and the potential trade or audience.

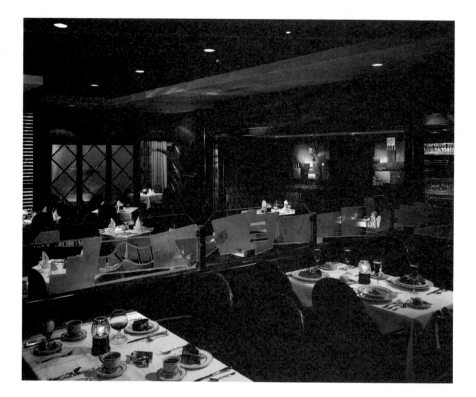

FIGURE 12.36 Lighting enhances the mood for leisurely, relaxed dining.

As in other types of facilities, the best general guideline is to mix different types of lighting for different activities and moods. General lighting is needed for circulation, orientation, and cleaning after hours. Task lighting should be added for specific activities, and accent lighting, for interest and mood. General lighting for a restaurant ranges from 20 to 50 footcandles, depending on the type of facility. Major sources of light, such as luminous ceilings, ceiling panels, or large fixtures, need to produce soft, not harsh, light. Luminaires that hang below the ceiling, such as chandeliers or pendants, should relate to the architecture of the space if the furniture is movable; if the furniture is fixed, pendant or other suspended fixtures can relate more specifically to the furniture. Luminaires mounted on the ceiling should relate to the design of the space. Intense downlights should not be placed over customers' heads, since they create unflattering and harsh shadows under the eyes and nose.

Direct light (downlight in pendants or recessed fixtures) over tabletops is a good way to create sparkle on table items. Wall-mounted fixtures can add to the decoration of a space but do not produce sufficient light for most restaurants. Wall washing is a good technique to emphasize a wall finish and reflect some light to add to the overall illumination (Figure 12.37). If low illumination is the design goal, higher illumination should be provided as a backup for cleaning the restaurant.

Dimmers should be incorporated in any restaurant lighting system, since the illumination level will generally need to change according to the time of day and for different atmospheres.

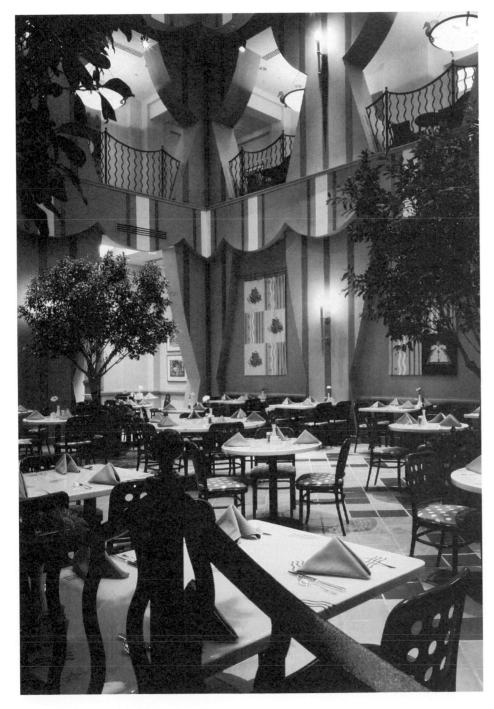

FIGURE **12.37 The use of wall sconces in the Coral Cafe empahsizes the wall treatment and provides focal points in the Walt Disney World Dolphin Hotels.**

Medical Facilities Lighting

Lighting requirements for medical offices can differ greatly, depending on the specialty and the size of the practice. However, some general guidelines apply.

Most examination rooms need at least a maintained general light level of 100 footcandles. For closer examination purposes, a physician will generally require a high-intensity portable lamp in each room.

Nurses stations require at least 100 footcandles of maintained illumination, and minor surgery rooms require from 100 to 150 maintained footcandles, depending on the procedures performed. In addition to the maintained illumination, surgery rooms usually have a ceiling-mounted high-intensity surgical light available.

A lower light level, between 30 to 50 footcandles, is appropriate for waiting rooms. Although task lighting is needed for those who wish to read, overall lighting can be designed to create an inviting atmosphere. Lighting in these areas can be achieved by direct or indirect luminaires. Incandescent or fluorescent lamps can be used, depending on the type of atmosphere desired (Figure 12.38).

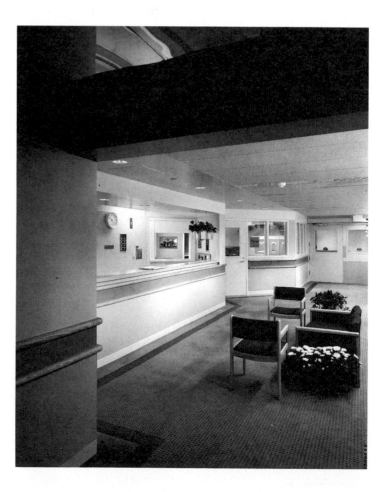

FIGURE 12.38 Direct lighting by recessed luminaires in the waiting area of James Whitcomb Riley Hospital for Children.

LIGHTING CODES AND REGULATIONS

Because protecting the health, safety, and welfare of the general public is a major concern for the interior designer, it is important for the designer or the design team to know which codes will be applicable to a given lighting system. Codes for lighting generally include emergency lighting designed to lead occupants to exit doors, fire-rated stairwells, or fire escapes.

Other building codes important to the lighting designer are the energy codes that reduce the use of energy-wasteful lighting systems. These codes limit the amount of watts per square foot of lighting permitted in new installations. Most code areas consider 3 watts per square foot reasonable; however, some codes are setting lower levels, such as 2 or even 1.5 watts per square foot, for maximum conservation.

REFERENCES FOR FURTHER READING

Egan, M. David. *Concepts in Architectural Lighting.* New York: McGraw-Hill Book Company, 1983.

Flynn, John E., A. Segil, and G. Steffy. *Architectural Interior Systems.* 2nd ed. New York: Van Nostrand Reinhold, 1988.

Grosslight, Jane. *Light: Effective Use of Daylight and Electric Lighting in Residential and Commercial Projects.* Englewood Cliffs, N.J.: Prentice-Hall, Inc., 1984.

Kaufmann, John E. *IES Lighting Handbook Reference Volume.* New York: Illuminating Engineering Society of North America (IESNA), 1981.

Lam, William M.C. *Perception and Lighting as Formgivers for Architecture.* New York: McGraw-Hill, 1978.

Lam, William C. *Sunlighting as a Formgiver For Architecture.* New York: Van Nostrand Reinhold, 1986.

Moore, Fuller. *Concepts and Practice of Architectural Daylighting.* New York: Van Nostrand Reinhold, 1985.

Nuckolls, James. *Interior Lighting for Environmental Designers.* New York: John Wiley, 1976.

Robbins, C. C. *Daylighting Design and Analysis.* New York: Van Nostrand Reinhold, 1986.

Sorcar, Prafulla C. *Architectural Lighting for Commercial Interiors.* New York: A Wiley-Interscience Publication, 1987.

Smith, Fran Kellogg, and Fred J. Bertolone. *Bringing Interiors To Light.* New York: Whitney Library of Design, 1986.

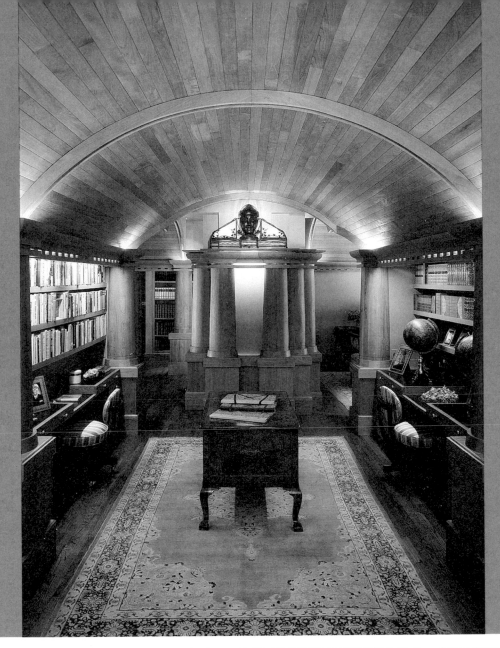

INTERIOR MATERIALS, ARCHITECTURAL SYSTEMS, FINISHES, AND COMPONENTS

P A R T F O U R

MATERIALS: CHARACTERISTICS AND APPLICATIONS

INTRODUCTION TO SELECTING MATERIALS

Materials are the basic building substances architects and interior designers use to create built environments and to give form, shape, variety, and distinction to interior spaces. Materials provide the physical and psychological form to the space, structure, finishes, and contents for human beings to use. Some materials are an integral part of a building structure; others are applied as a surface treatment or used on components, such as furniture or cabinetry. For example, materials such as stone and wood can be used as construction elements to enclose space and provide protection and privacy, yet supply color, texture, pattern, and durability as a finish to the space.

Materials change from period to period as technology advances. Not only do new materials appear in each generation, but new ways of using old materials also emerge. New technology and materials also give rise to new design ideas.

This chapter will introduce materials, describing their intrinsic (integral) characteristics, how they are produced (manufactured), and how they can be used as design elements. Chapter 14

will show how these materials serve a specific function within a building, for example, how wood is used in different applications, including as a flooring material or wall covering.

Before the nineteenth century, most common buildings were constructed of local or indigenous materials; that is, if the region was wooded, buildings were primarily made of wood. In temples, churches, monuments, palaces, and similar structures, however, quality materials such as marble were imported great distances, for these buildings and their use symbolized wealth, power, and luxury. After the nineteenth century, better manufacturing processes and transportation modes created greater opportunities for materials to be used beyond their regional borders and in all types of buildings.

Today, materials come from worldwide locations. However, some indigenous materials are still used regionally as a distinct design element. The adobe material used in the southwestern regions, for instance, gives the architecture there a look not common in other regions of the country.

Materials are used in their natural, converted, or artificial state. Some building elements might be constructed of a combination of these, such as a stone facing (natural) over a concrete wall (converted) that has integral steel (artificial) reinforcement (Figure 13.1).

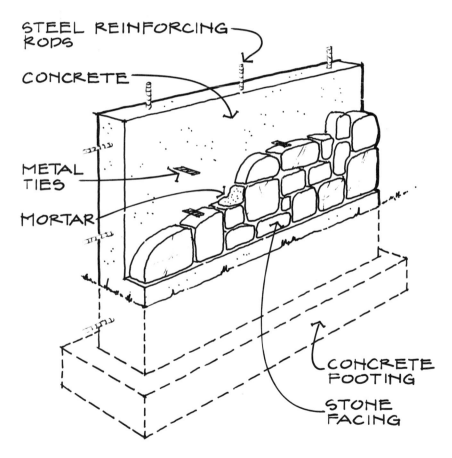

FIGURE 13.1 This composite wall is made of a natural material (stone) secured to a converted material (concrete) that is reinforced with steel (artificial material).

Natural Materials

Natural materials are those found in nature, either as organic or as inorganic substances. Organic materials are those that come from plants and animals; inorganic (nonliving) materials

are those, such as clay and stone, that exist in a natural state. Although either type might be modified, such as by cutting a tree (plant) into lumber or the stone into rectangular blocks, both are nevertheless considered natural materials.

Converted Materials

Converted materials are materials processed or manufactured into different forms. For example, clay exists as a natural substance, but when it is fired at high temperatures, it is converted into a new material called ceramic. In this converted state, clay possesses new characteristics and uses not possible in its original state.

Artificial Materials

Artificial materials are created by man-made processes that produce new substances. Plastics are one of the best examples, since they are artificially created from petroleum and chemicals. Plastics cannot be found in nature as a distinct product but are made from a combination of natural elements.

Material Selection

The interior designer must be knowledgeable about the intrinsic qualities and practical values of materials and must also have the sensitivity and aesthetic judgment to select the most appropriate material for the intended use. Materials can be chosen for their surface appearance, such as color or texture; however, this is in most cases not the best criterion. Materials should first be selected for their functional qualities, such as durability; insulating, acoustical, or fireproofing qualities; and ease of maintenance.

A prime consideration in the selection of materials is the use of space and its visual suitability for the intended atmosphere or mood to be created. Heavy, rough textures and dark colors would be inappropriate for a children's play area but might create a rustic mood in a restaurant.

A designer should select materials based on the following checklist of criteria for function, aesthetics, and ecological and economic factors:

1. Functional Characteristics
 —Appropriateness and suitability to use;
 —Durability and resistance to damage;
 —Ease of maintenance;
 —Safety and fireproofing where required;
 —Insulation and acoustical properties;
 —Regulations/codes that govern;
2. Aesthetic Considerations
 —Appropriateness to the design concept;
 —Surface qualities, such as texture and pattern;

—Color and light reflection and absorption qualities;

—Visual suitability to intended mood or atmosphere;

—Balance, size, and proportion of the space;

3. Ecological Considerations

—Environmental impact for acquisition and manufacturing;

—Renewable resources;

—Capability to be recycled;

—Nontoxicity to users;

4. Economic Considerations

—Initial cost of material, shipping, and installation;

—Availability of material;

—Cost of maintenance and possible replacement.

Materials and Environmental Concerns

Environmental concerns about the acquisition and manufacturing processes of new materials and the discarding of used ones are becoming widespread. Some production processes can result in pollutants harming our air, land, and water quality, which in turn can cause human health hazards and affect our quality of life.

Another concern is the reuse or recycling of materials. Although we think of creating or using newly manufactured materials and ultimately discarding them, many can be recycled. For example, used brick and timber are often reclaimed from former structures to be used in new or remodeled structures. Newspapers can be recycled into building insulation, such as cellulose, that is used in attics and walls. Glass, aluminum, and steel can be reclaimed and reconstituted into new materials.

Biodegradable materials are another major concern for the preservation of our environment. The primary impact comes from consumer products that are thrown back into the environment in landfills. The packaging used for building materials and leftover materials, such as foam packaging, compound the problems of waste. Discarded wood, however, can often be turned into sawdust and refined into particleboard, burned for fuel, or allowed to disintegrate into the environment eventually.

The designer must be aware of the impact that the overuse of some rare natural materials will have on our environment. For example, the dark, exotic woods, such as ebony, come from the tropics, and the rapid destruction of the rain forests where they grow is a global problem. The designer can help to save our environment by not specifying these exotic woods for unnecessary uses where more plentiful and renewable woods would suffice.

The "sick building syndrome" is caused by low levels of indoor pollutants and in turn causes occupants to experience eye, nose, throat, and lung irritations, as well as headaches, lethargy, and difficulty in concentrating. Many common types of hazardous gases polluting interior environments are produced from such seemingly innocent materials as paints, carpets, glues, particleboard, and man-made textiles. Manufacturers are continually trying to improve the quality of their materials in order to reduce air pollution hazards. The interior designer must understand the potential hazards of some materials before specifying them for use in these closed environments.

WOOD

Because of its abundance in nature and the relative ease with which it can be obtained and worked, wood has been used for centuries as a major material for buildings and furniture. Wood is also an excellent insulator and a renewable material. Although thousands of different species of trees exist, only about 100 species are used commercially as building materials.

Sawmills cut tree logs into lumber as boards of various sizes. When both the width and the thickness of lumber exceeds five inches (127 mm), these boards are called timber and are used mostly as posts and beams for structural support.

Physical Properties

The structural makeup of wood consists of longitudinal bundles of cellulosic fibers and pores (Figure 13.2). These fibers run parallel to the length of the tree; medullary, or pith, rays radiate from the center at right angles to these fibers. When wood is cut, the figure and grain are exposed, resulting in distinct patterns for each tree type and method of cut.

FIGURE 13.2 The visual appearance and strength of lumber sawn from a tree will vary according to the location and direction of the cut.

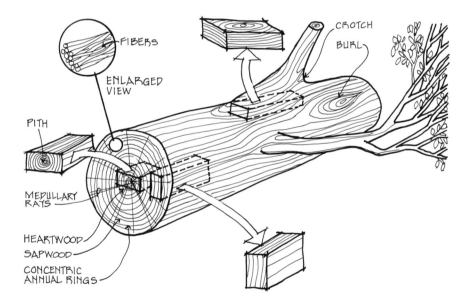

A tree grows new wood in the spring and summer in concentric annual rings over the older wood, thus increasing the tree's girth. The outer layers (sapwood) usually are softer and lighter in color than the center section, called the heartwood. Heartwood is generally the preferred wood but is more expensive, in redwood trees, for example.

The way in which a tree grows also has a marked influence on its strength characteristics. The wood can easily be split in a vertical or longitudinal grain direction—but must be sawed across the grain. For these reasons, wood has good physical strength; it is used in both tension (resistance to bending) and compression (resistance to loads of pressure). This versatility allows wood to be used both for beams to span long distances and for vertical posts to hold up floors or roofs. Its tensile (tension) strength allows it to be used in cantilever construction, such as in wood decks suspended from a building (Figure 13.3).

FIGURE 13.3 Wood has good properties in tension and compression, allowing it to be used in cantilever construction, as seen under the curved section of this balcony and in the roof overhang.

For construction purposes, wood is graded according to its appearance, strength, use, and defects (knots and pitch pockets). Aesthetic possibilities for the use of wood are seemingly endless. The many different wood types, their grains, and their colors offer a variety of possibilities for natural appearance and for finishing. Finishing includes both the natural weathering properties of wood and applied finish coats, such as oils, paints, and plastics.

SAWING OF LUMBER

Wood shrinks tangentially to growth rings and lengthwise from drying after it is cut. The methods of sawing produce different characteristics in the resulting lumber. The two basic ways of cutting wood are flat-sawing and quartersawing (Figure 13.4). Flat-sawn lumber consists of longitudinal cuts parallel to the log diameter, producing a variety of grain patterns, some display-

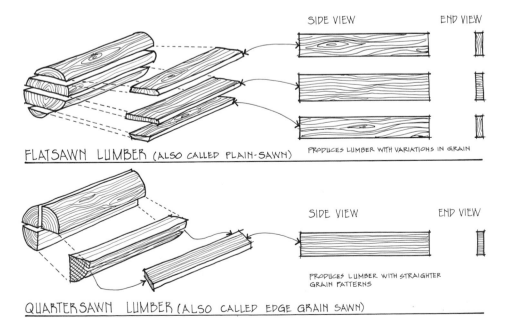

SIDE VIEW END VIEW

FLATSAWN LUMBER (ALSO CALLED PLAIN-SAWN) PRODUCES LUMBER WITH VARIATIONS IN GRAIN

SIDE VIEW END VIEW

QUARTERSAWN LUMBER (ALSO CALLED EDGE GRAIN SAWN) PRODUCES LUMBER WITH STRAIGHTER GRAIN PATTERNS

FIGURE 13.4 Plainsawn lumber has a variety of grain patterns and twists (or warps). Quartersawn lumber is more stable and produces more even grain patterns.

ing a cathedral-like effect. This wood tends to wear unevenly and to bend or twist when drying. Quartersawn lumber is produced by quartering the log and cutting each section in pieces parallel to the radius. This method is more expensive but produces more even, straight-line grain patterns; is more stable; and wears more evenly, having less twist as it dries.

STANDARD LUMBER SIZES AND UNITS

Lumber is cut to specific sizes and designated by its nominal size, not its actual size. Rough lumber is larger than surfaced lumber, although both are referred to as the same nominal size. The surfaced size of a nominal 2 × 4 is actually 1½ inches by 3½ inches (38 × 88 mm). Lumber designated as 1-inch (25 mm) thick is actually $^{25}/_{32}$ of an inch (20 mm) when seasoned. Standard lengths for lumber are generally produced in 2-foot (609-mm) increments, such as 8, 10, and 12 feet (2438, 3048, and 3657 mm).

The unit measure for lumber is the board foot. This is the amount of lumber equal to 1-inch (25 mm) thick, 12-inches (304 mm) wide, and 1-foot (304 mm) long. Lumber less than 1-inch (25-mm) thick is considered to be 1 inch (25 mm).

MOISTURE AND SEASONING

Wood expands when it absorbs moisture and contracts when it loses moisture. This loss can cause checking or cracking. It is necessary to dry the wood properly before using it because it can also twist, cup, bend, or warp as it dries. A drying process called seasoning is used to improve the wood's strength, stability, and resistance to attack from fungi, decay, or insects.

Wood can be seasoned by stacking and drying it naturally with air, but this procedure can take months to remove the moisture from cut lumber. Kilns are used to dry lumber quickly; with this procedure, wood reaches optimum dryness. Lumber is generally considered dry when its moisture content does not exceed 19 percent.

Even if wood is seasoned, it can still absorb or lose moisture depending upon the section of the country it is shipped to for use. This variation in moisture can cause problems of checking and warping if the wood is not properly protected in its final form by using various preservatives or paint finishes.

Hardwoods and Softwoods

Wood is classified into hardwoods and softwoods (Figure 13.5). Hardwoods come from broad-leafed or deciduous trees that lose their leaves in the winter, such as oak, maple, and walnut. Hardwoods generally have a finer grain and are used in interior trim, paneling surfaces, furniture, and finished flooring. They are more expensive than softwoods and harder to shape; however, they take finishes better.

Softwoods come from evergreen, or coniferous, trees that keep their leaves or needles throughout the year. These include cedar, pine, and redwood varieties. Softwoods are used mostly for structural members and general purpose construction. They are often the hidden parts in the framework of a building or the subframe of cabinets. Although hardwoods in general are harder than softwoods, this terminology does not necessarily refer to the actual strengths of wood, for some softwoods can be harder than some hardwoods. The softwood of yellow pine is actually harder than the hardwoods of balsa and basswood.

The designer selects the category of wood that best suits the aesthetic needs and purpose of the task. Hardwoods are reserved for durable door and window trims, for fine furniture, or where custom finishes are needed. In some cases, many softwoods can be used in place of hardwoods if maximum strength or other fine finish characteristics are not needed.

SPECIES	HARDNESS	CHARACTERISTICS	USES
ASH, White	Hard	Creamy white to light brown; open grain similar to oak	Cabinetry, trim, furniture
BASSWOOD	Soft	Creamy white; closed grain	Carvings & decorative molding
BEACH	Hard	Reddish brown to white; good utility wood; closed grain	Cabinetry, furniture
BIRCH	Hard	White to reddish brown; strong, heavy; closed grain	Cabinetry, paneling, furniture, flooring, trim
CEDAR, Western Red	Soft	Lightweight, weak strength; easily worked; reddish brown to white; closed grain	Mostly used on exterior for decay resistance; shingles, siding, paneling
CHERRY, Black	Hard	Reddish brown; durable strong; beautiful color; closed grain	Furniture, veneer, paneling, cabinetry, trim
CYPRESS	Soft to Medium	Yellowish brown; resists decay; weathers good; closed grain	Exterior siding, trim, posts, frames
FIR, Douglas	Medium	Reddish tan; good utility wood; closed grain	General framing, trim, paneling, plywood, cabinetry
MOHAGANY, African & Tropical American	Medium-Hard	Reddish brown; strong, dense; low shrinkage; open grain	Cabinetry, frames, trim, furniture, veneer
MAPLE, Sugar & Hard	Medium-Hard	White to light brown; dense; good utility hardwood; closed grain	Cabinetry, furniture, flooring, veneer
OAK, Red & White	Hard	White or pale gray to reddish brown; carves well; open grain	Cabinetry, furniture, flooring, paneling, trim
PINE, Sugar	Soft	Creamy white; easily worked; general usage; closed grain	Cabinetry, doors, paneling, trim, windows
PINE, Eastern & Ponderosa	Soft	White to cream; wide range of applications; closed grain	Carving, cabinetry, paneling, trim
POPLAR, Yellow	Medium	White to brown; easily worked; good utility wood; closed grain	Cabinetry, furniture, siding, trim, paneling

FIGURE 13.5 Common wood species and typical uses. (Continued on the next page.)

SPECIES	HARDNESS	CHARACTERISTICS	USES
REDWOOD	Soft	Reddish; high resistance to decay; closed grain	General construction, outdoor furniture, paneling, trim
TEAK	Hard	Yellow to dark brown; expensive; open grain	Cabinetry, furniture, paneling, trim
WALNUT, Black	Hard	Light to dark chocolate brown; fine, strong wood; open grain	Furniture, cabinetry, veneers, paneling, trim

Wood Layering

In addition to being used as boards and timbers, wood is layered in various ways to achieve different strengths and appearances, such as in veneers, plywoods, composite boards, and laminated wood (Figure 13.6).

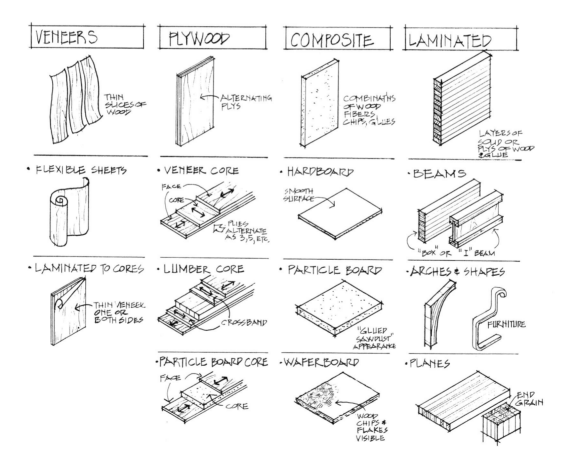

FIGURE 13.6 Wood can be cut, modified, and combined in many ways to serve specific purposes or feature advantageous characteristics.

VENEERS

Veneers are thin sheets of wood cut from a log; these vary from paper-thin slices to 1/8 inch (3 mm) thick. Veneers can be trimmed from a log as a continuous sheet (rotary cutting) or sliced as flitches. Veneer flitches are edge trimmed, matched in grain pattern, and glued to thicker backings, such as plywood. Veneers that come from a particular log are kept in order so they can be matched later in various grain patterns. The part of the tree and the manner of the cut will produce different veneer patterns. Cuts can be made from the crotch, stump, or burl of a tree to produce many grain patterns. Burl occurs where the tree has healed itself from damage and exhibits a swirling pattern where it is cut across.

Veneers are taken from logs by rotary cutting, slicing with a knife, or sawing (a method not used much anymore). Rotary cutting (Figure 13.7) is accomplished by rotating a log on a lathe against a long knife to produce a continuous, thin sheet, much like pulling wrapping paper from its roll.

FIGURE 13.7 Methods of cutting wood veneers.

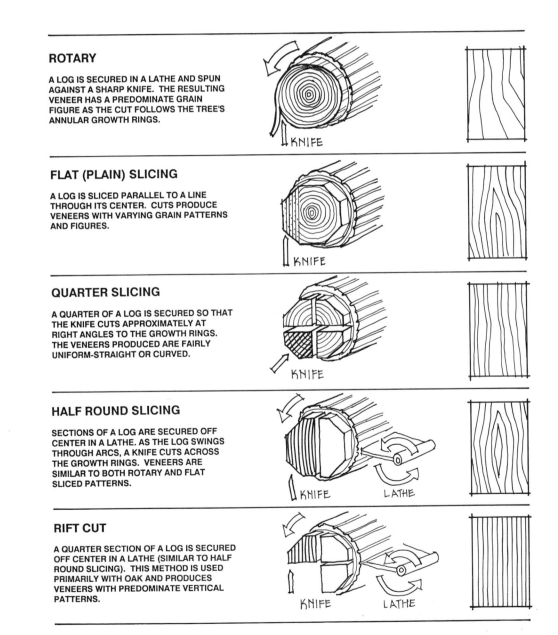

ROTARY

A LOG IS SECURED IN A LATHE AND SPUN AGAINST A SHARP KNIFE. THE RESULTING VENEER HAS A PREDOMINATE GRAIN FIGURE AS THE CUT FOLLOWS THE TREE'S ANNULAR GROWTH RINGS.

FLAT (PLAIN) SLICING

A LOG IS SLICED PARALLEL TO A LINE THROUGH ITS CENTER. CUTS PRODUCE VENEERS WITH VARYING GRAIN PATTERNS AND FIGURES.

QUARTER SLICING

A QUARTER OF A LOG IS SECURED SO THAT THE KNIFE CUTS APPROXIMATELY AT RIGHT ANGLES TO THE GROWTH RINGS. THE VENEERS PRODUCED ARE FAIRLY UNIFORM-STRAIGHT OR CURVED.

HALF ROUND SLICING

SECTIONS OF A LOG ARE SECURED OFF CENTER IN A LATHE. AS THE LOG SWINGS THROUGH ARCS, A KNIFE CUTS ACROSS THE GROWTH RINGS. VENEERS ARE SIMILAR TO BOTH ROTARY AND FLAT SLICED PATTERNS.

RIFT CUT

A QUARTER SECTION OF A LOG IS SECURED OFF CENTER IN A LATHE (SIMILAR TO HALF ROUND SLICING). THIS METHOD IS USED PRIMARILY WITH OAK AND PRODUCES VENEERS WITH PREDOMINATE VERTICAL PATTERNS.

In addition to rotary cutting, there are four slicing methods of cutting veneers, each producing a distinct grain pattern. These are flat slicing or plain slicing, quarter slicing, half-round slicing, and rift cut (actually a slicing process).

Veneer flitches are trimmed and glued to panels to produce different visual effects of matching (Figure 13.8). These are

(1) Book matching, which turns over every other flitch like the leaves of a book and produces a matching grain pattern at the edges, emphasizes maximum continuity of the grain. This method and slip matching are the most common for premium assemblies.

(2) Slip matching, which retains the flitch rotation but joins the pieces side by side to repeat the grain figure. However, the joints are not matched.

(3) Random matching, which results in a flitch mismatch through random selections of varying flitches, producing a boardlike look with large variations in pattern.

(4) End matching, which book matches the grain ends as well as the centers, producing uniform grain looks both vertically and horizontally.

FIGURE 13.8 Wood flitch veneers are cut and glued to panels in various methods to produce different grain patterns.

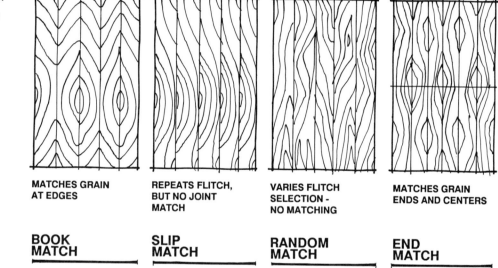

MATCHES GRAIN AT EDGES

REPEATS FLITCH, BUT NO JOINT MATCH

VARIES FLITCH SELECTION - NO MATCHING

MATCHES GRAIN ENDS AND CENTERS

BOOK MATCH

SLIP MATCH

RANDOM MATCH

END MATCH

PLYWOOD AND COMPOSITE BOARD

Plywood is a laminated or layered wood panel composed of veneers or wood plies, the grains running at right angles to one another. This alternation of plies (always an uneven number) gives added strength in two directions to reduce warping, splitting, and shrinking of the panel. This stability is useful for construction of floors, walls, roof sheathing, paneling, and even furniture. The outer layers can be of rough construction-grade finish, finely sanded, or attractive wood veneers. Plywood panels are made with various wood species and range from ⅛ inch (3 mm) thick to more than 1⅛ inches (28 mm). These panels are produced with three basic core types—wood veneers, lumber cores, and particleboard. Panels are made for interior or exterior use and commonly are 4 feet (1219 mm) in width. Lengths vary, although 8, 9, and 10 feet (2438, 2743, and 3048 mm) are the most common.

Composite boards are panels made from wood particles of various compositions; these are less expensive than plywood. Some are unfinished and used for general construction purposes, and others are finished with a thin wood veneer or a plastic face. Composites are made as hardboard, particleboard, or waferboard. Hardboards are constructed from exploded wood fibers

glued and pressed together. Hardboard, sometimes referred to as pegboard or masonite, is used for drawer bottoms, furniture, and general construction. Hardboard surfaces can be smooth or textured, imitate wood finishes, and be finished with plasticized faces.

Particleboard, made from wood bits and chips and resembling glued sawdust, is bonded with adhesives to provide various thicknesses and strengths. It is popular for subsurfaces for cabinets and furniture pieces.

Waferboard, constructed of glued wood chips and shavings, is similar to particleboard. However, it generally has a rougher finish and is used mostly for rough framing of floor, wall, and roof sheathing. This material is almost as strong as plywood, is more resistant to water damage, and is less costly. Builders often prefer waferboard for floor and roof sheathing.

LAMINATED WOOD

Laminated wood can be produced as large timber sizes for use in beams or in thin layers for furniture and other small assemblies. This layering and gluing of wood makes sizes, shapes, and strengths not possible with solid timber. The layers of wood are glued parallel longitudinally; varying grades of wood are used, depending on the purpose of the product. Laminated wood is superior to timber in its strength, stability, and size availability. "Glu-lam" beams and laminated arches are some of the most common forms available (Figure 13.9).

FIGURE 13.9 Wood can be laminated into straight or curved arches for strength and beauty of form.

Designing with Wood

Wood has great diversity for use as a building material because of its strength, finish appearance, and shape. It can be formed, combined with other materials, and finished in numerous ways. It can be produced as rough-sawn, resawn, or smooth and in coarse to fine surface finishes.

Although wood is an excellent building material, some precautions need to be addressed in using it. Wood can be subject to decay from fungi in warm, moist areas. However, timber that is

totally immersed in water can last indefinitely, for the fungi lack air, which they must have to attack the wood. Another problem is that various insects, such as termites, can attack wood and cause considerable damage.

Designing and working with wood usually modify its appearance by cutting and shaping it; however, unique applications can be achieved by using wood in its natural state. Specialty woods, such as rattan and bamboo, can be used in their natural state as a distinctive building material for structural elements, interiors, and furniture making.

Wood can be shaped into forms by straight-line cutting, carving, burning, or turning on a lathe. These methods can produce shapes that are geometrical and precise or beautifully carved and free-form. Shaping can also produce long, narrow strips of wood, such as moldings, that are applied to walls, ceilings, windows, and doors (Figure 13.10).

FIGURE 13.10 Wood is milled into various molding shapes for a variety of trimming purposes in interiors.

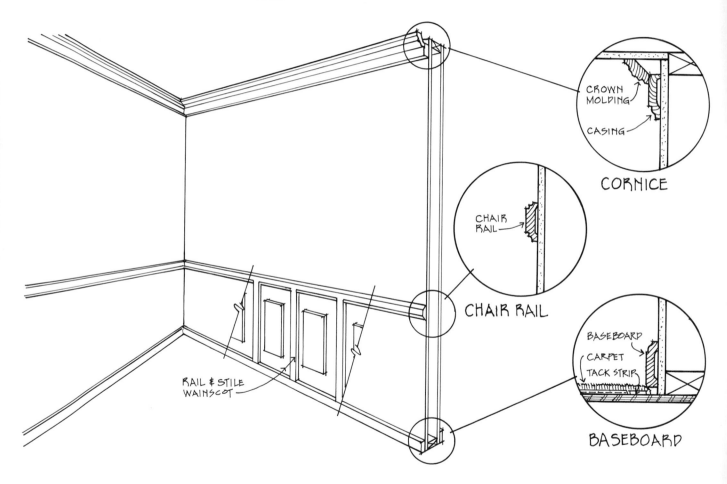

PIECING

Wood can be pieced together in a variety of ways; for example, the end grain can be exposed for butcher blocks, or inlays can be made of different woods and other materials. These constructions can produce contrasting textures and color patterns, such as in a mosaic in furniture and flooring. Another example of piecing wood, parquet utilizes wood strips laid in various geometric patterns, as seen in tables and floors. (See Chapter 14 for more information on wood flooring.)

JOINERY

Wood is joined in many ways for both general building construction techniques and interior paneling and trim, as well as for making casework and furniture. Many kinds of joints have been developed, and each has distinct advantages and disadvantages. Joints can be glued, nailed, bolted, or secured by specialized connectors. A designer needs a working knowledge of various joints and their applications to select a joint for its structural qualities, ease of production, and aesthetic appeal. Joints can be hidden from view, as in some cabinet and furniture construction, or exposed to show the beauty of the detail (Figure 13.11).

FIGURE 13.11 Some wood joinery is a work of art and exposed for an appreciation of the joint complexity, craftsmanship, and grain of the wood.

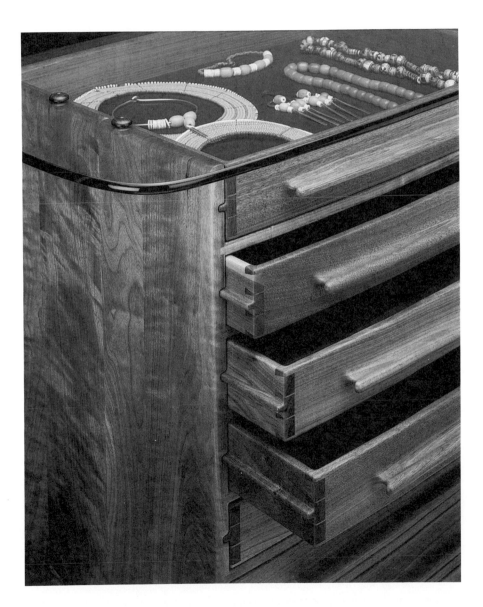

Figure 13.12 shows many of the common joints used for general construction, cabinetry, and furniture. Using these joints requires an understanding both of the various forces that act on a joint and of the ability of that particular type (and its material) to hold together.

FIGURE 13.12 Common wood joints.

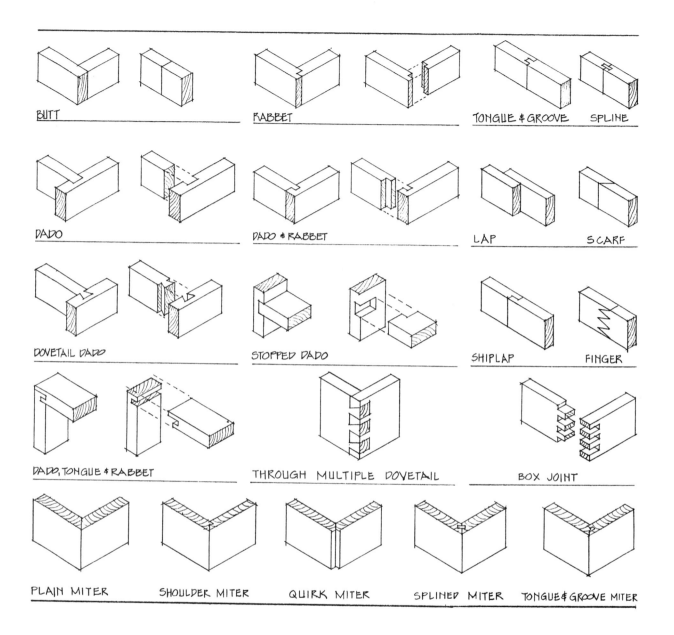

BUTT

RABBET

TONGUE & GROOVE SPLINE

DADO

DADO & RABBET

LAP

SCARF

DOVETAIL DADO

STOPPED DADO

SHIPLAP

FINGER

DADO, TONGUE & RABBET

THROUGH MULTIPLE DOVETAIL

BOX JOINT

PLAIN MITER SHOULDER MITER QUIRK MITER SPLINED MITER TONGUE & GROOVE MITER

Wood Finishes

Most woods need a protective treatment or finish to protect their beauty, minimize moisture content fluctuations, and keep them usable. Figure 13.13 lists the most common wood finishes and their characteristics.

Finishes can vary from a high gloss to a satin or matte appearance, depending on the finishing agent and the appearance or durability desired. Generally, glossy finishes are harder and reflect more light. Matte finishes produce a soft glow of surrounding light and show the beauty of the surface sheen and wood. Finishes can penetrate or remain on the surface; they can be opaque or transparent, colored or colorless.

TYPE	CHARACTERISTICS	TYPICAL USES
ACRYLIC	Water based synthetic resin; quick drying; durable; cleans up with soap & water	Wood siding and trim; cabinetry. Combined with latex for more durable latex coating
ALKYD	Oil modified resins; most popular paint vehicle; dries faster than oils; hard; clean up with mineral spirits	Exterior and interior primers; wood; brick; metal. Alkyds are combined with enamel, oil, and silicone paints
ENAMEL	Pigments mixed with varnish, lacquer, or alkyds; durable; clean up with mineral spirits	Furniture; floors; metal
EPOXY	Resin materials produced as a paint (esters) or as a two component mix (base and catalyst); hard, dense, film; clean up with special solvents	Tough finishes on most surfaces; waterproof
LACQUER	Nitrocellulose or acrylic resin based; fast drying; durable film finish; clear or pigmented; clean up with solvents	Furniture; cabinetry
LATEX	Water based; not as scrubable as acrylics or alkyds—but can be produced with these and enamel for tougher coatings; clean up with soap and water	Wallboard; plaster; masonry; acoustical tile
URETHANE	Synthetic resins; often called polyurethanes; very tough, durable; pigmented or clear; clean up with solvents; similar to epoxy	Interior and exterior wood; wood floors; furniture
VINYL	Synthetic compounds of polyesters, vinyls, polyurethanes, durable; resistant to abrasion; excellent flexibility; often factory applied	Furniture; wood paneling
VARNISH	Resins dissolved in alcohol or oil; clear or pigmented; tough, hard film; moisture resistant; mixed with epoxy, polyurethane, and others for very tough coatings, such as spar varnish; clean with mineral spirits	Wood products; furniture
SHELLAC	Made as lac resins in alcohol; dries quicker than varnish, but less durable; affected by heat, moisture, alcohol; clean up with solvents	Clear finish coats on wood; mostly used as undercoat and sealing of stains before overpainting
STAIN	Thin water or oil liquids with a colorant; brushed, rubbed or sprayed; sealed over with other finishes or mixed integrally. Made as solid body or transparent.	Wood building products, furniture
WAX	Made as clear or staining as paste or liquid; used alone or over varnish, oil, stain; requires periodic renewal; most not resistant to heat or water	Wood finishes; furniture; walls; floors

WOOD FILLERS

Some woods have large open grains and pores, requiring a filler before the final finish. Fillers are used on open-grain wood to prevent finishes (particularly stains) from accumulating more in some spots than others, which could result in a blotchy appearance. Liquid or paste fillers allow a more even texture and color.

ANTIQUED AND DISTRESSED FINISHES

Antiqued and distressed methods are specialized wood-finishing techniques used for interiors and furniture. Antiquing involves applying layers of paint or stain to a surface and then rubbing it off. This process produces an artificially aged patina.

Distressing imitates the appearance of insect damage to wood, such as wormholes. It is achieved through drilling, chopping, gouging, or denting with chains or other tools. This technique is sometimes used on wood floors, paneling, beams, and even furniture.

MASONRY

Masonry refers to installing natural rock, brick, tile, and other modular unit compositions. The impervious quality of masonry and its relative ease of stacking and binding with mortar have made it a timeless material. Today, it is still used widely for its appearance, low maintenance, and ability to withstand decay, insect damage, and combustion from fire.

All types of masonry have similar characteristics in that they are stacked, bound together by mortar, and installed by masons using techniques developed centuries ago. However, new methods of steel reinforcing and better materials that were developed in the nineteenth and twentieth centuries have increased the strength of masonry while lessening its overall weight and mass.

Although masonry has some excellent uses, it also has some drawbacks. Structurally, masonry is good only in compression, not tension. It is usually higher in cost than other building materials and techniques. In major earthquake zones, it must be reinforced with steel; it is subject to collapsing under its own weight, since it is not as resilient to ground movements as wood or steel framing is. Despite these drawbacks, it is an excellent material for both exterior and interior use.

Stone

Stone, or rock, is perhaps one of the oldest building materials. It is usually a combination of minerals made up of various inorganic chemical substances, but some rocks, such as sandstone, might be composed of only one mineral.

Stone used for construction is classified as igneous, sedimentary, and metamorphic. Most stone is quarried and cut into blocks or slab sheets for building purposes. Stone is selected as a building material for its aesthetic appearance, durability, and maintenance. The three stone categories that follow discuss the common building materials derived from each.

IGNEOUS (GRANITE)

Igneous stone is cooled molten rock found near the surface of the earth. It is very dense, hard, and durable; is fine- or coarse-grained; and is found in shades of green, pink, yellow, and

light to dark gray/black. Igneous stone can be precision cut and left with a coarse finish or polished to a highly reflective surface. Granite, an igneous stone, is used for wall veneers, tabletops, steps, flooring, and other applications that require considerable wear (Figure 13.14). Granite is harder than limestone, a sedimentary stone, and marble, a metamorphic stone, and is recommended for high traffic uses.

FIGURE 13.14 Steel and granite portals divide this banking facility into separate volumes along the main axis, and they are reflected in the highly polished granite floor areas.

SEDIMENTARY (SANDSTONE, LIMESTONE, AND SLATE)

Sedimentary stone is formed primarily by water, chemical action, and erosion. It is generally soft and easier than granite to cut but not as durable (Figure 13.15).

Limestone colors range from dark grays to white and tan. Travertine is a form of limestone that has various textures and pits. It is used for tabletops, fireplace surrounds, and special wall trims.

Slate is a rather brittle rock that splits readily into thin sheets. Its color usually is blue-gray, although black, green, and red are available. It is used mostly for tabletops, flooring, and roofing.

FIGURE 13.15 Sandstone, limestone, and slate are often used for floor paving. They can be rough cut and random in pattern, or smooth and regular in shape.

METAMORPHIC (MARBLE)

Metamorphic stone is formed by intense pressure and heat from igneous or sedimentary rock. Marble results from the crystallization of limestone and is a very hard (but softer than granite) and durable material (Figure 13.16). It comes in many colors and is usually polished into shiny, smooth surfaces. Marble is used for decorative wall panels, fireplaces, flooring, countertops, and tabletops.

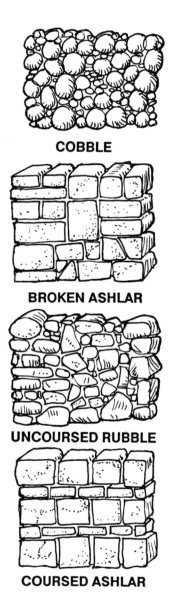

COBBLE

BROKEN ASHLAR

UNCOURSED RUBBLE

COURSED ASHLAR

FIGURE 13.17 Stone can be installed as uncut cobble and rubble or pre-cut (ashlar) in random (broken) patterns or coursed patterns.

INSTALLATION OF STONE

Stone can be installed as a floor, structural wall, column, or decorative element. It can be assembled with or without mortar, pinned with wire rods, or glued with synthetic resins. The method varies according to the strength, use, durability, and appearance desired. Stone can be stacked in rough rubble techniques or precision cut and installed modularly in square and rectangular patterns.

Stone textures, shapes, and the patterns in which they are laid vary greatly (Figure 13.17). Rubble is rough, uncut stone laid in a random pattern. Cobble or fieldstone generally has more round rocks than most other rubble exhibits. Ashlar is stone precut into square or rectangular shapes and laid in random or coursed patterns. Trim is specialty-cut stone used for decorative elements, sills, lintels, and the like.

Stone has many other applications as a building product. Crushed or graded stone is used as an aggregate for making concrete. Aggregate can be carefully graded by sizes and used as gravel fills or exposed on the surface of concrete walks and wall panels. Marble can be ground into chips and combined with cements and epoxies to create a tough material called terrazzo. For floors, this wet mix is poured over a subsurface, such as concrete. When the mixture dries, it is ground and polished to a glossy or satin finish that reveals a mosaiclike appearance. Terrazzo can also be cast into a variety of premade shapes, such as windowsills, shower bases, and stair treads.

Brick

Brick is an important building material that dates back more than 5,000 years. Early bricks were shaped from mud that had straw or hair added as a binder. These were dried in the sun and stacked with silt (mud) between the joints for wall construction. This method was improved with better clays and wooden forms and by baking the bricks in an oven. In the 1800s, machines were developed that mechanically shaped clay into standardized forms, allowing mass production of brick as a major building material.

Bricks are made from a variety of clays and fired in kilns at different temperatures to produce different colors, textures, strengths, and glazes. Although brickwork is more expensive to install than wood panels or siding in terms of both materials and labor, it is still a very popular material. Many people prefer brick because it is durable, weather resistant, fireproof, and known for its quality and permanence.

TYPES AND SIZES OF BRICK

Brick is produced in many types—face brick, firebrick, glazed brick, and pavers—and many sizes. Each type has distinct features that make it suitable for a specialized purpose; each type is produced in common sizes referred to as nominal and manufactured. Nominal dimensions include the actual size of the brick plus the thickness of a mortar joint in wall or floor construction. These dimensions help to determine how many bricks are required for a particular panel size. For example, if a wall is 8 feet (2438 mm) in length and made with a brick that is 12 nominal inches (304 mm), the wall will take eight bricks. Brick count can be calculated either horizontally or vertically for a wall. Reference tables in various publications estimate brick counts and dimensions for heights and widths of walls. Figure 13.18 shows the most common brick types and sizes.

Brick is also manufactured in a variety of thin-face slices, approximately ½-inch (12-mm) thick. These are sometimes used in interiors for a brick look without the weight and thickness of full brick dimensions.

BRICKLAYING

Construction with brick can achieve different strengths, durability, and appearance according to the method used, which is dependent on the pattern bond of laying (see "Pattern Bonds" for explanation), the strength of the mortar, and the finishing of the mortar joint.

Most brick walls are facings applied to another structural wall surface, such as concrete block or wood-stud framing. In these cases, the brick is usually secured to the backer wall with steel ties. However, brick walls are also constructed as solid and as cavity brick walls, which are the true brick-wall construction. The latter method consists of two wall planes with an air space (called *cavity*) between.

MORTAR AND JOINTS. Mortar (plain or colored) is a plastic mixture of water, fine aggregates, and cementitious materials, such as portland cement. Mortar is used in bricklaying to bond the brick, seal the spaces between bricks, and allow for dimensional differences of the units.

Joints in mortar are finished by troweling away excess material or by tooling into special shapes that compress the mortar into the joint (Figure 13.19). Each shape exhibits unique structural, visual, and tactile qualities, as well as unique weatherability characteristics.

PATTERN BONDS. Pattern bonds consist of brick and other masonry products laid in various horizontal and vertical patterns for appearance and strength of interlocking. The direction and placement of bricks within these bonds is commonly termed stretchers, headers, rowlock, or soldier courses, as shown in Figure 13.19. Some patterns project masonry units beyond the surface for decorative effects.

FIGURE 13.18 Modular brick sizes and their dimensions.

COMMON NAME	NOMINAL DIMENSIONS (inches)			MODULAR COURSING (in.)
	Thickness	Height	Length	
MODULAR	4	2 2/3	8	3C = 8
ENGINEER	4	3 1/5	8	5C = 16
ECONOMY or JUMBO	4	4	8	1C = 4
DOUBLE	4	5 1/3	8	3C = 16
ROMAN	4	2	12	2C = 4
NORMAN	4	2 2/3	12	3C = 8
NORWEGIAN	4	3 1/5	12	5C = 16
ECONOMY 12 or JUMBO UTILITY	4	4	12	1C = 4
TRIPLE	4	5 1/3	12	3C = 16
SCR BRICK	6	2 2/3	12	3C = 8
6" NORWEGIAN	6	3 1/5	12	5C = 16
6" JUMBO	6	4	12	1C = 4
8" JUMBO	8	4	12	1C = 4

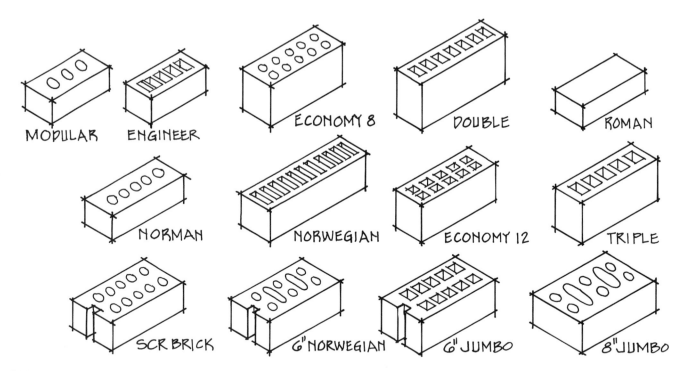

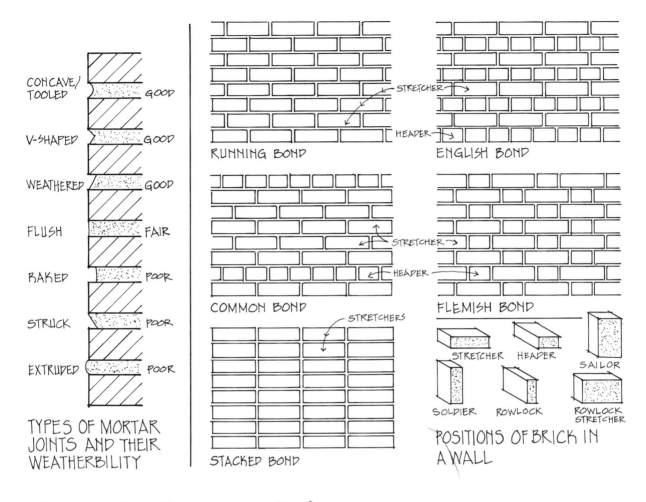

TYPES OF MORTAR JOINTS AND THEIR WEATHERBILITY

CONCAVE/TOOLED — GOOD
V-SHAPED — GOOD
WEATHERED — GOOD
FLUSH — FAIR
RAKED — POOR
STRUCK — POOR
EXTRUDED — POOR

RUNNING BOND
STRETCHER
HEADER

ENGLISH BOND

COMMON BOND
STRETCHER
HEADER

FLEMISH BOND

STACKED BOND
STRETCHERS

POSITIONS OF BRICK IN A WALL
STRETCHER HEADER SAILOR
SOLDIER ROWLOCK ROWLOCK STRETCHER

Concrete Masonry Units

Masonry units are also made of concrete in hollow or solid blocks and bricks. These are usually less expensive and stronger than brick and can be lighter in weight, depending upon the aggregate used. For these reasons, masonry units are generally used for structural walls or as subsurfaces for brick facings.

CONCRETE BRICK

Concrete brick is produced as slump brick or building brick. The latter type is similar to clay brick in function, size, and appearance but is often less expensive and can be made stronger. Slump brick, or what is sometimes called slumpblock, has an irregular face shape, resulting from the sagging or slumping of the wet mixture before it is fired.

CONCRETE BLOCK

Concrete block is a lightweight masonry unit composed of portland cement and porous aggregates, such as cinders, volcanic ash, or pumice. These blocks are manufactured in a variety of sizes and shapes. They are excellent for structural uses and can be made with various facing finishes or as decorative screen block. Split-faced block and blocks with fluted and ribbed faces are popular in exterior and interior installations. Concrete block is made as a nominal 8 by 8 by 16 inches (203 × 203 × 406 mm), although half sizes and other shapes are also abundant.

Because they are larger, concrete blocks can be laid more quickly than brick; their hollow cores can accommodate steel reinforcing and utility routing. Concrete blocks are used for general utility construction but can be ceramic faced or can be finished with paint, stucco, and in other ways if their natural state is not appropriate.

Concrete blocks are also specially made as pavers and concrete roofing tile, both of which are lighter and less expensive than clay tile. Concrete blocks can be cast in different colors and sometimes are difficult to distinguish from real clay products. Pavers are made in a variety of shapes, colors, and thicknesses, some as interlocking units.

Glass Block

Glass blocks were developed about 1900, were widely used during the 1920s and 1930s, and have seen a reemergence of use today (Figure 13.20). These units consist of two hollow half blocks of glass that have been pressed together, with the center partially evacuated of air or other gases added to the cavity. Some glass blocks are made as solid glass units for strength and are used in places where forced entry is to be prevented. Glass blocks come in many sizes, shapes, and surface finishes. Different light transmission through them can be created by varying the type of glass finish, such as frosted, rippled, textured, or clear. These variations can be made inside or on the surface of the block. Glass blocks are used on both the interior and the exterior of buildings, are nonstructural, and can be laid in curved sections.

FIGURE 13.20 The sweeping glass block wall guides visitors to the receptionist in this office entry.

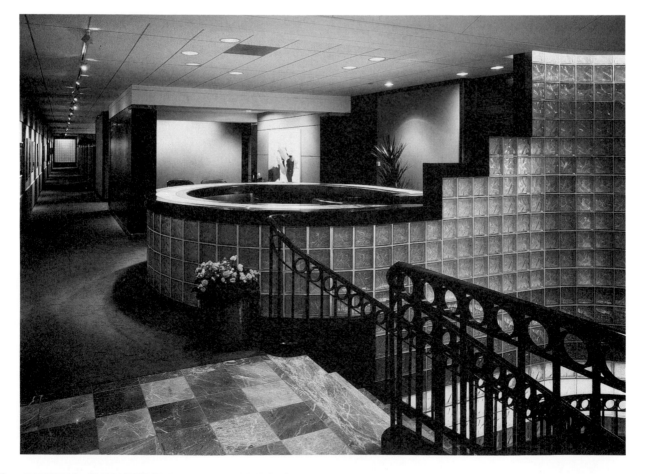

CONCRETE

The invention of concrete is generally credited to the Romans, who first used it to construct roads, bridges, and buildings. Today, it is both a structural and an aesthetic building material that can be poured, molded like clay, or precast into almost any special shapes. It can be finished with a variety of textures, patterns, and colors. Concrete is strong in compression, and thus is appropriate for use in walls and columns, but is weak in tension unless reinforcing steel is integrally added to bolster its use for concrete beams (see Chapter 14 and Figure 14.2).

Cement Manufacturing

Concrete is a mixture of portland cement, fine and coarse aggregates (sand and gravel), and water. The portland cement is made up of a combination of pulverized silica and limestone, which are burned to fuse together. That combination is then ground to a powder and fired in a kiln, and substances such as gypsum are added to make the final product. Other types of cements, aggregates, and admixtures can be added to alter concrete's strength, appearance, color, and workability.

The water-to-cement ratios affect the initial workability of the mixture and its ultimate strength after the concrete cures—in about 28 days. Generally, the less water used, the stronger the resulting concrete.

Plaster, Stucco, and Synthetic Mixtures

Plaster has been used since Egyptian and Greek times for painting murals and as a finish for ceilings and walls. It is a thick, pasty mix of gypsum and water, although other additives, such as sand and lime, can be mixed in. Plaster is troweled on in two or three layers over a lath subsurface. In earlier times, this subsurface was a series of spaced wooden strips. Now, most lath is metal; however, plaster can also be installed over masonry block or special gypsum board. Plaster (and stucco) can be molded into many intricate shapes or surface patterns before it dries (Figure 13.21). After curing, it becomes very hard and brittle, retaining that initial shape. Plaster is also used as a gypsum (plaster of paris), a thin coating material, and sprayed for various finishes.

Stucco is sometimes mistakenly referred to as plaster; however, stucco is made of portland cement, is used primarily on the exterior of buildings, and is more weather resistant than plaster. When stucco is used over wood or metal framing, a water-resistive subsurface and wire mesh are first installed to provide a bonding surface for the stucco. Like plaster, stucco is then applied in two or, preferably, three coats. In order of their application, these are a scratch coat, a brown coat, and a finish coat. The final coating can be varied, as it is in plaster techniques.

Both plaster and stucco finishes are thin, brittle coverings subject to cracking or chipping. Both can be painted or have integral colors added to the mix, rather than being overpainted.

Synthetic mixtures that resemble plaster and stucco are now made with various additions of acrylic resins and polymers. The synthetics can even be applied to a variety of subsurfaces to

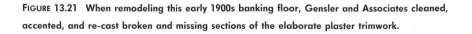

FIGURE 13.21 When remodeling this early 1900s banking floor, Gensler and Associates cleaned, accented, and re-cast broken and missing sections of the elaborate plaster trimwork.

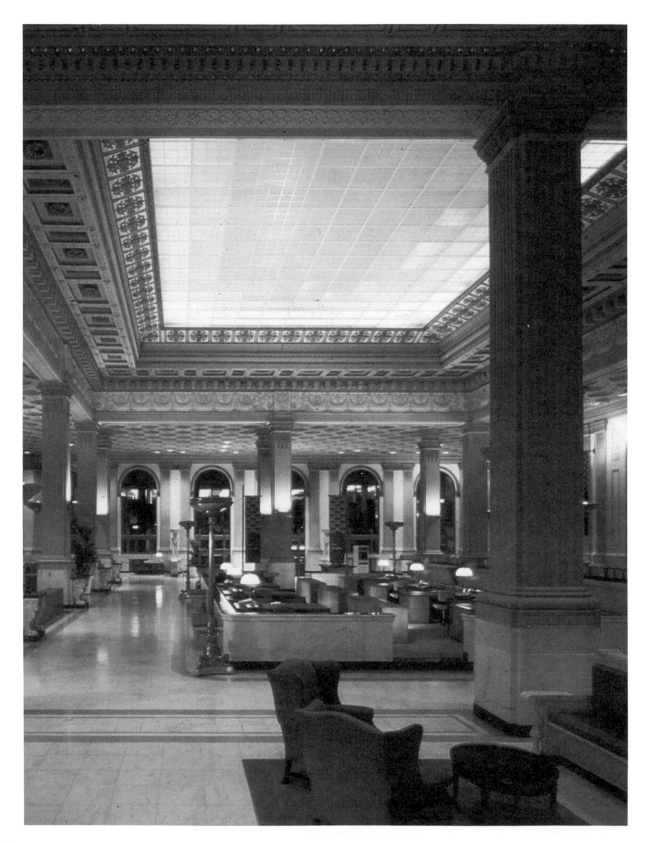

which real stucco and plaster will not adhere. Some of these underlayments consist of a fiberglass mesh applied over a rigid polystyrene insulation board that has been cut and shaped into various forms (Figure 13.22). These synthetic coatings are integrally colored, are much stronger, resist cracking, and can be rolled, sprayed, or troweled on.

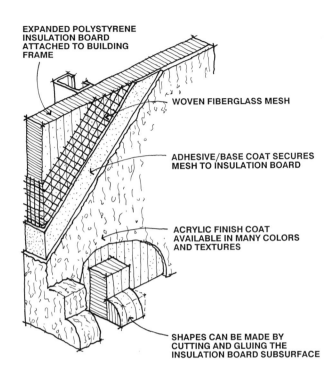

EXPANDED POLYSTYRENE
INSULATION BOARD
ATTACHED TO BUILDING
FRAME

WOVEN FIBERGLASS MESH

ADHESIVE/BASE COAT SECURES
MESH TO INSULATION BOARD

ACRYLIC FINISH COAT
AVAILABLE IN MANY COLORS
AND TEXTURES

SHAPES CAN BE MADE BY
CUTTING AND GLUING THE
INSULATION BOARD SUBSURFACE

FIGURE 13.22 Several brands of synthetic stucco-like materials are made that are more flexible and resistant than cementitous mixtures such as true stucco.

CERAMICS

Ceramics have been made for centuries (c. 4700 B.C.) both for utilitarian needs and as expressive art forms. Tiles made from ceramics have been used throughout the world as floor, wall, and roofing materials. Today ceramics are also used to make bricks, drain lines, and chimney flues. (Ceramics are also used for artificial teeth and in space-age technology for rocket nozzles and heat shields.)

Ceramics are made of clay that is shaped and fused or vitrified by firing in kilns. Ceramics can be unfinished, carved, painted, or glazed. (In glazing, a glasslike coating is fused by heat to the surface.) Different clays, additives, and glazes are combined to produce many variations in color, finish, and strengths in ceramics. Ceramics are classified into four general types based on their firing temperatures: earthenware, stoneware, porcelain, and china.

Earthenware and Stoneware

Earthenware is made of coarse-textured clay fired at relatively low temperatures (about 2,000°F or 1093.3°C) and can be glazed if needed. Bisque ceramics are fired but not glazed. Earthenware is usually porous, fragile, and opaque in its finished state. Colors of earthenware—sometimes referred to as terra-cotta, meaning cooked earth—tend toward red or brown. Objects such as bricks, flower pots, tiles, and folk pottery are commonly made from earthenware.

Stoneware is made of finer clays than earthenware and is fired at medium temperatures (about 2,200°F or 1,204.4°C) making it waterproof, strong, and durable. Colors are usually gray or light brown, and glazes can be given a matte finish, showing flecks in the glaze or clay. Stoneware is used for casual dinnerware, cookware, and sculpture.

Porcelain and China

Porcelain is the highest grade of ceramics and is made of feldspar (crystals) and white clay (kaolin). It is fired at high temperatures (about 2,400°F or 1,315.5°C) causing it to vitrify and become waterproof even if chipped. Porcelain is a very hard, white, translucent, and high-quality material that resists chipping. It is often used for fine dinnerware, art work, and finishes on sinks and bathtubs.

China is the name originally given to fine porcelain from the Orient or to its European imitations. A hard, translucent porcelain (made from a high proportion of animal bone ash) is called bone china or English china. China is fired at a much lower temperature than porcelain, but it is more durable than earthenware or stoneware.

Ceramic Tiles

One of the most popular uses for ceramic as a building material is as tile for floors, walls, cabinetry, tubs, showers, and even ceilings (Figure 13.23). Tiles are made in numerous sizes, shapes, thicknesses, and surface textures. They are classified as having impervious, vitreous, semivitreous, and nonvitreous qualities. All floor tiles can be used on walls and other surfaces, but not all wall tiles can be used on floors. Tiles are installed in portland cementitious setting beds (thick set) or with special epoxy adhesives (thin set). As in bricklaying, patterns and joints can vary a great deal. Grout, in many colors and finishes, is added between the tiles.

Ceramic tiles are made from different clays and shale mixtures. They are fired at different temperatures to produce specific glazes, surface finishes, and hardnesses. Ceramic tile is produced in three basic types—glazed, mosaic, quarry—as well as other miscellaneous tiles.

GLAZED AND MOSAIC TILES

Glazed ceramic tiles are used in many ways, both on building exteriors and in interiors. They are produced in modular sizes and often have matching trim pieces for corners, wall bases, and nosings. Floor tiles have a heavier coat of glazing than wall types, since floor units are subject to heavy traffic and must have very tough glazes as their finish coat.

Mosaic ceramic tile is made in small sizes for composing intricate patterns for use in murals on floors and walls. Mosaic tiles are made with clays or porcelain and sometimes are produced in units with a back-mounted fiber mesh to facilitate their handling and installing. These are generally smoother, brighter, and more impervious than other glazed tiles.

QUARRY AND OTHER TILES

Quarry tiles, made of graded shales and fine clays, are the thickest and strongest of the tiles. Their color is usually a result of the type of clay used. Quarry tiles generally are left unglazed in their terra-cotta state. These tiles are available in reds and browns; in some cases the faces might be flashed, producing a center lighter than the edges. Quarry tiles are long lasting and excellent for floors that receive a lot of abrasion.

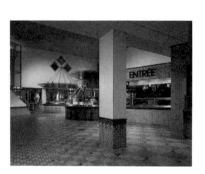

FIGURE 13.23 Ceramic tile is used as a decorative and durable finish on the floors, walls, and other elements in this cafeteria.

Other ceramic tiles have their own distinct characteristics. Mexican tile is produced by taking clay directly from the ground and hand shaping it. This tile exhibits a rough, uneven shape and thickness and is usually glazed or hand painted. Its appeal is in its handmade qualities and rustic imperfections. Mexican tile is more fragile than most other tiles, may be very porous, and may take special care to maintain.

Ceramic tile is also manufactured into durable roofing tiles, which can be flat pieces or rolled into interlocking sections that resemble Mediterranean roofing.

Historically, architectural terra-cotta tile was manufactured until the 1930s and used, either glazed or nonglazed, for exterior building facings and details. These pieces were cast in molds and can still be seen in many older buildings, such as those by Louis Sullivan.

GLASS

Glassmaking is an art form that has been practiced for more than 4,000 years. Most early glass was used for objects and beads, although evidence shows that the Romans used it for windows. Today, large windows or whole walls can be made of glass. However, glass does not have a high tensile strength and must be made in great thicknesses or by special techniques to prevent breaking. Glass is formed by high-temperature fusing of silicates, alkalis, lime, and other materials. The colors generally come from minerals that are added; the final product is finished in many ways.

Manufactured Glass

Glass can be manufactured in sheet form from $1/12$ inch to 2 inches (2 to 50 mm) thick for windows, mirrors, tabletops, and doors. These planes are produced in three basic ways: sheet, plate, and float. Sheet glass is produced by drawing out molten glass and subjecting both sides to heat. It is not further treated, and the resulting faces are not truly parallel, which produces ripples and some distortions. Most sheet glass is now found in older buildings, since the technique has been replaced by better methods.

Plate glass is ground and polished after being drawn from the molten state, producing more parallel surfaces without the imperfections commonly found in sheet glass. However, this method is costly.

Float glass has almost replaced both sheet and plate glass. It is made by floating molten glass over a molten metal, producing an even layer of glass that ends up polished on both faces. This type of glass is relatively distortion free and can be made in varying thicknesses and strengths.

Glass is also melted and forced through small orifices to produce thin glass fibers. These are used in manufacturing building insulations and various fibers for textiles.

Architectural Glass

Glass used in buildings is generally thought of as a flat, transparent, and fragile medium for windows, doors, and skylights. But glass is also made in different thicknesses, tints, colors, and

finishes. It can be frosted, ribbed, pebbled, or curved to suit a variety of purposes. Several specialized types of architectural glass are described below.

SAFETY GLASS

Glass can be made in several ways to increase its resistance to breakage from impact and thermal stresses. Normally, when sheet glass breaks, it falls in jagged pieces and slivers that can cause severe cuts. Tempered, wire, laminated, or security glasses are available to help prevent injury. Although most of these are clear, they can be colored or tinted and can have special surface finishes (Figure 13.24).

FIGURE 13.24 Common types of glass used in interiors. These can also be produced in tinted glass colors, or other films can be applied to their surfaces.

COMMON ARCHITECTURAL GLAZING MATERIALS (GLASS)

TYPE	CHARACTERISTICS	SAFETY	SOUND* CONTROL	SECURITY	APPLICATIONS
ANNEALED GLASS	Common glass; often called clear window glass; variety of thicknesses and quality.	Easily fractured produces sharp long splinters	Poor	Weak unless thickened	General usage glass for variety of products—doors, windows, mirrors, glass shelves
LAMINATED GLASS	Made with layers of other glass types; varying inner plastic layer can control heat, glare, and sound transmission	May crack on impact, but holds together, adhering to interlayer	Best of all, depending on no. of layers, thickness	Excellent as layers can be laminated to 2 inches	Safety glass in buildings and motor vehicles; overhead glazing
TEMPERED GLASS	Most common safety glass; heat strengthened during manufacturing	Difficult to break; shatters into non-cutting pebble sized pieces	Poor	Stronger than unheated, but must be thickened	Entry and shower doors; windows subject to impact
WIRED GLASS	Holds together when subjected to high temperatures, impact, and air pressures	Breaks similar to annealed, but wire holds it together; cut wires and sharp edges can occur at protruding hole	Poor	Better than annealed and tempered, but must be thick	Used as common safety and fire resistive assembly in buildings; overhead glazing

*Based on typical thickness. Better control by thicker sections.

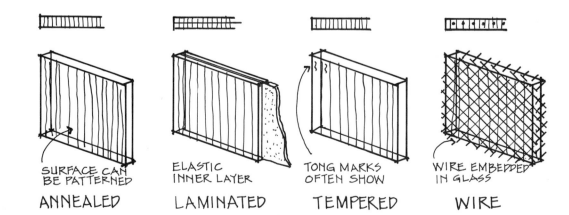

SURFACE CAN BE PATTERNED
ANNEALED

ELASTIC INNER LAYER
LAMINATED

TONG MARKS OFTEN SHOW
TEMPERED

WIRE EMBEDDED IN GLASS
WIRE

INSULATING GLASS

Insulating glass is made to reduce heat loss and gain in buildings. It consists of two or three layers of glass that are separated and hermetically sealed, with an air space (or a gas) between layers. These spaces vary from ¼ inch (6 mm) to more than ½ inch (12 mm) and are secured in place by metal-edged frames or welded-glass edges. The air spaces provide a better thermal insulation value for the unit and lessen the amount of condensation that forms.

REFLECTIVE AND HEAT-ABSORBING GLASS

Reflective glass and heat-absorbing (tinted) glass are used to reflect or absorb solar radiation. Reflective glass has a thin film of transparent metal or metal oxides bonded to the glass surface to reflect the sun's rays.

Heat-absorbing glass is produced by adding coloring agents during manufacturing. These agents are usually gray, green, or bronze tints that reduce glare, light, and heat transmission. Heat-absorbing glass is used in windows and, in special applications, on the interiors of buildings.

Some specialized glasses help maintain optimum thermal conditions in buildings. Metals are integrally cast into the glass and are charged electrically to become opaque or clear, depending upon the need.

Decorative Glass

Glass is an expressive material that can be used in both utilitarian and aesthetic treatments. Several types of decorative glass, most using age-old processes, are described below.

HAND-BLOWN AND MOLDED GLASS

Hand-blown glass is made by dipping a hollow metal rod into molten glass material and blowing a bubble. Before the glass cools, the glassblower uses tools to roll, twist, or shape it, creating a distinct, handcrafted look.

Molded glass is a mass production of the hand-blown process. Glass is blown or pressed into molds during the molten state. Many everyday glass items are made this way and can be intricate or simple in shape and texture.

ENGRAVED AND ETCHED GLASS

Engraved glass is made with wheels and various abrasives, producing fine decorative and pictorial effects. To produce etched glass, either sandblasting or acid techniques are used. The technique of etching produces a shallower design than is on engraved glass and is often used to imitate the more deeply incised engraved technique.

BEVELED, LEADED, AND STAINED GLASS

Beveled glass is made by grinding and polishing the edges of a piece of glass at an angle. Beveling is used for leaded glass windows, mirrors, and doors and in insets in wooden frames for decorative pieces.

The use of leaded and stained glass has been revived many times over the centuries. *Leaded glass* generally refers to transparent or colorless glass, such as in a window. Stained glass refers to glass that has been colored by glazing, pigmenting, and painting. It is set in lead or strips of copper foil for decorative uses, such as lampshades and windows (Figure 13.25).

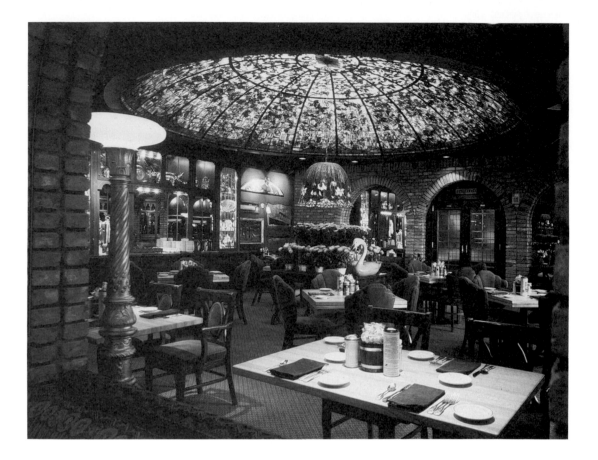

METALS

Metals are produced from ores. Hundreds of different types and alloys (mixtures) of metals are available. Metals are very versatile as they can be shaped by melting and casting, rolling, extruding, machining, welding, drilling, bending, and so on. Metals are used for structural and decorative purposes, either alone or in combination with other materials. The strength of metals contributes to their utility in slender, durable shapes not possible with other materials, such as wood, masonry, or ceramics. Metals are inorganic materials that do not rot, decay, or support combustion. However, they can melt at high temperatures and some can rust if not protected from moisture and chemicals. Most metals are good conductors of electricity and heat. However, when two dissimilar metals come into contact in a moist climate, a galvanic action can occur and disintegrate one of the metals. This is the reason aluminum, rather than steel, nails are used with aluminum siding.

Metals can generally be classified into ferrous (iron-bearing) and nonferrous (no-iron) types. Iron, a very abundant material in the earth, can be used alone or, preferably, alloyed with other metals. More than 60 different metal alloys and hundreds of combinations exist. Only those most important to interior design are discussed here and shown in Figure 13.26.

METAL	PROPERTIES	CHARACTERISTICS	USES
ALUMINUM	Produced as alloys for specific properties; can be brushed or highly polished	Lightweight; easily worked; corrosion resistant; ductile; silvery luster to soft gray	Cooking utensils; building components; screens; hardware; furniture
BRASS	Alloy of copper and zinc; takes high polish, but tarnishes readily; repolish or add protective coating	Easily shaped by casting, rolling, and stamping; yellow color	Lighting fixtures; hardware; bolts; screws; furniture; accessories
BRONZE	Originally copper alloyed with tin, but now alloyed with various elements of tin, silicone, aluminum	Fairly hard and durable; patinas with age; brownish red	Sculpture; bells; hardware; plaques
CHROMIUM	Used mostly as alloying element; can be brushed or polished	Durable; doesn't readily tarnish; used in plating blue-white	Lighting fixtures; furniture; small appliances
COPPER	Resistant to corrosion; surface will tarnish unless polished or protected with coating	Ductile; malleable; good conductor of electricity and heat; reddish orange color that oxidizes to dull greenish blue/brown	Electrical wire; water piping; roof flashing, gutters; cookware; accessories
GOLD	Considered a precious metal; takes high polish	Easily worked; made in thin sheets for gold leafing	Accessories; inlays; decorative elements
IRON	Pure iron oxidizes rapidly; galvinized or painted to resist rust; produced as cast or wrought iron	Strong; malleable; ductile; easily cast or worked; grayish	Building hardware; railings; furniture; cookware; grilles; fences
LEAD	Resistant to corrosion; alloyed with tin to make pewter	Soft; very dense; easily worked; vapors can be a health hazard; bluish-white	Waterproofing; radiation shields; stained glasswork
MAGNESIUM	Resembles aluminum; alloyed with other metals	Easily worked; resists corrosion	Furniture; hardware
NICKEL	Used primarily as an alloy with other materials; takes a bright polish	Makes other metals harder, corrosion resistant, ductile; grayish-white	Cooking utensils; sinks; hardware
PEWTER	Alloy of tin and other metals; takes high polish or rough finish	Resists tarnish; can be cast, hammered, machined; warm gray	Lighting fixtures; tableware; accessories
SILVER	Alloyed with other metals to increase hardness; alloyed with copper for sterling silver; takes high polish	Ductile; malleable; tarnishes easily; white metallic	Accessories; jewelry

FIGURE 13.26 Common metals used in interiors. (Continued on the next page.)

METAL	PROPERTIES	CHARACTERISTICS	USES
STEEL	Iron alloyed with carbon; surface deteriorates unless coated or other alloys added	Very hard; alloyed to make stainless steel—resistant to rust and tarnishing	Structural forms; furniture; cookware; door and window frames
TIN	Soft metal often alloyed with others; non-rusting and tarnish resistant	Easily worked; produced mostly in sheet form; soft silvery metal	Light fixtures; accessories; tin foil
TITANIUM	Important alloy; titanium oxides used in materials to make them white, bright	Easily worked; used as alloy for structural material	Furniture
ZINC	Used mostly as alloy with other materials	Easily worked; bluish-white	Major uses is in galvanizing or plating for corrosion resistant finishes

Ferrous (Iron-Bearing) Metals

IRON AND STEEL

Pure iron is a ductile (soft) material, generally too weak to shape. Adding carbon as an alloy increases its strength, as well as its resistance to warping and cracking. Iron is the main element used in making steel, but it can be manufactured alone as wrought or cast iron.

Wrought iron was developed about the fourteenth century with the introduction of blast furnaces that reached high temperatures (2,786°F or 1,530°C). These furnaces produced pig iron, which was then refined by remelting to become wrought iron, a high-purity, malleable material used for ornamental work, fences, pipes, railings, and furniture.

Cast iron is made with carbon additives, melted in furnaces, and cast into various shapes. It is hard, brittle, and fairly resistant to corrosion and has a high compressive strength. It was developed about 1700 and became a substitute for wrought iron, since it could be mass produced as castings rather than having to be hammered and bent.

Steel, invented in the mid-1800s, is an alloy containing iron, manganese, and proportions of carbon. It is stronger, more ductile, and less brittle than iron. Steel can be cast, bent, welded, rolled, and drawn into many shapes for use as a building material. It is used for fasteners, structural framing, concrete reinforcing, and a host of other functional and decorative applications. With the addition of other alloys, steel can be made corrosion resistant; it also exhibits varying strengths or ductility. It can be coated to develop a protective oxide rust to prevent further deterioration.

STAINLESS STEEL. Stainless steel, developed in 1912, has chromium added to make it corrosion resistant. It is used where greater protection is needed from moisture, such as in flashings, railings, hardware, fasteners, sinks, countertops, furniture, and cooking utensils. Stainless surface finishes are tough and can be polished to a mirror quality or brushed to a low luster. Stainless steel panels are available for use on walls or as column covers, corner guards, and splash guards (Figure 13.27).

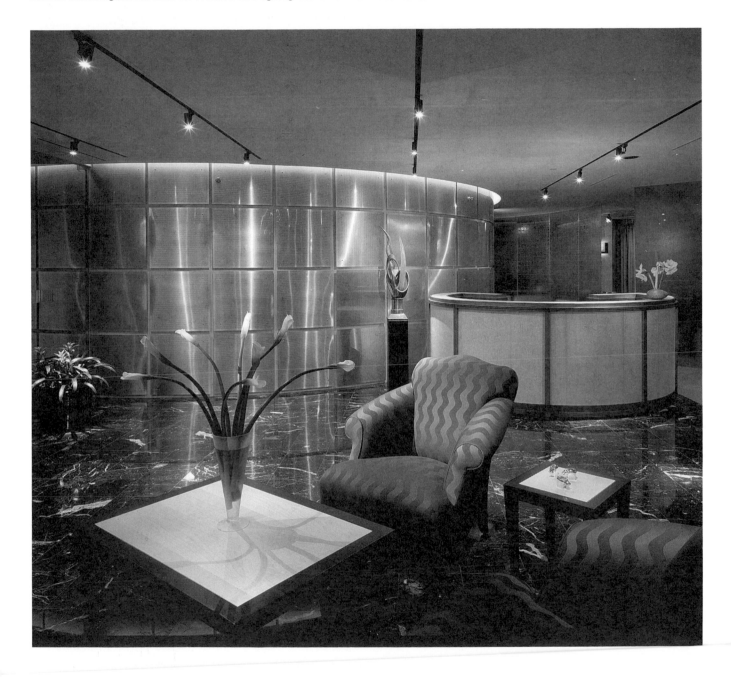

Nonferrous Metals

Most of the nonferrous metals are alloys, and most resist corrosion.

Aluminum is available in a variety of fabricated forms and is used for structural framing, door frames, screens, hardware, flashing, railings, and furniture. It is lightweight, is easily worked, does not deteriorate, and is a good reflector of heat.

Aluminum is produced by casting, rolling, and extruding. In a procedure similar to that used with iron, casting is accomplished by pouring or injecting molten metal into molds; this

procedure produces many utilitarian objects, such as grilles, handles, and electrical fittings. Aluminum is rolled using steel rollers; the resulting products include sheets, awnings, sidings, and other shaped planes. Extruding aluminum forces molten metal through a die shaped to the desired configuration, producing a long, continuous, and accurate section. This method is used for making door and window frames in a variety of shapes.

Aluminum finishes range from unfinished mill production to finishes that are polished, etched, and bonded over with plastic films. Anodized aluminum coatings are made by electrolysis, which increases the depth of surface oxide film. Surface oxides have hard finishes that can be integrally colored.

The other metals listed in Figure 13.26 are combined in many ways as alloys and other forms to produce a variety of special metals or to modify others. Brass and bronze are particularly useful in producing many building items and other items for daily usage.

Finishing and Coating Metals

The surface treatment of metals can be finished by different manufacturing processes and coatings. The finishes produced can be highly polished for mirror surfaces or be brushed for satin finishes. Textured or buffed finishes are created by scratching the surface with belt sanders, blasting with fine particles, or hand rubbing with steel wool. Chemical etching and acid dippings of metal can produce frosted surfaces and galvanizing qualities. Electrolysis is another method employed to create bright metallic finishes of one metal over another, such as a chrome finish on steel.

Coatings are applied to metals to produce durability and aesthetic effects. Varying in color and luster, these coatings can be sprayed, painted, or baked on. Other coatings, such as anodized and vitreous layers, are applied through chemical and heat processes. Vitreous layers are used on cast iron, for example for plumbing fixtures; anodizing is used on aluminum window and door frames.

PLASTICS

Plastics are chemical substances derived from common materials, such as coal, air, water, wood, and oil. Plastics are produced synthetically and can be molded and hardened for a wide variety of uses. Their performance abilities are similar to those of every other known material from soft rubber to steel. Early plastics were considered to be cheap imitations of natural materials, such as wood, marble, and metal. Design explorations and technological advances, giving plastics a wide range of properties, reasonable cost, and inherent design characteristics, have caused plastic to be more appreciated. Plastics are generally resistant to corrosion and moisture and are lightweight, tough, and easily molded into complex shapes. Because of their durability, cost, and low maintenance, plastics are even replacing natural building materials. Plastics are used for insulation, vapor barriers, window and door frames, exterior siding, plumbing pipes, countertops, tabletops, safety windows, floor coverings, furniture, and accessories.

Because the technology of plastics changes so rapidly, designing with plastics requires the interior designer to have a thorough knowledge of the properties and the methods by which they are fabricated into products. Some plastics are highly flammable and some give off dangerous fumes or explosive gases when burned. It is very important for the designer to understand the performance factors of the plastic material being specified because he or she could be liable for the protection of the public's health, safety, and welfare.

Recycling concerns have changed the perception of plastics from a throwaway material to a recyclable one. Plastics that can be melted down can be reclaimed and re-formed; however, not all plastics can be recycled this way. Researchers continue to work on ways for plastics to break down into harmless particles and either be reused or decompose naturally into our environment.

Thermoplastics and Thermoset Plastic

Plastics fall into the two categories of thermoplastics and thermoset plastics (Figure 13.28). Thermoplastics soften when heated and harden when cooled. Some examples of thermoplastics are acrylonitrile-butadiene-styrenes (ABSs), vinyls, and polyvinyl chlorides (PVCs). Many thermoplastics are flammable, which must be taken into consideration when using them in areas subject to fire. Thermoset plastics cannot be reshaped by heating because once formed in the manufacturing process, they become rigid. Some common thermoset plastics are melamines, epoxies, phenolics, and polyesters.

NAME	CHARACTERISTICS	USES
THERMOPLASTICS		
ABS	(Acrylonitirle-butadiene-styrene) hard, tough; resistant to chemicals and abrasion	Plumbing systems; furniture
ACRYLICS Lucite Plexiglas Corian	Lightweight; rigid; strong; good color and optical qualities; resistant to weather and temperature changes; scratches	Glazing; skylights; furniture; paints; accessories; corian (countertops)
NYLON Alpha Chemstrand Nypel	Rigid; resistant to chemicals and temperatures; high tensile strength	Furniture; bearings; gears; dinnerware; nylon yarn
POLYSTYRENES	Rigid; hard; resistant to chemicals, but not abrasion; breakable when bent; expanded to make styrofoam;	Furniture; kitchenware; insulation; tile
PVC	(Polyvinyl Chloride) rigid or made flexible with plasticizers; excellent resistance to wear and abrasion	Plastic plumbing, fixtures & fittings
VINYLS Ethyl Exxon Genon	Variable properties according to fillers and plasticizers used; foam and cellular; chemical resistant; stiffens at low temperatures	Vinyl floor coverings; upholstery; wall and ceiling coverings; coatings for materials

FIGURE 13.28 Common plastics and their uses. (Continued on the next page.)

NAME	CHARACTERISTICS	USES
POLYETHYLENES Dow Monsanto	Made rigid or flexible; lightweight; resistant to chemicals and temperature extremes; used in thin films for water and vapor barriers	Furniture; bowls; dish pans; squeeze bottles
THERMOSETS		
MELAMINES	Tough; resistant to stains, scratching, heat; used in thin layers to make plastic laminates	Cabinetry; furniture; countertops
PHENOLICS Bakelite	Strong; durable; resistant to heat and electricity	Electrical assemblies, paints, finish hardware
POLYCARBONATES Lexan	Very durable; good optics; high resistance to impact	Plastic glazing for shatterproof assemblies
POLYESTERS	Often reinforced with fiberglas and made into thin sheets; flexible or rigid; resistant to weather, chemicals; translucent	Furniture; patio covers; skylights; ceiling panels; yarns
URETHANES	Cellular plastic available in many different properties; formed in place	Insulation; cushions; fabrics; furniture

Plastic Fabrication

Plastics are formed in a variety of ways, such as foamed, molded, laminated, vacuformed, sprayed, injected, calendered (rolled), or blown. They can be produced in just about any weight, and almost any malleability from rigid to spongy, to create various forms and applications. Mineral or fabric fillers, such as mica, cotton, paper, sisal, and glass, are added for strength, moisture, and thermal resistance. As plastics are strengthened by fillers, they become less transparent. The strength of plastics to support heavy loads generally decreases as their flexibility increases.

Plastics are produced in powder or liquid form and are then fabricated into sheets, rods, strips, cylinders, or any other conceivable form. Through the application of heat and/or pressure, the surface quality of plastics can be changed by processes that include buffing, dipping, sanding, tumbling, and vaporizing.

Certain characteristics of plastics, such as the degree of flexibility or stiffness, tensile or impact strength, and sensitivity to environmental effects of moisture and sunlight, are controlled through the fabrication process. A high or low temperature range, colorability, and resistance to corrosion, cracking, staining, and scratching are also controlled in the fabrication stage.

Plastic Laminates

Plastic laminates are used extensively for interior surfacing, such as for wall treatments, furniture, cabinets, countertops, and tabletops (Figure 13.29). These are very durable materials available in a wide variety of colors, textures, and patterns. Plastic laminates are impervious to many chemicals and are easy to maintain.

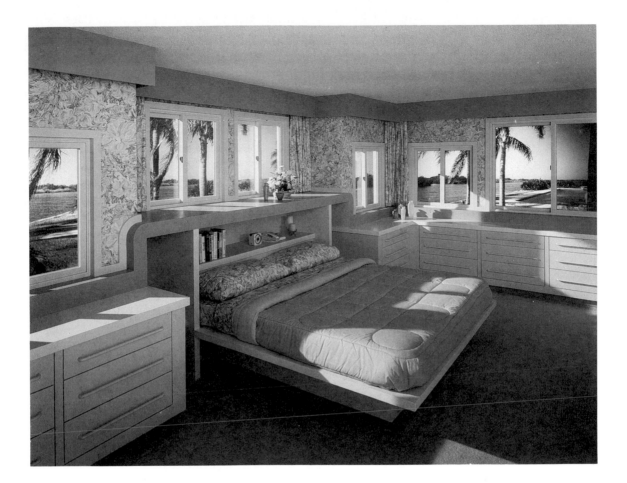

Thermosetting plastics are used in the fabrication process of high-pressure laminating. This process is different from other manufacturing processes because it involves high heat and pressure. Reinforcing materials, such as cloth, paper, wood, or fibers of glass, that comprise the body of the finished product are laminated between two sheets of plastic that hold them together. These added materials are impregnated with uncured resin or alternated with uncured plastic films, then pressed between two highly polished steel plates that are subjected to heat and high pressure. The plates squeeze the layers of material into a single sheet of desired thickness. Textured or patterned steel pressing plates transfer these characteristics to the surface of the laminate.

FIGURE 13.29 A variety of forms, colors, and textures are available in plastic laminates to produce custom interior products that are attractive and wear-resistant.

TEXTILES

Textiles are important materials that contribute to the overall design of an interior space. Textile fabrics humanize our interior environments, adding softness, comfort, flexibility, and dynamic movement to otherwise static spaces. Fabrics are used for both functional and aesthetic purposes in an interior environment, as illustrated in Figure 13.30.

Functionally they are used to control natural light, provide privacy without solid walls, insulate from heat and cold, and absorb noise. They also provide comfort as upholstery for sofas and chairs.

FIGURE 13.30 Fabrics, as in these triangular sculptural forms of nylon flagcloth, help diffuse intense light and add color and interest to this 8-story atrium at Lincoln Center in San Antonio, Texas.

Aesthetically, fabrics are pliable and can be manipulated to create any kind of mood or characteristic. They come in a limitless variety of colors, patterns, and textures and can be readily changed or replaced. Fabrics are excellent as a unifying element throughout an interior space and can be integrated with walls, windows, ceilings, and furniture.

Selection and Application of Fabrics

The selection of fabrics depends on their specific use within an interior space. The criteria governing the selection of textile end products depend on many variables. Some fabrics are

selected for their aesthetic characteristics; others may focus on function-related performance, maintenance, and installation factors; and some may be determined by economic factors. Figure 13.31 shows the variable characteristics involved in the selection criteria of fabrics for interior environments.

CRITERIA	CHARACTERISTICS/CONSIDERATIONS
AESTHETIC FACTORS Appearance Tactile Visual Coordination	Color, pattern size & repeat, visual textures, style. Touch: rough, smooth, soft; fabric weight and drapeability. Coordination with other interior elements.
FUNCTIONAL Durability Performance properties Maintenance needs	Abrasion and tear resistance; light fastness; color and texture retention; soil resistance; structural stability and flame resistance; repairability. Value for acoustical, static, insulative, and light control properties. Cleanability, stain removal, and touch up requirements.
ECONOMIC Material Costs Labor Costs Maintenance Costs	Material, delivery, and installation costs; maintenance, warranty, and replacement costs.

FIGURE 13.31 Selection criteria for fabrics used in interiors.

AESTHETIC FACTORS

Often a fabric is selected because of its aesthetic appeal; however, a designer must be sure that the fabric is also durable and appropriate for its intended use. Three attributes of a fabric that form the basis for aesthetic judgment are color, pattern, and texture. A fabric can also be judged on good design principles within itself and on how it will coordinate with other materials.

Color preference is sometimes the most important factor in the selection of fabric. Coordinating color schemes of fabrics with other materials in an interior space should support, enhance, and complement one another, not compete or cause visual irritation. The intensity and brightness of color within a fabric color scheme should be varied. If all colors are of a low value or dulled, the overall effect may be uninteresting or monotonous. If all the colors are intense, the effect may be unlivable.

Another consideration in selecting fabric color is the light within the space and how it will affect the color of the fabrics. The quality, type, and direction of light should help coordinate and enhance the fabric color scheme.

Pattern expresses the personality and character of a fabric. Pattern within fabrics should be well proportioned and exhibit good design composition. When coordinating two or more patterns, the designer should vary the scale of the fabrics, such as a small pattern with a large one. Support patterns and textures, such as stripes and geometrics, can be combined with a floral pattern, as well as with a plain, textured fabric. Pattern can also be used to relate a particular fabric to a period of time. Coordination of period styles and their patterns and motifs must be consistent to produce an authentic effect.

Fabrics possess both visual and tactile textural qualities. Textural characteristics range from a smooth and refined quality (satin, velvet, damask) to a coarse and sturdy quality (tweed,

matelassé, frieze). Textural relief within a fabric refers to the three-dimensional quality of the surface, such as the peaks and valleys created. This third dimension gives depth and interest to a fabric and accounts for the highlights and shadows in its appearance.

The weight of a fabric is also important in the selection process. Fabrics can be classified into four basic weight categories: sheer and/or thin, lightweight, medium-weight, and heavy-weight. Sheer and/or thin fabrics are typically used for window curtains or draperies, soft top window treatments, and canopy coverings. Lightweight fabrics can also be used for curtains, draperies, and top treatments, as well as for shades for windows, lampshades, and lined bed-spreads. Medium-weight fabrics are used for bedspreads, slipcovers, upholstery, draperies, shades, rigid top treatments, and heavier curtains. They can also be used as wall and partition coverings. Heavyweight fabrics are applied as furniture upholstery, wall coverings or hangings, and heavy bedspreads.

Good textural coordination within an interior depends on textural harmony. Generally a designer sets a theme, ambience, period, or style to work from that relates all the fabrics in a scheme. The texture of the fabrics must be appropriate for their intended use and the level of formality or informality within a space.

FUNCTIONAL CHARACTERISTICS

Functional characteristics include serviceability expectations, as well as design and performance qualities. Some fabrics will wear out faster than others because of the fiber, yarn, or construction method. Some fabrics may wear out aesthetically because of functional weakness, such as fuzzing or pilling; problems with colors fading or crocking (color rubbing off); or being difficult or impossible to clean.

A designer must also be aware of performance requirements, such as flame resistance, static reduction, or structural stability. Fabrics installed in commercial applications must meet minimum requirements for durability, colorfastness, and fire safety.

ECONOMIC FACTORS

Economic factors include cost limitations involved with the installation of the material and maintenance requirements. A designer should be aware of a fabric's ability to hide soil and still look good. The cleanability of a fabric is based on the fiber content, construction method, and durability of finishes.

Similar to the other basic construction materials (stone, wood, brick, and plaster), fabrics come from a natural or raw state and go through an average of six finishes to become marketable or usable as finished products. Before specifying or selecting fabrics for an interior space, the interior designer must understand the qualities of the basic materials, the process that fibers undergo in order to be transformed into fabrics, and the finishes and applied ornamentation of the fabrics.

Fibers

Fibers are any substance that can be separated into threads or threadlike structures and used for spinning and weaving. In interior design, the term is used for textile fibers. Fabrics are often named for the fibers from which they are made. Fibers are classified according to their chemical composition, how they are produced, and whether they are natural or manufactured. Further classification may be made according to the general source of each fiber; for example,

natural fibrous materials come from plants (cellulose) or animals (protein), and manufactured (man-made) fibers are produced from petroleum- or mineral-based compounds. Man-made has traditionally meant regenerated cellulosic fibers plus synthetics. The preferred term is *manufactured*. Fibers are further classified by their generic (based on chemical composition) names, such as acetate or acrylic. Basic fiber properties discussed in this chapter refer primarily to textiles. As carpet fibers are slightly different, they are discussed separately, in Chapter 14.

NATURAL FIBERS

Natural fibers come from two main sources—protein and cellulose. Protein fibers are derived from animals (wool from sheep) or insects (silk from silkworms). Cellulose fibers (cotton, linen, jute, ramie, sisal, and less common fibers) come from plants.

MANUFACTURED FIBERS

Manufactured fibers are produced from man-made substances—the usable fiber a result of industrial processing. Manufactured fibers can be divided into two categories: cellulose based and noncellulosic, or synthetic. Rayon, acetate, and triacetate are produced from cellulose, a natural raw material, to which various chemicals are added. Noncellulosic, or synthetic, fibers— nylon, polyester, olefin, acrylic, saran, vinyl, and many others—are synthesized from chemical compounds, such as petroleum, natural gas, coal, air, and water.

OTHER FIBERS AND BLENDS

Another category of fibers is natural/mineral fibers, processed in ways similar to those used for manufactured fibers. Natural/mineral fibers, limited in their use, include asbestos, rubber, glass, and metal. Asbestos, formerly popular for its fire-resistant properties, has been dropped from most use because it has been found to be a carcinogen.

Although a textile may consist of one type of generic fiber, frequently two or more are blended to increase the strength and aesthetic appearance, or to minimize the weakness, of a particular fiber. For example, natural and synthetic fibers can be blended to retain the appearance and texture of the natural fiber while gaining the soil resistance and durability of the synthetic fiber. Different fibers can be spun into one yarn, or different yarns can be blended into a single fabric. These combinations have produced some important changes in fabric characteristics. By combining polyester fibers with cotton in various proportions, the resultant textile is made wrinkle free and almost completely soil resistant. Wool's strength is increased when blended with nylon. Fabric manufacturers can devise almost endless combinations to obtain the best attributes of various fibers. However, some fiber blends can have disadvantages. Manufacturers are required by federal law to label fabrics with fiber content and method of care, which can help offset these disadvantages. It is extremely important for a designer to keep abreast of the characteristics of fibers and their probable performance. See Figure 13.32 for a listing of the advantages, disadvantages, characteristics, and applications of some common fibers.

Yarns

Yarns are long, continuous strands or threads made from fiber to prepare it for construction into fabric. Making yarn from natural fibers involves cleaning the fibers, pulling them out more or less evenly and parallel, and then twisting or spinning them into yarn. Manufactured

FIBER	TRADE NAME[1]	ADVANTAGES; CHARACTERISTICS	DISADVANTAGES	APPLICATION[2]
NATURAL				
ANIMAL (PROTEIN)				
Angora (rabbit) Camel's hair Cashmere (goat) Horsehair Mohair (goat) Wool (sheep)		Durable; resistant to stains, soiling; cleans well; variety of color and textures. High quality; dyes well; noted for appeal and warmth; special treatment processes increase properties and versatility; resists burning	Susceptible to insects; shrinks unless treated; sunlight deterioration	B,C,D,R,U,WC
Silk (silkworm cocoon)		Fair soil resistance; dimensionally stable. Lustrous; glossy; deep luster; burns slowly	Sunlight deterioration; damage by moisture and soiling	D,R,U,WC,L
PLANT (CELLULOSE)				
Cotton		Economical; excellent color range; stronger when wet. Versatile; dimensionally stable; irons easily; absorbent; lightweight to heavy	Soils, stains, wrinkles easily unless treated; burns readily	B,D,R,L,U,WC
Jute (Burlap, Gunnysack)		Economical; takes color well; strong. Used primarily as backing for carpets	Rots if left wet; fades, burns readily	D,WC
Flax (Linen)		Dyes well; natural luster. Strong fiber; washes and irons well	Soils, fades, and wrinkles easily unless treated	D,L,U,WC
MANUFACTURED				
CELLULOSIC				
Acetate	Celebrate Chromspun Estron Kodel	Resistant to moths, pilling, mildew, discoloration. Dries quickly; economical; dry-clean or wash according to specifications; silk-like sheen	Poor resistance to sunlight; low abrasion resistance; flammable	D,L,U
Rayon	Cuprammonium Fibro Rayon Tencel	Resistant to moths, pilling; excellent color range; strong, durable (in heavyweight fabrics). Resembles cotton; colorfast; drapes well; economical substitute for silk or cotton; versatile fiber	Very flammable unless treated; shrinks in hot water if not treated	B,C,D,L,R,U
Triacetate	Arnel	Resistant to aging, chemicals, insects, mildew, sunlight, wrinkling. Colorfast; excellent color range; holds shape well; dries quickly		B,D

FIBER	TRADE NAME[1]	ADVANTAGES; CHARACTERISTICS	DISADVANTAGES	APPLICATION[2]
NONCELLULOSIC (SYNTHETIC)				
Acrylic	Acrilan Creslan Dolan Orlon Zefran	Dyes well; resistant to chemicals, insects, sunlight, aging. Resembles wool; colorfast; soft texture; retains shape well	Subject to pilling; generates static electricity; flammable	C,D,R,U,W
Glass	Beta Fiberglas Pittsburgh PPG	Excellent resistance to sunlight, aging, and mildew. Good color range; resists most acids	Melts at very high temperatures	D,L.
Modacrylic	Kanekalon SEF	Resists water, insects, acids, aging; self extinguishing; retains shape well. Similar to acrylics but more resistant to stains; soft; buoyant	Low resistance to abrasion, sensitive to heat, melts when exposed to flame	B,D,R,U
Nylon (also available as Nylon 6; 6,6; 6,9; 6,10; 11,12)	Anso Antron Caprolan Ultron Wellon Zeftron	Strong, durable; stable; resistant to insects, moisture, aging. Lightweight; lustrous; retains shape well; high tensile strength	Generates static electricity; not resistant to pilling and soil	C,D,R,U,WC
Olefin	Alpha Herculon Marvess Spectra	Economical; durable; quick drying; fair resilience. Wool-like texture; resists acids; soil resistant	Susceptible to heat and sunlight deterioration; oily; flammable	B,C,U
Polyester	Alvin Dacron Fortrel Kodel Polyester Trevira	Resists fading by sunlight; strong, durable; resists wrinkling, mildew, insects. Wool or silk-like; retains shape well; colorfast; lightweight	Subject to pilling and abrasion; retains oil-borne stains; flammable	C,D,R,U
Saran	Enjay Saran	Very durable; dimensionally stable; resistant to chemicals, mildew, insects. Easy to dye; not affected by water; used for outdoor furniture and awnings	Heat sensitive; sunlight may darken colors, but resists sun damage	D,U
Spandex	Cleerspan Glospan Lycra Interspan	Strong, durable; stretches & recovers; resists chemicals and sunlight. Easily dyed; good moisture resistance	Low strength, melts when exposed to flame	U
Vinyl	Naugahyde Valcren PVC	Produced in many textures, weights, colors. Often used to imitate leather; fabric backing improves strength	Difficult to repair; melts when exposed to flame	U,WC

NOTES:
(1) Partial listing of trade names.
(2) Application code: B = blankets, C = carpet, D = drapes, L = linens (table/bed/bath), R = rugs, U = upholstery, WC = wall coverings.

fibers are made from a liquid or melted polymer, which is then forced through holes in a spinneret, which resembles a showerhead. The shape and size of the holes in the spinneret determine many fiber characteristics. The extruded filaments are then twisted into a yarn. Generic fibers can be combined in the liquid stage to make blended fibers for specific needs.

Yarns vary according to the type of fibers used (either alone or in combination); the type, direction, and tightness of the twist; the number of strands twisted together (called the ply); and the size of the finished product. Long fibers laid parallel and twisted tightly produce smoother and stronger yarns than short fibers placed randomly and twisted loosely. Silk is the only natural fiber that is one long, continuous fiber, although synthetic fibers can be made long and continuous. Any fiber, or combinations, can be cut into short pieces for different effects.

Besides having their component fibers tightly or loosely twisted, yarns can also be given a right- or left-hand twist to create special effects. Yarns differ according to the various methods of construction. The most common are described below.

MONOFILAMENT

In the monofilament process, a single filament or strand is treated as one yarn structure. For stability and strength, the filament is relatively large in diameter, stretched, and heat set. Monofilament yarns are generally used in the production of lightweight, transparent window coverings. They are also used in the construction of many interior textiles as a strong sewing thread. In the latter, the filaments may be clear or translucent to blend with the color of the textile.

MULTIFILAMENTS

A single multifilament yarn is produced by twisting several individual filaments together. Multifilament yarn can be used alone or spun with other fibers.

SPUN YARNS

Short-length fibers, such as wool and cotton, are converted into usable yarn strands by processing them through various spinning systems. Before the invention of the spinning machine during the Industrial Revolution, yarns were produced by hand spinning. Natural fibers have been blended with synthetic fibers in an attempt to produce a yarn that combines the best qualities of both.

TWISTED YARNS

Yarns can be twisted to increase their strength. Twisting is used for all spun yarns. A fabric's texture and appearance are influenced by the tightness and twist. Texture can be made by using yarns of different twist direction or varying twist direction within one yarn.

PLIED YARNS

Plied yarns are formed by twisting or plying two or more single yarns together, which increases the thickness and strength of the yarns and produces varied textures in fabrics. Special visual effects can be created by plying yarn strands of two or more colors.

COMPLEX AND NOVELTY YARNS

SLUB YARNS. Slub yarns are irregular in diameter and have coarse and fine segments along their length; these segments are produced by varying the level of twist used in spinning. Slub yarns give fabric a distinct texture.

STRETCH YARNS. Stretch yarns can be constructed with a stretchable, elastic core and covered with fibers wrapped around them. Or synthetic fibers can be crimped by a new process into a springy, coiled form. These stretch yarns are used for apparel, as well as for some upholstery fabrics.

Textile Construction

Fibers are made into a textile or cloth by various construction methods. Each method creates distinctive aesthetic and structural features that affect the fabric's serviceability, installation, and maintenance requirements. In turn, these factors will influence the suitability of the fabric for end-use applications. The method of construction also has a direct effect on the cost of the end product, which is an important criterion in the selection of most residential and commercial interior textile products. The most common fabrication methods use yarn as the basic element; however, there are some methods that do not require fiber in a yarn form. The most common fabric construction methods are described below.

WEAVING

Weaving is still the dominant form of fabric construction. Weaving is done on looms and is the interlacing of lengthwise yarns called warp and filling yarns called weft or woof; the latter run crosswise and usually at right angles. The filling yarns hold the warp together. The pattern of the interlacing and the number of yarns used determine the type of weave. Several basic categories of weaves—plain, leno, twill, satin, pile, and Jacquard—are produced on looms (Figure 13.33).

FIGURE 13.33 Common textile weaves.

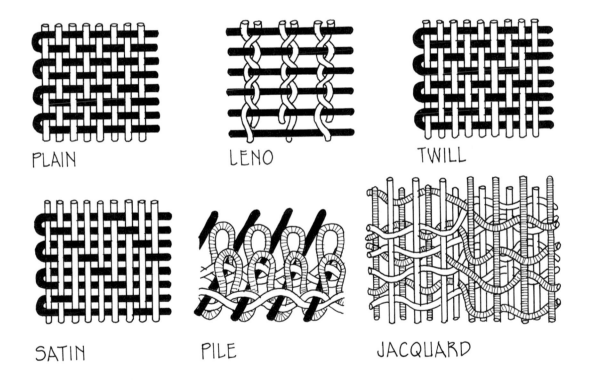

PLAIN

LENO

TWILL

SATIN

PILE

JACQUARD

PLAIN WEAVES. The plain weave simply interlaces one filling yarn over and under one warp yarn in a regular sequence. Using different sizes of yarns or adding extra yarns in one direction creates variety. For example, a rib weave creates a lengthwise or crosswise rib effect by interweaving heavy yarns with thinner ones, and a basket weave creates a distinct pattern by using two or more warp yarns interlacing two or more filling yarns.

LENO WEAVES. Leno weaves, a variation of the plain weave, are produced when the warp yarns form an hourglass twist. They interweave the filling strands to create an open, lacy effect that resists distortion better than a corresponding plain weave does. Leno is the most common lace weave and is often used for casement fabrics.

TWILL WEAVES. Twill weaves produce a definite diagonal line or wale on the surface of a fabric; this wale is created by having the warp yarns "float" across a number of filling yarns in a regular pattern. Textiles woven in twill weaves generally have high strength and resist soil and wrinkling better than textiles of plain weaves of similar quality. Typical twill-woven textiles include serge, houndstooth, denim, and gabardine.

SATIN WEAVES. One warp yarn is floated over four or more filling yarns in the satin weave. The floats in the satin weave are longer than in the twill weaves and minimize the over-under texture. Satin woven fabrics are characterized by high luster and sheen produced by fine, lustrous yarns and the reflection of large amounts of light from the smooth, uninterrupted surface areas of the floats. The level of luster will be reduced if abrasion ruptures the floating yarns during use. Textile examples of this weave category include satin, sateen, and chino.

PILE WEAVES. The pile weave adds a third set of yarns (pile yarns) to the basic warp and weft sets of yarns during the weaving process. In the finished textile, the pile yarns protrude from the background, introducing a dimension of height to otherwise two-dimensional fabrics. This extra set of yarns produces loops that can be left uncut, such as in terry cloth, or cut to produce velvet, corduroy, or plush textiles. Patterns can be created by cutting some loops and leaving the remainder uncut or by having some portions of the pile higher than others.

JACQUARD WEAVES. Jacquard-woven fabrics often have extremely complex patterns combining two or more simple weaves, multiple sets of yarns, and strategically placed colors. These weaves are produced on a highly complex machine that operates like a computer. The Jacquard loom was invented in the eighteenth century by a Frenchman, Joseph Marie Jacquard. It resembles an early computer in that hole-punched cards are utilized to control the interlacing of yarns. The holes in the card allow some threads to rise while others stay in their original position. The result is that large, complex patterns can be woven at a fraction of the cost of hand-woven fabrics. Today, this loom takes a long time to thread and set up, but once it is ready to operate, large runs of textiles can be produced at relatively little expense and in a reasonably short time. Damask, brocade, matelassé, brocatelle, and figured velvets are examples of Jacquard weaves.

KNITTING

Knitting is another method that can be used to combine yarns into textile fabrics suitable for interior applications. Knitting is a process whereby needles are used to weave a single strand of yarn into a series of interlocking loops. Patterns are created by a combination of stitches, such as plain, rib, purl, jersey, and interlock. Knitted fabrics are popular because of their wrinkle recovery, stretch recovery, and form-fitting characteristics.

OTHER FABRICATION METHODS

Bypassing the yarn stage is now possible because of new ways to produce fabric structures. Spun-bonding and spun-lacing, techniques similar to the age-old technique of felting, and the efficient method of needle punching are new methods being used to combine fibers directly into fabrics.

FELTING. Felting means matting together wool fibers to form a web. These fibers are layered and exposed to controlled heat, moisture, and pressure, which causes the fibers to intermesh and entangle, compacting and shrinking the fibers into felt. Felt is a dense cloth that is firm and slightly fuzzy and has comparatively low tensile strength. It is generally used as a backing fabric to prevent scratching or as an insulation material.

NEEDLE-PUNCHED FELTS. Needle-punched felts are constructed by pushing barbed needles through a mat of fibers to entangle them without the use of heat or pressure. This technique is used in the production of some carpets, wall coverings, and blankets.

BONDED-WEB FABRICS. Bonded-web fabrics are also nonwoven and consist of layers of fibers bonded through the use of a binding agent, such as an adhesive spray. The adhesive is first sprayed over the fibers to cause the nonthermoplastic fibers to adhere to one another; then heat is added to fuse the fibers together. Bonded-web fabrics are used as interfacing in upholstery to add body and weight. They are also used to interface the heading in curtains and draperies to support pleats and scallops.

SPUN-BONDING. Spun-bonding converts thermoplastic fibers directly into fabric. After the fibers are arranged in a thin web, heat or chemical binders are added to stabilize them. Compounds can be sprayed over them for additional strength, stability, and weight or for reduced transparency. Spun-bonded fabrics are used as tablecloths, bedding products, and backings for wall coverings and carpets.

SPUN-LACING. Textile fabrics produced by mechanically entangling fibers are referred to as spun-laced fabrics. These fabrics are stabilized or held together solely by fiber-to-fiber friction, rather than by an adhesive or other type of bonding agent. Spun-laced fabrics are used as backings for textile wall coverings, simulated leather upholstery fabrics, mattress pads, and comforters.

FILMS. Synthetic polymer solutions, such as polyester plastics, can be converted directly into film sheeting fabrics. This technique involves extruding the liquid solution through a spinneret that has a narrow slit rather than holes. As the polymer ribbon emerges, it is stretched into a thin sheet or film. The thickness of the material is controlled by varying the extrusion pressure and the amount of stretching. Film sheetings are used for interior products such as shower curtains, simulated leather upholstery, drapery linings, and plastic-coated wall coverings.

Textile Colorants

Color can be added at several stages of the textile-construction process. Although most natural fibers contain some color-producing substances, which may or may not be retained, no fibers or other textile structures have intrinsic color. Most textiles have color-producing substances added. In the textile industry, greige goods refers to undyed and/or unfinished fabrics. The importance of color-related variables to the selection of interior textiles is reflected in the methods used for applying color—dyeing, printing, and dyeing and printing combinations. In the selection of interior textiles, it is important to know what methods are used to add color, as the method used will effect durability.

DYEING

Dye can be added to fibers, yarn, or woven textiles. Most dyeing operations require the textile substance to be immersed in the dye solution. For some synthetics and plastics, dye can be mixed with the liquid form from which the fiber or film is made.

Solution dyeing and fiber or stock dyeing are the two methods of dyeing fibers. Solution dyeing is used only with manufactured fibers, but fiber dyeing can be used with both manufactured and natural fibers.

SOLUTION DYEING. In solution dyeing, the more permanent form of coloring synthetic fibers, dyes or pigments are added to the polymer solution before extrusion from the spinneret. This method locks the color inside the fiber. Manufacturers use the terms *color-sealed* or *produced-color* to identify solution-dyed fibers. Because the color is incorporated as an integral

part of the fiber, the process produces uniform color. Solution-dyed fibers have comparatively high color retention and stability but can be expensive.

FIBER OR STOCK DYEING. Fiber or stock dyeing involves immersing manufactured or natural fibers in a dye solution before they are spun into yarn. This method produces excellent results, since loose masses of fibers can absorb the dye more readily and thoroughly than fibers in the yarn or fabric state can.

YARN DYEING. Yarn dyeing involves adding colorants to the yarn before it is made into fabrics. Most yarn-dyeing methods, such as package dyeing, beam dyeing, and skein dyeing, produce single-colored yarns. However, space-dyeing techniques can be used to produce multicolored yarns also.

PIECE DYEING. In piece dyeing, yarn that has been fabricated into a fabric piece is immersed in a dye liquid. This process produces single-colored fabrics and is economical; however, the dye generally does not penetrate the fibers and yarns as well as in other dyeing methods.

CROSS DYEING. Cross dyeing is a color application process in which two or more fibers that are chemically different are dyed in the same bath, accepting the dye or dyes in different ways and producing a multicolored fabric.

PRINTING

Several printing methods can be used for adding colors and patterns to fabrics. The most common are described below.

BLOCK PRINTING. One of the oldest methods of printing, block printing involves carved wooden blocks inked with a dye paste and stamped onto a fabric. This method was popular in England and France before machine-printing operations were developed. Some patterns required as many as 100 different blocks. However, this method is not much used in commercial production.

ROLLER PRINTING. One of the most common printing processes was roller printing, which involves large metal rollers that are engraved or etched with a design. Separate rollers (a different one for each color) continually ink the large etched cylinder as the fabric moves around it. This process produces very fine-line prints and is fairly inexpensive. However, it has been almost entirely replaced by rotary-screen printing, which is much faster.

SCREEN PRINTING. Screen printing (often called silk screen) is a technique based on the principle of a stencil, with a fabric screen stretched over a frame. Some areas of the fabric are blocked by the screen to prevent the dye from reaching them. The two methods of screen printing are flat-bed screen printing and rotary-screen printing.

In flat-bed screen printing, large rectangular frames are covered with a fine, strong fabric. Today, nylon and polyester fabrics are used instead of silk because of the higher cost of the natural fiber. A rubber squeegee then presses the dye paste through the screen. A different screen is used for each color. Flat-bed screen printing is generally used for upholstery and drapery fabrics that are designed with large-scale motifs and pattern repeats.

Rotary-screen printing is also a stencil technique, but it is fully automated. The rotary screens are wrapped around circular drums that rotate the ink onto fabric that moves beneath the screens. Some rotary-screen printing machines can accept up to 20 screens, enabling them to print up to 20 different colors. Rotary-screen printing is more economical and faster than other screen printing techniques. This method produces a more uniform level of color when large quantities of fabric are being run.

TRANSFER PRINTING. Transfer printing is a heat-transfer process similar to that used for applying decals. A pattern is printed with dye onto a waxed paper, then transferred by applied heat and pressure onto the fabric. The fabric absorbs the dyes from the pattern. Transfer

printing was developed in the 1970s mainly for use with polyester knits because the inherent elasticity of these fibers caused them to shrink after the release of the tension used in the roller- and screen-printing operations. Transfer printing requires minimal fabric tension, which elimi- nates the problems.

ACID PRINTING. Acid printing, also referred to as burnt-out or etched-out printing, prints a design by using a chemical that dissolves one of the two or more fibers in a fabric. For example, in the printing process of a fabric blended of nylon and rayon, a weak sulfuric acid is printed on selected areas of the fabric, which destroys or "burns away" the rayon fibers. This process creates a higher level of transparency in the treated areas of the fabric. Another typical acid-printed fabric is a cotton-polyester semisheer in which the cotton is burned out.

DYEING-PRINTING COMBINATIONS

Combinations of dyeing and printing techniques involve immersing fabric in dye solutions in combination with printing procedures to produce interior textiles with colored backgrounds and noncolored designs.

DISCHARGE PRINTING. In discharge printing, areas of color (usually the patterned motif areas) are bleached out or replaced by another color. The fabric is first piece dyed, then printed with a reducing agent, such as bleach, wherever the design motifs are planned. This agent removes, or "discharges," the dye.

RESIST PRINTING. Resist printing is a technique in which parts of the fabric are protected from being absorbed by the dye. Artisans use several hand-resist methods to create distinctive interior fabrics. The two most common methods of resist printing are batiking and tie-dyeing.

Batiking is a hand-printing process in which parts of a fabric are covered with a hot wax to prevent the dye from penetrating. The wax is removed after the waxed cloth has been im- mersed in a dye solution. This process can be repeated a number of times with different dye colors to create interesting patterns.

In tie-dyeing, another popular hand-resist method, the fabric is tied with thread or knot- ted to prevent parts of it from coming into contact with the dye. This process can be repeated to create abstract patterns.

Fabric Finishes

Finishing is the process of converting textiles from their raw state to usable interior textile products. Until cloth is converted into a finished fabric, it may lack aesthetic characteristics, as well as structural stability and service-related performance features. The appropriate selection and proper application of finishes expand the variety of fabrics available to the interior designer and the consumer.

Finishes can be divided into three categories—prefinishes, functional finishes, and deco- rative or surface treatment finishes. Figure 13.34 lists the characteristics of some of these com- mon finishes.

PREFINISHES

Prefinishes prepare textiles for coloring or other finishes. Prefinishes are applied to both natural and manufactured fibers in their raw, untreated state.

FIGURE 13.34 Common fabric finishes.
(Continued on the next two pages.)

PREFINISHES

BLEACHING — Chemical process that removes unwanted color and whitens greige or gray goods.

BOILING-OFF OR SCOURING — Removes various compounds such as grease, sizing, or other unwanted components.

BRUSHING — Mechanical process that aligns pile yarns and pulls out unwanted short fibers.

CRABBING — Process used to set wool fabrics.

MERCERIZATION — Chemical process used on cotton or linen to increase the fiber's ability to absorb dye, increase strength, and luster.

PRESHRINKING — Process that subjects fabric to moisture and dry heat that lessens the tendency of the fibers to contract when exposed to moisture.

SANFORIZED — A trade name process of preshrinking to limit shrinkage to less than 1 or 2 percent.

SHEARING AND SINGEING — Remove short fibers, lint, and fuzz to prevent piling. Singeing is used primarily on cotton, cotton/polyester blends, linen, and rayon.

STABILIZING AND HEAT-SETTING — Processes that produce dimensional stability and aid in crease or pleat retention.

FUNCTIONAL FINISHES

ANTIBACTERIAL, ANTISEPTIC, OR BACTERIOSTAT — Chemical treatment to inhibit growth of mildew, mold, other fungi, and rot.

ANTISTATIC — Chemical treatment to prevent buildup of static electricity.

BURNT-OUT — An acid process (also called etched) that burns out one fiber in a fabric to produce a transparent or shear pattern.

CREASE/WRINKLE RESISTANCE — Chemical treatment to resist creases and wrinkles.

FIREPROOFING — Chemical or fiber treatment to inhibit flammability.

FIRE-RETARDANT — Chemical treatment to resist ignition and retard flame spread.

INSULATING	A coating of foam or other materials layered to the back of a fabric to increase insulative values.
MOTH-REPELLANT	Chemical treatment to resist damage by moths and other insects.
SCOTCHGARD	A trade name chemical process that conditions textures to be stain resistant.
SOIL-RESISTANT OR SOIL-REPELLENT	Chemical process that coats or impregnates fibers to make them less absorbent and make soil removal easier.
SOIL RELEASE	Chemical process that increases a fabric's ability to release soil through wet cleaning.
WATER-REPELLENT	Chemical process that coats or impregnates fibers with materials such as metal, resin, or wax to prevent soil and moisture from being absorbed.

DECORATIVE OR SURFACE TREATMENT FINISHES

BEETLING	Mechanical process that gives luster, absorbency, and smoothness to linen fabrics.
CALENDARING	Mechanical process that flattens and gives luster to a fabric by pressing with hot, heavy rollers.
CRUSHING	Mechanical process used mostly with velvet fabrics that flattens and orients pile yarns in various directions. Produces several levels of luster due to reflection of light in different directions.
CRABBING	Chemical process that tightens and sets the weave in wool.
DELUSTERING	Chemical process applied to fibers before spinning and produces a dull surface finish that diffuses light.
EMBOSSING	Mechanical process using engraved rollers that press a three-dimensional pattern into a fabric.
FLOCKING	Mechanical process that embeds extremely short fibers (called

FLOCKING *(cont'd)*	flocks) in an adhesive or resin compound and applied to the surface of a fabric. These are applied in a pattern or as a continuous layer.
FULLING	Mechanical or wet process that improves the appearance and softens wool fabrics.
GLAZING	Mechanical process that impregnates surface of a fabric with compounds and passes the fabric through high-speed calendar rollers. This produces a smooth and lustered surface. This process is frequently used on chintz fabrics.
MOIREING	Mechanical process of calendaring used on filling-rib woven fabrics that produces a wood-grain or water-marked appearance.
NAPPING	Mechanical process of hooks that pull fiber ends from low-twist, spun yarns. Produces a low, soft, fuzzy pile.
SCHREINERING	Mechanical process of calendaring that creates small hills and valleys on the fabric surface. Not a permanent finish unless resin or heat treatments are included.
SOFTENING	Chemical process that produces a softer feel to a fabric.
STIFFENING	Chemical process of applying resins and starch to the fabric surface to add crispness.
TEXTURIZING	Mechanical, heat treatment, or chemical process that produces a surface texture such as a wrinkle or pucker.

FUNCTIONAL FINISHES

Functional finishes are applied to fabrics to improve their performance and their resistance to environmental factors. These finishes also improve the quality and potential serviceability of the structural features. Functional finishes may be durable, finishes that will withstand repeated cleaning, or nondurable, finishes that can be removed with cleaning and need to be reapplied.

DECORATIVE OR SURFACE TREATMENT FINISHES

Decorative or surface treatment finishes are either durable or nondurable and are used to control the level of surface luster or embellishment on the fabric face for aesthetic and textural qualities.

Textiles for Interiors

Textiles in interiors are used as draperies (and curtains), upholstery, carpet, wall coverings, table linens, bedding, and towels, among others. The most common textiles, their characteristics, and their applications are shown in Figure 13.35.

The interior designer is often called upon to estimate the quantity and costs of fabrics used for curtains, draperies, upholstery, and wallcoverings. See Appendix 2 for more detailed information on how to arrive at these figures.

FIGURE 13.35 Some typical fabrics and terms used in textiles for interiors. (Continued on the next four pages.)

FABRIC OR TERMINOLOGY	FIBER	CONSTRUCTION	DESCRIPTION	APPLICATION
Sheer Weight				
BATISTE	C,SYN	Plain weave or Dobby loom weave	Delicate fabric often printed with designs	D,V
CHEESECLOTH	C	Plain weave	Cotton woven with low thread count; inexpensive; used as utility fabric	V
CHIFFON	S,SYN	Plain weave	Delicate, sheer fabric; usually soft. Term is also used to note a soft finish given to a fabric, such as "chiffon velvet"	D
DIMITY	C	Plain, rib weave	Warp spaced ribs give fabric a striped appearance; printed or plain	D
MARQUISETTE	C,S,SYN	Open leno weave	Sheer fabric for curtains or draperies	D
NET	SYN,V	Plain weave	General term for open work mesh fabric made fine or coarse and open like a fish net	D,V
NINON	V	Plain or novelty weaves	Sheer curtain or drapery fabric; sometimes referred to as "triple voile"	D
ORGANDY	C,SYN	Plain weave	Fabric used primarily for curtains and drapes; given a stiff, crisp finish	D,V
SCRIM	C,L	Plain weave	Loose constructed weave used for curtains and bottom of upholstered goods as dust cover	D,U
SWISS	C,S,SYN	Plain weave	Thin sheer fabric with crisp finish and dotted pattern. Also known as "dotted swiss"	D

FABRIC OR TERMINOLOGY	FIBER	CONSTRUCTION	DESCRIPTION	APPLICATION
Sheer Weight (cont'd)				
VOILE	V	Plain weave	Sheer drapery fabric with tightly twisted yarns; variety of patterns and color	D,V
Light Weight				
ANTIQUE SATIN	S,SYN	Satin weave	A reversible fabric that imitates silk shantung, a basic type of weave	D,U
BIRD'S EYE	C,L,SYN	Plain or Dobby weave	Overall pattern of small diamond shapes that have a small dot that suggests a bird's eye	V
BROADCLOTH	C,S, SYN,W	Plain, rib, or twill weaves	Tightly woven with fine cross ribs. Wool weaves have finely napped texture in a single direction	V
CALICO	C,SYN	Plain weave	Similar to broadcloth; usually printed with all over patterns	D,V
CAMBRIC	C,L	Plain weave	Fabric with glazed or soft luster; inexpensive	V
CASEMENT	C,V	Plain or figured weaves (leno)	Produced with a variety of textures, colors, patterns; general term for sheer window curtain fabrics	D
CHAMBRAY	C,L,SYN	Plain weave	Fine quality fabric with linen-like frosted finish. Produced in many colors and patterns	D,V
CHINTZ	C	Plain weave	Fine cotton or cotton blend with solid colors or printed; primarily glazed surface	D,U,V
FIBER GLASS	SYN	Various weaves	Various fabrics made from yarn produced with glass fibers; fireproof	D,U,V
FLANNEL	V	Plain or twill weaves	Term for any woven fabric (usually cotton or wool) brushed to produce a soft nap surface	U,V
GINGHAM	C,SYN	Plain weave	Woven from two or more colored yarns; produced in checks, stripes, and plaids; launders well	D,U
HOMESPUN	C,L,W, V	Plain or hand woven	Fabrics of coarse, irregular yarns that imitate handwoven textiles; similar to tweed	WC
JASPE CLOTH		Plain weave	Variety of yarns produce irregular, stripped effect; made in subtle colors	D,U
LACE	C,SYN	Machine or handwoven	Fabric of decorative open-work patterns used for curtains and table coverings	D
MUSLIN	C	Plain weave	Bleached or unbleached utility fabric; inexpensive	D,U

FABRIC OR TERMINOLOGY	FIBER	CONSTRUCTION	DESCRIPTION	APPLICATION
Light Weight (cont'd)				
OSNABURG	C	Plain weave	Often unbleached; strong and durable; coarse construction	D,U
PERCALE	C,SYN	Plain weave	Finely woven cotton or cotton blend fabric of high thread count. Used mostly on bed sheets.	V
POPLIN	C,V	Plain or rib weave	Fabric with pronounced small scaled ribs; used as base cloth	D
SATEEN	C,SYN	Satin weave	Horizontal stain cloth used for linings; similar to satin; glossy	D,U,V
SATIN	S,SYN	Satin weave; but combined with other weaves	Basic type of weave; smooth, delicate fabrics produced with high sheens	D,U
SEERSUCKER	C,SYN	Plain weave	Fabric with crinkled strips and ribs	V
SHANTUNG	S,SYN	Plain weave	Fabric with elongated irregularities and textures	D
TAFFETA	V	Plain or rib weave	Fabric with fine horizontal lustrous ribbing	D
Medium Weight				
ARMURE	C,SYN	Jacquard weave	Fabrics with small repetitive pebble surfaces simulating chain mail. Also made as small patterns on plain weave backgrounds	U
BATIK			Term referring to the handprinting process of resist-tyeing by waxing and dyeing	D,V
BROCADE	C,S,SYN	Jacquard weave (satin or twill background)	Raised floral or figure designs on multicolored and contrasting surfaces	U
BROCATELLE	S,L,SYN	Jacquard weave	Similar to brocade, but exhibits high relief surface designs	D,U
BURLAP	J,C,H, SYN	Coarse plain weave	Also called "gunnysack." Heavy coarse texture of single-ply jute	D,V
CANVAS	C,L,SYN	Plain or twill weave	Soft finished or highly sized; solid colors, or various printed designs. Similar to duck	A,U, Awnings
CRASH	V	Plain or twill weave	Made with uneven yarns to produce rough texture; often printed	D
CREPE	V	Plain or satin weave	General classification of fabrics with highly twisted yarns and a crinkled or puckered surface	V
CRETONNE	C,L,SYN	Plain, twill, or satin weave	Decorative printed fabric; similar to chintz, but has dull finish	D,U
DAMASK	C,S,V	Twill or jacquard weave	Intricate design on contrasting ground; reversible and firm	D,U,V

FABRIC OR TERMINOLOGY	FIBER	CONSTRUCTION	DESCRIPTION	APPLICATION
Medium Weight (cont'd)				
DENIM	C	Twill weave	Small woven pattern; durable; good utility fabric	U,V
DRILL	C	Twill weave	Cotton fabric; resembles denim; typically gray color; but also colored or printed	U,V
DUCK	C	Plain, basket, or oxford weave	Durable utility cotton fabric; often finished with protective treatments. Similar to canvas	A,U,V
EMBROIDERY	V	Hand or machine stitched on a ground	Threads sewn into a fabric for decorative surface ornamentation	V
GRASS CLOTH	V	Plain, unwoven, and hand weaves	Generic name for various fibers or grasses often secured on backing sheets of plastic or paper for wall coverings	WC
HOPSACKING	J,H,C,SYN	Plain or basket weave	Rough surface, loosely woven fabric; durable and often given soft finish	D,U
JERSEY	W,SYN	Knitted	Vertically knitted fabric with stretching characteristics	U
MONK'S CLOTH	C,J,H	Basket or plain weave	Fabric made by mixing cotton with various fibers; coarse and heavy; used mostly in its natural color	D,U
OXFORD CLOTH	C	Variations of basket or plain weave	Often used as base fabric; available in checks and stripes; used for curtains and shirting material	D,V
PAISLEY	V	Plain weave	Term applied to a fabric printed with an intricate all-over pattern of abstracted curved forms	V
PLAID	V	Plain or twill weave	Woven or printed designs in bars or stripes crossing one another	V
SAILCLOTH	C,L	Plain or basket weave	Similar to duck, but often heavier; used for outdoor items such as awnings	A,D,U
SERGE	V	Twill weave	Crisp fabric made in natural or synthetic fibers; smooth finish	V
TERRY CLOTH	C,L	Jacquard or plain weave	Absorbent fabric often used for towels	D
TICKING	C,L	Satin or twill weave	Stripped, strong, durable; often used as mattress or pillow covers	V
Heavy Weight				
CHENILLE	C,SYN,V	Plain weave	Fabric with short pile yarns; resembles fuzzy caterpillars	V

FABRIC OR TERMINOLOGY	FIBER	CONSTRUCTION	DESCRIPTION	APPLICATION
Heavy Weight (cont'd)				
CORDUROY	C,SYN	Pile weave over twill or plain weave	Raised cords of various sizes producing distinct lines with cut-pile ribs	U,V
FELT	W,C,SYN	Nonwoven fabric	Felts are made in many colors, weights; produced by joining fibers with heat and moisture	V,WC
FRIEZE	C,SYN,W	Jacquard	Heavy weight fabric with rough surface of uncut looped piles; often of wool and cotton	D,U
MATELASSE	C	Jacquard weave	Weave of double fabrics with quilted or puckered surface appearance	D,U
NEEDLEPOINT	W	Jacquard or handwoven	Wool yarn hand or machine stitched over backing fabric	U
PLUSH	W,SYN	Plain weave variation	Similar to velvet, but has longer pile; often imitates animal fur	U
TAPESTRY	C,L,W	Handmade and Jacquard weaves	Heavy fabric with pictorial patterns; also used as wall hangings	D,U
TWEED	V	Plain, twill novelty weaves	Originally made of wool, but now a combination; colored, stripped, or checked	U,V
VELOUR	V	Cut-pile weave	Durable, stiff pile with velvet-like texture	U,V
VELVET	V	Pile weave	Durable fabric with cut or uncut loops; dull or shiny; velveteen made with sheared, close, short pile	U
WORSTED	W	Various	Compact smooth yarns from combed and carded wool fibers	V

KEY TO SYMBOLS

FIBER

C = Cotton S = Silk
H = Hemp SYN = Synthetic
J = Jute V = Various
L = Linen W = Wool

APPLICATION

D = Draperies and/or curtains
U = Upholstery
V = Various
WC = Wall covering

MISCELLANEOUS MATERIALS

Rubber, Cork, and Leather

Rubber used for interior applications today is primarily a combination of synthetic materials, although it can also be obtained from rubber trees. Rubber is used in flooring in varying

thicknesses, types, and color. It can be made as solid sheets with raised circular or ribbed patterns or as interlocking tiles. Rubber flooring is used in locker rooms, air terminals, malls, elevators, and offices. Rubber can be combined with various nylon fibers and used for stair nosings, wall bases, and roofing membranes.

Cork is produced from the bark of a tree grown in the Mediterranean region. It is made in sheet or tile form and is used both as flooring and as wall surfaces. It is insulative, elastic, and fairly soft. Cork can be combined with vinyl or urethane for resistance to water and stains for use in kitchen or bath areas.

Leather comes from tanning hides of animals (primarily cattle and swine) and is cut into varying sizes and thicknesses. Leather can be dyed, embossed, and treated for many surface finishes. It is pliable, durable, and used for clothing, furniture, and other decorative elements.

Paint and Related Coatings

The interior designer uses paint and other coatings as design mediums, not just protective finishes. Color and the light-reflecting or absorption capabilities of these finishes make definite design statements. These can be bold, aggressive geometric relationships or quiet, subtle organic creations.

Paints are made from a wide variety of synthetic and natural materials. The designer needs an understanding of their types and characteristics to properly select the best paint for a situation (Figure 13.13). Paints can be applied to a variety of surfaces, such as walls, floors, ceilings, furniture, and cabinetry. Paints are composed of pigment (for color) carried in a vehicle and have other additives, such as fillers and driers, to provide specific applications. These vehicles are primarily water, oil (petroleum), or synthetic-based products.

Paint finishes range from flat or matte sheens to high-gloss, shiny surfaces. In between are satin or eggshell and semigloss finishes, which give a softer luster than high-gloss paints, yet are more reflective than flat paints. Paints are also made as texturizers and produce various rough textures.

Paint primers are made to serve as an undercoat application for paint finishes where the subsurface is not suitable for a final paint coating. However, some finish coats are self-priming. Primers and other sealers are used to provide a gripping base for paints and prevent the waste of expensive final coats being absorbed into a porous substrate.

REFERENCES FOR FURTHER READING

Corbman, Bernard P. *Textiles: Fiber to Fabric*. New York: McGraw Hill, 1983.

Guedes, Pedro, ed., *Encyclopedia of Architectural Technology*. New York: McGraw-Hill Book Co., 1979.

Harris, Cyril M. *Dictionary of Architecture and Construction*. New York: McGraw-Hill, 1975.

Jackman, Diane, and Mary Dixon. *The Guide to Textiles for Interior Designers*. Winnipeg, Canada: Peguis Publishers Ltd., 1983.

Larson, Jack Lenor, and Jeanne Weeks. *Fabrics for Interiors*. New York: Van Nostrand Reinhold, 1975.

Lyle, Dorothy Siegert. *Modern Textiles*. New York: John Wiley, 1983.

Ramsey, Charles George, and Harold Reeve Sleeper. *Architectural Graphic Standards*. 8th ed. New York: Wiley, 1988.

Reznikoff, S.C. *Interior Graphic and Design Standards.* New York: Whitney Library of Design/ Watson-Guptill, 1986.

————. *Specifications for Commercial Interiors.* New York: Whitney Library of Design/Watson-Guptill, 1989.

Riggs, J. Rosemary. *Materials and Components of Interior Design.* 2nd ed. Englewood Cliffs, N.J.: Prentice Hall, 1989.

Rupp, William, and Arnold Friedmann. *Construction Materials for Interior Design.* New York: Whitney Library of Design/Watson-Guptill Publications, 1989.

Smith, Betty F., and Ira Block. *Textiles in Perspective.* Englewood Cliffs, N.J.: Prentice Hall, 1982.

Smith, R.C. *Materials of Construction.* 3rd ed. New York: McGraw-Hill, 1979.

Sterling Publishing Co., Inc. *The Encyclopedia of Wood.* New York: Sterling Publishing Co., Inc., 1989.

C H A P T E R 1 4

ARCHITECTURAL SYSTEMS AND INTERIOR FINISHES

This chapter is organized the way buildings and interiors are constructed—from the ground up. However, buildings are actually designed structurally to hold weights of materials and people from the roof down, cumulatively adding these loads until they reach the ground. Buildings must not only support these types of loads but also counteract forces from wind, snow, and even earthquakes.

A building consists of various architectural systems that serve as floors, walls, and ceilings. These systems form spaces, hold up the building as shelter, and provide finish materials that enrich our physical and emotional needs. In some situations, such as the TWA terminal building at Kennedy Airport (Eero Saarinen, see Figure 3.20), the walls, roof, and ceiling structure form an integral, fluid design statement. Although any one of these can be viewed as a separate design element, together they are an integral part of the interior and of the building itself. They are not just a background element but an active generator of space, form, and surface quality that enhances our spaces.

Materials are chosen for structural integrity but can also contribute to the interior expression of space, form, finishes, and character. Materials have been shaped into basic structural forms over the centuries. A material's characteristics, such as strength and form, influence both the exteriors and the interiors of buildings.

This chapter will discuss the basic architectural systems of a building—floor, wall, and ceiling systems. The foundation system is not included, for it varies according to the type of building and soils and is designed by architects and engineers. It is not an integral part of interior spaces—unless, of course, there is a basement level.

Last, the many finishes available within each of the architectural systems will be presented. Criteria for selecting these materials and their finishes will be highlighted. Although components such as doors and windows (Chapter 15) are an integral part of the systems, they generally do not comprise a major structural element and so are not discussed here.

STRUCTURAL SYSTEMS FOR BUILDINGS

Although it is the architects and the engineers who are primarily involved in designing a building's structural system or remodeling it, the interior designer must be aware of fundamental principles and forms of structures while designing stairs, cutting openings in walls (both bearing and nonbearing), and designing ceiling systems. Because the interior designer often works as a team member with architects, engineers, and builders, he or she must be capable of conversing with these other professionals about the interface of structures and materials within the interior environment.

Structural Design

Historically, building construction was based upon trial-and-error knowledge of how far a material and a structural shape could be stressed before they failed. Later, with the integration of mathematics and better testing methods, new materials and analytical design methods were developed. Structural analysis of the anticipated performance of materials used within a system led to the field of structural design and theory. These improved methods allowed designers to predict performance of a system by using calculations rather than by building and testing. Today's building designs can be programmed into a computer, allowing variations in proportions, materials, and structural performance to be explored quickly.

The structural system of a building enables it to withstand loads against gravity, wind, earthquakes, and other impacts, such as vibrations (Figure 14.1). The building structure is designed to counteract these forces and maintain a state of equilibrium, or static balance. If these forces overpower the system's ability to resist them, failure can occur—a high wind could blow the building over, or an earthquake might shake the building to the ground.

Structural Characteristics of Materials

Materials used as structural elements (columns, beams, and walls) are selected to resist various stresses. If the material is overstressed, it may go into deformation, or change in shape.

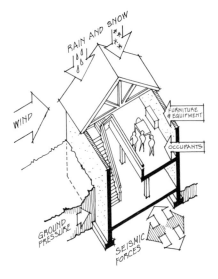

TYPES OF LOADS ON A BUILDING

□ DEAD LOADS		FIXED LOADS OF A BUILDING SUCH AS STRUCTURE AND MATERIALS
□ LIVE LOADS		MOVING LOADS SUCH AS OCCUPANTS, RAIN, SNOW
□ DYNAMIC LOADS		
	WIND	AIR PRESSURE FROM WIND
	IMPACT	VIBRATION, SHOCKWAVES, ETC.
	SEISMIC	EARTHQUAKE MOVEMENT

DEAD LOADS ARE FIXED WEIGHTS WHERAS THE OTHER LOADS CAN VARY IN MAGNITUDE, POINT OF APPLICATION, AND DURATION.

FIGURE 14.1 The structural elements of a building must withstand dead loads, live loads, and dynamic loads.

This change might be permanent, such as occurs with a piece of steel rod that will not return to its original shape when bent, or temporary, as in the case of a wood stick that springs back to its original position when bent. These deformations could be major, leading to failure of the system, or minor, within the limits for the material to function. For example, in the latter case, a wood beam or bookshelf might sag from a heavy load but not fail.

Materials can be selected for their structural ability to withstand two basic stresses—compression or tension. Compressive stresses are those placed on a material from a load that tends to crush it; an example is a heavy weight supported by a column, which places the column in compression.

Tension is the force that pulls a material apart; the tensile strength of a material resists this force. The vertical steel cable holding a heavy chandelier from a ceiling is under a tensile load.

A material can also be subjected to a combination of these and other complicated forces. When a beam is supported at each end by columns, the beam's material is placed in both tension and compression (Figure 14.2). In this example, a steel beam will perform better than a stone beam, since stone has less tensile strength than steel does. It is because of this factor that earlier civilizations could not span great distances with stone or other natural materials.

FIGURE 14.2 A material used in a structural system can be subjected to several different forces, depending on the direction, magnitude, and point of loading.

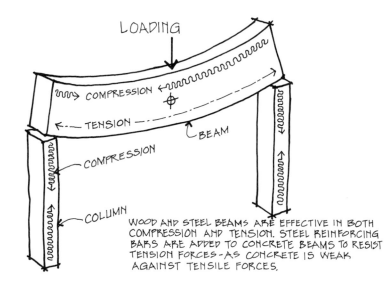

LOADING

COMPRESSION

TENSION

BEAM

COMPRESSION

COLUMN

WOOD AND STEEL BEAMS ARE EFFECTIVE IN BOTH COMPRESSION AND TENSION. STEEL REINFORCING BARS ARE ADDED TO CONCRETE BEAMS TO RESIST TENSION FORCES—AS CONCRETE IS WEAK AGAINST TENSILE FORCES.

Basic Structural Elements

Most buildings are composed of one of three basic structural elements—frame (skeleton), bearing wall (planar), or envelope (skin or shell) (Figure 14.3). However, some are constructed either of a combination of these types or of specialized components, such as an air-inflated structure assisted by steel cables. A building's shape and architectural design often reflect the basic structural form. In turn, the interiors might also have spaces and characteristics related to the exterior form and structural components.

The basic elements used in a building have developed over the centuries from post and lintel to arches, vaults, domes, and shells to suspension and tensile structures. Each has particular

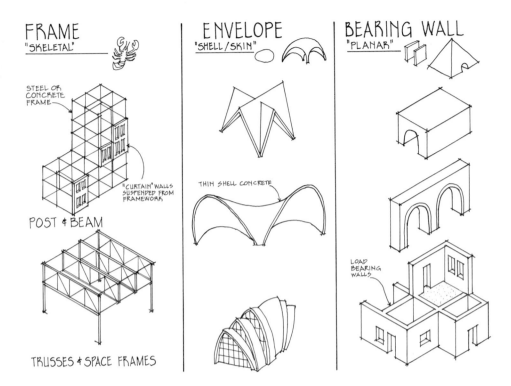

FRAME
"SKELETAL"

STEEL OR
CONCRETE
FRAME

"CURTAIN" WALLS
SUSPENDED FROM
FRAMEWORK

POST & BEAM

TRUSSES & SPACE FRAMES

ENVELOPE
"SHELL/SKIN"

THIN SHELL CONCRETE

BEARING WALL
"PLANAR"

LOAD
BEARING
WALLS

structural advantages and can exhibit a unique form and expressive character to a building and its interiors.

POST AND LINTEL

One of the first structural systems was the post and lintel arrangement, today referred to as column and beam. In this system (Figure 14.4), stone lintels (beams) were placed between columns to span the posts (columns) that in turn supported the roofs of these buildings. However,

FIGURE 14.4 Post-and-beam systems can be constructed as simple spans or be integrally made into composite sections, thus increasing their structural characteristics.

POST & BEAM SYSTEMS

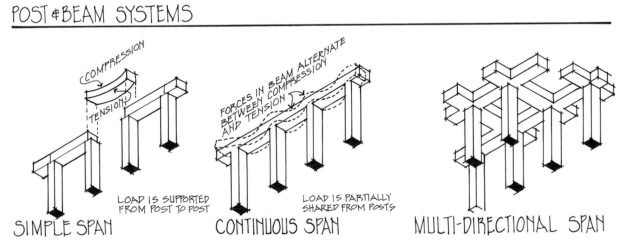

COMPRESSION

TENSION

LOAD IS SUPPORTED
FROM POST TO POST

SIMPLE SPAN

FORCES IN BEAM ALTERNATE
BETWEEN COMPRESSION
AND TENSION

LOAD IS PARTIALLY
SHARED FROM POSTS

CONTINUOUS SPAN

MULTI-DIRECTIONAL SPAN

the stone lintel spans were very short, creating a forest of columns in Egyptian and Greek buildings. The post and lintel principle was expanded to use large, wide slabs of stone rather than narrow lintels. No doubt timber was also used for beams, but unlike those of stone, timber beams have not survived over the centuries to give evidence of their widespread early use.

ARCHES AND VAULTS

In early times, stone and bricks were used to construct simple cantilevered sections called corbeled arches, which could span approximately 6 feet (1828 mm) (Figure 14.5). The Romans introduced the true arch, which could span about 80 feet (24.3 m). Later, the brick was replaced by concrete, allowing the arches to span greater distances and building sizes. Arches were further modified into Islamic and Gothic pointed styles, which reached great heights.

Although arches are generally associated with stone, brick, and concrete, other materials, such as wood, iron, and steel, have been used to construct them, often imitating the true arch. The steel arch for the Gateway to the East in St. Louis is an arch form, but it has a steel inner skeletal structure and steel skin that help transfer the loads of weight and wind to the ground (Figure 14.6).

FIGURE 14.5 BELOW, LEFT Arches and vaults transfer loads from above to the ground plane.

FIGURE 14.6 BELOW, RIGHT The St. Louis arch is a symbolic image of a gateway between the East and West. Structurally, it is a true arch that transfers loads to the ground.

CORBELED ARCH

TRUE ARCH

BARREL VAULT

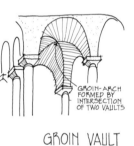

GROIN-ARCH FORMED BY INTERSECTION OF TWO VAULTS

GROIN VAULT

Arches extended in one direction produce the simple vault structure. These vaults provide more structural support than an arch in a lateral direction, help span greater distances, and provide more interior space. A groin arch is produced by the right-angle intersection of two vaults and permits the formation of a bay, often made open on all sides for passage or windows. These vaulting techniques were developed in the Gothic pointing and ribbed construction in cathedrals (Figure 2.21); the vaults so formed were topped with domes in the Renaissance. As the arches and vaults grew higher and thinner, flying buttresses were used to brace them and help transfer loads to the ground.

DOMES AND SHELLS

Domes are an important structural element developed by the Romans in the first century. The Pantheon (Figure 2.18) is an impressive dome structure of unprecedented size for its time (c. 120–124 A.D.). Domes became popular during the Renaissance to span large spaces, reach great heights, and cap building forms, as the Villa Rotunda in Figure 2.24.

Shell structures were developed early in the twentieth century and engineered into the hyperbolic paraboloid (Figure 14.7) in both concrete and timber.

FIGURE 14.7 Concrete shell structure built as a hyperbolic paraboloid.

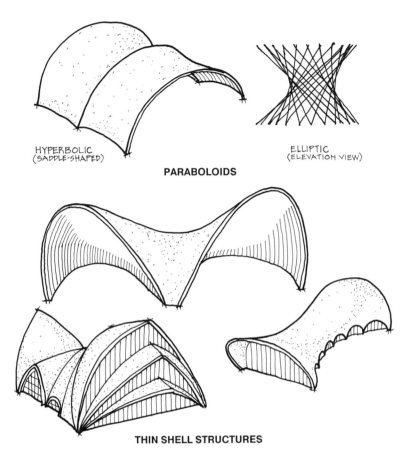

HYPERBOLIC
(SADDLE-SHAPED)

ELLIPTIC
(ELEVATION VIEW)

PARABOLOIDS

THIN SHELL STRUCTURES

Shells are vaultlike in form but much thinner and generally of reinforced concrete construction. They might be curved or folded in one direction like a vault or in two or more directions like the TWA Terminal at Kennedy Airport (Figure 3.20).

TRUSSES AND SPACE FRAMES

Simple, truss-like structures made of timber were developed during Roman times, but it was not until the nineteenth century that true large-span timber trusses and their complex forces were used. Large-span trusses were made of timber or iron and used for bridges as well as large buildings where great spans were needed.

In the twentieth century, these trusses were triangulated in three dimensions to produce what is commonly called space frames (Figure 14.8). The trusses can be used flat and supported on columns to span large roofed areas, generated as dome shapes such as Buckminster Fuller's geodesic domes, or used vertically for wind reinforcing of glazing and support columns.

TENSILE AND SUSPENSION STRUCTURES

Tensile structures support and encompass space based on a material's tensile properties. Many such structures are made in tentlike shapes, such as the roofs of buildings (Figure 14.9). Later, tensile structures were developed into large air-inflated structures that span great distances and are used primarily in sports arenas (Figure 14.10).

Suspension structures are a variation of tensile structures. The Golden Gate Bridge in San Francisco is a suspension structure made possible by the development of iron and steel. Although used mostly for bridges, suspension structures are also used for some building construction.

FIGURE 14.8 Space frame construction can span large areas with a minimum of supporting columns.

FIGURE 14.9 Many tensile structures are tent-shaped forms consisting of fabric stretched on steel cables and poles.

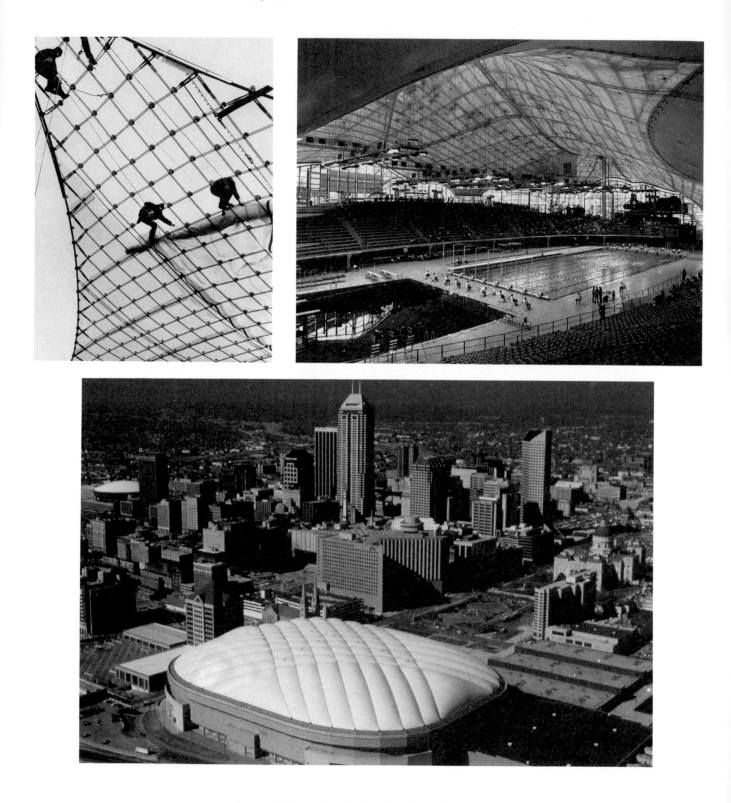

FIGURE 14.10 The Hoosier Dome in Indianapolis is a tensile structure constructed of fabric reinforced with steel cables and inflated with air.

Structural Systems

Most buildings are composed of structural systems, such as the foundation, floor system(s), bearing walls (or beams and columns), and roof/ceiling structure (Figure 14.11). These systems are interdependent and react to the various loads imposed on them, transferring these forces from the roof to the foundation below. In some instances, such as a geodesic dome or A-frame structure, the roof and wall are one element.

These systems might contain other elements, such as doors, windows, balconies, stairs, or separate ceilings suspended between floors or beneath a roof. Finish materials can also be an integral part of, or be applied to, the basic structure.

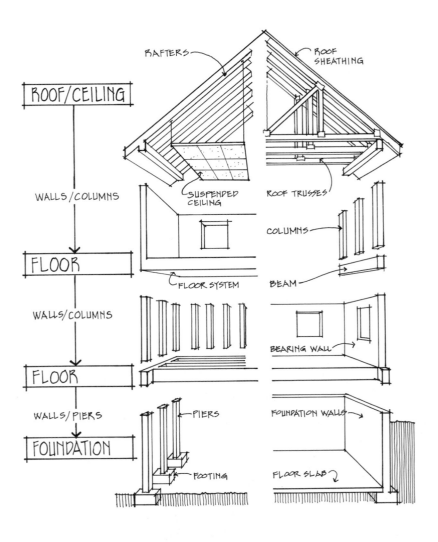

FIGURE 14.11 Most buildings have a structural system of a foundation, floor, walls (or columns), and ceiling/roof assemblies.

FLOOR SYSTEMS

Floors not only support the building's contents and occupants but also can become strong architectural elements that influence the character of a space, imparting a sense of stability and flow. Varying floor levels by a step or two can define different activities within an open space. Also, different floor finishes can suggest separate areas and traffic patterns.

The type of materials used for the structural design of flooring depends on several factors, such as the live loads, the dead loads (materials), and economics. In multistory buildings, the floor also provides acoustical control and is part of the fireproofing assembly to keep potential fires from spreading from floor to floor.

In some cases, the primary structural floor also serves as the finished flooring material. Floors that do not serve as the finished flooring material are often referred to as the subfloor. For example, a concrete or plywood floor system may not be appropriate for the desired finish and therefore serves only as a structural subsurface for an applied finish material.

Three primary types of flooring systems, used alone or in combination, are wood, steel, and concrete (Figure 14.12).

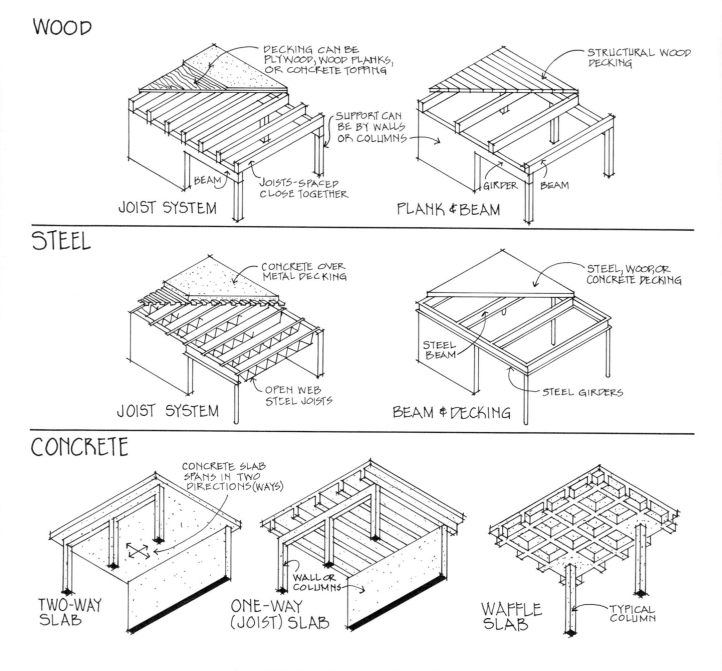

FIGURE 14.12 Three primary types of materials used in floor systems.

Wood Floor Systems

Wood floor systems are used primarily in residential and small commercial buildings because of their low cost, availability of materials, and ease of cutting and nailing for construction. However, concrete floors are also used in many multi-floor buildings for garages, for basements, and as the first level when placed on the ground. Most building codes restrict the heights and floor area of wood-framed structures, mainly because of the possibility of fire in large wooden assemblies. The codes further set minimum standards for the sizes, materials, fireproofing, and construction details of these wood structures.

Wood floor systems are typically constructed by the joists and decking system or the plank and beam system. In the former, floor joists are closely spaced on centers (often not to exceed 24 inches, or 609 mm) and overlaid with sheets of plywood, wood planks, or even thin concrete toppings. These joists can be solid lumber, composite sections, or wood-floor trusses. The other common method of wood framing, the plank and beam system, utilizes joists (that are now referred to as large beams) that are spread farther apart and spanned by thick wood planks. Sometimes the underside is left exposed as a ceiling for the floor below.

Steel Floor Systems

Steel floor systems are used primarily in nonresidential buildings as an integral part of a steel skeletal frame. Steel has great tensile and compression strengths. It can span longer distances than wood systems and be constructed higher for tall skyscrapers. However, steel can melt when subjected to high temperatures and must therefore be protected by fireproofing methods or encased in concrete.

Steel members are manufactured in standardized sizes and are used in a manner similar to wood joists, beams, and decking. However, spans can be greater and sections can be thinner than with wood members. Steel assemblies are welded, riveted, or bolted together. Most steel joist systems are covered with a ribbed metal decking over which 2 to 4 inches (51 to 102 mm) of concrete is poured to serve as the floor surface.

Concrete Floor Systems

Concrete floor systems can be a slab on grade or can serve as the floor systems in multilevel buildings. These floors can be poured as slabs and integral beams or made as precast units and delivered to the job site for erection. Concrete floors are reinforced with steel rods and designed as one- and two-way slabs, waffle slabs, flat slabs, and other configurations. These types generally refer to the way the concrete floor slab is poured and supported by the integral beams— from one or multiple sides or by coffered shapes, as shown in Figure 14.12.

In concrete systems, the entire structure of floors and columns is of reinforced concrete rather than all steel. Concrete construction is fireproof, since concrete will not burn. However,

care must be taken to protect the inner steel reinforcing within concrete because high temperatures can cause the steel to weaken.

Specialized Floor Systems

Specialized floor systems are designed for specific functions within buildings. For example, access flooring is a modular raised flooring system placed over a floor structure to provide easy access to wiring, air ducts, and plumbing needs. This type of flooring is primarily used in offices and computer rooms, where access is needed for maintenance, repairs, or changes to equipment connections.

FLOOR FINISHES AND SPECIFICATION CRITERIA

Floor materials can be the finished floor or can be overlaid with a floor covering. However, when discussing the wearing surface of a floor, we generally refer to it simply as the floor finish. Floor materials and their finishes are classified as hard, resilient, and soft. Hard (or nonresilient) flooring includes concrete, stone, brick, tile, and wood. Resilient floorings are vinyl, rubber, cork, and compositional tile. Soft floorings are carpeting and rugs.

Floor finishes are selected for their aesthetic, structural, durability, and maintenance qualities. These finishes are chosen for their harmonious relationship to the interior space, the contents, and the users. Each type of finish can impart a certain feeling or attribute to our activities, expressions, and quality of life and heritage. Stone floors, such as granite, can portray a sense of formality, prestige, or grandeur. Brick can be reminiscent of handcrafted works and impart informality and warmth. Ceramic tile offers a variety of visual excitement, permanence, and some of the grandeur of stone. Wood flooring can exhibit many different characteristics, depending on the species, how the flooring is installed, and its finish. Carpeting provides a visual and tactile quality that can lead the eye through space or can accent with pattern, color, and focal points.

Several considerations must be taken into account when selecting flooring materials for interiors (Figure 14.13). Functionally, the flooring must withstand traffic over a specific period of time and resist wear. For economic considerations, a designer must look at the initial cost, plus installation and maintenance costs, for the material, weighing these against the number of years it will last. An analysis of a cost per year (gained by dividing the total installed cost by life expectancy in years) may show that in the long run a more expensive, more durable material will be more economical than a less costly type.

Flooring materials are generally priced by the square foot (hard materials) or square yard (resilient materials and carpets). To find the square yardage, divide the square footage of the area by nine. Actual square footage or square yardage will generally give a fair estimate of the flooring amounts needed; however, material waste and special conditions during installation must also be calculated into the estimate. See Appendix 2 for more-detailed information on how to estimate floor finish material quantities.

CRITERIA	SPECIFICS
AESTHETICS	Visual and tactile qualities. Color, texture, pattern. Appropriateness to overall design concepts. Light reflectance or absorption.
ECONOMICS	Initial material and labor costs for installation. Possible costs for subsurface preparation. Warranty costs.
MAINTENANCE	Cleanability and frequency required. Costs of maintenance service.
CODE REQUIREMENTS	Flame resistance-wear resistance. Weight. Compliance for handicapped or special population use.
FUNCTIONAL CRITERIA	Acoustic and wear resistance properties. Soil repellency, hiding, and removal. Possible solar and energy benefits or drawbacks.

FIGURE 14.13 Checklist for specifying flooring systems and finishes.

Hard Flooring

Hard flooring materials are used for their high resistance to abrasion and durability. In general, they do not absorb liquids and are more impervious than other types to soiling. However, they are heavier and often more expensive. Some hard materials can also be damaged by heavy objects; for example, a vase dropped on a ceramic tile floor can cause breakage of the vase and the flooring. Hard materials also tend to reflect sound, creating acoustical problems in spaces with floors and walls of hard surfaces.

Hard flooring materials, such as concrete, stone, and brick, can be used in sunspaces and greenhouses as thermal mass (Chapter 11) for solar applications. Ceramic tile is also used for heat storage when applied over a thick concrete subfloor to increase its compositional mass.

Most hard flooring (except wood) tends to be cold to the touch unless it is heated by the sun or insulated from the cold. Area rugs are therefore often used over hard flooring.

CONCRETE
Concrete flooring is used mostly for structural support and is usually surfaced by other materials. However, garages, warehouses, manufacturing plants, and some unique or stylized interiors use concrete as the finished material.

Concrete floors can have a rough, textured, patterned, or smooth trowel finish. They can also be colored or have a finish of exposed stone aggregates. Concrete used as the final finish material can be painted or left in its natural color and is usually sealed with various substances, such as polyurethane, to help make the surface easier to clean and maintain.

STONE
Stone floor finishes are usually more expensive than most others but are very durable and beautiful (Figure 14.14). They are generally installed over a concrete subsurface and laid in various patterns, either random or coursed. They are set in a cement bed (thick set) or with special adhesives (thin set) and grouted at the joints. Most stone floors require only a damp mopping to clean, but some are waxed and polished to a high sheen.

All the stone materials listed in Chapter 13 are used as flooring. These include granite, travertine, marble, and slate. Terrazzo is popularly used for a floor finish where a high degree of

FIGURE 14.14 The marble floor in this hotel lobby features strong visual patterns within the material and is used as both floor material and countertops. The wood on the counter is installed in matching sizes and grain variations.

durability and low maintenance are needed. Colored marble chips are mixed with concrete and poured into floor areas divided by metal strips (to reduce cracking), then ground smooth and polished.

BRICK

Although most bricks are made of clay, some are made of concrete. Many colors, textures, finishes, and patterns of brick are available for interior and exterior use. Most bricks used for flooring, called pavers, are specially made and come in all shapes and thicknesses.

In most cases, brick flooring is sealed much like concrete to prevent it from absorbing spills. Brick is laid on a concrete or sand base (the latter popular in the Southwest) and can have the joints grouted like a wall or be closely set together with sand or dry cement, which is then brushed into the joints.

TILE

Tile may be used for either interior or exterior floor surfaces. The ceramic, quarry, and mosaic tiles described in Chapter 13 have commercial and residential flooring applications. Tile comes in a seemingly endless variety of shapes, textures, sizes, thicknesses, finishes, and colors (Figure 14.15). Most tiles have matching trim pieces for wall bases, stair nosings, and room corners. Tile is produced in varying densities and glazes that allow some to be used in wet locations (showers) or waterproofed installations (swimming pools).

FIGURE 14.15 Ceramic tiles can be used for durable and scrubbable floor surfaces as well as counter-tops and faces, such as in this cafeteria.

Tiles are installed over concrete surfaces and wood using both thick- and thin-set methods. Grouts for the joints are colored and lock the flooring together in a hard, durable surface. Some grouts are integrally siliconized and resist soiling, and others can be top sealed with special plastic coatings.

Special care must be taken when specifying tiles for flooring because some are slippery when wet. Most floor tiles are textured to some degree, have a matte face, or are installed in small pieces to prevent the possibility of slipping. Floor tiles are generally stronger, and have more durable finishes, than wall tiles.

WOOD

Wood flooring is used as a subfloor or applied as a finish material over a concrete or plywood subfloor. Hardwoods are most common for flooring, although some softwoods can be, and often were, used in older buildings. The most popular hardwood species for flooring are oak, maple, and birch (Figure 14.16).

Various organizations set standards to grade the quality of manufactured hardwood and softwood flooring. Gradings are based on length, number of imperfections (such as knots), and appearance. Higher grades have more-even visual characteristics and are more expensive.

Wood flooring is installed over concrete by using special nailing strips, called sleepers, embedded in, or attached to, the concrete surface. When installed over wood subsurfaces, the flooring is screwed, nailed (toe or blind), or glued down. The nailing or screwing methods often use a specialized layer of building paper between finish and subfloor to prevent any future "squeaking" of the two wood faces if the attachments become loose.

Wood flooring is manufactured in three general types—strip, plank, and parquet (Figure 14.17). Wood flooring is available with prefinished and unfinished faces; the prefinished is impregnated with stain colors and acrylic coatings for durability and appealing character. Some wood flooring is also treated with fire-retardant materials.

STRIP FLOORING. Strip flooring is made of tongue and groove boards and ranges in width from 1½ inches to 2¼ inches (38 to 57 mm). It is available in varied wood species, lengths,

FIGURE 14.16 The hardwood floor in this art gallery adds warmth and gives a distinctive characteristic to the space.

and thicknesses. The tongue and groove edges provide interlocking, and grooves cut on the backside facilitate laying over uneven subsurfaces.

PLANK FLOORING. Plank flooring is produced in widths from 3 to 8 inches (76 to 203 mm), and three different widths are usually used on a project. The planks are tongue and grooved and are available in varied lengths to produce random patterns when installed. Plank faces have beveled or square edges that produce a v-joint or flush face flooring when laid together.

Originally, plank flooring was installed using wooden plugs inserted into holes bored near the end of each board. These plugs were cut off and sanded smooth. Later installation techniques used screws countersunk into the ends, with wooden plugs added, sanded, and finished to show contrasting patterns. Today, nailing, screwing, and gluing are still used, with some planks premade with false wooden plugs.

PARQUET FLOORING. Parquet flooring is made of hardwood and varies in thickness from ⅜ to ¾ inches (90 to 190 mm). These small pieces can be joined with tongue and groove connections into a variety of patterns. Although parquet was originally installed as individual pieces of wood blocks (and still is in custom jobs), it is now produced in factory-made squares held together with mesh or metal spines. Some of these squares are laminated sections of several wood layers.

Resilient Flooring

Flexibility, or give, is one of the main advantages of resilient flooring materials. Their resilience helps to resist permanent indentation while providing comfort and quietness underfoot. Resilient flooring is relatively economical compared to other hard flooring materials. It is durable and, depending on the finish, can be relatively low maintenance.

Resilient materials include cork, rubber, and most vinyls. Resilient flooring is available in both tile and sheet form.

CORK

Cork tiles are made from chips of cork mixed with resin binders, rolled into sheets, and cut into tiles. Cork tiles are usually treated with a vinyl coating or impregnated with plastics to make them more durable, yet either process may decrease their resiliency. Cork tiles can be used in residential or nonresidential applications with low or limited traffic. Cork is a very insulative material and should not be used over floors where radiant heating systems are used or where solar gain is desired.

RUBBER

Rubber flooring material, now primarily synthetic, is made of butadiene styrene rubber and other synthetic materials. It is very resilient, durable, has good dent resistance, and is available in two forms, flat surface with marbleized pattern or a solid color with a variety of raised surfaces. The raised surface was designed to knock dirt and mud off shoes and to provide water drainage from the face to prevent slippage. Rubber tiles are excellent for entrances where dirt and mud can be tolerated and where traction is needed on wet floors.

VINYL

Vinyl flooring is a material composed primarily of polyvinyl chloride (PVC), a plastic solution that hardens to a solid film. The three basic types of vinyl flooring are vinyl composition, vinyl tile, and sheet vinyl.

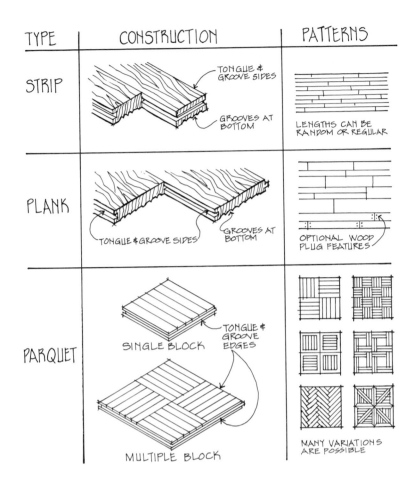

TYPE	CONSTRUCTION	PATTERNS

STRIP — TONGUE & GROOVE SIDES / GROOVES AT BOTTOM — LENGTHS CAN BE RANDOM OR REGULAR

PLANK — TONGUE & GROOVE SIDES / GROOVES AT BOTTOM — OPTIONAL WOOD PLUG FEATURES

PARQUET — SINGLE BLOCK / TONGUE & GROOVE EDGES / MULTIPLE BLOCK — MANY VARIATIONS ARE POSSIBLE

FIGURE 14.17 Three types of wood flooring and their patterns.

VINYL COMPOSITION. Vinyl composition (or reinforced vinyl) is a blend of vinyls, resins, plasticizers, fillers, and coloring agents formed into sheets under heat and pressure. The sheets are then cut into tiles. Asbestos fibers were originally added to these vinyl compositions but have been connected with adverse health effects and therefore eliminated.

Vinyl composition tiles are inexpensive, easy to install, and easy to maintain. Compared to solid vinyls and solid rubber, however, they exhibit low impact resistance, poor noise absorption, and semiporous qualities.

VINYL TILES. Vinyl tiles are made mostly of pure PVC and small amounts of other additives. Vinyl tiles are referred to as solid vinyl, since the color is not just on the surface, but throughout the depth. They are available as solid colors, in veined marble and travertine designs, and in brick, slate, and stone patterns. Vinyl tiles are tough and flexible, which makes them effective for floor and wall base trims. They are moderate in cost, durable, dent resistant, and easy to maintain. They can be produced in any degree of transparency. Some companies manufacture a floor covering with a real wood veneer sealed between layers of solid vinyl. The top layer is composed of a transparent pure vinyl that permits the natural wood color, grain, and texture to be visible, yet protected.

SHEET VINYL. Sheet vinyl is easy to maintain, having fewer seams to collect dirt than do tiles. Sheet vinyl is made in widths of 6, 9, or 12 feet (1828, 2743, or 3657 mm). The two methods of producing patterns in the manufacturing of sheet vinyl are inlaid and rotogravure. Inlaid vinyls are made of thousands of tiny vinyl granules that are built up in layers and fused by pressure and heat. The color and pattern penetrate the vinyl layers and will not wear off. Inlaid

vinyls are generally soft, thick, and very durable, making them a good choice for nonresidential applications or heavy traffic areas.

Rotogravure vinyls, also referred to as rotovinyls, are made through a combination of photography and printing. An image is photographed, printed on the sheet vinyl, and protected by a wear layer coating of vinyl resin or urethane. The vinyl resin coating produces a satin-gloss surface; the urethane coating creates a high-sheen appearance. The wear layer of vinyl resin is usually thicker than that of urethane.

Most sheet vinyls have an inner core of foam or a foam backing to cushion them and make them more resilient. Most sheet vinyls have a no-wax finish, which helps them to maintain a shiny surface appearance. However, this finish may wear off when subjected to heavy traffic. Since sheet vinyl is very flexible, it can in some cases be coved up on the wall to form its own base. Sheet vinyl is also made with nonconductive properties to reduce static electricity charges in areas, such as operating rooms, where sparks might ignite flammable gases.

Soft Floor Coverings

FIGURE 14.18 Carpet tiles provide an excellent removable floor finish when access is needed to a raised floor such as this.

Soft floor treatments include both carpets and rugs. Carpet is one of the most popular floor coverings used today because of its variety of colors, patterns, textures, touch, costs, installation techniques and cleanability.

Carpet is generally cut from a large roll that ranges in width from 27 inches (685 mm) to more than 18 feet (5486 mm), with 12 feet (3657 mm) being the most common size produced. Broadloom is a term frequently used to identify roll goods more than 54 inches wide (1371 mm).

Carpet tiles or modules are a popular alternative to roll carpeting, especially in commercial applications (Figure 14.18). These tiles are generally 18 inches (457 mm) square and can be glued directly to the floor with a permanent or releasable adhesive or laid freely with gravity holding them in place. Although initial material costs are high, the tiles can be easily installed, replaced, or rotated if damaged or soiled. They can also be lifted for underfloor accessibility.

Rugs are standard sizes of carpet material bound and finished at the edges and usually not fastened to the floor. Rugs can also be custom designed and woven, such as Oriental and Persian styles. Area rugs are available in a large range of sizes and shapes and can be used to define a furniture grouping or as accents calling attention to a specific area of a space, such as in an entry or an elevator lobby. They can also be hung on walls as decorative elements or for acoustical control.

Scatter or throw rugs are small rugs, generally 2 by 3 feet (609 × 914 mm) or less. They are used for decorative effect and where soiling or traffic is concentrated. These rugs can be relatively inexpensive but can also be a hazard because they can be tripped over and they slide on smooth flooring surfaces.

To select or specify carpet, a designer should understand its basic terminology and characteristics. The single most important question is, how long will the carpet last and continue to look good? The strength, soil resistance, abrasion resistance, moisture absorbency, resilience, density, heat resistance, static control, color retention, and flame resistance of basic carpet fibers should all be taken into account. Sound absorption and energy considerations of carpet installations should also be investigated. Still other considerations include texture, color, and pattern. Cost factors include the initial material costs, installation charges, and long-term maintenance expenses. Installation methods and padding are also important factors that contribute to the performance of a carpet.

BASIC FIBER PROPERTIES

Fibers generally are classified as either natural or synthetic. Virtually every fiber has been used in carpets, but today wool, nylon, acrylic, polyester, and polypropylene predominate. Fibers are also produced in several shapes to provide effective soil-hiding characteristics in carpets.

WOOL. Wool is traditionally the luxury fiber and has long been regarded as the finest carpet fiber, possessing all the most desirable characteristics. Great resilience accounts for wool's vital quality of retaining its appearance. Wool has warmth, a dull matte look, durability, and soil resistance. It takes colors beautifully, cleans well, and when cared for, retains its new appearance for years. However, wool carpet is very expensive and therefore is used mostly in high-quality spaces and residences.

NYLON. Nylon is highly resistant to abrasion. Its former problems of pilling (the tendency for a fiber to ball up) and fuzzing have been reduced, along with the problem of static electricity buildup. Nylon is soil resistant and has excellent cleanability, particularly in spot cleaning for stains. It is nonallergenic and is resistant to mold, mildew, and moths.

ACRYLIC. Acrylic (including Modacrylic) is similar to wool in appearance. Its outstanding characteristic is solution dyeability, and it is very resistant to abrasion and soiling. It cleans exceptionally well and has good crush resistance but some pillage. Acrylics rank second to nylons in quantity production.

POLYESTER. Polyester is a newer development in manufactured fiber carpet yarns than nylon and acrylic. Polyester has great bulk characteristics and combines the look and feel of wool with a durability approaching that of nylon. Stain and soil resistance are good, and polyester is easily cleaned, although there is some criticism about its crushing characteristics.

POLYPROPYLENE. Polypropylene is the best-known specific type of olefin. It is predominant in needle-punched carpets and popular for kitchen and indoor-outdoor carpets. Ease of care and its nonabsorbent nature are polypropylene's outstanding characteristics. Most stains lie on the surface, making it the easiest fiber to clean. Wearing qualities are comparable to nylon's, and polypropylene is completely colorfast.

FIBER PERFORMANCE CHARACTERISTICS

Fiber properties can affect the performance of a soft floor covering. Fibers have both inherent and engineered qualities; however, almost every inherent quality can be altered during the manufacturing process for better performance. The designer must balance appearance and performance qualities against any additional costs when selecting carpets.

STRENGTH. The ability of a fiber to withstand abrasion and wear is referred to as strength. All manufactured fibers are strong, and nylon is the strongest. The strength of a carpet determines how long it will last but not how long it will look good. A client might tire of looking at a nylon carpet long before the carpet will wear out. Polyesters and olefins are nearly as strong as nylon, making them both, like nylon, well suited for heavy traffic areas.

SOIL RESISTANCE. Carpet appearance is destroyed by soiling more often than by any other single factor. Certain fibers have a greater tendency to attract soil than others. Nylon is the most soil prone, which produces an overall dull appearance early in the carpet's life. However, nylons such as Antron have special soil-hiding characteristics and fiber shapes.

Pilling and static conductivity (the ability of a fiber to conduct electric charges) are also major soiling factors. Nylon pills easily and because of its unusual strength holds onto these pills. The pills themselves pick up dirt, giving a soiled appearance to the carpet. Improvements in fiber forms have produced continuous-filament fifth- and sixth-generation nylons that seem to have minimized this problem. Acrylic pills because of the soft nature of the fiber, but pills can be easily vacuumed away before soil has time to set.

MOISTURE RESISTANCE. All manufactured fibers resist moisture, some a great deal more than others. This factor determines the fiber's capacity to accept dyes, its stain resistance, and its maintenance characteristics.

Nylon, with the greatest tendency to absorb moisture, takes the widest range of colors and can be dyed using the largest variety of processes. Polyesters and acrylics both dye well, using various techniques. Olefin, the least absorbent fiber, has the most limited dyeing capabilities.

An absorbent fiber that dyes easily also will stain rapidly. Polypropylenes are very difficult to stain, while nylons stain more rapidly than any other manufactured fibers. Few substances can permanently stain manufactured fibers if mishaps are treated quickly. Like dyes, stains must set over a long period of time.

Whether the material is moisture resistant or absorbent also influences carpet cleanability. Since olefin is very nonabsorbent, it can easily be maintained by using everyday methods of care, such as vacuuming. However, nylon, polyester, and acrylic carpets need periodic specialized cleaning, such as wet or dry shampoo or steaming, to retain their original look.

RESILIENCE. Matting and crushing are governed by fiber resilience, the ability of a fiber to spring back to its original pile height and shape. If a resilience problem exists, a visible traffic pattern can be seen long before a carpet actually becomes worn. Carpet textures do much to determine resiliency.

Acrylic is the most resilient fiber, which accounts for its popularity in high-pile styles. Nylons and densely constructed polyesters also spring back well. Olefin regains its shape very slowly, so mills limit its use to low-height carpet construction.

Fibers have different densities, or abilities to cover square footage. Olefin, a high-bulk yarn, offers the greatest coverage, with acrylics and nylons following closely. Polyester trails in this area, and its reputation has suffered greatly because of that disadvantage. Actually, a polyester carpet tufted with a sufficient amount of yarn is every bit as full and dense as its counterparts.

HEAT RESISTANCE. Manufactured fibers do not actually burn but tend to melt or stick at different temperatures. Modacrylics, the most heat resistant of all, will not support combustion but will shrink at high temperatures. Polyester is claimed to be self-extinguishing, and polypropylene is the least heat resistant of any of the manufactured fibers.

STATIC ELECTRICITY. The level of static electricity generated by a carpet is determined by the electrical properties and absorbency of its fibers. Static electricity can be controlled during the manufacturing stage by adding compounds to the polymer solution before extrusion or by weaving metallic fibers into the floor covering to drain the charge continuously. Fibers can also be encased with special coatings of a conductive material. Static electricity could be a serious problem with carpeting in spaces where computers and other electronic equipment are housed. Carpet specifications will indicate whether it has been treated for static electricity.

CONSTRUCTION METHODS OF CARPETS AND RUGS

Carpets can be tufted, woven, needle punched, flocked, knitted, and handmade. These methods and their characteristics are more fully explained in Figure 14.19. One method is infrequently better than another, since each can produce several grades, depending on the yarn, density, backing, and method of finishing.

SURFACE TEXTURES

Most carpets have a third dimension, that of depth, which is known as the texture or pile (visible surface fibers). Variations in the surface appearance and texture depend on the style or type, height, thickness, sweep, and density of the pile.

PILE STYLE. Carpet styles fall into the categories of cut pile, uncut (loop) pile, and a combination of cut and uncut. The appearance of a carpet is further influenced by the level of

TYPE	CHARACTERISTICS

TUFTED

Yarn threaded needles punch back and forth through a preconstructed backing material and form loops which can be cut or uncut. Tufts are secured with a latex backing and a secondary backing of jute or other fibers is often applied. Tufting is the most used type of carpet construction.

WOVEN

WILTON

Produced with pre-punched cards on a jacquard loom that allows complex patterns and colors. Surface patterns vary from level cut pile to multilevel loop. Fibers are mostly wool and carpets are very expensive.

AXMINSTER

Woven on jacquard loom utilizing long spools of various colored yarn for a variety of color and pattern. Axminster carpets are seldom made today due to the cost and type of loom required.

VELVET

Produces a wide variety of color and textures, similar to axminster. Patterned design not possible, but tweed effects are made.

NEEDLEPUNCHED

Dense mass of short fibers rather than yarns that are punched into a backing. Often called indoor-outdoor carpet, as polypropolene fibers resist moisture well.

FLOCKED

Produced by blowing electrostatically short fibers on an adhesive backing to produce velvet-like texture. Not produced a lot as wearing qualities are low.

KNITTED

Mutliple needles loop pile yarn, stitching yarn, and backing together for uncut loop texture. Latex backing generally applied. Process not used a lot for carpet construction.

HANDMADE

Handwoven carpets are made by tied (knotted), untied, hooked, and braided techniques, yarns can be looped, straight, or have ends cut. The braided technique can also be imitated on commercial machines.

FIGURE 14.19 Some of the most commonly used methods of carpet construction.

twist used in cut pile yarns. Tightly twisted yarns create well-defined ends, and loosely twisted yarns have flared tips.

Figure 14.20 shows the wide variety of textures available in floor coverings through variations on cut and uncut yarn piles.

PILE HEIGHT, SWEEP, AND DENSITY. Pile height is the length of the pile yarns above the backing, which generally ranges from .187 to 1.250 inches (4.75 to 31.7 mm). The overall height is averaged when a carpet has a multilevel construction.

Pile sweep, also called the nap or directional pile lay, is the angle at which the pile yarns are oriented. The greater the angle, the more prominent the nap or shading created; this factor is important because the quantity of light reflected from a floor covering is determined by its pile sweep. When carpet is installed, it is important for the nap all to go in the same direction.

FIGURE 14.20 **Common carpet textures and their characteristics.**

TYPE	CHARACTERISTICS

CUT PILE (one level)

PLUSH OR VELVET

Uniform cut level in height. Loose twist of yarn ends to produce luxurious feel and appearance. Good wear resistance.

VELOUR

Similar to plush cut, but very short, fine, and dense. Good wear resistance.

SAXONY

Tight yarn twist that is heat set to reduce flaring at tips. Similar in height and density as plush. Medium wear resistance.

FRIEZE

Textures are rough, grainy appearance. Tightly twisted yarns of high stability and wearlife.

SHAG

Pile heights over one inch. Low pile density, informal appearance. Used mostly in residential applications, as wear resistance is low.

SPLUSH

Pile density and height between plush and shag carpets. Yarns tend to lay down in moderate and high traffic areas.

UNCUT PILE

LEVEL LOOP

Short, uncut loops. Dense, durable, wear-resistant. Good variations in color and texture. Used for residential and commercial areas for excellent wear resistance.

MULTI-LOOP

Different heights of looped pile. Random or specified for distinct pattern. High density increases durability.

TWEED

Similar to level loop, but larger loops and lower density. Cross-dyed with different colors for tweed pattern. Medium wear resistance.

CUT AND UNCUT (loop) PILE

SCULPTURED

Cut and uncut piles of different heights. Generally tall loops cut and short uncut to produce three-dimensional effect. Sometimes called high-low.

TIP SHEAR

Similar to plush. Selective shearing (cutting) specific loops for subtle pattern of texture and color. Medium wear resistance.

Density is important in judging the quality of carpet construction, for it affects the surface appearance, wear-life, and texture retention. Density refers to how close the pile tufts are, and is measured in stitches per square inch, gauge or pitch. Stitches or tufts per square inch means the number of tufts within one square inch of carpet. The more stitches per square inch, the denser the carpet. Gauge refers to the distance between rows of tufts across the width of a tufted carpet. Pitch is similar to gauge but refers to the method used in woven carpets to

determine the density factor. Pitch refers to the distance between rows of tufts but is counted only on a 27-inch (685 mm) width of carpet. The higher the density, the better the carpet. In low-density constructions, the backing material becomes visible when a section is folded or rolled.

COLOR

Color ranks second to cost as a determinant in the selection of carpet (wearability, carpet construction, and fiber are also among the five greatest factors). A neutral or subdued wall-to-wall carpet color can allow for changing color schemes or serve as a backdrop for other distinctive furnishings. Unusual colors, patterns, or bold graphic designs are not as versatile as neutral colors, thus limiting later choices; however, they are exciting and create strong visual impact.

Multilevel and multicolor carpets show less soiling than plain, smooth, one-color carpets. Colors that show less soil than others have high soil-concealment qualities. Blues and greens show the least soil, while white and all very light colors show soil and soon lose their original appearance. Dark colors show lint and dust if the carpet is darker than the soil.

Carpets are colored or dyed using the same methods as other textiles. (Refer to Chapter 13 under "Textile Colorants" for methods commonly used to dye carpets.) When selecting the dye method for a particular carpet, an interior designer will be concerned with the soil-hiding properties, fade resistance, economy, and aesthetics. Because some dyeing methods are not effective on all fibers, it is advisable to consult with a textile or carpet expert about this factor.

PATTERN

The size of the room, the style of furnishings, and the amount of pattern in walls and window treatments should influence the choice of a plain or patterned rug or carpet. If a strong pattern—either woven or printed—is used on the floor, then walls, window treatments, and upholstered items should be relatively subdued. Large, strong patterns tend to make a small room appear smaller, and little or no pattern gives the appearance of more space.

CODES AND REGULATIONS

Before purchasing or specifying carpet, the designer should be aware of certain codes and regulations relating to the manufacturing process and to the performance of the carpet. Various federal, state, and local regulatory agencies have established mandates affecting the design and performance of textile floor coverings for certain installations.

The Textile Fiber Products Identification Act (1960) requires a label on all rugs and carpet samples. Since no labels are required on orders of carpet cut for installation, the necessary information should be on a sample or the invoice. Each label or invoice should contain

- the manufacturer's or distributor's name and Federal Trade Commission registration number;
- the country of origin of an imported carpet;
- the common names of fibers in the pile and the percentage of each by weight.

Flammability requirements, controlled by federal regulations, are concerned with flame spread, surface flammability, radiant heat flux (where intense heat is radiated to the floor), ignition, and smoke generation. Manufacturers' specifications indicate the flammability rating by a letter code or by ratings developed by the American Society for Testing Materials (ASTM). Since all building code requirements are not the same across the United States or internationally, it is necessary for the interior designer to consult the building code in the area that has jurisdiction over a particular project.

INSTALLATION METHODS

The interior designer must be familiar with carpet installation terminology and methods, as well as with the materials, since the designer prepares the specification documents that contain installation instructions. There are two basic methods of installation: (1) the stretching method, in

which a tackless strip is used at the perimeter to stretch the carpet over a pad; and (2) the glue-down method.

The most widely used tackless method involves 1½-inch-wide (38 mm) plywood strips with pointed rows of protruding metal pins. The plywood strips are nailed to the subfloor at the perimeter of a room and other locations. The carpet is then tightly stretched over this strip, which holds the carpet in place.

The glue-down over cushion method uses adhesives to secure both a carpet and a cushion to the subsurface. The direct-glue-down method uses no cushion, securing the carpet directly to the subsurface. The latex-based adhesives used can be permanent (nonreleasable) or releasable. The releasable glue is used when periodic access is needed for running flatwire cable systems or for gaining access to the underfloor. Either releasable glue or double-stick faced tapes can be used to secure carpet modules in place.

Carpet is laid and seamed to provide a continuous covering. Piles should be uniform in their directional lay and seamed generally parallel with the pile rather than crosswise. Seams should not be placed perpendicular to a doorway (Figure 14.21) or linearly in the center of a hallway if heavy traffic is anticipated. Where possible, carpet seams should run perpendicular to windows for minimizing daylight patterns that might visually emphasize the seam.

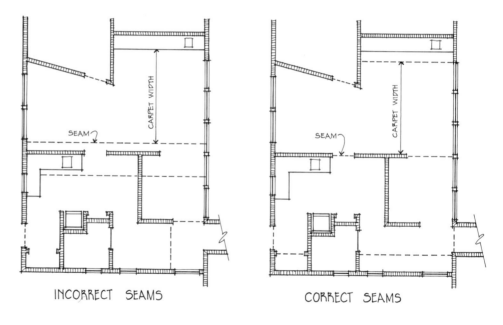

INCORRECT SEAMS CORRECT SEAMS

FIGURE 14.21 Carpet seaming is carefully planned to avoid piecing in high traffic areas.

CARPET PADDING OR CUSHIONING

Carpet padding, or cushioning, is used under carpeting primarily to protect it and provide comfort for the user. Figure 14.22 lists the specific benefits of padding.

The types of padding used are hair, felt, sponge rubber, and polymeric foam. Padding should be specified according to the needs of the user and the quality desired. Among the factors to be considered are the amount of traffic, noise absorption, impact noise reduction, resistance to fire, thermal conductivity, frictional resistance, mildew resistance, tear resistance, and budget. Other considerations include the following:

- Firmness vs. buoyancy. A hair pad gives firmness and some resilience. Sponge and rubber pads give resilience with buoyancy rather than firmness, unless the pad is very high density foam. The firmest is foam rubber on hair or fiber, which combines the advantages of both.
- Sponge or foam. Sponge is softest, but foam gives more uniform support.

BENEFITS OF USING CARPET PADDING OR CUSHIONING

ADVANTAGES

Increases durability of carpets and rugs.

Prolongs the life of carpet pile.

Improves carpet appearance; abrasion is lessened.

Retains carpet texture as pile is less likely to be flattened.

Increases carpet's resilience (ability to spring back after being crushed).

Increases sound absorption, making the carpeted area quieter.

Increases the absorption of static shock.

Helps in insulating and controlling temperature against cold floors.

Adds to the slippage safety of a carpet/rug with proper non-slip pad.

Provides for better cleaning.

Prevents subsurface cracks and roughness from "telegraphing" to surface of carpet.

DISADVANTAGES

Thick, bouncy pads could make a carpet difficult to walk on for elderly or handicapped persons.

Increases costs of installation and material.

FIGURE 14.22 Benefits of using carpet padding or cushioning.

• Special problems. Dense foam or sponge is preferable in humid or flood-prone areas because it will not mold or mildew. For radiant heat conduction, sponge or foam is better than jute or hair, although these can be used. In either type, heavy, thick padding should be avoided.

WALL SYSTEMS

Wall systems comprise both exterior and interior vertical planes in a building. They help set the limits, character, size, and shape of an interior. Walls are a major element in shaping and enclosing interior space. The interior designer can use them to keep in or push out various positive or negative influences, whether visual, physical, or psychological. Walls can be active generators of strong statements that dictate the use and character of a space. Walls can also be passive, subtle enclosures of our human activities and can be unintimidating—almost implied. In some spaces, it is difficult to tell where the wall's limits are because they might flow into the floor or ceiling. Walls are more than a background element; they are an integral part of the architectural enclosure, along with floors and ceilings.

Walls might be one continuous material, such as concrete block, or a composite of materials. They can be solid planes or pierced with doors, windows, and other openings. They can extend all the way from floor to ceiling or just partway. Walls also are used for supporting built-in elements of storage, furniture, and other equipment. Walls can be for support, or they can be space dividers or transparent dividers (perhaps glass); they can have integral pilasters or even be movable. Wall finishes can be the same as the building's construction material, such as concrete, or applied, such as wallpaper. Walls might also be composed of a combination of columns and beams.

Walls are generally classified as load bearing or nonload bearing (sometimes referred to as partition walls). Bearing walls support floor or roof systems above them; nonbearing walls support no weight from the structural system. However, some nonbearing walls do support minor elements, such as cabinets that are hung or placed on top.

Generally speaking, before cutting openings in or moving a bearing wall, the designer should consult an architect or engineer in order to ensure that the structural integrity of the building is maintained. Most interior nonload-bearing walls can be modified easily; however, in some cases they do serve some loading purpose that must be considered.

Figure 14.23 lists a number of considerations to be used when selecting wall systems and finishes. See Appendix 2 for more-detailed information on how to estimate wall finish material quantities.

CRITERIA	CONSIDERATIONS
AESTHETICS	Relationships and appropriateness to the overall design in terms of concept, color, texture, finish, etc.
DEGREE OF ENCLOSURE	Solid or punched with openings; opaque silhouetted, or transparent; partial; full height of space or low.
STRUCTURAL	Load bearing or non-load bearing; continuous or designated point loads.
DURABILITY	Related to wear, damage, repair, and maintenance.
FUNCTION	Intended use interior or interior/exterior assembly; permanent, free-standing, or moveable.
LIGHT QUALITIES	Lighting considerations of absorption and reflection.
ACOUSTICAL	Properties for absorbing, blocking or reflecting sound waves.
THERMAL	Characteristics needed for solar or energy conservation.
ECONOMICS	Availability of materials, initial costs, maintenance, and replacement or repair costs.
FIRE RESISTIVE	Required fire resistive characteristics to protect the occupants and the structural system from failure.

FIGURE 14.23 Considerations for selecting wall systems and finishes.

Wall Construction

Walls, both load bearing and nonload bearing, can be constructed as one solid material or a composite of columns and beams. The choice depends on the structural integrity of the building, economic factors, construction details, openings, and the desired finish of the wall. Typical wall construction types include concrete, masonry, and wood or metal frame. Exterior walls are constructed like most interior walls but have added insulation and special finishes to protect them from environmental conditions.

CONCRETE AND MASONRY WALLS

Concrete and masonry walls are used primarily as load-bearing elements and for fire resistance, although they are also used in specialized cases as bank vaults or subsurfaces for other

finishes. They generally are covered when used in occupied spaces except in utilitarian areas or for visual effects in interiors.

Masonry walls can be constructed solely of stone, brick, concrete block, or clay tile. However, most of these walls are constructed as veneer walls over frame walls (made of wood or steel) or concrete block. These veneers do not provide structural support but serve as a covering; they are connected with metal ties to the subwall.

If an interior concrete or masonry wall is to be finished with another material, such as gypsum board, then wood or metal furring strips are secured to it at intervals, and the finish material is attached to these supports.

WOOD AND METAL FRAME WALLS

Frame walls can be used as interior or exterior walls and be bearing or nonbearing. Wood or metal studs are placed vertically at intervals (usually 16 or 24 inches, or 406 or 609 mm, on center) and attached to a top plate and a bottom sole or runner.

With the advent of mass-produced lumber and nails, these framing techniques were developed using wood in the 1800s. Frame walls were formerly surfaced with wood lath strips, and wet plaster was applied in several coats for wall and ceiling finishes. Today, metal lath and plaster are still applied for finishes, but the use of premade gypsum wallboard panels, called drywall, is more economical (Figure 14.24).

Wood-stud walls usually have 2 by 4 inch (50 × 100 mm) nominal (1½ inch by 3½ inches, or 38 × 88 mm, actual) studs that provide support for sheets of finish materials to be applied. Such walls can structurally hold up floor loads from above and provide space for concealing wiring, plumbing, and ducts. Other stud sizes, such as 2 by 6 inches (50 × 152 mm), are used to accommodate more wall insulation (exterior) or contain larger drainpipes.

Wood-stud walls are usually framed in 8-foot (2438 mm) heights (mostly residential) and covered with gypsum wallboard. This product is a gypsum, chalklike material sandwiched between sheets of special paper or other materials. Gypsum wallboard comes in 4 by 8 foot (1219 × 2438 mm) sheets, although lengths of up to 14 feet (4267 mm) are also available. Thicknesses range from ¼ inch to 1 inch (6 to 25 mm), with ½ inch and ⅝ inch (12 and 15 mm) being the most commonly used. These wallboard sheets can be quickly cut, glued, nailed, or screwed to the studs. They are finished out with tapes and different-shaped metal casings and joint compounds (plasterlike material) to provide smooth wall surfaces for paint or a variety of other surface finishes. Gypsum boards can be added in layers to a wall to increase both the fire-resistive capabilities of the assembly and its ability to cut down on sound transmission.

Metal-stud walls are similar to wood-stud walls in widths, spacing, and finish coverings. However, the metal studs are lightweight shapes of steel that must be screwed or welded together, rather than nailed. They have cutouts in their webs to facilitate piping and wiring runs. Being steel, they will not burn and are often required in high-occupancy buildings.

SPECIALIZED WALLS

Interior wall systems are manufactured as movable or demountable partitions that can be assembled and disassembled for new locations or configurations, giving them a flexibility that other wall systems cannot provide. Most interior wall systems include doors, glazing, trims, and accommodations for wiring. They are frequently used in office installations where flexibility is needed.

Folding and sliding partitions are specialized units that provide flexible wall arrangements. Sliding panels of material in accordianlike folds are set in ceiling and floor tracks to create a wall or stack it out of the way, another arrangement that provides wall flexibility.

FIGURE 14.24 Gypsum board can be nailed to wood studs or screwed to steel studs. Additional layers are added for more resistance to sound or fire. (Courtesy of Georgia Pacific Corporation.)

Wall systems can also be manufactured as prefabricated units for both bearing and partition use. In the factory several composites of materials are sandwiched together and shipped to a project for erection. This prefabricated system usually cuts down on job-site construction time and features better quality control techniques, as well as cost control.

WALL FINISHES AND SPECIFICATION CRITERIA

Many wall finishes are available, some of them the same as or similar to the floor finishes previously discussed. All construction materials listed in Chapter 13 and all exterior wall finishes can be used on the interior. Some finishes are an integral part of the wall's structure, and others are applied as layers (ceramic tile) or coatings (paint).

Plaster and Stucco

For use as wall (and ceiling) finishes, plaster and stucco are applied over wood and metal studs by using metal lathing or are applied directly over concrete block. Plaster and stucco can be applied in a variety of textures and patterns and can be integrally colored with additives. As wall finishes, they are subject to easy soiling from scratches, fingerprints, and other markings. These materials are long lasting but more expensive than drywall.

Paint

Paint is one of the most often used finish materials for walls and ceilings because it is inexpensive, easy to apply, and available in an infinite color range (Figure 14.25). It can be applied

FIGURE 14.25 Paint is used as an economical design element in this library lounge to accent artwork and create interest in an otherwise stark interior.

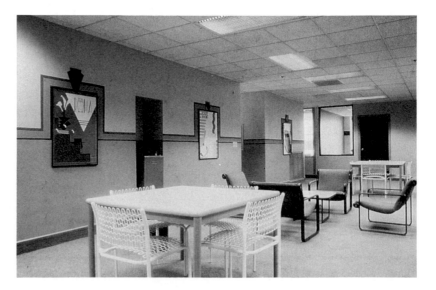

over numerous wall surfaces and can easily be changed later by overpainting. Painted wall finishes are generally referred to as flat (matte), semigloss, and high-gloss, depending on the visual characteristics and maintenance factors of the paint when dry.

Water-based paints are used in both residential and commercial areas, primarily when wear factors are not a problem. Oil- and plastic-based paints are more applicable to commercial areas, as well as residential kitchens and bathrooms, if a scrubbable finish is needed. In addition to being spread by brush or roller, paint can be stippled, spattered, sprayed, or sponged, alone or with other colors, to create a variety of patterns and textures.

Paints can be computer matched in color as a complement to or contrast with almost any other material. Often a designer has paint matched for coordination with fabrics.

Wood

Wood can be used as a wall finish in the form of boards, shingles, or veneered panels. Patterns, finishes, and joints can also be varied. Wood is used as trim for wall bases, ceiling molding, doors, windows, and paneling.

Wood finishes vary from none to heavy overpainting, although most finishes are selected to accent the natural beauty of the wood and its grain, pattern, or color. Wood to be used in high-occupancy areas can be chemically treated to make it fire resistive.

Wood paneling can be made as simple, flush designs or can be made more elaborate by adding moldings, such as those used for traditional panels and rails (Figure 14.26). Paneling can

FIGURE 14.26 Wood can be shaped into many forms for wall surfaces, such as this traditional wood paneling and molding used throughout this interior space.

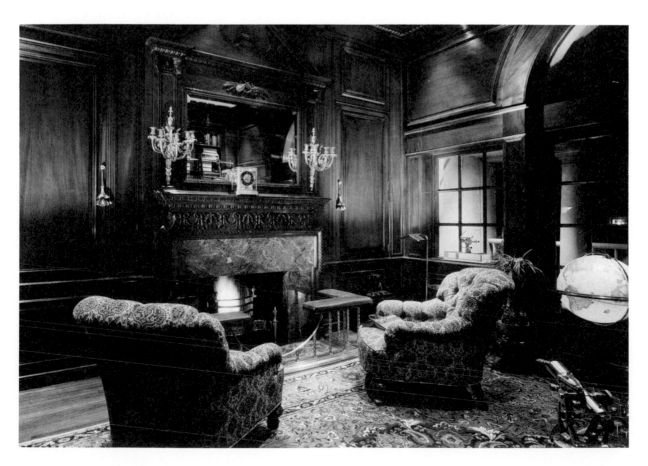

be made of hardwoods or softwoods and in plywood veneers or solid lumber sections. Manufactured paneling is generally produced in 4 by 8 foot (1219 × 2438 mm) sections with thin, unfinished wood veneers over plywood; these panels can be finished on the job site. Panels can also be produced with prefinished surfaces, photo reproductions, or plastic faces for a variety of installations.

Solid wood can be installed on walls (and ceilings) by various methods using tongue and groove connections or other assemblies (Figure 14.27). The wood can be applied in very simple vertical strips, in a design produced by a board and batten technique, or in other patterns. Often the solid planks are cut and shaped into moldings and other trim for flat wall surfaces or for door and window trims.

Wood boards are manufactured for wall applications as tongue and groove, beveled, shiplapped, and channel installations.

FIGURE 14.27 Solid wood is cut and installed in a variety of ways to produce a warm, natural finish, such as in this reading room.

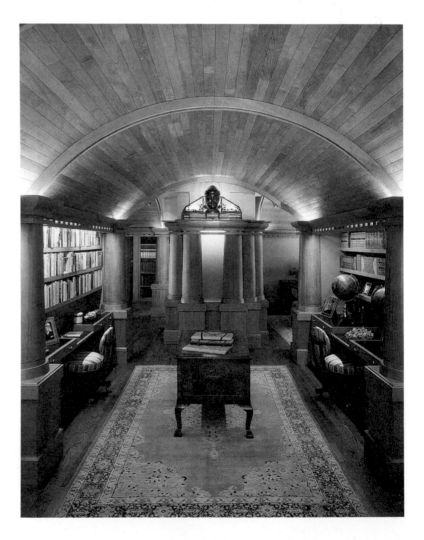

Stone and Masonry

Stone and masonry wall materials project an image of strength, solidarity, rich texture, and quality.

Stone and masonry can be installed in heavy, rusticated, random, and textured surfaces or in smooth, coursed, and reflective faces. These installations can be heavy, thick wall sections or made of thin veneers and reinforced by a supporting wall. The installations can be either classic and traditional or stark and modern for a contemporary look (Figure 14.28). Stone and masonry can, however, cause acoustical problems because they reflect sound within a space.

They can be effectively used in installations where mass is needed for solar heat storage in residential and small commercial buildings. Stone and masonry are excellent for fire resistance.

Some stone veneers are actually composed of stone and synthetic compounds, such as cast glass-fiber reinforced materials, that imitate stone (Figure 14.29). Often lighter, more stable, and less expensive than the real substance, these imitations may be visually almost indistinguishable from the genuine stone.

FIGURE 14.28 The rough stonework in this residence provides a rusticated heavy texture in contrast to the simple planes and elements of wood.

FIGURE 14.29 Although this store front (designed by Manchu Wok Ltd.) appears to be of cut stone, it is made of thin veneers and trim of cast fiberglass and resin, manufactured by Formulas.

Ceramic and Other Tiles

Ceramic tiles are used as a wall finish for both interior and exterior applications (Figure 14.30). These tiles are excellent for durability, ease of maintenance, and attractiveness. They are available to coordinate in color, style, texture, and thickness with floor tiles. Tile is especially suited for humid, wet locations where water or steam is present, as in swimming pools or commercial kitchens. Because their hard surfaces can be readily cleaned and are resistant to staining, tiles have widespread application in bathrooms and kitchens.

FIGURE 14.30 Small squares of tile can be used to create complex, colorful images or be arranged in simple geometric patterns as seen in the floor of this medical clinic restroom designed by Cunningham and Associates.

Plastics

Plastics for wall finishes appear in many forms, including rigid sheets of solid plastic, plastic laminated veneers over hardboard panels, or thin and flexible wall vinyls. Plastics are durable and easy to clean, although some can be damaged by abrasive cleaning agents. Most plastic finishes are difficult to restore to their original finish if damaged. Plastics are available in a wide range of colors and surface finishes, many imitating other materials, such as wood, grasscloth, and even ceramic tile. Plastic is used in sheets, such as Plexiglas or acrylics, and placed in wall areas subject to breakage (windows) or as accent panels, for graphic signage, and for dividers within spaces.

Metals

Metals are primarily used in both residential and commercial buildings as exterior wall surfaces in forms such as siding, tiles, or panels. These products are generally aluminum and steel, although copper also is used for roofing and gutters. Stainless steel panels and strips are installed in interiors on walls, ceilings, and columns for both durability and aesthetic considerations.

Finish techniques for metals include hammering, brushing, polishing, and etching.

Glass and Mirrors

Glass is used in doors and windows or as whole or partial walls either set in panels within wood and metal frames or made of glass blocks. Glass is used primarily for its light transmission, however, and other visual properties can be achieved since it can be colored and textured. Glass walls can be straight or curved.

Mirrors are glass with a back coating of silver or bronze alloys. Mirrors are often used to expand a space visually and can cover entire walls, columns, and even ceilings in large, single expanses or in tiny mosaic patterns. Mirrors can be antiqued, grayed, veined, or etched with designs and can have beveled edges. Mirrors are installed by gluing or by setting within frames or clips.

Fabrics

Fabrics have been used through the ages to cover walls and even to serve as walls (as in tent structures). Fabrics are primarily used as a finish to add softness, texture, color, and visual interest to a wall surface. If used as a wall hanging, fabric can become a focal point. Silks, linens, wool, canvas, carpets—almost every kind of textile—can be used as a wall covering. Fabrics on walls are subject to soiling; care should be taken where they are placed, avoiding heavy traffic areas where people might handle them.

Fabrics are glued, tacked, or stretched over frames as wall finishes. They can be applied as flat layers or folded, padded, or stitched into surface treatments.

Thick fabrics and carpets can be used as sound absorption surfaces. Many also can be specially coated with soil repellent or fireproofing material for commercial applications.

Wallpapers and Vinyls

Wallpapers are produced for residential and commercial uses in a seemingly endless variety of colors, textures, patterns, and pictorial images. Wallpapers can imitate many other materials, be coordinated with fabrics, or reflect historical periods, as seen in some classical reproductions. However, they should be selected to be compatible with the character of the building interior and furnishings.

Many wallpapers have self-adhesive or prepasted backings for ease of installation. Wallpapers are produced as sheets of paper that can be flocked, metallicized, and vinyl coated for

durability. Materials such as cork can be applied as a thin surfacing to the basic paper. Various fabrics or textiles are also laminated to wallpapers and produced in rolls. Wallpaper is sold in single 27-inch-wide (685 mm) rolls of 36 square feet (3.34 m^2). It is also made as a double roll and a triple roll.

Although vinyl wall coverings are a plastic, they are similar in style and application to wallpapers. However, they are stronger and are often produced in wider widths. Vinyls are more durable than most wallpapers and can be scrubbed. Some are heavily backed for installation over rough subsurfaces or even over cracks in walls.

CEILING SYSTEMS

Ceilings are perhaps the largest unobstructed area within an interior environment. Ceilings play an important role in shaping the visual, acoustical, and lighting characteristics in a space. Ceilings define the upper limits of a space as well as provide for physical and psychological protection. Other uses are for thermal and fire-resistant barriers, as shown in Figure 14.31, which lists considerations for selecting ceiling systems and finishes.

Ceilings should be designed as an integral part of interiors and not just be considered a flat surface over our heads. The height, shape, and finish of a ceiling have a major impact on the occupants, furnishings, and other objects within the space. Vertical dimensions of an interior space should be in proportion to the horizontal dimensions to achieve a feeling of balance. High ceilings

FIGURE 14.31 Considerations for selecting ceiling systems and finishes.

CRITERIA	CONSIDERATIONS
AESTHETICS	Relationships and appropriateness to the overall design in terms of concept, shape, color, texture, finish, etc.
DEGREE OF ENCLOSURE	Solid or partial; transparent or opaque; functional needs.
TYPE	Hung or attached versus part of the building's structural assembly. Whether elements will be hung or supported by the ceiling.
HEIGHT	Heights above floor; fixed and variable
DURABILITY	Related to wear, damage, repair, and maintenance.
COMPATIBILITY	Interfacing and details required to be compatible with light fixtures, HVAC equipment, and fire suppression sprinklers.
THERMAL	Possible needs for energy conservation.
LIGHT QUALITIES	Lighting considerations of absorption and reflection.
ACOUSTICAL	Properties for absorbing, blocking or reflecting sound waves.
ECONOMICS	Availability of materials, initial costs, maintenance, and replacement or repair costs.
FIRE RESISTIVE	Requirements needed to protect the occupants and the structural assembly from failure.

can create an open, airy, lofty feeling; low ones can create cozy and intimate spaces. Typical ceiling heights are 8 feet (2438 mm) in residential and usually a minimum of 9 feet (2743 mm) in commercial spaces. Some building codes restrict ceiling heights to a minimum of 7 feet 6 inches (2286 mm) in usable spaces.

Ceiling Construction

The construction of ceilings generally consists of a joist and rafter frame system similar to floor systems. However, these wood or steel members tend to be lighter and smaller, since the loads of a roof are usually not as great as those of a floor. In buildings of two or more stories, a floor system can also serve as the ceiling system for spaces below. The structural frame might act as the finish material, such as wood, concrete, or metal. However, false ceilings can also be installed beneath these floors to provide for lighting, aesthetics, fire resistance, mechanical systems, and acoustical barriers between floors.

Ceiling joists, rafters, and trusses are typically spaced at 12, 16, and 24 inches (304, 406, and 609 mm) on center. Other spacing modules can be used for lighter or heavier loading and framing details. Trusses can take the place of ceiling joists and rafters to allow a ceiling to take different forms and heights. They also allow for greater open spans because of their excellent strength characteristics.

Other ceiling shapes, such as the cathedral ceiling, use exposed beams, with the surface finish added directly to the rafters. With this type of construction system, interior ceilings can take on many forms and shapes created by the roof structure. Examples include shed or slanted, gable, cathedral, and domed ceilings. The coffered ceiling shape contains recessed paneled sections (structural or decorative) that can be rectangular, hexagonal, or other shapes (Figure 14.32).

FIGURE 14.32 The wood coffered ceiling in this office is executed with traditional molding details as related to the wall paneling, lending a formal atmosphere to the room.

ATTACHED AND HUNG CEILINGS

Ceiling surfaces are either attached or hung (suspended) from supporting systems. The attached type is the simplest, usually consisting of gypsum board, wood, or ceiling tile attached directly to the framing members. For example, gypsum-board finishes are usually secured directly to the frames.

Hung ceilings are suspended from the building structure by various methods (Figure 14.33). These configurations consist of main and secondary runners of lightweight steel suspended from wire hangers attached to the structure above. Metal or acoustical panels of various materials and sizes are installed, as are light fixtures and mechanical equipment, such as air registers. Hung ceilings can be placed close to the structure above or lowered to provide space for mechanical, plumbing, and electrical equipment.

FIGURE 14.33 A ceiling assembly is composed of metal runners suspended by wire from the building structure above. Light fixtures and ceiling panels lay within this gridwork.

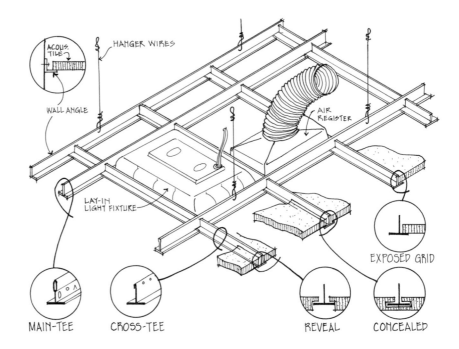

Ceiling Surface Materials

Several materials are available to finish ceiling surfaces. The most common are plaster, gypsum board, wood, and various tiles set in suspended ceilings. In turn, each of these surfaces can be treated in a variety of ways—with paints, ceramic tile, or custom ceiling tile products.

PLASTER

Plaster is one of the oldest forms of ceiling finishes. It is durable, rigid, moisture resistant, and fire resistive. The surface can be smooth or textured and can be molded into many shapes, both straight and curved. Plaster offers the opportunity to mold wall and ceiling planes smoothly with curved surfaces, such as the cove. Other highly decorative shapes and patterns can be created with plaster, an advantage not possible with other finishes. Plaster can be painted or, if it is smooth, can have vinyls and papers applied over it.

Plaster is either attached directly to a structural wood, metal, or concrete frame of a ceiling or installed on a suspended system. Both applications require a sound subsurface, generally a metal lath system to which the plaster is applied in several coats.

GYPSUM BOARD

Gypsum board, sometimes incorrectly called Sheetrock (a specific brand name), is less expensive and quicker to install than plaster. It is durable, rigid, and available in different thicknesses and can be highly fire resistive if layered. The surface can be smooth or textured. This texture, which can be light or heavy, can be applied by hand or sprayed. Gypsum board can be painted or not or, if the finish is smooth, can have vinyls and papers applied.

WOOD

When wood is installed as a decking over ceiling or floor joists, the joist and decking assembly can be left exposed to create a wood ceiling for the space below. Tongue and groove assemblies of various widths, stained or painted for the finish desired, are generally used for such installations. Examples of these can be seen in many old industrial buildings that have been reused for residential or commercial facilities. In these, the original wood floor system is cleaned and left as an exposed ceiling. Wood strips, similar to the types used for flooring, can also be applied to the ceiling from below. They are either secured directly or attached to suspended ceilings. Hung ceilings are also made with wood grids or grilles.

CEILING TILES

Ceiling tiles can be glued to smooth ceilings or stapled to wood furring strips attached to ceiling systems. These tiles are generally 12 inches (304 mm) square and have smooth or tongue and groove edges that produce a geometric grid or a continuous surface when installed.

Ceiling tiles can be installed in suspended ceiling systems in 2 by 2 feet (609 × 609 mm) or 2 by 4 feet (609 × 1219 mm) grids leaving the metal grid exposed, recessed, or concealed. These systems allow flexibility in rearranging if lights, mechanical diffusers, and damaged panels need to be changed or removed.

Panels of ceiling tiles can be designed with acoustical and fire-resistive ratings if required. These panels can also be vinyl or fabric coated, mirrored, plastic, or metal faced.

METALS

Metal or tin ceilings were mass produced in the 1800s to imitate ornamental plaster without the cracking or damage to which the latter is susceptible. These ceilings are reproduced today in a variety of patterns. Linear metal ceiling materials are made in 3- to 7-inch (76 to 177 mm) widths that attach to runners made of various metals. Metal or tin ceilings can be finished with bronze, brass, aluminum, and plastic coatings (Figure 14.34).

CERAMIC TILES

Ceramic tiles are used on ceilings for decorative accents, durable finishes, or resistance to moisture in damp locations, such as showers and kitchens. Ceramic tiles are glued over special water-resistant gypsum board or installed using a cementitious lath and plaster technique. Many decorative ceramic moldings are available to coordinate with the tiles.

PAINT

All the ceiling surfaces discussed above, except ceramic tiles, can be painted. Painting is often an economical solution for older ceilings, such as acoustical tile ceilings, that have faded or become discolored, yet are in good condition. The most common type of ceiling to be painted is made of gypsum board and already has a painted or stippled surface. Some surfaces will take paint better than others; all must be properly prepared before painting.

OTHER MATERIALS

A combination of ceiling materials to provide variety in surfaces and shapes can be used within a space. Colorful fabric panels can be hung or draped to create interest and visual excitement and to provide directional emphasis. Assemblies are also available in a variety of materials as baffles that create an egg crate look of various dimensions.

FIGURE 14.34 Linear metal ceiling panels are curved in this airport lobby to complement other curved forms and reflect light and images throughout the space.

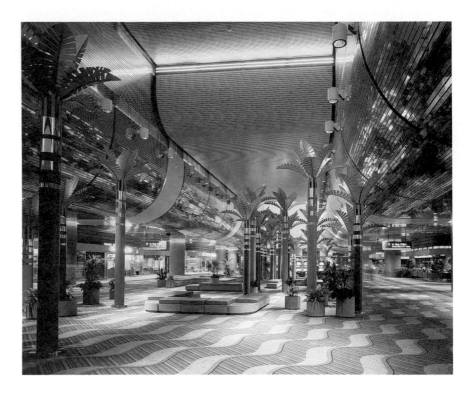

REFERENCES FOR FURTHER READING

Ching, D.K. Francis. *Building Construction Illustrated*. New York: Van Nostrand Reinhold, 1975.
———*Interior Design Illustrated*. New York: Van Nostrand Reinhold, 1987.
Ramsey, Charles George, and Harold Reeve Sleeper. *Architectural Graphic Standards*. New York: Wiley, 1988.
Reznikoff, S.C. *Specifications for Commercial Interiors*. New York: Whitney Library of Design, 1989.
Riggs, J. Rosemary. *Materials and Components of Interior Design*. 2nd ed. Reston, Va.: Reston Publishing Co., 1989.
Rupp, William, and Arnold Friedmann. *Construction Materials for Interior Design*. New York: Whitney Library of Design, 1989.
Yeager, Jan. *Textiles for Residential and Commercial Interiors*. New York: Harper & Row, Publishers, Inc., 1988.

SLIDING (BY-PASS)

SLIDING (SURFACE)

SLIDING (POCKET)

INTERIOR COMPONENTS

This chapter will detail major components within interior spaces that interface with the architectural systems of floors, walls, and ceilings. Specifically, stairs, doors, and windows, since they provide functional and visual passage between spaces, will be discussed. The relationship of fireplaces to the floor, wall, and ceiling as integral components of an interior will also be discussed. The aesthetic considerations, design, methods of construction, and finishes of these components will be related to the interior systems and how a designer incorporates them into those systems.

The styles and functional characteristics of typical forms of interior window treatments will also be detailed, and cabinetry will be discussed, since it falls between built-ins and furniture. Cabinetry functions, construction techniques, finishes, and aesthetic considerations will be looked at.

STAIRS

In addition to their functional use, stairs should reinforce the experience of visual movement through space and reflect the design character of the overall interior (Figure 15.1). Use, materials, and image determine whether stairs are designed for main or secondary purposes.

Safety factors and ease of ascent and descent are the governing functional factors of stair design. Building codes set minimum and maximum dimensions of stair widths, tread widths, riser

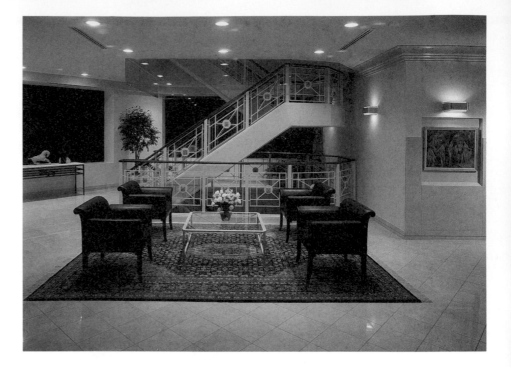

FIGURE 15.1 The stairway in this reception area serves as a focal point and is detailed with linear metal grillwork that is repeated in the table and other forms.

heights, and handrail design. Stairways should be wide enough to accommodate a number of people passing (commercial stairs) or several people carrying items (residential and private stairs). Often, commercial buildings have two sets of stairs for each floor so that one can serve as an alternate escape route if the other becomes blocked during an emergency, such as a fire.

Ramps are sometimes used in place of stairs to accommodate people with physical disabilities. These are strictly by the building codes (see Appendix 1).

Stair Construction and Design

Stairs are often designed as a part of the building's structural system and are incorporated into the framing. Although stairs can be designed in a variety of ways, six basic configurations, according to their runs and landings, predominate (Figure 15.2). These configurations are controlled by building codes for widths, required landings, locations, and ratios of riser-to-tread dimensions. Some stairs, such as the spiral, are not permitted as fire exits in commercial installations because it is difficult for a number of people to use them for quick evacuation in an

FIGURE 15.2 Six common types of stair design layouts.

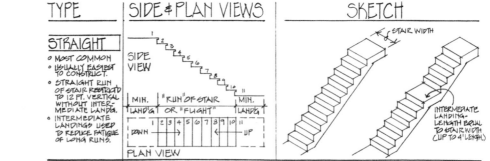

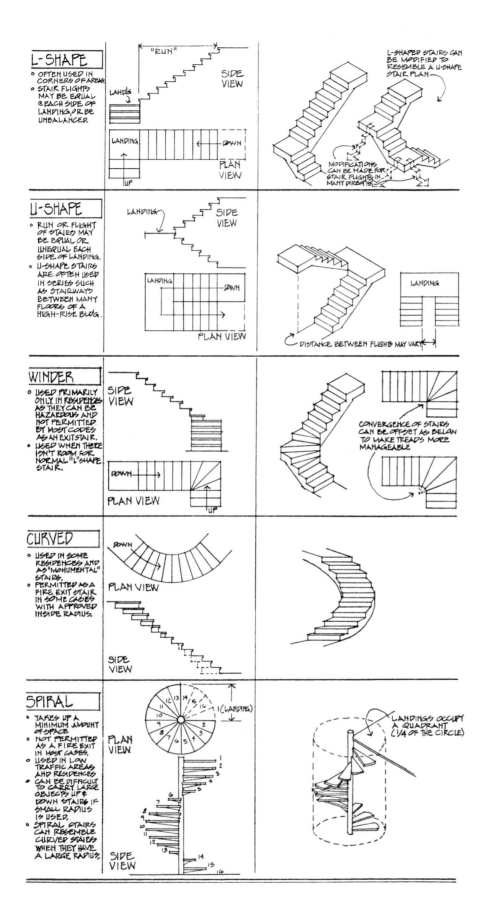

L-SHAPE

- OFTEN USED IN CORNERS OF AREAS.
- STAIR FLIGHTS MAY BE EQUAL @ EACH SIDE OF LANDING, OR BE UNBALANCED.

"RUN"

SIDE VIEW

LAND'G

LANDING

DOWN

UP

PLAN VIEW

L-SHAPED STAIRS CAN BE MODIFIED TO RESEMBLE A U-SHAPE STAIR PLAN

MODIFICATIONS CAN BE MADE FOR STAIR FLIGHTS IN MANY DIRECTIONS

U-SHAPE

- RUN OR FLIGHT OF STAIRS MAY BE EQUAL OR UNEQUAL EACH SIDE OF LANDING.
- U-SHAPE STAIRS ARE OFTEN USED IN SERIES SUCH AS STAIRWAYS BETWEEN MANY FLOORS OF A HIGH-RISE BLDG.

LANDING

SIDE VIEW

LANDING

DOWN

PLAN VIEW

LANDING

DISTANCE BETWEEN FLIGHTS MAY VARY

WINDER

- USED PRIMARILY ONLY IN RESIDENCES AS THEY CAN BE HAZARDOUS AND NOT PERMITTED BY MOST CODES AS AN EXIT STAIR.
- USED WHEN THERE ISN'T ROOM FOR NORMAL "L" SHAPE STAIR.

SIDE VIEW

DOWN

PLAN VIEW

UP

CONVERGENCE OF STAIRS CAN BE OFFSET AS BELOW TO MAKE TREADS MORE MANAGEABLE

CURVED

- USED IN SOME RESIDENCES AND AS "MONUMENTAL" STAIRS.
- PERMITTED AS A FIRE EXIT STAIR IN SOME CASES WITH APPROVED INSIDE RADIUS.

DOWN

PLAN VIEW

SIDE VIEW

SPIRAL

- TAKES UP A MINIMUM AMOUNT OF SPACE
- NOT PERMITTED AS A FIRE EXIT IN MOST CASES.
- USED IN LOW TRAFFIC AREAS AND RESIDENCES
- CAN BE DIFFICULT TO CARRY LARGE OBJECTS UP & DOWN STAIRS IF SMALL RADIUS IS USED.
- SPIRAL STAIRS CAN RESEMBLE CURVED STAIRS WHEN THEY HAVE A LARGE RADIUS.

PLAN VIEW

(LANDING)

SIDE VIEW

LANDINGS OCCUPY A QUADRANT (1/4 OF THE CIRCLE)

emergency. For residential spaces, however, a spiral staircase is a convenient means of access between levels, using a minimal amount of floor space.

Codes specifically govern most proportions between riser and tread dimensions. At this writing, most commercial stairs are limited to riser heights of 7 inches (177 mm) or less, and treads are to be 11 inches (279 mm) or more in depth. Residential risers can usually be up to 8 inches (203 mm) high and treads a minimum of 9 inches (228 mm) deep. The total rise and runs of a stair are governed by these riser height and tread depth variables, depending on the vertical distance between floor levels. Figure 15.3 shows the various parts and dimensions, as well as items such as handrails and headroom, required in most stair designs.

FIGURE 15.3 Parts and dimensions of common stair construction. The actual thickness and configuration of the framing members will vary according to the material used—wood, steel, concrete, or a combination of materials.

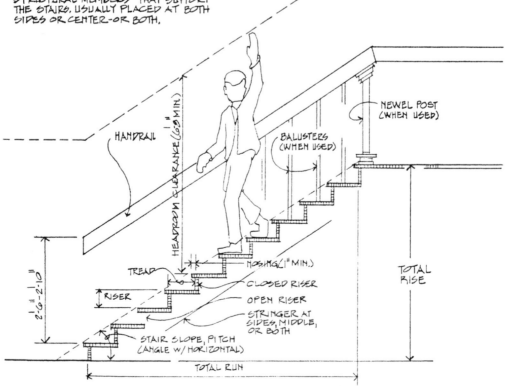

STAIR ASSEMBLIES:

- TOTAL STAIR RISE:
 VERTICAL DISTANCE FROM TOP OF ONE FINISHED FLOOR TO THE NEXT.

- TOTAL STAIR RUN:
 HORIZONTAL DISTANCE FROM START TO END OF THE STAIR LENGTH.

- BALUSTERS:
 POSTS THAT SUPPORT THE HANDRAIL AND/OR PREVENT OBJECTS & PEOPLE FROM FALLING OFF THE STAIRWAY. ALSO CALLED BANISTER.

- NEWEL POST:
 POST AT TOP OR BOTTOM OF STAIRS THAT SUPPORTS THE END OF THE HANDRAIL.

- HANDRAIL:
 THE RAIL THAT FOLLOWS THE RAKE OR PITCH OF THE STAIRS.

- HEADROOM:
 VERTICAL CLEARANCE (DISTANCE) FROM OUTSIDE EDGE OF RISERS (W/ NOSING) TO THE CEILING OR OBSTRUCTIONS ABOVE.

- STRINGERS:
 STRUCTURAL MEMBERS THAT SUPPORT THE STAIRS. USUALLY PLACED AT BOTH SIDES OR CENTER-OR BOTH.

STAIR PARTS:

- TREAD:
 THE HORIZONTAL MEMBER THAT ONE WALKS ON. MEASURED FROM FACE OF ONE RISER TO THE FACE OF NEXT RISER.

- RISER:
 VERTICAL ELEMENT OF STAIRS OR DISTANCE FROM ONE TREAD TO THE NEXT.

- NOSING:
 PORTION OF TREAD THAT OVERHANGS THE RISER BELOW. HAS MINIMUM PROJECTION OF 1". NOSING IS NOT CONSIDERED IN BASIC LAYOUT OF STAIRS.

Wood is the predominant material for stairs in residences and small commercial buildings. Other materials for stairs include steel and concrete. Depending on use and visual appearance, stairs can be left exposed or covered with several nonslip coverings, such as carpet, vinyl, and rubber. In commercial installations, codes control the fire-resistive properties of these finishes.

DOORS

Doorways allow visual and physical movement between spaces. Doorways control access and affect the traffic patterns within the space (Figure 15.4). They provide security and help control noise levels both between spaces and from outside the building.

Doors are also selected for their visual compositions and character. Their type, size, and finish are important parts of a building's exterior and interior design elements. Doors give a sense of human scale to a building's form and can be simple or elaborate, traditional or contemporary.

FIGURE 15.4 A serpentine glass wall separates this law office from the elevator lobby. The circular glass cutout at the right is a pull for the sliding glass door to close against the marble wall.

Door Types

Door types are classified by the action or operation of the door's mechanism. These range from the simple swing door to special doors that fold and then recess into a wall pocket (Figure 15.5). Doors can be automatic, activated by sensors to detect people's approach, or operated by hand. They can be connected to fire detection systems so that they will close automatically to prevent the spread of flame and smoke.

Doors in residences are generally 6 feet 8 inches (2.03 cm) in height and vary in width from 18 inches to 3 feet (45.72 to 91.44 cm). Most commercial doors are 7 or 8 feet (2.13 or 2.44 m) in height and range in width from 18 inches to 4 feet (45.72 to 121.92 cm). Door widths in buildings accessible to the physically disabled must comply with the dimensions and clearances required by various codes. (See Chapter 11 and Appendix 1 for these particulars.)

FIGURE 15.5 Various door types drawn in plan view.

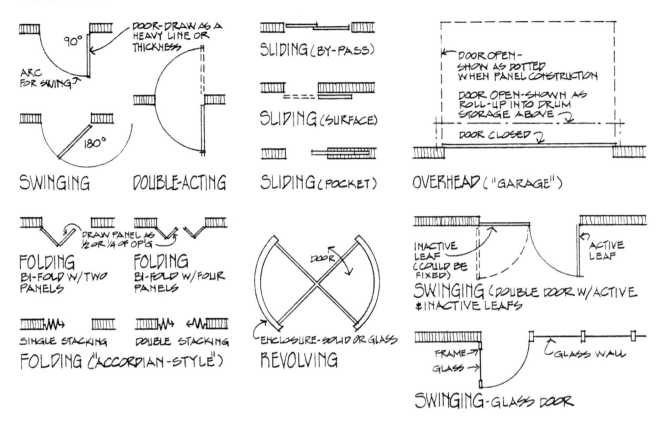

doors: PLAN VIEW - TYPES AS DEFINED BY OPERATION

SWINGING DOORS

Swinging doors are the most common type, since they are easy to operate, have simple hardware, and are the most effective for providing weather-tight and acoustical seals. However, space must be provided for the arc of the swing and an allowance for the door when it is open. Swinging doors are constructed in single or paired units, ranging in total width from 1 to 8 feet (304 to 2438 mm).

SLIDING DOORS

Sliding doors are supported by overhead and/or floor tracks and do not require usable floor space for the door arc. It takes more physical action to slide them back and forth in the track, but they are convenient when swinging doors cannot be used. Sliding doors are made as bypass, surface, and pocket units.

BYPASS DOORS. Bypass doors are made as double, triple, and multiple panels that slide on adjacent tracks to bypass other door panels within a door frame. The typical double types are used primarily for interior closets or sliding glass doors. They restrict the open area to 50 percent, since both panels cannot be completely open at the same time.

SURFACE DOORS. Surface doors are suspended from an overhead or floor track set in front of the surface of a wall rather than within the wall frame. They are used mostly for interior installations, although many farm and utilitarian buildings (such as garages) use them when weather tightness is not a major factor.

POCKET DOORS. Pocket doors are suspended from an overhead track and slide into a recessed wall pocket when opened. Like a swinging door, this type provides a 100 percent opening and eliminates the space requirements for the door and its arc. Pocket doors are used in interiors where tight acoustical control is not a concern.

FOLDING DOORS

Folding doors are used in interiors primarily for closets, storage rooms, and visual screening, that is, to seclude areas. They are manufactured with top and/or bottom tracks, as well as various hinging of the door panels. Bifold and accordian are two types of folding doors.

BIFOLD DOORS. Bifold doors, used mostly for interior closets, provide almost a 100 percent opening. They can be constructed as hinged two-panel sections that open to one side of the door frame or as double configurations of four panels, opening to both sides of the frame. Although bifold doors project into a space when open, they do not require as much room as a swinging door.

ACCORDIAN DOORS. Accordian doors are similar to bifold but have many narrow panels (alternately hinged and suspended from an overhead track.) Accordian doors are used for large openings, particularly as dividers between rooms. When opened, they can be made to stack to either one or both sides. They can be custom-made from the typical 6 foot 8 inch (2032 mm) height to as tall as 16 feet (4876 mm).

REVOLVING DOORS

Revolving doors, used in commercial installations, maintain a continuous weatherseal and prevent drafts into the building, cutting down on heat loss and gain. They can accommodate and quickly move large numbers of people. They are often flanked by swinging doors to accommodate physically disabled people and the transporting of bulky items.

OVERHEAD DOORS

Overhead doors roll up in hinged sections, forming a coil, or open as one piece, which requires special hardware. Although they are typically used as garage doors, overhead doors are also seen in commercial interiors, such as in shopping malls and institutional spaces. Available in a great variety of widths and heights, they can be connected to smoke detectors and provide an automatic fire closing door.

SPECIALTY DOORS

Specialty doors combine the operating action of several door types, such as swinging and sliding. Sliding doors are also made as flexible units that move along a curved track and coil or spiral at the end in a tambour action.

Some doors have doors within them, such as large sliding room dividers that have a swing door within. In fact, some of these doors, such as the ones that close retail store fronts, are more aptly termed gates because of their size and operation.

Door Styles and Construction

Although manufacturers produce many distinct door styles, such as French, Dutch, and louvered, in many materials, door styles are generally classified as flush or paneled (Figure 15.6), based on their appearance and construction. Flush-style doors are of solid- or hollow-core construction. Paneled doors can be a flat panel (perhaps with glass inserts) or a combination of stiles and rails.

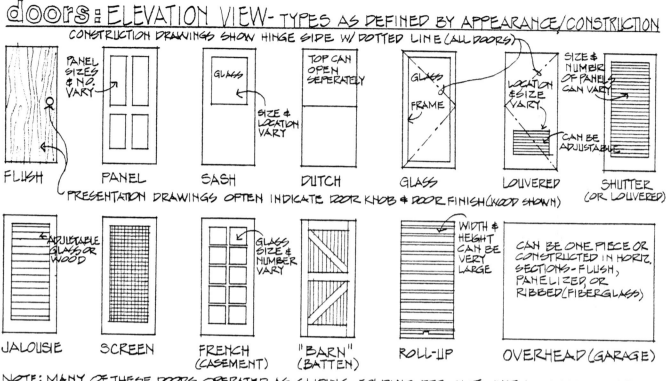

SOLID-CORE DOORS

Solid-core doors were originally made of solid sections of lumber. Today they have solid cores of wood blocks, strips, and particleboard, covered with wood veneers, plastic laminates, or metal. Solid-core doors, used for both exteriors and interiors offer fire protection, sound insulation, and weather resistance. They are generally heavier and more expensive than hollow-core doors. Solid-core doors can be flush style or can imitate panel construction.

HOLLOW-CORE DOORS

Hollow-core doors are not as strong and dense as solid-core doors and are primarily used for residential interiors. Their cores are made of a variety of materials, such as a cardboard honeycomb structure, plastic foams, and thin meshes. They are covered with wood veneers, plastic laminates, and metal. Their styles are similar to those of solid core, either flush or panel imitations.

RAIL AND STILE DOORS

Panel doors were originally constructed of a wood framework of horizontal (rail) and vertical (stile) members. Today many are still made like this but use a combination of materials, such as plywood, solid wood, louvers, screen mesh, and glass sections. Both hardwoods and softwoods are used to make these doors.

HOLLOW METAL DOORS

Hollow metal doors often imitate the styles of flush and paneled doors but are stronger and more durable. They are particularly effective for security, wet locations, and fire-resistive installations. Faces can be made of various metals or laminated with plastic in flush and panel

styles. The interior construction is hollow or filled with insulation materials. Various louvers and glass sections can be installed in these doors.

GLASS DOORS

Glass doors can be made in a rail and stile construction using metal and wood members or can be solid glass sheets held with hinges and handles in an all-glass construction (Figure 15.7). All types of glass doors are required, by building codes, to be made with tempered or safety glass.

FIGURE 15.7 The glass doors in these offices for Apple Computer, Inc., are designed to be simple glass panels to match the adjoining glass wall treatments. They are held in place by a minimum of hardware. (Courtesy of Gensler & Associates. © Peter Aaron/Esto.)

Door hardware consists of operating trim (knobs and levers), engaging mechanisms (locksets and latchsets), hinges, thresholds, and specialty items, such as door closers, kick plates, tracks, and weather stripping. Most hardware is made of various plastics and metals in many finishes.

DOOR FRAMES AND HARDWARE

Door frames (Figure 15.8) accommodate doors and their various hardware. The frame, consisting of a head (top), jamb (side), and sometimes a sill (bottom), also becomes the door "stop". Door frames, which are wood or metal, are manufactured as prehung (complete with door, frame, and hardware) or are handmade at the project. The frames are shimmed in the wall to permit proper alignment of the door and frame. Casing trim is then applied around the jambs and head of the door frame to conceal the shimming and fasteners.

FIGURE 15.8 Door frames are made in wood or metal and have a variety of construction features and terminology.

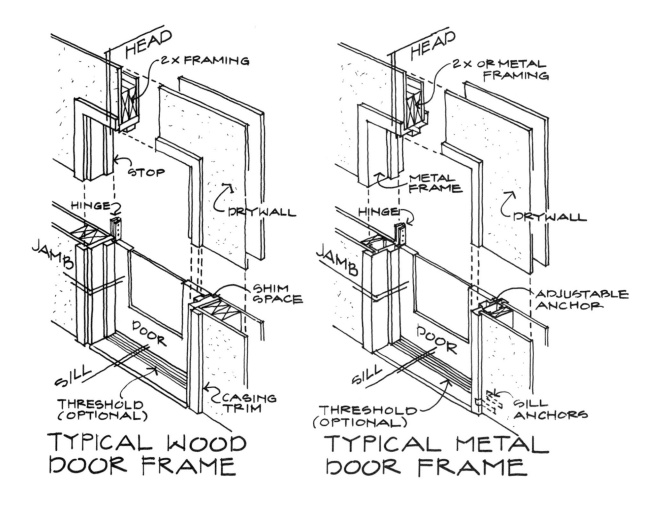

WINDOWS

Windows and their treatments have a direct influence on the physical and aesthetic qualities of a space. Originally, windows were simple openings made in a wall to provide ventilation and light. Today, windows serve many additional functions, such as providing protection from the natural elements; providing privacy; and serving as a design element, adding visual excitement or view (Figure 15.9).

When selecting windows and treatments, the interior designer should consider a number of external factors, such as climate, building orientation, prevailing winds, views, and architectural style. Interior considerations include natural light availability and desirability, the view to the exterior, ventilation, safety factors, furniture arrangement, and available wall space. The way windows will affect solar gain and energy conservation is also a major factor.

FIGURE 15.9 The windows in this office are created to be a major design statement as they set a repetitive geometrical pattern to the window–wall relationships.

The selection of the glass for windows depends upon the location, use, and aesthetics of the window. The various types of glass are discussed in Chapter 13.

Today, many high-rise buildings are sealed environments; that is, they have nonoperable windows or no windows at all. Although this might be an energy-efficient method for the building design, it could be a potential health hazard, because research studies have shown that people need a balance of full-spectrum light and natural air.

Window Types

Windows serve as a complement to the interiors and are selected for their function and style. They can serve to augment a historical style or add character to both the exterior and the interior. Windows are generally categorized as either fixed or operable (Figure 15.10). Fire safety concerns (access and escape), ventilation, and maintenance must be considered when deciding between these two types.

FIXED WINDOWS

Fixed windows do not open, their purpose being to admit light, serve as an acoustical or physical barrier, or provide a view. They are used when opening capability is not required, such as in store windows or sealed, air-conditioned spaces. Fixed windows, available in a number of sizes and configurations, can be placed with operable units. Round porthole windows and hexagonal,

windows: ELEVATION VIEW - TYPES AS DEFINED BY OPERATION

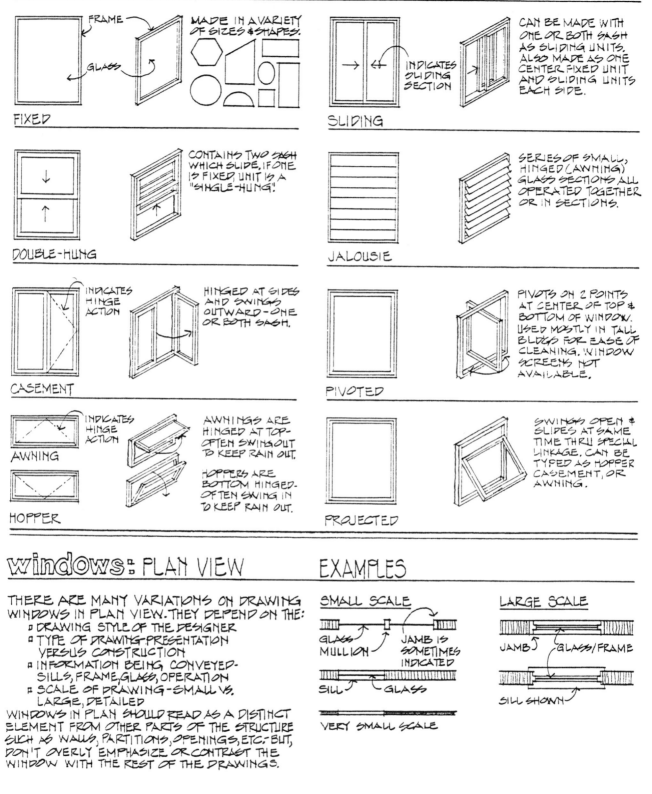

FIXED — FRAME, GLASS. MADE IN A VARIETY OF SIZES & SHAPES.

SLIDING — INDICATES SLIDING SECTION. CAN BE MADE WITH ONE OR BOTH SASH AS SLIDING UNITS. ALSO MADE AS ONE CENTER FIXED UNIT AND SLIDING UNITS EACH SIDE.

DOUBLE-HUNG — CONTAINS TWO SASH WHICH SLIDE. IF ONE IS FIXED, UNIT IS A "SINGLE-HUNG".

JALOUSIE — SERIES OF SMALL, HINGED (AWNING) GLASS SECTIONS ALL OPERATED TOGETHER OR IN SECTIONS.

CASEMENT — INDICATES HINGE ACTION. HINGED AT SIDES AND SWINGS OUTWARD - ONE OR BOTH SASH.

PIVOTED — PIVOTS ON 2 POINTS AT CENTER OF TOP & BOTTOM OF WINDOW. USED MOSTLY IN TALL BLDGS FOR EASE OF CLEANING. WINDOW SCREENS NOT AVAILABLE.

AWNING — INDICATES HINGE ACTION. AWNINGS ARE HINGED AT TOP - OFTEN SWING OUT TO KEEP RAIN OUT.

HOPPER — HOPPERS ARE BOTTOM HINGED - OFTEN SWING IN TO KEEP RAIN OUT.

PROJECTED — SWINGS OPEN & SLIDES AT SAME TIME THRU SPECIAL LINKAGE. CAN BE TYPED AS HOPPER CASEMENT, OR AWNING.

windows: PLAN VIEW EXAMPLES

THERE ARE MANY VARIATIONS ON DRAWING WINDOWS IN PLAN VIEW. THEY DEPEND ON THE:
- DRAWING STYLE OF THE DESIGNER
- TYPE OF DRAWING-PRESENTATION VERSUS CONSTRUCTION
- INFORMATION BEING CONVEYED-SILLS, FRAME, GLASS, OPERATION
- SCALE OF DRAWING-SMALL VS. LARGE, DETAILED

WINDOWS IN PLAN SHOULD READ AS A DISTINCT ELEMENT FROM OTHER PARTS OF THE STRUCTURE SUCH AS WALLS, PARTITIONS, OPENINGS, ETC.- BUT, DON'T OVERLY EMPHASIZE OR CONTRAST THE WINDOW WITH THE REST OF THE DRAWINGS.

SMALL SCALE — GLASS, MULLION, JAMB IS SOMETIMES INDICATED. SILL, GLASS. VERY SMALL SCALE.

LARGE SCALE — JAMB, GLASS/FRAME, SILL SHOWN.

FIGURE 15.10 Fixed and operable windows, as seen in elevation and plan views.

elliptic, and half-round shapes are popular variations that offer a contrast or can reinforce the lines of the architecture.

OPERABLE WINDOWS

Like fixed windows, operable windows are used to provide a view. Operable windows can also provide physical access, ventilation, and a means of escape in an emergency. They are also positioned where acoustical privacy is necessary, such as at a cashier's position in an office, and let items or communication pass from one area to another. Operable windows can be categorized as swinging, sliding, and pivotal. Swinging windows include casement, awning, hopper, and jalousie. Sliding windows include double-hung and horizontal sliders.

CASEMENT WINDOWS. Casement windows swing outward or inward like small doors. They are good for ventilation and can be easily opened with a crank, push bar, or handle but can create a safety hazard when projected. Therefore, the designer should be sure that casement windows will not interfere with walkways and furniture.

AWNING WINDOWS. Awning windows are hinged at the top and can swing inward or outward. They are opened with a crank or push bar. Good ventilators, awning windows offer protection from rain when they swing out. They are manufactured as either single units or multiple units stacked within a single frame. Awning windows, like casements, should be located so that they do not interfere with outdoor pedestrian traffic or indoor furniture arrangement or draperies.

HOPPER WINDOWS. Hopper windows are similar to awning windows but are hinged at the bottom and swing inward. These windows, designed for placement low on a wall or in a basement, are good for air circulation.

JALOUSIE WINDOWS. Jalousie windows consist of a series of horizontal slats (3 to 8 inches, or 76 to 203 mm, wide) of glass, plastic, or wood that operate in unison. Because of their narrow size, they do not present a safety hazard when open. Jalousie windows are a good choice when ventilation is a major concern, since the slats can be adjusted to control the amount of ventilation desired. However, they are somewhat difficult to clean.

DOUBLE-HUNG WINDOWS. Double-hung windows are the most common type of vertical sliding windows. These windows have two glass areas, called sashes, that slide vertically up or down for ventilation. Double-hung windows are generally taller than they are wide and seldom warp or sag. They do not project into the interior space, so they do not interfere with window treatments, furniture, or traffic.

HORIZONTAL SLIDING WINDOWS. Horizontal sliding windows slide on top and bottom tracks mounted inside the frame. These windows come in a variety of sizes and consist of two or more sashes, usually only one of which is movable. Like double-hung windows, horizontal sliders have no projecting parts to interfere with window coverings, furniture, or traffic.

PIVOTAL WINDOWS. Pivotal windows are similar to casement windows, but instead of side hinges they have a top and bottom pivot placed near the center of the window. The glass area pivots open to allow for ventilation. These are easy to clean and maintain, which is particularly important when the windows are located several floors above the ground.

COMBINATION WINDOWS

Any of the windows described can be combined to provide both operable and fixed elements. For example, sliding or swinging units can be placed on either side of fixed glass to form a three-section window. Awning windows are usually placed above or below fixed glass units to provide both ventilation and an unobstructed view.

Bay and bow windows are specific styles of combination windows. Bay windows project at angles from a building structure (Figure 15.11). The most common type consists of two

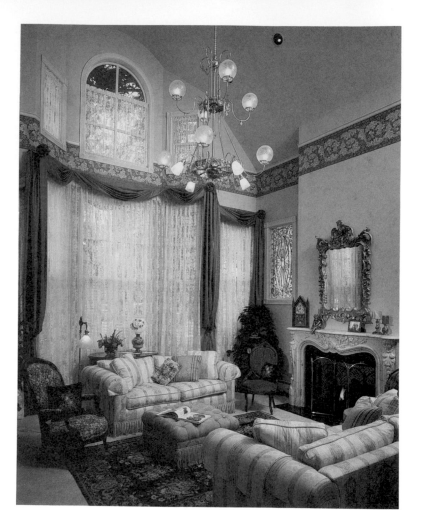

FIGURE 15.11 This bay window expands the space within this interior and creates a dominant element.

double-hung or casement windows with a fixed section in the center. Side units are generally placed at 45- or 60-degree angles to the exterior wall.

Bow windows form an arc projecting out from the exterior wall. They generally consist of fixed glass and operable windows and range from four to seven units.

SKYLIGHTS AND CLERESTORY WINDOWS

Skylights and clerestory windows are used to admit light into interior spaces that receive little or no natural light. Mounted in the roof, skylights are made of glass or plastic. Clerestory windows are available in a variety of sizes and are placed high on a wall. Clerestory windows are either custom-made or consist of a series of standard-size windows. Both skylights and clerestories can be fixed or operable, insulated with double layers, and tinted.

Window Construction

Windows are constructed with a frame, which includes the head, jamb, and sill; a sash (glass area); and casing (Figure 15.12). The sash area can include one or more sections held together by a top and bottom rail and side stiles. Sashes can be divided into several smaller rectangular areas by bars called muntins or mullions.

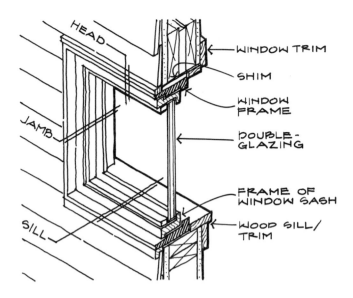

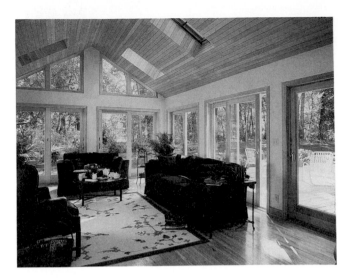

FIGURE 15.12 Typical window frame and its parts. These can be constructed in wood, metal, plastic, or a combination of materials.

FIGURE 15.13 The window and door trim in this home are simple in style and color to work in harmony with the treatment of the wood ceiling and floor.

Window frames are made of wood, aluminum, steel, or plastic. Although wood is a good insulator, it can expand and contract with different climate and moisture conditions, causing the frame to stick and create gaps. Wood needs to have protective coatings, such as paint, sealers, or vinyl, applied.

Aluminum window frames are generally less expensive than wood and have a maintenance-free coating applied to them. However, aluminum is not a good insulator; condensation can form when exterior temperatures differ greatly from interior temperatures. If that is likely, a thermal break of rubber or vinyl is installed. Vinyl frames are similar to metal frames but are better insulators.

Metal-clad wood frames are covered with aluminum either on both the interior and the exterior sides or on the exterior side only. If the frame is on the exterior side only, the interior side might be either wood or vinyl finish. Metal-clad wood frames offer the insulating value of wood and the low maintenance of aluminum.

On the interior of a space, the window generally consists of a casing and trim, which are used to conceal and finish gaps between the rough opening and the window unit. A variety of interior trims can contribute to the overall design and character of a space (Figure 15.13).

INTERIOR WINDOW TREATMENTS

A large variety of options are available for interior window treatments. The first question is: Why cover windows? The decision to cover a window must be based on several considerations: function, aesthetics of the interior, the view, code requirements, and cost.

Functional Considerations

The functional variables in selecting window treatments include the need for privacy, glare control, sound absorption, building code requirements, energy conservation, and light transmission and reflectance. Daytime and nighttime privacy can be important to personal safety and comfort. Privacy can be achieved with a sheer, semisheer, or casement curtain, drapery, or shade. However, translucent material will not provide complete privacy and should be fully lined with an opaque material. Vertical or horizontal blinds or shutters can also be adjusted to partially restrict a view.

Window coverings can be used to reduce glare while still allowing natural light to filter through. This is especially important in offices where glare on the computer or video screens must be eliminated or minimized.

Window coverings can help to absorb sound, but the sound absorption qualities of drapery fabric decreases as fabric openness increases. If sound absorption is a major concern, a closely woven fabric or compactly constructed material must be used.

Window coverings can reduce energy consumption. In winter, heat loss occurs when heated interior air rises and travels toward a cold surface, generally window glass. The heated air is then cooled and circulates within the interior space, which might cause the occupants to feel a draft. Window coverings can be used to prevent warm air from coming in contact with the cold glass. Window treatments insulate best if they are heavy and opaque. The most effective treatments to prevent heat loss include insulated fabric shades that are sealed on the top, bottom, and sides. Insulated shutters or heavily lined draperies that have sealed top treatments, reach to the floor, and are securely attached to the walls are also good choices.

During summer months, excessive heat gain within an interior is not only uncomfortable but can cause damage to or fading of interior furnishings. To prevent excessive heat gain, the most effective interior treatments are those that reflect a large percentage of sunlight back through the glass area. Either soft or hard window treatments can reflect most of the sunlight if they have a metallic or a light-colored backing.

All applicable building codes or fire codes must be considered when specifying window treatments.

Aesthetic Factors

The aesthetic choices available for window coverings depend on individual needs or preferences. However, window coverings and styles should not be selected on the basis of personal preference alone. The principles and elements of good design, such as proportion, scale, color, pattern, balance, rhythm, emphasis, and harmony, must be considered to assure that window treatments complement and support the interior design of a space.

Structural factors or visual defects may determine the kind of window treatments selected, such as covering two windows with a single treatment. Or there may be a need to alter the visual dimensions of a window through the treatment so the window is in harmony with the rest of the space.

Window treatments are selected not only for their aesthetic appeal but also to blend with and support the design and architectural style. Generally, window treatments should also harmonize with the exterior style and not distract from the architectural character. Windows can either

blend in with wall treatments and become part of the background or they can contrast with the background and become a focal point. Another consideration is whether the space is to be of contemporary or historical design, which the window treatments must follow.

Cost Factors

Before the final selection of window treatments, various cost-related factors must be taken into account. The initial material, labor, hardware, and accessories as well as life-cycle costs (relating to the replacement and maintenance of a system over its expected life) should be considered.

Types of Window Treatments

Window treatments can be categorized as soft, hard, and top. Soft window treatments include draperies, curtains, and shades (Figure 15.14) and generally are made of soft fabrics.

FIGURE 15.14 **Soft window treatments are generally composed of draperies, curtains, and shades.**

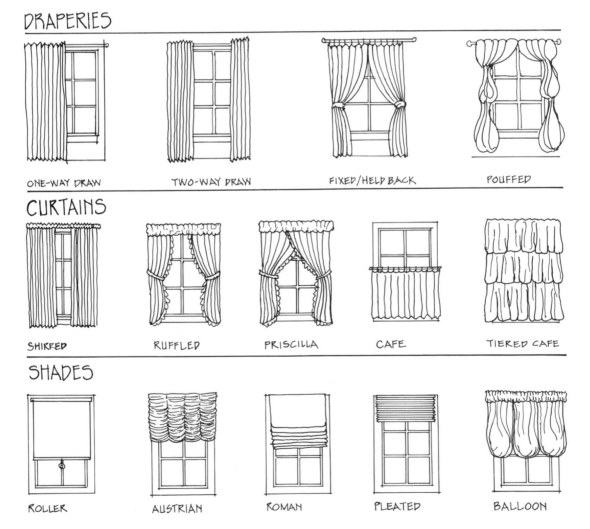

DRAPERIES

ONE-WAY DRAW TWO-WAY DRAW FIXED/HELD BACK POUFFED

CURTAINS

SHIRRED RUFFLED PRISCILLA CAFE TIERED CAFE

SHADES

ROLLER AUSTRIAN ROMAN PLEATED BALLOON

Hard window coverings include vertical and horizontal blinds, shutters, and screens made of wood, metal, or plastic, either alone or in combination with other materials. Top treatments can be made of either soft or hard materials and used alone at the top of a window or in combination with the other types of window coverings.

SOFT WINDOW TREATMENTS

Fabric at windows can visually soften the hard lines of the interior structure. Window fabrics can also screen glare, darken a room, absorb sound, add insulation, provide privacy, and add visual stimulation through color, texture, or pattern. Fabric window treatments can also augment a historical period, carry out a decorative scheme, or complement an architectural style. Many combinations of styles and fabrics can be used at the window to make it a creative design element.

DRAPERIES. Draperies are fabric panels that are generally pleated and hung on a rod. In most instances, they are installed at the ceiling or just above the top of the window frame. They can be made of a heavy opaque, casement (semiopaque), or translucent fabric. The many types of drapery pleats include pinch, French, and spring-rod pleats. Draperies are mounted on rods and can be drawn across a complete glass area, pulled to one side, or hung in a stationary position at each side. Draperies can be full and hang straight or be tied back. They can extend slightly below the bottom of the window frame or to the floor.

CURTAINS. Curtains are soft window treatments that generally are less formal than draperies. Curtains are either stationary or hand operable and can be hung inside a window frame or outside to unify a group of windows. Popular styles include shirred, ruffled, and cafe curtains in unlimited variations and combinations.

Shirred. Shirred curtains are gathered directly on rods and can hang straight down or be secured to another rod at the bottom. These treatments are sometimes referred to as sash curtains, since they are stretched across the sash of a window.

Ruffled. Ruffled curtains feature ruffles on the hem, in the middle (if to be pulled apart), and sometimes on the sides. They generally have a ruffled valance and tiebacks. The priscilla curtain is a ruffled curtain consisting of two panels that either meet in the center or crisscross, with one panel in front of the other.

Cafe. Cafe curtains, originally used in French cafes, covered only the bottom half of the window so that patrons seated by the windows would have some privacy without the natural light being blocked out. Cafe curtains are now made either in tiers and cover either the entire window or only the bottom half, with or without a valance at the top. The tops of the curtains can be looped, shirred, scalloped, or pleated.

WINDOW SHADES. The primary purpose of window shades is to control light by filtering or blocking it completely. Window shades come in a variety of styles and are made of fabric, vinyl, bamboo, or wooden slats. The main types are roller shades, Austrian shades, Roman shades, pleated shades, and balloon (pouf or cloud) shades. Some shades, such as roller and pleated, can block or filter the light and therefore are sometimes installed with decorative curtains to protect the curtains from fading. Most shades can be mounted either inside or outside the window frame.

Roller Shades. Roller shades consist of a strip of vinyl or fabric hung on a roller that rolls up when a spring mechanism is triggered. Most of these shades are pulled from the top down to cover part or all of a window sash; however, some can be operated from the bottom and pulled up. These inverted shades are held in place with a latch or a spring-loaded roller. Roller shades are available in translucent, opaque, or blackout material.

Austrian Shades. Austrian shades are pulled up by cords. These shades are made of sheer or semisheer fabric sewn into soft horizontal scallops and gathered vertically. They are more

formal in character than Roman shades and can be used in residences or commercial structures, such as offices, theaters, or restaurants.

Roman Shades. Roman shades operate like Austrian shades but fold into horizontal pleats when raised and hang flat when closed. Roman shades can be made of fabric or a woven wood (a combination of wooden slats and textile yarns), the latter giving them texture in a natural color. Roman shades are energy efficient if they are made of a moisture-barrier material, interlined with an insulative material, and have a heavy lining.

Pleated Shades. Pleated shades are factory made and when folded resemble an accordion's action. These shades require very little stacking space when raised. Pleated shades are constructed of semisheer or polyester fabric in plain or printed patterns. They can be transparent, translucent, or opaque, depending on the compactness of their construction and the application of back coatings. A metallic coating is sometimes applied for better insulation and also reduces static electricity, lessening the attraction of dust.

Honeycomb-Pleated Shades. Honeycomb-pleated shades are generally constructed of spun-bonded polyester fabrics that are permanently pleated and put together as two shades to create an insulating layer of air (Figure 15.15). The exterior face is white to provide heat reflection and to create a uniform appearance from the exterior. The honeycomb shade has pleats smaller than those in the accordion-pleated shade and requires even less stack-up space: a 96-inch-long (2438 mm) honeycomb shade requires only 3⅛ inches (79 mm) of stack-up space.

Balloon Shades. Balloon shades are also referred to as pouf or cloud shades because of the balloonlike poufs they form when raised. Balloon shades are pulled up with vertical cords, like Austrian shades. The top of the shade may be shirred or pleated, with the shade tailored (flat) or full (with ruffles and trimmings).

HARD WINDOW TREATMENTS

New materials, patterns, and styles have made hard window treatments very popular. Hard materials generally require little cleaning and are very durable. They offer privacy, light, and ventilation control. They can be installed inside a window frame to produce a clean and contemporary appearance or combined with soft window treatments to produce a more traditional or formal character. Generally, hard window treatments produce a simple yet versatile background that will coordinate with many different styles of furnishings. Hard window treatments include horizontal and vertical blinds, shutters, and screens (Figure 15.16).

HORIZONTAL BLINDS. Horizontal blinds consist of a series of horizontal slats, or louvers, held together by fabric tape or cords and operated by pull cords. The slats were historically made of wood and then of aluminum, both coated with a cream-colored enamel, like the venetian blinds used in the 1940s and 1950s. Today, horizontal blinds have narrower slats and are made of wood, molded polymer vinyl, and fashion-colored aluminum. These miniblinds have one-inch-wide (25 mm) slats; micro-miniblinds have one-half-inch-wide (12 mm) slats. The fabric tape and operating cords have now been replaced with tough nylon cords in matching colors and with plastic control wands of various lengths. These blinds can be tilted to control glare, airflow, and privacy. They can be installed inside or outside a window or door frame and can be used alone for a clean, contemporary character, as an undertreatment with draperies, or with a top treatment. They require very little stack-up space and are available in a wide variety of colors, patterns, and shapes. Custom graphics can even be incorporated into their design. Some slat blinds are designed to fit between double-glass window panes for better energy conservation and dust control (see Figure 15.17).

VERTICAL BLINDS. Vertical blinds consist of a series of vertical slats made of plastic, metal, or wood. The slats can have fabric or wallpaper inserts to coordinate with the design of a space. The slats are suspended vertically from the ceiling or wall on a traversing or nontraversing

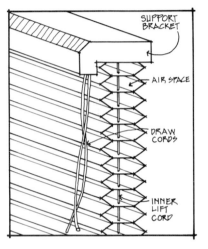

FIGURE 15.15 This honeycomb shade requires little stacking space when raised. It provides an insulative value from the air captured within the folds.

BLINDS - HORIZONTAL & VERTICAL

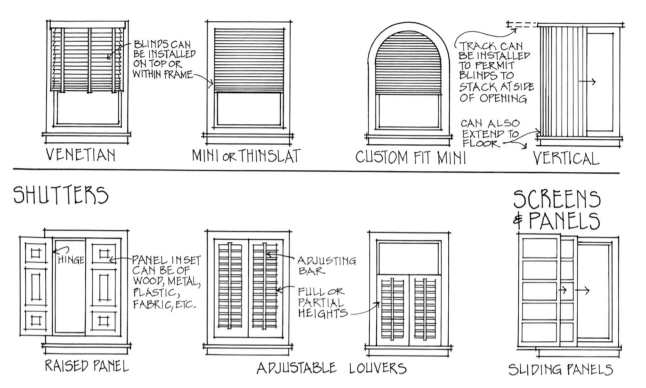

VENETIAN — BLINDS CAN BE INSTALLED ON TOP OR WITHIN FRAME

MINI OR THINSLAT

CUSTOM FIT MINI — TRACK CAN BE INSTALLED TO PERMIT BLINDS TO STACK AT SIDE OF OPENING — CAN ALSO EXTEND TO FLOOR

VERTICAL

SHUTTERS

RAISED PANEL — HINGE — PANEL INSET CAN BE OF WOOD, METAL, PLASTIC, FABRIC, ETC.

ADJUSTABLE LOUVERS — ADJUSTING BAR — FULL OR PARTIAL HEIGHTS

SCREENS & PANELS

SLIDING PANELS

FIGURE 15.16 Hard window treatments are composed of blinds, shutters, and screens.

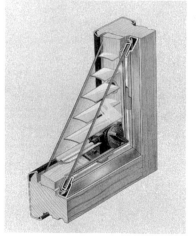

FIGURE 15.17 Pella makes a "slimshade" that is sandwiched and protected between two glass panels. These are set apart by a 13/16-inch air space for insulative purposes.

track. They can be held in place by a bottom track if necessary. If they are on a traversing rod, they can have a one-way or a two-way draw. Vertical blinds can be rotated for increased outward views and for inward light transmission or can be closed for complete privacy. They can be used to enhance the height of a room and made to fit odd-shaped openings. They gather less dust than horizontal blinds.

SHUTTERS. Shutters are perhaps the oldest of the hard window treatments and are available in both contemporary and traditional styles. Shutters are made of rigid panel frames, usually of wood, attached with hinges to open and close like small doors, thus allowing more light and ventilation to be admitted. The most common panel insert is the adjustable louver with a center bar to lower or raise the louvers. The width of the louvers varies from one to three inches (25 to 76 mm).

Other panel inserts include fixed slats or raised panels. Raised panel shutters consist of solid wood panels raised in the center. These shutters are more formal in character and can be stained or painted. Also, fabric inserts can be installed in a shutter frame to coordinate the design throughout an interior. Shutters can be used in combination with other window treatments, such as curtains, blinds, shades, or top treatments.

SCREENS AND PANELS. Screens and panels can be sliding or folding, either free-standing or installed on the outside frame of windows. These screens and panels can create a spectacular focal point within a space as well as mask views, filter light, or diffuse ventilation. They are generally constructed with a wood frame and can have inserts of lattice work, fabric, carved or painted wood, or a translucent backing. Japanese shoji screens and Chinese fretwork

panels are considered classics and are used in contemporary, traditional, or oriental interiors. Shoji screens are traditionally made with glazed mulberry or rice paper and set into a wooden frame of symmetrical panes. Since shoji screens are translucent, they do not provide complete privacy, but allow diffused light to enter a space. They can be installed in front of windows as sliding panels or can be used as freestanding screens or as wall divider units.

TOP TREATMENTS

Top treatments are installed at the head of a window to add a finished appearance to a space, as well as to conceal the top of a window covering and its hardware. Top treatments can be designed according to architectural detail within a space or inspired by furnishings. Top treatments can be made of soft or hard materials (Figure 15.18).

Fabric can be an effective material for overhead treatments and can unify a space by carrying the eye along the top of the walls and around the perimeter of a space. Top treatments

SOFT MATERIALS

 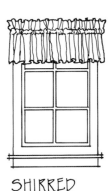 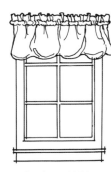 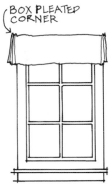

PLEATED SHIRRED BALLOONED SWAGS AND CASCADES FABRIC VALANCE

HARD MATERIALS

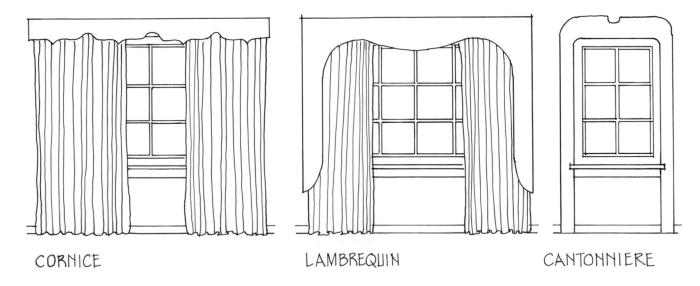

CORNICE LAMBREQUIN CANTONNIERE

FIGURE 15.18 **Typical top treatments for windows.**

made of fabric are called valances; these may be pleated, ballooned, shirred, or scalloped. Valances are generally constructed in the same manner as draperies or curtains and, in essence, become short window coverings. They can be used alone as a window treatment or in combination with soft or hard coverings. Some valances are very complex and decorative, such as swags, jabots, or cascades. Swagged valances are created by draping fabric horizontally over the top of the drapery or rod. Jabots and cascades are side treatments and generally are used in conjunction with a swag.

Cornices, lambrequins, and cantonnières are rigid treatments generally constructed of wood or metal. They can be covered with fabric, painted, or stained. Cornices are either straight or shaped and generally project four to six inches (101 to 152 mm) from the wall. Cornices are typically mounted at or near the ceiling and extend down far enough to cover the drapery heading and hardware. A lambrequin is similar to a cornice, with both sides extended to or near the floor. Cantonniéres are fitted flush to the wall, exposing the frame of the window, and have shaped overhead panels and sides extending to the floor. Most top treatments are energy efficient, since they help to control the airflow around the window.

CABINETRY

Cabinets are components that can be built in or attached to a wall or can be freestanding on the floor surface. They provide a multitude of functions, ranging from built-in storage to custom seating forms (Figure 15.19).

Cabinets are also called cabinetry or casework, although the latter term primarily refers to units premade at a plant, shipped to a project, and installed by carpenters. These units might be freestanding or be secured to a wall or floor and trimmed out with wood moldings.

FIGURE 15.19 A variety of custom millwork and standard cabinetry is used in this kitchen designed by Wayne Williams, CKD.

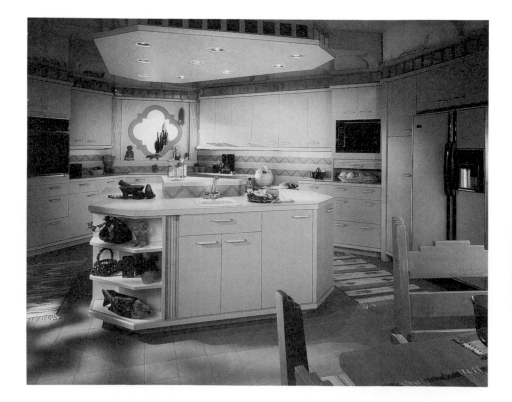

Custom cabinetry is designed by interior designers and architects; it is sometimes constructed at the job site but preferably is built in a woodworking shop. The latter types are then taken to the site for final assembly and trim out. In custom work, the designer draws the design and specifies the dimensions and materials. A woodworking shop then produces detailed shop drawings that precisely correspond to the construction particulars. After the designer approves the shop drawings, construction is begun on the unit and it is delivered to the job site for installation.

Cabinet Specifications

Cabinets can be constructed in a variety of ways ranging from the simple and economical to the elaborate and expensive. Specifications and standards have been set by several agencies to rate cabinet materials and construction in certain categories. The American Woodwork Institute (AWI) categorizes cabinets as economy, custom, and premium. The AWI publishes drawings and details that are characteristic of each type and specifies acceptable wood grades, finishes, joints, and hardware.

Cabinet Construction

When designing or selecting cabinetry, a designer needs an understanding of the way the materials and the construction details are combined to produce well-made cabinetry. Many of these materials and techniques (particularly the ones involving the joints) are similar to those used in furniture making.

Cabinets are generally classified as wall or base cabinets, depending on their placement. Standard wall cabinets are typically made to a depth of 12 inches (304 mm) and to heights of 12 to 48 inches (304 to 1219 mm). Their width ranges in 3-inch (76 mm) increments. Base units are made in many sizes; the most common depth ranges from 20 inches (vanity) to 24 inches (508 to 609 mm) (standard). Heights generally are 30 and 36 inches (762 and 914 mm) for casework, with custom units either the same dimensions or varying 1 to 2 inches (25 to 50 mm). Widths are produced in casework in 3-inch (76 mm) increments; custom casework can be any dimension. There are many special types of premanufactured cabinet units for sinks, ovens, computers, sewing centers, laundry rooms, and office systems.

The surfaces of cabinets are classified as exposed, semiexposed, and concealed. The cabinet material and finish depends on which classification they correspond to. The exposed sections are those visible when all drawers and doors are closed. Semiexposed sections are interior faces of doors, drawer sides, shelves, and other surfaces exposed when the unit is opened. Concealed elements, such as the underside of drawers and members used for construction, are normally not visible.

CABINET FRAMES
Cabinets are made as rail and stile framed units or as solid-piece panel construction (no frames), as seen in Figure 15.20. Materials used for cabinet frames vary as much as the styles and sizes. Most cabinet frames are constructed of hardwoods, particleboard, and plywood. Softwoods are generally used only for minor blocking and concealed pieces. Surfaces can be covered with paint, plastic laminates, metal, vinyl, or exposed woods that are stained and sealed.

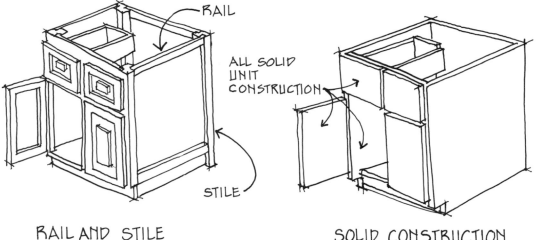

RAIL AND STILE SOLID CONSTRUCTION

JOINTS FOR CABINETS

Joints made in cabinetry construction are similar to the basic wood joints discussed in Chapter 13. However, many more types of joints —some highly specialized—are used in cabinet and furniture construction. Joints are of particular concern both for strength and for visual appearance in fine cabinetry and furniture, since they can be exposed to let the beauty of both the connection and the wood grain be appreciated.

DOORS AND DRAWERS

Doors and drawers are designed and constructed in two basic ways—exposed frame and flush frame. These types refer to the way the door or drawer meets the face of the frame, exposing or hiding it by various methods (Figure 15.21).

The exposed frame places the door and drawer flush with the face of the frame. Such frames require close tolerances, since space for operating must be left between the panel and the frame. The popular flush overlay frame is often referred to as having a contemporary or European look. This type conceals the frame below in varying degrees, partially revealing the frame behind or hiding it completely—showing only the doors and drawer fronts. This method allows for matching wood grain patterns on the fronts or for highlighting the clean, simple lines of the unit. Plastic laminates can be applied, becoming the dominant color and texture since the frame is hidden in the "cracks." However, hardware pulls or special latches might be required when the panels are so close that there is no room for recessed finger pulls.

The type of construction and the details of doors and drawers depend on the function of the cabinet, the visual impression, and the durability required. Thicknesses and materials vary according to the style, weight, and size of the panels. Panels are wood, plywood, particleboard, plastic, glass, and metal. Faces can be flush, paneled, or grooved into different shapes. Inserts of routed finger pulls and other additions can be made to the doors and drawers. Woods are finished with stains and sealers; other materials are covered with plastic laminates or paints.

SHELVES

Shelves are made of materials similar to those used for the doors and drawers. They can be fixed or movable, depending on the type of supports. Those supports include clips, pegs,

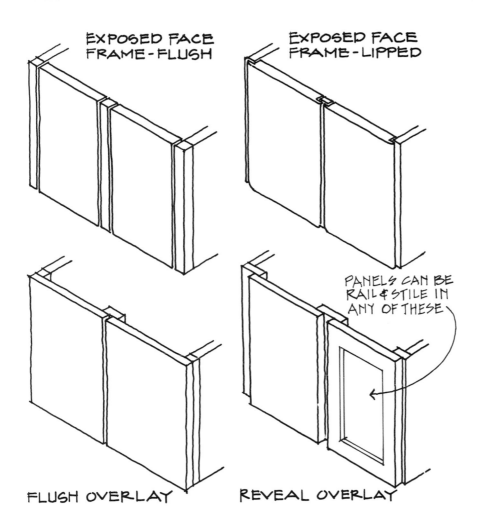

EXPOSED FACE
FRAME - FLUSH

EXPOSED FACE
FRAME - LIPPED

FLUSH OVERLAY

REVEAL OVERLAY

PANELS CAN BE
RAIL & STILE IN
ANY OF THESE

FIGURE 15.21 Doors and drawers can meet the cabinet frame in a variety of ways that will create different visual and functional styles.

grooves, and standards. Standards are metal strips specially punched to hold clips or brackets that are inserted at varying height positions.

Shelves are generally ¾ inches (19 mm) thick and span approximately 36 (914 mm) inches. Greater distances usually require intermediate supports, thicker sections, or supporting edges of metal.

Cabinet Hardware

The hinges, pulls, handles, and other mechanisms used to open, close, and operate movable cabinetry are called hardware. They are produced in a variety of styles and materials to fulfill different functions (Figure 15.22).

HINGES

Hinges are selected according to whether they are being used with a flush or an exposed door style. Hinges can be either exposed or concealed. They can be simple or very ornate. Most hinges are small, although some doors require a continuous, or piano, hinge for better support and operation.

Hinges can be designed as spring-loaded closing mechanisms. Pivot hinges are special devices that revolve around a central axis; these also can be either concealed or exposed.

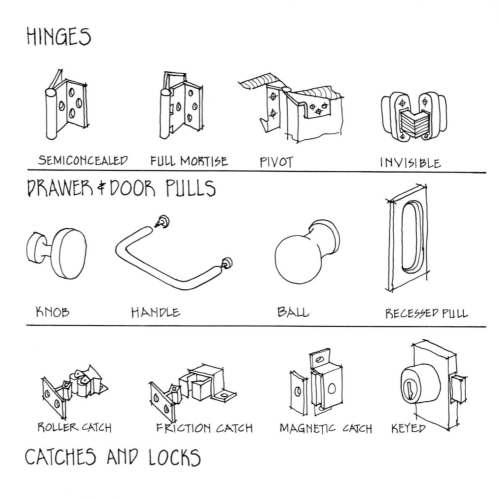

HINGES

SEMICONCEALED FULL MORTISE PIVOT INVISIBLE

DRAWER & DOOR PULLS

KNOB HANDLE BALL RECESSED PULL

ROLLER CATCH FRICTION CATCH MAGNETIC CATCH KEYED

CATCHES AND LOCKS

PULLS

Cabinet doors and drawers can be opened by pulling on knobs, handles, or recesses of various shapes. These pulls are made of wood, plastic, metal, or porcelain. Finger pulls can be cut as an integral part of the panel front by routing out the top, bottom, or sides of an area. The type of hardware is selected to be compatible with the design and weight of the door and the drawer.

CATCHES AND LOCKS

Cabinet doors can be self-closing or held by a catch. Just like doors, cabinets can be locked for security. There are five basic types of catches, with variations of each type. A roller catch engages a shaped tongue between one or two rollers; a magnetic catch relies on the placement of magnets; a friction catch holds by friction forces; a bullet uses a spring-activated ball held in place by a depression; and a touch latch releases when the door is pushed, freeing the door.

Cabinet Tops

Base cabinets are usually manufactured separately and are finished with various surface materials of plastic laminates, wood, plastic, metal, ceramic tile, and vinyl. The tops to go with them are generally manufactured in standard sizes and installed onto the cabinet base at the job site. Edge treatment are made in a variety of styles and materials.

FIREPLACES

Fireplaces can be constructed within a wall system or set freestanding, resting on the floor system, with their flues penetrating the ceiling and roof systems to exhaust gas, smoke, and sometimes heat.

In earlier times fireplaces and stoves were used for both heating and cooking and thus became a focal point. Today, they are primarily used for heating and because people appreciate their warm glow. The warmth and flames of an open fire entice people to gather around it. Even unlit, well-designed fireplaces can be a focal point or a center of interest within an interior environment (Figure 15.23). They can be installed in residential as well as nonresidential spaces, for example, in restaurants, bars and lounges, hotel lobbies, or recreational areas, such as ski lodges. Traditional masonry fireplaces are not as efficient for heating as are airtight stoves. Rising fuel prices, however, have caused a renewed interest in energy efficient fireplaces and stoves. Fireplaces can be an environmental concern today, since they contribute to air pollution; some cities have imposed "no-burn" days to help prevent this.

FIGURE 15.23 A fireplace can create a great impact on the interiors and use of a space.

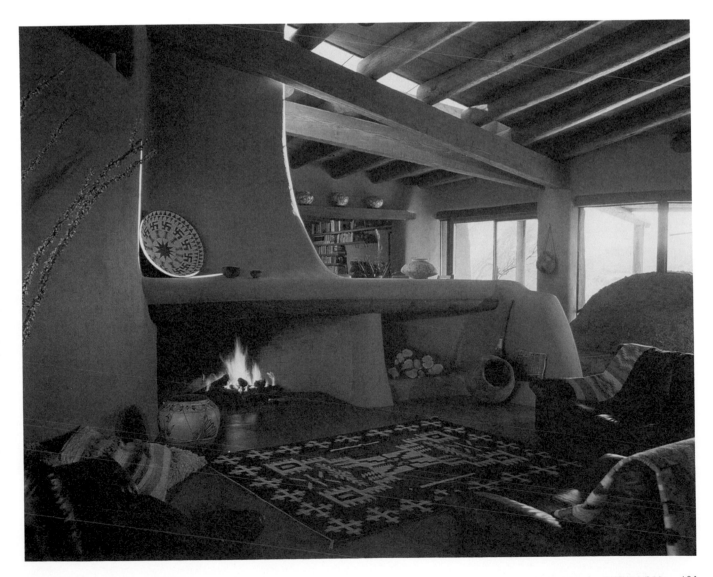

Since fireplaces are subject to building codes, it is important for interior designers to know how much space a fireplace takes; how it is constructed; and how the face, which includes the opening, surround, and hearth, can be treated with finish materials. In addition to these concerns, the designer must take into account that masonry fireplaces are very heavy and thus require special foundations.

Fireplace Construction

Fireplaces consist of a noncombustible base, a firebox, and a flue. Originally, fireplaces were made only of solid masonry; today they are also prefabricated as metal units containing the base, firebox, smoke chamber, flue, and damper (Figure 15.24). Metal fireplaces have double, and sometimes triple, walls to provide better airflow, insulation, and combustion, causing them to burn more efficiently than their masonry counterparts. Some units are built to draw outside air for combustion, and others draw in cool room air and recirculate warmed air back into the space. Prefabricated units are generally referred to as *zero-clearance* and can be built into combustible construction (depending on building codes), such as a normal stud wall. Most fireplaces burn wood, but some are gas or electric fired, yet give the appearance of a wood fire.

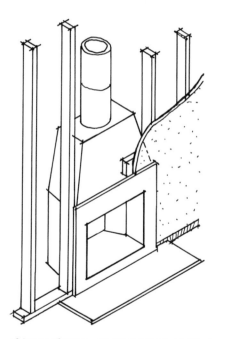
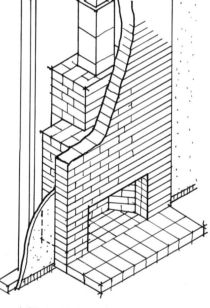

THESE ZERO-CLEARANCE TYPES CAN BE CONSTRUCTED INTO WOOD FRAMING.

PREFABRICATED

MASONRY TYPES ARE HAND MADE WITH A VARIETY OF STONE, BRICK, OR TILES.

MASONRY

FIGURE 15.24 Fireplaces are constructed as prefabricated metal units or traditional masonry construction.

Fireplace Types

The way a fireplace fits into an interior is important in determining how the total space will be arranged. Fireplaces can be built in many forms, as long as the functional parts are not

inhibited. Care must be taken to locate and orient a fireplace properly to avoid room drafts that could cause smoke problems. In addition to the common single-face opening, a fireplace can be open on two or three sides. If it is freestanding, it can be open all the way around (Figure 15.25).

FIGURE 15.25 The placement, openings, and orientation of a fireplace can produce a variety of functional and aesthetic features in an interior.

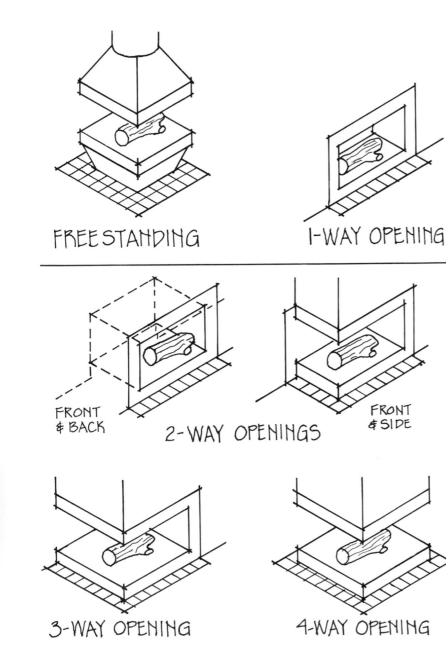

FREESTANDING

I-WAY OPENING

FRONT & BACK

2-WAY OPENINGS

FRONT & SIDE

3-WAY OPENING

4-WAY OPENING

FREESTANDING FIREPLACES ARE PLACED AWAY FROM WALLS AND CAN BE OF METAL OR HAVE A MASONRY BASE WITH A HOOD CONCEALING THE FLUE; OR THE FLUE CAN BE EXPOSED. THESE CAN SERVE AS A DECORATIVE ELEMENT WITHIN A SPACE AND BECOME A FOCAL POINT.

A SINGLE FACE FIREPLACE IS THE MOST COMMON, VARYING IN SIZE FROM 24-96 INCHES (609-2438MM) WIDE; WITH 36 INCHES (914MM) BEING THE MOST POPULAR. OPENING HEIGHTS RANGE FROM 24-40 INCHES (609-1016MM).

MULTI-FACE OPENING FIREPLACES ARE BUILT IN A NUMBER OF DIFFERENT WAYS, DEPENDING UPON THE DESIRED ORIENTATION.

ALL SINGLE AND MULTIFACED FIREPLACES ARE USUALLY EQUIPPED WITH SCREENS OR GLASS DOORS TO CONTROL FLYING SPARKS, OR IMPROVE THEIR HEAT EFFICIENCY/LOSS. VENTS, BLOWERS, AND DUCTS FOR DRAWING OUTSIDE COMBUSTION AIR CAN ASO AID IN IMPROVING EFFICIENCY.

Fireplace Locations

A fireplace should be located so that furniture can be grouped around it without disrupting the room's traffic patterns. The placement of a fireplace is important because it also affects a

room's proportion. A fireplace with a double opening can be used as a wall divider, emphasizing the division of space. A fireplace centered on a long wall will make the room appear shorter. To prevent heat loss, a fireplace should be located toward the center of a building, rather than on an outside wall.

A fireplace can be located flush into a wall or projected into a room. The flush type can be treated with various materials for the surround and hearth, making the fireplace either an active focal point or visually unobtrusive. The projected type can be open on one, two, or three sides. Fireplaces can also be set at a 45-degree angle in a corner and finished out as a single-faced unit. The hearths of all of these units can sit flush with the floor or be raised as much as 18 inches (457 mm) for supplementary seating. Building codes require hearths to be of noncombustible materials; they also specify the minimum space allowable in front and to both sides of the opening. These dimensions vary according to which building code governs.

REFERENCES FOR FURTHER READING

Ching, D. K. Francis. *Building Construction Illustrated.* New York: Van Nostrand Reinhold, 1975.
———*Interior Design Illustrated.* New York: Van Nostrand Reinhold, 1987.
Nielson, Karla J. *Window Treatments.* New York: Van Nostrand Reinhold Co., Inc., 1990.
Ramsey, Charles George, and Harold Reeve Sleeper. *Architectural Graphic Standards.* 8th ed. New York: Wiley, 1988.
Reznikoff, S. C. *Specifications for Commercial Interiors.* New York: Whitney Library of Design, 1989.
Riggs, J. Rosemary. *Materials and Components of Interior Design,* 2nd ed. Reston, Va.: Reston Publishing Co., 1989.
Yeager, Jan. *Textiles for Residential and Commercial Interiors.* New York: Harper & Row, 1988.

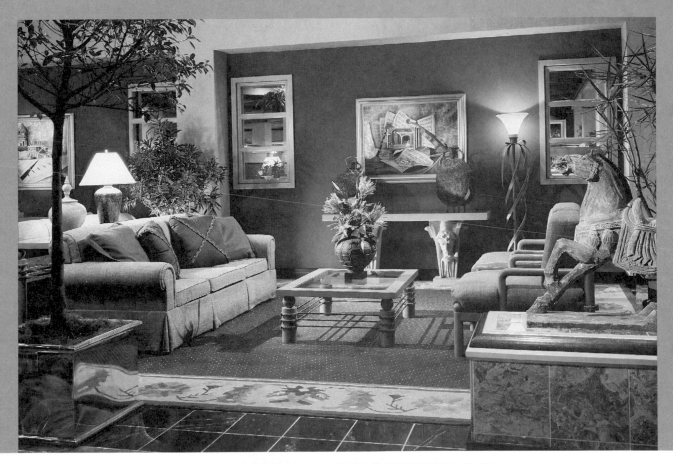

FURNITURE, FURNISHINGS, AND EQUIPMENT

PART FIVE

16 FURNITURE

17 FURNISHINGS AND EQUIPMENT

FURNITURE

Furniture is an integral element in the design of an interior space because it affects human functions and desires, such as sitting, working, sleeping, and relaxing. Furniture also provides the personalization of a space as it reflects individual preferences, activities, and needs. Most interior spaces require furniture, which provides the transition between the people and the architecture of the space.

This chapter does not divide furniture into residential and commercial categories, since similar furniture can be used in both. Some residential sofas and chairs can be upgraded with construction materials and coverings to serve the heavier and more frequent use in commercial situations. For example, many companies produce mattresses in a residential and a commercial grade, but the standard sizes are common to both uses. However, in residential spaces, the selection of furniture closely reflects the personal life-style and tastes of the people who inhabit them. In commercial spaces, furniture might more accurately reflect the corporate or business image the entity wishes to portray.

The interior designer includes furniture as a part of the furniture, furnishings, and equipment (FF&E) package that completes an environment for the users' daily needs. (This terminology is specified in printed documents available through professional design societies, such as ASID, IBD, or AIA. Furniture is planned for early in a project or may even be a design generator. For example, furniture can be used as an element to organize a space by defining traffic patterns, conversation areas, or the aesthetic character of a room. It is also used to fulfill the users' needs of comfort, utility, and social and behavioral interactions with others.

It is rare that a client will choose to discard all existing furniture and permit the designer to select all new. Depending on the existing furniture and the budget for the project, some or all of the existing pieces might be incorporated into the new designs. These pieces can be used in

their original condition or be refurbished to coordinate with the new visual and functional design concepts.

FF&E includes both freestanding and built-in items. These pieces can either be selected from manufacturers' product lines or be custom designed and constructed for a particular project.

DESIGNING WITH FURNITURE

Designing interiors with furniture is an integral part of the programming, space planning, and furniture selection processes and is not just furniture arrangement or choosing the pieces after the functional planning is complete. Although many of the details of exact placement and individual selection occur after the establishment of the space planning and design concepts, designing with furniture occurs throughout a project. Furniture selection occurs at different levels of involvement throughout the design process—from conceptual images and determining the functional needs of the pieces to exact selection, procurement, and placement.

Programming for Furniture

During the programming phase of a project (discussed in Chapter 7), the designer ascertains the client's activities in a space and what furniture is needed for seating, storage, conferencing, and other requirements. In this programming phase, furniture selection is generic, that is, exact furniture pieces are not yet specified. For example, a client might indicate that a conferencing or dining space needs individual seating and a table surface for eight people. The designer does not determine at this time whether the table is to be round, square, or oblong. Seating is specified only as to number of individual chairs; style and material are selected later.

Specifics would be noted, in this early programming stage, if the client has special needs, such as a furniture piece to hold a certain type of computer, its printer, and other related equipment, or has existing furniture that must be incorporated into a new design, especially if the pieces are unique. In such cases, most program phases will document these requirements through an existing furniture survey listing the function, size, color, condition, and other special features of particular pieces.

Space Planning and Furniture

During the design phase of space planning (discussed in Chapter 6), a designer sketches in furniture on a floor plan that indicates the spaces and circulation paths. The early steps of this phase primarily involve quickly determining furniture number, groups, and orientation to support user activities. These elements are drawn to the same scale as the floor plan to produce shapes that are in proper proportion to the activity, people, and space. The sketches are rough at this point. For instance, a designer will generally estimate and draw a chair at roughly 24 inches (609 mm) square; it can be refined to exact dimensions and even shaped later, during the design development phase (Figure 16.1).

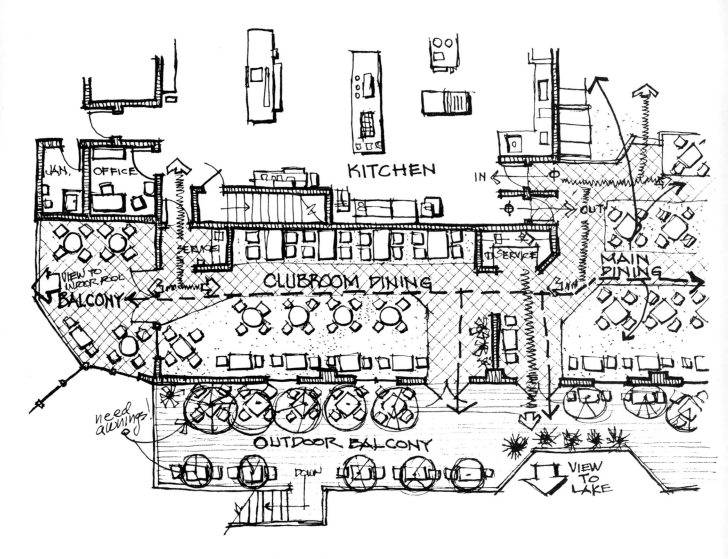

Several aids to designing with furniture in the design phase include methods to allow for quick scaling and orientation. The experienced designer can often visually estimate and sketch furniture accurately in plan, but the less experienced designer might rely on an architectural scale or plastic templates. Some templates are made as generic-sized furniture types, whereas some furniture manufacturers provide their own specialized templates. Other methods include cutting out furniture shapes from paper or cardboard and manipulating them on the plan until a solution is found. Various furniture kits are commercially produced to be used in a similar manner.

Computer aided design (CAD) programs offer a unique method of designing with furniture: A "library" of furniture can be called up on the computer screen and readily manipulated for space-planning schemes. Some programs will even quickly produce a three-dimensional view of the furniture in the space from any angle (Figure 16.2). These designs can be plotted out on paper for reference, or the furniture can at this time be specified and a purchase order compiled.

Groupings, orientation, and required clearances of furniture for residential design are discussed in Chapter 8. Chapter 9 contains several concepts demonstrating how design plans include furniture as a space-planning tool for different facility types.

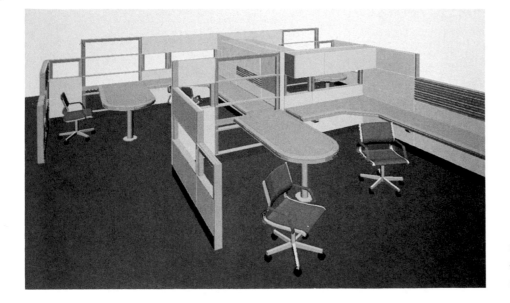

FIGURE 16.2 These three-dimensional furniture drawings were produced using ISICAD's 5000 System.

Furniture Plans, and Installation

As the designer works through the design process to refine the functions and aesthetics of a space, the furniture specifics and selections become more detailed. Pieces are sized accurately on the plan, building sections, and elevations. Chapter 18 presents a detailed description of these drawing types, which depict the scale, characteristics, and relationships to the interiors. During the construction drawing process, a furniture plan is developed and keyed to the type and manufacturer of the furniture, the location of the furniture, and its coordination with other requirements of the building systems (Figure 16.3).

COORDINATION WITH BUILDING SYSTEMS

Care must be taken when coordinating the placement of furniture with the various mechanical and electrical systems of a building. Furniture should be positioned to avoid blocking heating, ventilating, and cooling air registers and radiators (discussed in Chapter 11).

Coordination is also needed to ensure that furniture supporting telephones, computer equipment, or lamps is close to wall or floor receptacles. Of particular concern is furniture that requires special floor outlets because it is placed in the middle of a floor. These outlets are often more expensive than wall outlets and require removal, relocation, or capping if the furniture is later rearranged.

Lighting, both natural and artificial, must be coordinated with furniture placement in relation to user tasks. For reading and studying, the designer must ensure that, where possible, the furniture placement and orientation are designed to take advantage of natural daylight and are augmented with artificial light. Special furniture and equipment, such as computer screens, must be oriented so that there is no glare or reflection from windows or bright light sources. If strategic placement is not possible, window coverings and other screening devices must be used to alleviate these problems.

The latter stages of a project involve ordering the furniture, arranging for its delivery, inspecting goods for possible damage, and placing the furniture. Any problems or adjustments necessary are handled during this installation phase.

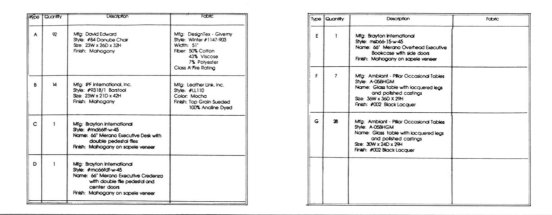

Type	Quantity	Description	Fabric
A	92	Mfg: David Edward Style: #84 Danube Chair Size: 23W x 26D x 32H Finish: Mahogany	Mfg: DesignTex - Giverny Style: Winter #1147-903 Width: 51" Fiber: 50% Cotton 43% Viscose 7% Polyester Class A: Fire Rating
B	14	Mfg: IPF International, Inc. Style: #9318/1 Barstool Size: 23W x 21D x 42H Finish: Mahogany	Mfg: Leather Link, Inc. Style: #LL110 Color: Mocha Finish: Top Grain Sueded 100% Analine Dyed
C	1	Mfg: Brayton International Style: #mc66tf-w-45 Name: 66" Merano Executive Desk with double pedestal files Finish: Mahogany on sapele veneer	
D	1	Mfg: Brayton International Style: #mc66fdf-w-45 Name: 66" Merano Executive Credenza with double file pedestal and center doors Finish: Mahogany on sapele veneer	
E	1	Mfg: Brayton International Style: msb66-15-w-45 Name: 66" Merano Overhead Executive Bookcase with side doors Finish: Mahogany on sapele veneer	
F	7	Mfg: Ambiant - Pillar Occasional Tables Style: A-05BHGM Name: Glass table with lacquered legs and polished castings Size: 36W x 36D X 29H Finish: #002 Black Lacquer	
G	28	Mfg: Ambiant - Pillar Occasional Tables Style: A-05BHGM Name: Glass table with lacquered legs and polished castings Size: 30W x 24D x 29H Finish: #002 Black Lacquer	

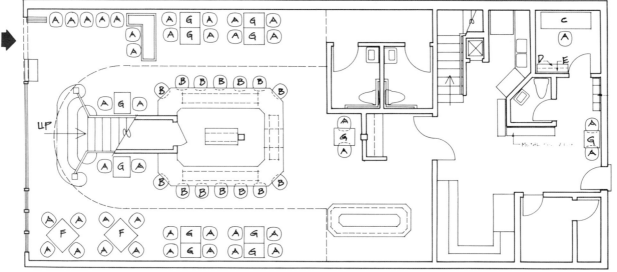

FIGURE 16.3 A furniture plan indicates where specific furniture, furnishings, and equipment are to be placed.

SELECTION CRITERIA FOR FURNITURE

An interior designer selects furniture appropriate for the function it is to serve and for its physical and design relationships to the environment and the users. The designer should also include estimates of furniture costs, length of service expected, and replacement costs where applicable.

Function

Although furniture is primarily chosen to serve a general purpose, pieces can also serve one or more specific functions. For example, seating units or chairs provide comfort, but some are more specific in their use, such as a highchair for a child or a lounge chair for relaxing.

COMFORT, EASE OF USE, AND ERGONOMICS

Comfort relates to the way furniture accommodates the human body. Comfort levels can vary for each person due to their differences in size and proportion as well as degree of psychological satisfaction. The physical fit, or interface, between the human body and furniture necessary to carry out a particular task, such as working at a computer station or reclining and watching television, requires proper posturing of different parts of the body. Furniture comfort must also satisfy several different users since pieces are rarely selected for only one person's use.

Ease of use refers to the user-friendly aspect of furniture pieces. For example, the controls for a reclining section of a sofa must be easy to operate. Ease of use also refers to the convenience factor in moving furniture for cleaning or repositioning. Heavy, bulky pieces should be on gliders or casters for ease of movement.

ERGONOMIC CONSIDERATIONS. Human beings vary in shape, size, and age, producing a wide range of anthropometric dimensions. However, most of our furniture and other parts of our built environment are designed to accommodate an "average" size, based on statistical studies of populations.

Some furniture, such as ergonomic chairs for office work, is kinetic, providing comfort for extended use by supporting the human form as it shifts and changes throughout the day's work activities (Figure 16.4). These self-adjusting chairs can properly support the body in an upright working position or adapt to a reclining position as the user leans back. Body weight is transferred from the buttocks to the back and thighs while the feet remain on the floor. These chairs reduce physical discomfort and contribute to user satisfaction and increased productivity. Other seating units and some desks can also be adjusted to accommodate different body dimensions or comfort positions.

PSYCHOLOGICAL CONSIDERATIONS. People not only differ physically, but they also have distinct emotional and psychological profiles. Furniture selection and placement can complement or detract from these feelings and needs. For example, some pieces that are large scaled can seem to overpower a person, and storage units that require too much stretching or are difficult to operate can be frustrating for the user.

Territoriality, or the need to have a space of our own, is a psychological characteristic and an important consideration in furniture selection and placement. A designer must understand how people use furniture. A sofa generally can accommodate three people comfortably, yet in commercial spaces, it is most often occupied by only two, since few want to sit in the middle. The selection of separate chairs or ganged chairs with arms might be a better solution.

Tolerance for crowding is associated with culture and personality. Some people enjoy simultaneous interaction with many others and can tolerate crowded conditions. However, others enjoy less involvement with many people and might find the effects of crowding confusing, undesirable, or overstimulating. When selecting and planning furniture placement, the designer must be sensitive to the psychological differences in personality and perception because the type, amount, and placement of furniture will affect the way people feel and react within an environment.

FIGURE 16.4 The Zen Seating System chair has a flexible shell that provides lower back support for many task positions.

MULTIUSE PIECES

Furniture can be used for many functions or specifically designed for one or two. A rocking chair serves a single specific function, but a bar stool used for seating in a residential kitchen can also have foldout steps that permit it to be used as a step stool.

KNOCKDOWN FURNITURE

A considerable amount of furniture is purchased by consumers in an unassembled, or knockdown, condition. Items such as shelving, end tables, storage units, entertainment centers,

and computer desks are just a few of the popular knockdown pieces. Although quite a few of these products are of medium- or low-quality materials and construction, they can be economical and do serve utilitarian purposes for many people.

Furniture for Special Groups

Very young, elderly, and physically disabled people have specific needs for size, proportion, coordination, mobility, and visual perception when functioning in the environment and interfacing with furniture units. For example, much of the furniture for the very young and elderly should be devoid of sharp edges that could cause accidents or injury if fallen on. Consideration must also be given to the physically disabled who might use furniture while in a wheelchair or while using other physical supports. For furniture to be user friendly, it must meet these special needs.

The designer must be careful when using chairs or tables for average sizes, for such selections can be inadequate for properly addressing the special requirements of these user groups.

Design Characteristics

Furniture style and personal preference must be considered in terms of the intended use and whether the design of the piece is appropriate to the environment. Two office desks might be identical functionally, but the design of one will be more suited to the interior in which it is placed. Also, a person might prefer one style over another, such as a traditional Queen Anne rather than a contemporary piece, for a formal area.

HISTORICAL INFLUENCES

Furniture produced by various cultures in the past directly influence furniture made today. Some of these pieces are used today, some are being reproduced, and some serve as inspirations for new designs.

The designs of some antique pieces have endured over the ages, whereas other early designs have been fads or fashions and have fallen from popularity. The enduring designs are considered classics and are still produced today (Figure 16.5). Unfortunately, some manufacturers have made inexpensive imitations that do not measure up to the originals in material, craftsmanship, proportion, or durability.

ANTIQUE FURNITURE. Although the U.S. Customs Service considers any article made before 1830 to be an antique, furniture is generally recognized as antique after a century of time. Antique furniture is often readily identifiable with major cultures, periods, countries, or individuals. Authentic antiques in good condition are generally very expensive.

Antiques can be incorporated into almost any design scheme as a feature or focal point. They are selected as much for their investment value as for their functional and aesthetic uses. (See Chapter 2 for specific historical periods and styles.)

MODERN FURNITURE. The term *modern furniture* applies to those pieces produced about the late 1800s by individuals such as Michael Thonet (1796–1871), Charles Rennie Mack-

FIGURE 16.5 Classics of design by Mies van der Rohe: The chair and stool were designed by Mies van der Rohe for the German Pavilion at the Barcelona Exhibition of 1929. The sofa and table were designed in 1930.

intosh (1868–1928), and the craftsmen of the Bauhaus movement. (Refer to Chapter 3 for a discussion of the most notable modern designers and their furniture creations.) Although people often interchange the terms *modern* and *contemporary,* the former is more accurately identified with the Bauhaus and international movements in design history.

Some postmodern furniture and other current creations bear little similarity to classics or, indeed, to anything produced before. Many of these pieces are finely conceived and crafted, yet some represent curiosities or perhaps passing fads.

Scale and Size

Furniture is manufactured in many sizes and proportions. In addition to purpose and comfort, selections should be made on the basis of space available, proportion to the overall environment, and scale with the human body.

Some chairs may seem visually scaled to a space, such as the chairs in the waiting area of a physician's office, but actually be too small for a person to sit on comfortably. Perhaps furniture might seem appropriate because of its dimensions, but the visual scale does not work in harmony with the space. For example, a large, overstuffed chair might be very comfortable but out of scale and context with a visually "light" interior that has small-scaled details throughout. In some cases, a chair might seem to overpower the person using it. Conversely, a chair can be scaled to create the illusion that a sitter is larger than he or she really is.

Quality of Construction

Craftsmanship and durability are important factors in materials and construction methods used for furniture. Since much of the evidence of furniture construction is hidden, it is important for a designer to be aware of the reputation of various products and manufacturers.

DURABILITY

The durability of a piece of furniture depends on its intended use. Furniture does not necessarily have to be indestructible. For example, a dining chair in a residence usually does not take the wear and prolonged use that a chair in a hotel room or restaurant might.

Some manufacturers supply information about the recommended care and cleaning of finish materials used with fabrics or other soft materials, such as vinyl. Other manufacturers coat their fabrics with protective films (such as Scotchgard) to improve soil resistance and durability.

GUARANTEES AND WARRANTIES

Manufacturers of furniture, textiles, and other products provide a guarantee or warranty that their merchandise will perform and last for a specified period of time, generally one year. These two terms are often used interchangeably, but some federal and state laws do specify differences. Some manufacturers will provide these promises as a limited warranty for a part of the product. Some warranties are implied or understood, such as that an "adjustable" chair obviously must be adjustable. These warranty and guarantee programs can help a designer ascertain how reliable a product is, particularly if the covered periods are longer than usual.

Life Cycle Costs

The initial cost of furniture is only one aspect of its cost. Life cycle costs, including maintenance expenses for the expected life of the piece and replacement costs, must be considered. Maintenance includes cleaning, repairing, reupholstering, and refinishing. Cleaning entails vacuuming and stain removal for upholstered pieces and the waxing or protecting of fine wood units.

Budgets might provide for the initial acquisition and installation of furniture, but life cycle costs might outweigh funds available to maintain the pieces. Usually it is better to invest more money initially for quality pieces that will not require as much expenditure over their expected life. Selections must be balanced to obtain the best quality for the best price. However, available money may limit the selection. The designer might then select less expensive items for appropriate places and choose better-quality pieces for prime locations, for extended use, or for image.

FURNITURE TYPES

Furniture types can be freestanding or built in as an integral part of the building. It may even be difficult to distinguish the furniture from the building. Some units are so well integrated into the architectural design that they become a dominant design element as well as functional pieces.

Furniture pieces can vary in form from linear or planar to volumetric, such as in an overstuffed chair or sofa. The lines of furniture can be curvilinear, rectilinear, angular, geometric, or freeflowing. Proportions can be horizontal or vertical, solid and sturdy, or light and airy. Finishes vary in appearance—slick or shiny, warm or soft, rough or heavy, multicolored or monochromatic.

The countless varieties of furniture available today are best classified by use rather than style or materials. Major categories include seating, tabular (tables), sleeping, storage, task (desks), and systems.

Seating

Today, most people spend the greater part of their waking hours sitting as they eat, study, work, relax, and travel. The functional requirements of a chair are simple. However, seating design is not simple, because the prime consideration should be proper body support. Sitting is actually an unnatural position for the human body, since it can strain the thighs, buttocks, neck, shoulders, and especially the back. Poorly designed seating units can cause backaches and contribute to varicose veins and a variety of heart and other circulatory problems.

Different types of seating units are available for different uses. Some units, such as sofas and modular units, seat two or more people; most seating units are available with or without arms and can be folded or stacked. No matter what type of seating is preferred, all units should be selected for proper body support. General guidelines for selecting all types of seating include specifications for the seat, the backrest, and armrests, if any (Figure 16.6).

The seat should be designed so that a person's feet rest on the floor without dangling (approximately 12 to 18 inches, or 304 to 457 mm, from the floor). There should be no pressure on the underside of the thighs, and the seat should not be too deep for comfort. If designed properly, a chair should provide the sitter some space between the front of the seat and the back of the knees so that his or her feet will not "fall asleep."

The backrest must support the lower segments of the spine in order to maintain a natural, concave curvature. The small of the back should be in contact with the back of the seating unit. If the chair back is too soft or cushiony, it will not support the spine and will cause it to curve conversely. A backrest should be high enough to support the back and shoulders in either an upright or a tilted position.

Armrests should be long enough to support the forearm and base of the hand. If a seating unit is intended for use by several different people for long periods of time, armrests should be adjustable.

FIGURE 16.6 Seating units are made in a variety of styles, sizes, and features but conform to some general guidelines and dimensions.

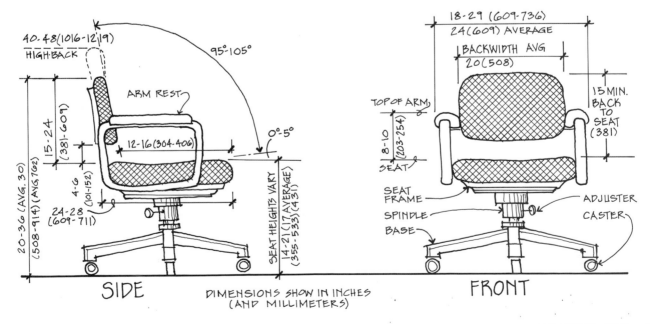

CHAIRS

Unfortunately, some seating units, especially chairs, are selected for appearance or to show status, ignoring the comfort aspects. Through the ages in many cultures, authority has been signified by a seated person. Our culture has endowed chairs in a university, we chair a committee, and we elect chairpersons of the board or of a department. Some executive chairs for offices are chosen for their thronelike aspect, having high backs in an expensive upholstery or leather fabric to complement the user.

Types of chairs include armchairs, side chairs, lounge chairs, desk chairs, and stacking and folding chairs. The main consideration in selecting one of these types is its comfort in relation to a particular use. A chair with an upright back for proper seating posture is better suited for dining or studying than is an overstuffed armchair (Figure 16.7). However, for extended use, a more ergonomically designed chair is a better choice.

FIGURE 16.7 Properly designed seating such as these chairs in the Palio Restaurant (Walt Disney World Swan Hotel) can be good looking, comfortable, and provide for proper posture.

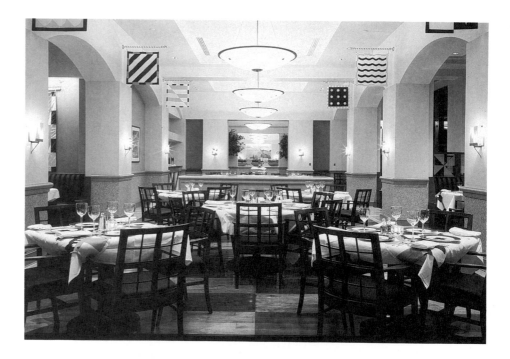

ARMCHAIRS. Armchairs are generally more comfortable than side chairs and are good for relaxing, conversation, or reading. Armchairs can be fully upholstered and are constructed of wood, plastic, steel, or a combination of materials.

SIDE CHAIRS. Side chairs are usually lighter in weight and scale than armchairs. Their relatively upright backs are appropriate for dining and keep sitters alert, so they are also good for studying.

LOUNGE CHAIRS. Lounge chairs provide relaxation in a semireclining position. This type of chair can range from a slightly lowered and back-tilted position appropriate for reading and conversation to a nearly fully reclined position suited to total relaxation or sleeping. Lounge

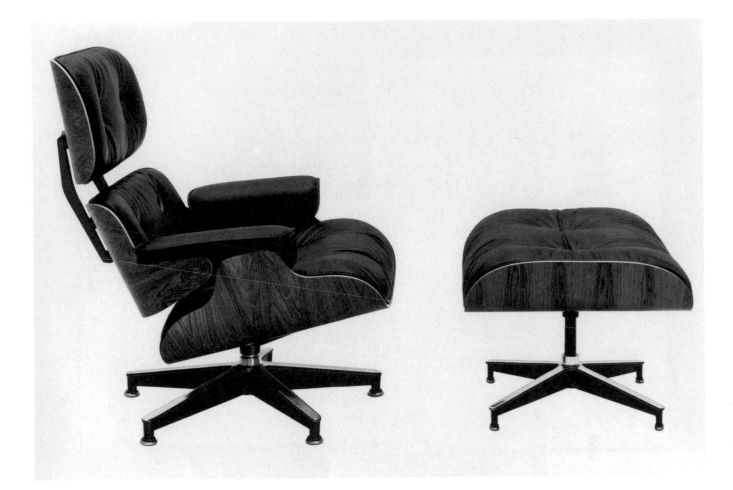

chairs should be easy to get in and out of, neither too low nor too soft. They should not put the
body into awkward or uncomfortable positions and should provide proper back support (Figure
16.8).

DESK CHAIRS. Desk chairs are specifically designed for tasks at a desk or table.
Although armchairs and side chairs might occasionally be used at a desk, they are an inappropriate
selection for ergonomic comfort. Desk chairs or office chairs have been traditionally identified by
the job category they are to be used for, such as secretarial, managerial, and executive. Generally,
secretarial chairs are small in scale and armless; managerial chairs have open arms and are larger
in scale; and executive chairs are of large dimensions with closed arms, wide seats, and tall
backrests. However, chairs should not be selected solely on the basis of the user's status within a
company. An executive might be physically small, so a large executive chair would not be appropri-
ate. More emphasis should be placed on whether the chair ergonomically fits the user's body and
whether the chair is appropriate for the user's tasks. If the user might spend many hours seated,
the proper chair selection is critical to provide comfort and increase productivity.

Desk chairs are designed to be flexible and mobile. They should have a swivel mechanism
to make it easy for the user to rotate to reach different working surfaces. Tilt mechanisms can

accommodate a variety of body positions, and rolling casters allow easy movement across a floor (Figure 16.9). Different sizes of casters are made for different flooring materials. Large, hard casters (usually stainless steel) are recommended for carpet; small, hard rubber ones are best for hard surface floors.

STACKING AND FOLDING CHAIRS. Stacking (Figure 16.10) or folding chairs are used for large gatherings of people or as auxiliary seating. They must be lightweight and modular for ease of moving, assembly, and storage. Stacking chairs are generally made of steel, aluminum, or plastic. Seats and backs can be made in matching or a combination of materials. Stacking and

FIGURE 16.10 The "Varix" stack chair by Samsonite is comfortable and can be stacked 24 high on a dolly for ease of transport and storage.

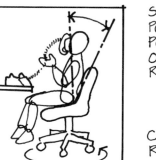

FIGURE 16.9 Flexibility, ease of movement, and body support are essential for chairs to accommodate a variety of user tasks.

FORWARD TILT POSITION PROVIDES POSTURE SUPPORT FOR COMPUTER AND GENERAL CLERICAL WORK.

CASTERS PERMIT AN EASE OF POSITIONING THE CHAIR FORWARD OR BACK FROM THE DESK.

STANDARD AND TILT BACK POSITIONS OF THE CHAIR PROVIDE POSTURE SUPPORT FOR A VARIETY OF RELAXED MOVEMENTS OR RELATED TASKS.

CASTERS PERMIT EASE OF POSITION RELATED TO THE DESK AND FOR SWIVELING TO OTHER LOCATIONS.

FIGURE 16.11 The "Plia" chair by Giancarlo Piretti is lightweight, comfortable, and folds to a width of only one inch.

folding chairs are also available with a minimally upholstered pad and with or without arms. Other attached accessories might include tablet arms, book racks, or even ashtrays.

One of the most popular types of folding chair is the *x* chair, reminiscent of the familiar director's chair of Hollywood fame. This chair is available in a variety of lightweight, flexible materials and is a convenient portable armchair. Other folding types are the front-to-back units that are made in many different patterns and materials (Figure 16.11).

Some stacking and folding chairs have special coupling devices attached to interlock the chairs. Some fire codes require this interlocking to prevent injury to the users in places of assembly. Unattached seating could be overturned or be pushed into an aisle, obstructing safe egress of occupants in a fire or emergency.

SOFAS

A sofa provides for seating of two or more people. Although some people call a sofa a couch, the latter term was originally applied to a long upholstered unit with one raised end and a low back for reclining. A loveseat refers to a small sofa with only two seating positions. Sofas generally are upholstered units and can be curved, straight, or angled. They are made with or without arms. Sofas can be arranged in L shapes or U shapes to provide conversation groups, and they can seat as many as eight or nine people. Sofas arranged in conversation groups are used for residences, reception areas, large private offices, hotel lobbies, or other waiting areas (Figure 16.12).

FIGURE 16.12 **A variety of seating and conversation groupings is provided by the sofas and chairs in this hotel lobby that was originally a train station.**

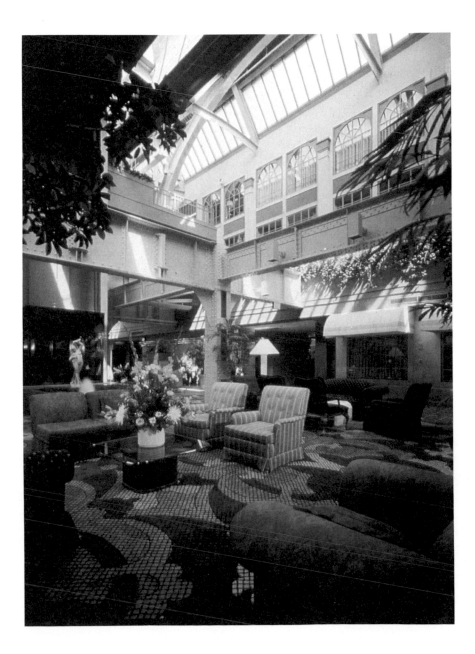

MODULAR SEATING

Modular, or sectional, seating is a good choice for large public spaces, such as airports, lobbies, and lounges. Modular seating refers to single seating units that can be arranged in a variety of ways to suit changing needs, locations, and flexibility (Figure 16.13). These single units are available armless, with a single right or left arm, or as a corner section. Modular seating can be arranged in straight, angled, curved, and many other configurations. End- or corner-table elements or planters are also available to create groupings for specific spaces or locations. Modular seating also refers to seating systems that have a continuous base with individual seats or elements added.

FIGURE 16.13 **Modular seating can be rearranged into many configurations by changing different individual components.**

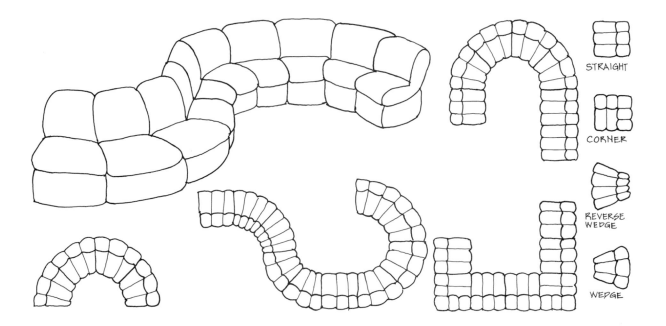

STRAIGHT

CORNER

REVERSE
WEDGE

WEDGE

Tabular Units (Tables)

Tables are used for a variety of activities, such as dining, working, storage, games, display, and conferencing (Figure 16.14). Regardless of the function, tables should be designed for strength and stability, as well as being the appropriate size, shape, material, and height for their intended use. See Figure 16.15 for common table sizes and shapes.

The top surface construction and finish of tables should be of durable materials. Table tops should be level and resistant to moisture, burns, scratches, and impact. They can be made of glass, plastic, wood, tile, metal, marble, or granite. Table tops can be supported by legs, trestles, or rectangular and circular pedestals, either hollow or of solid materials.

Table bases also, in terms of weight, size, and design, should be of durable construction. Bases should be designed in proportion to the size and shape of the tabletop. If a base is too small or not of a proper weight, the table will wobble or shake. Many people, especially the elderly, will use a tabletop for support when rising. This could cause the table to tip if the base is not properly weighted or if the supports are not appropriately proportioned.

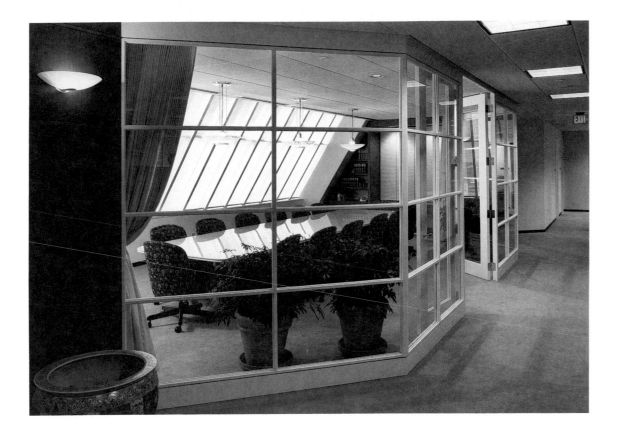

FIGURE 16.15 Various sizes, configurations, and seating capacities of tables.

SQUARE TABLES

WIDTH	30	36	42	48
LENGTH	30	36	42	48
SEATING	2	4	4	6

RECTANGULAR TABLES (NO SEATING COUNTED AT END)

WIDTH	24	24	24	24	30	30	30	30	30	30	36	36	36	36	36
LENGTH	48	60	72	96	36	42	48	72	84	96	48	60	72	84	96
SEATING	4	4	6	6	4	4	4	6	6	8	4	4	6	6	8

WIDTH	42	42	42	42	48	48	48	48	48	48
LENGTH	48	60	72	84	60	72	84	96	120	144
SEATING	4	4	6	6	6	6	8	8	10	12

OVAL TABLES

ROUND END

WIDTH	30	34	36	36	48	60
LENGTH	42	44	54	82	96	120
SEATING	4	4	6	8	10	12

ELLIPTICAL

WIDTH	30	34	42	48	48	48
LENGTH	60	72	84	96	108	144
SEATING	4	4	6	6	8	10

BOAT TOP TABLES

CENTER / END

END	30	32	32	34	36	38
CENTER	36	40	40	48	56	60
LENGTH	72	96	120	144	192	216
SEATING	6	8	10	12	16	18

NOTE: ALL DIMENSIONS IN INCHES. SEATING NUMBER IS AN APPROXIMATION, DEPENDENT ON CHAIR SIZE AND REQUIRED CLEARANCES.

Sleeping Units

Furniture for sleeping can consist of one or more components. Beds can be a simple pallet or mattress placed on the floor, a mattress or a mattress and box springs set on a base or frame, (the most common type), or a whole sleeping environment, including headboard, footboard, canopy, bedside tables, lighting, storage, and electronic controls.

Beds vary in size from a narrow single, or twin, to a king-size. Various bed (mattress) sizes and recommended clearances are shown in Figure 8.15.

Providing comfort and allowing rest are the main functions of a bed (Figure 16.16), which should be selected to respond to and support a person's body weight and shape. Mattresses are constructed of springs and padding, or foam; they can be air inflated or water filled. Personal preference and individual physical comfort are generally the governing factors in the selection of a mattress.

The selection or design of a sleeping unit depends on the amount of space available. Beds can be integrated into a wall storage system, can be built in to a corner or alcove, or can simply rest on a platform in the middle of a room, emphasizing the bed's horizontal surface. Fold-up and wall beds are good solutions for efficiency apartments or other areas in which space is limited (Figure 16.17). Sofa beds and futons, which convert into beds, are also good solutions for limited space or short-term sleeping arrangements. Bunk beds and loft beds utilize vertical space, stacking sleeping levels, storage, or working surfaces. The trundle bed is also a good choice for limited space.

Storage Units

Adequate, properly designed storage is an important consideration in the designing of residential and commercial interior spaces. Basic types of storage units include shelves, drawers,

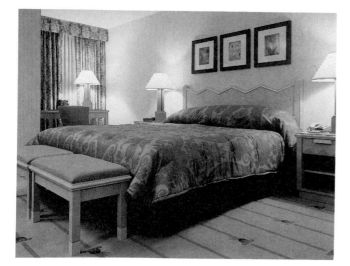

FIGURE 16.16 A bed becomes the focal point in typical guestrooms such as this one in the Walt Disney World Dolphin Hotel.

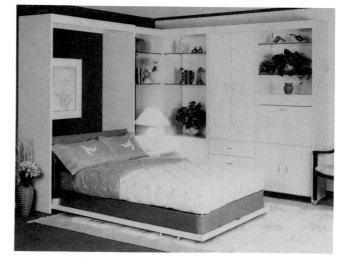

FIGURE 16.17 These fold-up bed and cabinet modules by Sico can gain valuable floor space in a room yet provide abundant storage and comfort.

and cabinets. Storage can also take the form of built-ins, be suspended from the ceiling, be mounted on a wall, or be a freestanding piece of furniture.

Storage requirements should be analyzed according to accessibility and need; convenience or frequency of use; the sizes and shapes of items to be stored; and visibility, that is, whether items are to be displayed or concealed for an uncluttered and clean appearance. Other considerations, such as the type and size of storage units, should be based on how far a person can reach while standing, seated, or bending over (Figure 16.18). Frequently used storage items should be readily accessible, and little-used or seasonal items can be placed in out-of-the-way spaces.

FIGURE 16.18 Storage areas should be designed for ease of retrieval within a range of dimensions convenient to the users.

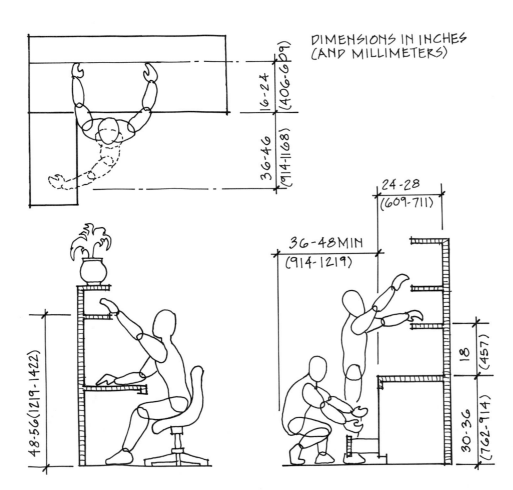

MODULAR STORAGE SYSTEMS

Modular or storage system furniture consists of standard components, such as open or closed shelving, drawers, fold-out writing surfaces, and cabinets. These systems can be grouped in a variety of configurations to suit specific storage needs. They can be assembled into a full floor-to-ceiling storage wall, fit within an existing closet (Figure 16.19), or serve as a freestanding partition wall with storage accessible from one or both sides. Storage systems also commonly incorporate elements for special purposes, such as pull-out swivel bases for televisions and other electronic devices. Shelving can be made adjustable with bookshelf standards or other assemblies. Units can be open for display or be equipped with transparent or opaque doors.

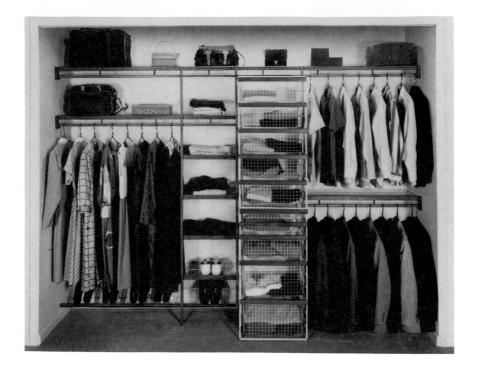

FIGURE 16.19 This storage shelving system by the Schulte Corporation can be installed in numerous configurations to meet specific needs. The ventilating wire sections are trimmed with oak.

CREDENZAS

Nonresidential spaces, such as offices, have specific storage needs that can be met by credenzas and filing systems. The credenza was first used during the Italian Renaissance as a sideboard for serving, as well as for storage of dishes, silverware, and linen. Today, credenzas serve similar purposes. For office use, they are generally in the same style as the desk and are placed directly behind or to the side of the desk for easy access from a swiveling desk chair (Figure 16.20). Most credenzas are 29 inches (736 mm) high, the same as the desk, and 18 to

FIGURE 16.20 This creative vice president's office by Donna Guerra, ASID, incorporates a series of modular file storage bins and credenzas, all within easy access from the working desk.

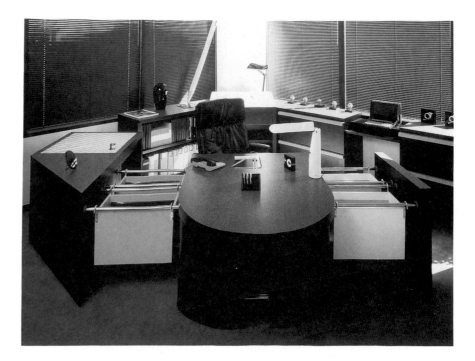

20 inches (457 to 508 mm) deep. The width varies, according to storage capacity required and space available. Credenzas can have box drawers, file drawers, or doors with shelves inside. Other options include pull-out shelves for machines and bar units. Some credenzas have open knee space instead of storage space and function as a second desk. If the unit is placed against a wall, the space above the credenza can be used for display or shelving, with task lighting incorporated below the shelves.

FILING SYSTEMS

A variety of types and sizes of file cabinets are available to serve storage needs (Figure 16.21). When selecting file cabinets, the designer should consider the filing needs of the client, the available floor space, and the quality of workmanship.

The traditional type of file cabinet is a vertical unit with two to five drawers. Tall units provide more storage space, of course, but may present problems for users less than 5 feet 4

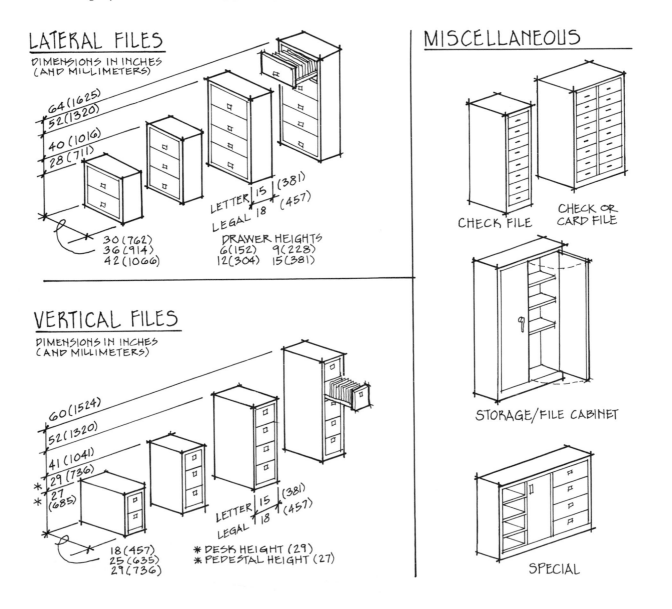

FIGURE 16.21 Filing cabinets are available in a variety of types and sizes. Consult the manufacturer's literature for exact dimensions, as these can vary.

inches tall (1625 mm) or for physically disabled workers. Vertical filing cabinets are generally 15 inches (381 mm) (letter size) or 18 inches (457 mm) (legal size) wide; their depth varies from 18 to 29 inches (457 to 736 mm).

Lateral files allow side or horizontal filing and storage capacity is measured horizontally. Depth is either 15 inches for letter-size files or 18 inches for legal size. Lateral files usually store more files per lineal inch than do standard files. Lateral files, like vertical files, vary from two to five drawers high. These files can be equipped with side tabs rather than top tabs for ease in reading. Optional drawer heights, ranging from 6 to 12 inches (152 to 304 mm), are available for special filing needs, such as card files. Lateral files can often fit into spaces too narrow for traditional file cabinets. The top surface of a two-drawer lateral file can also function as a credenza or secondary work surface.

Other filing systems include high-density, open-shelf units that move on tracks, eliminating permanent aisles and requiring less floor space. This type of filing system is often used in offices for the storage of large numbers of files (Figure 16.22)

FIGURE 16.22 These automated files slide on parallel tracks and can be closely stacked or opened at any location for aisle access.

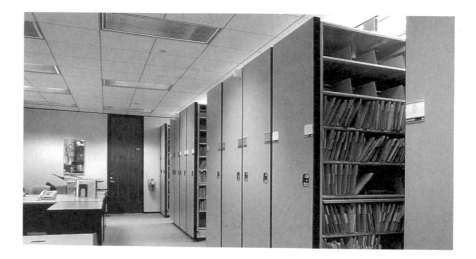

Task Units (Desks)

Desks can vary as much as seating in style and function; selection of a desk is dependent on the user's needs. Desk requirements can range from a simple work surface to multipurpose working surfaces, storage, and conferencing space.

Freestanding desks can take the form of a pedestal or a table. The traditional pedestal desk originated in the eighteenth century in England and consisted of a writing surface and two pedestals that contained cabinets for the storage of books and writing supplies. Today, these desks are available with a single or double pedestal. Usually desks have at least one file drawer and as many as four storage drawers. An extension (return) is available that forms an L shape, providing a secondary work surface or a space for a typewriter or a computer with keyboard and monitor (Figure 16.23).

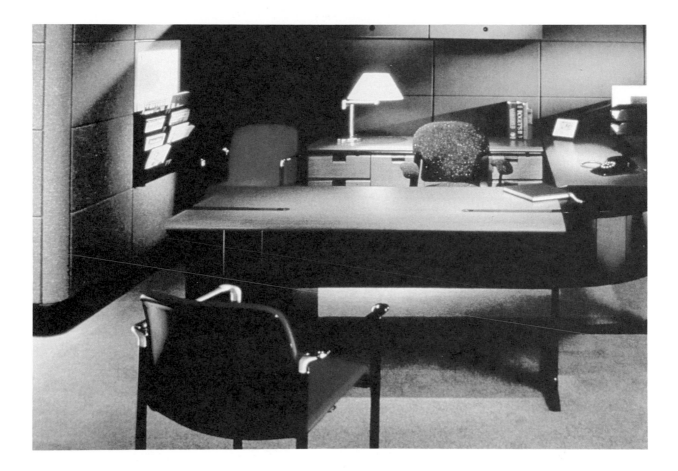

The standard desk height is 29 inches (736 mm); however, a 28-inch (711 mm) height is comfortable for people shorter than 5 foot 4 inches (1625 mm), and a 30-inch (762 mm) height is best suited for people taller than 5 feet 11 inches (1803 mm). For typing or keyboarding, 26 inches (660 mm) is most appropriate. Desks, like office chairs, are often classified as secretarial, middle management, or executive. However, job function and activities are better criteria for desk selection.

An executive who does not require much desk storage may prefer a large table desk rather than a pedestal. Table desks are a good choice for the user who spends most of the day meeting with others. Even small offices can accommodate a freestanding table that will seat three or four. An office with a table desk could also double as a conference room.

Table desks are available in many shapes and materials, depending on the room size, number of people to be accommodated, and personal preference. Tops can be of glass, wood, stone, plastic laminate, or leather. Shape can be round, oval, rectangular, or a truncated circle (Figure 16.24). The shape of a desk can also suggest a position of authority: Square or round shapes do not visibly indicate who is in charge, but other shapes do.

Back storage units or credenzas are generally necessary for other desk functions, such as storing documents, supporting telephones and other machines, and displaying work in progress. The credenza keeps the table desk free of clutter and eliminates distracting material (Figure 16.25).

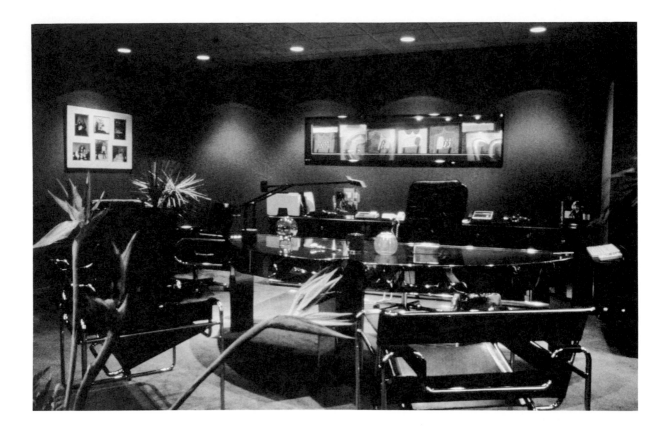

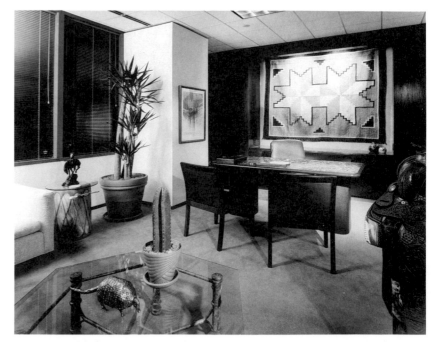

FIGURE 16.25 The desk in this office has no storage capacity as it is used primarily for conferencing and decision making. The back credenza provides for other needs.

Systems Furniture

Systems furniture includes vertical screen panels, work surfaces, and storage units that can be arranged in a variety of configurations (Figure 16.26). In office design, systems furniture forms what is generally referred to as workstations. These can be semienclosed areas that accommodate one or more users, located within a room or private office, or in an open office environment that integrates several workstations to enhance user communication and productivity. Open office systems generally offer greater flexibility and efficiency in space utilization and in suiting individual needs and specific tasks.

FIGURE 16.26 Systems furniture is manufactured to be assembled in a variety of configurations.

Workstations generally consist of vertical panels, work surfaces, storage components, and accessories, such as lighting and raceways for utilities. The size and number of components in a workstation are based on the needs and function of the user and are classified by most manufacturers as clerical, secretarial, supervisory, word processing, middle management, and executive (Figure 16.27).

FREESTANDING PANEL SYSTEMS

Open office systems range from the simplest arrangement of conventional office furniture (such as desks and credenzas with freestanding vertical panels) to panel-hung components. Where the latter type is used, it is often difficult to tell where the screens and components end and the desks begin. Freestanding panels are also useful for defining spaces, such as conference areas or separate departments.

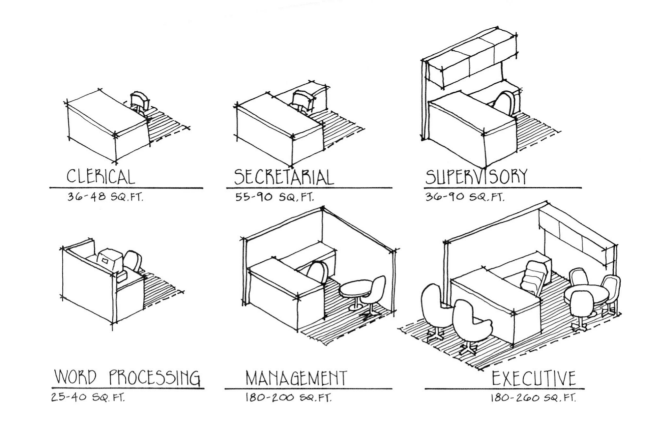

CLERICAL
36-48 SQ.FT.

SECRETARIAL
55-90 SQ.FT.

SUPERVISORY
36-90 SQ.FT.

WORD PROCESSING
25-40 SQ.FT.

MANAGEMENT
180-200 SQ.FT.

EXECUTIVE
180-260 SQ.FT.

FIGURE 16.27 Common work stations with sizes and shapes for various users.

FIGURE 16.28 High panels are used in this hospital administrative area to provide privacy and work spaces without building separate offices.

Panels generally are available in three basic heights, ranging from low panels (generally 30 to 48 inches, or 762 to 1219 mm, high) to high panels (approximately 80 inches, or 2032 mm, high). Low panels offer privacy when a person is seated, yet allow the user to communicate with standing individuals. Medium-size panels, approximately 60 inches (1524 mm) high, are tall enough for visual privacy without fully enclosing the user. High panels offer maximum privacy without full-height walls (Figure 16.28). Panels generally are sound absorbing and can be equipped with a pinup surface for displays or can incorporate a chalkboard and writing surfaces. Panel systems are made in a variety of horizontal increments and produced as solid, open, or glazed types.

PANEL-HUNG SYSTEMS

In panel-hung systems, components are supported by the panels along one edge or along two or three sides, or they can be cantilevered. These systems can form one workstation, or multiple stations can be back-to-back, sharing a panel (Figure 16.29).

Panel-hunt components consist of adjustable primary and secondary work surfaces that can be panel or floor supported. The components can be tilted or removable and can have pull-out surfaces. Storage components include panel-supported or mobile filing units, drawer units, shelf and overhead storage units, and wardrobe units. Accessories include pinup surfaces for display, coatracks, chalkboards, and modesty (privacy) panels.

Today, most manufacturers of systems furniture offer electrical power distribution integrated within a panel or component, permitting electronic equipment to be plugged directly into the system. This gives the panels internal raceways to conceal wiring and power connectors to the building and also permits one workstation to be plugged into the next (see Figure 11.15 in Chapter 11).

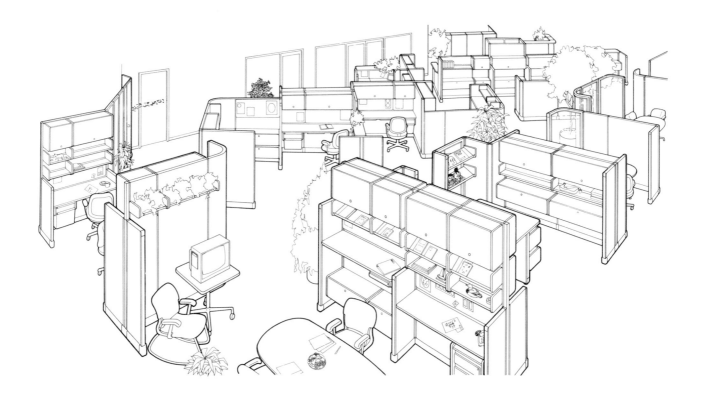

FIGURE 16.29 Panel-hung systems have a variety of accessories and can be put together in a number of configurations to serve specific functions.

Most systems offer task and/or ambient lighting fixtures as optional components. Task lighting fixtures can be attached to the underside of upper storage cabinets so that the fixtures will be close to the work surface. Plug-in lamps, which offer mobility, are another form of task lighting. Ambient lighting, or general illumination, can be supplied by fixtures designed to be integrated into the furniture system or by separate components mounted above eye level on top of a panel or vertical storage units. Another source of indirect light offered by systems furniture is a tall, freestanding fixture called a lighting kiosk.

Specialized Furniture

Nonresidential design often calls for specialized furniture. Many of these specialized units are tailored specifically for commercial offices, restaurants, libraries, hotels, or healthcare facilities. For example, furniture for healthcare facilities, such as hospitals or physicians' offices, includes pieces designed for examinations or surgery (Figure 16.30). Other examples include special banquet seating unique to restaurants or other food service facilities.

In the office environment, desks with tough finishes for durability can be made to accommodate a variety of attachments for specialized functions. Special desks, tables, and stands are made to accommodate computers, keyboards, printers, projectors, and screens. Storage is also customized for these electronic pieces and their supporting hardware and software.

Many facilities use furniture common to residential design, but the construction and materials are often more durable for increased public use. Hotel furniture can be similar to

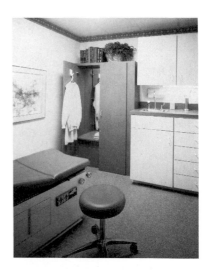

FIGURE 16.30 Furniture, equipment, and other custom units are designed specifically for healthcare needs.

residential units, but the finishes, doors, drawers, and mattresses are constructed of a commercial quality for durability. Fabrics for these facilities, as well as for restaurants and public lounges, are stronger and more resistant to soiling and wear than their residential counterparts. Commercial fabrics to be used in high-occupancy areas must also be treated for flammability resistance.

Manufacturers generally list their specialized products as commercial grade, or they must meet quality standards set by other regulatory organizations. The Business and Institutional Furniture Manufacturers Association (BIFMA) sets standards to be met by their members for performance of products. The Architectural Woodwork Institute (AWI) sets different levels of standards for woodwork materials and for craftsmanship (Chapter 13) in furniture and cabinet work.

FURNITURE MATERIALS AND CONSTRUCTION

Many materials are used in furniture construction, and the following sections cover the most common types.

Wood

Furniture can be constructed of wood alone or with other materials. Wood is easy to carve and shape into various forms, is strong, and can be finished in numerous ways (see Chapter 13). Most wood furniture is constructed of oak, maple, birch, or walnut. However, some softwoods, such as pine, are used for utilitarian pieces or for concealed blocking where strength and finish are not a major concern. Many pieces from American colonial times were of softwood construction.

SOLID WOODS AND VENEERS

Solid wood refers to the use of whole pieces of wood, such as the legs in tables or chairs, chair frames, and trim. Wood veneering can be used for decorative surface treatments or for the finish covering of a structural panel, such as plywood or particleboard. As wide boards of solid wood tend to crack, warp, or shrink when drying, veneered panel construction is more stable. It can produce larger areas of finished wood surfaces, such as in large sheets of veneered plywoods. The term *genuine* means that all solid woods or veneers in a furniture piece are made of a particular type of wood.

PLYWOOD AND COMPOSITE BOARDS

Veneers are applied as facings over strong panels made of plywood or various composite boards. Particleboard is used more than plywood for subsurfaces because the construction of the former is more stable and less inclined to warping, particularly if plastic laminates are applied only on one side. However, plywood can be molded by forcing the ply construction and wet glues into shaped molds to cure. Plywood's great strength is derived from alternating the layers at right angles to one another, which produces strength in two directions. Once released, the plywood retains the shape of the mold. This molded technique was originated in the early 1900s, and the molded plywood chair by Alvar Aalto (Figure 3.16) was one of the first classics to employ this process.

BENTWOOD AND LAMINATED WOOD

Bentwood furniture is made by placing thin strips of solid wood under pressure and steam to bend around various molds. When the piece has been dried and released, the shape remains permanent and can be joined with other shapes to produce a completed assembly. Michael Thonet used this process in the 1800s to produce his classic chairs (Figure 16.31). This technique is still used today, mostly in Europe.

Solid wood is laminated by layering thin strips or blocks (and glue) to produce various shapes, as in the curved bentwood process. Laminated wood is strongest in the direction of the grain but has a spring, or give, to it in all directions. Lamination is also a popular process to apply finished sheets of wood veneers, plastics, or metals to decorative and utilitarian surfaces.

FIGURE 16.31 Michael Thonet perfected the process of mass producing bentwood furniture in the mid 1800s. Thonet Industries still produce these pieces.

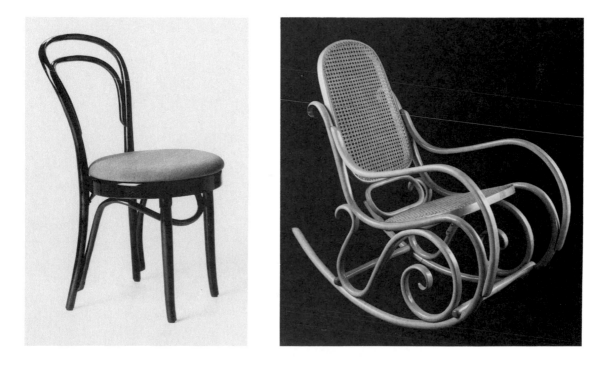

CONNECTIONS IN WOOD FURNITURE

Wood furniture can be connected by many methods, such as bolting, screwing, gluing, or joining. (The basic wood joints are discussed in Chapter 13). The rabbeted, mortise-and-tenon, dovetail, doweled, and mitered joints are used primarily for furniture construction. These joints can be further secured or reinforced with dowels, screws, metal splines, or strong glues. Some connections are exposed for their aesthetic qualities, and others are hidden from view.

Wood blocks and wedges are used to reinforce joints, corners, and subframes (Figure 16.32). These wood shapes are glued or screwed at corners and other hidden areas that need additional support, such as beneath a tabletop or where a back rail and side rail connect.

The hardware and construction of doors and drawers of furniture are similar to those discussed in Chapter 13 under cabinetry. However, adjustable furniture, such as chairs and tables, has many unique operating mechanisms (Figure 16.33). Sophisticated interlocking metal mechanisms are also used for some connections in wood furniture.

FIGURE 16.32 Blocking is used to reinforce joints and assemblies in furniture. It is often hidden from view by final coverings or located in inconspicuous areas.

HIDDEN
BLOCKING

FIGURE 16.33 This cut-a-way view of an office chair shows the many adjustable and construction features that make it user friendly.

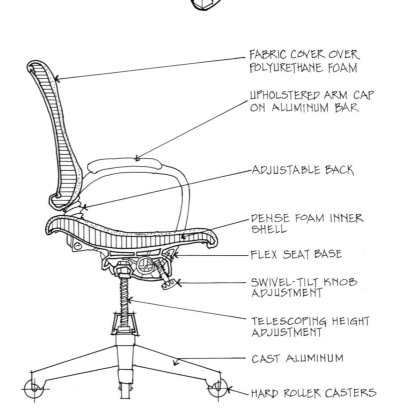

FABRIC COVER OVER
POLYURETHANE FOAM

UPHOLSTERED ARM CAP
ON ALUMINUM BAR

ADJUSTABLE BACK

DENSE FOAM INNER
SHELL

FLEX SEAT BASE

SWIVEL-TILT KNOB
ADJUSTMENT

TELESCOPING HEIGHT
ADJUSTMENT

CAST ALUMINUM

HARD ROLLER CASTERS

RATTAN, BAMBOO, CANE, AND RUSH

The plant materials of rattan, bamboo, cane, and rush are included with wood techniques since they are also living material that is renewable and used in making furniture.

Rattan is produced from the tough, solid, slender stems of the Asian palm tree. These poles, generally less than two inches (50 mm) in diameter, can be bent into many shapes, then

secured by lashing, screws, or nails. Thinner sections are often woven into wicker furniture. Wicker is not a material, but a technique that utilizes small twigs or strips to fashion furniture or baskets.

Bamboo is a tropical grass that can be small or large in diameter and has hollow stems and ringed joints. Sections or strips of this material are used in furniture making and in light building construction.

Cane refers to thin, flexible strips of plants, such as rattan and bamboo. The outer surfaces of these plants can be stripped to weave into a mesh for decorative panels or chair seats and backs. Cane produces a strong, airy, and comfortable surface for furniture making (Figure 16.34).

Rush is a tall marsh grass that is twisted into cords and woven into chair seats, baskets, mats, and ropes. It can also be made artificially with tough paper cords.

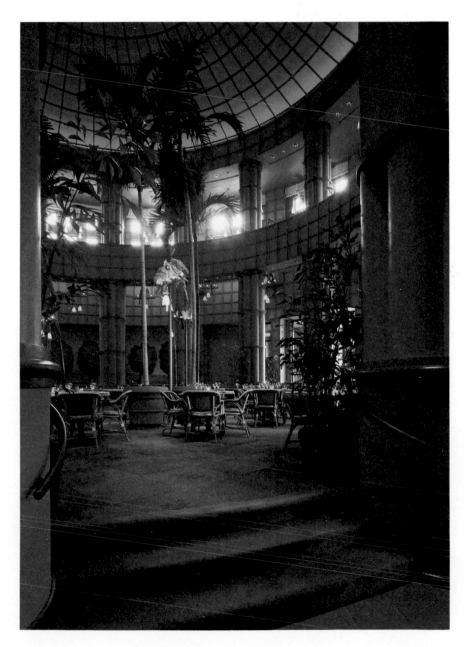

FIGURE 16.34 Within the Garden Grove Cafe at the Walt Disney World Swan Hotel, the columns resemble bundled palm reeds and the furniture style carries out the character and thematic intent of the surrounding environment.

Metals

Metals are used in many strong, fairly economical mass-produced furniture components and connectors. The quality of metal furniture can vary considerably—from well-crafted assemblies to inexpensive, poorly constructed pieces. Much modern metal furniture is made of hollow, tubular steel. Finishes vary widely and include plating or baking with enamels and lacquers (see Chapter 13 for a discussion of finishes).

The most common metals used for furniture are steel, aluminum, chromium (chrome), brass, and iron. Other metals are used primarily in a secondary role, such as for connectors, trim, or accessories. Metal has an advantage in some uses for interior spaces subject to fire hazards because the metal will not burn or contribute to a fire source. However, use of flammable coverings of foams and fabrics could offset these positive aspects. Metal furniture connections are made by welding, bolting, riveting, and gluing. Welding is very strong but not as flexible as bolting. The latter allows for adjustments, disassembly, or easy replacement of damaged parts.

Plastics

Plastics can be molded, foamed, sprayed, vacuformed, blown, or rolled into a seemingly infinite variety of shapes and surface characteristics. Plastics can be used with other materials, such as wood and steel, or alone. Most plastics are durable and easy to clean, such as the laminate finishes over particleboard subsurfaces. Integral coloring allows nicks and scratches to be nearly invisible on some plastics compared to other materials, such as wood, where the finish frequently is applied only on the surface.

Plastic furniture can be well designed and crafted if the medium is explored for its own composition and integrity (Figure 16.35). Foamed plastics offer unique features in the production of soft cushioning or lightweight structural sections. Plastic can easily be joined using synthetic glues and heat or screws and bolts.

FIGURE 16.35 These stackable plastic chairs and tile-top tables by Allibert Contract Manufacturing are made of a sturdy plastic that provides comfort and durability.

Care should be taken when specifying plastic furniture for some situations, such as in high-occupancy areas, since some plastics are highly flammable or can release toxic and explosive fumes if burned.

Upholstered Furniture

Upholstered furniture generally consists of a frame, cushioning materials, and an outer covering (Figure 16.36). Much of the inner materials and craftsmanship of upholstered furniture is hidden, making it difficult to ascertain the quality and durability of a piece. Some manufacturers provide information detailing the construction particulars of the inner workings.

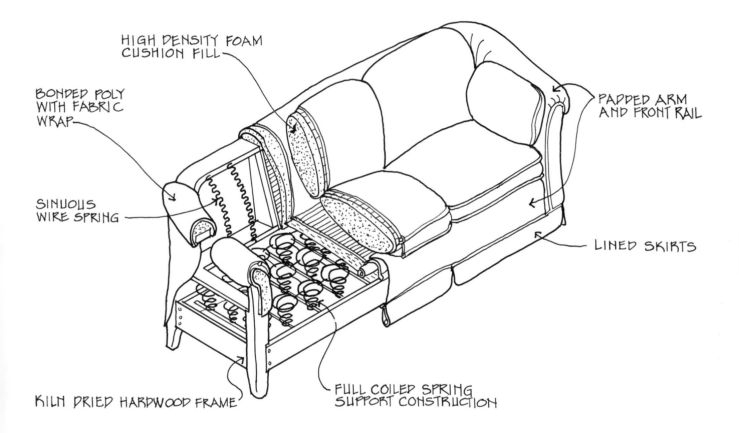

HIGH DENSITY FOAM CUSHION FILL

BONDED POLY WITH FABRIC WRAP

SINUOUS WIRE SPRING

PADDED ARM AND FRONT RAIL

LINED SKIRTS

KILN DRIED HARDWOOD FRAME

FULL COILED SPRING SUPPORT CONSTRUCTION

FIGURE 16.36 The inner construction features of upholstered furniture.

FRAMES AND SPRINGS

The frames and wedges of upholstered furniture are made of hardwood, metal, or plastic and should be structurally suited to the intended use of the piece. Frames should be securely connected with strong joints appropriate to the material and reinforced where necessary to ensure a long service life. The failure of the hidden frame can cause many of the problems associated with the durability of upholstered furniture.

Springs of various types are used to add support and a certain amount of give to the cushioning (Figure 16.37). Springs are made as coil, flat, and sinuous, or s-type, shapes and are commonly found in furniture seats and backs. Flat and sinuous springs and webbing made of

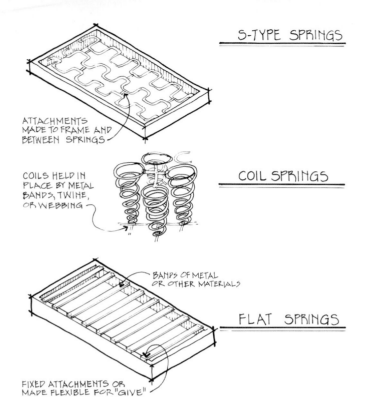

S-TYPE SPRINGS

ATTACHMENTS
MADE TO FRAME AND
BETWEEN SPRINGS

COILS HELD IN
PLACE BY METAL
BANDS, TWINE,
OR WEBBING

COIL SPRINGS

BANDS OF METAL
OR OTHER MATERIALS

FLAT SPRINGS

FIXED ATTACHMENTS OR
MADE FLEXIBLE FOR "GIVE"

FIGURE 16.37 Various types of springs used in furniture construction.

metal, rubber, and plastic produce a minimum amount of bulk compared to coil springs, which require more depth. Coil springs are attached to steel bands or webbing and are tied together at the tops to resist twisting or interlocking.

In bedding, innerspring mattresses are constructed similar to seating units but can vary in the sizes of coils within the mattress, and the coils can even be individually covered or pocketed. Box-spring mattresses are made with coil springs and support foam or innerspring units.

CUSHIONS

Cushioning, or padding, consists of a layer of material placed over the springs to give shape and comfort to the upholstered piece. Generally, burlap or other breathable materials are installed directly over the springs. This prevents the cushioning from working into the spring assembly.

Cushioning materials consist of feathers, down, cellular foams (primarily polyurethanes), polyester fiberfill, or a combination of these. In commercial uses, the choice of these materials is strictly governed by fire and building codes. Cushioning is also made in the form of loose pillows and pads that can be removed for cleaning or reversed for extended use.

COVERINGS

Coverings are the outer layers of upholstered furniture that are either permanently attached or removable for cleaning. Slipcovers can be replaced as they wear out or be removed for periodic changing.

Coverings are made in a range of materials that vary in design, cost, and quality. (Refer to Chapter 13 for specific information on textiles.) They can be purchased as a part of the manufacturer's product or specified as COM (customer's own material). COM means the designer can select fabrics from one manufacturer and have them shipped to a furniture manufacturer to be installed on the piece selected. Many dealers or manufacturers carry a supply of fabrics that can be selected from their catalogs or sample swatches.

REFERENCES FOR FURTHER READING

Boyce, Charles. *Dictionary of Furniture.* New York: Roundtable Press, 1985.

Emery, Marc. *Furniture by Architects.* New York: Harry N. Abrams, 1983.

Farren, Carol F. *Planning and Managing Interior Projects.* Kingston, Mass.: R. S. Means Company, 1988.

Fitzgerald, Oscar P. *Three Centuries of American Furniture.* Englewood Cliffs, N.J.: Prentice-Hall, Inc., 1982.

Gandy, Charles D., and Zimmerman-Stidham, Susan. *Contemporary Classics: Furniture of the Masters.* New York: McGraw-Hill, 1981.

Garner, Philippe. *Twentieth-Century Furniture.* New York: Van Nostrand Reinhold, 1980.

Lucie-Smith, Edward. *Furniture: A Concise History.* London: Thames and Hudson, 1985.

Panero, Julius, and Martin Zelnik. *Human Dimensions and Interior Space.* New York: Whitney Library of Design, 1981.

Pile, John F. *Modern Furniture.* New York: John Wiley and Sons, 1979.

Reznikoff, S.C. *Interior Graphic and Design Standards.* New York: Whitney Library of Design/ Watson-Guptill Publications, 1986.

Stimson, Miriam. *Modern Furniture Classics.* New York: Whitney Library of Design, 1987.

FURNISHINGS AND EQUIPMENT

Furnishings and equipment comprise two areas of the total FF&E program. They are an important part of the total interior environment and are generally selected by the interior designer. Interior spaces consist of more than walls, floors, ceilings, and furniture. Secondary elements support and enrich a space to make it "feel" completed. These supporting elements are referred to as furnishings in the interior design profession. They can be utilitarian or decorative, enhance the architectural features of a building, or perform all these functions.

Equipment consists of the specialized items that are necessary in a project for occupants to carry out their daily activities but that are not a part of the building systems, furniture, or furnishings. For example, equipment needed in commercial kitchens and teller equipment needed in banking facilities are specialized products unique to those operations.

FURNISHINGS

Furnishings not only serve user needs and aspirations but add the finishing touches to an interior. Furnishings can impart a person's personality and individual character to a space (Figure 17.1). They might be attached to the building, although most are freestanding and not an inte-

FIGURE 17.1 **The furnishings of artwork, collectibles, and plants reinforce the humanistic feel to an interior and provide a visual accent and interest throughout the space.**

gral part of the structure. Furnishings generally include accessories, such as figurines, baskets, personal collections, or clocks; artwork; plants; signage; and graphics. Specific furnishings that will need to be ordered to finish out a project are often detailed in the specifications (see Chapter 19).

When selecting supporting furnishings for a space, the designer must consider the principles and elements of design and the suitability of these furnishings to the total environment. Furnishings should be suited to an interior in terms of space, form, style, texture, scale, and color, in addition to serving a specific function and enhancing the overall design concept.

Residential furnishings are important supporting parts of the interior environment for the people who live in the residence. Many items, such as cherished photographs, personal collections, or a child's art creations, elicit memories and provide a sense of continuity. Most people like to surround themselves in their homes with objects that have special meaning. Planning where and how to place these keepsakes can be a difficult task for an interior designer because the aesthetic qualities of some objects may not be suited to the designed environment. However, these accessories, artworks, and other items can be integrated into the environment with some careful planning. It is better to work with a client to coordinate these objects than to ignore the objects and have them "mis-placed" into the design later.

Nonresidential furnishings can often require selections to be keyed to a theme, for example, an English Tudor motif for a restaurant. This aspect of commercial design is similar to creating a stage setting and can involve research into a particular style or historic period to ensure that the items are appropriate (Figure 17.2).

FIGURE 17.2 Eric Miller and Gary Saxton designed the "Rainbar" around a tropical theme. It is located in the lobby of a large hotel.

In work environments such as offices, people often want to surround themselves with personal items that support their feelings and territoriality. Designers should realize that workers might add pictures and personal mementos to their desktops or adjacent wall space. Although the environment might function well without these personal items, it will not meet the emotional needs of the users; that shortcoming could in turn be detrimental to workers' feelings of self-worth, perhaps lowering productivity.

Many people enjoy collecting objects that relate to their background, travels, or experiences (Figure 17.3). Some of these, such as pieces of fine art, antique dolls or toys, bottles, coins, or photographs, may be worthy of displaying and add a personal quality to the space. However,

FIGURE 17.3 This interior is accented with the owner's personal mementos and artwork.

space may not be available to display an entire collection, and discretion should be used to select the items most in harmony with the overall space design.

The designer should be aware that the significance of a space is added by the users, not just by the objects. The users return day after day to these spaces, and that experience should be meaningful.

Accessories

Accessories are used for adornment and ornament and generally are helpful, but not essential, to a space whether residential or nonresidential. Some accessories are both functional and decorative, for example, a decorative umbrella stand, clock, or wastebasket. Others may be purely aesthetic and serve no function, such as a wall hanging. Whichever is the case, accessories are important in any interior space, because without these elements a room can appear sterile and impersonal. Nonresidential spaces designed for work or public use generally are neutral or non-personal in character, since they are used by many different people and cannot reflect a particular personality. However, since people are what humanize a space, the designer should be careful not to overdo the accessories and allow them to get in the way of the users or appear to clutter a space.

FUNCTIONAL ACCESSORIES

A number of objects that appear in our interior environments are important functional elements, such as lamps, glassware, coatracks, and letter trays. These items are generally selected for their utilitarian aspects but may be creatively incorporated into the design as well (Figure 17.4). Accessories should be considered an important part of the total design concept and should be selected with sensitivity to their aesthetic qualities as well as their function. Repetitive elements, such as color, pattern, scale, or form, can act as unifiers and help tie these accessories to a design scheme. Well-designed accessories do not need to be expensive to be effective visual complements to the total design.

FIGURE 17.4 Desk accessories and other furnishings in this office are made to augment the daily activities of the user.

FIGURE 17.5 Decorative accessories in this bank by Ethel Armstrong-Merrian, ASID, include the shell wall hanging and various beach objects that serve as focal points.

Accessories can be serious or provide a sense of freshness or uniqueness to an environment, such as a large print of comic book characters. Decorative accessories include both nonutilitarian objects, such as rocks and shells, and purely decorative objects, such as ceramic figurines or other pieces (Figure 17.5). Some accessories are so highly ornamented that their function is almost secondary; an elaborately carved and gilded mirror frame is an example.

DESIGNING WITH ACCESSORIES

Accessories such as a large clock or an area rug can be used to create a visual center of interest. By their design and placement, they can serve to unify other interior elements. By careful arrangement and composition, they can create an illusion of height, width, or a particular shape in a space. The designer should be careful not to overload the senses by displaying too much in one area. The designer must decide on a concept—a feeling, mood, or emotion—and relate the supporting elements to it. A balanced relationship is necessary in order to achieve harmony. All components within a space, including the accessories, should relate to one another. Some movement and change in the use and selection of accessories is necessary; however, living, working, public, and special environments are never static and should not be designed as such.

Accessories include many different kinds of items that can be unique for different user needs and types of facilities. For example, in an office setting, accessories could include an accessory "package" that might consist of a wastebasket, letter tray, memo box, pencil cup, nameplate, and desk calendar. This kind of package could be further categorized into secretarial, management, or executive units, depending on the users' tasks. These packages simplify the ordering and distribution process.

Other accessories might include functional and decorative umbrella stands, ashtrays, or waste receptacles for public lobbies, hallways, or elevator areas. For restaurants or executive dining facilities, accessory packages might include tableware, flower vases, candle holders, and linens (Figure 17.6). The designer then must choose the specifics, such as type of flatware (stainless, silver plate, or sterling) and might also consider including vases, ashtrays, and serving trays.

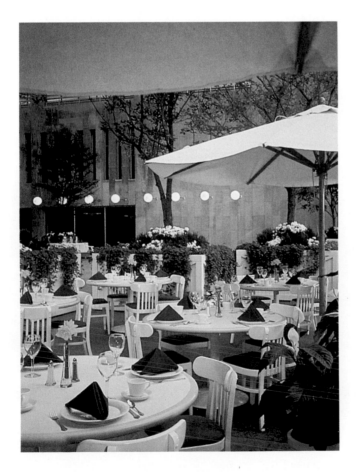

FIGURE 17.6 Designers selected tableware accessory items to complement the colors and furniture in this cafe.

Artwork

Art can be an integral part of interiors, used to enrich the design of a space and satisfy our needs for artistic expression and aesthetic delight. An interior is seldom complete without the addition of some form of artwork—an individual work, part of a collection, memorabilia, historical artifact, or other expressive pieces (Figure 17.7). Art can also be a good investment, with quality works generally escalating in value. Many individuals and corporations are very knowledgeable about artwork, have regular investment programs, and display their acquisitions.

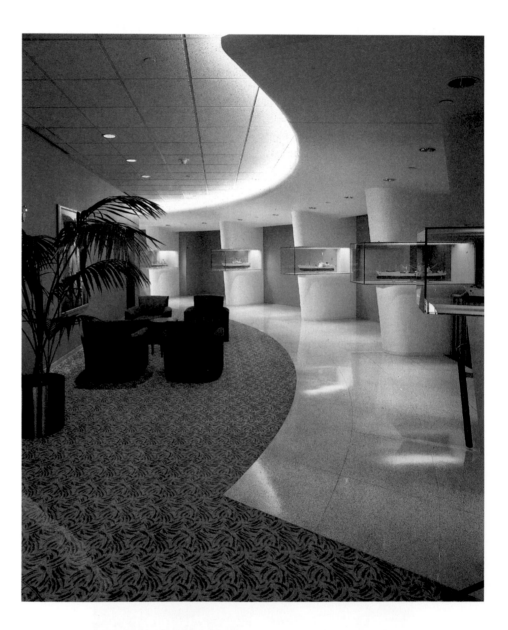

FIGURE 17.7 **This waiting area in a large corporate office was designed by Kasler & Associates to display the client's model ships.**

SELECTING AND ACQUIRING ARTWORK

Selecting artwork can involve choosing from a client's collection to determine which pieces will be displayed or selecting new works to complement an existing collection. It can also involve acquiring artwork to begin a collection. In the case of a collection, pieces might be used in

more than one space or on two or more floors of a building and might even be periodically changed through a program of rotation. The interior designer and the client should work together to decide on the types of art mediums and their placement.

Although actual pieces of artwork generally are selected toward the end of a project, concepts concerning their integration should be determined early in the design stages. Budgets, lighting, and finishes can be tentatively outlined with artwork in mind, and the possible mediums and sizes of artwork to enhance the interiors can be conceptualized. If art is not considered as an integral part of a space early in a project, the art budget is generally one of the first to be cut when a project has cost overruns. However, some states have laws that require a percentage of the construction budget in public buildings to be allocated for art.

Artwork can be acquired from a number of sources, including galleries, museums, retail shops, art dealers, festivals, or directly from artists, whether professionals or students. Although the latter have not established reputations, their relatively inexpensive prices and potential for future renown can make their work an attractive alternative. An artist can also be commissioned to produce a work, such as a tapestry or mural, of a specific subject matter or for a particular space (Figure 17.8).

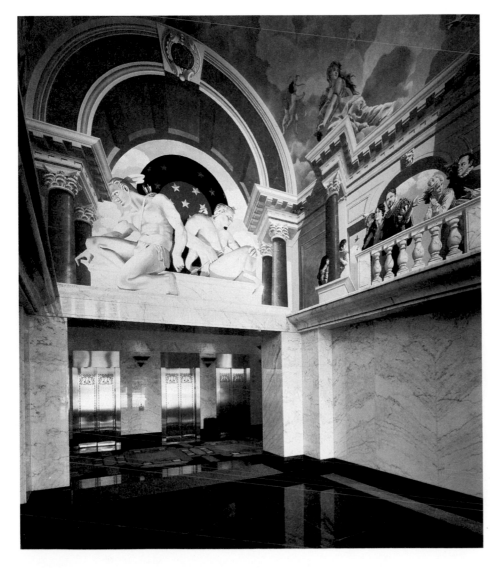

FIGURE 17.8 Artists were commissioned to paint large works specifically for this San Francisco building lobby.

Specialized art consultants are available as independents or through galleries and dealers. They can help the designer and the client make proper selections from the vast variety and large amount of artwork available. These professionals can also assist in advising on purchase prices and investment potential.

Corporations and some individual clients have an art program that sets their acquisition goals, type of art desired, inventory control, budget, and monitoring of the works. Pieces are cataloged according to title, artist, date, description of medium, date and price of purchase, and location where displayed.

Usually, art is purchased, but rental, loan, and consignment programs are available as well. Galleries and dealers often lease artwork, and some artists allow their works to be displayed in order to obtain exposure.

TWO- AND THREE-DIMENSIONAL ARTWORK

Works of art are produced in many mediums and sizes. They can be mounted on a wall, occupy small niches or shelves, sit on desktops, or occupy large amounts of floor space. They can also be in the form of sculpture hanging from the ceiling (Figure 17.9). Art is executed as realistic or abstracted forms, such as a realistic bird or an abstracted interpretation of flight.

Artwork falls under generalized categories, such as fine arts, crafts, folk art, applied arts, and decorative arts. Although these categories seem fairly definitive, many works overlap. Fine arts are those generally recognized over the centuries, including drawing, painting, printmaking, and sculpture. Photography, posters, reproductions, ceramics, metalsmithing, weaving, and other decorative arts are additional forms of art mediums. The medium does not always define the art form, since the work can incorporate many materials and techniques into the same piece.

DRAWING. Drawings are works done in pencil, charcoal, ink, grease pencil, or pastels, primarily on paper mediums. They can be an original finished work or a preliminary study for other mediums, such as paintings or sculpture. Drawings are generally less costly and smaller in scale than the other fine arts. Drawings require frames, mats, and other protective surfaces (of glass or plastic) to preserve and display them.

PAINTING. Paintings are one-of-a-kind works executed with colored pigments carried in various vehicles to canvas or other backings. These vehicles include oil, watercolor, tempera, and acrylics. They can vary considerably in subject matter, size, and price. Most require a frame and need protection from direct sunlight and other harmful conditions, such as moisture and excessive handling.

PRINTMAKING. Printmaking involves producing prints (often called multiples) on paper by processes such as silk screening (serigraphy), etching, wood cutting, drypointing, engraving, and lithography. Prints are made in limited editions, numbered in sequence, and signed by the artist. The numbers, such as 6/30, indicate that the print is the sixth of a total of 30 produced. Prints are often less costly than original drawings or paintings and are framed in a manner similar to that used for drawings.

PHOTOGRAPHY, REPRODUCTIONS, AND GRAPHIC ART. Photography, a medium introduced in the 1800s, is produced either in black and white or in color. Photographs can be composed of literal images or produced from darkroom techniques creating abstract multiple exposures. Photos can be one-of-a-kind works or, similar to prints, produced in limited editions. Although most photographs have protective coatings, some are encased beneath glass for protection.

Reproductions are copies of an artist's original work and are made as photographic prints or through commercial printing processes for multiple copies. However, some are reproduced in various media through hand-copied techniques. High-quality copies can be a good source of aesthetic pleasure and serve where the original work is too costly or unattainable.

FIGURE 17.9 This hanging sculpture provides a kinetic focal point to the building lobby.

Graphic art is two-dimensional work that includes posters, often advertising plays, concerts, and exhibitions. It can also be reproductions by well-known artists. Maps, logos, fashion drawings, and other graphic creations (Figure 17.10) also serve to provide economical sources of artwork.

SCULPTURE. Sculpture is three-dimensional art that can be large, freestanding pieces or small items placed on a shelf, table, or display unit (Figure 17.11). Placement should be carefully considered, for many pieces of sculpture are subject to handling by viewers. Sculpture is created in many different mediums and can be realistic or abstract in subject matter. Sculpture can be either static or kinetic, such as in hanging mobiles. Kinetic pieces can be moved by air patterns, motors, water, or viewer participation. Large pieces can be heavy and must be carefully placed because they are not easily moved.

FIGURE 17.11 A whimsical bird sculpture provides a sense of humor for dining patrons who pass through this restaurant portal.

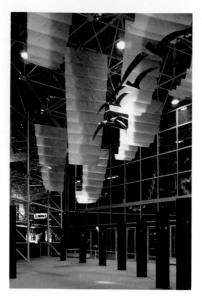

FIGURE 17.12 These sculpted nylon swags in the lobby of the Museum of Flight (Seattle, Wash.) are a good example of fabric art.

FIGURE 17.13 In the James Whitcomb Riley Hospital for Children, special wall niches were created in the corridors for prominent artwork.

CRAFTS AND DECORATIVE ARTS. Crafts include pottery (ceramics), glass (stained, beveled, and blown), metalwork, art fabrics, (Figure 17.12) basketry, and folk art. Some of these, such as ceramics, are seen as both fine art and applied art, which is considered functional art. Crafts can be produced as large objects or small, personalized pieces for collections. Generally, crafts are smaller and less costly than sculpture and paintings.

Folk art and other primitive artworks occupy a unique place in art, often providing a look at the culture and antiquity of peoples who produced them.

Decorative arts can be utilitarian or purely aesthetic displays. Many are mass-produced, and the pieces can range from quality art forms to cliché or poorly conceived and executed pieces associated with bad taste. The German term *kitsch* is often used to describe these latter pieces as foolish or pretentious art forms.

Other crafts and decorative arts that can be displayed include quilts, rugs, blankets, antiques (tools, weapons, glass, coins, and the like), tapestries, and weavings. Objects or historical documents such as letters, manuscripts, and charts, can also be displayed as a visual composition.

PREPARING AND DISPLAYING ART

Important design decisions must be made concerning the preparation of artwork to be displayed and its positioning in an interior space. The interior designer has an important role in these decisions and should work closely with the client and users of the interiors to create placements that satisfy both functional and visual compositions (Figure 17.13).

A frame, matboard, and glass must often be selected and coordinated to complement two-dimensional artwork. Stands have to be purchased or made for small sculpture that is not large enough to stand alone. Art supply stores and frame shops provide both unassembled frame kits and custom framing for two-dimensional work. They also offer colored mats for accenting and protecting the work, as well as clear and nonglare glass covers.

Art provides a complement to the total design and use of the space. Wall art, such as paintings, prints, and drawings, should be carefully positioned at eye level for proper and comfortable viewing. Large works are often placed alone on a wall to create a dominant effect.

Smaller pictures can be grouped in a composition; placed over an object, such as a piece of furniture or a fireplace; or be hung on a smaller wall surface.

Sculpture and other three-dimensional works require careful placement, taking into account the movement of a viewer and the proper viewing angle of the piece. Some pieces require the viewer to circulate around them, while other, smaller pieces might rest on a shelf, table, or special display unit.

All art requires both proper lighting for viewing and protection from abuse or deterioration. This lighting can be either artificial or natural; however, more control can be achieved with the former. Time of day and season can affect the quality and direction of natural light. Strong sunlight striking a work of art can cause glare, shadows, and reflections, affecting the visual appreciation of the piece. In some situations, sunlight will cause deterioration or other damage to a work of art.

Correct artificial lighting for artwork is specific to the type of art to be viewed. For example, two-dimensional work often requires either a good overall ambient level in the space or special accent luminaires, such as a framing projector, to highlight the work. Wall washers and spotlighting can also be used to bring the appropriate level and direction of light to the art. Three-dimensional work often requires special direct lighting to bring out the texture, color, shape, and other qualities of the piece. Consideration must also be given to multiple lighting for larger pieces that are meant to be viewed from more than one angle.

Plants

Plants have become as important as artwork for interior design elements. Human beings seem to have a natural affinity for a green environment. Plants are living art, like sculpture. They bring color, texture, and a variety of forms and shapes into our interiors (Figure 17.14). As our built environments expand and natural greenery disappears from the urban landscape, we find

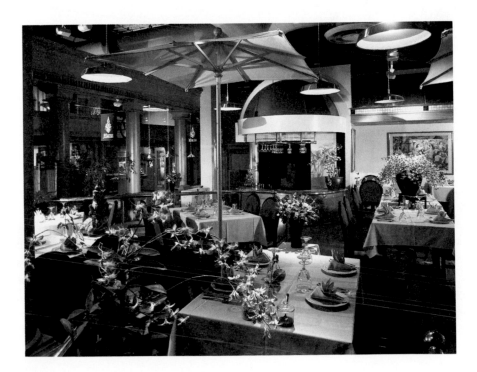

FIGURE 17.14 The dried and natural plants in this restaurant provide variety in shape, texture, and interest to the environment. The colors also complement the interior finish materials and furniture.

that plants bring a natural element to an otherwise artificial environment. Plants are used in interior environments as focal points, sculpture, screening, softening, and psychological elements. Commercial enterprises, designers, and employers have increasingly incorporated interior gardens and plants as an integral part of our environments, at work and at play, for the enrichment of the spaces and the well-being of users.

Plants serve both functional and aesthetic purposes within an interior. Some large species can serve as design components to divide space, accent the interiors, or define areas within large spaces (Figure 17.15). They can also be used to define circulation paths and to separate or visually screen workstations in open office areas. Plants can be used to create a center of interest. They can emphasize or deemphasize architectural details; they can create specific mood settings within a space and can identify status by setting apart an executive area.

FIGURE 17.15 Plants are placed throughout this hotel atrium to create a unique outdoor feeling and accent the mythical setting for the restaurant.

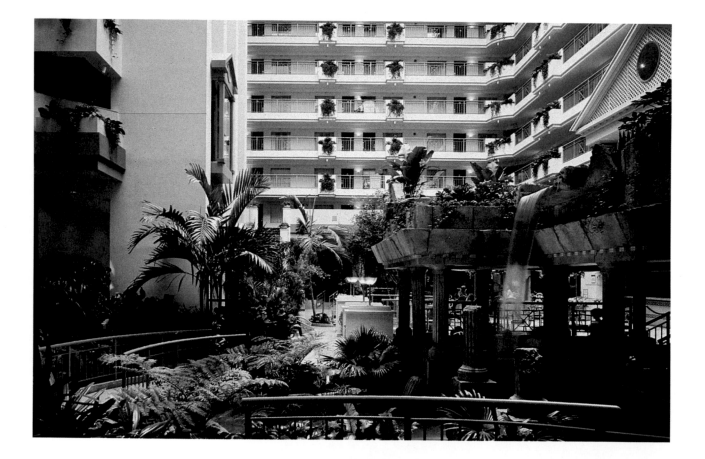

HEALTH CONCERNS. Plants return vital oxygen to the air and raise humidity levels by combining expelled water vapor with air. Although some individuals are allergic to particular plants, generally air quality within buildings can be improved by the addition of plants and foliage. Low levels of indoor pollutants may be the cause of what the Environmental Protection Agency (EPA) calls the sick building syndrome, in which workers in a new or poorly ventilated building experience eye, nose, and throat irritations, as well as headaches, lethargy, and lack of concentration. Research conducted by the National Aeronautics and Space Administration (NASA) on the effects of live plants and flowers on indoor air pollution has shown that living plants absorb gaseous substances from the air and release fresh oxygen and water vapor back into the air. NASA concluded that live plants and flowers are beneficial to humans beyond the plants' visual and

psychological impact. These studies have shown that plants absorb noxious gases through tiny openings in their leaf surfaces. They do not merely filter the material but actually metabolize or break it down physically and chemically to use as their food.

Plants are currently being tested for their effectiveness in "cleaning" the air. Studies conclude that a small ratio of plants-to-area (square feet of space) can do an effective job. For example, only 15 mother-in-law's tongue plants would maintain a formaldehyde-free atmosphere for an 1,800-square-foot (167 m^2) area of heated living space with an 8-foot (2,438 mm) ceiling. Research is also being conducted on the material in which the plant is grown and the amount of time a plant is exposed to light to determine their effect on the indoor environment.

Some types of plants can be poisonous or harmful to pets and small children, so the interior designer should be careful when selecting interior plants where these potential problems might occur.

SELECTION CRITERIA

Designers should select plants that will functionally and aesthetically complement the design scheme. Aesthetic considerations include the foliage color, size, shape, height, spread, and outline of the plant. Of vital importance is a compatible climate of the interior environment in which the plants will live. The interior designer must have a working knowledge of plant types and needs in order to select those that will thrive in a particular interior environment over time or can consult a qualified local plant services contractor or an interior plantscaper.

LIGHT REQUIREMENTS. Both the placement of plants and the amount of light available are key factors in a design scheme. A plant's position in relation to natural light from windows can affect its survival. Some plants require natural light, whereas others can survive on artificial lighting. When selecting interior plants, the designer must take into account the kinds and amount of light the space has—direct or indirect daylight, fluorescent or incandescent artificial light.

Lighting can be used for dramatic highlighting or to bring out the sculptural qualities of plants (Figure 17.16). Uplights can be used to create dramatic effects on plants, since most plants are seen with light from above.

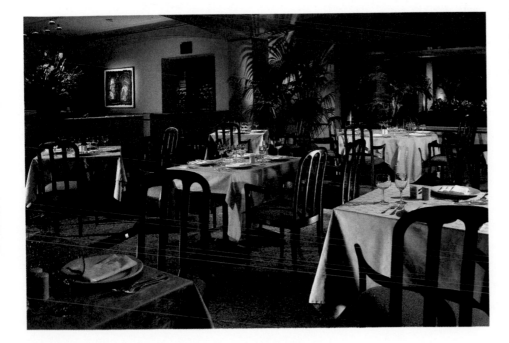

FIGURE 17.16 Dramatic lighting is used to accent the plants in this interior, increasing their visual interest in the space.

WATER AND HUMIDITY REQUIREMENTS. The ease with which interior plants can be watered is an important consideration in their selection. Plants suspended high overhead or placed high on a shelf may be difficult to water and can dry out more quickly. Generally, indoor plants are watered too frequently and inconsistently. Plants must be allowed to dry out so that the roots will take in oxygen. It is important for plants to be watered on a scheduled basis, rather than intermittently. In commercial installations, it is often best to leave the watering to plant specialists as part of a plant program.

PLANT PROGRAMS

Clients can purchase and maintain their own plants, lease them on a monthly basis, or buy them and pay for a monthly maintenance and replacement program. Frequently, these decisions are based on initial costs and maintenance factors. A maintenance program is highly recommended for the survival and growth of plants in an interior environment because they need consistent care. Plants must be sprayed for insects, pruned, fertilized, rotated, and polished on a regular basis.

The interior designer will generally prepare specifications for interior plants that specify details of plant size (height and width), trunks, stems, branches or canes, foliage, root system, and growing medium. He or she includes a schedule that lists individual plants selected, their location, and the container or planter to be used. The specifications generally request two alternate quotations: one for leasing the plants with a maintenance and replacement guarantee and the other for the purchase of the plants, with a replacement and maintenance guarantee included.

Another option offered by some plant services is the nonguaranteed maintenance program. With this program, the client pays a flat fee for monthly maintenance and pays an additional charge for plants that need to be replaced.

Another consideration in a plant maintenance contract is the inclusion of inspecting employee-owned plants that might introduce bugs or diseases. One infested or infected plant can transmit problems to many others within the same environment.

TYPES OF PLANTS

It is difficult to categorize plants because they are living organisms and have many different qualities. However, plants for an interior environment are usually categorized as live plants, artificial plants, and cut flowers.

LIVE PLANTS. Live plants are available in many different varieties and can be broadly categorized as flowering plants, foliage plants, and cacti or succulents. New methods of propagation and hybridization have made it possible to bring many outdoor plants (grown mainly in tropical regions or only in greenhouses) indoors. Also, tissue-culture technology has produced new varieties by genetic engineering and cross-pollinating the best characteristics of one plant with those of another.

Live plants are generally specified according to the variety of plant as well as to their size and height. Small plants are those under 12 inches (304 mm) tall; medium plants are 1 to 3 feet (304 to 914 mm) tall; and large plants are more than 3 feet tall. Other considerations must include minimum width, recommended interior light requirements, and moisture requirements (Figure 17.17).

ARTIFICIAL PLANTS. Artificial plants are generally not acceptable to designers. However, silk plants and flowers of high quality are a good alternative to using either live plants in hard-to-reach places or cut flowers, which can present an ongoing expense if they must be changed weekly or daily.

Dried flowers or other types of preserved plants, such as cat-o'-nine tails or grasses, work well in areas with no daylight and intermittent artificial light (Figure 17.18).

COMMON NAME	SIZE	WATER	LIGHT
ASPARAGUS FERN	Sm/Med	Moist	Med
BAMBOO PALM	Lg	Moist	Low
BENJAMIN FIG	Lg	Moist	High
BOSTON FERN	Med	Moist	Med
CANDELABRA CACTUS	Med/Lg	Dry	Med/High
CHINESE EVERGREEN	Med	Moist	Low
COLUMN CACTUS	Med/Lg	Dry	Med/High
CORNPLANT	Med/Lg	Moist	Med
CROTON	Med	Moist/Dry	High
DIEFFENBACHIA	Med/Lg	Moist/Dry	Low
ENGLISH IVY	Sm	Moist	Med
FALSE ARAILA	Med/Lg	Moist	Med
FISHTAIL PLAM	Med/Lg	Moist	Med
GOLDEN PATHOS	Sm	Moist/Dry	Med
GRAPE IVY	Sm	Moist	Low
HAWAIIAN SCHEFFLERA	Med/Lg	Moist	Med
HEART-LEAF PHILODENDRON	Sm	Moist/Dry	Med
JADE	Sm	Moist/Dry	Low
MOTHER-IN-LAW'S TONGUE	Med/Lg	Moist/Dry	Low
NEPHTHYTIS	Sm	Moist	Med
NORFOLK PINE	Med/Lg	Moist	Med
PARLOR PALM	Med/Lg	Moist	Low
PEACE LILY	Med	Moist	Low
RUBBER TREE	Med/Lg	Moist/Dry	Low
SPIDER PLANT	Med	Moist/Dry	Med
SPLIT LEAF PHILODENDRON	Med/Lg	Moist/Dry	Med
UMBRELLA TREE SCHEFFLERA	Lg	Moist	Med
WANDERING JEW	Sm	Moist/Dry	High

FIGURE 17.17 Selected interior plants and their characteristics.

SIZE (in feet; metric shown in millimeters)

Sm = 0–1 (304 mm)
Med = 2–3 (609–914 mm)
Lg = 4 and over (1219 mm)

WATER REQUIREMENTS

Moist = Keep plant damp—water once a week
Moist/Dry = Thoroughly dampen media and allow to dry (approximately 2 weeks) before watering again.
Dry = Water thoroughly and allow to dry. Water once every 2 or 3 weeks.

LIGHT REQUIREMENTS

High = Direct sun or over 200 fc (footcandles)
Med = Indirect sun or 80–150 fc
Low = Shade or 50–80 fc

CUT FLOWERS. Cut flowers can add sparkle, warmth, and lively color to an interior space, such as on a reception desk or on tables in an executive dining room. If a client desires cut flowers, the designer should specify appropriate vases in the accessory package. Arrangements for the delivery of live flowers weekly or daily can be included in the plant contract or handled separately through a local florist.

FIGURE 17.18 This dried plant adds to the dramatic display of merchandise at Bloomingdale's in Chicago.

FIGURE 17.19 The large plant containers here complement the forms and colors in this lobby area at the Walt Disney World Swan Hotel.

CONTAINERS

The container or planter is also a design element and must be selected to accommodate the size and shape of the plant as well as to complement the design of the interior space (Figure 17.19). Large containers would be considered part of the furnishings and would be drawn as such in the floor plan. Planters can be either leased or purchased and should be included in the plant program.

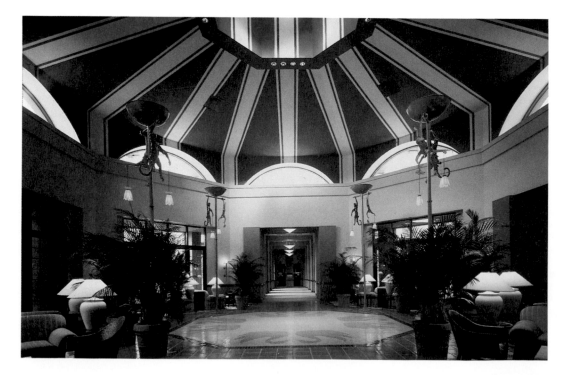

Signage and Graphics

Interior designers are often involved in signage and graphics selections for clients. These might be simple desk signs or elaborate graphic programs identifying directions, departments, and individuals in a large building (Figure 17.20). Signage can also include menu designs for restaurants, graphic designs for uniforms, or packaging for a client's products. Other forms of signage are displays for advertising and exhibitions.

SIGNAGE

Signage is generally classified as directional, informational, or emergency. The interior designer can control the type of directional or informational signage, although building codes and regulatory agencies usually control the size, shape, and location of emergency signage. These signs have to be immediately recognizable and standard in their appearance throughout the country.

Directional signage is used as an informational "directory." Signs are designed or selected by the designer to complement the interior design scheme, as well as to be clear and visually informative. Directional signage for organizations that anticipate changes is designed to be flexible.

Informational signs label special equipment and spaces, such as telephones, no smoking areas, toilets, conference rooms, and closets for electrical or mechanical equipment, as well as provide names of people (Figure 17.21).

Emergency signage includes exit ways for stairs, escape doors, fire extinguishers, and other life-safety concerns. Signs should be uniformly designed, be concise, and have clear, distinctive graphic images with a background that contrasts with the lettering for legibility and visibility. Signs should be appropriately sized to the distance at which they are to be encountered and read. They should be lighted where illumination levels are not adequate or where it is required by building codes.

FIGURE 17.20 BELOW, LEFT The directional signs in this health club stairwell are designed to provide information and are uniquely styled to the interior stairway elements.

FIGURE 17.21 BELOW, RIGHT The signs in these offices are created as simple linear bands between door entrys and accented by a wall-mounted linear light fixture.

Signage for accessibility to the physically disabled is of great importance. These signs address both emergency and safety concerns, such as exit ramp locations and the locations of accessible restrooms, drinking fountains, parking, and elevators. Many of these signs have been standardized in their graphics for universal recognition (Figure 17.22).

GRAPHICS

Graphics include the design and lettering of signage and other artwork for a client's logo, business cards, and letterheads. The graphic designs of restaurant menus, retail signs and custom artwork creations are all a part of the interior designer's role. He or she might create these in-house or retain independent graphic designers to produce these works.

FIGURE 17.22 Signs utilizing distinct international symbols can assist the physically disabled in locating proper facilities.

EQUIPMENT

Selecting equipment for interior design projects involves items either physically attached to a building or freestanding, including equipment for restrooms, kitchens, libraries, and laboratory spaces. The term *fixtures,* which includes bank teller, beauty shop, and other specialized equipment, is sometimes used (Figure 17.23). Fixtures include copy machines, computers, vending machines, X-ray equipment, retail display fixtures, and even drafting equipment.

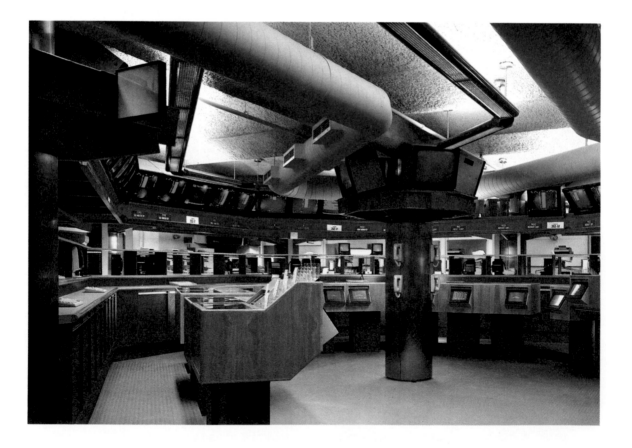

FIGURE 17.23 Specialized equipment was incorporated into this stock exchange trading floor expansion by Swanke Hayden Connell Architects.

Interior designers work with the user, installer, dealer, and manufacturer to gain specific information and guidelines for use when selecting this equipment. Consultants, such as commercial kitchen specialists, might be called upon to make presentations on equipment or to give recommendations on budgets and specific equipment. Because much of the equipment is specialized for particular facilities, close coordination is needed to select the correct items and provide proper lighting, electrical, spatial, and other requirements, in addition to choosing finishes, color, and style. The designer assists in coordinating the placement of equipment in a project with the architect and contractor.

The designer selects specialized equipment in the areas of residential, office, healthcare, hospitality, retail, and institutional design (Figure 17.24). He or she consults with other professionals, varied consultants, and manufacturers to select the proper equipment.

FIGURE 17.24 Healthcare design and equipment are often very specialized, as seen in this medical facility.

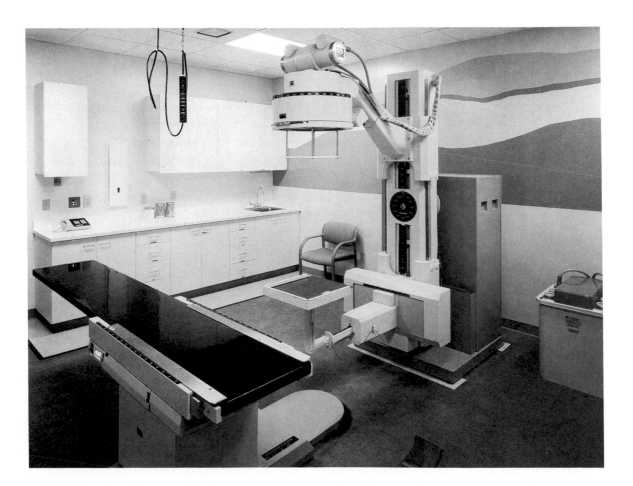

Residential Equipment

The designer selects equipment for both single- and multifamily housing. The interior designer works directly with a client in specifying single-family residential equipment or with the client and the architect in multifamily housing. The equipment includes appliances as well as built-in ironing boards, intercom systems, security systems, and other electronic equipment. Specialized housing types for the physically disabled and the elderly often use similar equipment or special units from healthcare facilities, such as serving trays or carts for geriatric chairs.

Office Equipment

Office equipment includes items necessary for a business to carry on its daily activities; these items might include word processors, computers, printers, copiers, and mailroom machines. Other equipment found in offices ranges from appliances for an employee break room to prefabricated shelving. Audiovisual and lectern equipment, as well as screens and electronic communication equipment, is often specified for conference rooms.

The designer is often asked to plan for a client's space growth and projected equipment needs. Spatial and electrical requirements are projected for new equipment acquisitions in various increments, such as 5 or 10 years.

Healthcare Equipment

Equipment for healthcare facilities comprises a large variety of highly specialized products that generally are specified by the client or user. The interior designer is mostly involved with coordinating the functional and aesthetic needs for the equipment and its placement in the space. For example, a physician might decide what equipment is needed for an operating room and leave the details of lighting, finishes, color, electrical connections, and spatial arrangement to the designer.

Healthcare units include dental, radiology, and hospital operating room equipment. More specifically, these might be autoclaves, examination tables, dental chairs, and X-ray machines. In addition, the interior designer also selects such items as refrigerators and additional equipment for staff rooms and other lounges.

Hospitality Equipment

Equipment for hospitality industries is as varied as the service and accommodations provided. Food service equipment includes units for food storage and preparation, cooking, food dispensing, serving, dishwashing, and cleanup. Ice machines, cash registers, bar equipment, and server stations are also part of this type of equipment.

Equipment for hotels and motels can include computerized check-in/out systems, room key monitoring, and carts for porters and housekeeping staff. Individual room equipment includes bathroom items, televisions, and appliances, such as small refrigerators and microwave ovens.

Retail Equipment

Retail equipment can include cash registers, display stands, manufactured shelving systems, and display cases (Figure 17.25). Equipment for specialized shops, such as a beauty facility, would include hair dryers, shampoo stations, operators' chairs, suntanning beds, and specialized skin care machines.

FIGURE 17.25 Equipment in retail facilities is designed and made in a variety of ways to store and display merchandise.

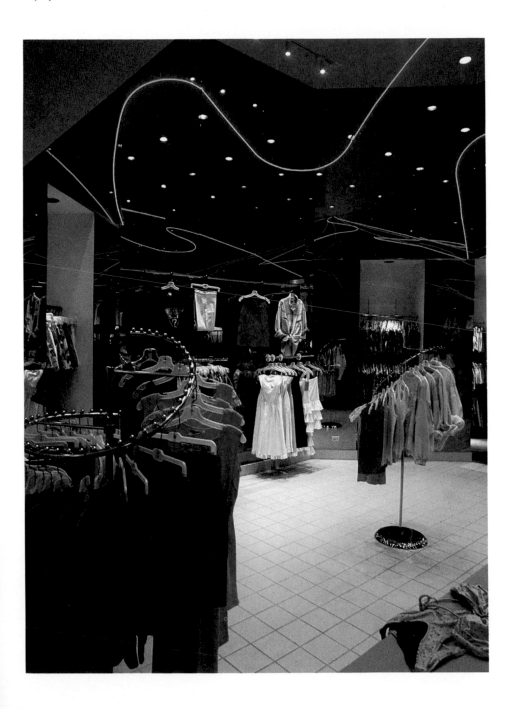

Institutional Equipment

Special equipment is made for libraries, museums, churches, schools, public facilities, and other institutions. These can include lockers, vending machines, audiovisual equipment, study carrels, and recreational equipment.

Davidson, William, ed. *The Illustrated Encyclopedia of House Plants.* New York: Exeter Books/ Simon & Schuster, Inc., 1984.

Eichenberg, Fritz. *The Art of the Print.* New York: Abrams, 1976.

Farren, Carol E. *Planning and Managing Interior Projects.* Kingston, Massachusetts: R.S. Means Company, Inc., 1988.

Gardner's *Art Through the Ages.* 7th ed. Rev. by Horst de la Croix and Richard G. Tansey. New York: Harcourt, Brace, Jovanovich, 1980.

Janson, H.W. *History of Art.* 2nd ed. Englewood Cliffs, N.J.: Prentice-Hall, 1977.

Klein, Judy Graf. *The Office Book.* London, England: Quatro Marketing Ltd., 1982.

Knobler, Nathan. *The Visual Dialogue.* New York: Holt, Rinehart and Winston, 1971.

Ramsey, Charles G., and Harold R. Sleeper. *Architectural Graphic Standards.* 8th ed. New York: John Wiley and Sons, Inc., 1988.

Reznikoff, Sivon C. *Specifications for Commercial Interiors.* New York: Whitney Library of Design/ Watson-Guptil, 1989.

———. *Interior Graphic and Design Standards.* New York: Whitney Library of Design, 1986.

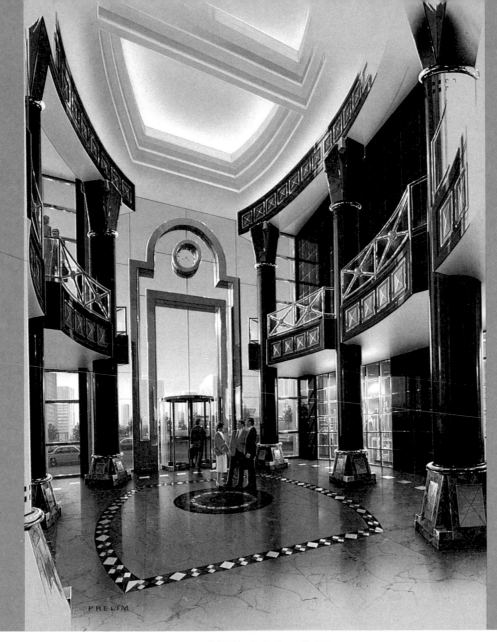

PRELIM

ASPECTS OF PROFESSIONAL PRACTICE

PART SIX

C H A P T E R 1 8

DESIGN COMMUNICATION

Communication involves transmitting, transferring, or making known specific ideas, information, opinions, or decisions. Thoughts, ideas, and plans are created in someone's mind, but to serve a purpose, these ultimately have to be communicated to others through some medium. Musicians use sounds to express their musical ideas, writers translate their ideas into words, and designers express their ideas through visualization and drawings (Figure 18.1). Although people may have many great ideas, these concepts must be communicated or they remain "big ideas" that never translate into reality. If an idea is not effectively communicated, it is essentially useless.

Most of the ideas designers have are communicated in visual forms, yet the receiver (generally a client) may not be trained to think visually. For example, a lawyer who deals mostly in verbal and written exchanges may not fully understand architecturally drawn plans, sections, and elevations. Designers should attempt to find the best form of communication to make their ideas clearly understood. As communication is a two-way process, designers must also listen to what a client is saying.

Designers communicate their ideas through a process that can be divided into three phases—design conception, design communication, and design implementation. The diagram in Figure 18.2 illustrates the design phases and communication flow, as well as areas of specifics each phase involves.

Design conception assists the designer in thinking through, and visualizing the solution to, a problem. Design communication helps the client to visualize how needs will be met by the designer's ideas, proposals, or solutions. To be effective, the designer should clearly define what needs to be communicated and the best way to do it so the proposal will be most accurately understood.

FIGURE 18.1 Designers execute sketches to explain their design ideas to a client, such as this sunroom in a proposed residence.

1 DESIGN CONCEPTION

Problem Identification and Definition
Research and Data Collection
Analysis
Concepts
Idea Generation

2 DESIGN COMMUNICATION

Preliminary Designs/Drawings
Visual/Verbal Presentations
Client Responses
Proposals and Budgets
Design Development

3 DESIGN IMPLEMENTATION

Construction Drawings
Specifications, Samples
Contracts and Business Documents
Construction of the Project
Scheduling and Budget Control
Construction Coordination
Move-In by Client

FIGURE 18.2 Designers use various communication modes and media during their involvement in a project.

This dissemination can be diagrammed (Figure 18.3) before and after each presentation to assure that the client clearly understands the design development. The third phase, design implementation, helps the builder or installer to understand clearly what is to be built.

Although a designer's presentation may be beautiful to look at and perhaps be considered by some a work of art, it is a means of communicating an idea that is to be physically carried out. In other words, design visuals are usually not the end product, but represent the designer's perception, analysis, and synthesis of a particular problem or situation and a proposed solution. Interaction must occur with other individuals to put these concepts into motion.

FIGURE 18.3 In this diagram of design dissemination, the designer can also become the receiver as the client becomes the transmitter.

People tend to perceive what they expect or want to see, rather than what is really communicated (Figure 18.4). They can interpret information quite wrongly if it is not clearly communicated. The surrounding environment or situation will often influence people's perceptions of what is being communicated.

The purpose of this chapter is not to teach design students how to draw but rather how to transmit design ideas most effectively through various mediums and methods of communication.

FIGURE 18.4 Individuals tend to perceive and interpret ideas differently. Clear communication is needed to convey specific thoughts, ideas, and solutions.

DRAWING AS DESIGN COMMUNICATION

Designers develop their ideas and communicate them through the visual language commonly referred to as drawing. Throughout the ages, people have been expressing their ideas, experiences, and expectations through drawing. Some drawings are realistic interpretations and others are abstract. Designers can translate their ideas from abstract drawings to realistic images that can be clearly understood and followed by others who may not be trained in the visual arts.

Drawing is a very powerful tool for the designer and has been the most direct and effective design communication medium available. Drawing is a learned skill that must be continuously developed. The only way to become proficient in drawing is to observe and PRACTICE, PRACTICE, PRACTICE.

In his book *Design Drawing*, William Lockard defines drawing in three basic categories—art, design-drawing, and drafting. He compares these forms and illustrates their differences based on their methods, uses, and value systems.

Drawing as *art* places value on self-expression, technique, levels of communication, and choice of subject matter. The drawing actually becomes the finished product as a one-of-a-kind original, such as a sketch by Picasso, and usually increases in value over time. Generally, this form of drawing is not used extensively in the interior design field, although a rendering may become a work of art to be hung on a client's wall or to be used for marketing purposes (Figure 18.5).

Design-drawing is a process or means to an end, not necessarily the finished product. It is an exploratory, changing, redefining technique to develop ideas and concepts for communicating to oneself and for others to follow. These drawings serve as a guide for developing and constructing a project (Figure 18.6). At times, however, the beauty of the drawings or the notable draftsmanship may place these visuals at the art plateau, and they might indeed become invaluable. Design drawings usually are created in the design conception and design communication phases and exhibit different degrees of finish or detail.

Drafting is a form of drawing that consists of formal rules of visual abstraction, such as legends and symbols, or of orthographic projections that are accurate to scale and serve as a pattern for building something. These drawings typically are created in the design implementation

FIGURE 18.5 Some interior renderings take many hours to produce and become a work of art, such as this rendering in tempera paint.

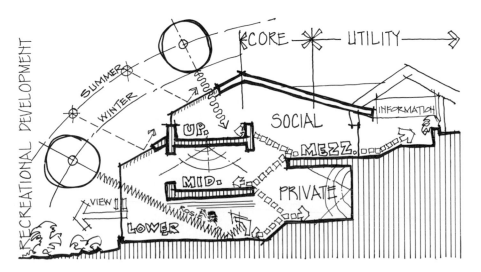

FIGURE 18.6 Design drawings help to develop and refine concepts that can be visually explained to others.

phase. The drafting process is an efficient, scaled set of drawing conventions commonly followed by individuals involved in designing, manufacturing, or constructing buildings, cabinetry, and furniture (Figure 18.7).

FIGURE 18.7 Example of construction drawings drafted to explain the details needed for construction.

This chapter deals primarily with the design and drafting forms of drawing, not with drawing as an art form. It will discuss when and what form of drawing the designer should use to develop concepts and communicate to others.

Although drawing is a very effective means of design communication, a designer should be aware of its limits as a medium. Drawings alone will not always fully explain an idea and will have to be augmented by a verbal presentation or even a three-dimensional scaled model.

Architectural Graphics

One of the first drawing stages in the design conception phase deals with certain symbols or visual abstractions commonly referred to as architectural graphics. These do not necessarily include detailed drawings of floor plans, elevations, or sections but rather portray basic issues, ideas, concepts, and physical relationships of a particular design.

At this stage, the graphics are fairly abstract and general in nature. The designer sketches and resolves the basic issues of the situation before moving on to details. Concepts are refined in these loose sketches and communicated to the client in a visual, graphic form. The designer works visually through a design process (Figure 6.6) beginning with schematic sketches, then developing bubble diagrams, zoning diagrams, and preliminary designs. Bubble and zoning plans (Figure 18.8) help define spaces and their relationships.

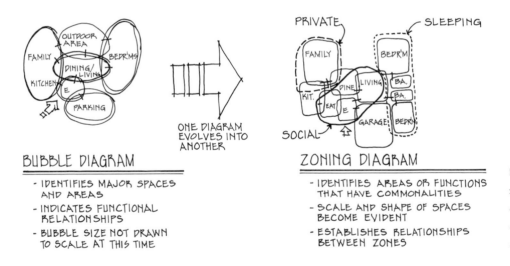

BUBBLE DIAGRAM

- IDENTIFIES MAJOR SPACES AND AREAS
- INDICATES FUNCTIONAL RELATIONSHIPS
- BUBBLE SIZE NOT DRAWN TO SCALE AT THIS TIME

ONE DIAGRAM EVOLVES INTO ANOTHER

ZONING DIAGRAM

- IDENTIFIES AREAS OR FUNCTIONS THAT HAVE COMMONALITIES
- SCALE AND SHAPE OF SPACES BECOME EVIDENT
- ESTABLISHES RELATIONSHIPS BETWEEN ZONES

FIGURE 18.8 Bubble diagrams and zoning diagrams are schematic drawings that help to visually establish relationships of spaces and needs of the users.

Graphics for interior design can be presented in many different forms, each with its own language or symbols. Graphics for building design can be broken down into two groups of relationships: (1) physical, which are spatial configurations, location in space, and elements; and (2) nonphysical, which are concepts, ideas, events, processes, and time. These graphics might include diagrams, charts, matrices, zoning, plans, circulation, spatial relationships, hierarchy, structure, and scheduling (Figure 18.9).

In most cases, architectural graphics are drawn primarily in the design conception and design communication phases. However, they can also be found in the design implementation phase in the form of a graphic guide for the construction process. Although the construction drawings, or blueprints, for a building are really graphic symbols, we usually refer to them as architectural drawings.

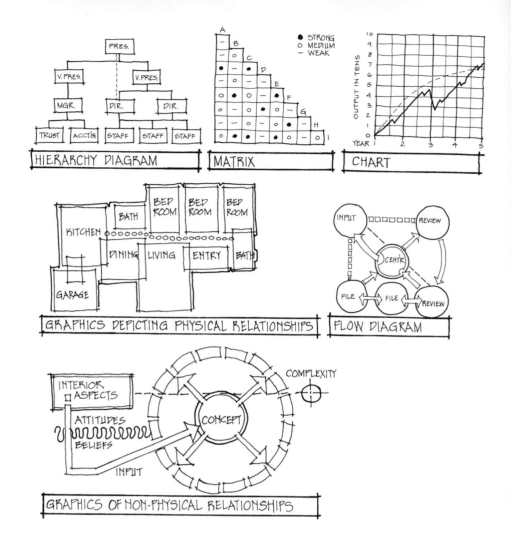

FIGURE 18.9 Graphics for design methodologies.

Architectural Drawings

Architectural drawings can be pictorial images of buildings, interiors, or components to be built. These drawings also illustrate materials and methods for constructing objects as drawn by a designer to serve as a guide for others to follow. Architectural drawings differ from schematic and architectural graphics in that they are usually more accurate in scale and detail (Figure 18.10). Architectural drawings for interiors include floor plans, sections, elevations, details, ceiling plans, finish schedules, and electrical plans. However, other kinds of drawings may be necessary before a total project can be constructed and installed. These might include a site plan, foundation plan, structural plan, and mechanical (heating, cooling, water, and waste) plans.

Architectural drawings are done as design or presentation drawings and as construction or "working" drawings.

PRESENTATION AND CONSTRUCTION DRAWINGS

Presentation drawings (Figure 18.11) are used to convey spatial relationships, elements, materials, color, furniture, furnishings, and equipment. Presentation drawings should be architecturally correct but should also present the space as "psychologically comfortable." This type of

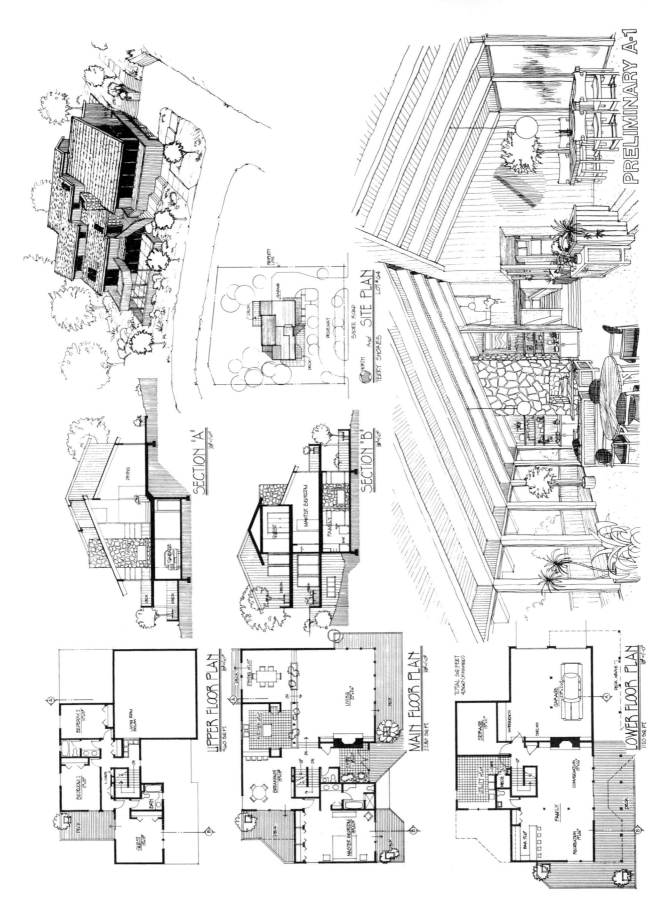

FIGURE 18.10 A presentation drawing for a new residence.

drawing should be both pleasing visually and easy to understand. For example, if the designer is using carpeting on the floor, it is often rendered in the drawing with color and texture. Or if wood flooring is being used, it is illustrated with wood color and grain (if the scale is appropriate). Furniture should also show detail, rather than merely indicating the outer edges of the piece. The arms, back, and shape of each piece are indicated where possible. A presentation drawing does not eliminate the need for a construction drawing, since the two are generated at different stages within the overall process.

Construction drawings (Figure 18.12) are graphic representations to communicate how to do the construction, remodeling, or installation of a project. These drawings include room labeling; dimensions; door, window, and fixture locations; materials; notes; and other proposed interior construction details.

FLOOR PLANS

Floor plans are used to illustrate the layout of spaces and elements, such as walls and doors, and to clarify relationships of one space to another. Floor plans are the basic reference point for most design projects and are one of the most important items presented to the client or the builder. They give a bird's-eye view of a floor level of the interiors. Floor plans have an imaginary horizontal cut made through the building walls approximately four feet (1219 mm) above the floor level, and the top of the building is then lifted away (Figure 18.13). Floor plans indicate the size and outline of a building as well as the location of the interior walls, doors, windows, fixtures, and other elements. Floor plans are drawn to scale, and furniture is often added to give a sense of scale and help define the use of each area. Labeling of spaces also assists in defining the function of the room if it is not visually apparent in the drawing. Color and textures of materials can be added to a floor plan to give it the character and spirit of the interior.

Floor plans are generally drawn to a scale of 1/8″ = 1′0″ or 1/4″ = 1′0″ (1:100 or 1:50 in the metric system); other scales can be used, depending on the size of the actual project.

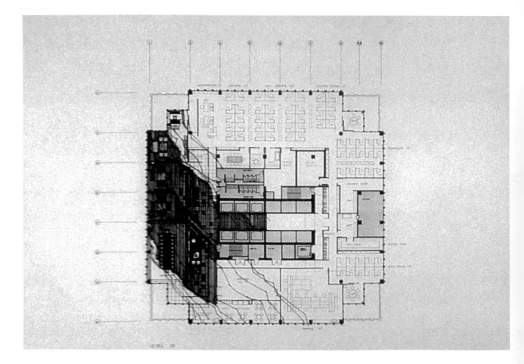

FIGURE 18.11 RIGHT **This partially colored floor plan of a proposed office is one of a series of presentation drawings by Perkins & Will.**

FIGURE 18.12 NEXT PAGE **Partial set of construction drawings for a family restaurant.**

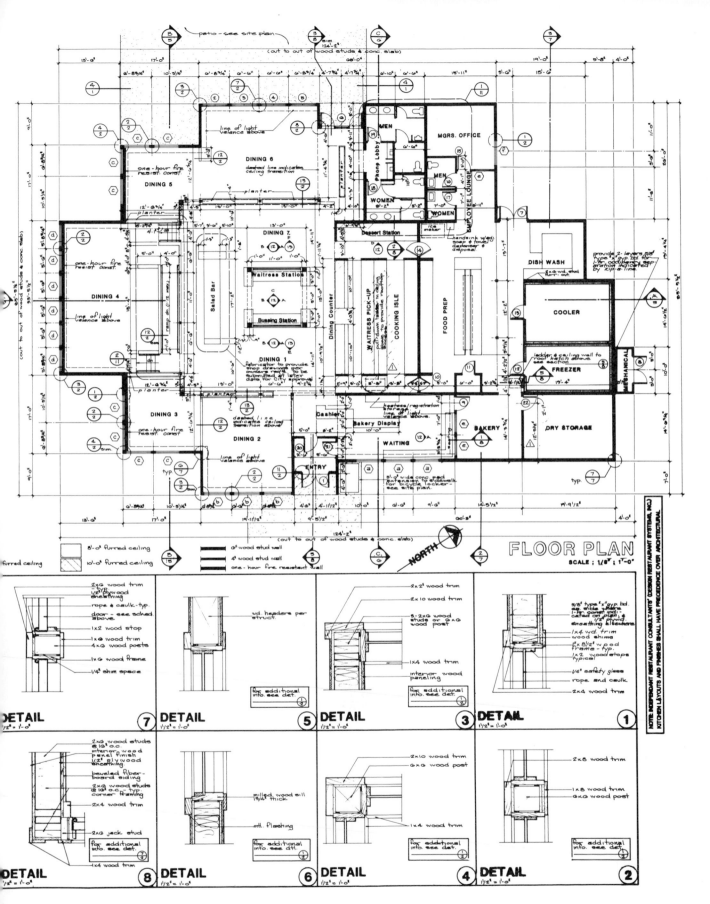

FLOOR PLAN

SCALE: 1/8" = 1'-0"

DETAIL 7
1 1/2" = 1'-0"

DETAIL 5
1 1/2" = 1'-0"

DETAIL 3
1 1/2" = 1'-0"

DETAIL 1
1 1/2" = 1'-0"

DETAIL 8
1 1/2" = 1'-0"

DETAIL 6
1 1/2" = 1'-0"

DETAIL 4
1 1/2" = 1'-0"

DETAIL 2
1 1/2" = 1'-0"

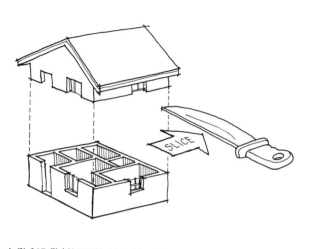

A FLOOR PLAN VIEW CAN BE IMAGINED BY SLICING
A LARGE KNIFE THROUGH THE BUILDING HORIZONTALLY
APPROXIMATELY 4 FEET (1220 MM) ABOVE THE FLOOR.

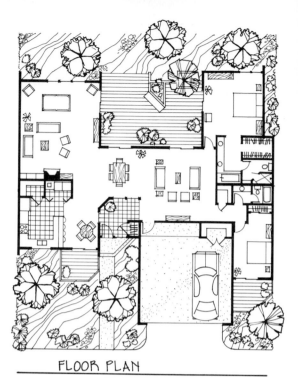

FLOOR PLAN

FIGURE 18.13 A floor plan view is created by slicing horizontally through a building.

As the metric system becomes more prevalent in the United States and for international clients, architectural scales will eventually evolve into that system. Plans are often referenced to a compass point of north or to other major geographical or building elements. Figure 18.14 shows a floor plan presented both as a presentation drawing and as a construction drawing.

SECTIONS

Sections are drawings representing a view of an object and its interior after making an imaginary vertical cut through it (Figure 18.15). This view represents what is drawn for the cross section. Sections show heights and vertical relationships between spaces, floors, and ceilings, as well as clarify certain building elements and details, such as stairs, walls, and beams. Sections can also give detailed information, such as the size of framing lumber, type of foundation, and type of interior flooring construction/materials, that is not clearly shown in other drawings.

Building cross sections show most of the important aspects of an interior; smaller cross sections (drawn at a larger scale) show details of individual portions of a building, space, or object. The designer provides as many cross sections as necessary to convey the information needed about the space/building.

Sections should ideally be cut in a straight, continuous line, using jogs in the cutting plane only when absolutely necessary. A section indicator is needed on the floor plan to show where the floor is cut and to indicate the direction of the section view. Building sections are usually drawn at 1/8″ = 1′0″ or 1/4″ = 1′0″ scale (1:100 or 1:50 metric). Large scales, such as 3/8″ = 1′0″, (1:35 metric) are usually used for detailed design sections. For large buildings and complexes, the scale might be reduced to 1/16″ = 1′0″ (1:200 metric) or smaller.

It is often a good practice when possible to include people in design sections to give a sense of human scale to the spaces. Figure 18.16 shows a building section as a presentation drawing and as a construction drawing.

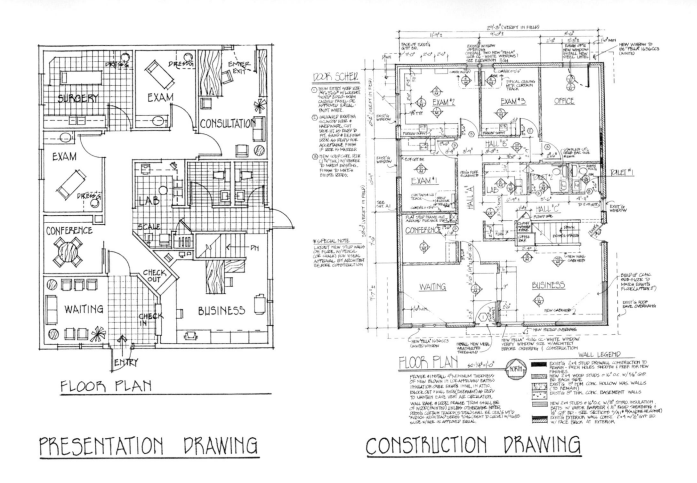

FLOOR PLAN

PRESENTATION DRAWING

CONSTRUCTION DRAWING

FIGURE 18.14 Examples of a presentation and a construction drawing.

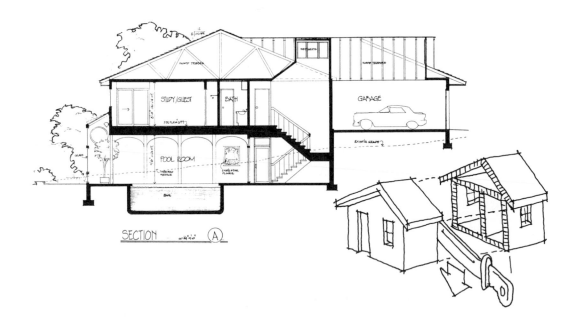

FIGURE 18.15 A section view can be imagined by slicing vertically through a building, as illustrated.

FIGURE 18.16 Examples of building section drawings.

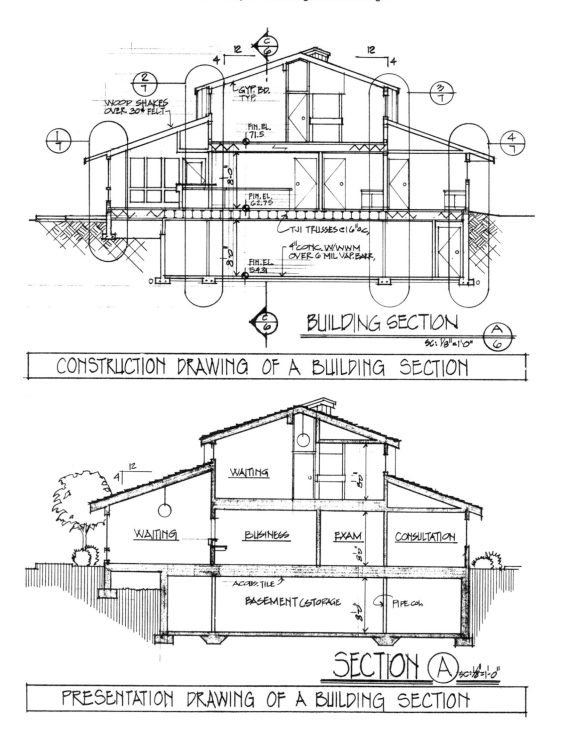

CONSTRUCTION DRAWING OF A BUILDING SECTION

PRESENTATION DRAWING OF A BUILDING SECTION

ELEVATIONS

Elevations are straight-on views of specific exterior or interior walls or of related elements, such as cabinetry. They convey a structure's form, door and window openings, materials, and texture. An elevation drawing shows no depth but does show height, width, and materials.

Interior elevations (Figure 18.17) are vertical projections of the inside walls used to indicate ceiling heights, placement, type, and size of built-in cabinetry and accessories. These

FIGURE 18.17 Interior elevations are straight-on views of a room wall and/or individual elements, such as built-in casework. Depth is not apparent in these drawings.

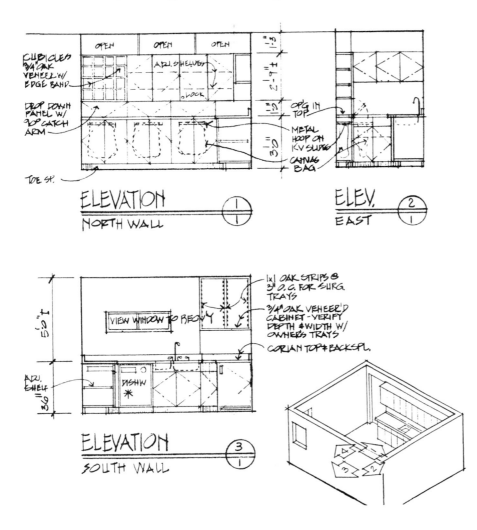

elevations might also show other special features attached to the walls, wall finishings, and other details appropriate for a particular space.

Exterior elevations (Figure 18.18) depict the roof, doors, wall finish, window style, and other elements from the outside. Exterior elevations illustrate how the structure is enclosed, that is, the external surfaces; these elevations are usually labeled according to the direction they face and are referenced to the floor plan.

Elevations used in design drawings and construction drawings can look similar. The major differences are that in design or presentation drawings, shade, shadows, and texture are often used to portray relationships and the character or form of a building (or interior).

DETAILS

Details are enlarged scale drawings of particular exterior or interior elements that need specific attention or further explanation, such as cabinets, window frames, built-in furniture, stairs, fireplaces, or even a skylight (Figure 18.19). The number of detail drawings depends on the complexity of the designs and construction materials/techniques needed. Detail drawings give exact materials; indicate dimensions, such as height, width, depth, and location; and are referenced to the other drawings.

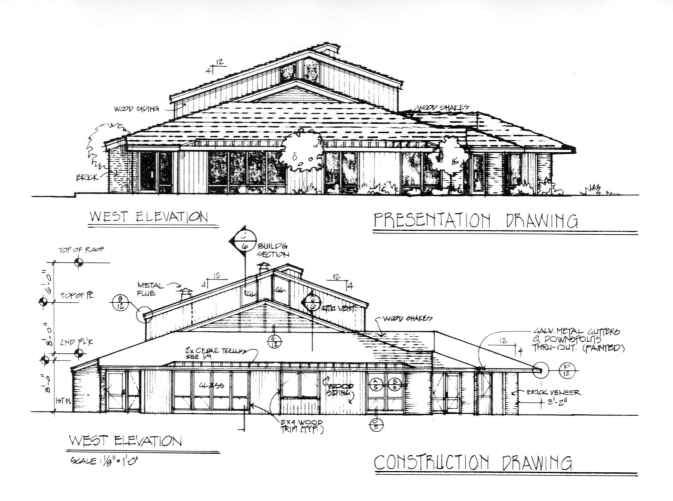

FIGURE 18.18 Elevations can be drawn as a presentation drawing or a construction drawing.

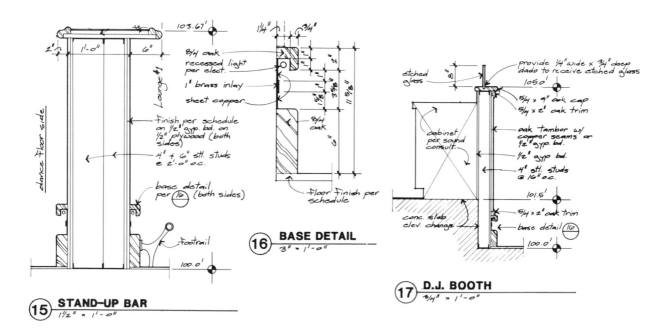

FIGURE 18.19 Example of detail drawings.

REFLECTED CEILING, LIGHTING, AND ELECTRICAL PLANS

A ceiling plan is usually drawn as if the viewer were looking down through a transparent ceiling at the floor plan. This image of the ceiling is referred to as a reflected ceiling plan and is drawn so that it has the same orientation as the floor plan (Figure 18.20). It is not reversed like a true mirror image.

The reflected ceiling plan involves a horizontal cut through the building; and is used to indicate information such as ceiling material and layout (acoustical tile panels), lighting fixtures (type, location, and switching), exposed structural members, custom ceiling treatments, heating/air-conditioning diffusers, and many other details.

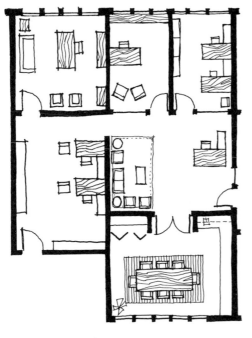

FLOOR PLAN

REFLECTED CEILING PLAN

FIGURE 18.20 A reflected ceiling plan must be oriented to the floor plan.

In a lighting plan (often drawn as a reflected ceiling plan), two common methods are used to indicate the location of the switches for a particular light fixture (Figure 18.21). One method uses an appropriate line to connect each luminaire and its switch or dimmer. In this system, a single line symbolizes the fixture connection within a single circuit. The electrical contractor or the electrical engineer will determine the actual number and size of the wires, as well as their exact physical location. The other method, used in large spaces, places a lowercase letter or number by each luminaire symbol, and that letter or number refers to a corresponding control, such as a wall switch, with the same lowercase letter or number.

A lighting schedule indicating all luminaires by type, description, wattage, lamp, manufacturer, and finishes is included with the reflected ceiling plan for easy reference.

Electrical plans are drawn as floor plans and generally indicate the location of wall or floor convenience electrical outlets. Electrical plans sometimes show the actual wiring circuit runs to the electrical panel. Other systems, such as telephone, computer, or special equipment, also are

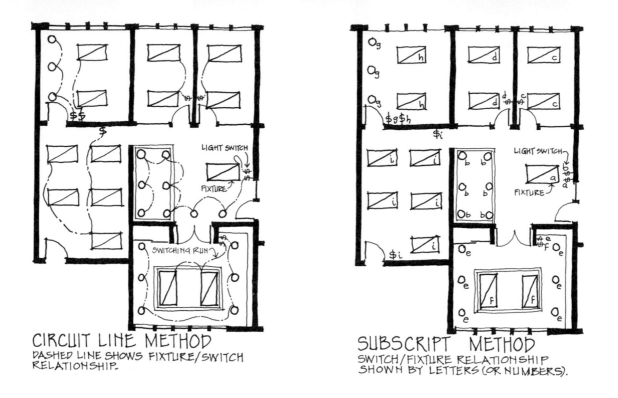

CIRCUIT LINE METHOD
DASHED LINE SHOWS FIXTURE/SWITCH
RELATIONSHIP.

SUBSCRIPT METHOD
SWITCH/FIXTURE RELATIONSHIP
SHOWN BY LETTERS (OR NUMBERS).

FIGURE 18.21 Two different drawing methods can be used for indicating the switching controls for a lighting system.

often indicated on the electrical plan. In small projects or residential construction, the lighting plan and electrical plan are often combined into one drawing or incorporated into the floor plan (Figure 18.22).

SCHEDULES

Schedules list elements important to a building or space and are usually made for doors, windows, furniture, room finishes, colors, and any other project components needing detailed clarification. Several schedules are usually required. For example, one schedule may show all the doors within a building or space, indicating their style, size, location, manufacturer, finish, and hardware (Figure 18.23), and a different schedule might do the same for windows.

Room finish schedules can be done in chart or plan view form (Figure 18.24). The chart schedule is keyed to a floor plan; the schedule includes the room name (or number) and sets up finish categories for the floors, wall bases, walls, ceilings, and miscellaneous trims. Vertical columns are established below headings that indicate types of room materials, such as vinyl, carpet, tile, wood, plaster, paint, or other finish.

A specialized finish plan in which materials are keyed directly on the plan is another way to indicate room finishes. An accompanying key indicates the type and location of the finish.

Since the format providing the information for one project may not be adequate in another situation, there are many ways to design schedules. Schedules should be clear and easy to read in order to avoid confusion or mistakes.

INSTALLATION PLANS

Installation plans are a part of the construction drawings and communicate the location of built-in or movable items, such as furniture, furnishings, or equipment. One of the most common installation plans is the furniture plan (Figure 18.25), which is often keyed to a furniture

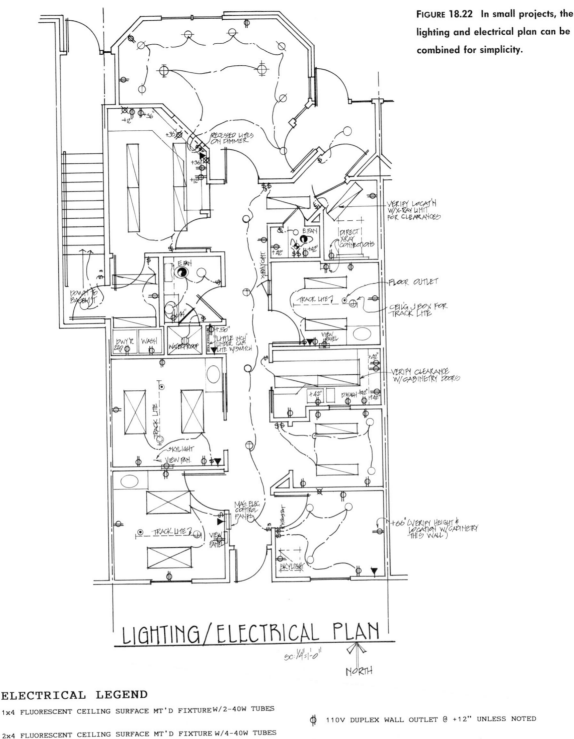

FIGURE 18.22 In small projects, the lighting and electrical plan can be combined for simplicity.

LIGHTING/ELECTRICAL PLAN

SC: 1/4"=1'-0"

NORTH

ELECTRICAL LEGEND

▭ 1x4 FLUORESCENT CEILING SURFACE MT'D FIXTURE W/2-40W TUBES

▭ 2x4 FLUORESCENT CEILING SURFACE MT'D FIXTURE W/4-40W TUBES

○ RECESSED INCADESCENT LIGHT FIXTURE-HALO H-410, 75W, R-30

⊕ SAME AS ABOVE BUT ON 24 HR. CIRCUIT-VERIFY DETAILS W/DESIGNER

KEYLESS PORCELAIN SOCKET FOR DARKROOM SAFELITE-60W

RECESSED WATERPROOF LIGHT @ SHOWER-75W

EXHAUST FAN-VENT DIRECT TO OUTSIDE FOR DARKROOM

⌀ 110V DUPLEX WALL OUTLET @ +12" UNLESS NOTED

⊙ 110V FLOOR OUTLET-VERIFY LOC. W/DESIGNER

⊠ CONDUIT FOR FUTURE COMPUTER TERMINAL-VERIFY HEIGHT W/OWNER

$ WALL MOUNTED LIGHT SWITCH

▶ TELEPHONE J BOX-VERIFY HEIGHT & LOCATION W/DESIGNER

⊖ RECESSED INCADESCENT WALL WASHER LITE-HALO- 75W, R-30

⊕ PENDANT MT'D INCADESCENT LITE FIXTURE- SELECTED BY DESIGNER

DOOR SCHEDULE

DOOR #	D'R TYPE	DOOR & OPENING				FRAME				HARDWARE	REMARKS
		WIDTH	HT.	DOOR TH'K	MAT'L	HEAD	JAMB	MAT'L	FIN.		
1	F	3'	7'	–	GL/AL	–	–	AL	AL	LOCKSET/CLOSER	
2	F	3'	7'	–	GL/AL	–	–	AL	AL	CLOSER	
3	A	3'	6'8"	1¾"	WD	3/10	3/10	WD	S/S	LATCHSET	
4	B	4'	6'8"	1¾"	WD	4/10	4/10	WD	S/S	REC. PULLS	SLID'G DR. HARDWARE
5	A	3'	6'8"	1¾"	WD	3/10	3/10	WD	S/S	LATCHSET/CLOSER	
6	A	2'8"	6'8"	1¾"	WD	3/10	3/10	WD	S/S	LATCHSET	
7	A	2'8"	6'8"	1¾"	WD	3/10	3/10	WD	S/S	LATCHSET	
8	A	3'	6'8"	1¾"	WD	3/10	3/10	WD	S/S	LATCHSET	
9	C	3'	6'8"	1¾"	WD	4/10	4/10	WD	S/S	REC. PULLS, END PULL	SLID'G DR. HARDWARE
10	A	3'	6'8"	1¾"	WD	3/10	3/10	WD	S/S	LATCHSET	PRIVACY LOCK
11	A	2'4"	6'8"	1¾"	WD	3/10	3/10	WD	S/S	LATCHSET	PRIVACY LOCK
12	A	3'	6'8"	1¾"	WD	3/10	3/10	WD	S/S	LATCHSET	
13	A	2'8"	6'8"	1¾"	WD	3/10	3/10	WD	S/S	LATCHSET	
14	A	2'8"	6'8"	1¾"	WD	3/10	3/10	WD	S/S	LATCHSET	
15	A	3'	6'8"	1¾"	WD	3/10	3/10	WD	S/S	LATCHSET/CLOSER	1-HR RATED
16	E	3'	6'8"	1¾"	STL	–	–	STL	PA	LOCKSET/CLOSER	1-HR RATED-PAINTED
17	A	2'4"	6'8"	1¾"	WD	3/10	3/10	WD	S/S	LATCHSET	PRIVACY LOCK
18	A	2'8"	6'8"	1¾"	WD	3/10	3/10	WD	S/S	LATCHSET	
19	F	3'	7'	–	GL/AL	–	–	AL	AL	LOCKSET/CLOSER	
20	F	3'	7'	–	GL/AL	–	–	AL	AL	CLOSER	

GL/AL = GLASS/ALUMINUM WD = WOOD STL = STEEL S/S = STAIN/SEAL PA = PAINT

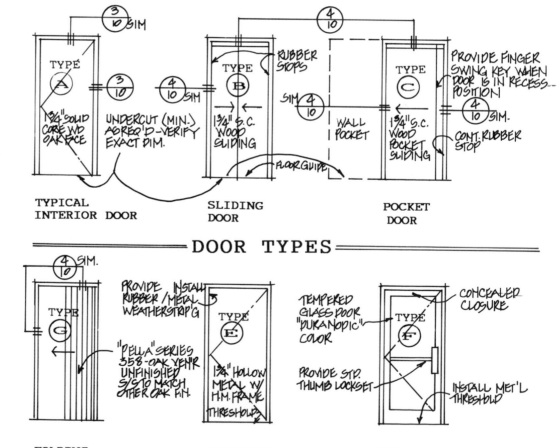

DOOR TYPES

TYPE A — 1¾" SOLID CORE WD OAK FACE — UNDERCUT (MIN.) AS REQ'D – VERIFY EXACT DIM.

TYPICAL INTERIOR DOOR

TYPE B — RUBBER STOPS — 1¾" S.C. WOOD SLIDING — FLOOR GUIDE

SLIDING DOOR

TYPE C — PROVIDE FINGER SWING KEY WHEN DOOR IS IN RECESS POSITION — WALL POCKET — 1¾" S.C. WOOD POCKET SLIDING — CONT. RUBBER STOP

POCKET DOOR

TYPE G — PROVIDE INSTALL RUBBER/METAL WEATHERSTRIP'G — "PELLA" SERIES 358-OAK VENEER UNFINISHED S/S TO MATCH OTHER OAK FIN.

FOLDING DOOR

TYPE E — 1¾" HOLLOW METAL W/ H.M. FRAME THRESHOLD

EXTERIOR DOOR

TYPE F — TEMPERED GLASS DOOR "DURANODIC" COLOR — PROVIDE STD. THUMB LOCKSET — CONCEALED CLOSURE — INSTALL MET'L THRESHOLD

EXT. GLASS DOOR

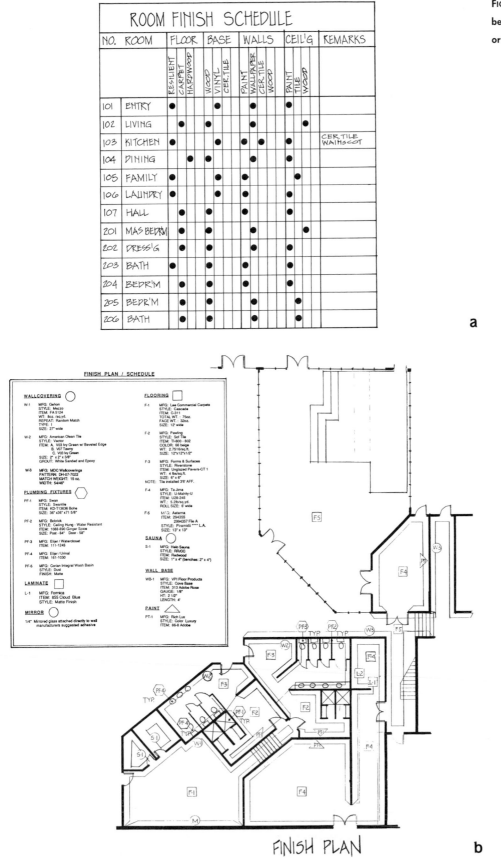

FIGURE 18.24 Finishes in a project can be specified in a chart/schedule form (a) or drawn as a finish plan (b).

FINISH PLAN

A WAITRESS STATION
scale: 1/4" = 1'-0"

B DESSERT STATION
scale: 1/4" = 1'-0"

C WAITRESS PICK-UP/COOK LINE
scale: 1/4" = 1'-0"

D FOOD PREP./COOK LINE
scale: 1/4" = 1'-0"

KITCHEN EQUIPMENT/FURNITURE SCHEDULE

#	ITEM	#	ITEM	#	ITEM
1	CUSTOM WALK-IN FREEZER	22	1 1/2 H.P. DISPOSER	43	BUSSING/SET-UPS/CONDIMENTS
2	CUSTOM WALK-IN COOLER	23	COCOA DISPENSER	44	HOT FOOD WARMER (2) (SPINACH DRESSING)
3	WALK-IN WIRE SHELVING	24	DISHWASHER	45	FIRE PROTECTION SYSTEM (ANSOL SYSTEM PER U.B.C. CH.20)
4	CUBER ICE MACHINE	25	UNDER COUNTER STORAGE CABINET	46	HOT FOOD WARMERS (2) (MUFFINS)
5	DRAIN TROUGH	26	SODA SYRUP UNDER COUNTER	47	DIPPER WELL
6	EMPLOYEE LOCKERS	27	POT & PAN CART	48	OPEN BURNERS
7	STORAGE SHELVING	28	VAPOR EXHAUST SYSTEM	49	COLD TABLE
8	SYRUP TANK AREA	29	OVER COUNTER SHELF	50	UPRIGHT REFRIGERATOR
9	DOUBLE DECK ROASTING OVEN	30	TILTING STEAM KETTLE	51	ROTARY TOASTER
10	SIX BURNER FLOOR RANGE (OVEN BELOW)	31	UNDER COUNTER FREEZER	52	MICROWAVE OVEN
11	EXHAUST HOOD (DUCTS & BLOWERS)	32	FRYER	53	HOT FOOD TABLE (4 COMPT.)
12	STAINLESS STEEL SHELF	33	SOUP CUP SHELF	54	U.C. REFRIGERATOR
13	FILLING FAUCET	34	GRIDDLE W/EGG BURNERS	55	SLICER
14	2-COMP. PREP. SINK W/DRAINBOARD INSERT	35	HOT SOUP WELLS(3) (FREE-STANDING)	56	COFFEE MAKER (3 POT BURNERS)
15	WORK TABLE W/KNIFE RACK	36	REFRIGERATED DRAWERS	57	TRASH CAN UNDER COUNTER
16	POT RACK	37	36" GRIDDLE W/GROOVES	58	BATTER INSERT
17	48" FLY FAN	38	9" LANDING AREA	59	MIXER
18	S/S WALL CORNERS	39	INSERT FOR CONDIMENTS	60	PAGING
19	CUSTOM DISH TABLES	40	SALAD PLATE SHELF	61	6-CUSTOM HEAT LAMPS (SEE ELEC.)
20	HAND WASH SINK W/SOAP & TOWEL DISPENSERS	41	WAFFLE'IRON	62	CALL LT. SYSTEM, DBL. FACED, OVERHEAD MTG.
21	PRE-RINSE UNIT	42	SALAMANDER	63	ORDER WHEEL

FIGURE 18.25 A furniture installation plan and schedule indicate where specific items will be placed.

KITCHEN EQUIPMENT/FURNITURE PLAN

scale: 1/8" = 1'-0"

NOTE: INDEPENDANT RESTAURANT CONSULTANTS' (DESIGN RESTAURANT SYSTEMS, INC.) KITCHEN LAYOUTS AND FINISHES SHALL HAVE PRECEDENCE OVER ARCHITECTURAL.

#	ITEM	#	ITEM	#	ITEM
64	(2) PRE-CHECK REGISTERS /DEDICATED LINES	85	SOUP WELL	106	CUSTOM BOOTHS
65	DESSERT STATION	86	HEATED BREAD DRAWER (3 DRAWERS)	107	(10) COUNTER CHAIRS
66	KWIPPER WHIPPED CREAM	87	ORANGE JUICE MACHINE	108	MENU RACK
67	ICE CREAM FREEZER	88	MOP CLOSET (CURB & HOSE BIB)	109	(2) PUBLIC TELEPHONES
68	ICED TEA	89	2-WAY COMMUNICATION TO COOK LINE	110	TELEPHONE
69	COFFEE MACHINE (5 POT BURNERS)	90	BAKER'S OVEN	111	CIGARETTE DISPENSER
70	COFFEE MAKER	91	PROOFER	112	TAKE-OUT COUNTER
71	MILKSHAKE MACHINE	92	(not used)	113	BAKERY CASE
72	CASHIER STAND	93	(not used)	114	COUNTER/CABINET
73	CASH REGISTER /DEDICATED LINE	94	(not used)	115	PLANTER
74	SOUP & SALAD BAR	95	(not used)		
75	BEER(1) / WINE(2) DISPENSER HEADS	96	(not used)		
76	ICE & WATER UNIT	97	(not used)		
77	GLASS RACK/COFFEE MUG RACK	98	(not used)		
78	4 FT. SOFT DRINK DISPENSER W/ICE MAKER	99	(not used)		
79	MILK DISPENSER	100	36" x 36" DINING TABLE		
80	SINK	101	30" x 48" DINING TABLE		
81	REMOTE DRAFT BEER/WINE SYSTEM	102	30" x 30" DINING TABLE		
82	CENTRAL VACUUM SYSTEM	103	30" x 24" DINING TABLE		
83	BULLETIN BOARDS	104	72" DIAMETER DINING TABLE		
84	UNDER COUNTER STORAGE	105	BENCH SEAT W/BACK		

schedule or specifications. The plan indicates exactly the unit to be positioned, its orientation, and possibly its alignment with electrical or communication systems. Other installation plans might include window treatments, electronic equipment, lamps, cabinetry, appliances, and other items that require directives for proper placement.

Three-Dimensional Drawings

The visuals discussed to this point are two-dimensional; that is, they illustrate space and elements in a flat view. For example, the floor plan usually shows the length and width of everything within a space. An elevation or section is then needed to illustrate height, but no third dimension or true depth is visually indicated. For this information, the designer creates a series of multiviews, called orthographic drawings (Figure 18.26), that depict reality through a group of related views.

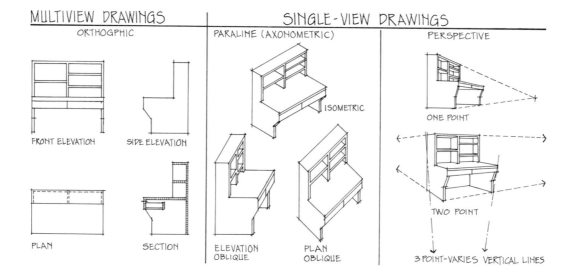

FIGURE 18.26 Examples of single-view and multiview drawings.

However, a single-view drawing can portray all three dimensions of form simultaneously and illustrate the relationships of space, objects, and materials in a more realistic or photographic manner. The two major types of single-view drawings are paraline drawings and perspective drawings. In paraline drawings the parallel lines remain parallel, but they converge to vanishing points in perspectives.

PARALINE DRAWINGS
Paraline drawings are categorized according to the axonometric and oblique methods of projection used to develop them. Some designers commonly refer to paraline as axonometric drawings; however, axonometric drawings include the isometric, diametric, and trimetric. Oblique drawings include the transoblique and the general oblique. The two most common types of paraline drawings used in interiors and architecture are the isometric and the oblique. Paralines are generally easier and faster to construct than perspectives, which makes paralines useful for quickly illustrating three-dimensional ideas, especially in the early stages of the design.

ISOMETRIC DRAWINGS. Isometric drawings (derived from the Greek words meaning equal measure) are based on 30-degree angles; their three principal axes of measure-

ment are two ground-plan axes and a vertical axis for height (Figure 18.27). These three axes collectively define the three edges of a basic isometric cube. Both ground-plan axes tilt 30 degrees above the horizontal plane line in an isometric drawing, and the height axis is a vertical line measuring true height.

The major pictorial defect of an isometric drawing is the visual distortion caused by parallel lines not appearing to converge at a point as they recede into the "distance." Isometric drawings are effective as a communication tool to depict single objects, such as furniture, and whole interior spaces.

FIGURE 18.27 This registration desk section is drawn as an isometric to help explain some of the materials and construction details.

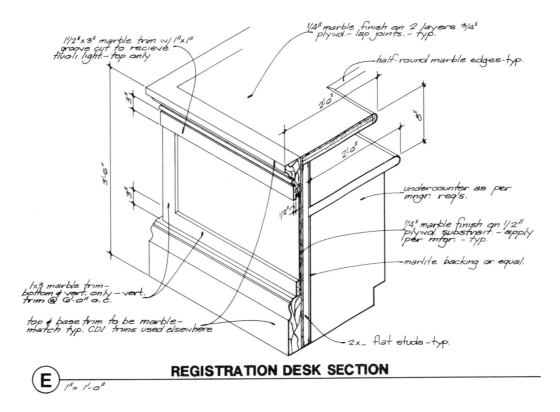

REGISTRATION DESK SECTION

E $1'' = 1'-0''$

OBLIQUE DRAWINGS. Oblique drawings can be categorized into plan obliques and elevation obliques. Oblique drawings consist of 90-degree angles between two adjacent planes or walls. Plan obliques are projected from the plan view of a building or space in which the objects retain their true size and shape (Figure 18.28). The advantage of an oblique drawing is that a building floor plan or elevation can be used directly to construct this type of paraline, whereas an isometric cannot use the plan or elevation directly. The plan is usually tilted at an angle, and height lines are drawn as verticals at true or proportional scales. Plan obliques are usually drawn at two 45-degree angles or at 30- and 60-degree angles.

Elevation obliques present the building or spaces in their true size and shape, which permits oblique paralines to be constructed directly from elevation views. Receding lines are generally drawn at 30-, 45-, or 60-degree angles to the elevation, and depths are measured along these receding lines. Oblique paralines are generally more effective when utilized for entire environments rather than for single objects.

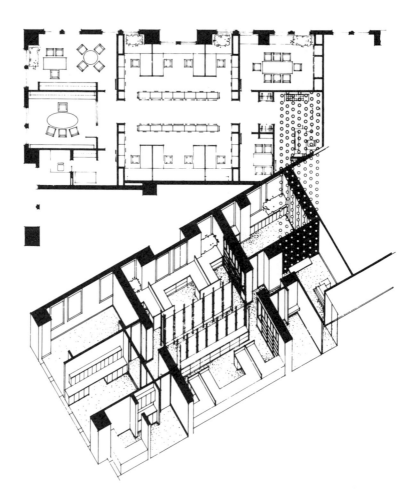

PERSPECTIVE DRAWINGS

Perspectives are one of the most realistic types of representational design drawings used in architectural and interior graphics. They are a popular method of illustrating a three-dimensional space on a two-dimensional plane (Figure 18.29). A perspective, like a paraline drawing, is a single-view drawing; however, the perspective drawing can eliminate the optical distortion caused by lines drawn parallel. The perspective is a more realistic view since it represents the reality of form in three dimensions, as we see it with our eyes.

Architects and interior designers frequently use perspectives both as design exploration sketches and as design presentation tools. Quick, freehand sketches can help to anticipate the essence or character of a space, that is, its form, scale, light, patterns, and textural qualities. For a presentation, perspectives are more precisely constructed and carefully rendered to depict the structure and its environment as realistically as possible. A perspective is carefully composed and often includes people, vegetation, furniture, textures, and accessories for animation. It is important to make the image believable and representative of the way a space will actually appear.

Architectural and interior designers utilize three basic types of perspectives—one-point, two-point, and three-point. The difference depends on the observer's point of view and the orientation of the object or space being seen.

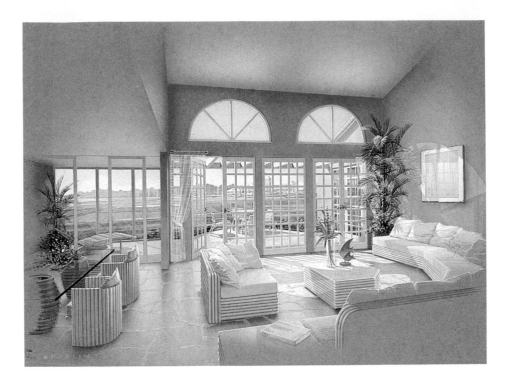

FIGURE 18.29 An interior perspective of a one-story condominium rendered in opaque watercolor with an airbrush technique.

ONE-POINT PERSPECTIVE. One-point perspective (Figure 18.30) involves drawing a line three ways—vertically; horizontally (always parallel to the ground line); and in perspective (converging to one point). In interiors, one-point perspectives usually illustrate three walls of a space. They are relatively easy to construct but can result in dull and static views if not composed properly.

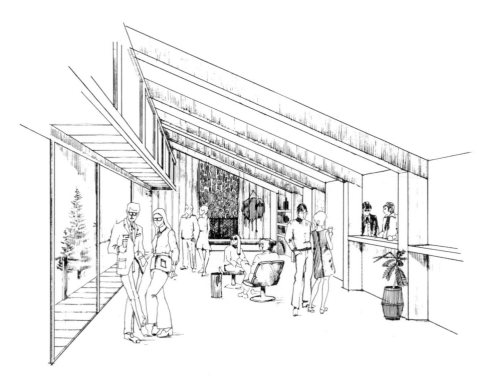

FIGURE 18.30 In a one-point perspective, lines depicting depth converge to one common vanishing point.

TWO-POINT PERSPECTIVE. Two-point perspective (Figure 18.31) involves two kinds of lines—vertical lines and perspective lines that converge at two different vanishing points. Both vanishing points are located on the same horizon line, and all vertical lines are parallel. A two-point perspective tends to present more dynamic illustrations than a one point, since the two point portrays a more natural view for the observer. Two-point perspective is a good way to illustrate a corner of a space or the relationship between two walls or planes.

THREE-POINT PERSPECTIVE. Three-point perspectives have three major vanishing points, and all lines converge at these points. These perspectives are similar to two-point perspectives except that in the three point the vertical lines are not parallel but, rather, converge at the third vanishing point. Three-point perspectives are generally used to illustrate exterior views of tall buildings or objects where the eye sees things vanishing to three points. In interior design, three-point perspective is effective in illustrating tall vertical spaces, such as multistory atriums.

The designer constructs perspectives utilizing plan projection methods and other perspective theories to build the view and rendering line by line. Through practice and computer-generated base drawings, the designer begins to rely more on the eye than on systematic, and often time-consuming, perspective construction. These factors allow the designer to make better use of time and money, spending them on design and communication instead of on drawing.

Shortcuts in preparing renderings can be taken to create effective drawings in a minimum amount of time. The designer might use commercially available perspective chart systems or

FIGURE 18.31 Two-point perspectives are drawn with two vanishing points.

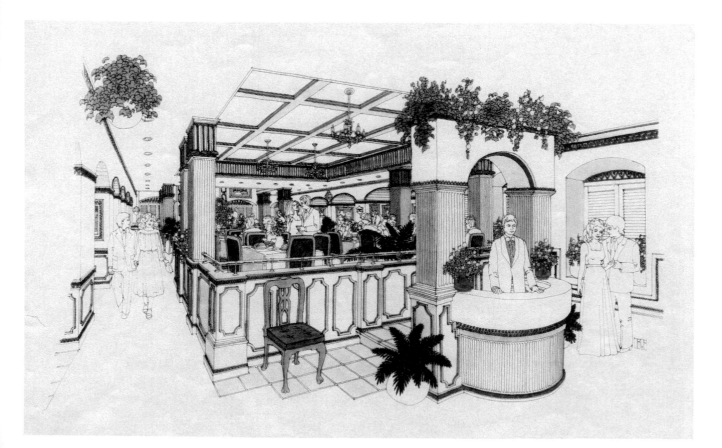

computer layouts that are correctly calculated for particular viewpoints. The designer then overlays these with a transparent sheet of paper and executes the perspective rendering over them. Computers can also create effective rendered perspectives from any view the designer chooses and can be shown as a presentation drawing to the client.

PHOTOGRAPHY AS DESIGN COMMUNICATION

The Renaissance period saw the development of systematic perspective systems that enabled draftpersons to create realistic pictures. Further scientific exploration led to the development of the camera and photography as we know them today. Almost every interior and/or architectural firm has a camera, slide projector, or video unit that is as indispensable a design communication tool as drawing equipment is.

Photographs and Slides

Photography has many applications in interior design. The camera can be used for taking photos (of printed reproductions) of furniture or equipment to be used on presentation boards. It is also used as a design communication tool for photographing existing spaces, elements, furniture, and models. The camera can also be used for slide presentations, shortcuts in preparing renderings, and recording design presentations or finished projects.

Photography has been combined with the printing and electronic industries into office machines such as the photocopier and facsimile (fax). Almost every business, school, and library, and many other institutions, use these devices daily to conduct their work. These machines not only instantly copy words and pictures but can enlarge, reduce, print, transmit, and receive them in color. Designers use these machines in their communications to produce and transmit multiple copies of reports, budgets, charts, plans, and other drawings. The machines are also effective in creating or revising design drawings by cut-and-paste techniques—often saving the designer countless hours.

An effective photographic medium for design communication is the use of slides projected onto a screen for viewing. There is a sense of theatricality about slide presentations—a darkened room, stage center (the slides and narrator), and a sense of planned "show." This type of presentation shows the client what the designer envisions. The slide show enables the designer to combine many mediums and communication techniques to explain proposals. He or she can choreograph photos of models, written words, architectural drawings, charts, spoken words, realistic pictures, or anything else that can be photographed to help explain the design concepts to the client and can use a dash of professional showmanship in doing so.

The designer must design the presentation, not just show a series of pictures, because the best slide visuals can be destroyed by poor preparation and delivery. A technique for assisting in planning and organizing a presentation is the storyboard—developed and used for years by the movie and television industries (Figure 7.19). The storyboard can be a series of drawings or cards

that indicate roughly what each slide will show, what is to be said about each, and the sequence of the entire presentation.

The designer who becomes proficient with slide projection equipment can add more sophisticated techniques to the presentation. However, visual effects that are too extravagant might distract from the actual design proposals and overshadow the designer's professional expertise. Unexpected equipment failure could also cause some communication problems and drastically affect the presentation.

Videos

Video cameras and projection systems are convenient for recording existing conditions in a project, presenting proposals, or serving as a public relations "brochure" for a design firm. Computer-generated images can be recorded onto a videotape to make a convincing "walk" through a space or show other multiple time images in a convincing sequence.

The designer might consider hiring a professional video production consultant for a high-quality video production, which, however, can be time-consuming, and expensive.

MODELS AS DESIGN COMMUNICATION

An effective way of communicating design ideas is to build a three-dimensional scale model of a proposed project. Clients can clearly see what the designer has in mind with regard to spatial configurations, sequential spaces, objects and scale. Color, materials, finishes, and furniture proposals can also be included. Unlike two-dimensional drawings, a model shows the client what is happening in all dimensions of the project. As the client moves around the model, he or she can see the relationship of the parts, whereas it would take a series of drawings to explain all these various features. A client does not need a background of visual training to understand a model, since most of the important features can be shown in a realistic manner.

Design models have been constructed since early civilizations to serve as a guide for developing or explaining ideas. Today, the aircraft, automobile, industrial design, and space industries construct miniature or full-size models as testing vehicles or for presentation purposes. The sophistication of these models has progressed over the years to include actual working models with moving parts and electronic circuitry.

Architects and interior designers build models of their proposed ideas to study their designs or present ideas to their clients. Models are used for various purposes and are constructed as conceptual models, study models, and presentation models.

Conceptual Models

After the design drawings are executed (or, sometimes, during their preparation), a rough or conceptual model (Figure 18.32) is constructed to aid the designer in studying the

FIGURE 18.32 This conceptual model of a residence shows no detail, just massing of forms. Glazed areas are simply left open.

physical relationships of ideas about mass, space, scale, and arrangement. The model might never be shown to the client.

The conceptual model, sometimes called a mass model, is usually simple in materials and construction and is void of detail. It may not even show building openings, such as doors and windows. Such a model is built of clay, wood, cardboard, heavy paper, or foam-core board and glued or taped together. A conceptual model can also be used to study various stages of construction or can be modified to become a finished model. This working model is rough, simple, and flexible for possible reconstructing as a key.

Study Models

The study model is a refinement of the conceptual model. It is used for more accurate representation of scaled detail or other physical elements, such as building openings and perhaps color. This model (Figure 18.33) is usually crafted more precisely than the rough model and may be used in presentations to the client.

FIGURE 18.33 In this "study model" for an employee cafeteria, seating is indicated with map pins and elements are shaped with simple blocks of foamcore board.

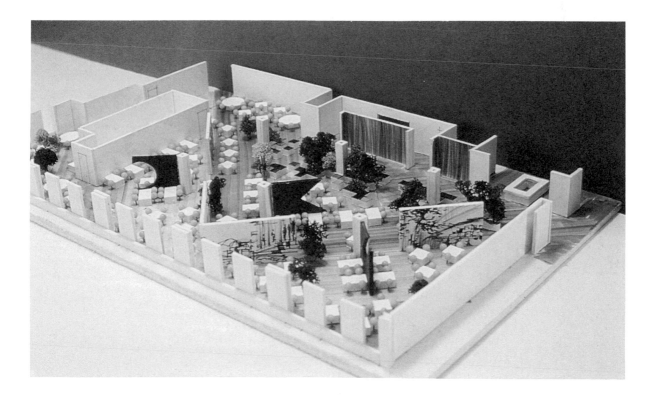

Presentation Models

A presentation, or finished, model (Figure 18.34) is a realistic, scaled representation of the completed project. It accurately portrays the designs through scale, materials, color, detail, and spatial and structural elements. The model is carefully crafted to show the client as nearly as possible what the final design solution will look like. Much time and money are put into these models; often they are encased in protective clear plastic.

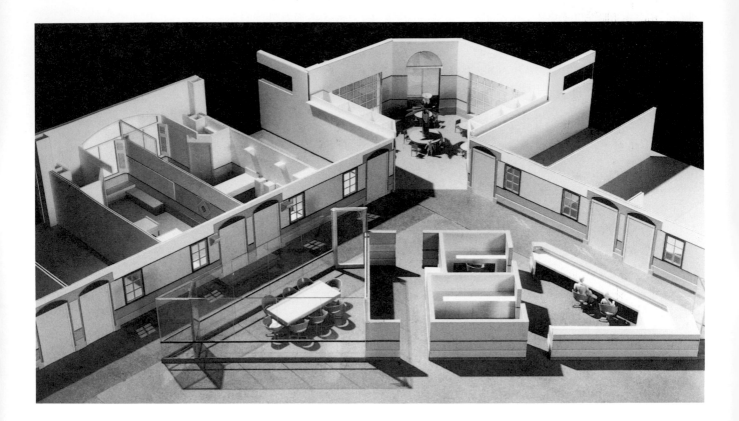

Building the Model

A designer should consider what is being communicated and the extent of realism and detail needed to convey the ideas. These decisions dictate whether to build a conceptual, study, or presentation model. Then the designer decides whether to construct the model or hire a professional model builder. Important factors to consider are the amount of time needed for construction and the monetary budget to build the model; it may be better not to construct a model than to have a half-finished model or one of poor craftsmanship.

SCALE AND MATERIALS OF THE MODEL

Choosing the scale and materials of a model is dependent on the size of the actual project and the resulting finished size of the model. The scale should be appropriate to show what is necessary to the client and should be conducive to using available model materials. The scale should have a convenient relationship to other design drawings; time can be saved if plans, elevations, and sections do not have to be converted to the model's special scale. Materials used to build scaled models are often simulated. For example, real carpet has too large a scaled texture to be convincing in a model; substitutions of felt or colored sandpaper are more in scale for a model's carpet.

SPECIAL MODELS

Sometimes a designer needs to demonstrate a particular feature in the designs that may not be possible to show in the above-mentioned three types of models. For instance, the design-

er's lighting proposal may have included both natural and artificial light sources. A special lighting model could be constructed that shows the client how natural light enters the space, illuminates the proper areas, and is augmented by artificial light. Other special models might include a full-size furniture mock-up that has moving parts or a scaled model of an audiovisual room that demonstrates visual angles for viewing projections.

Categories of model types are not clear-cut niches that encompass specific models. The categories often overlap; what began as a conceptual study model may be added to and further refined into a full presentation model.

MATERIALS, TECHNIQUES, AND REPRODUCTION

The interior designer employs a number of materials, techniques, and reproduction methods. These range from quick sketches using felt-tip markers on tracing paper to computerized drafting techniques on plastic sheets called Mylar.

Drawing Papers and Boards

A variety of papers are used for drawing and range from rolled transparent tracing paper (called bumwad, yellow trace, flimsy, canary, tissue, and other names) to more expensive rag paper, vellum, and plastic sheets. The flimsy papers are used for quick sketches and rapid development of ideas through creating a series of overlays and exploring with pencil or pen. As ideas are refined, better papers that can take more erasures and provide a better tooth for drawing with various mediums are used. Although ink drawings on paper can be erased, the designer instead may select a plastic Mylar for best line control, ease of changes, clarity of reproduction, and permanent record keeping.

Many cardboards also called boards, are used in interior design as a presentation medium, as mat framing for drawings, and for model building. Simple chipboard is effectively used for models and as a cutting surface. More expensive and colored cardboards are used for design presentations and detailed models. Drawings are also mounted on these or cut into windows for highlighting. An alternative to the cardboards is foam-core board, which is made in several thicknesses and consists of plasticized or kraft paper faces over a polystyrene foam center. Foam core is used for simple study models and for mounting drawings or manufacturers' samples.

Drawing and Lettering Aids

Plastic drawing templates are available that make quick work of drawing common or repetitive objects in plan or elevation. Templates are made for furniture, equipment doors, geometric shapes, plants, stairs, and so forth. Many of these are available from various manufacturers specifically for their products.

Although much of the lettering executed on drawings is hand done, many alternatives are available to the designer. In addition to using templates, the designer can use the Leroy and Rapidiograph processes for semihand-done lettering. Technology has also produced various forms of electronic and photographic lettering that can save time. Machines are now made that allow the designer to type directly onto a drawing or onto adhesive strips that are then secured to a drawing. A variety of transfer lettering, patterns, and symbols are also preprinted onto sticky-back sheets that can be pressed or rubbed onto drawings.

Blueprints and Photographic Reproduction

Copies of drawings can be made by the blueprint process. This terminology originated long ago for a light-sensitive paper that produced a copy of a drawing as white lines on a blue background. Today, the diazo process has replaced the old method, but the name still remains. The diazo process uses a transparent original that is placed over a chemically active paper, exposed to light, and run through a developer to bring out dark lines on a white background. Other diazo colors are available, such as blacklines, brownlines, and reproducible sepias or Mylars. Methods other than the diazo print include the photomechanical transfer (PMT) process. This photographic technique produces no permanent negative, since the image is transferred directly to a master positive sheet.

Reprodrafting or photoreproduction processes use a variety of camera techniques to produce drawings through a series of pasteups (composite drafting) and overlay drafting, then photograph these as a new master sheet. Overlay drafting uses a system of registration marks and overlay sheets on a base sheet similar to the printing industry. Pin registration bars are used to keep the sheets accurately aligned for photographing into a composite drawing. Photodrafting uses a photograph as the base sheet and adds other information to this. For example, a historic building is photographed and the image is transferred to a matte-surfaced film, then details and other notes are drawn directly over the image to convey the information required to do the work.

ORAL AND WRITTEN COMMUNICATION

Oral Dialogue

Oral dialogue between the designer and the client is perhaps the most common and basic form of design communication. Oral language is used to augment forms of visual presentations. When the visual mediums are not completely effective for translating ideas or the client is having difficulty in understanding the designer's concepts, dialogue between the parties is of immense help. It also allows immediate response and is often the only direct feedback from the client.

A good relationship between the designer and the client is the basic premise of effective dialogue. The two should try to understand one another's viewpoints, be considerate of any differences, and, above all, keep an open line of communication and strong rapport. Therefore, it

is suggested that the aspiring interior designer should at some time take coursework in speech and communication skills.

Oral presentations demand a sense of professionalism, along with an awareness of the client's expectations. The designer should be enthusiastic about the project and responsive to the client's questions. Humor and candidness can prevent a presentation from becoming boring, but the approach must still be professional. Before the presentation, the designer should outline what he or she wants to say and should make written or mental notes. The designer should plan the sequence of what is to be presented and determine what oral descriptions are needed. The oral presentation should begin with the overall concept, or theme, of the project and continue to explain why something was done, keeping the client's needs in mind.

The designer should not just present information but should also ask for questions and responses from the client since most clients feel the need to be involved in the presentation. The designer should be distinct and specific about the points he or she wishes to impress on the client. Talks should neither be too long nor give the impression that the presentation is an inflexible speech. The designer should be responsive and allow comments to vary from the planned outline if the client needs further discussion on a certain point. It is then the designer's responsibility to skillfully guide the presentation back to his or her control without offending the client. No oral presentations are alike because of the two-way nature of communication, but the designer should ultimately control the sequence and direction.

Written Communication

The written word is a powerful and effective means of communication in design. Designers are often faced with the problem of sifting through, analyzing, and organizing staggering amounts of information from the client. To achieve clear communication among all those involved in a design situation, the designer collects all the input data, documents them, and carefully organizes those facts into an appropriate format, such as a program (see Chapter 7). The material is usually presented in written and graphic form for the client to review. This procedure enables the designer and the client to have a clear understanding of the entire design proposal in both written and graphic form. Programs are communication tools for recording client needs and expectations and ensuring that these parameters are met before construction of the project begins.

Many design firms prepare and design their own programs or reports in a brochure format, utilizing written information and graphics to convey concepts (Figure 18.35). The documents are photocopied in multiples and supplied to concerned parties who may share some responsibility for the project. Many programs/brochures are very sophisticated in their makeup and are often prepared by a handful of the design staff; in large firms, a few designers may be involved only in this area on all the firm's projects.

Other forms of written communication are budgets, specifications, and purchase orders (see Chapter 19). Added to this list might be letters of transmittal, letters of agreement, work orders, contracts, and other legal documents. These forms are specialized documents that can be commercially printed, then used by the designer to communicate with the various parties throughout the project.

One of the prime written communication devices the designer might use during design and construction is the letter. A letter should be composed with a sense of organization and composition and a clear understanding of what is being communicated.

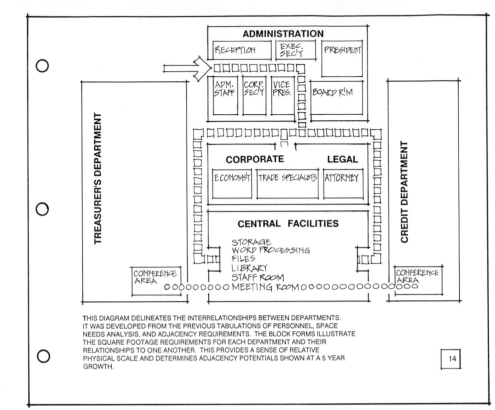

THIS DIAGRAM DELINEATES THE INTERRELATIONSHIPS BETWEEN DEPARTMENTS. IT WAS DEVELOPED FROM THE PREVIOUS TABULATIONS OF PERSONNEL, SPACE NEEDS ANALYSIS, AND ADJACENCY REQUIREMENTS. THE BLOCK FORMS ILLUSTRATE THE SQUARE FOOTAGE REQUIREMENTS FOR EACH DEPARTMENT AND THEIR RELATIONSHIPS TO ONE ANOTHER. THIS PROVIDES A SENSE OF RELATIVE PHYSICAL SCALE AND DETERMINES ADJACENCY POTENTIALS SHOWN AT A 5 YEAR GROWTH.

FIGURE 18.35 Example of a page from a written/graphical program.

EXPERIMENTAL TECHNIQUES

Three-Dimensional Photography

Years ago, a popular form of parlor entertainment involved the hand-held stereoscope that produced realistic three-dimensional (3-D) photographic images when viewed through the eyepieces. Modern examples of 3-D photography can be seen in the Viewmaster manufactured for children's markets. Photographs of exterior scenes and interior settings have a convincing depth of field when viewed through this device.

Although little 3-D photography or drawing is used in the field of interior design because of the cost and time-consuming setup, either can be a very effective visual aid for design communication. It is worth considering these mediums as potential aids to communicate spatial relationships in interior spaces.

Holography

Holography is a photographic process involving a laser beam as the light source to produce a hologram, a three-dimensional representation of a given object or space. For design

communication purposes, perhaps the holographic image is the best pictorial alternative to having the actual object or space present.

The hologram is made by exposing a special photographic film plate to laser light that has been reflected from the real object. When this negative or slide is projected by the same laser beam that created it, it presents an image possessing almost all the physical qualities of the object and, perhaps most important, accurate perspective views of sides, top, and bottom. As an example, when the holographic technique is used to photograph and then project a simple object such as a teacup, the observer can actually view several sides of the cup using one single image, that is, the same slide. In addition to these views, the observer is also able to peer over the rim of the cup in the same projected image and examine some of its interior.

Although there is no attempt here to discuss the physics of this remarkable medium, it is worthwhile to speculate on how the design field might in the future apply laser holography as a visual presentation and communication device.

This medium can offer a new way of communicating three-dimensional objects and spaces when the real phenomena to be presented or studied are too large, fragile, expensive, or inaccessible to transport and display. The hologram could make three-dimensional objects accessible to the designer and the client in a manner that permits communication aspects never before possible with projected images.

The field of holography in some sense is still in its infancy, yet holography is no longer merely a scientific curiosity. Three-dimensional computer-generated holograms will eventually pave the way for drawing 3-D pictures of everything from complex molecules to skyscrapers—almost as fast as details can be fed into the computer.

COMPUTERS IN INTERIOR DESIGN

Computer technology in interior design offices has created exciting aids in design, drafting, accounting, word processing, and other uses. Great strides are being made in using computers and electronics in our everyday life and will continue as well to impact the design profession.

Computer hardware (machines) and software (programs) are constantly becoming more sophisticated, smaller, and less expensive. The designer does not even need to own such equipment; access is readily available through various communication networks, such as telephone lines, satellite linkages, and television systems. Picking up the telephone can put the designer in touch with, and in control of, computers to perform various activities without leaving the office or home. Individuals can hook into time-sharing terminals or be billed for programming time from specialized companies that offer these services.

Manufacturers are beginning to offer more computer aids directly to the design profession to assist in specifying products for interior projects. As computer technology advances, costs will come down, software will become more user friendly, and more design firms will replace much of their conventional drawing equipment.

Computer-Aided Design and Drafting

Two innovations in computer technology that have had significant impact on interior

design practice are computer-aided design (CAD) and computer-aided design and drafting (CADD). Programs for these operations can produce simple line drawings or complex, three-dimensional colored renderings. As the designer becomes more proficient at working with CAD and CADD, he or she can generate more sophisticated drawings and exploration of spatial concepts at a quicker pace, saving both time and money for the client and the designer.

Many interior and architectural firms utilize computers to produce design drawings, renderings, and construction/installation drawings for communication to their clients (Figure 18.36). Information and designs are placed on video terminals to work out and present ideas for the projects. The equipment can generate plans, elevations, sections, and perspectives of proposed interior spaces and components. Stored data, such as furniture, finishes, and line-by-line budget items, can be instantly called up while designing. Sophisticated computer-aided drawing in interior space planning can present a very effective three-dimensional view of a space that is immediately displayed from any fixed or moving point of view (Figure 18.37). The operator can quickly move objects about in the space. The computer images can be printed out on plotters (automated drafting machines) in multiple ink colors and line widths.

Eventually, perhaps all drawings and written information the interior designer prepares will not be placed on paper but instead will be electronically transmitted from a video screen directly to the client's video module. At the same time, it might be transmitted to a contractor's computer for instant pricing and to an engineer's module for verifying environmental support systems needed. The interior designer could be on the beach in Hawaii (complete with a briefcase computer), hooked up by satellite link with the client's electronic module in a New York home, both discussing the visuals in a teleconferencing meeting with a banker in Alaska. Face-to-face business communication may eventually be replaced by the electronic mediums of the future, but despite this technological wizardry, we will still have the basic human need for personal contact with other human beings.

FIGURE 18.36 ModelView is Intergraph Corporation's software for photographically rendering computer models. The Pixie interface to ModelView, shown in this image, allows the user to test a variety of colors, patterns, and textures on any interior or exterior surface, including furniture, walls, and floors. Simple movements of a mouse allow the user to map these surfaces. The software provides many textures, and the user can scan in others of his choice to customize an interior.

Data Bases and Spreadsheets

Software programs of data bases and spreadsheets store, organize, and retrieve groups of information (data) in a variety of ways. These files can include such information as every client's name and address for information gathering or mailing labels. Data bases can manage and track budget estimates, inventory furniture, estimate fees, project costs and square footage comparisons, and disseminate manufacturers' product information.

Word Processing

Word processing uses a keyboard and cathode-ray tube (CRT) screen for flexibility in composing and writing. Changes and additions can easily be made to correspondence, reports, documents, contracts, purchase orders, and specifications. Word processing programs can store large amounts of information, do spelling checks, print out multiple copies, or do mail-merge. The latter process adds personalized features to a base document for mailing purposes. Software merging graphics and text on the same page (called desktop publishing) can be used to produce high-quality brochures, reports, newsletters, press releases, and other documents that were formerly prepared only by using outside printing firms.

FIGURE 18.37 Designers proposing to adapt a conference room for video teleconferencing created this image to test scenarios for design and lighting.

PUTTING THE PRESENTATION TOGETHER

Design communication takes place in a presentation in which the designer is giving, showing, or presenting ideas, information, and proposals to a client. The designer might be trying to persuade a potential client to select his or her firm to do a project or might be presenting design ideas to a client for approval. The first instance usually involves a portfolio of the designer's past works, whereas the latter is a presentation of new ideas to be carried out. The format, mediums, and elaborateness of the designer's presentation can be similar in each case or can vary greatly according to the type of communication selected. There are no rules, since the types of presentations, elaborateness, and costs vary not only from project to project, but also from the presentation procedures established by a particular design firm.

Some designers have access to complex audiovisual presentation rooms for impressive, theatrical formats, and others show just a pencil sketch while sitting in the client's office. Presentations can be categorized as formal or informal, depending on each situation. Experience, the working relationship with a client, and design judgment dictate the form and content of the presentation. Design presentations often vary according to what mediums are currently popular. Interior designers and architects have shifted several times in past years from carefully inked, delineated drawings and elaborate, time-consuming presentation formats to quick-sketch techniques and informal presentations. No doubt, these trends will shift again, following current design movements in the profession and in schools of design.

Presentations should always convey a sense of honesty about what is being proposed, not "sell" the client a bad or inappropriate solution. The designer should not use elaborate, beautiful presentations to hide weak or poor design work.

REFERENCES FOR FURTHER READING

Ching, Frank. *Architectural Graphics.* New York: Van Nostrand Reinhold Co., 1975.

Diekman, Norman, and John Pile. *Drawing Interior Architecture.* New York: Whitney Library of Design, 1983.

Doyle, Michael, *Color Drawing.* New York: Van Nostrand Reinhold Co., 1980.

Gebhard, David, and Deborah Nevins. *200 Years of American Drawing.* New York: Whitney Library of Design, 1977.

Hanks, Kurt, and Larry Belliston. *Design Yourself!* Los Altos, Calif.: William Kaufmann, Inc., 1977.

Lin, Mike W. *Architectural Rendering Techniques.* New York: Van Nostrand Reinhold, 1985.

Lockard, William. *Design Drawing.* Tucson, Ariz. Pepper Publishing, 1982.

Ratensky, Alexander. *Drawing and Model Making.* New York: Whitney Library of Design, 1983.

Rochon, Richard. *Color in Architectural Illustration.* New York: Van Nostrand Reinhold, 1989.

Staebler, Wendy W. *Architectural Detailing in Contract Interiors.* New York: Whitney Library of Design, 1988.

Tate, Allen. *The Making of Interiors: An Introduction.* New York: Harper & Row, 1987.

Wakita, Osamu, and Richard M. Linde. *The Professional Handbook of Architectural Working Drawings.* New York: Wiley, 1984.

Walker, Theodore. *Plan Graphics.* West Lafayette, Indiana: PDA Publishers, 1975.

Wu, Kingsley K. *Freehand Sketching in the Architectural Environment.* New York: Van Nostrand Reinhold, 1990.

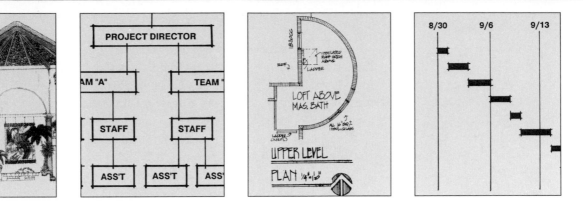

C H A P T E R 1 9

THE PROFESSIONAL PRACTICE OF INTERIOR DESIGN: BUSINESS, MANAGEMENT, AND THE FUTURE

INTERIOR DESIGN AS A BUSINESS

The practice of interior design is an art, a science, a career, a life-style, and, above all, a business. It is an exciting profession involving the use of creative ideas to solve problems effectively for real-world situations. The profession entails using other people's money and having

them trust in the services and/or goods the interior designer provides. The practice of design is similar in its business aspect to that of other professions, such as medicine, law, dentistry, and architecture. All of these provide a service and operate as a business entity.

One of the primary reasons a business exists is to make a profit. However, a successful business also serves a need in society and for the individual. Business entities, whether individuals, small firms, or large corporations, all have responsibilities—personnel, facilities, and supplies—that must be managed to keep the businesses functioning. Effective business procedures and management are vital to a firm's well-being—to permit its staff members to have time to do their jobs; in the case of design, this means permitting the designer to solve problems creatively by generating exciting solutions to problems.

This chapter is divided into four parts: The first introduces interior design as a business, the second illustrates how a design business operates, the third deals with the management and scheduling of projects within a professional firm, and the fourth looks at the future of interior design.

Residential and Nonresidential Practice

Interior design is a service-oriented profession that involves different types of expertise in working with facilities within the built environment. The practice of interior design is commonly divided into residential or nonresidential (contract or commercial) design. Although a designer can do both kinds of work, there seems to be a tendency to specialize in one of these areas. This specialization can occur because of the type of projects the designer enjoys, his or her business conduct, expertise, working habits, or profit motives. Designer-client working relationships are different in these two general categories and ultimately reflect the designer's own desires and aspirations. Residential work does not generally require the stringent written rules and protocol demanded in commercial work, but both categories call for strong personality and communication skills for client contacts.

Specialization

The strong tendency toward specialization in the field of interior design will probably continue as technology and society become more complex, demanding more knowledge and expertise from designers. The specialist seeks projects involving specific types of interiors, such as restaurants or banks. The generalist works with a variety of project types, sometimes including both residential and commercial work. The specialist believes a client gets the benefit of more expertise, efficiency, and in-depth services because the designer has refined and improved his or her knowledge of a particular type of interior. Specialization can lead to greater profits for the designer, since the scope of work and services required to solve the problem are similar in most cases. The designer therefore is able to build a knowledge base and become more task efficient. Some of the most noted designers and well-publicized projects are a result of specialization. However, specialization may lead to a decrease in creativity, for a designer may tend to solve all projects in a similar manner—which may not be the best and most personalized solution for each client. A designer must guard against creating a typical solution to any problem, because each

project and each client is different. (See Chapter 8 for a list of specializations within the field of interior design).

Type of Services Offered

The designer can offer many different kinds of services depending on the project and the client's needs. These services might range from drawing preliminary sketches for a client's furniture arrangement to designing, specifying, inspecting, and coordinating all elements for the move-in to a new facility. Traditionally, there are several ways the designer offers services: design/specify, design/merchandising, and contracting. However, these services can be combined or modified depending on the client's needs.

DESIGN/SPECIFY

When the designer provides consultation without buying or reselling products, this is commonly called design or specifying services. The designer might select furniture or equipment by specifying in detail the type or required performance of products. In some cases, the designer might prepare the purchase order for the owner but not get involved in the actual outlay of money for purchasing. Many interior design firms primarily involved in commercial work operate this way. The designer is paid on a fee basis, by the hour, or by a percentage of the project cost.

DESIGN/MERCHANDISING

When the designer becomes involved in the buying and selling of products for the client, the services are recognized as merchandising; if the designer also provides design services, this is known as design/merchandising. The designer actually becomes a merchant who procures products at a discount, places a markup on them, and resells them to the client. The designer might also charge on a hourly basis for time spent. In the design/merchandising arrangement, the designer often must obtain a resale license from a state jurisdiction and can become responsible and liable for the product sold. In many small communities there may be no source of the needed products, so the designer fulfills the necessary role of one by personally obtaining the proper products.

The designer might be employed by a retail store offering both design expertise and products. In this situation, the designer might receive both a salary and a commission from the store. Generally, the client does not pay a fee for the designer's services if purchasing products from the store; however, the store may charge a fee in addition to the retail sales, depending upon the services offered, the structure of the establishment, and its location.

The majority of interior designers charge a design fee for their services, rather than merchandise goods for a profit.

CONTRACTING

At times, a designer might act as a contractor and hire subcontractors for construction, painting, hanging drapery, or installing wallpapers. Or, a designer might operate a workroom for upholstery or window treatments if he or she has developed a specialty operation or these services are not readily available in the community. In this capacity, the designer becomes directly involved with and responsible for the materials, labor, and results of the construction. In either case, payment is made to the designer for materials and labor, just as most other contractors receive their money. Some states require the designer to obtain a contractor's license in this type of operation.

Entering the
Business World

With a degree in design, the fledgling designer is ready to get on with the business aspect of his or her education and enter the working world. Interior design involves a commitment to hard work and creativity and a passion for the profession. Let's look at several ways a designer can enter the business world, move up in it, and possibly start a business.

EMPLOYEE

The typical graduate enters the design field as an employee of a design firm. The employee is paid an hourly rate, a salary, a commission if products are sold, or a combination of these. In addition, the company might include paid holidays, vacation, and other fringe benefits, such as health insurance, overtime pay, retirement benefits, even profit-sharing bonuses. As the employee gains experience and becomes a more valuable asset to the company, rewards come in the form of raises and other special compensations. Eventually, with hard work, the employee moves up, gaining seniority and administrative responsibilities. He or she might eventually become an associate, officer, partner, or part owner in the firm.

ASSOCIATE/OFFICER

Associate status in a firm is different from being an employee; in some cases an associate is part owner of the firm. The associate perhaps is involved in management decisions and direction of the firm's goals and usually shares in profits he or she helps to generate. Associate status varies with the size, type, and operation of the firm. It is a great learning experience to participate in running a business but not be saddled with the liabilities of complete ownership.

Oftentimes, an associate is identified as an officer in a firm, such as vice president, denoting title and status. Benefits vary according to the firm, but most officers have a say in the operations and usually have their names visible on the firm's business letterheads or other signage.

PARTNERSHIPS AND OTHER VENTURES

After a period of hard work and teamwork, an employee or associate might advance to the point of joining an existing design partnership or becoming part of a corporation. This advancement allows the designer to participate more fully in the firm's operations and often means a bigger share of the profits. However, along with these benefits come some of the responsibilities of keeping a firm running smoothly. In most cases, the new partner must buy into the existing partnership or corporation. Some companies will allow this required investment to be paid over a period of years to offset large upfront sums.

BUYING A BUSINESS

It can be advantageous to buy an existing business with an established clientele and reputation. This opportunity sometimes occurs with the death, retirement, or relocation of the original owner(s). There are, however, some disadvantages to be taken into account. For instance, if the former management, employees, or facilities are not operating efficiently, it can take a considerable amount of time and money to get the business back on the right profit-making track.

STARTING A BUSINESS

Many new businesses are started every year, and many of these become successful. However, some fail, which can cause immense financial and psychological stress to the owner(s). Starting a business can be an exciting venture, but regular paychecks, vacations, set hours, and the luxury of leaving the job at the office at the end of each day are often no longer guaranteed. A designer must be strongly committed to making the business work. A considerable amount of

personal time will be absorbed by the management process, rather than by designing. Neverthe-less, the profit incentives and freedom to decide how the firm is to operate and grow is worth the effort to many designers.

BUSINESS OPERATIONS

Types of Business Organizations

In starting a new business, the designer must consider a number of issues. One of the first is the type of operation—the sole proprietorship, the partnership, or the corporation. Each of these involves a different kind of legal ownership.

SOLE PROPRIETORSHIP

The simplest business formation for the small design firm is that of sole proprietorship. All profits and responsibilities belong to the sole owner. The entity and often the name of the company are that of the owner, which does not necessarily mean only one individual makes up the company; some employees might be given titles for operational functions, such as Vice President of Production.

The sole proprietorship is perhaps the least expensive business to start and the easiest to run. The owner has complete control over everything, and all profits are the owner's. On the other hand, the owner is responsible for the taxes, liabilities, debts, and any other problems. The owner must meet the company's debts with personal assets and is responsible for employee errors or omissions.

PARTNERSHIP

A partnership is made up of two or more persons (co-owners) who operate a business enterprise for profit, sharing both the risks and the financial rewards. These associations are usually made up of individuals who complement one another and support the idea of sharing creativity as well as risk. The partners assume joint liability for debts and obligations.

Various states have specific guidelines that govern partnerships and often require a legal agreement between the parties. Even if this formal document is not required, it is vital to have it prepared in order to protect the rights and wishes of the partners for times when differences might arise.

Partnerships can be established as general or limited associations. In the general type, all partners have equal responsibility for debts and liabilities, whereas in the limited arrangement, the limited partners are liable primarily only for their investments. General partners might have more of a voice in management decisions and receive a greater share of profits than do limited partners.

CORPORATION

The third type of business organization is a corporation established as a legally distinct entity. It exists apart from the principal people comprising it. A corporation can offer some tax advantages and protect the individuals who own or run it from personal liabilities and debts. The owners' personal assets can be protected from debtors, and the corporation can continue to exist if members die or sell their shares. However, corporations are subject to governmental scrutiny and can be complicated to run because of the many regulations and tax requirements.

Operational Goals and Objectives

To be successful in a new or existing business, a person must set goals, objectives, and commitments. Goals are ideals or what one aspires to achieve, whereas objectives serve as the methods or stepping stones to achieve those goals. Commitment involves a dedication to adhere to the plan and make changes as necessary to move in an orderly fashion to realize the results desired.

PERSONAL GOALS

An individual can establish personal goals by taking stock of where he or she is and looking to the future. These goals might need to be set in increments of 1, 5, 10, or more years to be realistically attainable. Goals should be written and organized into specific achievements—including life-style, profession, and relationships to others. These personal goals should be reviewed periodically to see if they have changed or need revision.

BUSINESS GOALS

Although a business must make a profit, there are other considerations. The designer must ascertain what kind of work he or she wants to do and enjoys doing and what his or her contribution to society will be. The designer must establish business plans and list steps to achieve goals effectively. A business must be analyzed according to its strengths, weaknesses, and future projections. Some of the methods used to research and establish business goals are considered below.

MARKET ANALYSIS

The success of a business depends on the market from which it derives its profits. Design offices are established to seek and foster clients in order to keep the business running, execute good work, and make a profit. It is important to do an analysis of the market in which the business operates. The client profile, the number of potential clients, competition from other designers, location of the design office, and other factors can greatly affect the success of the business. These must be carefully analyzed to see if the projected business can successfully operate in a particular business community.

POTENTIAL CLIENT PROFILE. Potential clients must be analyzed by number, profile, and type. For example, in some communities, the population profile might indicate that the local inhabitants are not really interested in investing money in the design of their surroundings and that they are happy without change. A design business would probably fail if the population did not really want the services or if there were not enough who did to justify starting a new interior design practice in the area.

COMPETITION AND SERVICES OFFERED. A business must size up its competition: How many competitors are there, and what kind of services do they offer? Perhaps a new business can offer services the current competition cannot. However, if there is too much competition for the size of the client base or community, enough work may not be available for all the design firms to operate successfully. Also, fees for services must be in line with what other firms are charging since most clients will not pay substantially higher costs for one firm than for another.

LOCATION OF OFFICES

The location of offices performing interior design is as varied as the type of individual or firm. Location can be very important to clients and staff in terms of accessibility, convenience, and professional image; however, in some cases the location is not critical. For example, if clients do not normally come to the office, it often is not necessary to locate in their immediate area.

Interior design firms usually select a home, a retail store, or a professional office for their business location. Each has advantages and disadvantages.

RESIDENTIAL STUDIO. Perhaps the simplest and most economical location for establishing an interior design business is the residential studio or home office. This can be a room in the house that is segregated as a distinct office with its own entry and identity. Many designers, particularly those starting out, choose this type for its economy—both in monetary outlay and in personal travel time. As computers and electronic media advance, we may see an increase in this type of office location, since it is becoming less important to commute to a central office location for the day's work.

However, offices located as residential studios can have some disadvantages. Disruptions from the business, such as after-hours phone calls, deliveries, and salespeople, can upset the home routine. In turn, daily home distractions, such as noisy children and neighbors who come to visit, can affect the business operations and professional image.

RETAIL STORE. A second location for an interiors operation can be in a retail or manufacturing establishment, such as a furniture showroom, home furnishings store, or even part of a large department store. In all of these, the retail aspect of the operation is generally the prime profit-making motive, and design services are secondary. The services and expertise of interior designers can vary greatly from store to store, depending on what the retail establishment expects in terms of sales volume. Some retail stores hire outside designers; others have a full staff of professionally trained designers.

PROFESSIONAL OFFICE. The third type of location is the professional office set up exclusively to offer design services (Figure 19.2). The professional office might be an independent interior design firm or operate within an architectural firm that has an interior design department. In a full-service organization, architects, engineers, planners, and graphic designers might also be housed in the office.

The location, size, and image of the design office will vary according to the community size and client base. Some firms will locate in a central business district and cater primarily to downtown clients who seek office spaces or other centralized facilities. Other firms will locate in suburban areas, office parks, or manufacturers' showroom districts. The latter have the advantage of saving the designer and client time by providing quick access to showrooms for selections of furniture and other goods.

OTHER LOCATIONS. In addition to these three common locations, there are other sites for the practice of interior design. Facility management operations of large companies and institutions might have their own design staff. Some developers, realtors, and leasing agents for high-rise office space also might have a small staff of interior designers or architects for space planning functions and tenant development.

SMALL AND LARGE OFFICES

Interior design is practiced by individuals working alone, by small firms, and by large organizations. Each office varies in physical size, staff organization, and type of services offered. Generally speaking, small design firms restrict their work to small projects that do not require a large staff. These firms can offer the benefit of having one or two designers do all the work on a project; therefore, the designer or designers gain experience in all areas, encompassing client contact, budgeting, drawing, supervising, and many others. In a large design firm, the designer may not be involved in all aspects of a project. The size of the project might be so large that one person cannot do the whole job and needs to concentrate on only a part of it. The trend in larger firms is to specialize in order to move projects efficiently through the office.

Design firms are often divided into two or three groups of staff functions: administrative and production (Figure 19.1) or administrative, design, and production. The administrative arm is

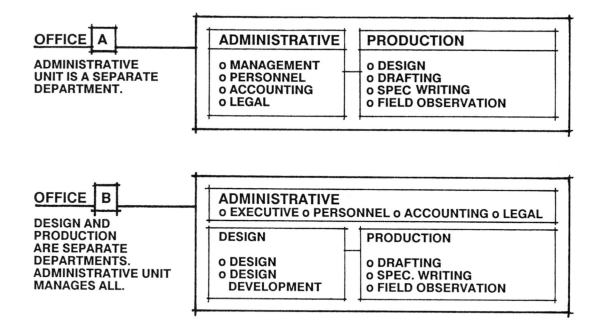

OFFICE | **A** |

ADMINISTRATIVE
UNIT IS A SEPARATE
DEPARTMENT.

ADMINISTRATIVE	**PRODUCTION**
o MANAGEMENT	o DESIGN
o PERSONNEL	o DRAFTING
o ACCOUNTING	o SPEC WRITING
o LEGAL	o FIELD OBSERVATION

OFFICE | **B** |

DESIGN AND
PRODUCTION
ARE SEPARATE
DEPARTMENTS.
ADMINISTRATIVE UNIT
MANAGES ALL.

ADMINISTRATIVE
o EXECUTIVE o PERSONNEL o ACCOUNTING o LEGAL

DESIGN	**PRODUCTION**
o DESIGN	o DRAFTING
o DESIGN	o SPEC. WRITING
DEVELOPMENT	o FIELD OBSERVATION

responsible for activities such as personnel, financial management, legal, and other general functions of maintaining the business operations. These duties might be performed by business specialists or the principals of the firm.

The design and production departments of a design office render services such as feasibility studies, design sketches, construction drawings, and the coordination of duties during construction. Design and production can be combined in one department or split into two departments with distinct functions and responsibilities.

Design firms are organized so that each staff member is assigned work in relation to his or her experience, capability, and potential to carry out those responsibilities efficiently. These employees are often organized into teams and assigned to a particular project. In turn, each individual or team is assigned to a senior person or project director to ensure that all the work meshes. Because most firms handle many projects at a time, this designated project director guides several jobs at once, coordinating the work of each project. In turn, project directors report to the owner or partners.

Marketing, Public Relations, Ethics

MARKETING AND SELLING

Marketing and selling are important parts of a design firm's operations because they keep the firm in business by seeking potential contacts to secure the kind of work the firm is capable of doing. All successful design firms have a sound business development program that augments their creative and production endeavors. Marketing consists of identifying clients and

their needs; selling requires securing commissions from clients or closing deals. Firms use various techniques, such as business call forms, work sheets, and follow-up memos, to pursue leads for commissions. Successful firms know how to market their services aggessively rather than waiting for the telephone to ring or a client to walk through the front door. These firms develop marketing tools such as brochures and portfolios to provide prospective clients with information about the services and skills of the firm.

PUBLIC RELATIONS

Public relations for an interior designer is an image-building process. Wide exposure is a key factor in the public recognizing who designers are, their services, and the benefit they contribute to society through their work. Getting completed projects and information published in newspapers, magazines, and other media helps to gain exposure. Designers should join local civic organizations or serve in volunteer organizations for additional community exposure. Although the prime motive for community involvement should be for the good of the citizenry, it can also lead to contacts with those who might later need the services of a designer.

ETHICS

As physicians, attorneys, and architects have a code of ethics, so do interior designers. Professional societies, such as the American Society of Interior Designers (ASID) and the Institute of Business Designers (IBD), have a written code of ethics that their members pledge to uphold. These codes set a minimum standard for the designer and address conduct, competency, integrity, and responsibilities. Members who violate these rules can be subject to disciplinary action by the judicial boards of the organization. For designers who might not belong to professional societies, unwritten ethics standards serve to promote the image of interior designers as professional, capable, and responsible practitioners to their clients, each other, and society.

Business Consultants

The complexity of rules, regulations, and technological advances can create a mountain of knowledge for the interior designer to keep abreast of. At times, it seems impossible to know every detail and requirement a project entails. Consultants and other sources can assist in getting the job done. These team players augment the designer's resources by offering more services and expertise to respond to clients' needs.

ATTORNEYS, BANKERS, ACCOUNTANTS, INSURANCE AGENTS

Other consultants—attorneys, bankers, accountants, and insurance agents—are of vital importance to the interior designer for business operations.

Attorneys help in the firm's legal matters, such as assisting in setting up the initial structure of the business and offering advice for contract preparation or interpretation. Attorneys can also be an asset in a contract dispute or a lawsuit.

Bankers can provide monetary support when the designer is starting up a business or can provide help when the financial operations need additional cash or a loan to buy a building or equipment or, occasionally, to meet payroll demands, for instance.

Accountants handle matters such as finances, taxes, credit arrangements, and the fiscal operations of accounts receivable and payable. They can assist the firm in determining the actual profits made and project how to continue the business as a profit-making entity.

Insurance agents provide a multitude of types of coverage for the designer and the business, including medical and life insurance for the staff and protection of the building and

equipment. There is even omissions and errors insurance for the firm that covers designers' services and is similar to the malpractice insurance that doctors carry.

Fees and Compensation

Methods for charging for interior design services vary. No set fees will apply for every designer or project—each can be its own unique arrangement. In estimating what a designer should charge for his or her services, the scope of the work must be defined in terms of staff needs and time required to do the work. The designer should know both what the competition is charging and what the client expects. The designer can utilize several methods of fee structuring. Those presented below are the most typical but can be altered or combined by the designer to better suit the services provided, the client's needs, and the scope of the project.

HOURLY FEE

The designer can charge a set rate for each hour actually spent on the project. This rate is generally marked up to include overhead, profit, and operating costs.

FIXED, FLAT, OR STIPULATED FEE

When the designer agrees to do the work for a specified amount of money, this is called a fixed, flat, or stipulated fee. Although this method of charging might appear simple, the designer must accurately estimate time and overhead for a project, which can be difficult if the scope of work is not clearly defined or unexpected events (such as clients changing their minds) occur throughout the project. However, this method can be profitable if the designer has done many similar jobs.

PERCENTAGE OF A PROJECT COST

A designer can charge a fee as a percentage of the project cost, which can include the materials used and the labor expended by others. The percentage fee varies in a constant proportion to the size and cost of the project and the designer's time expended. The percentage is usually higher for small projects than for larger projects. This type of fee can be advantageous when the project has changes that result in higher costs and complexity since the designer's fees increase proportionately to the amount of time needed to do the work.

FEE PLUS EXPENSES OR PERCENTAGE

On small jobs or when the scope of the designer's services is not clearly defined, the fee can be based on a set fee plus expenses or even a set fee plus a percentage of the project costs. Project costs can be determined from construction, furniture, and/or furnishings costs.

MARKUP FEE

The markup fee basis involves buying furniture and other goods, then selling them to the client and receiving a profit on the marked-up price. A designer can make more profits this way than on a fee basis. For example, to select a client's new sofa may take the designer three hours and be billed at $70 per hour, for a total of $210. On the other hand, if a markup of 20 percent is added to a $2,000 sofa, the designer's profit is $400. However, a designer may feel that the markup method puts more emphasis on selling merchandise than on designing.

AREA OR PER SQUARE FOOT FEE

The area or per square foot fee is used on a specialized basis when the designer has considerable experience and knows the competition's fees very well in the same type of market. The area or per square foot fee is used in the specialized field of tenant development—planning spaces in office buildings. The fee can range from 25 cents a square foot up.

Contractual Agreements

Contractual agreements are needed between various parties involved with interior design projects to indicate each party's responsibilities. Agreements can be oral or written, but it is preferable and more professional to put everything in writing to prevent possible disagreements later. A contract serves as a legal agreement between two or more parties and is recognized as a binding relationship for those who enter into it. In interior design, the three most common contracts are owner/designer, owner/contractor (also called installer, supplier, or manufacturer), and designer/consultant.

OWNER/DESIGNER CONTRACTS

Written contracts between the owner (or client) and the designer protect both parties and confirm each party's rights and obligations in their relationship. Although some designers work without a written contract, it is professional practice to clearly define the responsibilities and anticipated performance of both the owner and the designer. These documents can be simple work orders (Figure 19.2), letters of agreement, or preprinted contracts provided by various professional design societies. For example, ASID and AIA have jointly produced several copyrighted documents for interior designers to use (Figure 19.3). They all encompass some of the essential parts listed below.

SCOPE OF SERVICES. The scope of services defines what services the designer is likely to provide to solve the client's problem, including programming, schematic design, design development, contract document preparation, contract administration, move-in, and follow-up evaluation if necessary.

PROJECT DESCRIPTION. Project description defines the location and particulars of what is to be designed, built, or installed. It lists the location, approximate size, and limits of the areas the designer is to address.

IDENTIFICATION OF THE PARTIES. The parties entering into the contract are clearly defined using the legal name(s), titles, and addresses of the client and the designer. The contract specifies who is responsible for signing (if the client is a company) and paying the designer's fees and identifies the client's representative if it is a large corporation or has more than one partner.

TERMS AND CONDITIONS. The terms and conditions of the contractual agreement are detailed so that both parties have a clear understanding of their responsibilities and of what is expected of each. The contract also defines any additional requirements, exceptions, and other parts of the total contract. For example, the contract might require that the client furnish temporary electrical power in a renovation, but not insurance for the workers.

FEES AND COMPENSATION. The fees and compensation are set out in the contract, which also specifies when payments are due to the designer. Clauses are usually added to cover reimbursable expenses, penalties for late payments, and retainers. A retainer is a sum of money (usually 10 percent of the total fees) sometimes given to the designer at the beginning of the project. Retainers are required if the client and the designer are working together for the first time or if the designer is supplying merchandise. The retainer represents good faith on the part of the client.

DATE AND SIGNATURES. Dates and signatures are added to the contract to show that all parties have read it and agree to its conditions. Each party keeps a copy of the contract, which then serves as a legal document.

WORK ORDER

Number _____

Date _____

(Your firm) _____

(Your address) _____

(Your phone no.) _____

Client _____

Address _____

Phone _____ Date Job Completion Requested _____

Services Requested _____

☐ A. Fixed Fee of: $ _____ ☐ With partial billings monthly commensurate with job progress.

☐ To be billed at completion of job.

☐ B. Services to be billed monthly at current hourly charge rates per hour; plus expenses for the individuals working on the project (i.e. blueprints, copying, long distance phone calls.)

Remarks _____

PLEASE READ, SIGN, AND RETURN ONE COPY TO DESIGNER AT ABOVE ADDRESS. Payment will be due and payable by the end of the month in which the work is billed. 1½% per month will be charged on the unpaid balance on accounts after 30 days. The above order for work is hereby approved. If it is necessary to retain an attorney to enforce collection, the undersigned agrees to pay reasonable attorney fees and court costs in addition to the aforesaid interest.

☐ Work will not commence or be scheduled until signed copy is returned.
☐ Work will begin without signed work order being returned, but may be terminated without notice if signed copy is not returned within 10 days.

By: _____ By: _____
Designer Date (Person responsible for payment) Date

FIGURE 19.2 Example of a simple work order form for design services.

OWNER/CONTRACTOR CONTRACTS

The owner and the contractor enter into a legal written contract similar to the owner/designer agreement, although the owner/contractor contract is often more specific. This contract itemizes in detail the work to be done and the cost. It usually specifies the length of time in which the work is to be completed. The designer's drawings and specifications are made a part of the contract to clearly delineate the scope of the project and the quality of workmanship expected. The professional societies have all prepared standardized documents for these owner/contractor agreements.

AIA Document B171

Standard Form of Agreement for Interior Design Services

1990 EDITION

THIS DOCUMENT HAS IMPORTANT LEGAL CONSEQUENCES; CONSULTATION WITH AN ATTORNEY IS ENCOURAGED WITH RESPECT TO ITS COMPLETION OR MODIFICATION.

AGREEMENT

made as of the day of in the year of

(In words, indicate day, month and year)

BETWEEN the Owner:
(Name and address)

and the Architect:
(Name and address)

1. AIA copyrighted material has been reproduced with the permission of the American Institute of Architects under license number 91054. Permission expires June 1, 1992. FURTHER REPRODUCTION IS PROHIBITED.

2. Because AIA Documents are revised from time to time, users should ascertain from the AIA the current edition of this document.

3. Copies of the current edition of this AIA document may be purchased from The American Institute of Architects or its local distributors.

4. This document is intended for use as a "consumable" (consumables are further defined by Senate Report 94-473 on the Copyright Act of 1976). This document is not intended to be used as a "model language" (language taken from an existing document and incorporated, without attribution, into a newly-created document.) Rather, it is a standard form which is intended to be modified by appending separate amendment sheets and/or fill in provided blank spaces.

For the following Project:
(Include detailed description of Project, location, address and scope.)

The Owner and Architect agree as set forth below.

B171-1990 1

FIGURE 19.3 A pre-printed contract produced jointly by AIA and ASID for design services.

DESIGNER/CONSULTANT AND OTHER RELATED CONTRACTS

Other related contracts are entered into by various parties in order to complete a project. These are of a specialized nature and are designed to specify the details of the transaction between two or more people. The most common types are designer/consultant agreements, purchase orders, and owner/subcontractor agreements.

Bookkeeping and Accounting

To run an interior design business effectively and efficiently, either an in-house or an independent accountant must maintain cost control of the firm's operations. Various forms and books of the firm's accounts receivable and payable are established and maintained on a regular basis. These can range from simple ledger books in smaller organizations to complicated computer analyses in large firms (Figure 19.4). Another method of accounting is to use employee time sheets (Figure 19.5) for computing billable time on a project.

FIGURE 19.4 Example of an accounting document for a small interior design firm.

PROFIT OR LOSS STATEMENT
WILD ROSE INTERIORS
PERIOD ENDING JULY 31, 199X

Gross Income			
From Fees		$38,685	
From Sale of Goods	$26,500		
Freight-in	1,855		
Delivery	2,279		
		$30,634	
Gross Income		$69,319	
Other Revenue			
Interest		400	
Total Gross Income		$69,719	$69,719
Cost of Goods			
From Sale of Goods:			
Cost of Products Sold	$17,500		
Freight-in	875		
Delivery	1,400		
From Fees:			
Direct Labor	27,080		
Supplies	985		
Reproduction Expense	395		
Telephone	205		
Total Cost of Sales & Fees		$48,440	
Gross Profit			$21,279
Operating Expenses			
Advertising & Promotion	$ 200		
Auto Expense	750		
Dues and Subscriptions	160		
Furniture - Depreciation Expense	225		
Insurance	175		
Legal/Professional Services	150		
Salaries	12,500		
Payroll Taxes	1,875		
Group Insurance	105		
Rent	800		
Utilities	300		
Telephone	150		
Travel Reimbursements	150		
Supplies and Postage	325		
Professional Consultant Fees	250		
Printing	75		
Interest Expense	225		
Total Operating Expenses			$18,415
Net Profit			$ 2,864

TIME SHEET Name: _____ Week Ending _____

BILLABLE HOURS		Time in hours							
Client Name	Project Number	Sun. Sat.	Mon.	Tues.	Wed.	Thur.	Fri.	Total Hrs.	Comments

NON-BILLABLE HOURS		Time in hours							
Name	Project Number	Sun. Sat.	Mon.	Tues.	Wed.	Thur	Fri.	Total Hrs.	Comments

SUMMARY	Time in hours						Total	Comments
Total Billable Hours								
Total Non-Billable Hours								
Grand Total								

FIGURE 19.5 Example of an employee time sheet.

PROJECT MANAGEMENT

The managing of designers' projects is crucial to the successful operation of the business and to future work. Projects must be efficiently handled to solve the client's needs in a timely manner, bring recognition to the designer, and keep the business operating by generating a profit. Whether an individual designer or a group is to accomplish the work, there must be a clear understanding of the project, the required design services to solve that situation, and the sequence of steps necessary to get the project accomplished.

Design Teams and Staff Organization

The trend toward working in groups or teams is increasingly common in the design fields. Designers acting as teams can more efficiently offer services by combining expertise—either within a firm or in association with other firms or consultants.

When a project is brought into an office, the staff is organized to work with the client, consultants, contractors, and others to bring the finished product to fruition. Generally, design firms use two basic approaches to organizing their staffs—vertical or horizontal (Figure 19.6). These arrangements are set up in such a way that each person is assigned work in relation to his or her experience, capability, work load, and potential to get the job done efficiently.

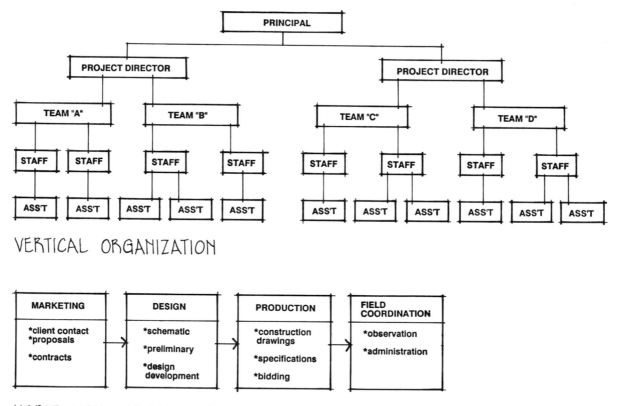

FIGURE 19.6 Vertical and horizontal approaches to organizing a design firm's staff for efficient work flow.

The vertical organization, or studio approach, is used if the firm consists of a group of generalists rather than specialists. In this arrangement, each person is involved in all phases of the project. On large projects, a design team is set up with specific leaders to assist less experienced staff in gaining knowledge and skills. This arrangement has the advantage of training staff in all levels and experiences of a project.

The horizontal organizational method consists of a series of the firm's specialists or departments working on only one or two aspects of a project as it moves through the firm—like an assembly line. This specialization increases the efficiency of the firm's output and is helpful on large projects. However, staff may not get exposure to all parts of a project and may get pigeonholed in one area. Sometimes design firms use both of these approaches, depending on the size and scope of a project.

Project Consultants
and Resources

ARCHITECTS, ENGINEERS, AND OTHER CONSULTANTS

Architects and engineers are professionals who can be very much a part of the designer's team, since they have the expertise to offer unique services to the designer. The architect has been educated, trained, and licensed to give not only technical advice but also suggestions on matters of aesthetics and problem solutions in a project. Whether it is the interior designer retaining the architect or vice versa, it is the teamwork between these individuals that can make a truly successful project. In great buildings and interiors, it is hard to distinguish the work of the interior designer from that of the architect.

Engineers undergo lengthy professional preparation and are qualified to offer technical assistance to the designer. There are many specialized areas within the field of engineering, such as electrical, structural, mechanical, acoustical, and lighting.

Other consultants the interior designer might work with are landscape architects, industrial designers, or graphic designers.

MANUFACTURERS AND TRADE SOURCES

A good resource for the designer is the manufacturer or members of the trade source. These include individuals and companies, such as manufacturers' representatives, dealers, wholesalers, craftsmen, suppliers, and contractors, providing materials, assemblies, and installation of interior products, including furniture, light fixtures, floor coverings, and finishes.

These sources not only provide products but can assist in specifying how the product is to be installed and what standards it should meet. For example, a manufacturer of ceramic tile publishes detailed information about how its product will perform under varying conditions and specifies how the subsurface is to be prepared to ensure this performance. Instructions are also included for installing the tile in a workmanlike manner. A carpet manufacturer can assist a designer by recommending which of its products will best serve the designer's specific needs on a project.

The Client's
Budget and Costs

The client's budget is as great a concern to the designer as is creating the project solutions. The designer should not avoid discussing budget constraints with clients. Proposed concepts and designs can be very beautiful, but if they exceed the client's budget, the project probably will not be completed or the designs will have to be redone to bring the costs down. Very few clients will leave the budget open. The designer must estimate project costs and adhere to them throughout the job.

ESTABLISHING AND CONTROLLING BUDGETS

The budget for a project might either be established by the client or be submitted by the designer, based on his or her experience with a similar project. In either case, the budget becomes the limit for the designer. If design solutions cannot be met within the established amount, the designer should discuss revisions of the project with the client. Sometimes a designer must redo the project designs to bring down costs—without the client paying the fees of the designer to do

this. The designer who constantly overruns on projects will have a damaged reputation.

Estimating budgets for projects can be difficult for the inexperienced designer. The designer without years of experience in budget estimating can consult other professionals, such as architects, contractors, or estimators. Since the complexity of economics in materials and labor can cause price fluctuations, a designer should never promise that a project or item will not exceed the budget.

Working within a budget can be difficult. The designs, materials, and labor for the project must be carefully monitored to ensure staying within projected costs. At the beginning of the job and throughout the subsequent phases, preliminary cost comparisons and actual expenditures must be made on a regular basis and presented to the client. In this manner, cost overruns and any hidden expenses can be avoided.

Project Scheduling

At any given time, a design firm might be working on more than one project in varying stages of development. Careful scheduling moves a single project through its stages, yet allows the staff to be involved in more than one project at a time. Each job must be given individual attention and must fit the firm's overall work schedule.

Although the actual construction of a project is usually scheduled by the contractor, the designer attempts to establish overall schedules of design and drawing time, as well as anticipated construction times, to assist the client and execute his or her own services at the proper times required for coordination (Figure 19.7). The principal or a senior partner oversees all scheduling and tracks all projects to ensure that the work flows well in all phases of production.

Projects are typically phased in relation to the design services and the amount of construction required. Although the individual stages of interiors presented here may vary from project to project, most scheduling will progress through the following distinct steps.

FEASIBILITY STUDIES AND PROGRAMMING
The initial phase in most projects consists of the feasibility study and programming (Figure 19.8). A feasibility study represents preliminary investigations and the assessment of the validity of a project to ascertain what the client needs and to what extent design services are required. Discussions and preliminary research take place with the client and others to define the scope of the problem.

Programming is a more formal method of researching, documenting, and defining specific goals of the client and project (see Chapter 7). It establishes current and projected requirements needed for space, people, construction, costs, and other items of the project under study. A probable cost estimate or project budget is established for the amount the client will need to spend for the consruction and installation of the project. This preliminary estimate is adhered to or modified in later phases, depending upon changes required by the client. A letter of agreement or contract is also drawn up between the client and the designer for the required services and fees for this and subsequent phases.

SCHEMATIC AND PRELIMINARY DESIGNS
Using the program that was developed earlier, rough conceptual sketches or schematics are created to depict physical and nonphysical relationships of the project. These might be in the form of rough architectural drawings or graphic sketches to test concepts and get feedback from the client. During this phase, the designer might utilize input from consultants to help define basic premises and requirements about the project.

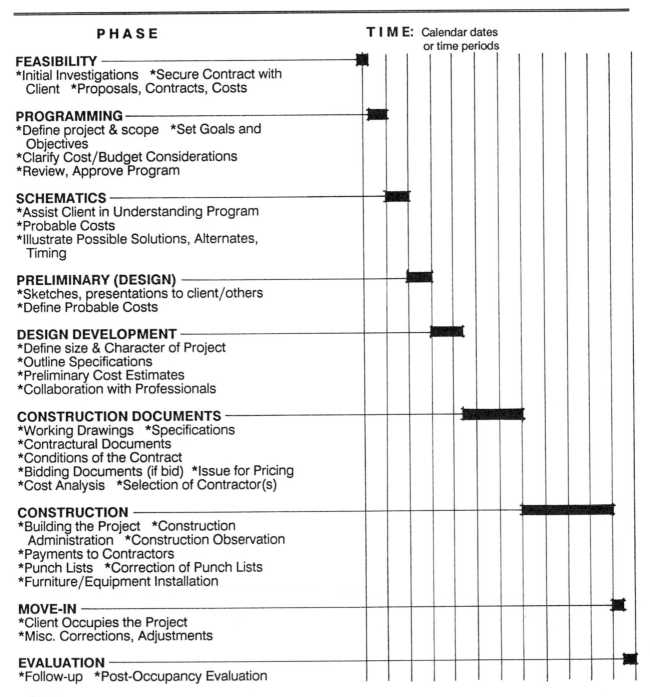

PROJECT SCHEDULING

PHASE

TIME: Calendar dates or time periods

FEASIBILITY
*Initial Investigations *Secure Contract with
 Client *Proposals, Contracts, Costs

PROGRAMMING
*Define project & scope *Set Goals and
 Objectives
*Clarify Cost/Budget Considerations
*Review, Approve Program

SCHEMATICS
*Assist Client in Understanding Program
*Probable Costs
*Illustrate Possible Solutions, Alternates,
 Timing

PRELIMINARY (DESIGN)
*Sketches, presentations to client/others
*Define Probable Costs

DESIGN DEVELOPMENT
*Define size & Character of Project
*Outline Specifications
*Preliminary Cost Estimates
*Collaboration with Professionals

CONSTRUCTION DOCUMENTS
*Working Drawings *Specifications
*Contractural Documents
*Conditions of the Contract
*Bidding Documents (if bid) *Issue for Pricing
*Cost Analysis *Selection of Contractor(s)

CONSTRUCTION
*Building the Project *Construction
 Administration *Construction Observation
*Payments to Contractors
*Punch Lists *Correction of Punch Lists
*Furniture/Equipment Installation

MOVE-IN
*Client Occupies the Project
*Misc. Corrections, Adjustments

EVALUATION
*Follow-up *Post-Occupancy Evaluation

NOTES
*This scheduling of phases is the traditional way utilized by most interior designers and architects. It
 can vary by type, size, & procedures of the firm.
*Project phasing & scheduling will also vary with the uniqueness of the particular project.
*The designer should secure the client's written approval of each phase before proceeding to the
 next.

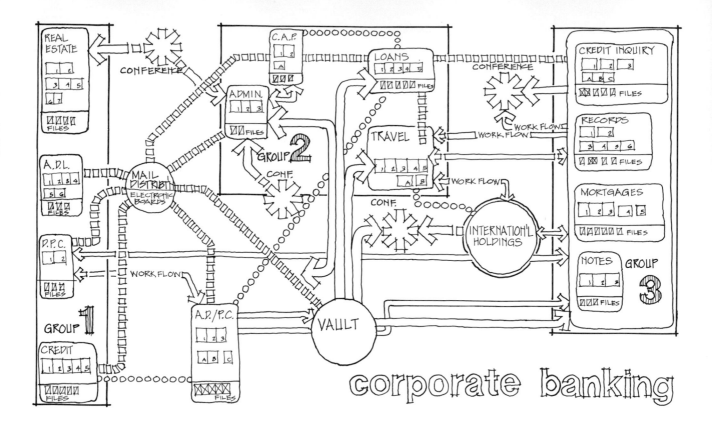

FIGURE 19.8 Feasibility and programming can be presented in a graphic manner to visually explain concepts.

From the schematics, preliminary designs are developed to present operational, functional, and conceptual relationships of the project. These, along with a more refined budget estimate, are presented to the client for input and approval before moving to the next phase. The designer is paid for services either at the end of this phase or monthly if it is a lengthy project.

DESIGN DEVELOPMENT AND PRESENTATION

After the client approves the preliminary design concepts, the project moves into the design development phase, in which drawings and material selections become more specific to determine the character, size, and details of the entire project. Appropriate finishes, furniture, and furnishings are studied and coordinated in the design concept. Then these elements are drafted and assembled with careful craftsmanship since the designer is presenting his or her best effort for the project.

The designer's ideas and solutions are presented to the client in what is called a presentation format (Figure 19.9). Each designer or firm has a different presentation style and format. Some are very formal with a theatrical flair, and others are more informal. Budget modifications are made as required and the designer bills for services rendered.

CONSTRUCTION DOCUMENTS

Once the design is complete and approved by the client, the designer is ready for the construction documents phase, which details what is to be constructed and installed and how and where that will occur. Construction documents are composed of the construction drawings (working drawings), the specifications, and the various contracts needed to legally bind the client, the contractor, and other parties. These documents are first used by contractors to obtain final cost figures and then become a guide to execute the actual construction of the project. The drawings (Figure 19.10) note specifics, such as construction details, exact finishes, cabinetry, all materials, and other items needed to build what the designer envisioned. The specifications

FIGURE 19.9 This drawing by Gary Saxton is part of a series for presentation to a client for the design of a new hotel and convention center.

(Figure 19.11) are written descriptions of materials, methods, and level of acceptable workmanship. The designer's services for this phase generally represent the largest part of his or her fees because it can take a considerable amount of time to prepare these documents accurately.

SELECTION OF CONTRACTORS

The selection of contractors can be seen as a distinct phase, particularly on a large project or when several contractors want the job. Either contractors bid competitively for construction work or the designer assigns one after negotiating a fair price for the work.

In competitive bidding, the designer might assist or represent the client in finding the lowest price to do the project, based upon the contract documents. All the contractors are following the same drawings, so their prices can be compared. The client usually reserves the right to select any bidder, since the lowest bidder might produce substandard work.

In negotiating with only one contractor, the client seeks a fixed and reasonable cost or might allow the contractor to do the work on a time (labor) and materials basis. If the latter approach is taken, the contractor bills the client for the work and includes a fee for profit. Negotiation instead of competitive bidding is appropriate if the contractor has a good reputation, charges fair prices, and allows an adequate time frame in which to complete the project.

CONSTRUCTION AND CONTRACT ADMINISTRATION

The construction and contract administration begins when the contracts are awarded to the various contractors and suppliers. In large projects, many people will work together as the project moves through this phase. It is important for the designer to follow the project closely in

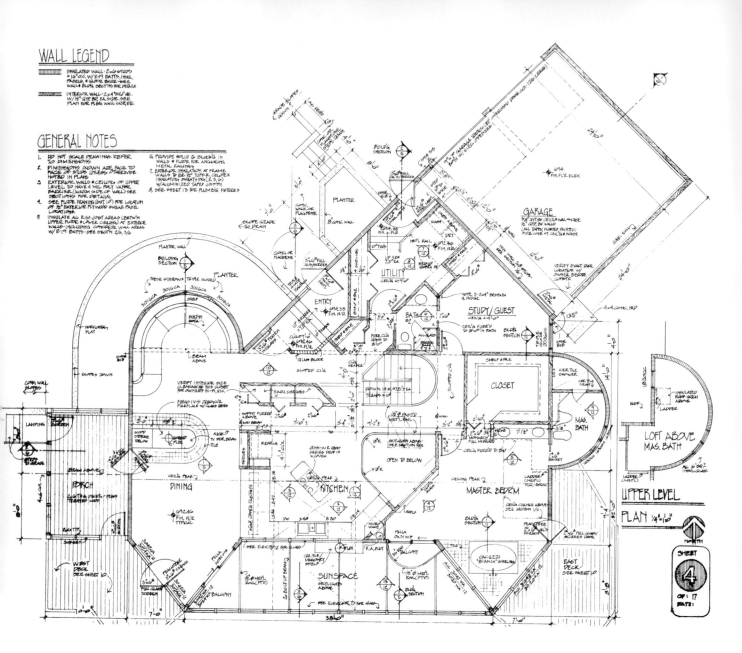

FIGURE 19.10 Construction drawings detail the exact size and other particulars of a project to be built.

order for work to progress smoothly to the end. During construction and installation, the designer acts as the agent for the client by visiting the building site, keeping abreast of the work, and reporting to the client on the quality and progress of the work. The designer reviews the project and the progress of the work in accordance with the contract documents.

Construction of a project must proceed in a timely manner and in a logical sequence. For example, the carpenters must first install floors and walls before the electricians and plumbers can rough in their materials. Next, the finishes are applied, and then the electrical covers, lights, plumbing fixtures, and other units are trimmed out. This sequence is controlled by the general contractor, who uses a scheduling technique such as PERT (Project Evaluation and Review Technique) or CPM (Critical Path Method) (Figures 19.12 and 19.13). The designer does not control the schedule or supervise the work; that is the contractor's responsibility. A designer might refer to this stage as supervision; however, the service is better described as coordination and observation. Supervision can imply that the designer is responsible for the outcome of the work, which could cause him or her to be named in a lawsuit if the project fails. The client could decide to sue

SECTION 09680: CARPETING

PART 1—GENERAL

1.1 DESCRIPTION

A. Work included: Provide carpeting and carpet accessories where shown on the Drawings, as specified herein, and as needed for a complete and proper carpet-and-pad installation.

B. Related works
1. Documents affecting work of this Section include, but are not necessarily limited to, General Conditions, Supplementary Conditions, and Sections in Division 1 of these Specifications.

1.2 QUALITY ASSURANCE

A. Use adequate numbers of skilled workmen who are thoroughly trained and experienced in the necessary crafts and who are completely familiar with the specified requirements and the methods needed for proper performance of the work of this Section.

1.3 SUBMITTALS

A. Comply with pertinent provisions of Section 01340.

B. Product data: Within 5 calendar days after the Contractor has received the Owner's Notice to Proceed, submit:
1. Materials list of items proposed to be provided under this Section:
2. Manufacturer's specifications and other data needed to prove compliance with the specified requirement:
3. Shop Drawings showing location of seams and locations and types of carpet metal and accessories.
4. Samples of the full range of colors and patterns of carpet and of exposed accessories available from the proposed manufacturers in the specified qualities.
5. Manufacturer's recommended installation procedures which, when approved by the designer will become the basis for accepting or rejecting actual installation procedures used on the Work.

1.4 PRODUCT HANDLING

A. Comply with pertinent provisions of Section 01640.

PART 2—PRODUCTS

2.1 CARPET

A. Provide seam adhesive recommended for the purpose by the manufacturer of the proposed carpet.

B. Provide carpet adhesive recommended for the purpose by the manufacturer of the proposed carpet for the direct glue installation of carpets.

C. Provide other materials not specifically described but required for a complete and proper installation, as selected by the Contractor subject to the approval of the Designer.

PART 3—EXECUTION

3.1 SURFACE CONDITIONS

A. Examine the areas and conditions under which work of this Section will be performed. Correct conditions detrimental to timely and proper completion of the Work. Do not proceed until unsatisfactory conditions are corrected.

3.2 SURFACE PREPARATION

A. Make substrata level and free from irregularities. Assure one constant floor height after carpet is installed, filling low spots and grinding high spots as required.

3.3 INSTALLATION

A. General:
1. Glue directly to the floor, using no pads and no foam.
2. Scribe the carpet accurately to vertical surfaces.
3. Align the lines of carpet, as woven, using no fill strips less than 6" wide, laying all carpet in the same direction unless specifically directed otherwise by the Architect.

B. Seams:
1. Locate seams only where shown on the approved Shop Drawings, or where specifically otherwise approved by the Designer.
2. Locate seams to the maximum extent practicable out of the way of traffic.
3. Fabricate seams by the compression method, using a butt joint, and properly bead and seal and/or hotmelt tape.
4. Make seams as inconspicuous as possible, flat, unpuckered, and completely free from glue on the exposed surfaces.
5. Do not stretch seams.
6. Corners on 90° borders to be seamed with a 45° mitered seam.

C. In addition to the cleaning requirements stated elsewhere, thoroughly clean carpet and adjacent surfaces prior to final acceptance of the carpeted areas by the Owner.

3.4 PROTECTION

A. Provide a heavy non-staining paper or plastic walkway as required over carpeting in direction of traffic, maintaining intact until carpeted space . . .

FIGURE 19.11 Example of a partial carpet specification. Specifications are composed of three basic areas: general directions, products to be used, and execution needed for proper installation.

FIGURE 19.12 Project evaluation and review technique in the form of a bar chart that graphically shows the time span required to complete project activities.

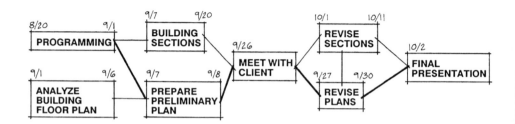

	8/30	9/6	9/13	9/20	9/27
CONTACT WITH CLIENT					
SEND PROPOSAL/SECURE CONTRACT					
MEASURE EXISTING BUILDING					
FEASIBILITY/SCHEMATICS					
PRESENT TO CLIENT					
PRELIMINARY DRAWINGS					
PRESENT PRELIMINARY DRAWINGS					
DESIGN DEVELOPMENT					
FINAL PRESENTATION TO CLIENT					

FIGURE 19.13 Example of a critical path chart indicating the shortest time of the project activities noted in the darker lines.

both the contractor and the designer if a problem arises. Architects have mostly eliminated the use of the term *supervision* in their work after many lawsuits were awarded on the premise that if an architect supervised a project, he or she—not the contractor—was then responsible for the finished project. However, the designer does carefully track the schedule and assists the contractor in keeping things moving properly. A regular meeting time is generally scheduled with the client to discuss any changes during the construction phase. Various business forms are available to use throughout this phase, such as the change order, transmittal, and field reports (Figure 19.14).

During construction and installation, the designer performs services that are commonly called contract administration. In this phase, the designer sometimes approves the money amounts due to the contractor and suppliers and makes recommendations to the client for proper payment. However, if the designer finds the work or materials not up to the standards called for in the contract documents, he or she can recommend that the client not pay until problems are corrected. The designer is generally paid monthly at an hourly rate for services in this phase, although in some cases, a percentage of the construction cost is paid.

PURCHASING

A unique phase in the interior design field is that of purchasing items such as furniture, accessories, furnishings, and many other products that are not purchased or installed by the contractor. The designer is involved in this phase in a number of ways.

If the designer is specifying only, he or she will assist the client by selecting the proper items and coordinating with the supplier to get the product placed in the interiors at the appropriate time. The designer might prepare purchase orders for the owner and help check prices and delivery schedules.

If the designer is merchandising as a part of promised services, he or she prepares written purchase orders (Figure 19.15) and sends them to the client for approval. Partial pay-

TRANSMITTAL FORM

PROJECT: _____ PROJECT NO: _____

_____ DATE: _____

RE: _____

IF ENCLOSURES ARE NOT AS
NOTED PLEASE CONTACT US.

TO: _____

_____ IF CHECKED BELOW, PLEASE:
() RETURN ENCLOSURES TO US
_____ WHEN DONE

WE TRANSMIT:
☐ herewith ☐ under separate cover via _____
☐ as requested _____

THE FOLLOWING ITEMS:
☐ Drawings ☐ Change Order ☐ Samples
☐ Specification ☐ Shop Drawings ☐ Copy of Letter
☐ Products/Literature ☐ Other _____

FOR YOUR:
☐ approval ☐ distribution to parties ☐ information
☐ record ☐ review & comments ☐ use
☐ other _____

QUANTITY	DESCRIPTION	DATE

REMARKS:

BY: _____ COPIES SENT TO: _____ w/enclosures
 ☐
_____ _____
_____ _____

FIGURE 19.14 In the construction and contract administration phase of a project, transmittal forms are used to communicate with others and provide a record of those particulars.

ment of the cost of the item is requested at this time, and the order is sent to the supplier. When the item arrives, the designer inspects it for damage and has it stored, or preferably delivered, to the project at the appropriate time. The final payment is then requested from the client.

OCCUPANCY OR MOVE-IN

When construction has progressed to an appropriate point, the client occupies, or moves into, the project. The designer assists the owner in overcoming any obstacles that disrupt a smooth relocation. The work might be completely finished, or a few small items might still remain for the workers to do. The term *substantial completion* is used to determine whether the project is complete enough for the owner to move in. If the area is not completely finished, the designer compiles a punch list to indicate which items need to be finished or corrected before the owner makes final payment to the contractor. In some cases the designer might be requested to prepare moving specifications for the moving company or even take bids from several firms to do the work.

POST-OCCUPANCY EVALUATION

After the installation is complete and the client has occupied the project for a specified length of time, the designer should go back and assess the performance of the new environment

PURCHASE ORDER

Designer's Company Name
Address

Date_____

Project Name_____

P.O. No._____

TO_____

ATTN:_____

Quantity	Description of Item(s)	Net Unit Cost	Extended Amount

PLEASE COMPLY WITH THE FOLLOWING:

_____ Above purchase order should be billed direct to Designer.
_____ Acknowledge receipt of this Purchase Order and confirm delivery date, as the time schedule will be critical.
_____ Tag the order as instructed.
_____ Delivery is estimated to be _____ weeks.
_____ The order should be drop shipped, FREIGHT PREPAID, to the client.
_____ The order must arrive on the project site no later than _____.
_____ These items should not arrive on the project site before _____.
_____ Please advise the Designer at once if there are any changes in schedule.
_____ Delivery required inside of building.
_____ Any additional cost to the above order (i.e. packaging, crating, etc.) must be verified in writing for approval within five (5) days of receipt of this purchase order.
_____ Bill of Lading and name of carrier must be attached to invoices sent to Designer.

Authorized Signature

FIGURE 19.15 Example of a typical purchase order used for ordering furniture and other interior items.

and his or her own work. This post-occupancy evaluation can be performed at six months, a year, or longer, depending upon the agreement between designer and owner. If problems have occurred, it is better for the designer to be a part of the problem-solving team than to be blamed for executing bad solutions. From these evaluations, the designer can translate what was learned and apply these findings to new projects. Compensation for this work is arranged with the owner. A designer might perform this evaluation at no cost if he or she deems it important to the education process and for securing future work.

THE FUTURE OF INTERIOR DESIGN

Interior design is the future. The interior designer already looks to and works in the future. Designing today is concerned with producing ideas or products that will be realized in the immediate or long-range future. For example, an interior designer designs an environment in the present time, but it will not be built or occupied until a future date. In a sense, it can be said that interior design and the future are currently one and that the relationship is not really a new or special one.

As people expand their locations into hostile or new environments, such as space and other areas requiring technological microspheres for human necessities, the interior designer will be more in demand to create these responsive and responsible environments. The interior designer is committed to the betterment of our environments and the integration of all people's needs and aspirations for a quality life-style.

Interior design will continue to be explored, expressed, and reinterpreted into new directions, relationships, and theories. There really is no utopian pattern or method that the theory and practice of interior design will fall into. Design will continue to evolve through various philosophies and contrasts to former periods, as has occurred in the past. However, interior designers *will* continue to design and influence the future for the betterment of our world and the interrelationships of it and all civilization.

Interior design is as exciting and dynamic as the projects and people who make up the field. The interior designer can be an integral part of this future and have a substantive impact on the directions the field takes by actively committing to, and participating in, the professional practice of interior design.

Some of the issues facing interior design in the future include global awareness, human needs and participation, technology and design, and professionalism and regulation.

Global Issues

The interior designer must become more actively involved in global issues that shape our society. The designer should integrate social, political, economic, and environmental concerns into their design concepts. Global issues involve everything from technology to politics and have a great impact on the designer and the future.

The threat to worldwide peace has renewed our concerns for energy efficiency, global pollution, and environmentally sick interiors. Hazardous gases that come from building materials and products that pollute indoor air must be lessened for the users' habitation. The designer must strive to update knowledge and keep abreast of new research and developments in environmental issues and energy-efficient alternatives.

The designer must encourage the use of new materials that will not further deplete our scarce resources, such as the supply of exotic woods from the rain forests in South America and Africa. The designer can impact the future by influencing manufacturers and clients to use and appreciate new materials made from chemical and biochemical processes. He or she must learn to appreciate these new materials for their greater strength, light weight, and inherent beauty instead of using endangered materials and depleting our natural environment. Concerns for the

recycling of materials and components as well as the use of biodegradable materials (see Chapter 13) must also be addressed.

Human Needs and Participation

Interior spaces will be more carefully designed for optimum usages as both living and working units. These spaces will become smaller and will share a variety of activities and needs instead of being designed for specific, fixed uses. Creative living centers will be formed to promote a variety of group or single activities within the living environment, and team centers or resource centers will be added to working environments.

The designer will have to become more aware of the application of environmental psychology to maximize human productivity, achievement, and sense of well-being while minimizing undue stresses often associated with smaller environments and confinement. The interiors of the future will be loaded with sophisticated electronic equipment that will be more user friendly. These interiors will become mini-environments or microspheres that will automatically sense an individual entering the space and accordingly adjust lighting, heating, cooling, and acoustics and will provide psychological support to the individual. The latter component might be in the form of changing the spaces' colors, textures, shapes, or even materials. The interiors will actually seem to come alive and be responsive to the individual's needs, instead of the individual having to adapt to the environment.

Furnishings will become more modularized and systemized. Products will lose their mass identity and will seemingly be designed for individualistic expression. Seating units will conform to the individual's anthropometric needs and even heat or cool the body.

Users will become more actively involved in the design process. Through widespread research and education, the public will become more aware of design and want to participate in the process as they become better educated and more economically minded.

Technology and Design

Our society and economy will become more responsive to technological advancements, services, and instantaneous global informational exchanges. The interior designer will keep pace with these changes and create environments that are more conducive to functioning on micro- and macro-scaled linkages to other people, distant locations, and varying user needs. Furniture, equipment, and accessory improvements will create better communication between individuals meeting face to face and over great distances. Electronic developments and telecommunication networks will permit more decentralization of work environments and result in interiors that will create more integration of residential and nonresidential uses and spaces. However, these environments will become smaller as a result of economics and the availability of open spaces. The interior designer will need to design more creatively for optimum usage, flexibility, and quality of life in these integrated housing/work environments.

Interiors in the future will become more standardized in the usage of electronic equipment, yet provide more variety in type, uniqueness, and flexibility. This will all be accomplished using smaller amounts of natural resources for the generation of energy and will be more ecologically compatible with the global environment.

Computers will become more of an everyday use in our lives, including in the interior design office. Technological advances in these machines, software, and their related equipment will reduce the size of an office and workspace an interior designer needs, yet provide more support for designing increasingly complex projects while offering more services to a client. As computers become more user friendly, the interior designer will explore new concepts and directions in the creative design processes. The computer will become more of an extension of the mind, eye, and hand—freeing the user from mundane tasks and time-consuming drawing and permitting more instantaneous explorations of alternative design solutions. As the computer becomes a more common tool, the daily use of a computer by a designer will integrally involve graphic imaging as a logical extension of creative thinking, problem solving, and communication.

Professionalism and Regulation in Interior Design

Trends of regulation and professionalism will continue to develop in interior design. Education and training of interior designers will expose students to solving more complex problems, integrating design for quality of life, and keeping abreast of technological advancements. Client needs, concern for our environment, and design for cultural differences will create more demands on educational training and in turn raise the levels of expertise and professional standards in interior design.

Interior design is becoming a regulated profession through various licensing, certification, and accreditation agencies. These directions will continue to move the professional practice of interior design toward legal recognition and responsibility. The public will become more aware of these movements and will commission dedicated professionals instead of unqualified practitioners for interior design projects.

REFERENCES FOR FURTHER READING

Farren, Carol E. *Planning and Managing Interior Projects*. Kingston, Mass: R.S. Means Company, Inc., 1988.

Knackstedt, Mary V. *The Interior Design Business Handbook: A Complete Guide to Profitability*. New York: Whitney Library of Design, 1988.

Loebelson, Andrew. *How to Profit in Interior Design*. New York: Interior Design Books, Inc., 1983.

Murphy, Dennis Grant. *The Business Management of Interior Design*. North Hollywood, Calif.: Stratford House Publishing Company, 1988.

Piotrowski, Christine M. *Professional Practice for Interior Designers*. New York: Van Nostrand Reinhold, 1989.

Siegel, Harry, and Alan M. Siegel. *A Guide to Business Principles and Practices for Interior Designers*. Rev. ed. New York: Watson-Guptill, 1982.

Stasiowski, Frank. *Negotiating Higher Design Fees*. New York: Watson-Guptill Publications, 1985.

Veitch, Ronald M., Dianne R. Jackman, and Mary K. Dixon. *Professional Practice*. Winnipeg, Canada: Peguis Publishers Limited, 1990.

APPENDIX 1

ACCESSIBILITY STANDARDS FOR THE PHYSICALLY HANDICAPPED

ADAPTED FROM THE AMERICANS WITH DISABILITIES ACT
(Dimensions shown are in inches—with corresponding millimeters in parentheses.)

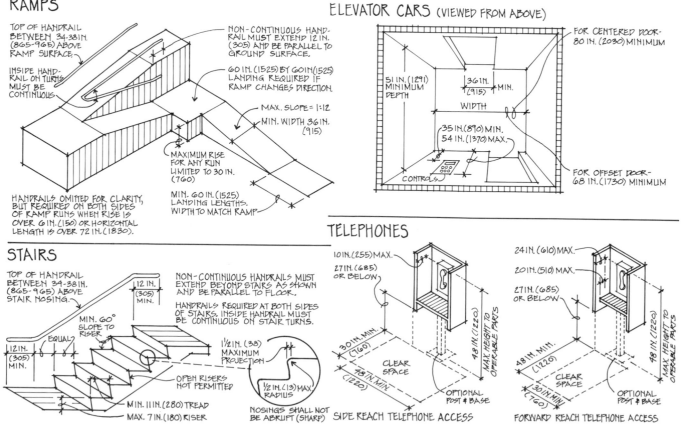

RAMPS

TOP OF HANDRAIL BETWEEN 34-38 IN. (865-965) ABOVE RAMP SURFACE.

INSIDE HANDRAIL ON TURNS MUST BE CONTINUOUS.

NON-CONTINUOUS HANDRAIL MUST EXTEND 12 IN. (305) AND BE PARALLEL TO GROUND SURFACE.

60 IN. (1525) BY 60 IN. (1525) LANDING REQUIRED IF RAMP CHANGES DIRECTION.

MAX. SLOPE = 1:12

MIN. WIDTH 36 IN. (915)

MAXIMUM RISE FOR ANY RUN LIMITED TO 30 IN. (760)

HANDRAILS OMITTED FOR CLARITY, BUT REQUIRED ON BOTH SIDES OF RAMP RUNS WHEN RISE IS OVER 6 IN. (150) OR HORIZONTAL LENGTH IS OVER 72 IN. (1830).

MIN. 60 IN. (1525) LANDING LENGTHS. WIDTH TO MATCH RAMP

ELEVATOR CARS (VIEWED FROM ABOVE)

FOR CENTERED DOOR- 80 IN. (2030) MINIMUM

51 IN. (1291) MINIMUM DEPTH

36 IN. (915) MIN.

WIDTH

35 IN. (890) MIN. 54 IN. (1370) MAX.

CONTROLS

FOR OFFSET DOOR- 68 IN. (1730) MINIMUM

STAIRS

TOP OF HANDRAIL BETWEEN 34-38 IN. (865-965) ABOVE STAIR NOSING.

12 IN. (305) MIN.

NON-CONTINUOUS HANDRAILS MUST EXTEND BEYOND STAIRS AS SHOWN AND BE PARALLEL TO FLOOR.

HANDRAILS REQUIRED AT BOTH SIDES OF STAIRS. INSIDE HANDRAIL MUST BE CONTINUOUS ON STAIR TURNS.

MIN. 60° SLOPE TO RISER

EQUAL?

12 IN. (305) MIN.

1½ IN. (38) MAXIMUM PROJECTION

½ IN. (13) MAX RADIUS

OPEN RISERS NOT PERMITTED

MIN. 11 IN. (280) TREAD

MAX. 7 IN. (180) RISER

NOSINGS SHALL NOT BE ABRUPT (SHARP)

TELEPHONES

10 IN. (255) MAX.

27 IN. (685) OR BELOW

30 IN. MIN. (760)

CLEAR SPACE

48 IN. MIN. (1220)

48 IN. MAX. HEIGHT TO OPERABLE PARTS (1220)

OPTIONAL POST & BASE

SIDE REACH TELEPHONE ACCESS

24 IN. (610) MAX.

20 IN. (510) MAX.

27 IN. (685) OR BELOW

48 IN. MIN. (1220)

CLEAR SPACE

30 IN. MIN. (760)

48 IN. MAX. HEIGHT TO OPERABLE PARTS (1220)

OPTIONAL POST & BASE

FORWARD REACH TELEPHONE ACCESS

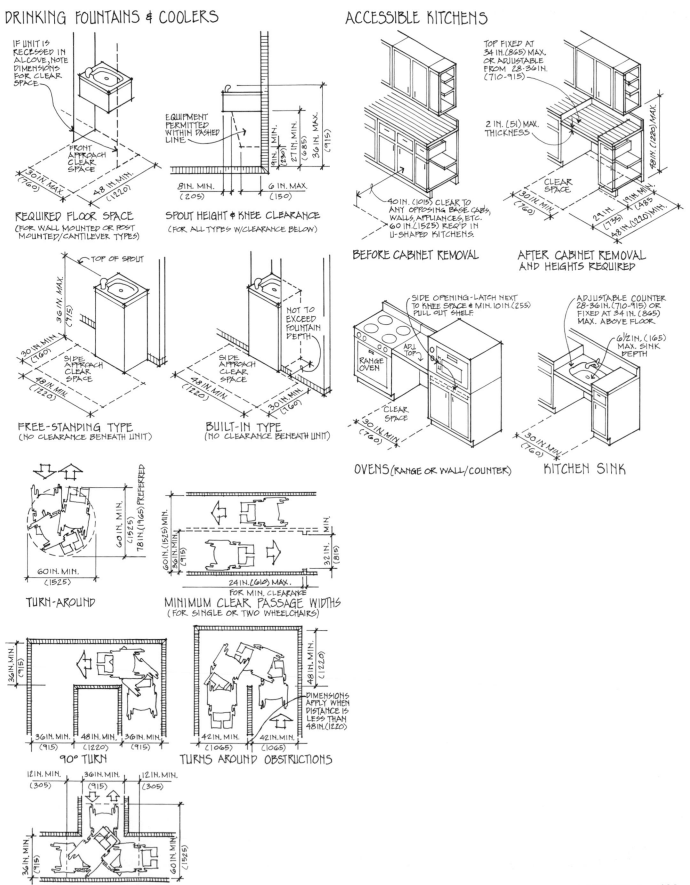

DRINKING FOUNTAINS & COOLERS

REQUIRED FLOOR SPACE
(FOR WALL MOUNTED OR POST MOUNTED/CANTILEVER TYPES)

IF UNIT IS RECESSED IN ALCOVE, NOTE DIMENSIONS FOR CLEAR SPACE

FRONT APPROACH CLEAR SPACE

30 IN. MAX. (760)
48 IN. MIN. (1220)

SPOUT HEIGHT & KNEE CLEARANCE
(FOR ALL TYPES W/CLEARANCE BELOW)

EQUIPMENT PERMITTED WITHIN DASHED LINE

9 IN. MIN. (229)
27 IN. MIN. (685)
36 IN. MAX. (915)

8 IN. MIN. (205)
6 IN. MAX. (150)

FREE-STANDING TYPE
(NO CLEARANCE BENEATH UNIT)

TOP OF SPOUT

36 IN. MAX. (915)
30 IN. MIN. (760)

SIDE APPROACH CLEAR SPACE

48 IN. MIN. (1220)

BUILT-IN TYPE
(NO CLEARANCE BENEATH UNIT)

NOT TO EXCEED FOUNTAIN DEPTH

SIDE APPROACH CLEAR SPACE

48 IN. MIN. (1220)
30 IN. MIN. (760)

TURN-AROUND

60 IN. MIN. (1525)
78 IN. (1965) PREFERRED

60 IN. MIN. (1525)

MINIMUM CLEAR PASSAGE WIDTHS
(FOR SINGLE OR TWO WHEELCHAIRS)

60 IN. (1525) MIN.
36 IN. (915) MIN.
32 IN. (815) MIN.

24 IN. (610) MAX. FOR MIN. CLEARANCE

90° TURN

36 IN. MIN. (915)

36 IN. MIN. (915)
48 IN. MIN. (1220)
36 IN. MIN. (915)

TURNS AROUND OBSTRUCTIONS

48 IN. MIN. (1220)

DIMENSIONS APPLY WHEN DISTANCE IS LESS THAN 48 IN. (1220)

42 IN. MIN. (1065)
42 IN. MIN. (1065)

180° TURNS AT T-SHAPED SPACE

12 IN. MIN. (305)
36 IN. MIN. (915)
12 IN. MIN. (305)

36 IN. MIN. (915)
60 IN. MIN. (1525)

ACCESSIBLE KITCHENS

BEFORE CABINET REMOVAL

40 IN. (1015) CLEAR TO ANY OPPOSING BASE CABS, WALLS, APPLIANCES, ETC. 60 IN. (1525) REQ'D IN U-SHAPED KITCHENS.

AFTER CABINET REMOVAL AND HEIGHTS REQUIRED

TOP FIXED AT 34 IN. (865) MAX. OR ADJUSTABLE FROM 28-36 IN. (710-915)

2 IN. (51) MAX. THICKNESS

48 IN. (1220) MAX.

CLEAR SPACE
30 IN. MIN. (760)

29 IN. (735)
19 IN. MIN. (485)
48 IN. (1220) MIN.

OVENS (RANGE OR WALL/COUNTER)

SIDE OPENING-LATCH NEXT TO KNEE SPACE & MIN. 10 IN. (255) PULL OUT SHELF.

APL TOP

RANGE OVEN

CLEAR SPACE
30 IN. MIN. (760)

KITCHEN SINK

ADJUSTABLE COUNTER 28-36 IN. (710-915) OR FIXED AT 34 IN. (865) MAX. ABOVE FLOOR

6½ IN. (165) MAX. SINK DEPTH

30 IN. MIN. (760)

APPENDIX 2

ESTIMATING MATERIAL NEEDS FOR INTERIORS

The interior designer is often asked to prepare estimates of quantity and costs for materials, as well as the cost of labor to install them. The material amounts and costs can easily be determined; however, the labor to do the work has many variables, such as estimated time to do the job, hourly wage costs, and profit margins. Other details, such as subsurface preparation requirements and tools needed, can also vary these costs.

Final material and cost estimates are best left to the various professional contractors, workrooms, dealers, and suppliers who are daily involved with material costs, labor rates, and installation details. However, the interior designer does prepare preliminary material and budget estimates that include calculations for soft flooring (carpets, vinyl, and others), hard flooring, drapery, and wall coverings.

CARPET AND VINYL FLOORING Carpeting is estimated in quantity and price by the square yard. To determine the approximate yardage needed, use the room(s) dimensions to ascertain the total square feet and divide by nine to convert to square yards. This method provides only a rough estimate, however, because carpet ordinarily is made in widths of 6, 9, 12, and 15 feet, and you must plan so that the most economical and practical layout of seaming these widths is determined. More accurate calculations can be performed by placing tracing paper over a scaled floor plan and plotting various layouts so that a particular carpet roll width will produce a minimum of seams, with those being at acceptable locations.

Once the total number of lengths required have been determined (in lineal feet), multiply the appropriate width in feet by this total number of lineal feet. Divide by nine to determine the total yardage required. Then add 5 to 10 percent for waste (angles, small pieces, leftover narrow strips) and some allowance for matching any pattern repeats.

In addition to the carpet price, any required padding or cushioning is calculated in yards and added to the carpet price. Installation costs are also usually priced by the square yard, although they can be calculated as a total figure on small jobs, and added to the carpet and pad costs.

Carpet squares or modules are estimated by generally determining the total square footage (or yardage) needed to cover the floor, and including a small allowance for waste.

Vinyl and other roll flooring materials are generally produced in 6-foot widths. Yardage needed is calculated according to seaming, similar to the process used with carpeting. Allowances must be made for seaming locations, waste, and pattern repeats.

HARD FLOORING Cost of hard flooring materials, such as ceramic tile, stone, and wood, is calculated by the square foot. The total square footage of the area to be covered is estimated, and allowances

for waste and pattern layouts are added. Installation costs per square foot also are added in, as are costs for miscellaneous cutting and subsurface preparation.

PAINT To estimate the quantity of paint needed to cover a surface (wall, ceiling, or floor), calculate its total square footage. To arrive at the total number of gallons needed, divide by the number of square feet a gallon will cover. Most containers are marked by the manufacturer to indicate their estimated square foot coverage, which ranges from 200 to 500 square feet. However, this coverage will vary according to the surface material's porosity, previous color, and rough texture. Labor costs are generally priced by the square foot or, on small projects, by the job.

WALL COVERINGS Methods of estimating wall-covering materials are as varied as the type of material used. Vinyls, wallpapers, and fabrics are manufactured in rolls and priced by the roll, square foot, or square yard. Widths of these rolls vary as the direction of pattern repeats requires.

Wall paper is priced in single, double, or triple rolls. A single roll is generally 27 inches wide and covers approximately 30 square feet, allowing for some waste. However, waste allowances can vary more than 20 percent, depending upon pattern matches and surfaces that may not be perfectly square or plumb. The amount of wallpaper needed is determined by calculating the total square footage of the wall or ceiling to be covered and dividing by 30 to obtain how many single rolls are required. Installation costs are priced by the square foot, by the number of rolls, or by the job.

Vinyl and fabric wall coverings usually are produced in roll widths of 52 inches but vary according to the specific type and manufacturer. These coverings are generally priced by the running yard. To estimate the number of running yards, calculate the surface area in square feet and divide by the appropriate roll width (converted to feet). This will indicate how many feet a roll will cover; this amount can be divided by 3 to determine the running yardage needed. Allowances must be made for waste and pattern repeats.

DRAPERY Fabrics for drapery material are made in widths of 36 to 118 inches. Estimates are made in linear yards, as related to a particular width purchased. Allowances are added for waste, pattern repeats, and fullness or degree of fold desired. Although various methods of construction are used for different types of draperies and curtains, some generalized estimates can be obtained by doing the following:

1. Measure width of the window or space to be covered.
2. Determine fullness factor (such as 1.5) and multiply it by the width gained from step 1.
3. Divide the total from step 2 by width of the fabric roll to determine number of widths required.
4. Determine finished length required by measuring height of space to be covered and adding 6 to 12 inches for hems at the bottom and top. This will result in the total height or length of each panel width needed.
5. Multiply height dimension (in inches) from step 4 by the number of panels and add approximately 10 percent for waste.
6. Divide the total from step 5 by 36 to determine the yardage required.
7. Add allowances to this total yardage for pattern repeats and other special features.

UPHOLSTERY The manufacturer's catalog or price list usually provides estimates of the upholstery material needed to cover a piece of furniture. This is particularly helpful when the designer is specifying COM (customer's own material) fabrics.

Upholstery yardages (cut from 52-inch widths) range from 2 yards for small chairs to 5 yards for executive or large chairs to 6 to 12 yards for various sofas. Waste allowances are added to take into account the direction and matching of patterns.

GLOSSARY

abstract design A type of design derived from natural or geometrical designs, but stylized to a level that makes it difficult to determine the source.

accessible A building, facility, or portion thereof that can be used by people with a physical handicap.

accessible route An unobstructed path through a building or facility that can be negotiated by persons in wheelchairs or with physical disabilities.

achromatic Colors that lack hue—specifically, black, white, or gray.

adaptability The capability of buildings or portions to be altered to accommodate persons with varying degrees of disabilities.

adobe Sun-dried bricks of earth and straw. (Some modern adobe contains cementous additives.)

afterimage When the human eye focuses on a strong hue, then switches to a neutral ground, the complement hue appears.

analogous colors Colors that are adjacent on a color wheel.

analysis Breaking down or dissecting the whole to study the parts and their interrelationships.

anthropometrics The measurement and study of the proportions and size of the human body.

antique An object from earlier time periods, often 100 years ago or before 1830 (according to U.S. customs laws).

applique Transfer process for color or pattern that uses a pressure-sensitive coating on one material to allow transfer to another.

arabesque Decorative motif containing a leaf and scroll pattern with stems spiralling from a root or other element.

armoire A large, free-standing cabinet or wardrobe piece with doors.

ashlar Masonry construction of rectangularly cut stone.

asymmetrical balance Arrangement of different objects so that they tend to stabilize or balance one another.

atrium A central space or courtyard surrounded by a building. Historically, it was the center courtyard of a Roman house, today it can also mean a glassed-over central space.

balance The arrangement of objects that creates a physical or visual equilibrium.

balustrade A series of vertical supports of a stair rail.

banquette A built-in seating unit or upholstered bench along a wall; usually found in restaurants.

batten A strip of wood or metal used to cover the joints between panels or boards.

bauhaus A school of art, design, and architecture in Germany from 1919 to 1933 advocating the integration of art and technology. It led to the development of modern design.

beam Large horizontal member in a structural system that carrys loads to vertical columns or walls below.

bentwood Wood strips softened with steam and bent around forms for permanent shapes when dry.

biodegradable The capability of something to readily decompose naturally in the environment.

bond Method of joining masonry that affects the strength of the assembly, durability, and appearance.

brown coat The second coat of a three-coat plaster application.

buttress A structure built against a wall to reinforce or support it.

cabriole leg Furniture support resembling the shape of an animal's leg.

cant A bevel or slope on a material.

cantilever A horizontally projecting element (beam or structure) that is secured at one end only.

capital The uppermost portion of a column or pillar.

casement window A window that has outward swinging sashes, similar to a door swing.

cement A powder of alumina, silica, lime, iron oxide, and magnesia that is burned in a kiln. Cement is used as the binding ingredient in concrete and mortar.

chamfer A beveled edge or corner, usually cut at 45 degrees.

chroma The intensity or saturation of a particular hue.

clerestory A windowed wall placed high in a building, usually between two roof levels.

coffer A three-dimensional decorative pattern in a ceiling, dome, or vault. (Also, a chest or strongbox.)

complementary colors Any two colors directly opposite each other on a color wheel.

concrete Cement and aggregates combined with water to become moldable. It cures to a strong, heavy, permanent building material.

conduction The transfer of heat energy through matter, as from a warm material to a cooler material.

convection The transfer of heat energy through the atmosphere, such as in air currents.

cornice The crowning horizontal member of an architectural composition. A horizontal band near the ceiling or at the top of a window for concealing drapery tops and rods.

daybed A couch that can also serve as a bed.

design process A sequential method of creating and solving design problems.

distressed A technique used on wood to give the finish an appearance of age.

dormer A vertical window set in a sloping roof, or the roofed projection from a sloping roof.

ductile Property of a metal that allows it to be drawn into a wire shape.

dutch door Style of door with independent, swinging lower and upper halves.

eclectic An effect achieved by choosing motifs and forms from various sources, philosophies, and periods.

egress The path and related elements of a building that provide a safe exit and meet the applicable regulatory codes.

ergonomics The study of human beings and their relationships to working conditions and environments.

emphasis A design principle that gives importance to an area or object to make it stand out and hold the interest of the viewer.

entablature The upper portion of a classical order, which is composed of the architrave, cornice, and freize.

fascia A horizontal band or facing, generally found on a building's roof projection.

flat slicing Method of cutting wood veneer from a log by slicing parallel to a line through the center of a log.

float glass Sheet glass produced by floating molten glass over a layer of molten metal.

fluorescent Light produced in a glass tubular lamp by discharging electricity through mercury vapor to produce light.

form The three-dimensional shape of an object that exhibits volume and mass.

geodesic dome A hemispherical structural form based on straight bar-shaped members or triangulated surfaces.

girder A large beam generally placed horizontally to support roof and floor joists or other, smaller beams.

grout A thin paste mortar used to fill cracks, provide setting beds, or join masonry and tile units.

gypsum board Thin paper-faced panels of gypsum (a plaster-like substance) used for basic interior and exterior walls, ceilings, and other surfaces. Also called wallboard or drywall.

harmony A design principle that expresses a combination of parts into a pleasing whole.

hassock An upholstered footstool or seat.

hopper window Type of window that is hinged at the bottom and swings inward or outward.

hue The distinctive attributes of a color that enable it to be named and assigned a specific place in the color spectrum—such as red, yellow, or blue.

ideate The process of imagining or conceiving an idea.

indigenous Native, or related to a specific country, region, or geographical area.

infrastructure Environments that integrate systems for people movement, communications, power, wastewater disposal, and information.

inlay A design produced by inserting one material into another, producing a flush, decorative surface.

insulation Materials that prevent the excessive transfer of heat, cold, sound, and electricity from one space or medium to another.

integrity The quality of being honest, sincere, or complete in principle.

intensity Brightness or dullness of a hue (color).

international style Twentieth century style of design that emphasizes structure, function, and material and is devoid of ornament or a national identity.

jalousie window Type of window composed of narrow glass (or other material) slats held horizontally in an adjustable frame and that operates similar to venetian blinds.

jamb The vertical side sections of a window or door frame.

joist A horizontal framing member of a floor or roof that supports a bearing surface and generally frames into a beam or other members.

juxtapose To place side by side or closely related together.

landing A horizontal platform at the bottom, intermediate area, or top of a stairway.

latex Elastic compound or paint, usually water based.

lath Metal or wood base material to which plaster or stucco is applied.

line A design element that connects two points. Can also depict the outline of a form or shape.

lumen The measure of the flow of light as a unit of time from a point source.

lux Unit of illumination equal to one lumen per square meter.

mantel The horizontal shelf projecting over a fireplace.

marquetry An inlay technique that sets shells, ivory, metal, or woods into a wood veneer.

metamerism The effect of different kinds of illumination in modifying the appearance of a color.

mezzanine Story placed between two floor levels; a balcony that projects over a floor level.

modular A standardized series of units or measurements that are scaled in a manner to allow their integration with one another in a variety of ways.

molding Strip of wood or plaster that protrudes from a plain surface, such as a ceiling, door, or wall.

monochromatic Color scheme based on a single hue.

mortar A mixture of cement, plaster, or lime with water and sand, used to bond units in masonry and tile construction.

mullion The vertical dividing bar in windows, glass doors, or other glazed assemblies. Also referred to as "muntin."

multifamily dwelling A building containing more than two dwelling units.

muntin See mullion.

nap A fabric surface that appears fuzzy due to the composition of short fibers or hairs.

nave The main part of a church, usually between the side aisles and extending from the entrance to the chancel.

niche Small half-domed recess or hollow in a wall used primarily for the display of a statue or other focal piece.

nosing The projecting edge of a tread over a riser in stairs.

oculus Relating to the eye or lens of an optical instrument. Also, the circular roof opening in the Roman Pantheon.

orders The name given to the classical architectural styles of Greek and Roman columns and their related parts.

orientation Alignment, arrangement, or placement of something in relation to other factors, i.e., the points of a compass.

ottoman A low, cushioned footstool sometimes referred to as a hassock.

pagoda A religious structure of the Far East. Generally a pyramidal temple of several stories.

paradigm A model or example of something.

patina Finish on wood or metal surfaces produced by age, waxing, use, or exposure to the elements, particularly moisture.

pediment A triangular form above a door, window, or portico.

pilaster A vertical column or support projecting partially from a wall.

plaster Thick pasty material of lime, sand, and water which hardens when dry. Used for finishing interior ceilings and walls.

plenum A concealed space below the floor or above the ceiling used for mechanical and electrical equipment or operations.

portico Porch, covered entry, or colonade of a building.

postmodernism A design movement in the 1970's and 1980's which is a reaction against the modern movement.

proportion The relationship of parts to each other or to the whole.

proxemics The study of the cultural and spatial needs of people and their interactions.

quoin The wedge-shaped keystone of an arch or a large angled stone at the corner of a building.

radial balance Arrangement similar to symmetrical balance, but radiating outward from a center.

radiation The transfer of energy through the air by way of electromagnetic waves, such as from the sun.

reflectance The amount, expressed in a percentage, of incident light that is reflected from a surface.

refraction The deflection or bending of light rays from their direct path when passing through a specific medium.

reinforced concrete Concrete will steel reinforcing rods added to increase the tensile strength.

rendering A pictorial representation of a proposed design, generally in perspective; it can be in black & white or in color. Also called delineation.

rhythm A design principle characterized by a regular recurrence of features or elements.

riser The vertical section of a stair between the treads.

run The overall total horizontal distance of a stair; the sum of all the treads and any landing.

r-value A measure of resistance in a material to thermal transfers.

scale The relative size of an object as related to a familiar standard, i.e., the human body.

settee A small sofa or bench with a back and arms.

shade Value of a hue produced by adding black or white.

shape The identifiable contours of an object or space.

shellac A liquid film used in finishing wood and other surfaces. Made from dissolving the wastes of the lac bug in alcohol solutions.

simultaneous contrast The contrast or differences between intensity, value, and hue. A perceived change of color when one color appears as two different hues when placed on, or adjacent to, different colored backgrounds.

sleeper Recessed wood or metal furring strip in a concrete floor to which floor-finishing material adheres.

soffit The horizontal underside of a projecting cornice, eave, or ceiling. Also, the boxed-in section of a ceiling above a sink, cabinets, etc.

space A design element consisting of a continuous expanse of distance extending in all directions.

stain Part of a finishing process in painting that involves pigments suspended in oils, water, or other agents.

stainless steel Steel alloyed with chromium to make it rust and stain resistant.

steel A metal alloy of carbon and iron.

stoneware A durable, dense, and waterproof pottery containing silica or sand and flint in the clays. Often used for distinctive dinnerware.

stucco A plaster-type mortar mix used primarily on exterior surfaces.

symmetrical balance Arrangement of objects in a mirror-image axis. Also called bi-lateral balance.

synergism The combined working efforts of the parts that together produce a total output greater than their individual effects.

synthesis Integrating the parts together to form a whole.

task lighting Light required for performing a specific activity.

taxonomy System of ordering and arranging something into groupings or related categories.

tensile strength Capacity of a material to resist tearing apart under longitudinal stresses.

terrazzo Stone flooring made by combining crushed stone and cement, then grinding and polishing to a smooth surface.

tetrad colors Any four colors spaced equidistantly around a color wheel.

textile A fabric construction made by weaving, knitting, etc.

texture Apparent surface quality as perceived through tactile or visual senses.

threshold The doorsill or piece of material that lies beneath a door or doorway.

tint The shading of a color resulting from the addition of white.

tone The value or quality of a hue—tint or shade.

track light A luminaire mounted on a surface or recessed electrical raceway that can be repositioned or removed.

tread The horizontal portion of a stair; the part that is stepped on.

triad colors Any three colors that are equidistant from on another around a color wheel.

trombe wall A passive solar system utilizing glazing panels over dark-colored masonry or concrete walls. It collects, stores, and releases heat into the interiors of a building.

Trompe-l'oeil A painting of scenes or objects that creates an illusion of reality for the observor. From the French, "Deceive the eye".

uniform building code (ubc) One of several national building codes that sets standards of materials and construction methods for compliance to health, safety, and welfare needs of the general public.

unity A design principle that produces a harmonious relationship among all the parts of an object or space.

valance A header assembly over the top of a window that directs natural or artificial light upward or downward.

value The darkness or lightness of a color in a gray scale from black to white.

variety A design principle that is used to express differences in objects or spaces to counteract monotony or sameness.

veneer A thin surface of a quality material that is applied over another of lesser quality; usually seen in plywood construction where thin plys are layered over composite wood construction.

ventilator A device that allows for the admittance or expulsion of air.

vernacular Belonging to the distinguishing characteristics of a peoples' culture and native language.

vestibule Small entry room or hall to enter a building or pass between other interior rooms.

visible spectrum The portion of visible light energy that we can see and those that contain visible colors.

wainscot Paneling or wall treatment that does not reach the ceiling.

water closet The technical name of what is usually called a toilet.

wavelength Distance measured between the progression of a wave (such as light) from any given point to the corresponding point in the same phase.

work triangle The imaginary triangular path in kitchen design that connects the three major centers (refrigerator, cook range, and sink).

yarn A string produced by twisting fibers or other materials for use in fabric construction.

zero clearance A term used to describe a metal fireplace that can be set into combustible walls with little or no clearances.

zoning Designation and allowances in an area for specific types of uses, activities, enterprises, and buildings.

PHOTO & ART CREDITS

FIGURE 1.1 UN Photo 153477/Peter Magubane. **1.2** © George Holton/Photo Researchers, Inc., N.Y.C. **1.3** Alinari/Art Resource, N.Y. **1.4** Marburg/Art Resource, N.Y. **1.5** Residence of Elsie de Wolfe. Dining Room Before Redecorating, 1898. The Byron Collection, Museum of the City of New York. **1.6** Residence of Elsie de Wolfe. Dining Room After Redecorating, 1898. The Byron Collection, Museum of the City of New York.

FIGURE 2.2 © David M. Stone PHOTO/NATS. **2.3** © David M. Stone PHOTO/NATS. **2.4** Courtesy of the Henry Ford Museum, Dearborn, MI. **2.5** Courtesy of Susan Ewing/Interalia Design. Photographer, Rick Potteiger. **2.6** Courtesy of Bannerworks, Inc. Photographer, Karl Bischoff. **2.7** Courtesy of Kevin Longhran Designs, Santa Barbara, CA. **2.8** Alinari/Art Resource, N.Y. **2.9** Courtesy of Transamerica Corporation. **2.11** © George Holton/Photo Researchers, Inc., N.Y.C. **2.14** Courtesy of Designer: The Rowland Associates, Inc. **2.17** Alinari/Art Resource, N.Y. **2.18** Alinari/Art Resource, N.Y. **2.19** Marburg/Art Resource, N.Y. **2.21** Marburg/Art Resource, N.Y. **2.22** PPG Place, Pittsburgh, PA, headquarters of PPG Industries, Inc. **2.24** Scala/Art Resource, N.Y. **2.25** Alinari/Art Resource, N.Y. **2.34** Giraudon/Art Resource, N.Y. **2.37** © A.F. Kersting, 37 Frewin Rd., London S.W. 18. **2.38** Bridgeman/Art Resource, N.Y. **2.43** Courtesy of The Henry Francis du Pont Winterthur Museum. **2.48** © Photo R.M.N. Musees Nationaux. **2.49** Courtesy of Victoria and Albert Museum, London. **2.53** Courtesy of The Henry Francis du Pont Winterthur Museum. **2.55** Color lithograph by J. Nash. From Dickenson's *Comprehensive Pictures of the Exhibition*, 1854. **2.56** SEF/Art Resource, N.Y. **2.58** Art Resource, N.Y. **2.59** SEF/Art Resource, N.Y. **2.60** © Andrew Rakoczy/Art Resource, N.Y.

FIGURE 3.2 Courtesy of the Victoria and Albert Museum, London. **3.3** Courtesy of the Waltham Historical Commission; City of Waltham. Photographer, Richard Cheek. **3.5** Sandak, Inc., Boston, MA. **3.6** Hedrich-Blessing, Chicago. **3.7** Hedrich-Blessing, Chicago. **3.13** Courtesy of Thonet Industries, Inc., Statesville, NC. **3.14** Angelo Hornak Library, London. **3.16** Courtesy of ICF. **3.17** Courtesy of Herman Miller, Inc. Archives. **3.19** Courtesy of the Knoll Group, Saarinen Collection. **3.22** Courtesy of Herman Miller, Inc. Archives. **3.23** Courtesy of The Kimbell Art Museum. Photographer, Michael Bodycomb. **3.24** © Yan Lukas/Photo Researchers, Inc., N.Y.C. **3.27** Courtesy of Michael Graves, Architect; Assoc. Architect Alan Lapidus; Photo by Steven Brooke. **3.30** Courtesy of Michael Graves, Architect; Assoc. Architect Alan Lapidus; Photo by William Taylor.

FIGURE 4.2 © Paolo Koch/Photo Researcher, Inc., N.Y.C. **4.4** Courtesy of the Chrysler Corporation. **4.5** Photo Researchers, Inc., N.Y.C. **4.6** Photography: Image Source, Inc./John C. Jenkins Fiber artist: Iran Lawrence. **4.7** Alinari/Art Resource, N.Y. **4.9** Courtesy of Leslie Carabas, Berkeley, CA. **4.13** Courtesy of McNall & Blackstock Advertising and Design, Pasadena, CA. **4.15** Courtesy of Michael Graves, Architect. Photographer, Kim Sargent. **4.17** Photographer, James R. Steinkamp. Courtesy of Murphy/Jahn. **4.18** Courtesy of

Eric Miller Architect. Drawing by Gary Saxton. **4.19** © Timothy Hursley, Little Rock, AR. **4.21** Courtesy of Kasler & Associates, IN. **4.22** Courtesy of Gensler and Associates/Architects, Photographer, Nick Merrick/Hedrich-Blessing, Chicago. **4.23** Courtesy of The Rowland Associates, Inc. Mar Dan Photography/Dan Francis. **4.25** Courtesy of Perkins & Will, Chicago. Photographer, Wayne Cable; Cable Studios, Inc. **4.26** © Beryl Goldberg, N.Y. **4.27** Courtesy of Sandra Christine Q. Berger, Designer. Photography, William A. Porter **4.28** Courtesy Department of Library Services, American Museum of Natural History. **4.29** Courtesy of Andrea and Timothy Biggs. **4.30** Courtesy of Kuleto Consulting & Design, Sausalito, CA. **4.31** Courtesy of Armstrong Interiors, Inc. Chevy Chase, MD, Photographer: Robert C. Lautman. **4.32** Courtesy of EverGreene Painting Studios, Inc. **4.33** Courtesy of WILSONART. Photographer, Greg Hursley. **4.34** Courtesy of Andersen Window Corporation. **4.36** Courtesy Dixon Associates AIA/Architects. Photographer, Michael A. Dixon, AIA. **4.37** Courtesy of Andersen Window Corporation. **4.38** Hedrich-Blessing, Chicago. **4.39** Courtesy of Gensler and Associates Architects. Photographer; Jaime Ardiles—ARCE, N.Y. **4.40** Designer, Hammond Beeby and Bubka, Inc. Photographer, Timothy Hursley, Little Rock, AR.

FIGURE 5.1 Courtesy of Bannerworks, Inc. Photographer, Sam Fortress. **5.2** Courtesy of G.E. Lighting. **5.3** Courtesy of G.E. Lighting. **5.4** Courtesy of G.E. Lighting. **5.4** Courtesy of G.E. Lighting. **5.6** Courtesy of G.E. Lighting. **5.8** Courtesy of G.E. Lighting. **5.9** Courtesy of G.E. Lighting. **5.11** Figure from *Inside Today's Home*, Third Edition by R. Faulkner, Copyright © 1968 by Holt, Rinehart and Winston, Inc., reprinted by permission of the publisher. **5.12** Courtesy of G.E. Lighting. **5.14** Figure from *Design Through Discovery*, Third Edition by M.E. Bevlin et al, Copyright © 1977 by Holt, Rinehart and Winston, Inc.; reprinted by permission of the publisher. **5.15** Courtesy: Munsell Color, Baltimore, MD. **5.16** Courtesy: Munsell Color, Baltimore, MD. **5.17** Figure from *Design Through Discovery*, Third Edition by M.E. Bevlin et al, Copyright © 1977 by Holt, Rinehart and Winston, Inc.; reprinted by permission of the publisher. **5.18** Figure from *Inside Today's Home*, Third Edition by R. Faulkner, Copyright © 1968 by Holt, Rinehart and Winston, Inc.; reprinted by permission of the publisher. **5.19** From Frans Gerritsen's *Theory & Practice of Color*, © by Cantecleer BV, De Bilt, The Netherlands. **5.20** From Frans Gerritsen's *Theory & Practice of Color*, © by Cantecleer BV, De Bilt, The Netherlands. **5.21** Harald Kuppers' *Color* p. 69/1973, Van Nostrand Reinhold (Ltd.), London. **5.22** Harald Kuppers' *Color* p. 118/1973, Van Nostrand Reinhold (Ltd.), London. **5.25** Courtesy of Mary Jean Thompson, ASID; Reno, Nevada. **5.26** Courtesy of Bannerworks, Inc. Photographer, Edward Jacoby **5.27** From Frans Gerritsen's *Theory & Practice of Color*, © by Cantecleer BV, De Bilt, The Netherlands. **5.28** Josef Albers' *Interaction of Color*, Plate VI-3, 1975; © Yale University Press. **5.29** From Frans Gerritsen's *Theory & Practice of Color*; © by Cantecleer BV, De Bilt, The Netherlands. **5.31** Josef Alber's *Interaction of Color*, Plate VII-4, 1975; © Yale University Press. **5.32** Courtesy of Gensler and Associates Architects. Photographer, Sharon Risedorph. **5.33** From Frans Gerritsen's *Theory & Practice of Color*; ©

by Cantecleer BV, De Bilt, The Netherlands. **5.34** Courtesy of Design Plan, Inc.

FIGURE 6.18 Courtesy of Michael Creed.

FIGURE 8.4 Courtesy of Hunter Marine Corportation. **8.6** Courtesy of Deck House, Inc. Action, MA. **8.8** Courtesy of WILSONART. Photography, Dan Ham. **8.10** Courtesy of Charles Cunniffe & Associates, Aspen, CO. **8.12** Zeiloporm Torino Anthracite by Allmilmo Corp., Fairfield, NJ & West Germany. **8.14** Courtesy of Murphy Bed Company. **8.19** Hedrich-Blessing, Chicago. **8.20** Hedrich-Blessing, Chicago. **8.22** Courtesy of WILSONART. Photographer, Dan Ham **8.23** Courtesy of Ralph Wilson Plastics. **8.24** Courtesy of Charles Cunniffe & Associates, Aspen, CO. **8.26** Courtesy of Ralph Wilson Plastics. **8.31** Courtesy of Pella/Rolscreen Co. **8.33** Courtesy of Florian Greenhouse, Inc., West Milford, N.J. **8.34** Courtesy of California Redwood Association.

FIGURE 9.1 Courtesy of Gensler and Associates Architects. Photographer, Jaime Ardiles-ARCE. **9.2** Courtesy of Pacific Bell Administrative Complex. Photographer, Jane Lidz. **9.3** Courtesy of Gensler and Associates/Architects. Photographer, Jaime Ardiles—ARCE. **9.10** Designed and occupied by Haines Lundberg Waehler. Photographer, Peter Paige. **9.11** Courtesy of Steelcase, Inc., Grand Rapids, MI. Photographer, Rick Mendoza. **9.12** Courtesy of Gensler and Associates/Architects. **9.13** Designer, Haines Lundberg Waehler; Photographer, Peter Paige. **9.14** Designer, Haines Lundberg Waehler; Photographer, Peter Paige. **9.15** Courtesy of Gensler and Associates/Architects. Nick Merrick/Hedrich-Blessing. **9.16** Union Federal Savings Bank, Indianapolis, IN. Interiors by DesignPlan, Inc. **9.17** Courtesy of Armstrong Interiors, Inc. Chevy Chase, MD. **9.19** Courtesy of Armstrong Interiors, Inc. Chevy Chase, MD. **9.20** Designer, Booth/Hansen and Associates; Photographer, Wayne Cable. **9.21** Courtesy of Kubula Washatko Architects, Inc. Cedarburg, WI. Photographer, Mark Heffron. **9.22** Food Court, Town Center at Boca Raton, Boca Raton, FL. RTKL Associates Inc., Architects. **9.23** Courtesy Irvine Associates Architects, Inc., Houston, TX. Photographer, George Gomez. **9.24** Lighting Design, Ross De Alessi and Brian Fogerty, Luminae Souter Lighting Design. Photographers, Ross De Alessi and Loretta Lowe. **9.25** Courtesy of Gensler and Associates. Photographer, Sharon Risendorph. **9.26** Courtesy of Gensler and Associates. **9.28** Courtesy of Kovacs and Associates, Inc., Toluca Lake, CA. Photographer; Milroy/McAleer. **9.30** Courtesy of Eric Miller, Architect. Drawing by Gary Saxton. **9.31** Construction by R.D. Olson, Anaheim, CA. Photographer, Milroy/McAleer. **9.34** Anso IV Nylon Carpet, Photo Courtesy of Allied Fibers.

FIGURE 10.1 Courtesy of Media Five Limited, Honolulu, HA. Photographer, Ron Starr. **10.2** Courtesy of the Arco Santi Foundation, Phoenix, AZ. **10.12** Courtesy of Hnedak Bobo. Photographer, Jeffrey Jacobs. **10.13** Courtesy of Kasler & Associates.

FIGURE 11.2 Courtesy of The Neenan Company. **11.9** Courtesy of PPG Industries. **11.17** Courtesy of GE Plastics. **11.20** Courtesy of Schindler Elevator Corpora-

tion. **11.24** Photographer, Christopher Little/Courtesy of Hardy Holzman Pfeiffer Associates.

FIGURE 12.1 Courtesy of Cooper Liaghting/Halo Lighting. **12.5** Courtesy of Illuminating Engineering Society of North America, New York. **12.6** Courtesy of G.E. Lighting. **12.10** Courtesy of Philips Lighting Company, a division of North American Philips Corporation. **12.13** Courtesy of Philips Lighting Company, a division of North American Philips Corporation. **12.15** Courtesy of Philips Lighting Company, a division of North American Philips Corporation. **12.17** Courtesy of Murphy/Jahn Architects. **12.18** Designer, The Rowland Associates, Inc., Mar Dan. Photographer, Dan Francis. **12.21** Courtesy of Design Plan, Inc., Indianapolis, IN. **12.22** Designer, Victor Huff Partnership Inc. Photographer, Karl Francetic. **12.26** Courtesy of Kasler & Associates, Inc. **12.29** Courtesy The Neenan Company. **12.30** Courtesy The Neenan Company. **12.33** Courtesy of Designer: The Rowland Associates, Inc. Photographer, Barry Rustin. **12.34** Courtesy of HTI/Space Design International, New York. Photographer, Don Broff. **12.35** Courtesy of GE Lighting. **12.36** Photographer, Ron Starr. **12.37** Courtesy of Michael Graves Architect; Associate Architect, Alan Lapidus. Photographer, Steven Brooke **12.38** Courtesy of Kasler & Associates, Inc. Indianapolis, IN.

FIGURE 13.3 Courtesy of Eagle Window and Doors, Inc., Dubuque, IA. **13.9** Courtesy of Evergreen Systems USA Inc. **13.11** Courtesy of Edward S. Wohl Woodworking and Design. Photographer, Bill Lemke. **13.14** Courtesy of Gensler and Associates Architects. Photographer, Jaime Ardiles—ARCE. **13.15** Courtesy of Charles Cunniffe & Associates, Architects. **13.16** Courtesy of Kasler and Associates, Cincinnati, Ohio. **13.20** Photographer, John Hubbell Architectural Photos, Dallas, TX. **13.21** Courtesy of Gensler and Associates. Photographer, Chas McGrath. **13.25** Line Design by Kathy Barnard; color and glass by Larry Etzen, Kansas City, MO. **13.29** Courtesy of Andersen Window Corporation, Inc. **13.30** Courtesy of Bannerworks, Inc. Photographer, Richard Neill.

FIGURE 14.6 © Photographer, Photo Researchers, Inc. **14.8** Courtesy of Pearce Structures. **14.9** UPI/Bettmann. **14.10** Photographer, Rob Banayote. **14.14** Courtesy of Designer: The Rowland Associates, Inc. Photographer, Elliot Fine. **14.15** Courtesy of Designer: The Rowland Associates, Inc. **14.16** Courtesy of Design Plan, Inc. **14.18** Hedrich Blessing, Chicago. **14.25** Courtesy of

Designer: The Rowland Associates, Inc. **14.26** Courtesy of Architectural Paneling, Inc. **14.27** ©Timothy Hursley, Little Rock, AK. **14.28** ©Timothy Hursley, Little Rock, AK. **14.29** Courtesy of Formglas Interiors Inc., Ontario, Canada. **14.30** Courtesy of WILSONART/Ira Montgomery. **14.32** Courtesy of Architectural Paneling, Inc. **14.34** © Timothy Hursley, Little Rock, AK.

FIGURE 15.1 Courtesy of Kasler & Associates, Indianapolis, IN. **15.4** Courtesy of Architect: Perkins and Will. Photographer, Van Ingewen. **15.9** Courtesy of Andersen Window Corporation. **15.11** Courtesy of Charles Cunniffe Architects. Photographer, © Steve Mundinger 1990. **15.13** Courtesy of Anderson Window Corporation, Bayport, MI. **15.17** Courtesy of Pella/Rolscreen Company, Pella, Iowa. **15.19** Courtesy of WILSONART/Ira Montgomery. **15.23** © Jack Parsons, Santa Fe, New Mexico.

FIGURE 16.2 Courtesy of ISICAD, Inc. © 1989. **16.4** Courtesy of Panel Concepts, L.P. Santa Ana, CA. **16.5** The Mies Van Der Rohe Barcelona Collection, The Knoll Group. **16.7** Courtesy of Michael Graves, Architect; Associated Architect, Alan Lapidus. Photo Credit, Steven Brooke. **16.8** Courtesy of Herman Miller, Inc., Zeeland, MI. Photographer, Earl Woods. **16.10** Courtesy of Samsonite. **16.11** Courtesy of Krueger International, Green Bay, WI. **16.12** Courtesy of the Designer: The Rowland Associates, Inc. Photography: Elliot Fine. **16.14** Courtesy of Kasler and Associates, Cincinnati, Ohio **16.16** Courtesy of Michael Graves, Architect. Assoc. Architect, Alan Lapidus; Photo Credit, Steven Brooke. **16.17** Courtesy of Sico Incorporated, Minneapolis, MN. **16.19** Courtesy of Schulte Corporation, Cincinnati, Ohio. **16.20** Courtesy of WILSONART/John Fry. **16.22** Courtesy of the Spacesaver Group, Fort Atkinson, WI. **16.23** Courtesy of Herman Miller, Inc., Freeland, MI. **16.24** Courtesy of the owner, Charles Larman, and the designer, The Rowland Associates, Inc. **16.25** Courtesy of Ratio Architects, Indianapolis, IN. **16.28** Courtesy of Allied Fibers, New York. **16.29** Courtesy of Herman Miller, Inc. **16.30** Courtesy of WILSONART/Ira Montgomery. **16.31** Courtesy of Thonet Industries, Inc., York, Pa. **16.34** Courtesy of Media Five Limited, Honolulu, HA. Photographer, David Frazer. **16.35** Courtesy of AL-LIBERT CONTRACT, Stanley, N.C.

FIGURE 17.1 Courtesy of Victor Huff Partnership, Inc. **17.2** Courtesy of Eric Miller, Architect. Drawing by Gary Saxton. **17.3** Courtesy of Architectural Paneling Inc.

17.4 Courtesy of Andersen Corporation. **17.5** Courtesy of Armstrong Interiors, Inc. Chevy Chase, MD. **17.6** Courtesy of Gensler and Associates, San Francisco, CA. Photographer, George Jardine. **17.7** Courtesy of Kasler and Associates, Cincinnati, Ohio. **17.8** Courtesy of Evans and Brown, San Francisco, CA. **17.9** Courtesy of Fabrique, Inc., Phoenix, AZ. "Kinetikos" #5 by Pam Castano. **17.10** Courtesy of the Designer: The Rowland Associates, Inc., Indianapolis, IN. Photographer, Barry Rustin. **17.11** Courtesy of Kubala Washatko Architects. Photographer, Mark F. Heffron. **17.12** Courtesy of Bannerworks, Inc. **17.13** Courtesy of Kasler & Associates, Inc. **17.14** Courtesy of Media Five Limited, Honolulu, HA. Photographer, David Franzen. **17.15** Courtesy of CSO Interiors, Indianapolis, IN. **17.16** Courtesy of Kenneth Hurd & Associates. Photographer, Edward Jacoby. **17.18** Courtesy of HTI/Space Design International, New York. **17.19** Courtesy of Michael Graves Architect. Assoc. Architect, Alan Lapidus; Photo Credit, Steven Brooke. **17.20** Courtesy of Whyte-Kerner Environmental Graphics and Design, Atlanta, GA. **17.21** Courtesy of Perkins & Will, Architect. Photographer, Van Ingewen. **17.23** Courtesy of Swanke, Hayden, Connell, New York. Photographer, Robert Miller. **17.24** Courtesy of Marshall Erdman and Associates, Madison, WI. **17.25** Courtesy of Media Five Limited, Honolulu, HA. Photographer, David Franzen.

FIGURE 18.1 Courtesy of Environmental Systems Design, Longmont, CO. Drawn by V. Thornton. **18.5** Courtesy of Prelim Inc., Dallas, TX. Designer, Werner Boone. **18.7** Courtesy of Eric Miller, Architect. **18.11** Courtesy of Perkins and Will, Chicago, IL. **18.12** Courtesy of Eric Miller, Architect. **18.19** Courtesy of Eric Miller, Architect. **18.25** Courtesy of Eric Miller, Architect. **18.27** Courtesy of Eric Miller, Architect. **18.28** Courtesy of Perkins and Will, Chicago, IL. **18.29** Courtesy of Prelim Inc., Dallas, TX. Cayman Islands Condo. **18.31** Courtesy of Eric Miller, Architect. Drawing by Gary Saxton. **18.32** Courtesy of Environmental Systems Design, Longmont, CO. **18.33** Courtesy of Gensler and Associates. **18.34** Courtesy of Lannon Architects, Grand Island, NY. **18.36** Courtesy of Integraph Corporation. **18.37** Courtesy of Fluor Daniel, Irvine, CA and Integraph Corporation.

FIGURE 19.3 © AIA Document B171 1990. **19.9** Courtesy of Eric Miller, Architect. Drawings by Gary Saxton. **19.11** Courtesy of Design Plan, Inc.

Index

Page numbers in italics refer to figures.